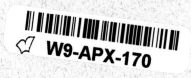

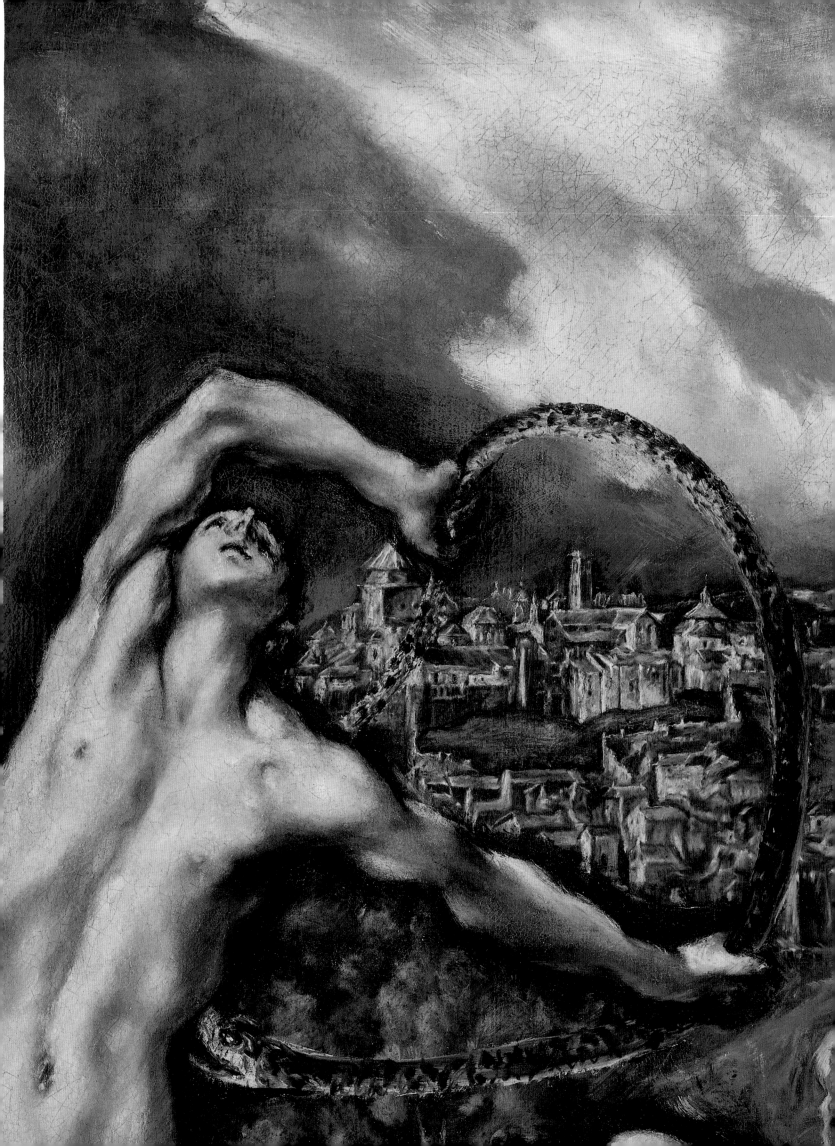

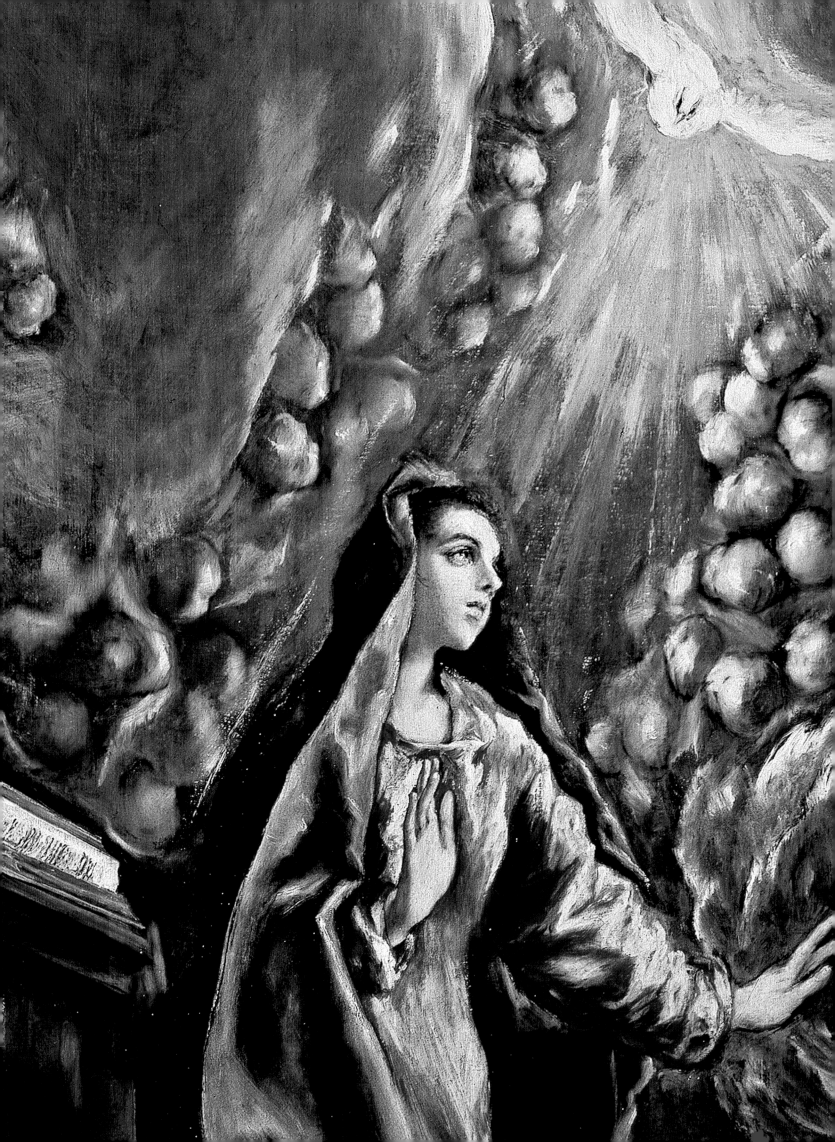

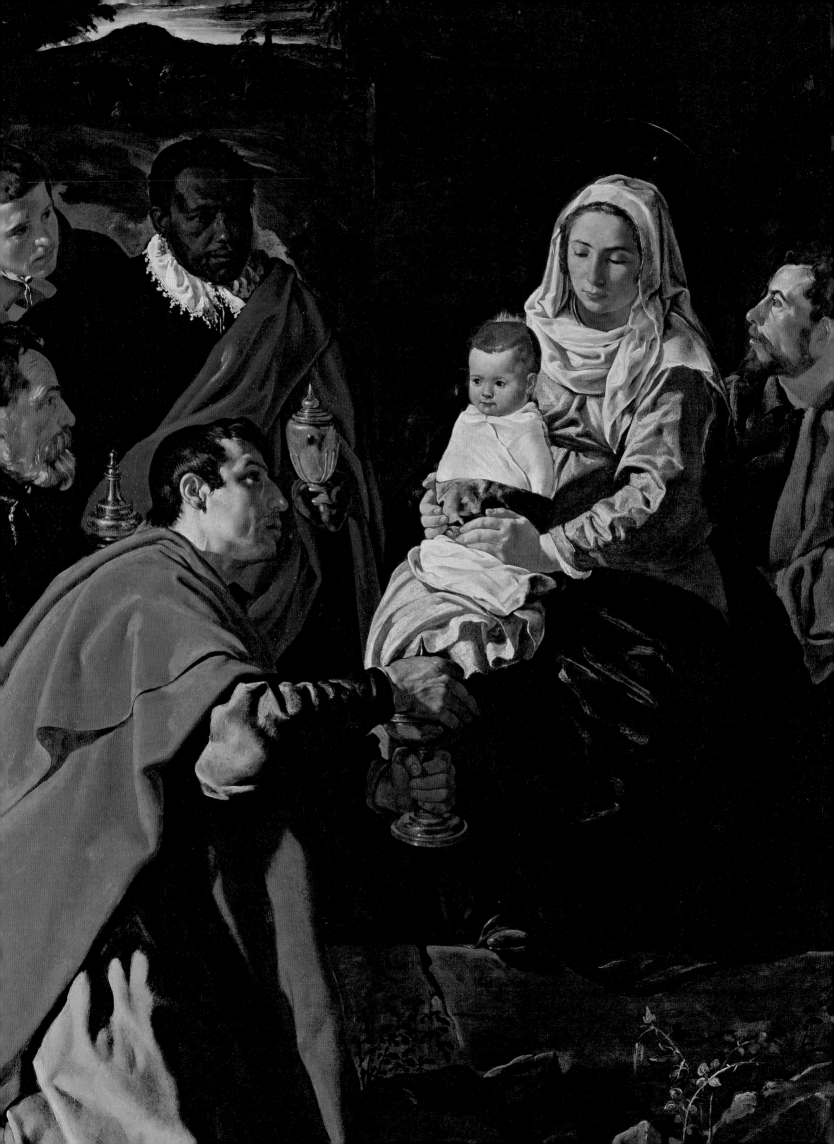

EL GRECO
TO
VELÁZQUEZ

Art during

the Reign of

Philip III

SARAH SCHROTH AND RONNI BAER

with essays by

Ronni Baer, Laura R. Bass, Antonio Feros, Rosemarie Mulcahy,

and Sarah Schroth

MFA PUBLICATIONS

Museum of Fine Arts, Boston

Published in association with the Nasher Museum of Art at Duke University

MFA Publications
Museum of Fine Arts, Boston
465 Huntington Avenue
Boston, Massachusetts 02115
www.mfa-publications.org

This book was published in conjunction with the exhibition "El Greco to Velázquez: Art during the Reign of Philip III," organized by the Museum of Fine Arts, Boston, and the Nasher Museum of Art at Duke University.

Museum of Fine Arts, Boston
April 20, 2008–July 27, 2008

Nasher Museum of Art at Duke University
August 21, 2008–November 9, 2008

The exhibition is sponsored by Bank of America.

Additional support provided by the National Endowment for the Humanities, The Homeland Foundation, and the National Endowment for the Arts.

The exhibition and this catalogue are presented with the collaboration of the State Corporation for Spanish Cultural Action Abroad (SEACEX), which is supported by the Spanish Ministry for Foreign Affairs and Cooperation and the Ministry of Culture.

SEA CEX
Sociedad Estatal
para la Acción
Cultural Exterior

Generous support for the catalogue was also provided by Scott and Isabelle Black.

Special thanks to the Mary Duke Biddle Foundation; the William R. Kenan, Jr. Charitable Trust; the Program for Cultural Cooperation between Spain's Ministry of Culture and United States Universities; the Edward T. Rollins, Jr. and Frances P. Rollins Foundation; the John A. Schwarz III and Anita Eerdmans Schwarz Family Endowment; and the Office of the President and the Office of the Provost, Duke University.

For a complete listing of MFA Publications, please contact the publisher at the above address, or call 617 369 3438.

Front cover:
El Greco, *Saint James (Santiago el Mayor)*, detail (catalogue 33)
Back cover:
Juan Bautista Maino, *Adoration of the Magi*, detail (catalogue 21)

Edited by Matthew Battles
Copyedited by Julia Gaviria

Designed and produced by
Cynthia Rockwell Randall
Printed and bound at
Arnoldo Mondadori Editore, Verona, Italy

Available to the trade through
D.A.P. / Distributed Art Publishers
155 Sixth Avenue, 2nd floor
New York, New York 10013
Tel.: 212 627 1999 · Fax: 212 627 9484

FIRST EDITION
Printed and bound in Italy
This book was printed on acid-free paper.

Contents ⚜

Directors' Foreword

The Museum of Fine Arts, Boston, and the Nasher Museum of Art at Duke University are pleased to present this seminal exhibition, which brings together works of art created in Spain during the reign of Philip III (1598–1621) and offers audiences an opportunity to gain new insights into a fascinating but relatively little-known period. Although the great painters of this time—those whose names we recognize—have been the subjects of monographic exhibitions in the United States (Velázquez in 1989, Ribera in 1992, and El Greco in 2003), they have never been seen in the context of the art created by their contemporaries. Americans, even those knowledgeable about the history of art, are hard pressed to name a single artist active in Spain during the period from El Greco's first Madrid commission to Velázquez's earliest production. This exhibition and its catalogue, conceived and brought to life by Sarah Schroth, Nancy Hanks Senior Curator at the Nasher Museum of Art at Duke University, and Ronni Baer, Mrs. Russell W. Baker Senior Curator of European Painting at the Museum of Fine Arts, Boston, are meant to remedy that lack of familiarity. Visitors will be surprised by the superb artistic quality and innovative subject matter of this group of painters and sculptors who are virtually unknown outside Spain. We believe that *El Greco to Velázquez: Art during the Reign of Philip III* will bring about a reevaluation of the art of this period by revealing the artists' splendid accomplishments in creating a new visual language that addressed the political, religious, and social demands of their particular time.

El Greco to Velázquez: Art during the Reign of Philip III takes issue with the commonly held view that Philip III was an unsophisticated art patron whose decadent and misguided reign was managed by the duke of Lerma, a self-serving and corrupt favorite who abused the tremendous power granted him by a weak and indolent king. The new thesis is based on recent scholarship by Antonio Feros, a contributor to this catalogue, that successfully challenges the dominant model by examining the positive accomplishments and novel political ideas introduced by the king and Lerma, who in essence was the first European prime minister. Furthermore, the discovery of Lerma's household inventories by Sarah Schroth, revealing that he owned more than two thousand paintings, has established him as one of Europe's first major nonroyal collectors. Because of Lerma's example, picture collecting became a fashion at court. Artistic influences from other European centers were felt in Spain, through the importation of Italian and Flemish paintings, through local commissions that were executed by foreign artists, and through travel by artists to and from Spain. This cross-pollination helped to develop

new stylistic currents and led to many iconographic innovations in early-seventeenth-century Spanish art.

In contrast to Philip II's austere and solemn style of governing, Philip III and the duke of Lerma organized gala celebrations and intricate religious fiestas, including elaborate *Semana Santa* (Holy Week) processions. They also conducted several major building campaigns (the duke of Lerma built, enlarged, or restored no less than five palaces), and made popular the ideas of recreation and travel among members of the court. Noblemen were admitted into the circle of the king for the first time since the mid-fifteenth century, creating new opportunities for wealth and power. This "new style of grandeur" is evident in the lace, armor, and other indications of luxury and power found in the portraiture of the period as well as in the duke of Lerma's *camarín*. This room, evocatively re-created for the exhibition, featured Chinese and Iberian ceramics and Venetian and Catalan glass, and was meant to impress the visitor through a dazzling display of artistic virtuosity and geographic diversity.

At the same time, Philip III, known as "Pious Philip," understood the power of art to assert the primary dogmas of the Catholic Church in dramatic and readily accessible imagery. The religious art of the time reflected the new, intense forms of devotion that were based on the practices of contemporary Spanish mystics who, in the previous reign, had been questioned by the Inquisition.

The book published on the occasion of this exhibition features much new scholarship. Antonio Feros provides an historical framework in which to understand the Spain of Philip III. Ronni Baer has written a narrative of the lives of the artists based on documentary evidence that has been gathered, updated, and published for the first time in English in the biographies. Sarah Schroth provides the first complete synthesis of the art of the time, explicating how it reflects the political goals, the religious atmosphere, and the social changes of the period. Rosemarie Mulcahy takes as her subject the images, personages, and institutions that reflected and promoted the position of the Catholic Church during the reign of Pious Philip. Laura R. Bass focuses on the great Spanish Golden Age figures of Cervantes, Lope de Vega, and Luis de Góngora, the subject of Velázquez's great portrait in the exhibition. The work of these fine scholars will provide the foundation for much future research on the Spain of Philip III.

Projects of this size and complexity require the financial support of enlightened individuals, foundations, and corporations. We are once again deeply indebted to Bank of America for their most important and continuing partnership with the Museum of Fine Arts, Boston, and now, for the first time, with the Nasher Museum of Art at Duke University. We are also most grateful to the State Corporation for Spanish Cultural Action Abroad (SEACEX), the National Endowment for the Humanities, The Homeland Foundation, the National Endowment for the Arts, Scott and Isabelle Black, the Mary Duke Biddle Foundation, the William R. Kenan, Jr. Charitable Trust, the John A. Schwarz III and Anita Eerdmans Schwarz Family Endowment, the Edward T. Rollins, Jr. and Frances P . Rollins Foundation, The Program for Cultural Cooperation between Spain's Ministry of Culture and United States Universities, and the Office of the President and the Office of the Provost of Duke University for their belief in the power of art to move, educate, and delight audiences. It is not an exaggeration to say that this ambitious exhibition could not have been realized without these generous benefactors. We are also extremely grateful to have been supported by an indemnity from the Federal Council on the Arts and the Humanities.

Early in their planning of the exhibition, the curators were fortunate to receive the generous assistance of the Spanish Ambassador to the United States, Carlos Westendorp, and the Cultural Counselor, Jorge Sobredo, who embraced the project enthusiastically and offered invaluable advice. Crucial loans that brought the project to life were graciously promised by the Museo Nacional del Prado; the Metropolitan Museum of Art; the National Gallery of Art; the National Gallery, London; the Kunsthistorisches Museum, Vienna; and the inimitable Plácido Arango. We are extremely grateful to these lenders, and to all the other public institutions and private lenders who generously allowed us to exhibit their precious works of art. Finally, we would like to thank the curators, Sarah Schroth and Ronni Baer, for their dedication, persistence, and enthusiasm.

MALCOLM ROGERS
Ann and Graham Gund Director
Museum of Fine Arts, Boston

KIMERLY RORSCHACH
Mary D. B. T. and James H. Semans Director
Nasher Museum of Art at Duke University

Acknowledgments

We extend our very deep gratitude to the lenders, on whose generosity this exhibition rests. At the Kunsthistorisches Museum in Vienna: Wilfried Seipel and Karl Schütz; at the Musées royaux des Beaux-Arts de Belgique in Brussels: Michel Draguet and Valérie Haerden; at the Fitzwilliam Museum, Cambridge: Duncan Robinson and David Scrase; at the National Gallery in London: Charles Saumarez Smith, David Jaffé, and Dawson Carr; at the Ashmolean Museum in Oxford: Christopher Brown and Catherine Whistler; at the Musée des Beaux-Arts in Orléans: Annick Notter and Isabelle Klinka; at the Musée du Louvre: Henri Loyrette and Vincent Pomarède; at the Musée des Beaux Arts in Strasbourg: Fabrice Hergott and Dominique Jacquot; at the National Gallery of Scotland in Edinburgh: Michael Clarke and Aidan Weston-Lewis; at the Glasgow Museums: Robert Wenley; at Nuestra Señora de Consolación in El Pedroso: Rdo. D. Fernando García Gutiérrez and Rdo. D. Juan José Andrés Romero; at the Museo de Bellas Artes in Granada: Ricardo Tenorio Vera. In Madrid we were accorded many important loans; we are indebted to Plácido Arango; Rosa Regàs, Isabel Ortega, and Isabel Clara García-Toraño at the Biblioteca Nacional; Miguel Granados Pérez and José Miguel Granados; Felipe and Marcela Hinojosa; Fernando Betero and Hermano Ministro Antonio Pérez Aranda at the Hospital de la Venerable Orden Tercera de San Francisco; Carlos FitzJames Stuart, Duque de Huéscar, and Cristina Partearroyo Lacaba at the Instituto de Valencia de Don Juan; Paz Cabello Carro, Letizia Arbeteta Mira, and Ana Castaño Lloris at the Museo de América; Miguel Zugaza, Gabriele Finaldi, Leticia Ruiz, and Alejandro Vergara at the Museo Nacional del Prado; Rosendo Naseiro; Yago Pico de Coaña de Valicourt, Juan Carlos de la Mata González, Rosario Diez del Corral Garnica, Carmen Cabeza, and Ana García Sanz at the Patrimonio Nacional; Víctor Nieto Alcaide and Mercedes González Amezua at the Real Academia de Bellas Artes de San Fernando; and José Luis and Juan Varez Fisa. At the Cabildo Catedral Metropolitano in Seville, our loan request was supported by Carlos Amigo Vallejo, Francisco Navarro Ruiz, and Teresa Laguna; at the Museo de Bellas Artes in Seville: Ignacio Cano Rivero and Antonio Alvarez Rojas; at the Museo del Greco in Toledo: Ana Carmen Lavín Berdonces and Luis Caballero García; at the Museo de Bellas Artes in Valencia: Fernando Benito Doménech and José Gomez. In Valladolid our visit was graciously facilitated by Jesús Urrea Fernández, director of the Museo Nacional de Escultura. In that city we are grateful to Javier Carlos Gómez Gómez at the Church of San Miguel/San Julián; José-Luis Fernández Medina and Carmen Santamaria at the Confraternity of Nuestra

Señora del Carmen Extramuros; and Ramiro Ruiz Medrano and Concha Gay at the Diputación Provincial de Valladolid. At the Art Institute of Chicago, James Cuno, Douglas Druick, and Martha Wolff generously assisted us; at the Cleveland Museum of Art: Timothy Rubb and Charles Venable; at the Corning Museum of Glass: David Whitehouse and Dedo von Kerssenbrock-Krosigk; at the Kimbell Museum in Fort Worth: Timothy Potts and Malcolm Warner; at the Wadsworth Atheneum in Hartford: Willard Holmes and Eric Zafran; at the J. Paul Getty Museum in Los Angeles: Michael Brand and Scott Schaefer; at the Minneapolis Institute of Arts: William Griswold and Patrick Noon; at the Metropolitan Museum of Art: Philippe de Montebello, Keith Christiansen, Larry Kanter, Ian Wardropper, Jessie McNab, Danielle Grosheide, and Denny Stone; at the North Carolina Museum of Art in Raleigh: Lawrence Wheeler and David Steele; at the Peabody Essex Museum in Salem: Dan Monroe and William Sargent; at the San Diego Museum of Art: Derrick Cartwright and Steven Kern; at the Fine Arts Museums of San Francisco: John Buchanan and Lynn Federle Orr; and at the National Gallery of Art in Washington: Rusty Powell, David Alan Brown, Philip Conisbee, and Gretchen Hirschauer.

We would like to acknowledge the following scholars and friends for their help, guidance, and support in seeing the project to fruition: Carlos Alberdi, Christopher Aller-González, Judith Ara Lázaro, Miguel Angel Cortés, Bentley Angliss and Richard de Willermin, Laura R. Bass, Isabelle and Scott Black, Mrs. Nicholas Biddle, Xavier Bray, Jonathan Brown, Enrique de Calderón and José Antonio de Urbina, Carmen Cerdeira, Fernando Checa, David Davies, Antonio Feros, Susan Freudenheim, Carmen Garrido, Julie Hall, Enrique Iranzo, Chiyo Ishikawa, Willam Jordan, Patricia Leighten, Rafael López-Barrantes, Gloria Martínez, Miguel Morán Turina, Padre Waldo Moreno Fernández, Rosemarie Mulcahy, Diego Olivé, Marilyn Orozco, Viorica Patea, Carlos Robles, Susan Schulman, Suzanne Stratton-Pruitt, and Jesús Urrea.

The work of a few individuals facilitated every aspect of this project, and the curators are deeply grateful to them. Carolina Sánchez Cordova and Xiomara Murray were indispensable to the realization of both the exhibition and its catalogue. Crucial research and translations were also provided by Christopher Atkins, Niria Leyva-Gutiérrez, Susie Wager, and Lisa Banner. Tracey Albainy (1962–2007), the Russell B. and Andrée Beauchamp Stearns Curator of Decorative Arts and Sculpture in the Art of Europe at the MFA, gave unstintingly of her time and expertise to help choose the objects for the *camarín*. It is our great regret that she did not live to see its installation in the exhibition.

At the Museum of Fine Arts, other colleagues in the Art of Europe, including George Shackelford, Frederick Ilchman, Marietta Cambareri, Deanna Griffin, John Steigerwald, and Brooks Rich, have helped in ways both large and small. Hao Sheng, Wu Tung Curator of Chinese Art, affably and capably aided us in selecting objects from the rich holdings of the MFA for the *camarín*. The director, Malcolm Rogers; deputy director for curatorial affairs, Katie Getchell; director of exhibitions and design, Patrick McMahon; and Matthew Siegal, chair of conservation and collections management, encouraged, supported, and facilitated this project in countless ways. The team at MFA Publications—Cynthia Randall, Terry McAweeney, Mark Polizzotti, Jodi Simpson, Esther Paredelo, Julia Gaviria, and especially Matthew Battles—beautifully rose to the challenge of publishing a complex book by producing a volume to accompany the exhibition that is lovely both to hold and to read. Bill McAvoy and his team did an admirable job of

fundraising; Melissa Gallin was especially helpful in preparing grant applications. Kim French, Dawn Griffin, Jennifer Weissman, and Phil Getchell creatively and enthusiastically promoted the exhibition. In Museum Learning and Public Programs, we benefited from the collaboration and wisdom of Barbara Martin, Ben Weiss, and Lois Solomon. The demands on our library were great; Deborah Smedstad, Lorien Bianchi, and Liz Prince provided indispensable assistance with our innumerable requests. Our able registrar, Patricia Loiko, spent an extraordinary amount of time and care in getting the objects safely to and from the exhibition venues. In conservation, Rhona MacBeth for paintings and Abby Hykin for objects provided essential advice, information, and technical support. Andy Haines took care of the frames and Steve Deane and Brett Angell made the mounts, enabling the *camarín* to shine. The beautiful installation was designed by Jaime Roark; Janet O'Donoghue and Jennifer Liston Munston were responsible for the handsome graphics. Dave Geldart and his talented craftsmen and crew gave the exhibition at the MFA its final physical form.

At the Nasher Museum of Art at Duke University, Director Kimerly Rorschach was a constant source of support during this project in every way possible. We would like to acknowledge the extraordinary efforts of the Nasher's small staff in coping with such a major undertaking: Lieutenant Martha C. Baker and William Gray expertly coordinated all aspects of security; Rita Barden proved invaluable in managing catalogue inventory and keeping the office running smoothly; Michelle Brassard organized our events with panache; Juline Chevalier and Julie Thompson devoted endless hours to making the exhibition accessible to all; Dorothy Clark, our deputy director for operations, served as spokeswoman and manager, selflessly pitching in; Ken Dodson solved every technical and facility challenge; Jamie Dupre offered support whenever needed; David Eck expertly handled our visitors' needs; Brad Johnson and his installation staff, Harvey Craig, Alan Dippy, and Patrick Krivacka, made the show look elegant and impressive; Wendy Livingston successfully promoted the exhibition beyond all our expectations; Catherine Morris assisted in all aspects on the business end with thoroughness and good humor; Trevor Schoonmaker and Anne Schroder assumed countless extra curatorial duties, and Anne shouldered the outreach to faculty at Duke and area universities; Myra Scott and Shelby Spaulding handled all registrarial matters with great professionalism; Rebecca Swartz led our fundraising efforts; and Alicia Emr helped create a successful marketing and promotional effort.

At Duke, we are especially grateful to the university's President Richard H. Brodhead, Executive Vice President Tallman Trask III, and Provost Peter Lange for their enthusiastic support. These members of the university assisted our small staff in realizing the complex preparations for this exhibition: Vice President of Campus Services Kemel Dawkins, our legal counsel Ralph McCaughan, Cynthia Brodhead, Aaron Greenwald, Stephen Jaffe, Scott Lindroth, and Ellen Medearis. We owe a special debt of gratitude to Nasher Museum Board of Advisors member Michael Marsicano for his advice and advocacy, as well as the longtime supporters of the project Tom Kenan, Mary Semans, John and Anita Schwarz, and Frances P. Rollins. We are indebted as well to the late Raymond D. Nasher and Nancy Nasher, who have been great champions for this exhibition.

Finally the authors would like to thank Nick and Joe Cariello, the Schroth family, Daniel and Cherie Baer, and Steven, Jake, and Jane Elmets for their unstinting support and encouragement.

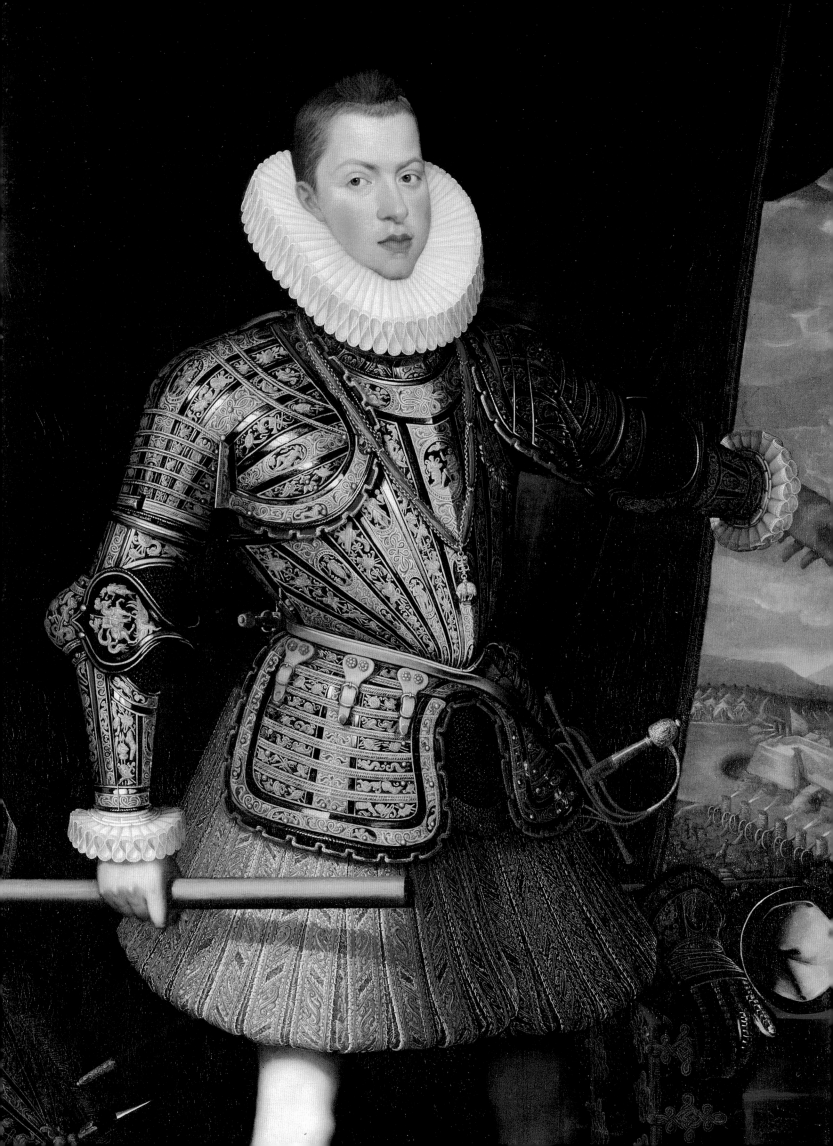

Art and Spanish Society:
The Historical Context, 1577–1623

ANTONIO FEROS

Domenicos Theotokopoulos (1541–1614), better known as El Greco, moved to Spain in 1577 in search of Philip II's artistic patronage. Forty-six years later, in 1623, another painter, Diego Velázquez (1599–1660), moved from Seville to Madrid to become royal painter. During this period, between 1580 and 1623, the Spanish monarchy was without doubt the most powerful European polity. Many European contemporaries of El Greco and Velázquez believed that Spain was, or at least aspired to become, a "universal monarchy," or to use today's concept, a superpower.

In reality Spain did not then or afterward achieve such preeminence, but by all standards Spain did have an impressive monarchy created by conquest, marriages, and dynastic alliances. The list of lands ruled by the Spanish monarchs still impresses us today: all the kingdoms in the Iberian Peninsula, including Portugal and its empire from 1580 to 1640; the kingdoms of Sicily and Naples as well as Milan in the Italian Peninsula; the Low Countries, known today as Belgium and Holland; many territories in the Americas, extending from Florida in the North American continent to the area today called Chile and Argentina in South America; the Philippine Islands in Asia; a few possessions in Africa; and the Canary Islands in the Atlantic. No wonder that Philip represented his power, and perhaps his most secret ambitions, through a favorite motto, "The World is not Enough."[1]

Territorial expansion gave the Spanish monarchs prestige and (although less than historians claim) riches with which to raise powerful armies. But territorial expansion also conveyed enormous responsibility and created numerous occasions to spend the taxes paid by their subjects as well as silver from the Americas. Given the extent of their rule, Spanish monarchs believed that every conflict and crisis anywhere in the world affected the internal stability of their kingdoms. With respect to Europe, Spanish rulers believed it was their obligation and prerogative to intervene in the internal affairs of other polities whenever they understood Spanish geopolitical interests or the security of Catholics to be compromised. Modern historians have defined these views as "messianic imperialism," signifying that Spanish monarchs believed, as Philip II certainly did, that they had a preeminent role in world politics, because they had been selected by God to unify the world under the aegis of Spain and the Catholic Church.[2]

Contemporary Spaniards agreed, at least until the end of the sixteenth century, that Spain was the most powerful nation of their times, and many approved of Philip II's international policies, even the most radically expansionist. But, at the same time, Philip II's and Philip III's subjects were aware of the contradictory nature of their age; they perceived the intricacies of their political world, participated in the debates taking place within the monarchy itself about the state of Spanish institutions, and wondered whether there were signs of an impending decline.

While later commentators would date the so-called Spanish decline to the last years of the sixteenth century, contemporaries of El Greco and Velázquez viewed the situation in more complex ways. Given the power of the Spanish monarchy and the richness of its court culture, many Spaniards believed they were living in a Golden Age, a time of hope and vision, of political reform, of new and brilliant artists and painters. Spaniards were also aware that they were living in what Don Quijote called an Age of Iron, when economic crisis was creating an enormous army of vagabonds and criminals, when war was destroying the financial and moral foundations of the society, a time defined by anxieties, plagues, political corruption, military defeats, violence, and religious persecution.[3]

Changes in the Monarchy

Spaniards were aware that the political system in which they lived was not static. People living between 1575 and 1623 knew three monarchs—Philip II (r. 1556–98) (fig. 1), his son Philip III (r. 1598–1621) (see cat. 7), and his grandson Philip IV (r. 1621–65) (fig. 2)—each of them very different in personality and style, in political views and goals, and each supported by his own men and advisers. Many other components were integral to the Spanish body politic during this period, which was very much alive with political debates and struggles for power.

El Greco was motivated to leave Venice for Toledo by the hope of finding employment with Philip II for the decoration of the royal palace of El Escorial, officially finished in 1584. This unique palace—a complex of royal residence, royal necropolis, and monastery—with its paintings and sculptures and the contents of its library, represented in various ways the historical significance of the Spanish monarchy. Philip and the designers of the palace wanted to convey that the Spanish monarchs had a special relationship with the Christian church and, at the same time, to represent Spain as the New Jerusalem and Philip II as a ruler mystically linked to the biblical kings who were represented by the sculptures of Jehosaphat, Hezekiah, David, Solomon, Josiah, and Manasses created by the Spanish artist Juan Bautista Monegro for the facade of the palace.[4]

Whether Philip, his ministers, and his subjects fully accepted the message of these artistic representations is less important than what these images and ideas tell us about the purpose of the existing political system. The iconological programs of El Escorial celebrated a political system that was at the highest point of its prestige and political stability. When the palace was finished, the Spanish monarchy was without doubt the most stable polity in Western Europe. Since the early 1520s, there had been no significant political conflicts. Only the so-called

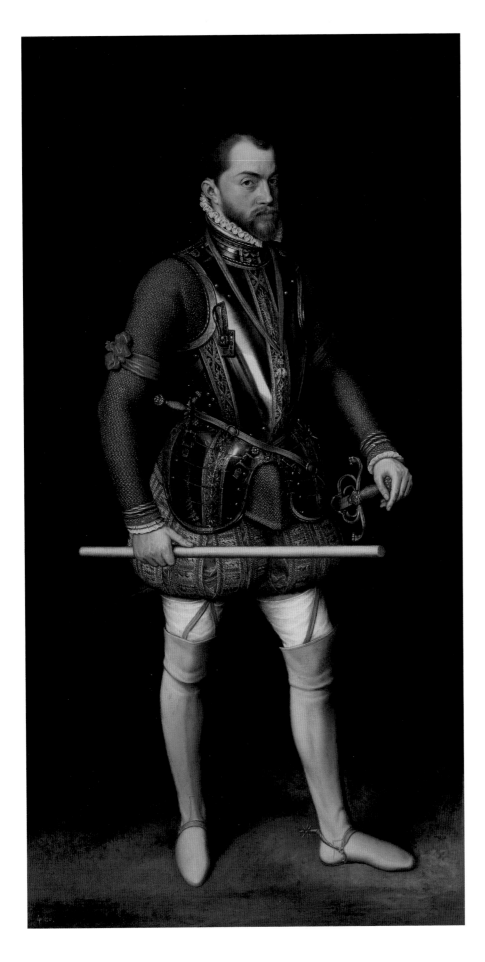

1
Antonis Mor
Portrait of Philip II, about 1557
Oil on panel, 54⁵⁄₁₆ x 49³⁄₁₆ in. (138 x 125 cm)
Real Monasterio San Lorenzo de El Escorial,
Madrid

2
Diego Rodríguez de Silva y Velázquez and workshop
Philip IV, 1624
Oil on canvas, 82⅛ x 43⅜ in. (208.6 x 110.2 cm)
Museum of Fine Arts, Boston

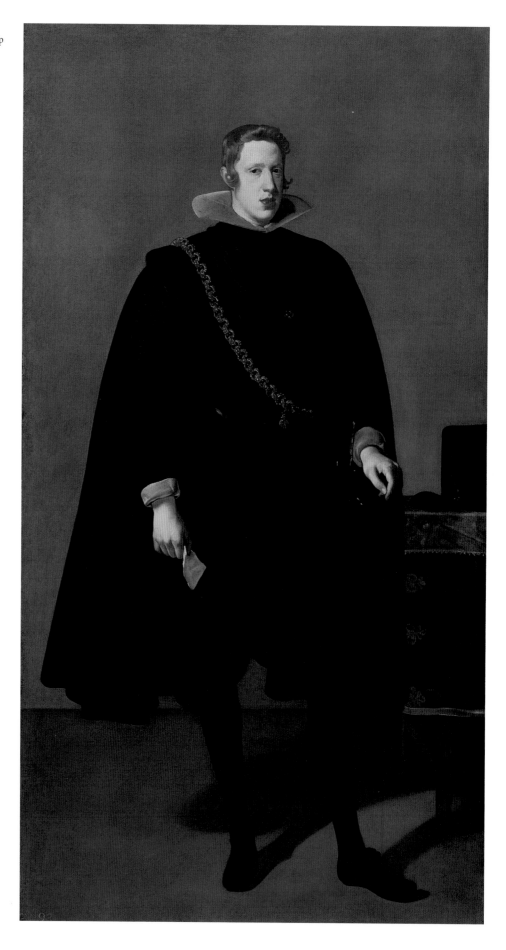

War of Granada (1568–70), a military conflict provoked by the rebellion of the region's *moriscos* (Muslim converts to Christianity) and the short-lived political disturbances in Castile and Aragon in the early 1590s temporarily altered a social and political peace that lasted from the 1520s to the 1630s.

Many factors contributed to the stability of the Spanish monarchy. The Inquisition and other institutions promoted social peace by suppressing the religious diversity and dissent that created civil and military conflict elsewhere in Western Europe. Equally important, a majority of Philip II's subjects viewed monarchy as the best political system. Furthermore, they believed that Philip's government encompassed the various members of the body politic, representatives of the king but also of the kingdom as a whole. In the Spanish case, dominant political theories stated that the monarch derived his powers not directly from God but from the community. As a result of this theory of the origins of political authority, the Spanish monarch was given many rights but also many duties, among them to protect the commonwealth, to respect the laws of the realm, and to administer justice. In other words, the monarch had the obligation to exercise his office not for his own benefit but for the good of the commonwealth. It is fascinating to observe that the metaphors most frequently used to depict the ruler's role and power in the Spanish monarchy were those of father, judge, and protector.[5] Few expressed this vision better than Martín González de Cellorigo, who in a book published in 1600 wrote, "The monarch owes his subjects Justice, Defense and Peace." According to the theories of the time, a stable and harmonious commonwealth could only be created by a monarch with the capacity to inspire the love, respect, and obedience of his subjects, a monarch who believed that the interests of king and kingdom should march in complete agreement.[6]

The best warranty that a monarch would fulfill these duties was the creation of what Justus Lipsius, the Jesuit Pedro de Ribadeneyra, and most other contemporary commentators called a "mixed" government, one in which the ruler would be forced to rule with the assistance of highly educated and experienced advisers. In such a monarchy, the role of these royal counselors was therefore as consequential as the role of the king himself. The king was the noblest part of the body politic, its heart, wrote Ribadeneyra in a book published in 1590, but the king's counselors were no less transcendent because they were "the soul, the reason, and the wisdom of the commonwealth." These ideas were translated into a complex institutional structure. All matters concerning the king's office were handled by councils, a total of fourteen, charged with discussing public affairs and suggesting policies. Although appointed by the king, counselors held their offices in perpetuity and had other important prerogatives as well. They acted as supreme judges, proposed candidates for major and minor offices, distributed patronage, and voiced the interests and needs of other members of the body politic.

Spanish monarchs had another obstacle to their capacity for independent action: they were not the rulers of a unified state but rather of a disaggregated realm. By using the word *Spain* to identify all the territories under the sovereignty of Philip II and his successors, scholars give the false impression that the monar-

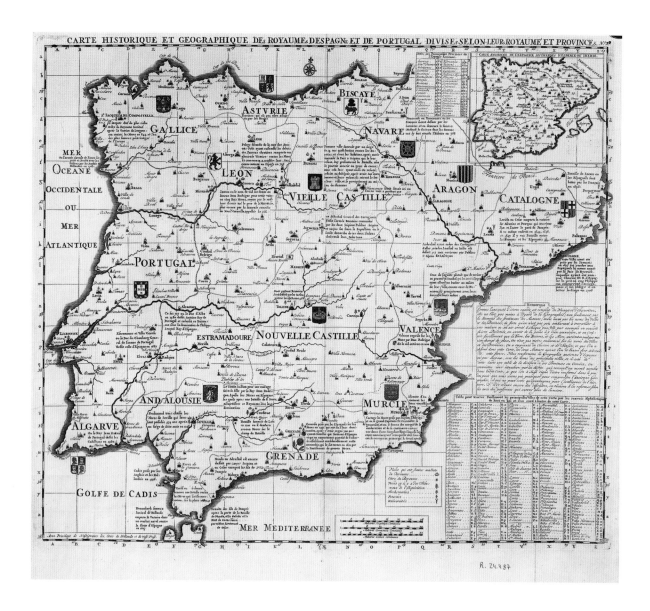

3
Historical and Geographic Map of the Kingdoms of Spain and Portugal Divided According to Their Kingdoms and Provinces, 1705–39
17 ⅝ x 21¹¹⁄₁₆ in. (45 x 55 cm)
Biblioteca Nacional de España, Madrid

chy was a unified and centralized polity. The reality was very different. To use a concept popularized by two English historians, Helmut G. Koenigsberger and John H. Elliott, Spanish monarchs were the rulers of a "composite monarchy," meaning a monarchy consisting of distinct kingdoms, each with different laws, institutions (e.g., a parliament in each of them), and political traditions. Although Philip II and his successors sporadically used the title "King of Spain," it did not officially exist. Formally, the Spanish monarch was addressed serially as the king of each separate kingdom—King of Castile, King of Portugal, King of Aragon, and so forth. In each kingdom, he had a different set of powers and prerogatives, and scholars have amply demonstrated that during the period 1575–1625, there was a radicalization of the kingdoms' distinct identities, as witnessed by the publication of numerous treatises on the different origins and histories of each kingdom, and by the increasing political role played by their parliaments (fig. 3).[7]

The Spanish monarchy was not, however, a regime that remained static from its formation to its demise. From a political perspective, the reigns of Phillip II and his successors encompassed an era of intense political debates and discord, a period of political reforms aimed at resolving what many believed was a political stalemate between king and kingdoms. Initiatives came especially from monarchs seeking to consolidate power, but those who defended the existing system also had a very active role. The reforms attempted by monarchs and their governments between 1575 and 1623 were not radical, however. Reform of the entire system was perhaps considered impossible; but reformers attempted to implement some changes to make royal authority more effective. It is not clear whether these reforms and political initiatives were successful, but they did raise new political tensions that would affect the monarchy until at least the 1650s.[8]

During the 1580s a new political ideology started to take hold in the territories of the Spanish monarchy. Promoted directly by the royal circles, this new theory, known as "reason of state," was used to justify an increase in the ruler's executive prerogatives. Enhancement of the king's power was seen as the necessary prerequisite for the preservation and advancement of the state. Although none of the proponents of increased executive power denied that the best interests of the monarch and the monarchy required the king to respect the rights of his subjects and the political roles of other institutions, they believed that if the preservation of the monarchy was threatened, then the king's authority should prevail over "rules of justice or constitutional proprieties."[9] Social and political progress was possible, they stated, but only if the realms were under the guidance of a monarch who had total control over the decision-making process and was able to execute his policies without opposition.[10]

To accomplish this, the monarchy required a slightly different organization. Although no one recommended the elimination of councils and parliaments, there were those who believed that these institutions should give advice only when the king requested it. What the king needed was more executive institutions fully under his control. Starting with Philip II, Spanish monarchs created numerous *juntas* (ad-hoc committees), which were staffed by members of the monarch's inner circle and were fully committed to implementing the king's orders. The most notable political reform of the period, however, was the appointment of a de facto prime minister, the king's favorite. Although not exclusively a Spanish phenomenon, each of the three Spanish monarchs who ruled during this period had a favorite at his side, and everything indicates that their rise to power was strictly political.[11] Modern historians tend to view the presence of these favorites as a sign that Philip II's successors were weak monarchs, puppets in the hands of powerful and greedy aristocrats. Contemporaries, even those who opposed the power and influence of the favorites, viewed this phenomenon in quite different terms. The acquisition of new territories and the increasing confrontations with other European powers meant that a monarch had many more matters to resolve than he could possibly attend to alone. Many claimed that a man in the king's confidence, a favorite, could help his master manage public affairs, serve as the

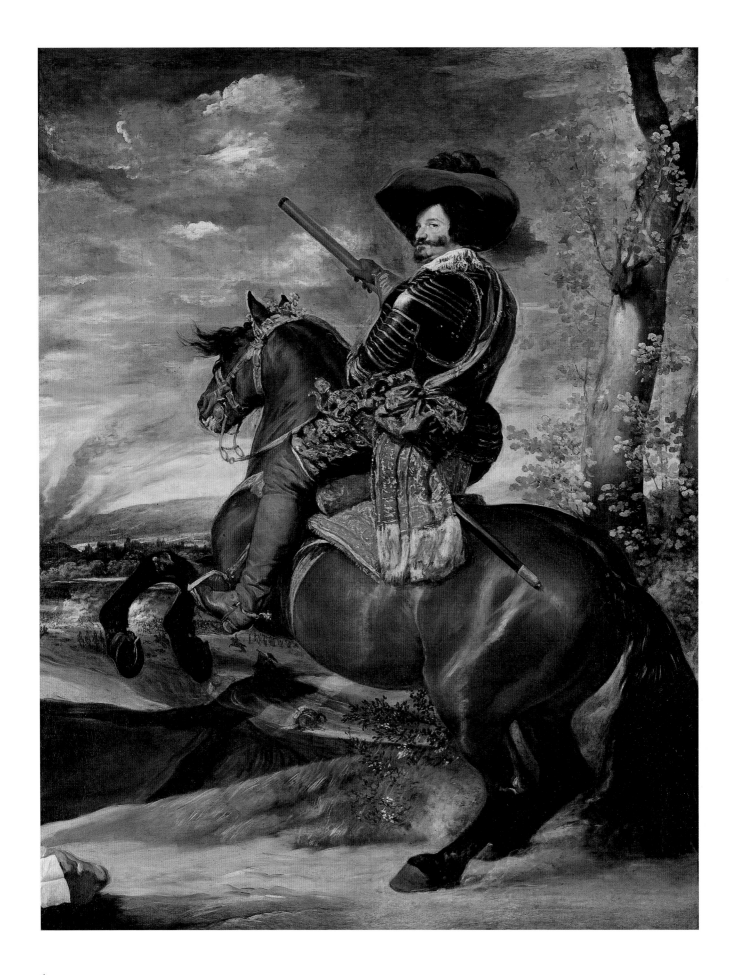

4
Diego Rodríguez de Silva y Velázquez
Don Gaspar de Guzmán, Count-Duke of Olivares, 1634
Oil on canvas, 123⅝ x 94½ in. (314 x 240 cm)
Museo Nacional del Prado, Madrid

king's representative to other institutions and to the various kingdoms, and protect the monarch against his subjects' inevitable complaints. After the 1560s many persons, most of them members of the aristocracy with years of political experience, occupied this role. Famous among Philip II's favorites are the duke of Alba, the prince of Eboli, and the Portuguese Cristóbal de Moura. But the most prominent of these favorites were those who served under Philip III and Philip IV—Francisco Gómez de Sandoval y Rojas, duke of Lerma (1552–1625) (see cat. 11), Philip III's favorite from 1598 to 1618, and Gaspar de Guzmán, count-duke of Olivares (fig. 4), Philip IV's favorite from 1621 to 1643. The royal favorites became not only powerful politicians but also important art collectors and patrons. As leaders who needed to legitimize and publicize their new role and power, the royal favorites (especially Lerma and Olivares) transformed the Spanish court into a lively and elaborately ceremonial stage. Indeed, writers of the period believe that, begin-ning with Lerma, the royal court acquired a new splendor lacking in previous reigns.[12]

It would be a mistake to believe, however, that monarchs and their inner circle had complete control of political actions and discourse during the period 1580–1623. The councils did not see their role and power diminished, and counselors, such as Don Diego del Corral y Arellano (fig. 5), still viewed themselves as representatives of the community charged with limiting any attempts by the king to become an absolute prince.[13] For their part, the parliaments of the several kingdoms did not give up their privileges and laws but actually increased their political demands every time the monarch asked for financial support. Very much noticed at the time were the decisions made by Philip III and Philip IV to curtail visits to non-Castilian kingdoms to avoid having to pledge royal support for the kingdoms' privileges and constitutions. Some of the most influential authors of the period—such as Ribadeneyra, Juan de Mariana, and Juan de Santa María—continued to publish tracts defending the composite and contractual character of the monarchy and calling on kings to moderate their appetite for power. Attacks upon royal

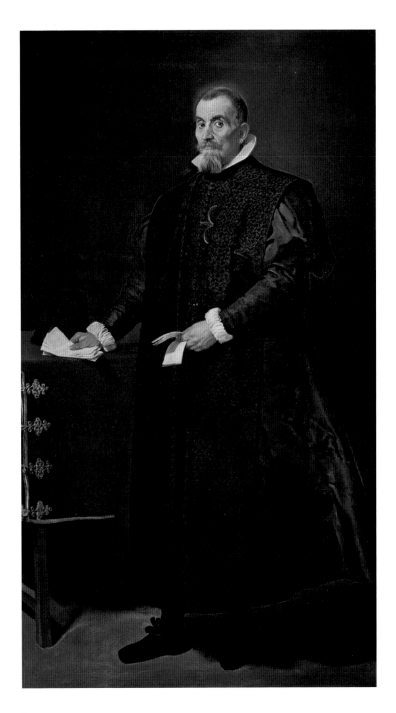

5
Diego Rodríguez de Silva y Velázquez
Don Diego del Corral y Arellano, about 1632
Oil on canvas, 84⅝ x 43⁵⁄₁₆ in. (215 x 110 cm)
Museo Nacional del Prado, Madrid

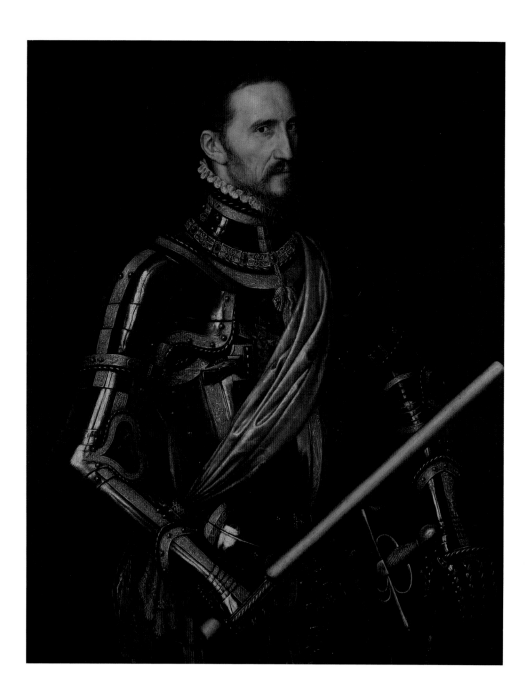

6
Antonis Mor
Portrait of Fernando Álvarez de Toledo,
Third Duke of Alba, about 1549
Oil on canvas, 41¾ x 33¹/₁₆ in. (106 x 84 cm)
Musées royaux des Beaux-Arts de Belgique, Brussels

favorites and their clients also increased during these years, portraying them as individuals who were interested in their own gain, not in the well-being of the king or his kingdoms. Symptomatic of this political atmosphere was the increasing criminalization of politics. Several favorites and many of their allies were at some point publicly accused of corruption; some were imprisoned and executed, as is the case of Lerma's men, Alonso Ramírez de Prado and Pedro Franqueza, both sent to prison in 1607, and Rodrigo Calderón, detained in 1619 and executed in 1621.[14]

The Social Body

Though the world of the Spanish political elite was complex, the social body, perhaps the most diverse in Europe, was no less complex. Although economically similar to other European societies, Spanish society included varied and diverse ethnic and religious communities. It was precisely at the end of the sixteenth century, however, that Spanish society began to suffer enormous pressures from the government and the Church to increase homogeneity and uniformity.

When analyzing the society of their times, Spanish observers believed that since the late sixteenth century something had been going acutely wrong. To settle on the causes was difficult because there were different opinions concerning the origins of the crisis. Many believed the causes were natural—Spain, like any other "body," was suffering the ills provoked by age. Others thought the causes were divine—Spain was losing God's favor. Still others held that the causes were partially political (Spain's leaders were unable to understand what was going on in the country) and partially moral (Spaniards were losing the good virtues of the past).[15] Everybody agreed, however, about the symptoms, and they were gloomy enough to provoke very negative commentaries, such as the one by González de Cellorigo, one of the most perceptive analysts of the situation in the early seventeenth century. These "times are the worst ever," he wrote, "because Spain has become a place where virtue is despised and vice praised, a country inhabited by lazier, greedier and more violent individuals."[16]

It is clear that Spanish society was going through a process of change and crisis. The situation was in many ways similar in every kingdom or territory under the sovereignty of the Spanish monarchs, but given the enormous social and ethnic complexity of the American colonies, we will limit ourselves to comment on the peninsular kingdoms. Everybody who wrote about Spain's population agreed that the Iberian Peninsula, with about six million inhabitants in 1590, was underpopulated compared to other European monarchies. The situation became even worse when a plague from Northern Europe killed about seven hundred thousand Spaniards between 1596 and 1605. The Iberian Peninsula would not recover the population levels of 1590 until the second half of the eighteenth century.[17]

Like other European societies, Iberian society was socially divided. In general historians refer to the existence of three social estates in this period: *mayores, medianos,* and *menores* (greater, middling, and lower classes). The *mayores* were the members of the aristocracy and other nobles like the duke of Alba (fig. 6)— by 1630 no more than two hundred families—in whose hands were enormous fortunes and vast territories. The number of nobles with titles increased during this period, a 150 percent increase in the first twenty years of the seventeenth century, although the total number was still very small.[18]

The *medianos* included traders, doctors, university-educated individuals, some playwrights and painters, but especially the so-called hidalgos, individuals who claimed they descended from parents who were "noble" and "old Christians"— a name used by those who claimed *limpieza de sangre* (purity of blood) for their families. Although not rich by any account, hidalgos enjoyed an important privi-

lege: exemption from taxation. The number of individuals claiming the status of hidalgo increased during this period to become almost 10 percent of the population by 1610, and the proportionate number of claims was even higher in some regions—the Basque provinces, Santander, Burgos, and Asturias.

The *menores* included the peasants, small artisans, workers, and servants. Although they could be hidalgos, this was the group that had to shoulder the bulk of the fiscal burden and military service, and who suffered enormous hardships in a period of economic instability, plagues, and crises of subsistence. Although several cities had important textile industries, such as Segovia, Toledo, Córdoba, and Valencia, and others were important commercial centers, such as Barcelona, Burgos, and Seville, most *menores*, between 60 and 70 percent of the population, lived and worked in the countryside. Significantly during this period, the state, the Church, and the Inquisition paid closer attention to the *menores* than to any other social group. For the state, the reasons are clear: its need of taxes and soldiers made royal officials collect information about their numbers and their attitudes toward the monarchy, religion, and work. The Church in turn initiated campaigns geared to eliminate what they called "popular religious deviations" in an attempt to eradicate religious heterodoxy. Between 1540 and 1700, for example, 58 percent of the cases managed by the Inquisition affected old Christians, a majority of them from the lowest classes.[19] And as attested elsewhere in this book, artists in general counted as artisans and thus shared in the struggles of the *menores*.

The clergy and members of the religious orders, a relatively important group comprising almost 1.5 percent of the total population, or one hundred thousand individuals, exercised economic and social influence that varied from diocese to diocese. The diocese of Toledo, for example, was very rich, but the dioceses of La Mancha and Galicia were not. Certain religious orders, such as the Jesuits, for example, were powerful and influential, while others were very much in decline during this period. Authors who commented on the state of society in this time, as well as many members of the Castilian parliament and some royal servants, disapproved of the high number of clergy, monks, and nuns. They petitioned the Crown to restrict the creation of new religious orders or new convents and pointed out that continued increase in this sector of the population would certainly compromise demographic growth, the state's finances, and economic productivity.

Nevertheless, the clergy and friars exerted enormous influence. The Church, and religion in general, was a constant presence in the life of every single individual, including the king. From the moment of birth until the time of death, an individual in this society was under the authority of the Church; baptism, confirmation, first education, first communion, confession, marriage, mass, college, and death were provided or regulated by the clergy. The Church and the religious orders controlled many lands, collected taxes, and in some cases even invested in the trade of slaves to the Americas. The influence of the Church extended to the Inquisition; all the tribunals were composed of members of religious orders, especially the Dominicans. Both institutions, the Church and the Inquisition, were very active in this period, fully engaged in the so-called internal missions, geared at compelling everybody in the peninsula to follow the principles and customs

approved at the Council of Trent in the 1560s. Given the central role of the Church, and indeed its power, it should not be a surprise that a majority of the paintings commissioned and the books published in Spain were religious—a situation, however, very similar elsewhere in Europe,[20] which remained in the grip of the political and cultural struggles set in motion by the Reformation and Counter-Reformation.

For El Greco's and Velázquez's contemporaries, the roads of Spain were full of bands of vagabonds and the unemployed as well as criminals and bandits, some of them already convicted and being transported to prison or to serve in the galleys (as *galeotes*). Statistics from the period indicate that there were about 150,000 condemned criminals in the peninsula in the first half of the seventeenth century. The level of criminality and the toughness of Spanish justice can be ascertained from the fact that in Seville, between 1578 and 1616, 570 persons were condemned to death, of whom 300 were actually executed. Contemporaries also referred to thousands of vagabonds and *pícaros* (rogues) who often behaved like petty criminals. Although the increased vagabondage of the late sixteenth century is a phenomenon not very well understood, it is well attested. Early on, this population claimed the public imagination through literature as the main characters of picaresque novels—a popular literary genre then and now—as in the anonymous *Life of Lazarillo de Tormes*, Francisco de Quevedo's *La vida del Buscón*, Miguel de Cervantes's *Rinconete y Cortadillo*, and Mateo Alemán's *The Life of Guzmán de Alfarache*, all of them (with the exception of the Lazarillo) published between 1590 and 1620. And although it took a little longer, *pícaros* also were depicted by some of the most important painters of the time. Among the lowest social estates were approximately one hundred thousand slaves, a majority of them brought from sub-Saharan Africa and the Magreb and destined to work as domestic slaves, as workers in the mines of Andalucia, or as *galeotes* in the royal galleys.

During the seventeenth century, women were the majority population in Spain and elsewhere in Europe. In theory and in practice, women everywhere were discriminated against individually and collectively. The profound misogyny of Spanish society is well attested in numerous tracts denouncing the natural weakness of women and the need for them to submit to male authority. In practice women were excluded from the political process and from institutions of higher education; they could not become the heads of their families, especially not among the nobility.[21] Few women received any formal education; about 1620, between 50 and 60 percent of men knew how to read, compared to 20–30 percent among women. In turn, domestic violence was rife in every region of the country.[22]

Nevertheless, the condition of women in Spain was more complex than these facts indicate. Despite their official exclusion from politics, women at the court could exercise their influence outside the institutional channels and participate in the political debates and power struggles, as they did, for example, during the reign of Philip III, when Queen Margaret of Austria (1584–1611) (see cat. 8) and some of her ladies-in-waiting led the opposition against Lerma and certain of his allies.[23] Other spheres, religion, for example, permitted women to take active roles. Teresa of Avila (1515–1582; see cat. 41) is perhaps the best known of such women,

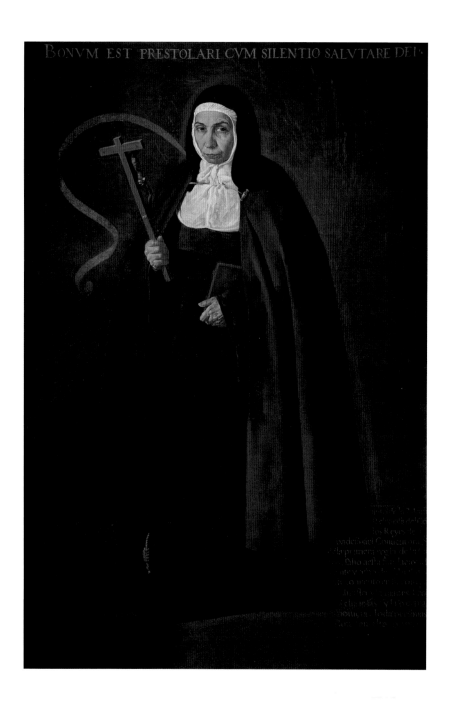

BONVM EST PRESTOLARI CVM SILENTIO SALVTARE DEI

7
Diego Rodríguez de Silva y Velázquez
The Venerable Madre Doña Jerónima de la Fuente, 1620
Oil on canvas, 63 x 43⅝ in. (160 x 110 cm)
Museo Nacional del Prado, Madrid

but she was not alone. After many years of harassment by ecclesiastical authorities and the Inquisition, Teresa of Avila became an important figure leading a group of pious women with enormous influence on the religious lives of many of their male and female contemporaries, including members of the royal family and royal counselors and favorites. In 1617 the Castilian parliament appointed Teresa copatroness of Spain, and in 1622 she was canonized with two other Spaniards, the Jesuits Ignatius of Loyola and Francis Xavier. Her example inspired women like Jerónima de la Fuente, portrayed by Velázquez in 1620 before she left Spain to become the first abbess of the convent of Santa Clara in Manila (fig. 7). Women were also novelists and playwrights, such as the gifted María de Zayas y Sotomayor (1590–about 1661). Others were even famous adventurers, such as Catalina de

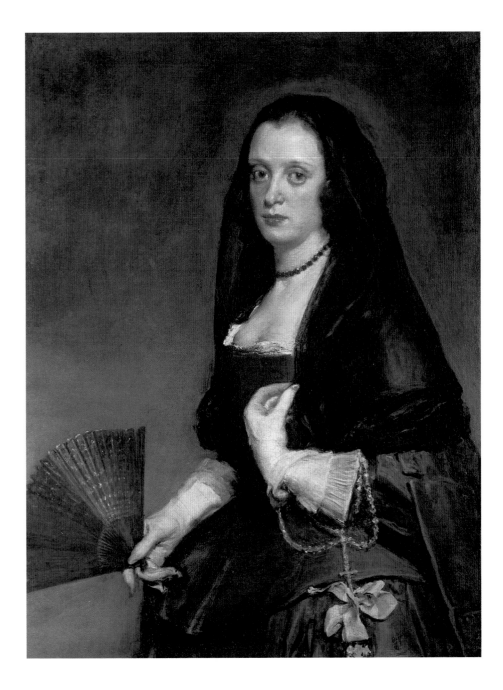

8

Diego Rodríguez de Silva y Velázquez
The Lady with a Fan, about 1630/50
Oil on canvas, 27³⁄₁₆ x 20⅛ in. (69.1 x 51.1 cm)
The Wallace Collection, London

Erauso (1592–1650), better known as the Lieutenant Nun, who, dressed as a man, fought in the American colonies, dictated her memoirs in the 1620s, and was the subject of a portrait, now lost, by Juan van der Hamen. In a society where manufacture was essentially domestic, women played an important economic role and, despite legal limitations, they sometimes became the owners of shops and printing houses. Advised to remain within their homes or convent walls, women nevertheless participated in many of the public celebrations in their towns and villages. They also appeared as subjects in the paintings of the period and as essential characters in the plays of the Golden Age (fig. 8), played by female actors.[24]

According to many historians, Spanish society of the seventeenth century became highly stratified, polarized between the rich and the poor, as the middle

sector declined in number, wealth, and political influence. At the same time, new and stricter rules for entry into the nobility created an impediment to upward social mobility. As a result, some historians are persuaded that this was a period of social gentrification, when an elite culture, fully formed, first emerged. We would, however, be mistaken to conclude that during this period social classes became completely closed and separated from the rest and with distinct cultures for each of them. Although little is known about marriages between individuals from different social or ethnic groups, there is sufficient evidence that such unions were not uncommon. We know as well that, despite the efforts by the Church and the Inquisition, local varieties of Catholicism did not completely disappear and that their adherents included men, women, nobles, and common people. Monarchs, aristocrats, rogues, lawyers, peasants, hidalgos, and men and women shared many literary tastes, all of them enjoying chivalric and picaresque novels and the plays of Lope de Vega, Tirso de Molina, and Calderón de la Barca.[25]

The statistics and the judicial records mentioned above clearly indicate that this was a society full of violence and cruelty, of increasing social and ethnic distance between individuals. And yet there was also proof of social connectivity and generosity. Few examples better represent this phenomenon than debates about how to deal with vagabonds and beggars. From the 1550s there were intense debates about the causes of poverty and unemployment, with some proposing that poverty was the result of individual character and habit and others—a majority of the writers—suggesting that it was the result of social and economic inequalities. The former proposed corrective imprisonment or temporary enslavement in the galleys for the more recalcitrant vagabonds; the latter, in contrast, recommended institutionalization of support and the collective enactment of Christian charity. This debate intensified in the late sixteenth century and the first decades of the seventeenth century, and those suggesting the need to help vagabonds and beggars—Cervantes and Alemán among them—had a stronger influence than those who proposed to establish tough regulations.[26]

Perhaps the social aspect that has claimed most of the attention of historians is the religious and ethnic diversity that characterized this period of Spanish history. We do not know exactly how many *conversos*—Christians of Jewish or Muslim descent—lived in the Iberian Peninsula, although scholars suggest between four hundred thousand and five hundred thousand. After the 1560s every single inhabitant of the Iberian Peninsula was officially Catholic. Nobody, in public or in private, could practice religious rites other than Catholic, and every suspicion of religious dissidence was persecuted and punished by the feared Inquisition. If we take into consideration the information produced by the Inquisition, however, after 1570, religious persecution of Jewish *conversos* decreased following several decades of cruel and bloody maltreatment.[27] Of all the cases run by the Inquisition between 1560 and 1614, 6.2 percent concerned Jewish *conversos*, while between 1615 and 1700 the total number of cases increased to 18.3 percent. It is important to note, however, that individuals accused of "judaizing" formed a majority of those executed in this and other periods (1.8 percent of the cases viewed by the Inquisition between 1540 and 1700 resulted in execution). We also know that in

the first three decades of the seventeenth century there were many critiques directed against the statutes of purity of blood, which prevented all *conversos* from obtaining public offices (secular and ecclesiastical), honors (hidalgo and nobility), college degrees, and other markers of social status. On some occasions royal ministers (Lerma and Olivares among them) supported or sponsored these condemnations of statutes that penalized family ancestry rather than religious beliefs and practices.[28] In addition, it was during this period when some Sephardic Jews living outside Spain decided to come back to the Iberian Peninsula and convert to Catholicism and when many Jews and Jewish *conversos* from Portugal moved to Castile in the belief that the monarchy was going to protect them.[29]

The situation was different in the case of the the Muslim *conversos*, the *moriscos*. Although many commentators claimed that the alleged unwillingness of the *moriscos* to become true Catholics resulted from the lack of missionary efforts by the state and the Church officials, most Spaniards during this period had increasingly negative perceptions of the *moriscos*. We know that after 1590, for example, the Inquisition increased the persecution of *moriscos*, especially during the years 1605–9. According to Inquisitorial information, between 1560 and 1614 almost 32 percent of its cases involved *moriscos*. The main reason behind this increase—in the previous period 18.3 percent of the cases involved *moriscos*—was not religion but politics. Many Spaniards viewed the *moriscos* not only as enemies of the Christian faith but also as internal political enemies who conspired with foreign powers, especially with the Ottoman Empire, to destroy Spain. This public perception made the *moriscos* an important subject in the debates on international policy, and in 1609 Philip III gave the order to expel the *moriscos*—three hundred thousand of them—an order which coincided with the signing of a peace agreement with a Protestant opponent, the Dutch Republic.[30]

War and Peace

Despite the many territories under Spanish rule, this period was one of economic and financial crises. Documents of the period are very clear about a few of the reasons. By 1595 the amount of silver coming from the Americas had started to diminish; depopulation in several regions had reduced the number of taxpayers and economic activity, forcing Castilian cities to request tax reductions by the early 1590s. Equally noteworthy is that after the 1590s the parliaments and the main cities of each kingdom increased their opposition to granting new subsidies to the monarchy.[31]

Everybody agreed, however, that the financial crisis resulted partially from the enormous resources committed by Philip II to his international adventures. His decision to invade the Low Countries, his campaigns against England, and his military attempts to prevent the crowning of the Protestant Henry of Navarre as king of France in the 1590s provoked a radical increase of the annual expenses and, ultimately, a rise in the level of public debt. By 1600 public debt (25 million ducats) more than doubled the annual budget of the monarchy (12 million ducats).[32] The connection between Philip II's international policy and the internal

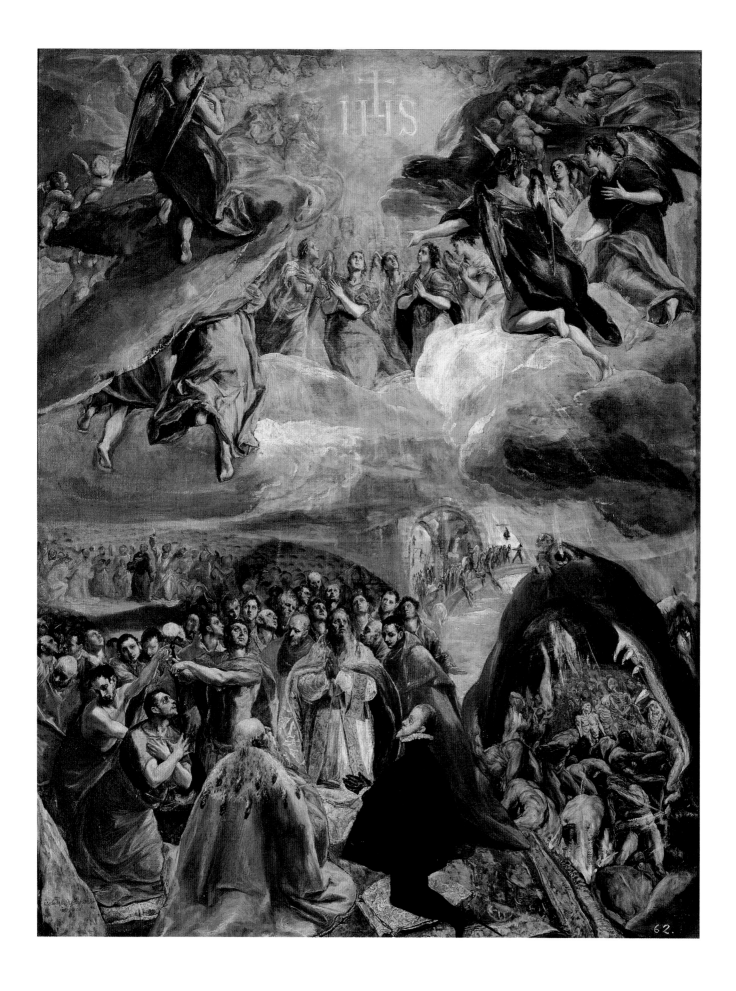

economic and fiscal crises served to initiate a public debate about Spain's international role and policies. Moreover, it is important to point out that this debate went beyond economic preoccupations to touch upon more strategic and ideological matters, transforming international policies into the most debated matter of this period, in the political institutions but also among the people.[33]

The Spanish monarchy had been involved in continuous conflicts since the end of the fifteenth century, first against France, for control of the Italian Peninsula and European hegemony, and also against the German Protestant princes and other rulers. The treaty of Château-Cambrésis (1559) with France offered the possibility of a period of peace and recovery that was, in the end, only an illusion. The need to suppress the Protestant revolt in the Low Countries, which started in 1568; the confrontation with England, which began almost immediately after Elizabeth became queen in 1558; the involvement in the civil and religious conflicts in France (the so-called Religious Wars that affected the French monarchy from the 1560s until 1595); and the conquest of Portugal in 1580 demonstrated that peace was the exception, not the rule. It also demonstrated that, especially after Philip II became king of Portugal in 1581, Spain was the only polity of the time that could put together a "grand strategy": a combination of defensive and offensive wars that could redesign the European political and religious map.

According to his own declarations, two goals dominated Philip II's international policies: first, the defense of the territorial integrity of the Spanish monarchy; second, the defense of Catholicism both in Spain and in the world at large. Philip and his ministers were convinced that both goals were fundamentally intertwined. Philip believed that should he be defeated, Catholicism would likewise be defeated. Indeed, he viewed himself as the only ruler who could keep Europe from falling into religious and political chaos. In addition, Philip and his counselors believed their defense of Catholicism guaranteed God's protection as well as the solidarity and support of Catholics everywhere in the world, including France, England, Ireland, and Scotland (fig. 9).[34]

Few Spaniards opposed this vision before the early 1590s. Until then Philip II had the support and agreement of a majority of his peninsular subjects and was also able to extract increased taxes from them to finance his international campaigns. For example, during the preparation of the Grand Armada against England in 1587–88, almost all of his subjects encouraged his action, and the Castilian Parliament in particular made enormous efforts to provide Philip with enough resources to successfully attack and occupy England. The defeat of the Spanish Armada in 1588 did not immediately change the attitudes of Philip's subjects. The Spanish monarchy was able to reconstruct its fleet and its armies, and by the early 1590s Spain had increased its military intervention in France and the Low Countries and was again planning a military campaign against England.

By the mid-1590s, however, things started to change. First, the local elites grew more and more disillusioned with the war effort. The debates in the Castilian cities and parliament, and popular sentiment as well, revealed that by

9
El Greco
The Adoration of the Name of Jesus, 1578–79
Oil on canvas, 55⅛ x 43⁵⁄₁₆ in. (140 x 110 cm)
Chapter House, Monasterio de San Lorenzo, El Escorial

the mid-1590s many Spaniards believed that to promote what they called "foreign wars," Philip was destroying his peninsular kingdoms. In the opinion of many, not even the persecution of Catholics could justify offensive wars, because no polity had the right to impose its power, way of life, and religion on other European nations. Philip felt the pressure of common opinion to change priorities, to limit himself to fighting defensive wars, to avoid meddling in the internal affairs of other European polities, and to invest the taxes paid by his subjects in the improvement of his peninsular kingdoms.[35]

Philip II did not heed this advice, but in the last years of his reign economic reality hit harder than the admonitions of his subjects. In 1596 he had to declare the bankruptcy of the monarchy, due to the inability of his government to pay financial loans. A few months before his death in September 1598, he was forced to sign a treaty of peace with his archenemy, Henry IV of France (the peace of Vervins), and the same year, in May 1598, he named his daughter Isabella Clara Eugenia and her husband-to-be, Archduke Albert, as sovereigns of the Low Countries, explicitly acknowledging his defeat and asserting that the pacification of the Low Countries could not succeed through force alone.

Historians are still debating what attitude the new rulers—Philip III and his favorite, Lerma—held toward Philip II's grand strategy and international policies. In the first years of the new reign some evidence indicates that Philip III wanted to follow in the footsteps of his father. He ordered the preparation of an armada to help the Irish Catholics against Elizabeth—an armada again defeated, this time at the battle of Kinsale (1602). He also invested heavily in a military surge to defeat the Dutch Republic.[36] Other evidence indicates, however, that Lerma and his allies, and then the king himself, supported political change from the first moment of the new reign. This political turn was not just tactical—the desire for peace as a way to allow the monarchy to recover after many decades of military conflict—but was ideological. After all, as the Spanish historian Gil Pujol has stated, Lerma and some of his allies belonged to the "generation who read Giovanni Botero," an important influence on the development of reason-of-state theories as the author of *Ragioni di Stato* (Reason of State) published in Italian in 1589 and immediately translated into Castilian.[37]

Botero and other writers, among them many Spaniards, enunciated several principles on the conduct of international relationships. First, for these writers the period of territorial expansion was over; the new times called instead for "conservation," to avoid the loss of territories. Second, ideological wars could only be conducted against non-Christians, in the case of Europe only against Islam. Third, in relation to other Christian polities, wars could only be defensive, and the Spanish monarchs should avoid interference in the internal affairs of other polities. Fourth, those territories that had once belonged to the Spanish monarchy but which were de facto now lost—a reference to the Dutch Republic, which Spain's monarchs had ruled for more than a half century—should be abandoned. But perhaps their most radical advice was the call for a new kind of politics. In traditional political theory, the main goal of a Christian prince was to defend

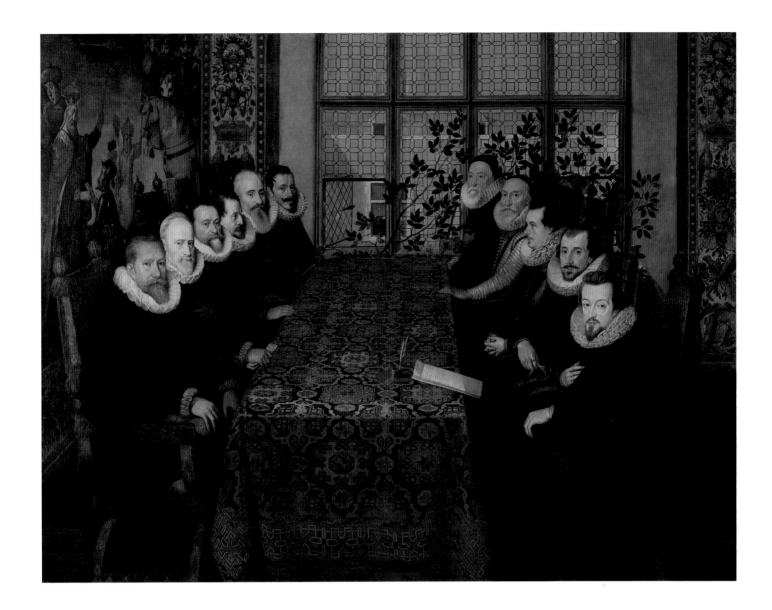

"good" and fight "evil." The practical corollary of this principle meant that the ruler had to defend Christian principles and policies, specifically the Catholic Church and Catholics everywhere, regardless of the consequences for his kingdoms and himself. Defenders of reason of state believed, however, that a good ruler must be able to distinguish the "useful" from the "harmful." This principle implied that before taking any action, the king had to assess the state's strategic interests, the strength of its enemies, and the political consequences of his actions. According to the new theorists, action against rebels and heretics should depend on the given set of circumstances, and a policy of compromise with the country's enemies might be wiser at certain times than an aggressive policy, which could result in defeat or, even worse, the spread of internal conflict and dissension. The Church and Catholicism must be defended, but the preservation of the state must become the king's highest priority.[38]

10
Juan Pantoja de la Cruz (attributed to)
The Somerset House Conference, about 1604
Oil on canvas, 81 x 105½ in. (205.7 x 268 cm)
National Portrait Gallery, London

These ideas inspired many of the policies adopted by the new regime from 1603 onward. The first step was the opening of peace negotiations with England immediately after the death of Elizabeth in 1603. The result was immediate: the signing of the Treaty of London, subscribed by James I of England in 1604 and Philip III in 1605 (fig. 10). One year later, in 1606, representatives of Philip III and the governors of the Low Countries agreed to a cease-fire and the opening of peace negotiations with the representatives of the Dutch Republic. These negotiations resulted in the Twelve Years' Truce, ratified by Philip III on April 14, 1609. Finally, in 1614 a double marriage took place, between then-Prince Philip (the future Philip IV) and Isabelle of Bourbon, sister of Louis XIII of France, who himself married Anne of Austria, sister of Prince Philip and daughter of Philip III. These two treaties and the matrimonial alliance with France indicated that continuation of European wars was harmful to the state and that the only useful action was to sign peace treaties, even ones that implicitly recognized Dutch independence and the impossibility of restoring Catholicism in England and the Dutch Republic.[39]

This policy for dealing with other European powers was followed by Philip III and his advisers for almost the rest of the reign. After 1609, whenever confronted, Spain avoided direct interventions and convinced its allies that diplomacy should always be the preferred approach to international affairs. This attitude was accompanied by increased activity against Islam. Early in his reign, Philip III had already ordered the preparation of armadas against Mediterranean pirates and their strongholds in Northern Africa. These actions, however, brought few noteworthy results other than the occupation of Larache in northern Morocco in 1610 plus a few frustrated attacks against Marmora and Algeria.

This confrontation with Islam coincided with growing ministerial approval for the expulsion of the *moriscos* from Spain. The order of expulsion took effect on April 14, 1609, precisely the same day that Philip III approved the Twelve Years' Truce with the Dutch. He did not, however, make public his decision until September, when the first decree ordering the deportation of all *moriscos* from Valencia was published, thus initiating a long process—from 1609 to 1614—of repression and expulsion of more than three hundred thousand *moriscos*. In his justification for adopting such a measure, Philip III adduced his duty to "protect his subjects and kingdoms against everything that could scandalize and hurt them . . . destroy everything that could destroy the state, and especially everything that offends and displeases God." Despite the cruelty of this measure, despite its demographic and economic costs, the expulsion of the *moriscos* was celebrated throughout the various kingdoms and became central to the politics of propaganda during the reign of Philip III and afterward (fig. 11).[40]

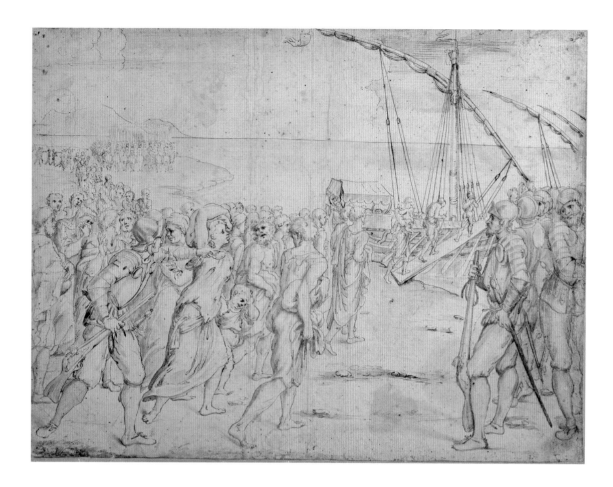

Epilogue: A New Regime

Lerma's fall from power in October 1618 resulted in the opening of intense debate on politics and the overall condition of Spain. The Council of Castile delineated the situation in a memorandum sent to Philip III on February 1, 1619, in which the council decried the increasing depopulation and decline of Castile (attributed to excessive taxation, to the large number of individuals living at the court, and to the excessive creation of religious foundations and communities); the crisis in agriculture (resulting from the depopulation of the countryside); the fiscal crisis; and the absence of justice and the increasing corruption in the administration of the kingdom. The Council of Castile considered the current crisis to be without precedent, one which only radical measures could solve: "The sickness [of the monarchy] is grave indeed," they wrote. "[So grave that] it cannot be cured by ordinary means. Bitter remedies are usually the healthiest for those who are ill, and in order to save the body sometimes it is necessary to cut the arm, and cancer can only be cured with fire."[41]

Nothing was done to address these problems during the last years of the reign of Philip III, who died on March 31, 1621. His son and heir, Philip IV, and the new

11
Vicente Carducho
The Expulsion of the Moriscos, about 1627
Graphite, pen, and blue wash on paper,
12⅛ x 19¹³⁄₁₆ in. (30.8 x 50.3 cm)
Museo Nacional del Prado, Madrid

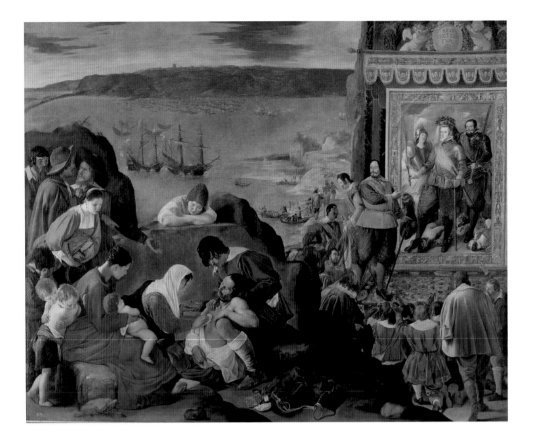

12
Juan Bautista Maino
The Recapture of Bahia in 1625, 1634–35
Oil on canvas, 121¹¹⁄₁₆ x 150 in. (309 x 381 cm)
Museo Nacional del Prado, Madrid

royal favorite, the count-duke of Olivares, in contrast, viewed themselves as active players fully committed to addressing the ills of Spain. Although the system of government under the new rulers was very similar to the one designed and implemented under Philip III and Lerma, the new regime's ideology was closer in its principles to Philip II's and so were its internal and international initiatives.[42]

The new government initiated, for example, a program aimed at creating a more unified monarchy, questioning some of the attitudes and rights of the various kingdoms. They also started a program to enhance the fiscal capacity of the monarchy, extending the number of communities subject to taxation, thus creating new taxes, and promoting the creation of new industries. Philip and Olivares also believed that it was their duty to restore the international power of Spain. Their goal was to position the Spanish monarch as the major player in European politics, even if this meant renewing old conflicts or opening new ones. In 1621 the king and his favorite confirmed their support of the Holy Roman Emperor in his conflicts with Protestant princes, this time initiated by the rebellion of Bohemia in 1618, which started a general conflict known to us as the Thirty Years' War (1618–48). This war would in 1635 bring Spain and France face to face. In 1621 the new rulers decided to allow the truce with the Dutch to expire, reinitiating a conflict that would last more than thirty years. A few years later England broke the peace agreement signed in 1604 between both monarchies.

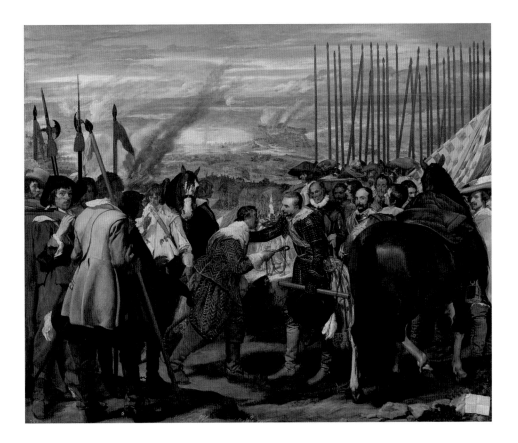

13
Diego Rodríguez de Silva y Velázquez
The Surrender of Breda, 1634–35
Oil on canvas, 120⅞ x 144½ in. (307 x 367 cm)
Museo Nacional del Prado, Madrid

Ultimately, these policies led Spain to its worst crises ever. The economic and fiscal situation worsened, Spain lost the wars against France and the Dutch Republic, Portugal became independent after a rebellion in 1640, and Catalonia also rebelled in 1640, remaining separated from the Spanish monarchy until 1652. But the first decade of the new regime, the first years of Velázquez as the court painter, was a time of optimism, a time of military victories, commercial expansion, and grand designs to transform Philip IV into the king of a truly unified and strong monarchy. Velázquez and many other artists were called upon to celebrate this optimism on several occasions but especially in the decoration of the Salón de Reinos (Hall of Realms), the main room of a new royal palace, the Buen Retiro, built in the 1630s. Here observers could stand in the presence of a celebration of the monarchy and the body politic and also of Spanish military victories, especially those that took place in 1625, the *Annus Mirabilis* of Philip IV's reign. At the same time, the room is a celebration of the brilliance of Spanish painters—of Juan Bautista Maino, who contributed a splendid painting celebrating Spanish victories in Brazil (fig. 12), Francisco de Zurbarán, who contributed several paintings narrating Hercules's deeds, but especially of Velázquez, who contributed a majority of the paintings in the hall, among them the portraits of Philip III and Queen Margaret of Austria, Philip IV and Queen Isabelle of Bourbon, the count-duke of Olivares, and many more (fig. 13).[43]

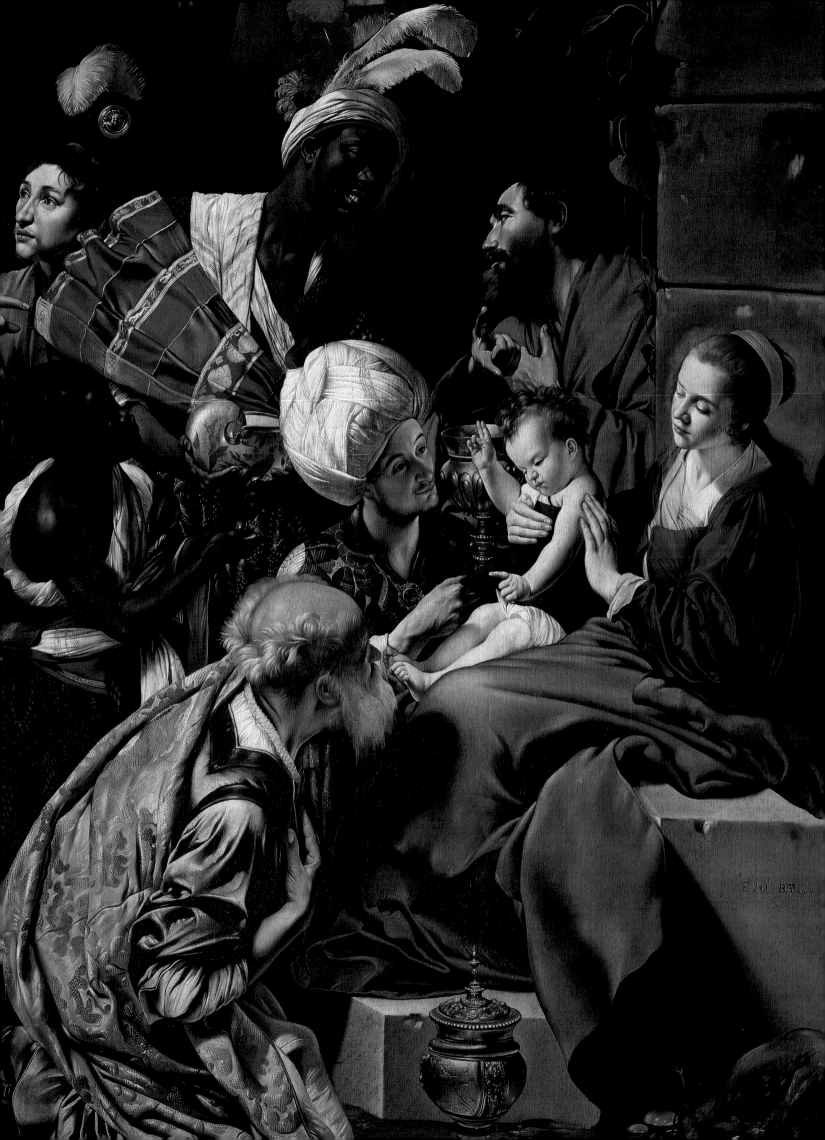

El Greco to Velázquez:
Artists of the Reign of Philip III

RONNI BAER

By the time the new king ascended the throne, El Greco was fifty-seven years old. After training in Crete and spending several years in Italy, he arrived in Spain in 1576. By the next year, he was working for the Cathedral of Toledo, the city in which he ultimately settled. It would prove an auspicious choice: Toledo had been the capital of Spain until Philip II (1527–1598) moved the court to Madrid in 1561; it was still the seat of the Spanish Church and home to a thriving intellectual and artistic community. As the art historian William B. Jordan noted, "Its proximity to Madrid [about forty-five miles to the south] and the longstanding ties of the aristocracy to its many religious institutions ensured that developments in one place were almost immediately known in the other."[1] From 1577 until 1579 El Greco worked on his first major commission in Toledo, for eight paintings for the new church of the Bernardine convent of Santo Domingo el Antiguo.

Madrid was the relatively small, relatively new seat of the court, where artists worked not only for the crown and its courtiers but also for the convents and monasteries they founded and supported. By concentrating the kingdom's huge financial resources in this one place—Spain was then the largest and richest monarchy in the world—and by becoming the most important secular patron of the arts, Philip II had transformed this young city into the primary artistic center of Spain. From the 1560s until his death, he employed teams of Italian and Spanish painters to work on the decoration of El Escorial, the palace-monastery complex he founded as a royal mausoleum located twenty-eight miles northwest of Madrid. His taste for foreign art, demonstrated most remarkably by his devotion to Titian, was evidence of a sophisticated sensibility developed during an extended trip to Italy, Germany, and the Netherlands, and informed by the example and quality of the collections assembled by his father, Charles V, his great-aunt Margaret of Austria, and his aunt Mary of Hungary.

In 1582 El Greco delivered to El Escorial the *Martyrdom of Saint Maurice*, which he had painted on commission from Philip II for one of the chapels. The artist's attempt to curry royal favor was unsuccessful, however, as the king ordered the painting removed. This would be the only time El Greco would work directly for the Crown.

In his history of the Hieronymite order, published in Madrid in the early years of the seventeenth century, Fray José de Sigüenza indicated his own objections to

El Greco's art—and, by extension, the source of the king's displeasure. According to Sigüenza, El Greco's painting was neither naturalistic nor clear in its narrative. The friar admitted, however, that the painter, whom some found very knowledgeable, had admirers.[2] Indeed, El Greco, who possessed an important library and wrote treatises on art, was a learned painter, and he worked in large part for like-minded patrons who were also men of learning and letters, including doctors of canon law who held positions in church administration. This select clientele, in turn, established a fashion for El Greco's art, which, though not appreciated at the court of Philip II, became sought after by the wealthy and cultured of Toledo.

In 1596 the artist signed documents with the Royal Council of Castile for the retable and paintings for the high altar of the church of the Colegio de Doña María de Aragón (dedicated to Our Lady of the Incarnation) in Madrid. The *Annunication* (cat. 19), because of its theme and format, was probably the central panel of the lower tier of the altarpiece. In 1600 the paintings were transported from Toledo to Madrid, where they were assessed by the royal portraitist, Juan Pantoja de la Cruz, acting for the seminary, and Bartolomé Carducho, acting for El Greco. A Florentine artist who had come to Spain to paint the cloister at El Escorial and older brother to one of the artists discussed below, Carducho remained in the Spanish royal service after his compatriots returned to Italy and was named painter to the king (*pintor del rey*) in 1598.

There were to be no further commissions for El Greco in Madrid, although he and his son Jorge Manuel (who in 1603 appeared for the first time in documents as his father's assistant and business partner) continued to receive important commissions for altarpieces in and around Toledo. In 1611 they were asked to provide a monument for the funerary celebrations in Toledo Cathedral for Queen Margaret of Austria, Philip III's wife. This monument was praised in a sonnet by Fray Hortensio Félix Paravicino, the celebrated preacher and poet whose portrait El Greco painted about 1609 (cat. 12). The *Vision of Saint John* (cat. 5) was intended for the side altar of the chapel of Toledo's Hospital of Saint John the Baptist, El Greco's last and among his most important commissions. The painter died in Toledo in 1614 and was buried in the church of Santo Domingo el Antiguo. In a sonnet published in 1627 entitled "Inscription for the Tomb of Domínico Greco," Luis de Góngora y Argote (see cat. 17) praised "the softest brush ever to give soul to a panel, life to canvas."

In 1603 Luis Tristán (fig. 14) served as witness to El Greco's contract to paint the altarpieces for the Hospital de la Caridad in Illescas (Toledo), and, as Antonio Palomino (1655–1726) recounted, he was probably El Greco's apprentice by this time.[3] Documents signed by Tristán from 1604 and 1606 attest to his continued close association with the master and his family. He signed his name as Luis de Escamilla, which he would continue to do until 1613. Tristán's birthdate and birthplace are unknown;[4] in a document of March 19, 1615, he declared himself to be "more than twenty-five years old," so he was likely born shortly before 1590. The origin of the name Tristán is obscure; his parents were Domingo Rodríguez and Ana de Escamilla, and he remained extremely close to his family (especially to his mother) throughout his life.

14
Luis Tristán
Self-Portrait
Oil on canvas, 18½ x 14³/₁₆ in. (47 x 36 cm)
Whereabouts unknown

The annotated copy of Vasari's *Lives* owned by El Greco, with notes both by him and by Tristán, indicates that Tristán visited Milan, Florence, and Rome;[5] this Italian trip would have taken place between late 1606 and mid-1612.[6] According to Martínez, Tristán spent time in Italy in the company of Jusepe de Ribera.[7] The latter was in Parma by 1610, so the Italian sojourns of these two artists could well have overlapped.

Back in Toledo, the commission Tristán carried out for the councilman of the city, Luis Sirvendo, included large religious paintings and small landscapes and paintings of the months of the year.[8] In 1612 he was paid by the Jesuits of Toledo for twenty-four paintings of Jesuit martyrs, and the following year he signed and dated the *Holy Family* (cat. 26) and contracted for three paintings for the nearby monastery of Santa María de la Sisla. Newly returned from Italy, Tristán found himself much in demand.

The artist married Catalina de la Higuera on June 26, 1614, and the childless couple was relatively well off.[9] They are documented in the following years as leasing a succession of houses in Toledo as the demand and size of Tristán's commissions grew. El Greco had died just a couple of months before Tristán's marriage, leaving Tristán as the most sought-after painter in the city. Among his major commissions in these years were altarpieces for Yepes (1615), for the churches of Cedillo and San Martín in Ocaña (1617), and for San Andrés in Casarrubios (1618). He was asked by Jorge Manuel, with whom he remained close, to value the painting of the *Adoration of the Shepherds* for El Greco's sepulchral chapel in Santo Domingo el Antiguo (now in Museo Nacional del Prado, Madrid), and on September 26, 1618, he testified that he saw El Greco paint it—the first mention of Tristán's presence in the master's studio and proof that they remained in contact until El Greco's last days.

On March 15, 1619, Tristán was paid for a portrait of the powerful Bernardo de Sandoval y Rojas (d. 1618), the archbishop of Toledo Cathedral, from whom he had rented a house the year before.[10] The evidence of the artist's activity as a portraitist combined with documents that mention his landscapes and large and small religious paintings provide a glimpse of the multifaceted nature of Tristán's artistic production. That same year Tristán took on both Pedro de Camprobín and Miguel de Montoya as apprentices. The fact that he could accommodate them and others (Alonso Gutiérrez de Castro came in 1621, Bartolomé García and Mateo del Pino in 1622, and Francisco de Herrera in 1623) points to the thriving nature of his workshop.

Tristán's brother-in-law, Manuel de Acebedo, also worked in his studio, and the two agreed to make "a series of six canvases and panels" to be signed by Tristán and finished by late December 1620, in partial payment of a debt to the merchant Pedro de Alcaya. The short timeframe seems to indicate that the artists either worked from well-developed *modelli* or used partially completed paintings already in the workshop.[11] In 1620 Tristán signed and dated the *Adoration of the Shepherds* (cat. 23), part of the altarpiece of *Las Cuatro Pascuas* for the church of the convent of Jerónimas de la Reina. Antonio Ponz (1725–1792) saw it there and praised it in his *Viaje de España* (the first volume of which was published in 1772), the earliest comprehensive catalogue of art and architecture in Spain; so too did Juan Agustín Ceán Bermúdez (1749–1829), whose six-volume *Diccionario histórico de los más ilustres profesores de las bellas artes en España*, published in 1800, surveyed Spanish artists from the medieval period until the eighteenth century. In 1621 Jorge Manuel and Tristán executed the catafalque erected by the city council of Toledo to honor the memory of Philip III. If comparable to those erected in Madrid and elsewhere, it would have been composed of allegorical scenes.[12]

In early 1622[13] Tristán signed a contract to paint the high altarpiece ("quatro quadros y seis tableros")—working with the sculptor Juan Fernández, the joiner Gaspar de Muñoz, and the painter and gilder Diego de Aguilar—of the convent of Santa Clara in Toledo.[14] According to the last will and testament of Diego de Aguilar, by January 8, 1624, the "canvases" of the altarpiece had been finished and paid for,[15] and indeed the date of 1623 appears on the altarpiece. By then, Tristán was well enough known that when his wife's mother died, the burial entry in the church register referred to her only as "the mother-in-law of Luis Tristán."[16] In November 1624 the artist contracted to paint works for the confraternity of Las Ánimas del Purgatorio in

the Chapel of Saint Peter in the Toledo Cathedral and to execute four paintings for an altarpiece for Alameda de la Sagra. In the midst of this wealth of work, in less than a month his old friend Jorge Manuel would witness his last will and testament, which Tristán was too ill to sign. The painter died on December 7, 1624, and was buried in the church of the Dominican monastery of San Pedro Mártir.

Juan Bautista Maino received the major commission for the paintings for the high altar of the church of San Pedro Mártir on February 14, 1612 (cat. 21). The commission stipulated that the altarpiece be finished in eight months, but it apparently took longer as two of the paintings are signed by "fray Juan Bautista Maino," indicating that he had already professed as a monk (he was accepted into the Dominican order in July 1613).[17] The altarpiece, known as *Las Cuatro Pascuas*, comprised the *Adoration of the Shepherds*, the *Adoration of the Magi*, the *Pentecost* (all in the Museo Nacional del Prado, Madrid), and the *Resurrection* (Museo Balaguer, Vilanova i la Geltrú), in addition to four small landscapes with saints and half-length portraits of Saint Catherine of Siena and Saint Dominic.

Maino was born in October 1581 in Pastrana (Guadalajara, fifty-nine miles from Madrid) to a Milanese father and Portuguese mother. Palomino and Ceán called him one of El Greco's best pupils,[18] but this is a tutelage for which there is no evidence, either documentary or stylistic. He was probably trained in Italy. He would have just missed the slightly older Eugenio Cajés in Rome (see below); according to Martínez, Maino was a disciple and friend of Annibale Carracci (who died in 1609) and a great companion of Guido Reni (who arrived in Rome in 1601).[19] It seems likely that Maino was in Pastrana in 1608, so his Roman sojourn probably occurred before this date.[20] In mid-March 1611 he authorized Fray Rodrigo de Portillo of the Order of Saint Francis in Milan to settle his accounts with the administrators of his family goods there.

Maino's first documented commission, in early 1611, was for the Cathedral of Toledo. This was the year the artist and author of *Arte de la pintura*, Francisco Pacheco, visited Toledo from Seville (see below); one wonders whether Maino's path crossed with his.[21]

Although there is only one documented portrait by Maino's hand,[22] Martínez extolled his half-length figures "of good taste and perfection" and singled out the "special grace" of Maino's portraits (compare cat. 16)—especially the small ones, which he says surpassed those of everyone else.[23]

On September 19 Maino was mentioned as a novice at San Pedro Mártir, and in July 1613, after having proved that he was an old Christian of pure blood ("limpio de sangre y cristiano viejo"), Maino professed as a Dominican monk. He apparently painted very little after that. A year and a half later, the prior and brothers of the monastery allowed him to request in the name of San Pedro Mártir t he goods he inherited from his father. He is next mentioned as resident in Lisbon, where he is referred to as "maestro de pintura del Príncipe," or Prince Philip's painting teacher. According to Martínez, Philip III, who had heard of Maino's fame, was so pleased by a painting that Maino showed him that he chose him as "master and teacher of this noble profession" for his son.[24]

Maino moved to Madrid and lived in the Colegio de Atocha there in 1620

when he testified on behalf of the painters in legal proceedings against the gilders, whom Maino distinguished from his colleagues as being mere craftsmen.[25] When Philip IV came to power, Maino, as his art teacher, had already known him well for some time.[26] In 1621 the king interceded on his behalf via the Spanish ambassador in Rome, requesting the prompt execution of a papal bull for Maino's pension of 200 ducats. His name also appears on a document of patronage bestowed on the count-duke of Olivares, Lerma's successor, in 1626, by which time Maino was living at the Dominican monastery of Santo Tomás in Madrid. In 1630 he was among the artists praised by Lope de Vega in his *Laurel de Apolo*. Maino's contribution to the Hall of Realms in the Buen Retiro was the *Recapture of Bahía* (fig. 12, p. 38), for which he was paid in 1635 and which was praised that same year in a collection of eulogistic verse published by Diego de Covarrubias. His last large commission was for six paintings for the chapel of the count of Castrillo in the monastery of Espeja in Burgos. He died in 1649 in Santo Tomás in Madrid and was buried there in the chapel of Our Lady, under one of his paintings.

When Philip II left Flanders in 1559, he brought Antonis Mor (about 1520–about 1576) back to the Spanish court with him. Mor developed a type of static royal portraiture in which the figure, dressed in elaborate costume and accompanied by a symbolic accoutrement or two, was sharply lit and placed against a dark background. In essence Mor married the northern predilection for painstaking detail to Titian's pictorial conception of the powerful governor, creating the image of the Hapsburg ruler that would endure until the dawn of the eighteenth century.[27] When Philip III came to power after the death of his father in 1598, the royal portraitist, Juan Pantoja de la Cruz, was already at work. According to the will he made in 1599, Pantoja had learned to paint with Alonso Sánchez Coello, who in turn had been trained by Mor. Pantoja was born probably in 1553;[28] he married Francisca de Huertos in Madrid in 1587 and signed and dated his first portrait in 1588, the year of his teacher's death. About 1590 Pantoja was recorded as painting in Simancas, the seat of the royal archives. The artist painted portraits of members of the royal family in the early 1590s,[29] and in 1596 he was first documented as drawing a salary as royal painter.[30] In that capacity, in July 1600 Pantoja was asked to value the paintings in the estate of Philip II.

Pantoja also worked for members of the royal circle. For example, in 1595 he painted a portrait of the Knight of Calatrava, Fernando Pacheco of Toledo, chamberlain to the king, and a portrait of Fray Hernando de Rojas, the rector of the Augustinian Colegio de Doña María de Aragón, a seminary whose church was frequented by the king and his entourage.[31] In 1597, the year after El Greco began work on the high altar for the *colegio* church, Pantoja painted escutcheons for it. The *colegio* further commissioned from Pantoja paintings of *Saint Augustine* and *Saint Nicolas of Tolentino* in 1601.

According to his 1599 will, Pantoja painted large allegories of the Four Elements and, in 1592, three *bodegones de Italia* (Italian still lifes). Also in 1599 he contracted for work for the chapel of the Mercedarian cloister and the church of the Misericordia and, in 1600, for a large winged altar for the Augustinian cloister

outside of Madrigal de las Altas Torres (Avila). Like many of the artists active during the reign of Philip III, he worked in a range of genres, painting not only portraits but also religious images, still lifes, allegories, and animal pictures (listed in the inventory of his goods in 1608).

In 1601 the king moved his court from Madrid approximately 130 miles northwest to Valladolid, where it remained until 1606. The city, visited regularly by itinerant monarchs of Castile, had recently been rebuilt after fire destroyed its center. Pantoja is documented as working for Philip III and his queen throughout their residency in Valladolid.[32]

Pantoja was not the only artist to follow the king to his new seat. A couple of years after the court moved from Madrid, the accomplished Flemish artist Peter Paul Rubens (1577–1640) (fig. 15) arrived in Valladolid. He had come to Spain as part of a diplomatic mission on behalf of his patron, Vincenzo Gonzaga, duke of Mantua. Rubens was charged with delivering to the court, among other splendid things, a gift of close to forty paintings. He arrived in Valladolid for what would be a more than eight-month stay on May 13, 1603. On the four-hundred-mile trek across Spain from Alicante, the artist-diplomat experienced rains and storms that damaged many of the works of art he was conveying. He set to work painting *Democritus and Heraclitus* (fig. 38, p. 95)[33] in substitution for a couple of the paintings deemed damaged beyond repair. In July Rubens was charged by the duke of Lerma to paint him a picture of his own invention. In a letter of September 15 to Annibale Chieppio, the ducal secretary of state, Rubens referred to a "large portrait on horseback" of the duke that he was to paint (cat. 11); it is not clear whether this particular idea was generated by the patron or the artist but it could well have been a collaborative effort.[34] Sarah Schroth has suggested that Rubens relied on the face in Pantoja's image of the duke (fig. 75, p. 200) as he was finishing this great equestrian portrait.[35] On November 13 Annibale Iberti, the duke of Mantua's representative in Valladolid, wrote his employer that the portrait was finished and that Lerma was extremely pleased.[36]

While discussing the damage sustained by the paintings en route, Rubens wrote in a letter to Chieppio of May 24, 1603,

> I agreed to [apply all my skill in restoring the damaged painting], but I am not inclined to approve of it, considering the short time we have, as well as the extent of the damage to the ruined pictures; not to mention the incredible incompetence and carelessness of the painters here, whose style (and this is very important) is totally different from mine. God keep me from resembling them in any way! . . . Moreover, the matter will never remain secret, through the gossiping of these same assistants. They will either scorn my additions and retouches, or else will take over the work and claim it as all their own, especially when they know it is in the service of the Duke of Lerma. . . . By its freshness alone, the work must necessarily be discovered as done here. . . , whether by the hands of such men, or by mine, or by a mixture of theirs and mine (which I will never tolerate, for I have always guarded against being confused with anyone, however great a man). And I shall be disgraced unduly by an inferior production unworthy of my reputation, which is not unknown here. . . . [The duke of Lerma] is not without knowledge of fine things, through the particu-

lar pleasure and practice he has in seeing every day so many splendid works of Titian, of Raphael and others, which have astonished me, both by their quality and quantity, in the king's palace, in the Escorial, and elsewhere. But as for the moderns, there is nothing of any worth.[37]

Rubens's contempt for his Spanish painter contemporaries has historically been taken at face value. However, his observations, if understood in the context of the situation at court, belie the fact that he was in competition with these very painters for Lerma's favor.[38]

One wonders what Rubens thought about the sculptors working for the court. Among the local artistic talent in Valladolid was the sculptor Gregorio Fernández (fig. 16). Fernández was Galician by birth; he was born in Sarria (Lugo) in 1576 and was first documented in Valladolid in May 1605. At that time he collaborated with Milán Vimercado on the decoration of the *templete* (little temple), erected in the *salón de fiestas* (banqueting hall) of the royal palace in Valladolid, for the baptism of the future Philip IV. In June of the following year, he agreed to make the sculptural group of *Saint Martin and the Beggar* for the church of San Martín (Museo Diocesano, Valladolid), and later that year he contracted for nine large and ten small sculptures for the high altar of the church of San Miguel.[39] Fernández took as an apprentice Manuel Rincón at the end of 1608; the boy was the newly orphaned son of Francisco Rincón, who had been the most notable sculptor in Valladolid before his premature death in August of that year.[40]

At some point between 1609 and 1612 the duke of Lerma donated to the Dominican monastery and church of San Pablo a sculpture by Fernández of *The Supine Christ* (fig. 58, p. 133).[41] In February 1613 Fernández signed a contract for sculptures for the high altar of San Pablo, another commission from the duke of Lerma. The sculptor committed to make nine more sculptures for Lerma in 1615, this time for the high altar of the Colegiata of Lerma. This courtly patronage brought the sculptor much prestige and many more commissions.

Fernández continued to work for local parish churches, monasteries, and convents, and more far-flung destinations in the second decade of the century. In June 1611 he rented a house, livery stable, and garden outside the Puerta del Campo to accommodate his growing workshop. He collaborated with the esteemed joiners Cristóbal and Francisco Velázquez on work for the confraternity of the Misericordia (1610), on a commission for the church of Santos Juanes in Nava del Rey in the former diocese of Salamanca (1611), and for the Jesuits' Casa Profesa in Valladolid (1613), for whom he also made reliquary busts of the Fathers of the Church in 1616 and busts of the counts of Fuensaldaña, for which he was paid in 1620. He was asked to make the sculptures for the high altar of the church of Nuestra Señora de la Asunción in Tudela de Duero (Valladolid) (1611), for the monastery of Santa María la Real de las Huelgas in Valladolid (1613) (fig. 53, p. 126), and for the church of San Andrés in Segovia (1616).

Fernández was also much in demand as a fabricator of *pasos*, the sculptures carried through the streets in the religious processions of Holy Week. The guild of passementerie manufacturers paid him to make a *paso* entitled *Sed Tengo*

15
Peter Paul Rubens
Self-Portrait with Isabella Brant in a Honeysuckle Bower, 1609–10
Oil on canvas, 70 1/16 x 53 3/4 in. (178 x 136.5 cm)
Bayerische Staatsgemäldesammlungen, Alte Pinakothek, Munich

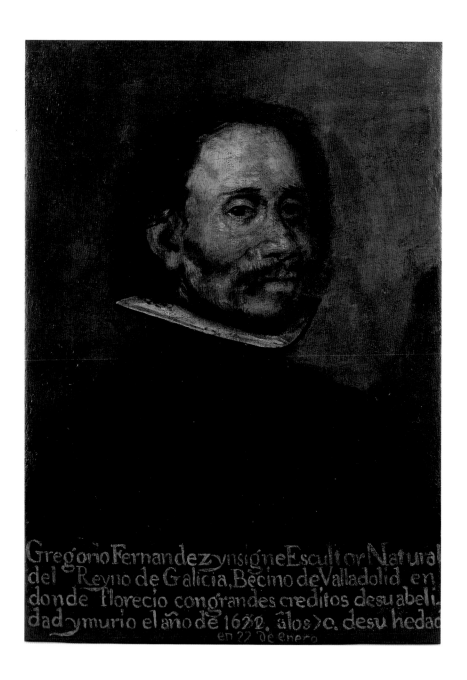

Gregorio Fernandez ynsigne Escultor Natural del Reyno de Galicia, Becino de Valladolid, en donde florecio congrandes creditos desu abeli. dad y murio el año de 1672, ålos 70 desu hedad en 22 de enero

16
Diego Valentín Díaz
The Sculptor Gregorio Fernández, about 1623
Oil on canvas, 21¼ x 15⅜ in. (54 x 39 cm)
Museo Nacional de Escultura, Valladolid

(I Thirst) for the penitential confraternity of Jesus of Nazareth (1612), and he contracted with the confraternity of the Passion to make four figures for *The Road to Calvary* (1614). In 1617 twenty-eight men were paid to bring the *paso* of *La Pietà* (which, with the two aforementioned works, is now in the Museo Nacional de Escultura, Valladolid) from the sculptor's house to the church of Las Angustias in Valladolid. Each of the five penitential confraternities of the city managed to acquire at least one Passion scene created by Fernández.[42] According to Palomino, the sculptor was a virtuous and pious man: "He did not undertake to make an effigy of Christ Our Lord or of His Holy Mother without preparing himself first by prayer, fast, penitence, and communion. . . . His house was well known to the poor [who] went there for all their needs."[43]

In 1614, the year of Saint Teresa's beatification, Fernández made the first of his sculpted versions of her holding a pen and a book (cat. 41);[44] another, for the convent of the Unshod Carmelites, was paid for in 1619. He used the death mask and the portrait of Ignatius Loyola by Alonso Sánchez Coello for his image of that saint (cat. 42) in 1622, the year of Loyola's canonization.[45] Fernández became a member of the confraternity of the Immaculate Conception after he had made for them his *Virgin of the Immaculate Conception*, which was placed in the monastery of San Francisco. He made another *Inmaculada* for the confraternity of the True Cross in Salamanca. Well into the reign of Philip IV, he continued to execute these kinds of commissions. Fernández died in 1636 and was buried in the monastery of the Shod Carmelites of Valladolid, but not until the monarch declared him to be "the most highly skilled sculptor in my kingdom."[46]

Pantoja de la Cruz remained busy during the court's sojourn in Valladolid. In 1605 he signed and dated the *Resurrection* (cat. 31), which he made for the church of the Hospital General de la Resurrección in Valladolid (of which the duke of Lerma was patron).[47] The artist also contracted to paint the high altarpiece for the church of the convent of San Augustín in Valladolid, an unrealized commission he undertook with Bartolomé Carducho.

Perhaps Pantoja's most important commission during the court's stay in Valladolid came as a result of a fire in 1604 at El Pardo, the royal hunting lodge to the north of Madrid in the foothills of the Guadarrama Mountains. Pantoja was charged with painting thirty-five portraits for the new gallery there (intended to be a pictorial geneology of the house of Austria) and, with Francisco López (1554–1629), the fresco painting on its ceiling.[48]

Pantoja proceeded to work for members of the court upon their return to Madrid as well. On May 15, 1607, he received payment from the duke of Lerma's treasurer for two portraits of Their Majesties and two of the duke and duchess of Lerma. In December he received further payment for a portrait of the duke and one of His Majesty. He also signed and dated the portrait of two of the king's children (cat. 9) in 1607. The artist continued to work for noble families, as evidenced by the signed and dated portrait of Doña Antonia de Toledo y Colonna of that year.[49] Pantoja made his second will on October 7, 1608, which was witnessed, according to one writer, by Bartolomé González.[50] In the will Pantoja mentioned that he had almost finished the burial chapel for Philip III's chamberlain, Don Francisco Guillaumas, in Avila.[51] The artist died, with the Valencian painter Francisco Ribalta as one of his debtors, less than three weeks later. Pantoja was buried in the Franciscan church of San Ginés in Madrid and was shortly thereafter included as one of the "modernos insignes en Pintura" (notable modern painters) by the writer and judge Cristóbal Suarez de Figueroa (1571–after 1644) in his *Plaza universal de todas ciencias y artes*, published in Madrid in 1615.[52]

In 1609 Pantoja's heirs entered into a contract with Bartolomé González to complete many of the portraits for El Pardo that Pantoja had left unfinished at his death. Documents concerning González's life are scarce so we are unusually

dependent on the accounts of Palomino and Ceán. According to Ceán, González was born in 1564;[53] Palomino established that he was born in Valladolid and studied with Patricio Cajés,[54] one of the Tuscan artists who came to Madrid to work at El Escorial. When the court returned to Madrid from Valladolid in 1606, González moved there as well.

In 1608 the artist began to work for Philip III, who commissioned him to paint full-length portraits of his children for El Pardo (among them, cat. 10) in 1612. A document of 1617, witnessed and valued by the royal painters Vicente Carducho and Santiago Moran (d. 1626), lists seventy-five portraits made by González for the king between January 1, 1608, and the end of August 1617. In addition to those for El Pardo, the paintings were dispatched to Hapsburg relatives in Flanders, Germany, Poland, and the court at Graz. On August 12, 1617, González was named to fill the post of *pintor del rey* left vacant by the death of Fabricio Castello (d. 1617), despite the Sevillian painter Juan de Roelas's best efforts to secure the position for himself.[55] An account made of paintings González executed for the monastery of the Capuchins at El Pardo later that year underlines the fact that, in addition to his portrait production, the artist painted religious subjects. The works included "a picture of Our Lady of the Angels" valued by Roelas at 200 ducats and a "picture of Saint Francis . . . where the saint is sick in bed and an angel is playing him music" valued at 70 ducats.[56] The following year González and Eugenio Cajés, Patricio's son, appraised three canvases by Roelas for the king.

González was given an advance in 1620 to paint six portraits of Queen Margaret's siblings intended for the royal palace in Madrid (the Alcázar), for which he was paid in full by 1625. On March 10, 1621, a last document dating to the reign of Philip III mentions sixteen additional portraits González made for the king beginning in 1619; this one was witnessed and valued by the royal painters Eugenio Cajés and Francisco López. Carducho, Cajés, and González were commissioned in 1625 to paint companion pieces to Velázquez's equestrian portrait of Philip IV (all now lost). González's last will and testament, dated October 8, 1627, requested that he be buried in San Ginés in Madrid, the resting place of his parents and siblings and of Pantoja de la Cruz. In 1629 his paintings and materials were valued by Antonio Lanchares (about 1590–1630), who lobbied for the post of *pintor del rey* on González's death; among the paintings were copies by González of a landscape by Pedro Orrente, a *Saint Peter* by Jusepe de Ribera, and an *Ecce Homo* by Caravaggio.[57]

In 1865 J. Cruzada Villaamil, one of the first important Spanish art historians, wrote that Pantoja and Vicente Carducho contributed greatly to the formation of a Madrid school of painting. Carducho (fig. 17) was born in Florence probably about 1576.[58] According to Ceán he came to Spain in 1585 with his older brother Bartolomé and accompanied him to El Escorial, where Vicente did his apprenticeship.[59] In 1599 (according to his own testimony of July 1606) Carducho worked on the triumphal arches erected for the royal entry of Queen Margaret into Madrid, and in May 1601, he was again documented in Madrid, authorizing the collection

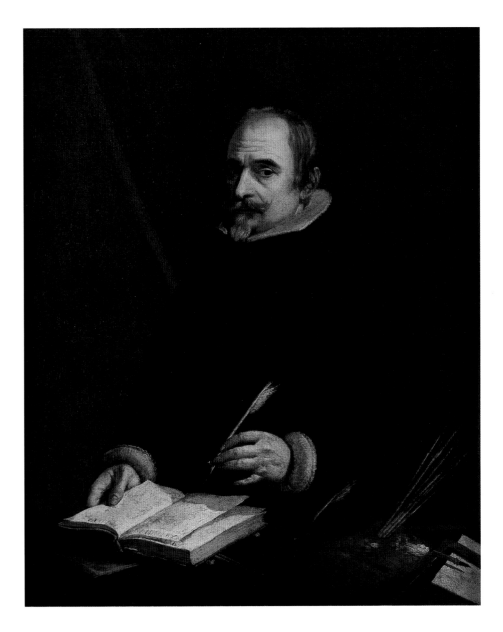

17
Vicente Carducho (attributed to)
Self-Portrait
Oil on canvas, 39¾ x 33⅞ in. (101 x 86 cm)
Stirling Maxwell Collection, Pollok House, Glasgow

of debts owed him. The following year Carducho's name appeared in the accounts of the palace of Valladolid in connection with gold leaf used in the *camarín* of the duke of Lerma, the oratorio of the duchess, and the quarters of the count of Fuensaldaña. In 1603 he was paid for a painting of the *Holy Spirit* for the palace, and is documented several times more as working for the duke, not only for his palace but also, in collaboration with his brother, for the new Franciscan monastery of San Diego (which adjoined the ducal quarters and was built by Lerma between 1603 and 1604), and for his suburban palace, La Huerta de la Ribera. Carducho returned to Madrid with the court in 1606.

The artist was among those who, in that same year, entered into an agreement with the monastery of San Bartolomé de la Victoria in Madrid to house an academy of painters; the painters' efforts to incorporate an academy was resumed under Philip IV in 1624, but neither time succeeded. Nevertheless, Carducho's *Diálogos de*

la pintura, a spirited theoretical defense of painting as a noble pursuit and of the artist as a learned humanist, published in Madrid in 1633, expressed the practice and purpose of art as an academy—had there been one—would have done.[60]

In 1607 Carducho, along with other painters including his brother and Eugenio Cajés, contracted for paintings for El Pardo. A valuation of August 11, 1612, lists Carducho's work in fresco and gilding of the vaults both of the royal chapel and of the South Gallery (*galería del mediodía*) in the palace; his Italian background allowed him to excel in this type of decoration.[61] In 1608, the year of his marriage to Doña Francisca de Benavides, he was paid for work on the catafalque for Queen Margaret's mother, Maria Anna of Bavaria, in San Benito, Valladolid. Vicente was appointed to his brother's place as painter to the king in 1609.

In the second decade of the century, Carducho executed altarpieces for the Hieronymite monastery of Santa María del Parral in Segovia and for the main and collateral altars of the convent of La Encarnación in Madrid, founded by Philip III and Margaret in 1611. He was also commissioned in 1615, with Cajés, to paint and gild the Capilla del Sagrario in the Cathedral of Toledo. The decoration, which consisted of frescoes that covered the lunettes, dome, pendentives, and walls, was the richest work created for the cathedral in the first half of the century.[62] Again with Cajés, he painted the high altarpiece for the royal Hieronymite monastery of Our Lady of Guadalupe in the western province of Cáceres and an altarpiece for the parish church in Algete (Madrid). In October 1619 Carducho contracted to paint the altarpiece of San Sebastián in Madrid, a commission originally given to Antonio Lanchares, a former student of Cajés, who found himself too busy with his work for the Cartuja in Segovia to finish the work in San Sebastián.[63]

Carducho and Cajés decorated the catafalque of Philip III in San Jerónimo el Real with coats of arms and skulls in 1621, the year Lope de Vega included a poem in *La filomena* praising Carducho's ability to express in painting what can only poorly be said in words.[64] Carducho was an extremely productive artist throughout his career,[65] and he continued to execute important commissions during the reign of Philip IV, including one in 1626 for fifty-six paintings for the Cartuja del Paular (Madrid). He clearly had a well-organized workshop by this date to be able to carry out work on such a large scale.[66] In 1627, with Cajés and Velázquez, Carducho was on the committee to appoint a successor to González as *pintor del rey*, a position that was ultimately suppressed. As already mentioned, in 1625 he was among those commissioned to paint a companion piece to Velázquez's equestrian portrait of Philip IV. He also competed with Cajés, Angelo Nardi (1584–1663/65), and Velázquez for the royal commission for a painting of the *Expulsion of the Moriscos from Spain by Philip III* (all now lost); Juan Bautista Maino and Giovanni Battista Crescenzi (1577–1635), a Roman nobleman, architect, and amateur painter living in Madrid, judged Velázquez the winner. Carducho made his first will in 1630. Whatever prompted him to do so must not have been dire, however, as in 1633, the year his *Diálogos* was published, he worked with Cajés to have the sales tax on paintings repealed. The following year he participated in the royal commission for battle paintings for the Buen Retiro; one of his three paintings for this project, the *Siege at Rheinfelden* (Museo Nacional del Prado,

Madrid), is dated 1634. He made his second will in 1635, and its codicil, dated November 14, 1638, states that Carducho was ill in bed. He died that year "very esteemed," according to Martínez, "by all of the best talents in Spain and by the great court gentlemen," and was buried in a chapel in the Hospital of the Third Order of Saint Francis (of which he served as adviser and minister).[67]

Carducho's friend and collaborator, Eugenio Cajés, was baptized in early January 1574.[68] Cajés was born in Madrid to Casilda de la Fuente and the Tuscan painter Patricio Cajés. If Martínez is to be believed, he probably studied in Rome before marrying the daughter of one of the king's carpenters in 1598.[69] By 1599 he knew Pantoja, from whom he borrowed money in January and April.[70]

Cajés was commissioned by the accountant Ochoa de Urquiza, an official of the Casa de Contratación in Seville,[71] to work with his father Patricio on a retable for the church in the town of Esquino in Vizcaya in 1601. The following year he was asked by the Madrid resident Fray Pedro de Medrano of the Order of the Trinitarians to paint a series of the Infancy of Christ.[72] As early as 1603 he was among the artists who sent a petition to the king requesting his support in founding an academy of painting.[73] He copied Correggio's *Leda* the following year,[74] which was a busy one for Cajés, as he also received commissions for a retable for San Felipe el Real in Madrid (for which *Joachim and Anne Meeting at the Golden Gate* [cat. 20] was made) and one for the San Segundo chapel in the Avila Cathedral.[75] His first dated portrait, that of Cisneros, was also signed in 1604. On September 20 Cajés took on his first apprentice, Francisco de Aguilera. In 1606 he worked for the duchess of Feria, contracting to make altarpieces for the chapel of Santa Marina in Zafra (Badajoz). There is no indication that Cajés went with the court to Valladolid. In the year 1607 he began to work closely with Carducho (compare cats. 27 and 28).

Ceán recorded that in El Pardo, Cajés "adorned with stucco and cartouche decorations the audience rooms of the king, and he painted in fresco the *Judgment of Solomon* in the middle of the vault with majesty and flair; he painted different virtues in the spaces; and countries in the lunettes."[76] In 1609 Cajés was celebrated by Lope de Vega in *Jerusalén conquistada*;[77] years later, in 1630, the poet would raise Carducho and Cajés to the "beautiful top" of Parnassus in his *Laurel de Apolo*.[78] Cajés took on Julián de Pascual as an apprentice in April 1612, and in August of that year was made *pintor del rey* in place of his father. He continued to value works of art, among them Pacheco's *Nuestra Señora de la Expectación*,[79] and to collaborate with Carducho on their major commissions in the Toledo Cathedral (1615),[80] at the royal monastery of Our Lady of Guadalupe in Cáceres (commissioned in 1615 and finished in 1618), and at the parish church in Algete (1619). In 1620 Cajés signed and dated a painting of the *Annunciation* for Santo Domingo el Antiguo in Toledo,[81] and in 1621 he contracted to paint the high altar for Nuestra Señora de la Merced (Our Lady of Mercy) in Madrid.[82] In 1622 Cajés was paid for an *Annunciation* he made for La Encarnación. When Philip III died in 1621, Cajés worked with Carducho on the decoration of his catafalque in San Jerónimo el Real in Madrid.

Many of the important commissions Cajés received in the succeeding reign are discussed above. In 1628 Cajés petitioned the king to become *ujier de cámara* (usher of the chamber), which was authorized but never came to pass. In 1631 he was also unsuccessful in obtaining an increase in his wages. Nevertheless, that year he painted the *History of Agamemnon* for the Alcázar (now lost) and a few years later was among the painters who contributed battle scenes to the Buen Retiro.[83] Cajés signed his last will and testament on December 13, 1634, in which he expressed his desire to be buried in the habit of Saint Francis in San Felipe el Real in Madrid. He owed Carducho money and had still not been paid by Nuestra Señora de la Merced, despite having sent them several bills. He was also owed money by the king for his work at El Pardo, the Buen Retiro, and for his salary as well.

In the monastery of the Shod Trinitarians in the Calle de Atocha in Madrid (the building is no longer extant), Ponz described a series of religious paintings with life-size figures in the lower cloister that had been made by Eugenio Cajés and Juan van der Hamen, "with great respect for Nature."[84] A generation younger than Cajés, Juan van der Hamen (fig. 18) was baptized in the Madrid parish of San Andrés on April 8, 1596. His father, originally from Brussels, was a member of the king's guard of archers (*arquero del rey*),[85] and his mother was a noble half-Flemish, half-Spanish native of Toledo. In 1615 he was allowed to marry the young Eugenia de Herrera without giving the customary three weeks' public notice because of unspecified pressing business outside of Madrid.[86] Their son, Francisco, was born the following year.

Van der Hamen's first documented painting commission is recorded in September 1619, when he received payment from King Philip III for a still life of fruit and game for the South Gallery of El Pardo, intended to supplement a set of overdoors that had been acquired from the collection of the Toledan archbishop Bernardo de Sandoval y Rojas, who had recently died. In 1621 the artist signed and dated, among other still lifes, *Still Life with Sweets* (cat. 54); *Still Life with Sweets* (cat. 56) was among those he dated the following year. And in 1622 Van der Hamen's sister-in-law, Juana de Herrera, returned to the artist four fruit still lifes upon the death of her husband, the tailor Diego de Alfaro, that had been inventoried in her husband's house but not paid for.

The artist was appointed to follow in his father's footsteps as royal bowman on January 1, 1622, shortly after Philip IV became king.[87] In 1625 Van der Hamen dated the *Adoration of the Apocalyptic Lamb* that he made for the Capilla del Cordero in the convent of La Encarnación (in situ; see fig. 18). He continued to paint still lifes, but he also painted a death-bed portrait of the recently deceased Doña Juana de Aragón, duchess of Villahermosa, who had died in childbirth on May 3, 1623. In 1626 he painted the portrait of Cardinal Francesco Barberini during the visit of the papal legate to Madrid.[88] While no early dated or documented religious paintings or portraits by Van der Hamen have come down to us, it is possible that he began producing imagery of this type during the reign of Philip III.[89]

In 1627, Vicente Carducho and Van der Hamen valued the mostly religious paintings in the collection of the late duchess of Nájera, Doña Luisa Manrique,

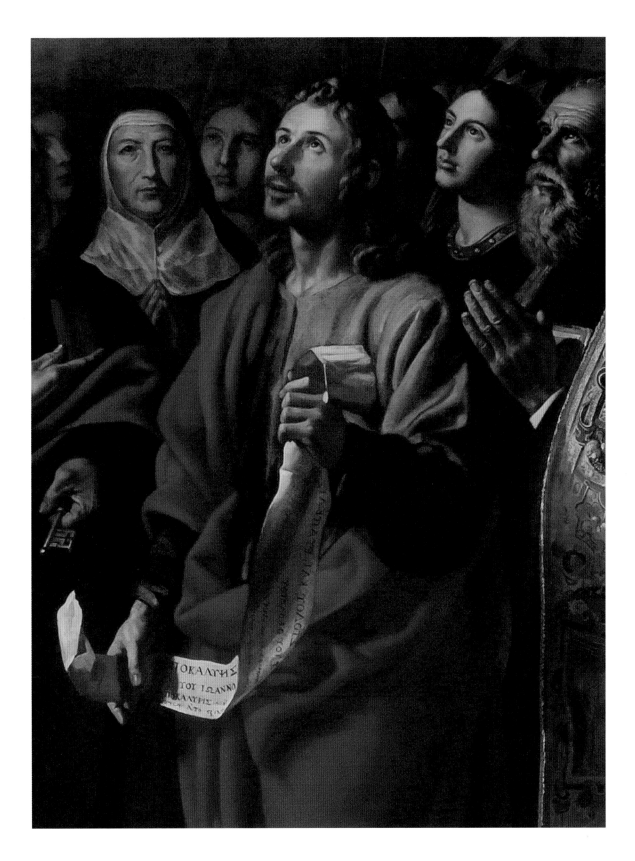

18
Juan van der Hamen y León
Adoration of the Apocalyptic Lamb (detail), 1625
Oil on canvas, 118⅛ x 93⁵⁄₁₆ in. (300 x 237 cm)
Convento de la Encarnación, Madrid

and the following year Van der Hamen unsuccessfully solicited the position of *pintor del rey*, vacated on the death of Bartolomé González. Toward the end of the decade, the Royal Palace commissioned the artist to make three paintings of festoons of flowers, fruit, and putti. He was also asked to paint works for the gallery of the apartment of the Cardinal Infante Don Fernando, Philip IV's younger brother. Van der Hamen died on March 28, 1631, and an inventory of his estate was made on April 4.

Among Van der Hamen's belongings at his death were twenty bust portaits of "illustrious persons"; his portrait of his brother Lorenzo (cat. 15) was probably part of this series.[90] In *Para todos* (1632), which included a compendium of intellectuals at the court (including Van der Hamen, the only artist to be named), Juan Pérez de Montalbán (1602–1638) intimated that what most impressed Van der Hamen's contemporaries was the broad range of genres that he dominated.[91] In *Arte de la pintura*, published posthumously in 1649, Pacheco commented that he preferred Van der Hamen's still lifes to his "figures and portraits."[92] Lope de Vega, in his sonnet "A Juan de Vander Hamen Pintor Excelente," published by Palomino in 1724, mentioned the painter's history pieces and portraits but saved his highest praise for the still lifes and flower pieces.[93] Van der Hamen's paintings were a comparatively late flowering of the still-life genre.

Approximately twenty years earlier and back in Toledo, Juan Sánchez Cotán signed his earliest dated still life, *Still Life with Game Fowl, Fruit and Cardoon* (1602) (Museo Nacional del Prado, Madrid). The unattributed still life described as "Another picture in which there is fruit painted—a melon, quince, pomegranate, orange, carrots and cardoon" in the 1599 death inventory of Pedro Girón García de Loaisa (1534–1599), the archbishop of Toledo who was closely associated with both Philip II and his son, might also have been painted by Sánchez Cotán.[94]

The artist was baptized in the parish church of Orgaz near Toledo on June 25, 1560. According to Pacheco, Sánchez Cotán was the student of Blas de Prado (about 1546–1599), who is known to have painted still lifes. Blas de Prado and Sánchez Cotán were certainly well acquainted; in 1593 the former authorized the latter to collect money owed for an altarpiece Blas de Prado painted for the parish of Campo de Criptana (Ciudad Real), and six years later he named Sánchez Cotán guarantor of a contract with the church in Madridejos (Toledo). Furthermore, Sánchez Cotán was among the artists who pledged to finish paintings for the altar of San Bartolomé de la Vega in the outskirts of Toledo, contracted for by Blas de Prado in 1593 and left unfinished at his death. As late as 1602 Sánchez Cotán collected money for work on the altars of the church of the Toledan monastery of Los Mínimos originally contracted for by Blas de Prado. El Greco was somehow indebted to the young artist; on December 13, 1599, Martín Ramírez agreed to pay the older artist for his work on his family chapel, 500 ducats of which was to go to Sánchez Cotán.

On August 10, 1603, on the eve of his departure from Toledo, Sánchez Cotán signed his testament, leaving his house to his brother, part of another house to his sister, and listing the ecclesiastics, professional men, and a few nobles who owed

him money (for religious paintings but also for a painting of a hunt and for portraits). He authorized Juan de Salazar and Diego de Valdivieso to sell his goods and recover his debts and his brother to collect that which Melchor de Acevedo owed him. Sánchez Cotán was indebted to no one. Among the paintings that figured in his inventory, which was drawn up a few days later, were "A canvas on which are a quince, melon, cucumber and a cabbage" (cat. 51) and "A canvas of fruit in which are the duck and three other birds which belongs to Diego de Valdivieso" (cat. 52).

On July 29, 1604, Sánchez Cotán prepared evidence of the purity of his Spanish blood (*limpieza de sangre*) and on September 8, 1604, at the age of forty-three, he professed as a lay brother in the Charterhouse of Granada. After this time he painted religious works only (see cat. 46). In this strict monastic order, the lay brothers, who took the same vows as the monks but wore brown habits instead of white, carried out menial tasks so that the monks could concentrate on higher matters.[95] Shortly after his arrival, he painted the retable of the *Assumption of the Virgin*, recorded in the monks' Chapter Room.[96]

In 1610 Sánchez Cotán was back in Toledo, where he collaborated with his nephew Alonso, a registered sculptor and joiner, on an altarpiece for San Pablo de los Montes. According to Ceán, in 1612 he went to the town of Alcázar de San Juan to adjudicate a disagreement between his brother and nephew and a certain Ignacio García Escucha, who would eventually marry his niece.[97] The same author recounted that between 1615 and 1617 Sánchez Cotán painted the main canvases of the Charterhouse of Granada, consisting of four scenes from the life of Saint Bruno and four of the English martyrs.[98] These were characterized by Pacheco as "famous works. . . . imitating nature."[99] The artist, lauded by Palomino as virtuous, moderate, and pleasant, died "with the reputation of venerability" in Granada on April 8, 1627.[100]

We are far less informed about the short life and career of the much younger Alejandro de Loarte, who we know lived in Madrid by June 1619, when he married María del Corral, the young widow of Gaspar Carrillo, court notary, in the parish of San Sebastián. If he married at eighteen or nineteen, which was common at the time, he would have been born between 1595 and 1600, making him the contemporary of Juan van der Hamen.[101] When he signed his dowry contract on October 16, 1619, he described himself as a painter resident in Madrid, the son of Jerónimo de Loarte, also a painter. Perhaps he trained with his father.[102] According to Ceán, Loarte was probably working and living in Toledo by 1622, the date on the *Miracle of the Loaves and Fishes* (whereabouts unknown) that was in the refectory of the Toledan monastery of los Mínimos.[103] In 1624 he took on the apprentices Francisco de Molina and Juan de Sevilla Villaquirán, and the following year, exceptionally, the fifteen-year-old girl, Eugenia de Olmedo. On May 14, 1625, he contracted to paint the *Martyrdom of Saint Catherine* for a chapel in the parish church of Bórox (Toledo) (in situ). While this is his only documented religious painting, nearly half the paintings in the inventory of his belongings taken after his death were religious works.[104] Loarte took on a journeyman, Félix de Melgar, in September

of 1626, but on December 9 of that year he made his last will and testament. He died a few days later. His executors were his wife and the older painter Pedro Orrente, who at that time was resident in Toledo.

The number of still lifes found in Loarte's studio at his death far exceeded those left by Sánchez Cotán twenty-three years earlier. In the generation separating the two, still life was no longer collected only by the aristocracy and intellectual elite but was now being painted for the middle class. The few known still lifes that Loarte signed and dated span only four years—from 1623 to 1626[105]—and those years belong to the reign of Philip IV. Nevertheless, stylistically and thematically the *Still Life with Fruit Bowl* (cat. 53) continues in a general way the type of painting introduced to Spain by Sánchez Cotán, and the *Birds with Kitchen Scene* (cat. 58) indicates a use in Castile of the same kind of Flemish prototypes that Velázquez relied on in Seville for his *bodegones* (cat. 59).

The peripatetic Pedro Orrente (fig. 19), Loarte's friend and executor of his estate, was among the most famous artists working during the reign of Philip III. Baptized on April 18, 1580, in Murcia in southeast Spain, the son of a Frenchman who had married a local girl, Orrente is next documented in Toledo, where on September 11, 1600, he contracted to paint an altarpiece for the chapel of the Virgin del Saz in the town of Guadarrama (Madrid). The artist painted a *San Vidal* for Jerónimo Castro of Murcia; on December 18, 1604, Castro agreed to pay Orrente's father for the painting by the end of the following February.

Martínez reported, "He spent a good deal of time in Italy and in Venice learning from Leandro Bassano [1557–1622], studying his work and adopting his manner of painting. Although Bassano dedicated himself more to medium-sized figures, our Orrente adopted a grand manner in which his grand spirit was manifested. And although Bassano was excellent and superior in painting animals, our Pedro Orrente was not inferior."[106] In August 1605 Orrente is documented in Venice; he likely left Spain in 1602 and visited Rome before arriving in Venice.[107] While there, he might have met the painter Angelo Nardi, who arrived in Spain from Venice in about 1607. Orrente's understanding of the art of the Bassanos evident in the *Blessing of Jacob*, signed and dated 1612 (Pitti Palace, Florence), would have been nurtured in Venice, although there were already many paintings by the Bassanos that had been imported into Spain by Bartolomé Carducho and collected by the duke of Lerma.[108] Orrente was probably back in Murcia in 1607.[109]

On January 31, 1612, Orrente authorized Nardi, then resident at the royal court, to collect from Pedro Pérez Carrión, silversmith and resident of Madrid, a painting of *The Martyrdom of Saint Catherine* or its price.[110] There is no document, however, that actually places Orrente in Madrid at any point in his career.[111] In 1612 Orrente married María Matamoros in Murcia. In 1614 Orrente is mentioned as owner, with his brother Patricio, of their father's house in Santa Catalina, Murcia.

About 1800 Don Marco Antonio Orellana (1731–1813), a lawyer and amateur historian, mentioned having seen a multifigured painting by Orrente of the *Martyrdom of Saint Vincent*, signed and dated 1616 (now lost), in the house of Don Henrique Castellví, the count of Castellar, who was canon of the cathedral

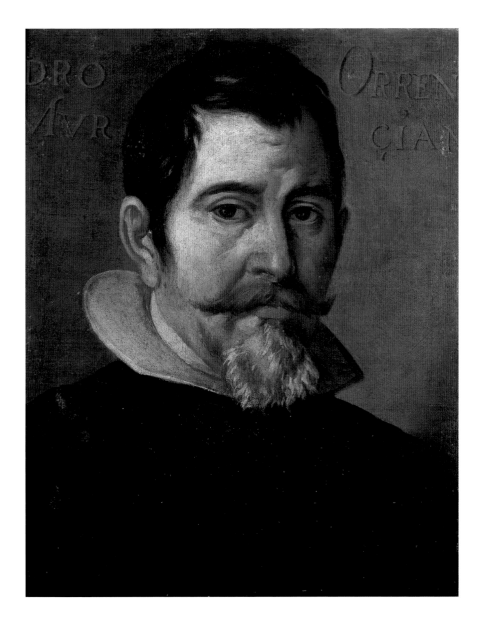

19
Pedro Orrente
Self-Portrait (Inscription: *Pedro Orrente Murciano*)
Oil on canvas, 17¹¹⁄₁₆ x 14³⁄₁₆ in. (45 x 36 cm)
Museo Nacional del Prado, Madrid

in Valencia. Orellana proceeded to recount the legend (that he did not believe) that shortly after Orrente received this commission, he entered into a curious competition with the Valencian painter Francisco Ribalta. Ribalta is said to have referred disparagingly to Orrente as "that . . . painter of sheep" (compare cat. 57), to which Orrente took offense. This insult and Orrente's reaction to it resulted in Ribalta's (apocryphal) challenge to him to paint the *Martyrdom of Saint Sebastian* (Valencia Cathedral; a reduced version is cat. 32) while Orrente required Ribalta to paint a *Saint Lawrence*.[112] While Ribalta was reportedly underwhelmed by Orrente's work (as it only represented a single figure), by the late eighteenth century Ponz considered it the best painting he had seen by the artist.[113] Orrente's connection to the city of Valencia was evidently strong by this date, although he is again recorded as an inhabitant of Murcia in November 1617, when he was paid for the *Saint Leocadia* (Toledo Cathedral). This painting was commissioned by Cardinal Bernardo de Sandoval y Rojas, whose portrait would be painted by Tristán.

This is the extent of Orrente's documented activity during the reign of Philip III, but a few events in his subsequent career are worth mentioning in this context. We know that by the end of 1626, when he was named Loarte's executor, he was living again in Toledo. The following year and again in June 1629 he served as godfather to a child of Jorge Manuel. On October 21, 1630, Orrente was paid for a *Nativity* for the Capilla de Reyes Nuevos in the Toledo Cathedral, which, according to Palomino, he made as a pendant to Eugenio Cajés's *Adoration of the Magi*.[114] In 1632 he is mentioned in a document as an inhabitant of Valencia, and in the following year he and his wife are said to be living in a small town near Murcia. He evidently spent time in both cities, although he seems to have left Murcia for good by 1639. He drew up his will in Valencia on January 17, 1645, and died there two days later.

Documentation concerning the work of Orrente's "rival," Francisco Ribalta (fig. 20), is plentiful. He was baptized on June 2, 1565, in Solsona (Lérida, in Catalonia), but his family sold their vineyard and house and moved to Barcelona when he was still a young boy. In 1581, when Ribalta was only sixteen years old, his parents died and he left Barcelona for Madrid. His first extant dated painting, the *Nailing to the Cross* (Hermitage), is from the following year and exhibits stylistic affinities to works associated with the masters active at El Escorial. The sources are silent about the artist for some time; in Madrid on December 23, 1591, Ribalta signed a contract with the court jurist Matías Romano Cuello for delivery and payment of a canvas depicting the *Annunciation*. A life-size *Crucified Christ*, the example of "a painting by Ribalta at Court," described thus by Palomino[115] and seen (in ruinous state) by Ponz and Ceán,[116] was in the cloister of the Madrid Colegio de Doña María de Aragón. Despite the fact that work on the building was still in progress in 1618,[117] we know from the commission for El Greco's retable there (December 1596) that the decoration of the *colegio* was already underway in the last decade of the sixteenth century. While Ribalta's painting for the *colegio* is no longer extant, a replica of the painting (made for the monastery of San Felipe el Real and probably the one now in Poblet) has been stylistically dated to this time.[118]

Although there is no information regarding Ribalta's marriage, he and his wife Inés Pelayo had a son, Juan, who was born in Madrid probably in 1596.[119] On February 12, 1599, Francisco Ribalta is referred to in a document as being a resident of Valencia. In April of that year, he enrolled in the Cofradía de la Virgen de los Desamparados, a confraternity in Valencia active in charitable enterprises.[120] That same month the city was in the throes of preparations for the royal wedding. The duke of Lerma, who had been viceroy of Valencia from 1595 to 1597, escorted the young queen, Margaret of Austria, to Valencia to meet her husband, the new monarch, Philip III. The ceremony, a double wedding with Philip III's sister, Isabella Clara Eugenia, and Archduke Albert, took place on April 18 in the Cathedral of Valencia and was presided over by Archbishop Juan de Ribera (1532–1611) and the papal nuncio Camilo Caetani.[121]

Valencia was a bustling Mediterranean commercial port in Aragon where a mingling of Eastern and Western cultures survived as a reminder of the historical succession of Moorish and Christian conquests of the city. Ribera, who would

20
Francisco Ribalta
Saint Luke (detail), 1625–1627
Oil on canvas, 32 ¹¹⁄₁₆ x 14 ³⁄₁₆ in. (83 x 36 cm)
Museo de Bellas Artes de Valencia

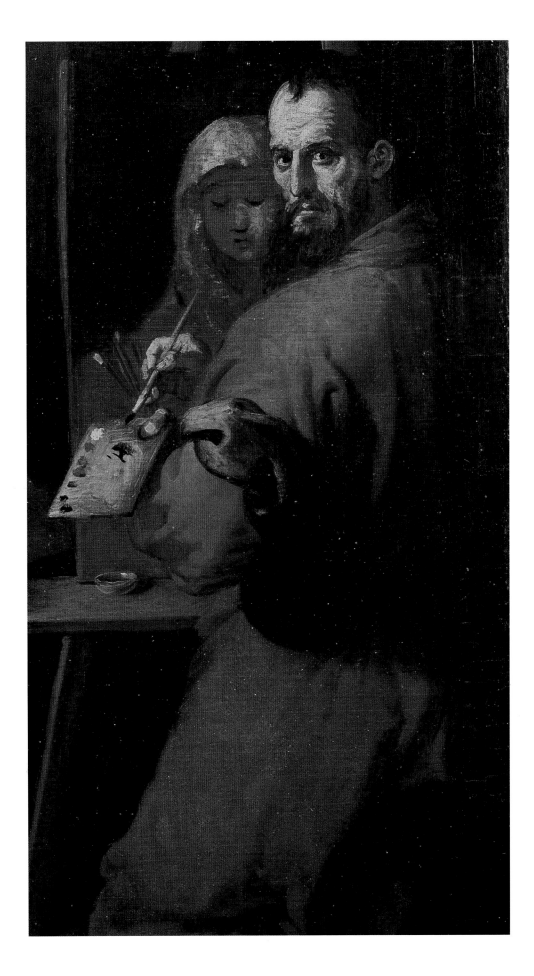

carry on Valencia's distinguished record of religious, intellectual, and cultural achievement, was at the time engaged in decorating his newly founded Colegio de Corpus Christi, which was committed to the education of priests according to the spirit and dictates of the Council of Trent. It might have been the prospect of working for Ribera, who was to become the artist's most important patron, that drew Ribalta to Valencia. Ribalta is first mentioned in connection with the *colegio* on October 3, 1601, when he received payment for the price of blue pigment used to "paint and retouch" the *Martyrdom of Saint Andrew*. Two days later he entered into partnership with the accomplished fresco painter Bartolomé Matarana (about 1545–1605),[122] the master in charge of the project; Matarana was responsible for gilding, painting, and coloring the retable of the main chapel of the *colegio*'s church, and Ribalta was to act as guarantor of the completion of the work. In March 1603 Ribalta's shop boy collected payment for three days' work on this altarpiece; it has been suggested that this money was paid for Ribalta's collaboration with Matarana.[123] That same year Ribalta painted *Presentation of the Virgin* and *Christ Child* for the Patriarch Ribera's *casa de estudios* in Burjasot, just east of Valencia. It is possible that at the end of 1603 Rubens traveled to Valencia to return to Italy from a nearby port; according to Ceán, Rubens was impressed by the abilities of Ribalta and other local painters.[124]

Ribalta was also active as a portraitist in these early years in Valencia. He painted a portrait of the bishop *Don Miguel de Espinosa*, the first rector of the *colegio*, to be used as a model for a fresco by Matarana. He was commissioned by Pedro Juan Esquerdo to paint two portraits of the venerable Dominican friar *Domingo Anadón*, almoner of the monastery of Santo Domingo in Valencia, and Orellana described a group portrait by the artist of *Father Anadón founding the Administration of the "Pila"*.[125] A few years later he painted two portraits of *Fray Francisco del Niño Jesús* and a portrait of *Pope Paul V* for the patriarch. He also made a portrait of *Sister Margaret Agulló*, an Augustinian nun venerated by Ribera.

The date of 1603 appears both on the *Martyrdom of Santiago* and *Santiago Matamoros* (*Appearance of Santiago at the Battle of Clavijo*), two of the twenty-seven paintings by Ribalta and his shop that made up part of the altarpiece of the parish church of Santiago Apóstol in Algemesí, about twenty miles south of Valencia.[126] During the initial time he worked on this altarpiece and lived in Algemesí, he remained in contact with the patriarch, who probably had recommended Ribalta for the commission.[127]

In 1605 Ribalta was back in Valencia, where he received payment for a painting of *Christ Appearing to Saint Vincent Ferrer* for the chapel of the Colegio de Corpus Christi, and a painting of *Christ* commissioned by Ribera for the Capuchins of Alcira. Ribalta continued to work on various important commissions for the *colegio* and the patriarch during the succeeding years, including the monumental *Last Supper* for the high altar of the *colegio* church. In his acknowledgment of receipt of payment for this work, the artist agreed to finish the painting to the satisfaction of the marquis of Malpica, the nephew of Juan de Ribera, for whom Lope de Vega was personal secretary.[128]

Ribalta was elected to a minor post in the Colegio de Pintores in 1607, the year this professional guild was founded.[129] That same year the painter contracted to complete within four years a commission from the silversmiths' guild for an altarpiece composed of nine paintings dedicated to Saint Eligius for the parish church of Santa Catalina. On November 19, 1608, Ribalta was listed as one of Pantoja de la Cruz's debtors.

When Juan de Ribera died on January 6, 1611, Ribalta had likely already returned to Valencia from Barcelona, having valued there the dome decoration for the chapel of San Jorge. He painted a small portrait of the patriarch at that time, which remains in the cell where Ribera died.[130] Although the *colegio* commissions did not end with Ribera's death, Ribalta increasingly began to work for other patrons.

In 1612 Ribalta received payment from the estate of a Don Joaquín Real, *regente de la cancelleria* (regent of the chancellery), for pictures representing "the faculty of painting." This document indicates a broadening not only of his patronage but also of the subjects of his art. That same year, the artist was commissioned to paint the *Vision of Father Simón* (cat. 44) for the church of San Andrés in Valencia, where the cleric had been ordained in 1605. The following year Ribalta was paid for three more paintings of Simón, ordered by the *cabildo* (chapter) of Valencia Cathedral, to be sent to Pope Paul v, King Philip iii, and the duke of Lerma.

Ribalta painted several more portraits in the next years, in addition to a signed and dated *Nailing to the Cross* (1615, Provincial Museum, Valencia) and a large altarpiece of *Saint Thomas of Villanueva* for the Colegio de la Presentación, commissioned by the *cabildo* of Valencia Cathedral and paid for on August 16, 1616. This was the last commission from the cathedral chapter, received the same year Orrente painted his *Saint Sebastian* for them. In that year too Ribalta is again mentioned in the documents of the Colegio de Pintores, now as one of the second-ranking *mayorales*. These years saw a dispute between the conservative guild to which Ribalta belonged and those who went before the *jurados* to demand that the protectionist ordinances of the *colegio* be revoked. When overruled by the *audiencia*, who upheld the painters' rights, the *jurados* took the case to the king. The painters in their turn made a plea to Philip iii, who left the decision to the regent Lucas Pérez Manrique. The protectionist cause defended by Ribalta was ultimately lost.[131]

Palomino asserted that Ribalta studied in Italy,[132] and Ceán recounted an anecdote about Ribalta going to Italy to become a more accomplished painter to win the hand of "his master's daughter" in marriage.[133] Although it has been suggested that such a trip occurred sometime between mid-1618 and late 1619,[134] research has unearthed documentation that records the artist in Valencia in 1618 and 1619.[135] Ribalta signed a small (undated) canvas that faithfully reproduces Caravaggio's *Martyrdom of Saint Peter* (Santa Maria del Popolo, Rome), although it may derive from another copy of the painting that was owned by Juan de Ribera rather than from Ribalta's study of the original. According to some, the artist could as easily have adopted the strong tenebrism that entered his work

during the 1620s as a result of a stay in Madrid, where he would have seen contemporary paintings newly arrived from Italy, as from a trip to Rome.[136] There is, however, no firm documentation regarding a trip either to Italy or to Madrid about this time.

In 1620 Ribalta executed a *Last Supper* for the refectory of the Capuchin monastery of Sangre de Cristo in Valencia. His painting of *Saint Francis Embracing the Crucified Christ* (cat. 40) was made for a side altar of their church.[137] Ribalta's last major commission was for the church in the Carthusian monastery of Porta Coeli near Bétera (Valencia). He was asked to gild the wooden structure of the retable for the high altar and to provide it with paintings, which he and his workshop executed from 1625 through 1627. Ribalta also painted his *Christ Embracing Saint Bernard* (Museo Nacional del Prado, Madrid) for the Charterhouse, where Ponz saw it in the last quarter of the eighteenth century and called it one "of the most beautiful, well-painted and expressive [paintings] by Ribalta."[138] The artist died of apoplexy on January 13, 1628, and was buried in the church of the Santos Juanes in Valencia. According to Jusepe Martínez, he was diligent and patient, humble and devoid of vanity in life, and was mourned by the entire city of Valencia.[139]

Palomino ended his account of the life of Ribalta by saying that he was the first teacher of Jusepe de Ribera,[140] who spent his entire career in Italy, where he was known as *il Spagnoletto*. There is no documentary or stylistic evidence of this relationship, but since Ribalta was the most well-regarded artist working in Valencia at the time, Ribera might well have been apprenticed to him. In fact, there is almost no documentation about Ribera's early years; we do know, however, that he was baptized in Játiva, thirty-one miles from Valencia, on May 12, 1593, the son of a shoemaker.

Nothing more is heard of Ribera until he is mentioned in Parma in 1610 and again in 1611. By 1613 he was in Rome, where he lived for two and a half years. The painter Ludovico Carracci (1555–1619), in a letter to Carlo Ferrante Gianfattori dated December 11, 1618, described Ribera as taking "after the school of Caravaggio closely."[141] About 1620 Giulio Mancini (1558–1630) reported that he "for the most part follows the path of Caravaggio;"[142] Giovanni Pietro Bellori (1613–1696) elaborated that he "took after the spirit of Caravaggio, and also gave himself to imitating Nature and painting half-lengths."[143] Palomino wrote that "he applied himself assiduously to the school of Caravaggio, and he achieved that vigorous chiaroscuro manner in which he improved daily through the constant imitation of nature."[144]

Mancini further recorded that Ribera "made many things here in Rome, and in particular for *** the Spaniard, who has five very beautiful half figures representing the five senses [see cat. 61], a *Deposition of Christ* and others, which in truth are things of most exquisite beauty."[145] By the summer of 1616 Ribera was living and working in Naples, which traditionally had had close relations with Valencia,[146] a territory of the duke of Lerma's family. A *Saint Sebastian* attributed to Ribera mentioned in documents connected to the collection of Bernardo de Sandoval y Rojas, who was instrumental in bringing tenebrist naturalism to Spain, may have been one of the earliest works by the artist to have reached that

country.[147] Ribera received 9 ducats in October 1616 from Don Fernando of Aragon for an unspecified painting, and later that year he married Caterina Azzolino, daughter of Giovanni Bernardino Azzolino (about 1572–1645), a successful Sicilian painter working in Naples.

In August 1617 Ribera received payments for painting banners for four of the "duke of Elma's" (Lerma's?) galleys; unfortunately, nothing more is known about this commission.[148] By March 1618 Ribera was working for the duke of Osuna, the Spanish viceroy of Naples from 1616 until 1620. De Dominici, the eighteenth-century biographer of Neapolitan artists, recounted that they had met when Ribera set the *Martyrdom of Saint Bartholomew* outside to dry[149] and that the viceroy subsequently appointed Ribera as his court painter.[150] Whether or not this legend is true, a document of March 6, 1618, mentions that Ribera was painting a *Crucifixion* for Catalina Enríquez, the duchess of Osuna. This painting, along with nine others (among them the *Saint Sebastian*, *Saint Jerome*, *Penitent Saint Peter*, and *Flaying of Saint Bartolomew*, all by Ribera and still in Osuna), was sent in 1627 to the Colegiata of Osuna near Seville and was singled out for praise in a letter of gratitude written from the chapter to the duchess—further evidence of Ribera's connection to the Spain of Philip III.

In *Diálogos de la pintura*, Vicente Carducho discussed the king's collection in the eighth dialogue, making particular mention of works attributed to Titian, Rubens, Cajés, Velázquez, Ribera, and Domenichino.[151] Pacheco, writing in the 1630s, was also impressed by Ribera's work; he had seen six paintings by the artist when he visited the collection of Fernando Enríquez Afán de Ribera (1583–1637), the third duke of Alcalá (the patriarch's first cousin, once removed), in the Casa de Pilatos in Seville in 1631. Pacheco lauded the naturalism of Ribera's figures and heads, which appeared to him "alive and everything else seems only painted," and also praised Ribera as a great colorist.[152]

Alcalá, who spent from 1629 until 1631 in Italy (during which time he would have encountered Ribera in Naples), was among the most important art collectors and patrons of Seville. At that time, Seville was a city of convents, churches, and spectacular religious processions on the one hand and a cosmopolitan port with large foreign communities and close ties to other European ports and the Indies on the other.[153] Alcalá's early taste in collecting was for painters employed by the royal court, including Pantoja (who painted two portraits of him) and Carducho, and the inventory of his collection lists two copies of paintings by "Oreme."[154] He also patronized artists of the "Sevillian school," including Velázquez and Juan de Roelas. But the first artist he employed to remodel and redecorate the Casa de Pilatos about 1603 was Francisco Pacheco (fig. 21), who painted the ceiling with the mythological scene of the *Apotheosis of Hercules*.

Pacheco, the son of a sailor, was baptized in Sanlúcar de Barrameda (Cádiz) on November 3, 1564; he is first recorded in Seville on March 2, 1583, when he was admitted to the Hermandad de Nazareno de Santa Cruz en Jerusalem, one of the city's brotherhoods that participated in the Holy Week processions.[155] During his early years in Seville, Pacheco probably lived with his uncle and namesake, the

canon of Seville Cathedral. In 1585, designating himself as a painter, he rented a house. The eleven-year-old Agustín de Sojo entered his workshop as an apprentice at the end of November 1589, and he married María Ruíz de Páramo on January 17, 1594. That year he also executed royal banners for the fleet of New Spain.

Throughout the decade of the 1590s, Pacheco worked on various local religious commissions—one for the Jesuits in Marchena (Seville) and another for the parish church of Santa María in Guadalcanal, taking on a second apprentice, Lorenzo Lozano, in 1596. When Philip II died, the artist was among those who participated in the creation of a funerary monument to the king erected in Seville Cathedral. In 1600 he began to paint six canvases for the main cloister of the monastery of the Shod Order of Mercy, commissioned by Padre Fray Juan Bernal.

In 1599 Pacheco was elected a governor of the painters' guild. He also began work on his *Libro de retratos*, a book of portrait drawings of famous, primarily Sevillian, men (see cat. 18), accompanied by short biographies and poetic eulogies.[156] With the death of Canon Pacheco in 1599, his nephew assumed a leadership role in the local academy that had been founded in the 1560s. This informal association of theologians, poets, antiquarians, and other writers, to which Pacheco would invite a new generation of scholars (among them the third duke of Alcalá and Lope de Vega), was united "by their respect for the aims and methods of humanistic scholarship in the fields of classical antiquity and Catholic theology."[157] Many of their concerns would be reflected in Pacheco's *Arte de la pintura*, the treatise he began writing about 1600 and finished in 1638 but that would be published only after his death.[158] Pacheco wrote that as early as 1593 he consulted Fray Juan de Espinosa and Father Juan de Soria on alternatives for painting the decapitation of Saint Paul. Frequently the artist would seek counsel from important ecclesiastics regarding the interpretation of religious scenes, establishing himself as the artistic defender of spiritual values and Catholic orthodoxy in Seville.

Pacheco continued to receive numerous commissions in the first and, to a lesser extent, the second decades of the new century. Several of these were for altarpieces for religious institutions in Seville that specified that he work together with the sculptor Juan Martínez Montañés. In 1611 the painter undertook a transformative trip of several months to Castile. He went to El Escorial and Madrid, where he would have visited the royal and aristocratic collections, and where he met and befriended Vicente Carducho. In Toledo, Pacheco visited El Greco, whom he thought of as cultured and of "keen sayings" and, despite his use of a certain sketchiness and "different and disjointed colors," was to be included among the great contemporary painters mentioned in *Arte*.[159] He returned from his trip to train a new apprentice in his studio, Diego Velázquez.

In October 1611 Pacheco contracted to execute part of the catafalque erected by the Cathedral of Seville on the occasion of the obsequies of Queen Margaret of Austria. In 1613 he petitioned the king and gentlemen of the royal council to obtain privileges (*cierta gracia e merced*) in his quest to be designated royal painter. In 1619, the year he signed and dated the *Virgin of the Immaculate Conception with Miguel del Cid* (cat. 45),[160] he swore to renounce any claims to a salary for the title. Despite Velázquez's efforts on his behalf in 1626, this appointment would never be made.

The city council of Seville named Pacheco overseer of the art of painting in 1616, a month before Alonso Cano entered his workshop. In that role Pacheco granted

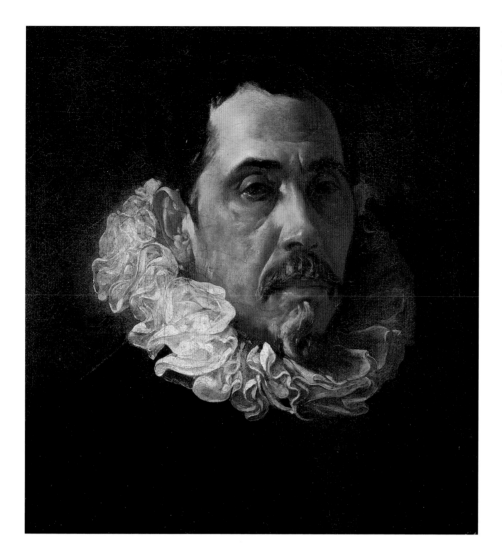

21
Diego Rodríguez de Silva y Velázquez
Francisco Pacheco (detail)
Oil on canvas, 16⅛ x 14³⁄₁₆ in. (41 x 36 cm)
Museo Nacional del Prado, Madrid

Velázquez a certificate of examination the following year. On April 23, 1618, Pacheco's sixteen-year-old daughter, Juana de Miranda, married Velázquez. That same year, Pacheco was named by the tribunal of the Inquisition as overseer of sacred images, requiring that he supervise the religious decorum in the art of his Sevillian colleagues. He was buried in the parish church of San Miguel on November 27, 1644.

Juan de Roelas is mentioned three times in *Arte de la pintura* and each time is bitterly criticized. First he is censured as a painter who either lacks skill or employs an archaic technique by choosing to use gold;[161] later his iconography of *Saint Anne Educating the Virgin* (painted for the monastery of the Shod Order of Mercy in Seville, for whom Pacheco also worked, and now in the Museo de Bellas Artes, Seville) is classified as "skillful in color but lacking in decorum"; and finally Roelas is upbraided for including a nude baby Jesus in his painting of the *Adoration of the Shepherds*, dependent on a Bassano model, for the high altar of the Casa Profesa (in situ). We now know that Juan de Roelas was

born in Flanders. He might have traveled to Italy before he was recorded as living with his father, also a painter, in Valladolid in early 1594.[162] That year they rented a house and Juan was mentioned as being "over twenty-five years old." He must therefore have been born about 1568 and was thus only slightly younger than Pacheco.

In 1597 Roelas signed and dated his first known work, a print of the *Elevation of the Cross*. The following year he executed paintings for the funerary monument of Philip II at the behest of the University of Valladolid, who delayed paying him. The move of the court to Valladolid was apparently a boon for Roelas. The 1601 account books of the duke of Lerma mention that the artist was paid for various coats of arms he painted for the church and convent of San Pablo. That Roelas committed to buy houses in Valladolid in April 1602 apparently indicates the need for space for his workshop there.[163] However, by January 1603, he appeared in the accounts of the church of Olivares near Seville as chaplain. He would continue in this post until March 1606, at which time he moved to the city of Seville.

The Jesuit Casa Profesa, an important educational establishment in Seville, commissioned Roelas to execute the majority of the paintings for their high altar in 1604. This commission must have come as a blow to the well-established Pacheco and might have been the source of some of his animus toward Roelas.[164] In the succeeding years Roelas received significant commissions from the Cathedral of Las Palmas (in the church correspondence, the painter is praised), the Cathedral of Seville, and other religious institutions in the city, including the Church of the Savior for which he was chaplain by 1611. That year, because of illness, he asked for a substitute chaplain and made a will, but he seems to have recovered, as in the following year he executed commissions for the Hermandad de Sacerdotes Beneficiados de San Pedro and the Hospital de los Viejos. In the 1613 contract for the commission for the high altar of the church of San Isidoro, the most important commission in Seville during the first third of the seventeenth century,[165] Roelas is referred to as a priest ("clérigo presbítero"); he finished the painting of the *Death of Saint Isidore* (in situ) in April 1616, at which time he asked for payment.[166]

Roelas moved to Madrid in 1616. He executed three paintings for Philip III in this year, for which he would be paid only in 1618. On July 6, 1616, Roelas, on behalf of the king (via Juan Gómez de Mora, overseer of the king's works), valued the paintings of an altarpiece made by Vicente Carducho for the royal convent of La Encarnación in Madrid (Cajés valued them on behalf of Carducho). The following year Roelas applied for the vacant position of *pintor del rey*; the report presented to His Majesty stating Roelas's merits read: "'el licenciado Roelas' [a designation indicating his religious training], cleric, who came from Seville a year ago with the desire to be employed in this ministry and whose father served the king for many years, is very virtuous and a good painter."[167] The post, however, was ultimately awarded to Bartolomé González. Roelas was charged with valuing paintings in the royal monastery of El Pardo, the list of which had been drawn up by the royal painters Bartolomé González, Jerónimo Cabrera (about 1550-1618), and Vicente Carducho. Roelas and Eugenio Cajés were asked to value more paint-

ings by Carducho for La Encarnación. In 1619, in connection with a commission by Don Manuel Alonso, duke of Medina Sidonia, for the high altarpiece of the church of the monastery of the Unshod Order of Mercy in Sanlúcar de Barrameda, Roelas was referred to as "chaplain of His Majesty."

By 1621 Roelas had left Madrid and was back in Olivares, where he is listed in the books of the mass performed by the clergy. He continued to work there on paintings for Sanlúcar de Barrameda until late in 1624 and was buried in the church in Olivares, of which he was prebend, on April 25, 1625.

Roelas's work was extremely popular in his time and his reputation (notwithstanding Pacheco, who did not even mention him among such cleric painters as Sánchez Cotán and Maino)[168] was as a pious and virtuous man and outstanding artist.

Pacheco's friend and colleague Juan Martínez Montañés (fig. 22) was the leading sculptor in Seville, the southern counterpart to Gregorio Fernández in the north. He was born in Alcalá la Real in the province of Jaén in 1568, the son of an embroiderer of church vestments. Pacheco, quoting the sculptor himself, recorded that Montañés's teacher was Pablo de Roxas of Granada.[169] Montañés was already in Seville by June 1587 when he married Ana de Villegas, daughter of the joiner Juan Izquierdo. He became a licensed sculptor the following year and received his first recorded commission the year after that for a stone relief of the *Last Supper*. He worked in various materials (stone, unpainted cypress, ivory) before settling on polychromed wood as his medium of choice. Other skilled craftsmen were often involved in his projects: an architect would draw up the plan for a framework; joiners (*ensambladores*) did the carpentry; and wood carvers (*entalladores*) added the ornamental carving.[170] The painters responsible for the polychromy, which was deemed as important as the sculpture itself, were usually paid as much as the sculptors for their work.[171]

By 1590, Montañés was receiving frequent commissions for religious imagery from, among others, the Dominican, Hieronymite, and Franciscan communities, and he took on two apprentices that year to help with the work load. For the order for a *Crucifixion* carved from cypress from Alonso Antunes of Portalegre (Portugal), Miguel de Cervantes served as witness to the contract. The following year, Montañés was accused of murdering Luis Sánchez and imprisoned; in September 1593, after paying blood money to Sánchez's widow, he was pardoned. In the meantime, Montañés continued to receive commissions. Cristóbal Suárez de Ribera, who would be portrayed by Velázquez in 1620 (on loan to the Museo de Bellas Artes, Seville), ordered a *Crucifixion* of unpainted cypress on a cross of ebony from the sculptor in 1592, and Francisco Pacheco acted as guarantor. This is the first document linking the two artists; from 1605 until 1621, they were frequent and close collaborators, Pacheco applying the polychrome to Montañés's figures or acting as the sculptor's guarantor.

In 1592 Montañés and his wife became members of the confraternity of El Dulce Nombre de Jesús, for whose chapel in the church of San Pablo he had carved a figure of the Virgin. Throughout the decade of the 1590s, the sculptor received numerous commissions for religious works that were to be painted, gilded and finished in *estofado* (a decorative technique for imitating brocade or the texture of clothing on statuary, achieved by selectively incising paint to reveal the underlying gold or silver

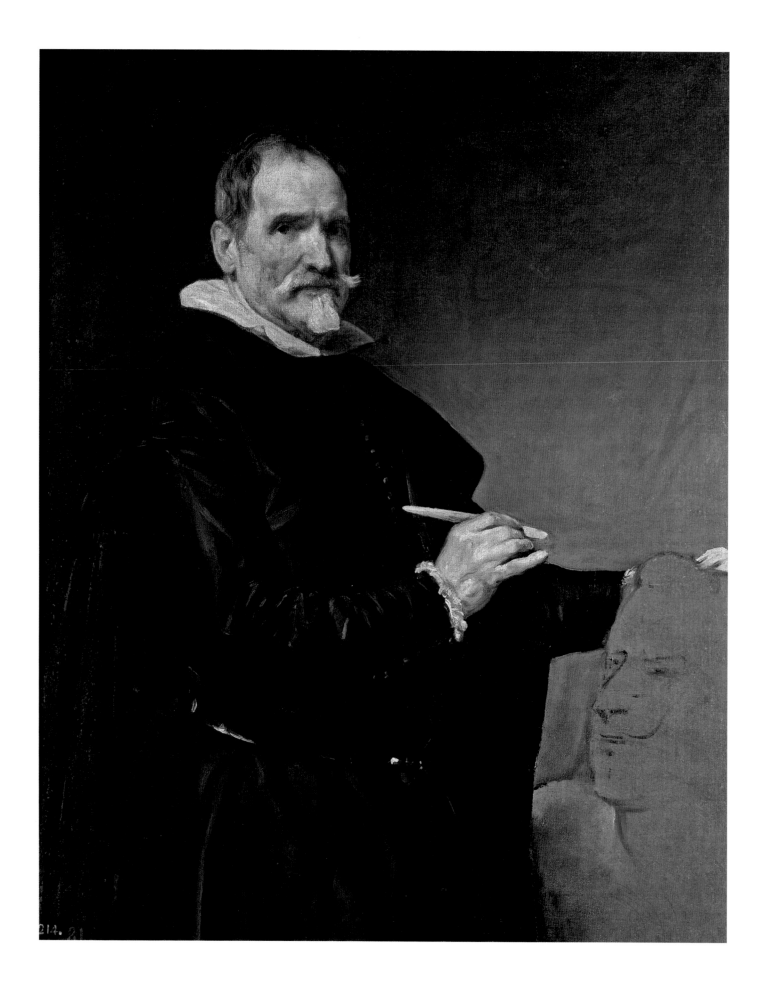

leaf). Montañés received his first royal commissions just prior to the death of Philip II in 1598, when the monarch ordered ten wooden tabernacles to be sent to the Dominican monasteries of the Nuevo Reino de Granada (now Colombia) and twelve more to be sent to the Augustinian monasteries there and in the provinces of Quito and Popayán.

For the catafalque of Philip II that was erected in Seville Cathedral after the king's death, the artist modeled two statues that were compared favorably to the work of the ancients.[172] He also made the wooden maces carried in the proclamation ceremony of Philip III in Seville. The new king continued his father's patronage of the sculptor in 1601 by ordering five tabernacles for Franciscan monasteries in Venezuela and five more for Dominican monasteries in Santo Domingo.[173] At the end of 1601, Montañés and his wife bought houses in the Calle de la Muela where he would live and work for the rest of his life. By this time, the artist had a thriving and well-organized workshop, necessary for the production of the individual commissions, processional statues, and major tablernacles for which he was responsible.

Another large commission for the New World approved by royal *cedula* was awarded in 1604, this time for thirteen ebony tabernacles for the Franciscan Order in Nueva Granada. The year before, Montañés had been contracted to execute for Mateo Vázquez de Leca, archdeacon of Carmona, a *Christ of Clemency* (fig. 56, p. 130) that was significant to both patron and artist. Vázquez de Leca, who had given up a dissolute life, stipulated that the Christ figure was "to be alive, before He had died, with the head inclined towards the right side, looking to any person who might be praying at the foot of the crucifix, as if Christ Himself were speaking to him and reproaching him . . . ; and therefore the eyes and the face must have a rather severe expression, and the eyes must be completely open." Montañés clearly valued the opportunity and is quoted in the contract as saying, "I have a great desire to complete and make a work like this to remain in Spain and not be taken to the Indies nor to any other country, to the renown of the master who made it for the glory of God." Pacheco polychromed the crucifix, which is now in the Seville Cathedral.[174]

On May 9, 1606, Montañés signed the contract for a retable for the chapel of Saint Catherine in the parish church of Nuestra Señora de Consolación in El Pedroso, which features the first of his images of the *Virgin of the Immaculate Conception* (cat. 47).[175] Montañés decided that a simple peasant girl would be a suitable model for the Virgin. He would return to this theme, important during the reign of Philip III, several times throughout his career.[176]

Montañés was at the height of his fame and productivity during these first twenty years of the seventeenth century. He not only executed large retables for home and abroad but also carved statues to be carried in procession. His image of the *Christ Child*, commissioned in 1606 for the confraternity of El Santísimo Sacramento of Seville Cathedral and made to carry in procession on Corpus Christi, became so pop-ular that it was imitated many times.[177] Like Fernández, Montañés made a statue of *St Ignatius Loyola* (1610; Seville, University Chapel) to celebrate the Spanish saint's beatification. Also like Fernández, Montañés used a copy of Ignatius's death mask (presumably the plaster cast owned by Pacheco) as

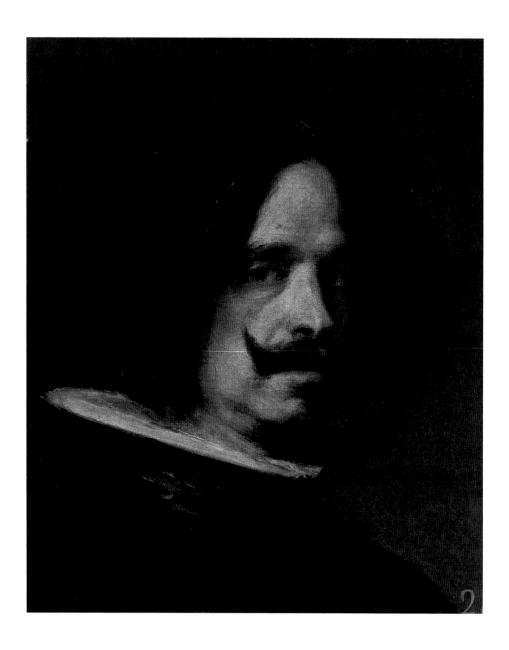

a model; his statue of the saint was recorded as made by "a skilled craftsman and celebrated sculptor . . . from whose hands it came finished with two special excellencies—simplicity and perfection—so that in the opinion of those of the profession, it is the finest and most beautiful of any that the sculptor has created up till now." It was dressed in a black velvet soutane embroidered by nuns, who bore the statue on their shoulders to the convent and brought it back, splendidly garbed, in procession.[178]

In November 1621 Montañés signed a contract to execute the architecturally elaborate main retable for the convent of Santa Clara in Seville. In this instance, the sculptor was allowed complete control over the sculpture, painting, and gilding of the altarpiece rather than having to contract out each of the specialties. This arrangement enraged the painters, who felt their rights had been violated.

The situation was exacerbated when it was discovered that Montañés intended to keep three quarters of the 6,000 ducat payment.[179] Pacheco took up the painters' cause by writing an open letter the following year addressed to them (*A los profesores del arte de la pintura* was the title of his tract) supporting his claim of the superiority of painting over sculpture with many learned references. He further complained that the sculptor had not been examined in the profession of painting and argued that the painters should receive equal pay. With his usual acerbity, Pacheco continued,

> Nor will I set myself up to judge the defects of his works, even though the connoisseurs of Seville find them in those with which he has taken the greatest pains; for I am convinced that he is a man like others, and it is not surprising that he errs like all human beings, and for that reason I should advise my friends to refrain from praising or condemning his works, for the first he can do better than anyone, and the second someone will surely do, as we have said.[180]

This attack evidently did not deter Montañés from working with Pacheco; in February 1628, the painter was contracted to polychrome Montañés's retable in the chapel dedicated to the Immaculate Conception in the Seville Cathedral.

Montañés worked briefly in Madrid in 1635 (the only time he left Seville) on a portrait bust of Philip IV made to aid the Florentine, Pietro Tacca, who was working on a bronze equestrian statue of the king.[181] Exceptionally then, Montañés, called "the god of wood" (*el dios de la madera*) by his contemporaries, worked for all three Philips. He died in 1649, having effected, with the grandiose conception of his themes and the monumentality of his figures, a new sculptural style.[182]

Pacheco held his friend Montañés in high esteem, but his unwavering and most fulsome praise was reserved for the only artist of the younger generation he included in *Arte de la pintura*, his son-in-law Diego Velázquez.

Documentation about the genial Velázquez (fig. 23) during his early years in Seville is spotty. He was baptized in the church of San Pedro in Seville on June 6, 1599, the son of Juan Rodríguez de Silva and Jerónima Velázquez. On December 1, 1610, his father apprenticed him to Pacheco, although the contract of apprenticeship was only signed on September 17, 1611. On March 14, 1617, with Pacheco as overseer, Velázquez was examined and accepted as "master painter of religious images, and in oils and everything related." This allowed him to practice independently anywhere in the kingdom, to have his own workshop, and to paint for churches and public palaces. As stated above, in April 1618 he married Pacheco's daughter, Juana, and in that year signed and dated his first extant paintings, *Old Woman Cooking Eggs* (cat. 62) and *Kitchen Scene with Christ in the House of Martha and Mary* (cat. 59).[183] The couple's first daughter, Francisca, was baptised in May 1619, and in that year the artist signed and dated the *Adoration of the Magi* (cat. 22). The following year his first apprentice, Diego de Melgar, entered his workshop and the year after that, his second daughter, Ignacia, was baptized. In April 1622 Velázquez visited Madrid for the first time and at the request of Pacheco painted *Luis de Góngora y Argote* (cat. 17), which, according to Pacheco, "was very celebrated in Madrid." By January 1623 Velázquez was back in Seville but only for a short time. His illustrious career as *pintor del rey* to Philip IV would soon begin.

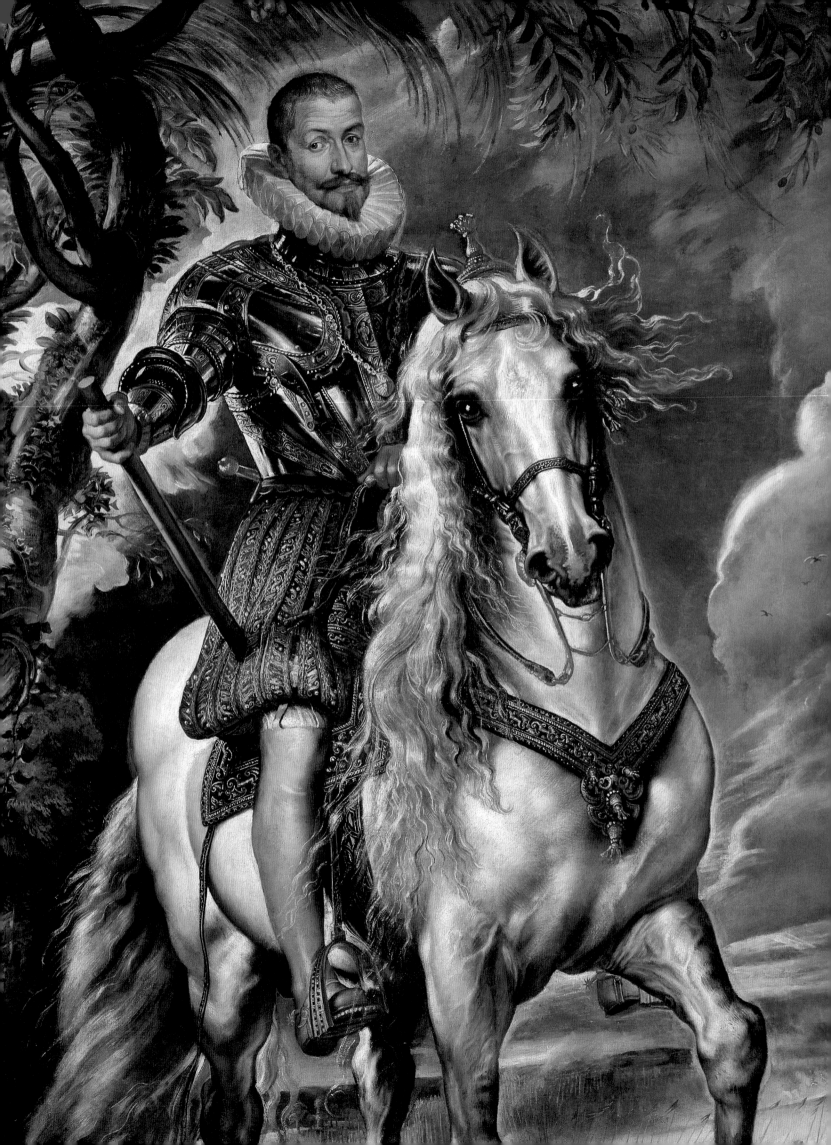

A New Style of Grandeur:
Politics and Patronage at the Court of Philip III

SARAH SCHROTH

In February 1599, six months after becoming king and head of the Spanish Empire at age twenty, Philip III traveled over 217 miles from Madrid to Valencia to greet his new queen, Margaret of Austria, daughter of Archduke Charles of Styria and Maria Anna of Bavaria, on her arrival in Spain. Contemporary accounts claim that more than six hundred noblemen followed the king on his route; participants, adorned in "gold, diamonds, pearls and gems," brought along a large party of family members, favorite horses, "innumerable pages, lackeys and servants and confidants who themselves wore incredible rich *libreas* (clothing given to servants)."[1] The great playwright Lope de Vega traveled with his patron the marquis of Sarría, later the count of Lemos, to whom Cervantes would dedicate part two of *Don Quijote* in 1615. Juan Pantoja de la Cruz, the official court portraitist, accompanied hundreds from the royal household,[2] including important members of the clergy close to the king. One such clergyman was Philip III's former tutor, the inquisitor general and archbishop of Toledo, Cardinal García Loaisa, who was to perform the marriage ceremony in April.[3] A member of the intellectual elite in Toledo with progressive tastes, Loaisa was one of the earliest collectors of a new genre of painting first seen during this reign, the independent still life.[4]

A grand entourage was needed for the lavish entertainments planned for welcoming the woman who would become the Spanish queen; Cabrera de Córdoba, the court chronicler, reported that even the highest aristocrats had to borrow enormous sums to assemble a suitable retinue for the event.[5] The more sumptuously adorned the better to compete for the young king's attention—it was a new age and a new reign, and significant changes within the intimate circle of Philip III gave hope to many noblemen and artists who had been excluded from Philip II's court.

During their two-month stay in Valencia, and on the long, circuitous journey back—eight months of travel via Barcelona, Zaragoza, and dozens of smaller towns—the king and his bride visited each of the crown's kingdoms and were honored with specially erected triumphal entry arches, processions, visits to miraculous images such as the Madonna of Montserrat (both Margaret and Philip were noted for their piety), and elaborate masses with choral music.

The religious events were always combined with secular festivities, including *comedias* (plays), dancing, *cañas* (tournaments), fireworks, and bullfights. Philip's reign, barely a year old, thus began on a note of extended celebration; as a contempo-

rary historian observed, the young Philip III was "issuing in a new style of grandeur" in the construction of his official public image as the new king.[6]

The historical significance of the 1599 wedding trip was not lost on the king's subjects: not only was this the first time a Spanish Hapsburg king had traveled so far to welcome a new queen; it also represented the most ostentatious royal journey ever made according to witnesses.[7] Carefully planned by the king's image makers at court, above all by the soon-to-be duke of Lerma, this "happy journey"[8] was intended to give the public an impression of a festive and lively new court, appropriate to the age of the new king, to strike a contrast with the last gloomy decade of the previous king's reign. Philip II's public image was somber (fig. 24); he had dressed in black since 1568, when he lost his wife Elisabeth of Valois, who died in childbirth. His elder sons had died one after the other—first Carlos in 1568, then Carlos Lorenzo in 1575, Fernando in 1578, and Diego in 1582—leaving Philip (son of his fourth wife, Anna) to inherit the throne, and his reign had been damaged by political miscalculations, such as the shameful loss of the Grand Armada.

Always present at the king's side during this trip was the one nobleman who benefited most from changes within the institution and character of the monarchy of Philip III: Francisco Gómez de Sandoval y Rojas, the fifth marquis of Denia and fourth count of Lerma (see cat. 11), a larger-than-life figure who was on his way to becoming the most powerful man at court, and the leading art patron during the reign. He was head of the prestigious but insolvent Sandoval family and had worked hard to improve his status in life by developing a special relationship with Philip before he ascended the throne, successfully winning the heir's favor and affection. Within the first months of his monarchy, Philip had selected Sandoval as his *caballerizo mayor del rey* (master of the horse), which privileged him to ride alongside the king on all excursions outside the royal palace. Sandoval's encouragement of the prince's love of the outdoors and excellent equestrian skills obviously paid off. In an unprecedented move, the king also appointed Sandoval his *sumiller de corps* (groom of the stole), which made him the key administrator in the enormous royal household and the king's most intimate servant, attending him in his private chambers. These two posts, the highest offices in the court, had never been held by a single person. When the court returned to Madrid, Philip III elevated Sandoval's title from fourth count to first duke of Lerma, and named him a member of the councils of state and war. These honors were further public acknowledgments of Philip's fondness for this man, whom he had chosen as his sole *valido*, or favorite.

Philip's father, Philip II, had ruled for a long period of time, from 1556 to 1598. Most Spanish subjects had known him as the only king to reign in their lifetime,[9] who had established a quasi-absolute monarchy, with the king as the source of all the political power. By the end of his reign, Philip II had been sharply criticized for ignoring the advice of the councils (of war, of state, of the Indies, and of finance, among others), meddling in church affairs, taxing his subjects to excess, and allowing the grandees no role in the government.[10] Although his father had trusted counselors whom he consulted for advice, the younger Philip's relationship

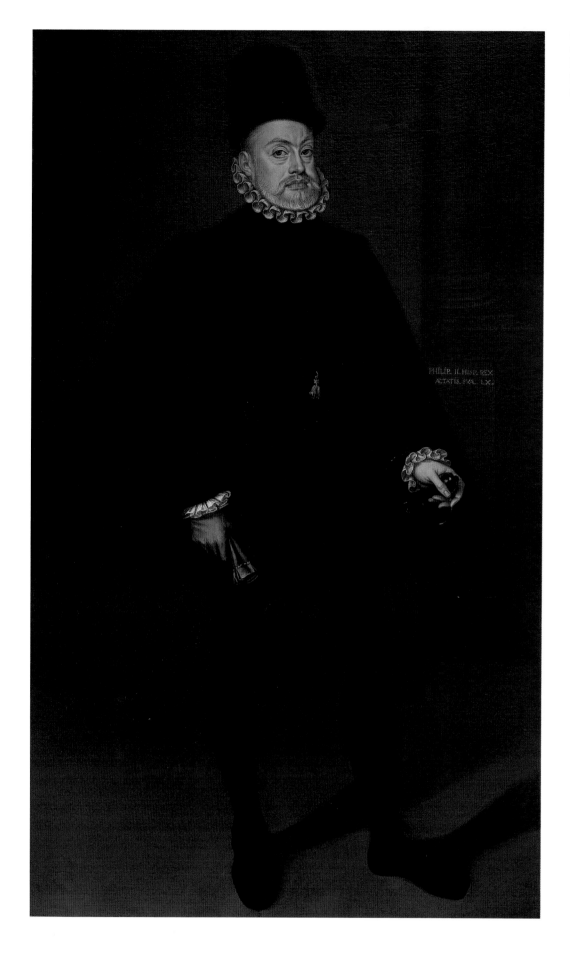

24
Alonso Sánchez Coello
Portrait of Philip II of Spain, 1566
Oil on canvas, 70 x 40 in. (178 x 104 cm)
Galleria Palatina, Palazzo Pitti, Florence

with Sandoval was entirely different. On becoming king, Philip III had immediately installed a de facto prime minister (the first in Europe) who could operate as his alter ego and help him govern on every level. In a system where access to the king meant everything, Philip III had granted his "special and loyal friend" (to use a contemporary description) a position of the greatest privilege in Spanish society and one of the most influential political posts in the known world. Spain, after all, still ruled an empire larger than Rome's. Like "issuing in a new style of grandeur," publicly choosing a single favorite to help him rule was another decisive departure from his father's style; the new king had introduced a drastic change that would forever alter the character of the Spanish monarchy and its balance of power.

Historians have tended to view Philip III as a weak, indolent, unintelligent monarch, compared with his father. The duke of Lerma, likewise, has not been judged well: as self-serving and corrupt, guilty of abusing the unprecedented power granted to him by a young and impressionable king. As Antonio Feros illustrated, however, historians have excised from their collective memory any positive accomplishments of the reign of Philip III, such as a redefinition of Spain's role in world politics.[11] During this time, Spain ended conflict, established peace, and redistributed capital from foreign wars, allowing a surge of conspicuous consumption at home that changed tastes and encouraged the production of luxury goods. Similarly, historians have failed to acknowledge that Philip III introduced a "prime minister" not out of weakness but to modernize the "defective government" and answer the critics of his father's reign who believed the monarchy was in a crisis.

The campaign of systematic misrepresentation of the reign of Philip III was begun by Lerma's enemies as early as 1611, and reinforced by the count-duke of Olivares, who followed in Lerma's footsteps as the powerful favorite of Philip IV.[12] The success of Olivares's campaign extended into artistic circles: a treatise written by the court artist Vicente Carducho, which was published in 1633 and dedicated to Olivares, makes no mention of the duke of Lerma, although he was the artist's first supporter and patron. Lerma is even absent from Carducho's section on collectors, although it is documented that in 1603 the artist appraised Lerma's collection, which was not only more important and grander than many he does cite but also the progenitor of the new custom of picture collecting among Spanish noblemen.[13]

Philip III is usually portrayed as an uninformed patron of the arts, with only second-rate painters at his disposal; he is seen as overshadowed by his father, Philip II, a brilliant, engaged patron of the arts, who left behind El Escorial (deemed the eighth wonder of the world in his own time), a first-class royal art collection, and an important library, among other things. Philip III is overshadowed too by his own son, Philip IV, the connoisseur who recognized and supported the genius of Velázquez and Rubens.

The historical slighting of Philip III has been echoed in assessments of Spain in the years of his reign; it has been seen as a cultural backwater until Velázquez bursts upon the court scene after the death of Philip III, and lagging far behind Italy, where the Baroque was coming into its own.[14] El Greco is generally viewed as a sixteenth-century Mannerist artist working in Toledo, an isolated genius with no impact on his contemporaries. "In art, as in politics, the reign of Philip III seems

to suffer by comparison with those that came before and after," Jonathan Brown begins his description of the reign in his *Painting in Spain 1500–1700*; "Philip II and Philip IV stand high among patrons and collectors of their day, while the Philip in between is scarcely visible as a presence in the world of art, or anywhere for that matter."[15]

These criticisms undoubtedly have some merit. But perhaps they have achieved undue prominence because the art has been viewed out of context, in isolation from the political, religious, and social changes of the reign. Some aspects of court culture, religion, and society did not change with the accession of Philip III to the throne, but there were other, profound shifts that occurred during his reign that had a clear effect on the artwork produced during this period. Long marginalized and relegated to a position outside the mainstream of art history, the artists working at this time were highly esteemed by their contemporaries and capable of making works of exceptional quality; the masterpieces in *El Greco to Velázquez: Art during the Reign of Philip III* alone present support for a reevaluation of the period. Beginning with the pioneering work of Miguel Morán Turina and Jesús Urrea,[16] scholars have begun to challenge the negative depiction of Philip III by pointing out these artistic accomplishments of his reign and publishing new archival research.[17] In the same vein, I argue that artists and patrons alike were caught up in the particular spirit dominant in Spain between 1598 and 1621, which was embraced by Philip and his queen and those around them. There is actually a discernible pattern in style, subject matter, and emotional tenor that distinguishes art made during Philip III's reign, which is the foundation for a unique school of painting and sculpture we call the Spanish Golden Age.

Visualizing Political Change

The artistic response to changes in the political climate of the reign is most clearly represented in its portraiture, which functioned as propaganda for the new style of government and attitude at court. The royal portraitist Juan Pantoja de la Cruz arrived at a strategy that befitted the self-fashioning of the major players and that remained the dominant portrait style throughout most of Philip's reign, regardless of who was executing the work. Pantoja's *King Philip III of Spain* (cat. 7) is one of the earliest official images of the king.

Splendor and the Construction of Identity

The wedding trip illustrated one important component in the construction of the public identity for Philip III's reign, the new style of grandeur operative at his court. There was a clear desire to evoke an image of richness and magnificence. In this context, it makes sense that the armor the king chose for his first formal portrait is not functional battlefield armor but a costly suit of fancy dress armor. Pantoja's treatment of light in the painting announces his unique approach to royal portraiture. A strong light coming from the upper left casts realistic shadows on the king's figure and other objects, such as his baton. The vividly white face of the king, however, is lit directly from the front, not obeying the naturalistic lighting system of the rest of the canvas.

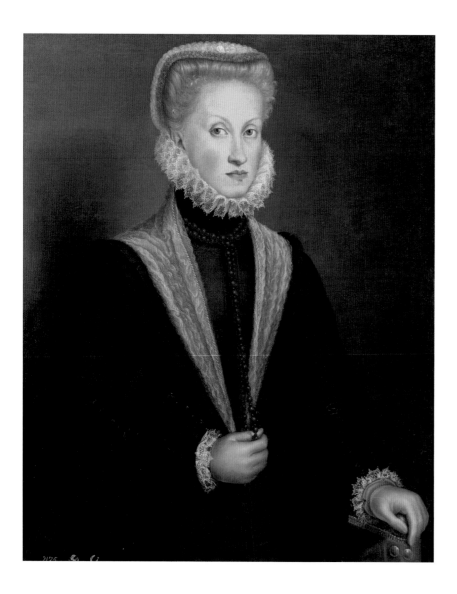

25
Sofonisba Anguissola
Anne of Austria, about 1570
Oil on canvas, 33 x 26⅜ in. (84.1 x 67.1 cm)
Museo Nacional del Prado, Madrid

Pantoja's first official portrait of the queen, *Queen Margaret of Austria* (cat. 8), was painted when she was pregnant with her first child, Anna (future wife of Louis XIII), who was born in October 1601. At least three exact replicas of this portrait of the queen existed in collections in Spain and abroad,[18] indicating its importance in announcing the fertility of the young queen and celebrating her role as a propagator of the realm. Representations of a queen with child had been painted before; Margaret's own mother-in-law, Anne of Austria (1549–1580), was depicted in this state by Sofonisba Anguissola, although her condition is hidden by the position of the queen's gloved hand and dark dress (fig. 25).[19] By comparison, Pantoja's portrait, for all its flatness, is far more naturalistic—he makes no effort to conceal Margaret's condition; in fact, the pose and costume emphasize it. Her pregnancy is the subject, with hindsight an appropriate context in which to portray a queen who bore Philip eight children in eleven years, gaining the affection, loyalty, and great respect of the king and his subjects.[20]

The distinguishing trait in Pantoja's portraits is the combination of archaic and progressive styles. A "modern" interest in naturalism, the bold representation

of the queen's delicate condition, and the rendering of naturalistic light effects are juxtaposed with elements that are distinctly archaic. Pantoja eliminated all folds in the queen's dress, limited the space like a stage, and abstracted the king's and queen's faces, so that they have the hard and artifical look of a mask.

The archaicisms we see in Pantoja's *King Philip III of Spain* and *Queen Margaret of Austria* can best be understood as an expression of the political changes taking place and the new position of the monarchy in Spain. In the new dispensation, one person stood at the apex of the political structure of the monarchy, and it was not the king but a front man, who attended council meetings, held audiences, granted favors, and even signed royal documents in the king's place. If the duke of Lerma was the figure everyone had to appeal to and please, if he was the only person privileged with access to the king, royal authority would be threatened, unless images of the king and queen could somehow project the continued strength and viability of the institution of the monarchy. The court of Philip III, therefore, had to be especially preoccupied with the portrait as message, driven by the political need to distinguish between the two types and bases of power, the monarchs, on the one hand, and the king's favorite, the duke of Lerma, on the other.

Inaccessibility

For his royal portraits, therefore, Pantoja de la Cruz invented a new visual language, deliberately combining the devices of naturalism and archaism, to create an image not of the individual but of the ideal monarchs—preeminent rulers, selected by God, icons of the Spanish monarchy. The intentionally retrospective style derives from an earlier international style of court portraiture, in particular, the propagandistic portraits of Elizabeth I of England (fig. 26). An image of Elizabeth certainly could never be found in Philip II's collections—after his failed proposal of marriage to her, she became the official heretical archenemy; but in the new dispensation, the duke of Lerma owned a portrait of her in his private collection.[21] The portrait would have been an anomaly in Spain, one that must have struck Pantoja and his patrons as a perfect conceptual model for representing the Spanish monarchs at this time of radical political change.

The ever-youthful mask, white face, lack of shadow, and form reduced to decorative shape as pattern were Elizabeth's favorite devices to propagandize her legend as the imperial Virgin Queen.[22] The remote and stiff reserve, the glittering display of magnificent finery, and archaic formalism turn the human being into a cult image, intended as a symbol of state and power.[23] Philip III and Margaret borrowed this lesson from England to convey a similar message to the body politic—to appear as inaccessible, divinely appointed protectors of the realm, icons of power.

Philip and Margaret became invisible, withdrawing from public view; even within their own royal palaces, the duke of Lerma controlled and limited access to the monarchs' private rooms.[24] When the king and Lerma had decided to move the court from Madrid in 1601 to further disassociate this reign from Philip II's, the concept of the inaccessibility of the monarchs was reinforced by a novel archi-

26
Marcus Gheeraerts the Younger
Queen Elizabeth I ("The Ditchley portrait"),
about 1592
Oil on canvas, 95 x 60 in. (241.3 x 152.4 cm)
National Portrait Gallery, London

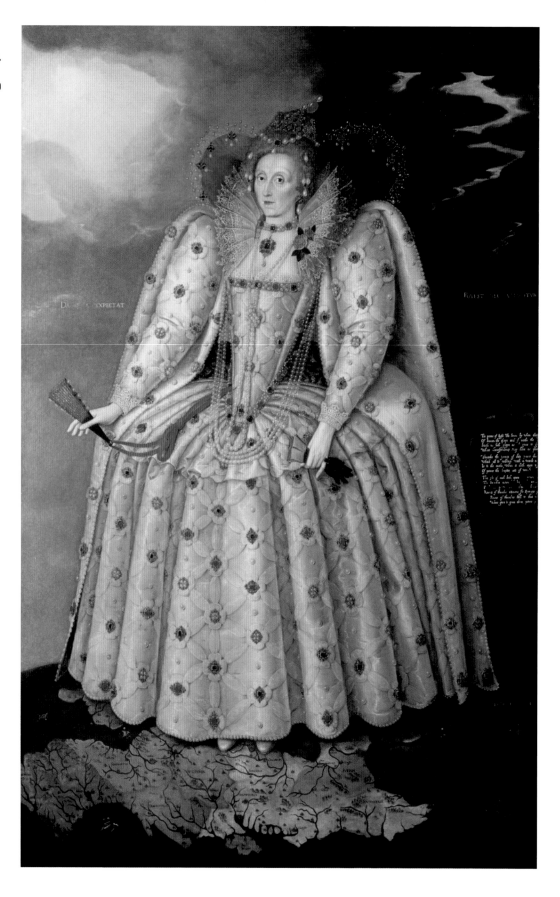

tectural element designed by the court architect, Francisco de Mora, and often described in contemporary accounts: the *pasadizo,* an elevated passageway over the streets that connected the royal palace to other buildings. If one were standing in the Plaza de San Pablo in Valladolid in 1601, facing the church, on the right one would have seen a *pasadizo* connecting the royal palace to the church of San Pablo; to the left, another *pasadizo,* connecting the left side of San Pablo to the next nearest building; and straight ahead, many more of these elevated *pasadizos* crisscrossing the entire city, forming a continuous passageway from the royal palace all the way to the Pisuerga River, to link up with the duke's property, La Huerta de la Ribera. In many ways, the *pasadizo* was a signifier of the reign, a characteristic and ever-present architectural element used not only in Valladolid but later in Madrid, Toledo, and Lerma. It reflected the special preferences of the court of Philip III—the monarchs wanted to have the freedom to move around the city without being seen, remaining as inaccessible to the public as their portrait images.

Peace (and War)

There is another key in viewing political change in Pantoja's 1601 portrait of the king. Philip III's symbols of general's baton, armor, and sword of justice fulfilled another propagandistic need: to assure the people that, despite his introduction of luxury and extravagance at the court, Philip also pictured himself (at least in the beginning of his reign) as the imperial warrior, the Christian knight, the protector of the empire and defender of the Catholic faith, like his great-grandfather, grandfather, and father before him. Pictured inside a wine-red battle tent at Ostend (although he was never at the site), the young king seems to be celebrating his reign's first real siege of strategic importance against this Dutch stronghold in the middle of the territory of Catholic Flanders governed by Philip III's older sister, Isabella Clara Eugenia, and her husband, Archduke Albert.[25] When the portrait was made, Philip may still have held out hope for many victories under his reign. As a prince, Philip had been ready to go to battle himself when the English attacked Cádiz; the courage and eagerness he had shown when he begged his father to let him fight had shocked everyone at court.

Except for Ostend and a few other minor victories and defeats, however, the king's foreign policies would tend toward making peace rather than war. Spain could ill afford continuing warfare: it had suffered losses among the male population, and precious funds had been spent on arms and soldiers' salaries, in times of dwindling shipments of silver coming from the New World. Thus, the king and the duke of Lerma, known for his formidable diplomatic skills, set about making peace with their Protestant enemies: England in 1604, the United Provinces (Twelve Years' Truce) in 1609, and France in 1615.

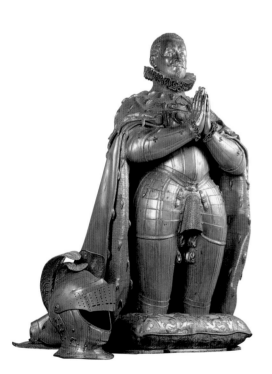

27
View of Lerma showing the Colegiata de San Pedro and the Palace.

28
Pompeo Leoni and Juan de Arfe
Francisco Gómez de Sandoval y Rojas, Duke of Lerma, about 1603–8
Bronze, 64 x 42 x 53 in. (162 x 106 x 135 cm)
Museo Nacional de Escultura, Valladolid

A Sole Favorite and Role of Patron

In the construction of new political identities at the court of Philip III, the role of art patron also shifted and was redefined, at the same time that picture collecting came into its own.[26] In the sixteenth century King Philip II had controlled most of the artistic patronage and collecting in Spain. Philip III, on the other hand, seems to have been either content with the riches his father left him or less interested in banking his reputation on art patronage, choosing a different path. Perhaps in reaction to his father's style and his obsession with collecting, Philip found a way to distinguish himself as a benevolent, selfless, and pious king who would commission art mainly to give away to religious institutions. According to Baltasar Perreño, the king "[did] not waste his time on building sumptuous palaces, arrogant buildings, vineyards, woods, gardens, houses of recreation and other things he would wish, instead rare and singular works of piety."[27]

In this respect, the duke of Lerma also acted as the king's alter ego; it was Lerma who made use of the royal architects to build and renovate five residential palaces, including a complete urban complex in his seignorial village of Lerma, with a splendid ducal palace, plaza mayor, Colegiata church, and six convents and monasteries (fig. 27). He created a mini-Escorial in the old church of San Pablo in Valladolid, complete with burial crypt and gilded bronze cenotaph figures of family members for either side of the main altar (fig. 28), designed by Pompeo Leoni, the Italian sculptor who had made the royal cenotaphs at El Escorial. When Lerma first entered the court as gentleman to the king in 1574, Philip II had *entregas* (deliveries) of paintings from his collection shipped from other royal locations to El Escorial so he could supervise their installation personally. In a similar fashion, Lerma transferred hundreds of works from his personal collection to San Pablo, notable among them Fra Angelico's *Annunciation* (fig. 29).

Philip III did not delegate all artistic projects to Lerma. In fact, the list of his commissions and initiatives shows that he did have a healthy interest in the arts: he enriched the royal collections with more than four hundred paintings, including a good part (if not all) of the count of Mansfeld's collection of sculpture and paintings from his castle outside of Luxemburg,[28] and six hundred more works were acquired through the purchase of the duke of Lerma's *villa suburbana*, La Huerta de la Ribera, in Valladolid.[29] The latter acquisition included a characteristic sculpture by Giambologna (1529–1608) (fig. 30).[30]

Following a fire in 1604, the king ordered a complete renovation of the interior decoration of his favorite residence, the palace of El Pardo in Madrid (fig. 31). The architect in charge, Juan Gómez de Mora (1586–1648, nephew of Francisco de Mora), wrote that Philip III made El Pardo better than it was under the old regime, and made a special note that the king filled the entire palace with paintings "high and low, stairways, halls, porches" with hunting scenes, battles, animal pictures, and portraits.[31] He hired seventeen artists at court to fresco the ceilings. Unfortunately, the frescoes that have survived have been harshly cleaned and heavily repainted, so that—judging from Vicente Carducho's design (fig. 32)—all we see now are caricatures of the originals.[32] Philip also ordered vast improvements to the Casa de Campo, Valasín, and Aranjuez, the other royal

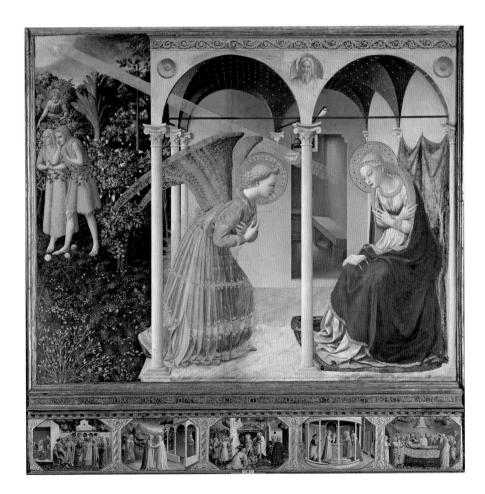

29
Fra Angelico
Annunciation, about 1426
Tempera on wood, 61 x 76 in. (154 x 194 cm)
Museo Nacional del Prado, Madrid

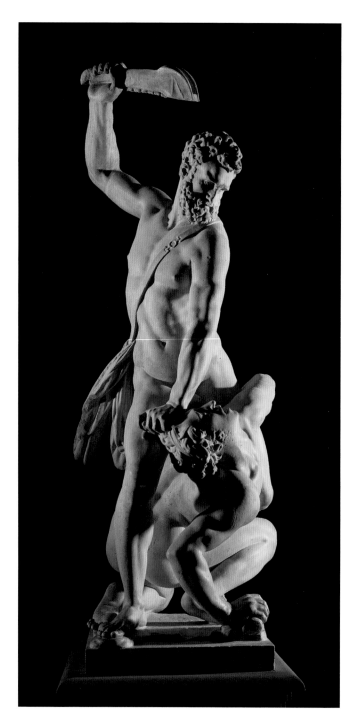

30
Giovanni Bologna (Giambologna)
Samson and a Philistine, 1500–50
Marble, H. 83 in. (210 cm)
Victoria and Albert Museum, London

country palaces. He purchased the cigarral of Cardinal Quiroga in Toledo, added a modern facade to the Alcázar, and was responsible for other improvements to the city of Madrid, including the impressive Plaza Mayor. He hired the Italian noble painter-architect Giovanni Battista Crescenzi, who came to the Spanish court in 1617, to plan and carry out the design of the Pantheon within El Escorial (fig. 39). The sumptuousness of the multicolored marbles and jasper of the walls, floors, and royal tombs reflects this court's dedication to grandeur, an assertion of Philip III's taste amid the austerity and lack of ornamentation of the Philip II monument.

For the most part, however, Philip left it to the duke of Lerma to assume the public role of patron of the arts and to become the driving force behind much of the artistic activity at court. With the vast wealth that came with his position, and the numerous lands and other favors granted to him by the king, Lerma soon became the second wealthiest nobleman in Spain, and he used art as a manifestation of his new status. The Lerma inventories, consisting of thirteen household accounts dating between 1603 and 1636, list the works of art installed in his five residences and in the monasteries and convents he patronized, providing a clearer picture of the duke's importance as a major player in the formation of early Baroque artistic culture in Spain. His picture collection, which contained a few brilliant masterpieces we can still trace, such as Veronese's *Mars and Venus* (fig. 33), was enormous by current standards, numbering (depending upon the method of calculating works that reappear in several inventories) from about 1,500 works to an estimated 2,747.[33] The scale and content of Lerma's collection qualified him as Europe's first nonroyal "mega-collector." He started a trend. As Fernando Checa and Miguel Morán have pointed out, "From this point forward, and for many years, politics and collecting would go hand-in-hand."[34]

The duke had more than just pictures, of course. Rich tapestries, jewels, splendid armor, resplendent clothing, gold, and silver reliquaries are also listed in the inventories. In his Madrid palace, Lerma had an amazing *camarín* (small room) filled with 847 pieces of foreign and domestic glass and ceramics (see pages 287–89).

Lerma's influence in the art world can be seen in his choice of painters and sculptors, a taste in collecting that was often imitated. He was the first to commission the powerfully moving *Supine Christ,* the famous polychrome sculpture by

31
Louis Meunier
General view of El Pardo Palace
Engraving
British Library, London

32
Vicente Carducho
Design for ceiling of El Pardo
Pen and ink on paper
Biblioteca Nacional de España, Madrid

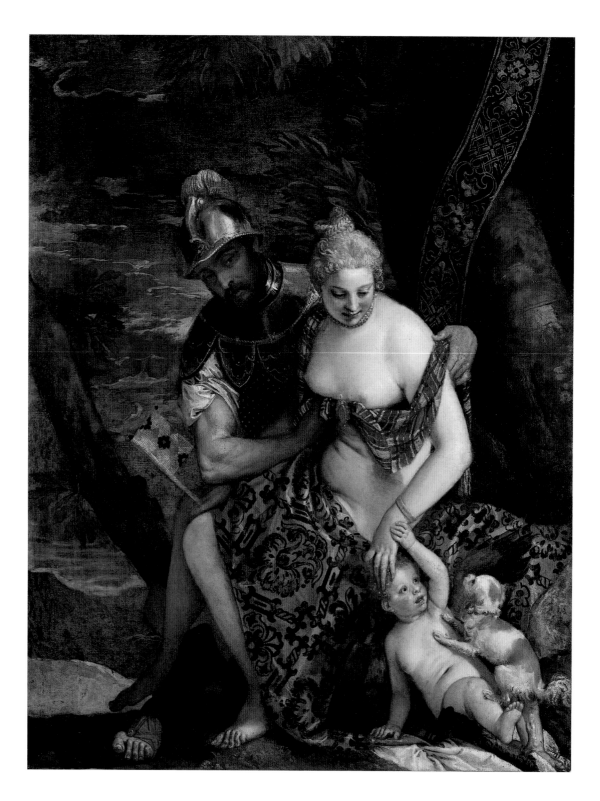

33
Paolo Veronese
Mars and Venus, late 1570s or 1580s
Oil on canvas, 65 x 50 in.
(165.2 x 126.5 cm)
National Gallery of Scotland, Edinburgh

Gregorio Fernández (see fig. 58, p. 133). It became one of Fernández's most popular subjects; at least eleven versions exist.[35] The first was made about 1609–12 for Lerma's church of San Pablo and is still in its original location, functioning as originally intended—as a *paso* to be carried through the streets during Holy Week.[36] The king followed the example of the duke of Lerma and gave a superb version to the Capuchin monastery he had constructed next to El Pardo in 1614.

Lerma's patronage of El Greco at this point in time must also have been influential. El Greco's *Saint Francis Venerating the Crucifix* (cat. 37) may well have belonged to the duke: it fits the description of entries in his inventories. In 1607 a "Saint Francis by El Greco" was recorded in the church of San Diego,[37] the Reform Franciscan monastery the duke of Lerma had constructed near the royal palace and his ducal quarters in Valladolid; another reference to an El Greco "Francis" appears in the 1636 inventory of Lerma's Madrid palace, with the added information that it is a Saint Francis "in Ecstasy" with a "cross and a skull" and that it is "original."[38] An image of the saint, alone and contemplating a crucifix and skull, occurs in only two instances in El Greco's oeuvre: one is currently in the Fine Arts Museum, San Francisco, and the other in the Torelló collection, Barcelona. Of the two, the painting in San Francisco is more likely to be the one owned by the duke. It was made about the time Lerma began to collect, and nine extant versions are known, attesting to its popularity.[39]

The fact that this work also appears in the 1636 inventory of paintings owned by Lerma's grandson implies that the duke withdrew his El Greco from the church of San Diego and kept it with him until he died in 1625. It was clearly a favorite, for he donated the majority of his pictures to religious foundations between 1611 and 1618. Lerma's acquisition of a single-saint picture by El Greco is significant, especially since part of his collecting strategy was to follow the taste of Philip II, who had rejected El Greco and disapproved of his work. Undoubtedly Lerma helped to set a pattern for collecting single-saint images by El Greco at Philip III's court; his continued ownership tells us that he greatly valued El Greco's image, and the favor he showed toward this particular picture of his name saint (the duke's first name was Francisco) no doubt influenced many of his imitators and flatterers to desire a picture of Saint Francis by El Greco for their own collections.

Support by the king's favorite likely contributed to the increased demand for El Greco's work after 1600—a demand that was obviously too great for the artist to supply on his own; the master had to enlarge his workshop during the reign of Philip III to meet his new clients' needs.[40]

Another instance of Lerma's long-lasting effect on Spanish art and collecting habits was his taste for paintings by the Bassano family. He owned twenty-nine originals, including Jacopo Bassano's *The Supper at Emmaus*, now at Kimbell Art Museum in Fort Worth (fig. 34) and *The Annunciation to the Shepherds* (fig. 35), as well as seventeen paintings after their works.[41] As Jonathan Brown has pointed out, one feature shared by nearly all inventories of Spanish collections through-out the seventeenth century is the appearance of a number of paintings by the Bassano family. Lerma's obsession with gathering pictures by his favorite artist, therefore, was responsible for creating a market for Bassano

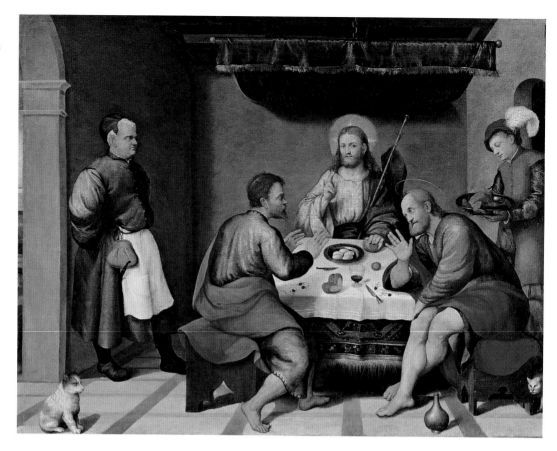

34
Jacopo Bassano
The Supper at Emmaus, about 1538
Oil on canvas, 39⅝ x 50⅝ in.
(100.6 x 128.6 cm)
Kimbell Art Museum, Fort Worth,
Texas

paintings in Spain, which continued to be strong and, in 1605, propelled Pedro Orrente to train with the Bassano family in Venice to fill the demand. His *Jacob Conjuring Laban's Sheep* (cat. 57) is a good example of his assimilation of their style and subject matter.

Lerma modeled some of his collecting activities on Philip II, acquiring many of the same artists featured in the royal collection (Bosch, Correggio, Mor, Titian [for example, *Salomé*, fig. 36], and Tintoretto), and there were Bassano paintings in Philip II's collection as well. But Lerma acquired many more of this artist's works, indicating an interest in naturalism more intense and progressive than that of the king. He owned many paintings that were specifically described as *pintado de noche*, nighttime scenes or nocturnes, which we see artists experimenting with in this period, such as Pantoja's *Resurrection* (cat. 31), commissioned by the duke of Lerma in 1605 for the hospital he patronized in Valladolid. He also collected still-life paintings and *bodegones*.

Last, there is the duke of Lerma's relationship to Peter Paul Rubens. When the twenty-six-year-old Fleming visited the Spanish court in 1603 bearing gifts as an envoy for the duke of Mantua, he saw Lerma's collection and commented on the connoisseurship of the king's favorite: "He is not without knowledge of fine things, through the particular pleasure and practice he has in seeing everyday so many splendid works of Titian, of Raphael and others, which have astonished me, both by their quality and quantity, in the King's palace, in the Escorial and

elsewhere."[42] "Elsewhere" probably meant Lerma's palaces in Valladolid, which were crammed with paintings: what Rubens called "the public gallery" in the ducal quarters in the royal palace, a suite of fourteen rooms hung with 890 pictures; the monastery and church of San Pablo; the Reform Franciscan monastery, San Diego, under construction; and, undoubtedly, Lerma's riverside retreat, La Huerta de la Ribera, which would become the destination for the paintings Rubens made while there.

At the beginning of his visit, without invitation, Rubens decided to paint a picture of two ancient philosophers for the duke's collection, cunningly filling in a gap in a collection dominated by portraiture, religious paintings, and maps. Rubens presented his *The Philosophers Democritus and Heraclitus* (fig. 38) to the duke along with the other thirty-nine paintings sent as a gift from Mantua. That same evening the duke tried to acquire Rubens as court painter. When Lerma's

35
Jacopo Bassano
The Annunciation to the Shepherds, 1533
Oil on canvas, 41¾ x 32½ in. (106.1 x 82.6 cm)
Museo Nacional del Prado, Madrid

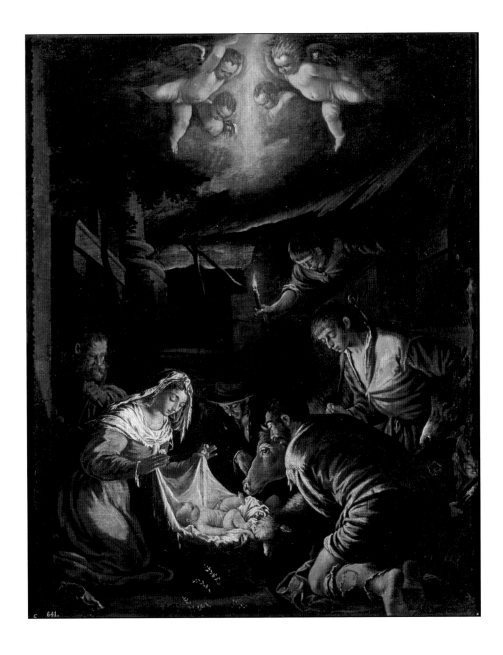

36
Titian
Salomé, about 1515
Oil on canvas, 35³⁄₁₆ x 29 in. (89.3 x 73 cm)
Museo Nacional del Prado, Madrid

37
Peter Paul Rubens,
Saint Matthew, about 1611
Oil on canvas, 43 x 33 in. (108 x 84 cm)
Museo Nacional del Prado, Madrid

offer was politely declined, he negotiated an extension of Rubens's stay so that he could paint the duke's portrait—a magnificent equestrian image that conveys the imperial ambitions of the monarchy while asserting Lerma's position as the one born to help the king carry them out (cat. 11).

Although Rubens did not stay at court, Lerma's interest in him illustrates a change in taste at the moment; he was the first personal contact for Spanish painters and collectors with the international Baroque style.[43] Rubens was greatly admired and continued to produce works to send to Philip III's court. Two series of the twelve apostles by him came to Spain by 1612; the panels in the Museo del Prado today (among them, fig. 37) are the set that belonged to either the duke of Lerma or his own favorite, Rodrigo Calderón.[44] While his unique flamboyant style did not rub off on any of the artists working in Valladolid at the time, Rubens's ambition, erudition, self-assuredness, courtly manners, and, above all, his sense of entitlement had to be impressive to the artists at court, especially those anxious to raise their status. Vicente Carducho, for example, only one year older than Rubens, had a keen interest in playing a more important role at court, with the aim of becoming a true courtier, but he was spending as much time painting balconies as pictures for Lerma. Just as Velázquez would benefit from Rubens's cosmopolitanism when the Fleming made his second visit to the court in 1628,

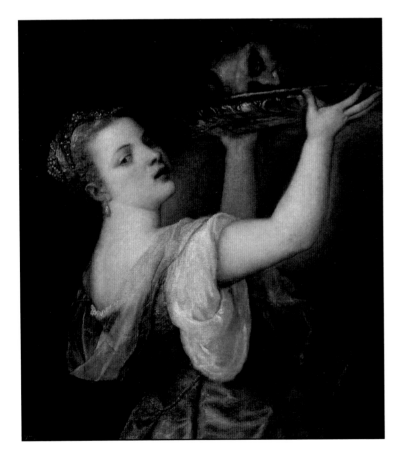

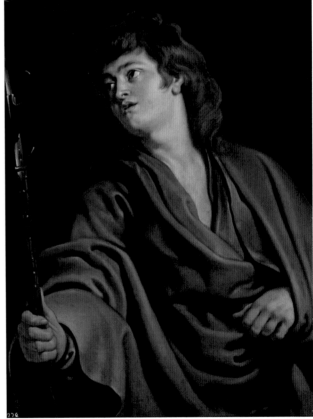

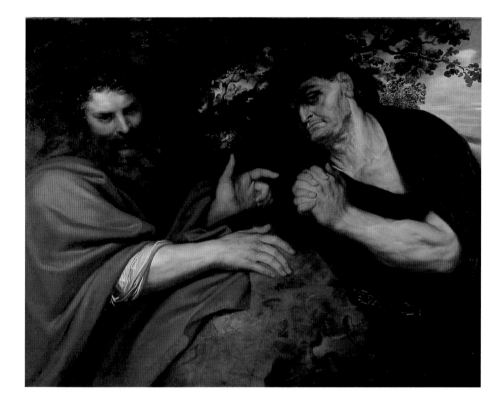

38
Peter Paul Rubens
The Philosophers Democritus and Heraclitus, 1603
Oil on canvas, 37 x 49 in. (95 x 125 cm)
Museo Nacional de Escultura, Valladolid

Vicente's lifelong fight to elevate painting to the status of the seven classical liberal arts, his struggle for better treatment and pay for Spanish artists, and his love of reading and acquiring books (he had the largest library of any artist in Spain) may be rooted in Rubens's visit to the court of Philip III in 1603. In many ways, Vicente's role in advocating for a higher status for artists laid the foundation for Velázquez's claim to knighthood in the next reign.

Victory of Catholicism and Spanish Reform

The new style of grandeur at the court of Philip III would not have been possible without the belief that the deep, pervading sense of danger posed to the Catholic Church by the Reformation movement had largely passed. Philip II's ardent defense of faith was no longer urgent; the Counter-Reformation movement codified by the decrees of the Council of Trent (1563) had succeeded: Europe and other Spanish territories had not been overtaken by the Protestants or the Ottoman Empire. Philip III could pursue a monarchy of diplomacy and peace and redirect the royal coffers toward more joyful projects and festivities.

The same "easier deportment and determination to enjoy life" can be seen in the activities of the contemporary popes in Rome, Clement VIII (r. 1592–1605) and Paul V (r. 1605–21), who believed Protestantism was on the defensive.[45] A sense of security allowed the popes to redirect their attention to earthly matters. Clement VIII finished the nave and facade of Saint Peter's and assigned the dome decoration to his favorite artist, the classicizing late Mannerist, Cavaliere Giuseppe Cesare d'Arpino.[46] Paul V created his sumptuous burial chapel, the Cappella

39
The Royal Pantheon
Basílica del Monasterio de El Escorial, Madrid

Paolina in Santa Maria Maggiore (1601–16), employing every artist of note in Rome: from the old school, including Cesare d'Arpino, Cigoli, Passignano, whose works came to Spain, and Pietro Bernini (Gianlorenzo's father), to the younger artists Guido Reni, Lanfranco, and Francisco Mochi (official papal taste excluded the revolutionary art of Caravaggio). It is no wonder that the glittering splendor of the Cappella Paolina with its use of gilding, colored marbles, and precious stones is so much like that of the Royal Pantheon of El Escorial (fig. 39)—Giovanni Battista Crescenzi supervised both projects.

Just before and throughout the reign of Philip III there was a marked change in devotional practices, which influenced official taste and art forms. With the victory of Catholicism, a second wave of reformers gradually replaced the figures of the Counter Reformation who initially had confronted the rise of Protestantism, creating a second reform movement within the church, which has been called the "Catholic Reformation."[47] With the replacement of the Counter Reformation by the Catholic Reformation, energies were directed inward in an attempt to reach out to the Catholic laity who, although they had resisted Protestantism, might need spiritual renewal to make the practice of their faith an integral part of their lives. In 1598 Clement VIII asked bishops around the world to adopt a new catechism, the Jesuit Robert Bellarmine's *Doctrina Cristiana*, because it successfully summarized church doctrine in the simple language of the people.

The Catholic Reformation in Spain was characterized by a more tolerant Inquisition, a relaxation of prohibited books, an intense campaign to beatify and canonize Spanish religious figures of the past, an increase in the number of convents, monasteries, and churches (especially reform orders), diocesan reform (including oversight of artistic images made for churches), and a newfound acceptance of forms of devotion that were considered unorthodox before. The second-generation reformers embraced popular piety and works of devotional literature produced by Spaniards, especially Ignatius of Loyola's *Spiritual Exercises* and Teresa of Avila's mystical texts (not published until after her death, in 1588), all of which had been seriously questioned by the Inquisition of the previous generation. Teresa (d. 1582) founded the Unshod Carmelites, a reform branch that imposed stricter rules of poverty and pious behavior on the nuns; her practical advice ("The Lord walks among the pots and pans helping you both internally and externally") and humble records of her visions, which she matter-of-factly called "visits from God," had massive appeal because she made direct communication with the divine seem so simple. Ignatius of Loyola began the Jesuit Order and wrote the *Spiritual Exercises* in 1548 as a series of meditations on the life of Christ, employing vivid pictorial language to guide the devotee in the use of his or her individual, personal imagination and all five senses to reconstruct sacred scenes that would evoke great empathy and profound religious feeling.

In their lifetimes, these practitioners of mental prayer, or contemplatives, operated at the margins of church society. Since the center of a Catholic's spiritual life was meant to be the celebration of the Mass and the sacraments, the unorthodox form of devotion of the mystics was regarded as subversive. Their claim that one could have direct, unmediated experience of God, not necessarily in the Mass, was a threat to the power and authority of the Catholic Church's clergy and its communal rituals.[48] In the last decade of the sixteenth century, perhaps beginning with the first publication of Teresa's writings, however, the second wave of reformers recognized that the mystic's personal form of meditation was one of the best methods to advance the Catholic Reformation within their country.[49]

The return to intense forms of devotion that had been stifled during the first half of Philip II's reign had an enormous impact on Spanish religious art, but it is usually discussed in terms of the post-1640 works by Zurbarán and Murillo. In fact, artists were already moving "away from the doctrinal to the emotional" in Philip III's period.[50] The power of the religious images made during the reign of Philip III correlates directly with the deep personal relationship to the faith felt and demonstrated by both patrons and artists. According to Palomino, the extremely devout Gregorio Fernández, the sculptor who worked for Lerma and Philip III, prepared himself to create his polychrome statues of Christ and Mary carried in procession (fig. 40) by "prayer, fast, penitence, and communion."[51] An unusual number of artists displayed their strong personal commitment to the Church by becoming priests or monks (Maino, Roelas, Góngora) or lay brothers (Sánchez Cotán, Vicente Carducho, Cervantes), or by joining a religious confraternity (Pacheco, Martínez Montañes, Tristán, Ribalta, Orrente).

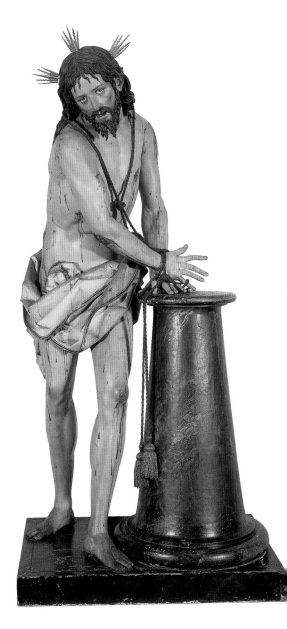

40
Gregorio Fernández
Christ at the Column, about 1625
Polychrome wood, H. 63 in. (160 cm)
Convento de la Concepción de Madres Carmelitas
Descalzas, Valladolid

41

Juan Pantoja de la Cruz
Empress Maria of Austria, about 1607
Oil on canvas, 83¼ x 60¼ in. (211.5 x 153 cm)
Monasterio de las Descalzas Reales, Madrid

Vicente Carducho, for instance, belonged to the Third Order Regular of the Franciscans, the branch for laymen, and was active in the order in Madrid. Like King Philip III, Carducho asked to be buried in the simple brown habit of the Franciscan order. His strikingly original and personal image, the *Stigmatization of Saint Francis* (cat. 38), was painted for the hospital run by the third order in Madrid, located next to the order's thirteenth-century church, San Francisco (destroyed in the eighteenth century and replaced by San Francisco el Grande). Vicente's association with the lay Franciscans in Madrid dates from at least 1610.[52] Although undated, the *Stigmatization* represents, at the very least in spirit, the type of simple, sincerely felt, intensely personal religious picture belonging to this reign of Philip III. Borrowing from Teresa's descriptions of the sense of levitation she experienced when in rapture, Carducho lifts Saint Francis higher than any artist had done, to the same height as the divine being who becomes his own size. It is an unorthodox image, departing from Pacheco's doctrinal instructions, and one of the most intimate treatments of the theme to date. Carducho's image perfectly communicates the now accepted belief in the possibility of a private relationship with God.

Like many of the artists, the monarchs and the king's favorite supported and in many ways embodied the new Catholic-Reformation movement in Spain. Their backgrounds contributed to the way in which they each embraced changes in religious thought and practice. Observers commonly noted the pious nature of Prince Philip. One can only imagine the effect of growing up in the sacred environs of El Escorial with an extremely devout father (who never expected that the baby in the family, Prince Philip, would become heir to the throne). From an early age Prince Philip took part in the solemn ceremonies at El Escorial and elsewhere. In 1587 he held the tasseled cord attached to the urn of Santa Leocadia when her body was brought back from Flanders to the Cathedral of Toledo. Since he was motherless at two years of age, the prince also spent a great deal of his youth inside the cloistered convent of Las Descalzas Reales in Madrid under the auspices of his great-aunt, the empress Maria (fig. 41), who retired there to live the life of a nun after the death of her husband, Maximilian II. The environments in which he grew up were intimately connected to the Church and must have served as the basis for the king's extremely devout nature. It was when Prince Philip was just ten years old that the new Catholic Reformation began; Teresa's collected works, edited by Fray Luis de León, were finally approved for publication and were widely disseminated and highly influential.

The queen had a childhood directed toward piety and charity, and was well educated in Tridentine Catholicism; indeed, she had plans to enter the convent before her marriage was arranged.[53] Queen Margaret's most important artistic legacy, the convent and chapel of La Encarnación (fig. 42), was founded for the reform Augustinian nuns; she also founded the convent of the Unshod Franciscans in Valladolid. As queen of Spain, therefore, we see that she supported reform orders, that is, the Unshod, or *Descalzas*, branches, so named for the sandals they wore all year long as demonstrations of their extreme poverty and humility. And

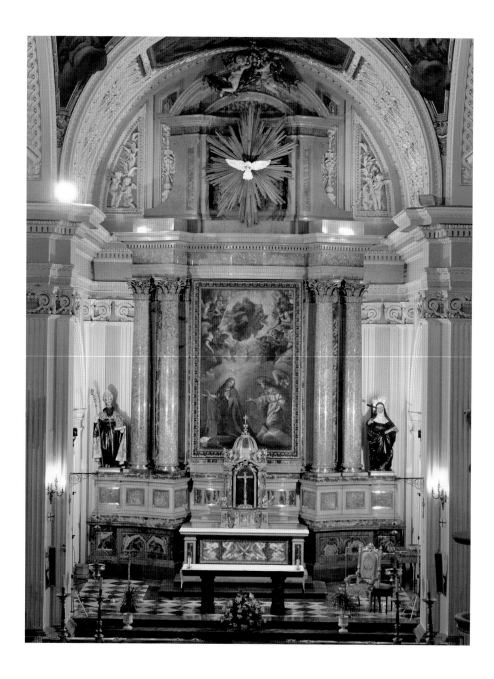

the queen served as a model in her intense daily worship and charitable works until her death in 1611. The portraits "a lo divino" commissioned by the queen, such as her portrayal as the Virgin Annunciate (see fig. 59, p. 137) may seem sacrilegious to our eyes; in her day, however, it represented Margaret's close personal identification with the queen of heaven.

These monarchs advocated for popular forms of piety that the decrees of the Council of Trent had not succeeded in eliminating.[54] We know that Philip III petitioned Rome to support canonizations and the popular belief in the doctrine of the Immaculate Conception, which the Church prohibited from becoming dogma until 1854. The devotion of the monarchs to popular miraculous images was well known and first made public during their wedding trip, which Philip constructed in part as a pilgrimage to pay homage to Spain's sacred images and sites: San

Vicente Mártir in Valencia; the Black Madonna of Montserrat in Barcelona; and in Zaragoza, the Virgin of Pilar. Before leaving Madrid to meet his queen, the king also visited the Virgin of Atocha.[55]

The duke of Lerma's environment in his early years also molded his religious outlook. His childhood was spent in the enclosed world of the royal convent of Santa Clara in Tordesillas, where his grandfather and father served in the mock court of Queen Juana "La Loca." His mother, Isabel de Borja, was a direct descendant of Rodrigo Borgia (1431–1503), Pope Alexander VI, and she was the daughter of the count of Gandía, Francisco de Borja (1510–1572), who became Third General of the Jesuit order. As it had for Prince Philip, growing up in an environment with powerful noblewomen living in royal cloistered convents undoubtedly formed the basis of the duke's spiritual life, and contributed to making him a fervent member of the Spanish Catholic-Reform movement.

Even more fundamental is the fact that Lerma spent part of his youth tutored by his uncle, Cristóbal Rojas y Sandoval (1502–1580), a well-known first-generation reformer, who served as a delegate to the second session of the Council of Trent.[56] During this time, Cristóbal was bishop of Badajoz (r. 1556–62), where he aligned himself with the mystics by enthusiastically embracing asceticism, personal meditation, and mental prayer. As a youth, Lerma would have witnessed his uncle's protection of the Jesuits and may have been present when Cristóbal called them to Badajoz to preach and say Ignatius's *Spiritual Exercises*.[57] Under the influence of his uncle, Lerma would have practiced the three-week program as outlined in the *Spiritual Exercises*. Cristóbal Rojas y Sandoval's fervent personal spiritualism parallels the intense devotional paintings by Badajoz's celebrated artist, Luis de Morales (1509–1586). The painter's work must have made an impression on the young Lerma when he was in Badajoz; a copy of a Morales picture, *The Tears of Saint Peter* (fig. 43), later appears in Lerma's inventories.[58]

Lerma remained close to his uncle, who became his protector at court. After six years in Badajoz, Cristóbal became bishop of Córdoba (r. 1562–71), and in 1571 he was named archbishop of Seville, at which time he acted as the protector of Teresa of Avila in her efforts to create reform Carmelite convents in Seville, an unpopular stance with the official Church.[59] By all indications, he belonged to the most extreme currents of Spanish religious piety of the moment, and exposed the young Lerma to a progressive form of mystical Catholicism.[60] When Cristóbal died in 1580, he was buried in the church in the village of Lerma, but the duke planned that his remains would be transferred to the elaborate family burial chapel he was building in San Pablo in Valladolid. He ordered a bronze cenotaph to be made of his uncle, to match the gilded bronzes of the duke and duchess (fig. 44).

Cristóbal Rojas y Sandoval was also the tutor of another nephew, Bernardo de Sandoval y Rojas (1546–1618), the future archbishop of Toledo and the second most powerful art patron during the reign of Philip III. As is evident from their later careers, Bernardo and Lerma were marked by their experience with Cristóbal Rojas y Sandoval and carried forward their uncle's revolutionary form of prayer practice and its representation in emotionally intense art made for personal devotions.

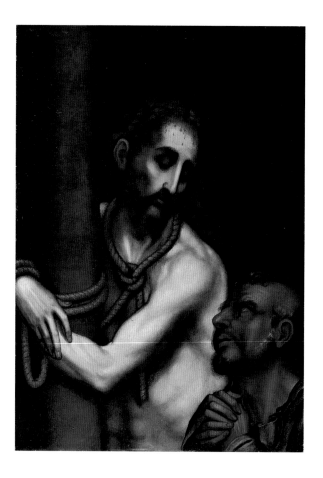

There can be no question that the duke of Lerma was a very pious man. Just before becoming head of the Sandoval family in 1575, Lerma expressed the wish to join the Franciscans, but was held back by his maternal grandfather, Francisco de Borja.[61] In 1605 and again in 1612 Lerma asked the king's permission to become a cleric, but he was both times refused.[62] In the end he was elected cardinal, in part to protect him from charges of corruption after his fall from power in 1618. But it also seems to have fulfilled a lifelong desire to join the Church. Lerma's projects in Valladolid, Madrid, and Lerma stand out in the history of patronage for the number of convents, monasteries, and churches he erected on his own property; his last will and testament records his support of forty religious institutions in all.[63] Like the monarchs, Lerma was a strong supporter of reform orders. He founded, among others, the Reform Franciscan monastery of San Diego in Valladolid and built a convent for Teresa's order, the Unshod Carmelites, in Lerma.

Because of his family connection, the duke of Lerma always had close ties with the Jesuits.[64] Throughout his life he was devoted to the canonization of his grandfather, Francisco de Borja, who led the Jesuits until his death in 1572. The duke built a Jesuit house on his Madrid estate for the purpose of founding a new community in the city and to house Francisco de Borja's remains, which he had had transferred from Rome in 1617 (see fig. 45). Largely through Lerma's efforts, Borja was beatified in 1624.

Throughout this reign, tremendous effort was made to secure canonization for the Spanish mystics of the previous generation: Teresa of Avila (d. 1582) and John of the Cross (d. 1591), the cofounder of the Reform Carmelite order; the Augustinian mystic and royal preacher Alonso de Orozco (d. 1591); as well as three Jesuits, Saint Ignatius Loyola (d. 1556), the zealous missionary Francis Xavier (1506–1552), and Francisco de Borja (d. 1572). Others included the priest Francisco Jerónimo Simón (1578–1612) of Valencia, and Isidro (1082–1172), the popular cult patron of the city of Madrid. The duke of Lerma supported these campaigns for canonization; his collection included portraits of the holy figures well before they were canonized.[65] Some of the campaigns were successful—in 1622 Paul v's successor, Pope Gregory xv, canonized four Spanish saints: Teresa, Ignatius, Francis Xavier, and Isidro.

It was in this reign that some of the first images reflecting the mystical movement came into being. In 1612 Francisco Ribalta painted the spiritual visions of his contemporary Father Simón of Valencia, who had a reputation as being exceptionally holy and devout (cat. 44). Ribalta's patron Juan de Ribera was another famous reformer who had succeeded Lerma's uncle Cristóbal as Bishop of Badajoz in 1562 and had been named patriarch of Antioch and archbishop of Valencia in 1569. While in Badajoz, Ribera was also taken by the art of Luis de Morales. Bishop Ribera brought Morales into his household as his *pintor de cámara;* Morales's atemporal, profoundly mystical style, with its tragic treatment of the

44
Pompeo Leoni and Juan de Arfe
Archbishop Cristóbal Rojas y Sandoval,
1600–10
Bronze
Colegiata de San Pedro, Lerma

45
Anonymous
Reliquary casket with portrait of San Francisco
de Borja, 1550–99
Wood, mirror, gold, 11 x 17 x 10⅝⁄₁₆ in.
(27.7 x 44 x 26.3 cm)
Monasterio de las Descalzas Reales, Madrid

religious figures, perfectly fit the personality and devotional habits of Juan de Ribera.[66] Like Cristóbal, Juan de Ribera was a progressive first-generation reformer, who was taught by Saint John of Avila, was a close friend of Fray Luis de Granada, and greatly admired the Jesuits.[67]

The archbishop Juan de Ribera, a patron of Luis de Morales, brought works like the latter's devotional triptych of *Ecce Homo* (fig. 46) with him when he moved to Valencia. In it, Morales paints Ribera as fervently meditating on the wounds of Christ, just as Ignatius instructs in the *Spiritual Exercises*. Ribera thereby receives spiritual renewal by being moved to compassion for Christ. Ribera's taste for the emotional effect of intense, dramatic works of art influenced Francisco Ribalta, who moved to Valencia from Madrid in 1599. For the *Vision of Father Simón* (see cat. 44), Ribalta borrowed compositional elements from Sebastiano del Piombo's *Christ Carrying the Cross* (Museo del Prado) and adopted the emotional tenor of Morales's works. Ribalta's painting exhibits the same elements that heightened the emotional impact of these artists' works: "the geometric simplicity of the composition, the monumentality of the figures, the legitimacy of action, abstraction of form, and sentiment of religious melancholy."[68] The way Ribalta positioned the cartellino with his signature on it implies that Ribalta (or the viewer) was also a recipient of the vision, as if he, like Simón, was kneeling at the

side of Christ receiving His gaze.[69] The monumental figures placed near the picture plane do indeed suggest a close proximity to the vision, and would have acted as an aid to the viewer in realizing Ignatius's instructions to prepare for mental prayer by imagining oneself in the presence of the sacred persons. The effect is the same as that evoked by Morales's devotional pictures painted some forty years earlier, only now, the artist/viewer is also a participant in the drama of an actual vision of a contemporary figure.

In 1613 three paintings of Ribalta's *Vision of Father Simón* were commissioned by the Cathedral of Valencia as gifts for Pope Paul v, King Philip iii, and the duke of Lerma.[70] In Valencia popular piety for Padre Simón was so strong that riots broke out when an edict was published in 1619 ordering the removal of all altars and images of Simón.[71]

The original iconography for depicting Teresa of Avila (cat. 41) and Ignatius Loyola (cat. 42) also fell to Spanish artists of the reign of Philip iii. Another Spanish holy figure for which a canonization campaign had been launched was the Blessed Fray Alonso de Orozco (1500–1591), the royal preacher and Augustinian monk whose severe acts of penance and model life devoted to Christ earned him the reputation of saint before his death. A Catholic-Reform commission to interpret the mystical writings of Alonso de Orozco, in fact, inspired the major artistic event of religious patronage in Madrid at the beginning of the reign: El Greco's altarpiece for the chapel of the Seminary of the Incarnation, known as the Colegio de Doña María de Aragón after its founder who died in 1593. Installed in 1600, it included his remarkable *Annunciation* (cat. 19) as the central panel of a large six-panel altarpiece.[72] In the words of Richard Mann, "El Greco probably considered his work at the seminary to be the most prestigious and important commission

46
Luis de Morales
Triptych: Ecce Homo, Dolorosa, Saint John the Evangelist and Juan de Ribera, about 1562–68
Panel, 31 x 41 in. (80 x 104 cm)
Museo de Cádiz

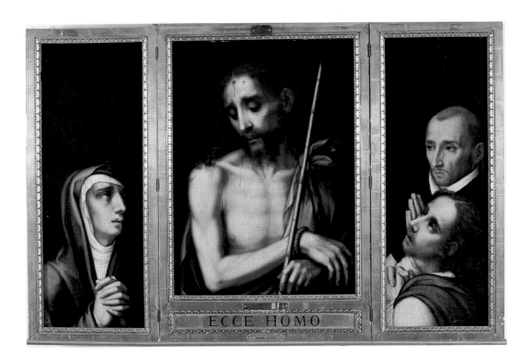

of his career," because it brought him "closer to achieving the status of a court artist than at any other time."[73] It was El Greco's first large-scale commission in Madrid, responsible for creating a shift in his clientele from the intellectual elite in Toledo to courtiers in Madrid.

Even before the construction of the seminary beside it, the old Augustinian church was a popular place of worship for the most important noblemen of the city of Madrid, who were drawn to the moving sermons given by Alonso de Orozco and later visited his burial site within the church. Philip ii and his entourage often attended Mass there.[74] As a child, Philip iii would have accompanied his father on occasion to hear Mass there and would have known Orozco, who was connected to the court as royal preacher. He would also have known Orozco's patroness and founder of the seminary, Doña Maria, because she served as lady-in-waiting to his sister Isabel Clara Eugenia.[75]

When Doña Maria died, she left money to build a seminary for the Augustinians in Orozco's honor and memory. Orozco's successor as rector, Hernando de Rojas, and Jerónimo de Chiriboga, executor of Doña Maria's will, planned all the architectural and decorative work for the *colegio* and must have been responsible for giving the commission for the main altarpiece to El Greco. El Greco's job was to somehow incorporate Orozco's visionary ideas into subject matter that was conventional for altarpieces—scenes from the life of the Virgin and Christ.

He succeeded brilliantly. The evaluations of the altarpiece of the *colegio* submitted by Bartolomé Carducho, on behalf of the artist, and Pantoja for the estate of the patron proved the court artists had a high opinion of the outstanding quality of El Greco's achievement: it was the highest fee El Greco ever received. El Greco's efforts for this altarpiece led to success within the circle of the court of Philip iii, which was more liberal in terms of orthodoxy than Philip ii's had been. El Greco was in a different world from the earlier constraints placed upon him for his lack of doctrinal correctness.

The Colegio de Doña María de Aragón became an important source of commissions for other painters and sculptors throughout the reign of Philip iii. Pantoja de la Cruz created images of Saint Augustine and Nicholas Tolentino for the side altars, as well as a portrait of the rector Hernando de Rojas. Vicente Carducho's pupil Bartolomé Román (d. 1647) was represented,[76] as was Francisco Ribalta (whose painting was described by Palomino as of "superior quality," a "life-size effigy of the Crucified Christ in the cloister next to the staircase,"[77] which by the time of Ponz had been "destroyed by humidity and retouches").[78]

In one of the corners of the cloister, Palomino described "an excellent picture of the naked Christ during his most holy Passion being contemplated by his loving Mother" by Eugenio Cajés, which fits the description of the work in the exhibition (cat. 28). It is a theme and composition that Vicente Carducho would repeat in his *Christ at Calvary* (cat. 27)[79], with subtle yet telling differences. The subject is an imagined scene, not described in the scriptures, but reflects the importance of the artist's visual image as an aid to Spanish mystical prayer. Again, Ignatius wrote, "I will see the persons in my imagination . . . observe, consider and contemplate what they are saying or might say, observe and consider what they are doing, smell and taste in my imagination the infinite fragrance and sweetness of the Divinity . . . imagine standing in the presence of our Lord God."[80]

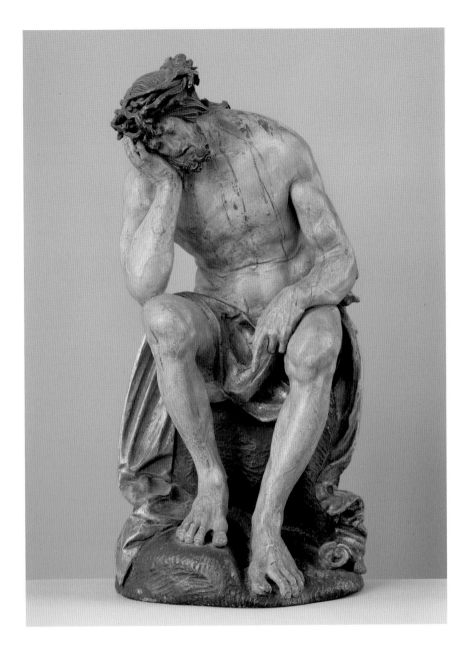

47
Hans Leinberger
Pieta, about 1525
Limewood, H. 29½ in. (75 cm)
Skulpturensammlung und Museum für Byzantinische
Kunst, Staatliche Museen zu Berlin

The source for these works by Carducho and Cajés partly follows the traditional Man of Sorrows motif used by Albrecht Dürer, Hans Leinberger, and other Northern European artists (fig. 47), with Christ in a melancholic pose, seen too in a few Italian and Spanish pictures.[81] Carducho and Cajés, however, interpret the story in a new way.

But why did the two artists paint the same composition? Vicente Carducho and Cajés often collaborated on altarpieces and frescoes, working side by side, and the answer may relate to one of their most important joint projects, commissioned in 1614 by the archbishop of Toledo, Bernardo de Sandoval y Rojas.

Cardinal Bernardo de Sandoval y Rojas was the most important of the second-generation reformers during the reign of Philip III, not only because of his connection to the duke of Lerma and their mutual education under Archbishop Cristóbal Rojas y Sandoval but also because Bernardo was a significant art patron

with immense resources and sophisticated taste. His patronage touched the lives of many of the painters of this reign, and he was responsible for bringing to Spain "modern" painting from Italy.

After being educated by his progressive and powerful uncle Cristóbal, Bernardo attended the universities at Alcalá and Salamanca and became canon of the Cathedral of Seville in 1574, while his uncle was there. During his time as canon, contemporary historical accounts called him *el padre de los pobres* (father of the poor) as he traveled widely to the remote poor parishes in the diocese, giving away more than half of his income in alms.[82] In 1585 Philip II appointed him to bishoprics in Ciudad Rodrigo, Pamplona, and Jaén. His fortunes changed overnight when his nephew became the favorite of the king. The duke of Lerma used his influence to attain for his uncle the highest ecclesiastical post in Spain, that of archbishop of Toledo. Elected in 1599, Bernardo remained in the position until his death in 1618. The archbishop of Toledo was the primate of Spain, a title blessed by the pope that signified the ceremonial head of and spokesman for the Spanish Church.[83] As leader of the largest archdiocese in Europe, controlling eight large and high-income dioceses (Toledo, Segovia, Osma, Sigüenza, Cuenca, Cartagena, Jaén, Córdoba) set within a vast geographical area, it was also the richest archdiocese in Europe, second only to the pope's own.

As part of a political strategy to surround himself with family members he could trust (or thought he could; his own son and his uncle Bernardo would contribute to his downfall) and loyal supporters, the duke of Lerma also had Bernardo appointed to the councils of Castile and state. He was offered the office of inquisitor general in 1602, which at first he refused to accept, an early sign of his strong independence from the duke and his disapproval of the government of favoritism, which would only grow with time.[84] In 1608 he finally relented to the pressure, and under his leadership the Spanish Inquisition entered a more tolerant phase.

Bernardo published new Indexes of Prohibited Books (*Index librorum prohibitorum et expurgatorum*) in 1612 and 1614, which were less rigid than those issued earlier by the archbishop of Toledo under Philip II, Gaspar de Quiroga (1512–1594). The 1612 Index, for example, granted dispensation to "pious men and doctors" to read Rabbinic and Moorish literature, even if the books contained arguments against the Christian faith.[85] Bernardo obviously was a lover of literature; he is best known as the patron of Cervantes and maintained close relationships with the poet Luis de Góngora, who was painted by Velázquez in 1622 (cat. 17), and with the religious writer Fray Hortensio Félix Paravicino, painted by El Greco in 1609 (cat. 12).

Bernardo was equally interested in the visual arts and sought out the best artists in Toledo. The diocesan synod he convened in 1601 addressed the Church's control over expenditures and the propriety of all artistic production in the huge diocese, and his committee for oversight sometimes included El Greco and his son Jorge Manuel.[86] On occasion El Greco advised the cardinal-archbishop on his numerous architectural projects for the cathedral;[87] one of these was the renovation of the sacristy, the site of El Greco's controversial *Disrobing of Christ* painted

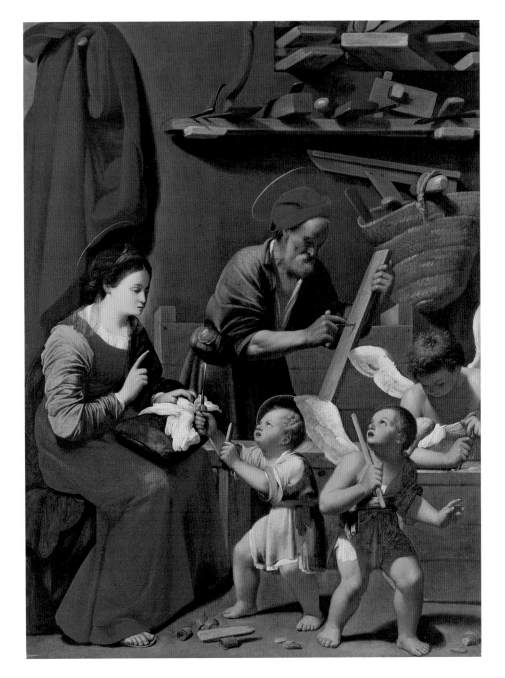

48
Carlo Saraceni
The Holy Family in Saint Joseph's Workshop,
about 1615
Oil on canvas, 44 9/16 x 33 3/16 in. (111.8 x 83.8 cm)
Wadsworth Atheneum Museum of Art,
Hartford, CT

in 1577. Evidence suggests that Cardinal Sandoval commissioned El Greco to
paint an *Apostolado* (series of thirteen canvases of Christ and his twelve apostles)
for the sacristy renovation. In 1615 Bernardo de Sandoval y Rojas commissioned
the *pintores del rey,* Vicente Carducho and Eugenio Cajés, to paint the frescoes
and paintings for the Chapel of Our Lady of Sagrario, his major project in the
cathedral. He also asked them to paint closely related subjects for the sacristy
anteroom, the crucified apostles Peter and Andrew, which allows for the juxtapo-
sition of their different styles.

 While commissioning El Greco and two Escorial-trained court artists, Cardinal
Sandoval also imported from Rome eight paintings by Carlo Saraceni, the Venetian
follower of Caravaggio whose type of early Baroque painting combined

49
Luis Tristán
Crucified Christ, about 1617
Oil on canvas, 188 x 69 in. (300 x 175 cm)
Cabildo Primado, Toledo

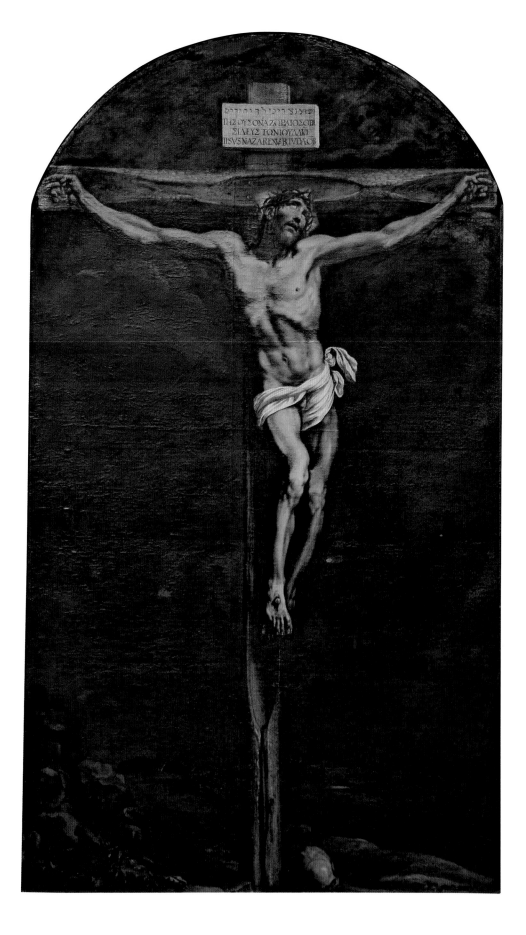

Caravaggesque naturalism with an ideal classicism and "mood of poetic innocence, lucid design, tranquil figures, quiet harmony" (fig. 48).[88] Three were placed in the Sagrario, probably commissioned by the archbishop, and five were added to his personal collection, along with other modern pictures brought from Rome: one Caravaggio (probably a copy); a *Saint Margaret* by Guido Reni; and a *Saint Sebastian* by Jusepe de Ribera.[89]

The archbishop's sizeable collection contained the greatest concentration of works from Caravaggio's immediate circle in Spain in the early seventeenth century.[90] His collection of about 129 paintings, although considerably smaller than Lerma's, was equally important for its representation of current Italian Baroque masters and for the evidence it provides of his support of local artists. His taste was not straightforwardly progressive, as the collection also contained works by the older Toledan artists Blas del Prado and El Greco, as well as many devotional works, including one by Luis de Morales. And one of the conservative royal portraitists to whom he had access must have painted the portraits of Philip III, Margaret, and the duke of Lerma he owned.

The Toledan artist Luis Tristán was represented by six pictures in the archbishop's private collection, such as the *Crucified Christ* (fig. 49) still in the Cathedral of Toledo. Its strong play of light and shadow and elements of naturalism reflect Tristán's ability to adapt to the cardinal's Caravaggesque taste. Sandoval was responsible for supporting other Toledan artists who had recently returned from Italy, commissioning a work from Maino (now lost) and one from Orrente, his naturalistic *Santa Leocadia* (Toledo Cathedral). With his support of these younger artists as well as of El Greco, Carducho, and Cajés, it would be fair to categorize his taste as eclectic, perhaps attributable to his dual roles as private priest and public statesman; his modern tastes for Roman art belonged to his personal side, while as a statesman he patronized El Greco and the official conservative court artists Carducho and Cajés.[91] However, this might overly polarize the archbishop's taste and categorize the artists as either modern or conservative. The fact is, eclecticism is one of the true characteristics of this transitional period, when the conservative and progressive are constantly seen and collected side by side.

In terms of the Catholic Reformation, the artists and themes Bernardo de Sandoval y Rojas selected to decorate his church were highly influential. But more important than style was his taste for and patronage of the trend toward representing religious subjects in a natural and convincing manner, meant to incite the viewer to prayer and meditation and heighten the empathy between the viewer and image. This tendency was promoted by Archbishop Sandoval's introduction of current models from Rome and by his support of local artists whose iconography, or style, or mundane settings for sacred scenes met these second-reform requirements.

Social Changes

Spanish society during the reign of Philip III was open to new possibilities, to diverse solutions and alternatives, but at the same time it was a hierarchical and enclosed culture, trying to establish a stable nation by peace and a unified national identity by strengthening the well-established traditions of the Spanish monarchy and Catholicism.[92] Miguel de Cervantes's *Don Quijote*, published in 1605 (part 1) and 1615 (part 2), is often interpreted as a reflection of a complex, diverse, and changing society, full of uncertainty and anxiety. And yet this same society allowed Cervantes to make a bold, decisive change in literary forms: the novel was born, a narrative specifically directed at the masses rather than only at the elite class. It had immediate success in Spain and beyond.[93]

In the visual arts, Juan Sánchez Cotán created the most sophisticated still-life paintings in all of Europe before 1603 (cats. 50–52), elevating this radically new genre to another level, far beyond what his teacher, Blas del Prado, had done. In these works Sánchez Cotán demonstrated his knowledge and command of the early international Baroque language of tenebrism (strong contrast of light and dark), naturalism (a new manner of observing and depicting reality), and illusion (the fruits and vegetables are so perfectly rendered they seem real). But in his religious paintings, such as the *Virgin of the Immaculate Conception* (cat. 46) painted about 1617, the same artist seems to have rejected any modern, foreign influence and reverted to an old-fashioned, less progressive manner.

El Greco, Cervantes's exact contemporary and Sánchez Cotán's older colleague in Toledo, also created daring pictures in this period, unlike any he had made before. The mysterious appearance in his oeuvre of a lone mythological picture, *Laocoön* (cat. 6), the idiosyncratic invention of the strange emaciated *Saint Jerome as Scholar* (cat. 3), and the ambiguity and distortion in the *Vision of Saint John* (cat. 5) are related to societal as well as political and religious changes. Although the three spheres are deeply interwoven, it is possible to identify a few specific changes in Spanish society between 1598 and 1621 that are reflected in both new forms of expression and, at times, a stubborn adherence to tradition.

The first change is the multilayered mobility of this society. Don Quijote's adventures on the road, where he had the opportunity to interact with a wide variety of social types, reflect a common social phenomenon of the time.[94] Travelers offered experiences of other traditions and cultures: there was the continual migration of the pilgrim; fairs drawing merchants and buyers; shepherds crisscrossing the great Castilian *mesa* twice a year; soldiers stationed abroad in many different countries; New World inhabitants writing letters home; traveling gypsies; and visiting foreigners.[95] Not only travelers but also the homebound occupants of the land through which they passed savored the new and different.

Most artists during the reign of Philip III experienced displacement too; they often had to travel with a monarch who rarely stood still. From 1599 to 1606 the court itinerary shows that the king and his close circle almost never stayed in one place for more than two weeks before moving on to the next royal palace or to one of the duke of Lerma's residences, according to the hunting season and the

social and liturgical calendar. The decision to move the entire court from Madrid to Valladolid in 1601, and when that failed, back to Madrid only five years later, caused at least forty-seven thousand persons connected to the court to relocate, among them the court artists.

Court painters and sometime collaborators Eugenio Cajés and Vicente Carducho, for example, established their permanent residence in Madrid but were working on projects requiring constant relocation, to Valladolid, Lerma, El Pardo (according to the artists, too far outside of Madrid to travel back and forth), Toledo, Segovia, Guadalupe, and Algete. Of the nineteen artists in the exhibition, only one, Van der Hamen, had the stability afforded by working primarily where he was born. Perhaps the most displaced of all was Pedro Orrente, the "Spanish Bassano," who was not connected to the court.

The specific effect of the displacement upon the artists cannot be known, but it must have contributed to a general sense of instability felt by many of Philip III's subjects and indeed characterizes his reign.[96] Instability may partly explain the lack of consistency in style that is often seen in this period. Even more pertinent in understanding artistic production of this time is the fact that there was more mobility in social status than ever before, which created a new art market, new types of clientele, and made the artists more aware of their own position in Spanish society.

One sector of new clientele was made up of members of a growing urban society, with relationships, interests, and habits that were different from those of the previous generation.[97] Thanks to the fixed court in Madrid beginning in 1606, the town became a city, the population increased from sixty-five thousand inhabitants at the end of the sixteenth century to one hundred fifty thousand by 1617,[98] and the same development took place in other urban areas—Seville had been a bustling city since the discovery of the New World, but it reached its peak in the early seventeenth century. Growing urbanism created a new level of society, a relatively cosmopolitan class of people who demanded cultural forms that they could enjoy and to which they could relate.[99]

Artists borrowed from elements of the urban society itself to appeal to that segment of the population.[100] The Spanish *bodegón* (tavern scene) differed from its Flemish prototypes by focusing on snapshots (albeit staged) of the daily life of the poor rather than on crowded scenes with religious, allegorical, or satirical overtones. The Spanish *bodegón* could parallel the picaresque novel in describing low life in realistic ways; Velázquez's *Old Woman Cooking Eggs* (cat. 62) created in 1618 has been compared to a scene in Mateo Alemán's *Guzmán de Alfarache*, published in 1599–1604, where the *pícaro* (a young delinquent living on the fringes of society) is fed rotten eggs by an old woman.[101] But Velázquez's figures were created from models on the street and, as has often been pointed out, are portrayed as dignified and innocent rather than roguish.[102] When Jusepe de Ribera executed his *Sense of Taste* (cat. 61) for a Spanish patron about 1615, he choose a real-life model from a minority group often used as a literary character type, a gypsy, who is identified by the small gold earring and other signs of nomadic life: a grease-

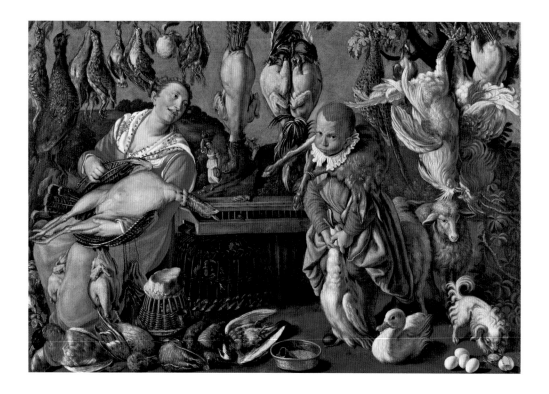

stained, ill-fitting shirt, dirty fingernails, and humble meal. In *The Kitchen Maid* (cat. 60) Velázquez chose a mulatto model from the slave underworld in Spain. We know that *bodegones* and maps were imported from Flanders and collected in numbers so large that Cristóbal Pérez de Herrera, writing in his *Discursos del amparo de los legitimos pobres, y reducción de los fingidos* (Madrid 1598), proposed an official school to teach Spanish artists to produce these genres at a lower cost.[103]

Spanish society, however, seemed to prefer the Northern and Italian examples (see fig. 50). No Spanish artist made a specialty of the genre. Instead, the *bodegón* was a rare experiment and, as far as we know, was collected mainly by the educated elite. The same was true of the independent still-life painting in its earliest manifestation in Spain. Bowls of fruit and flower arrangements had long been painted by artists as part of religious and secular scenes, but the concept of fruits and vegetables as the sole subject matter was a novelty in 1600 and was intimately connected to an intellectual interest in classical literature, which described such paintings in antiquity.[104] Sánchez Cotán's revolutionary *pinturas de frutas* (fig. 51; cats. 50–52) were first collected by aristocratic churchmen, appearing in the inventories of the two archbishops of Toledo of this time, García de Loaisa and Bernardo de Sandoval y Rojas. The duke of Lerma also owned nine anonymous *lienzos de frutas* that hung in La Ribera in Valladolid and entered the royal collection when he sold the palace to Philip III.

After Sánchez Cotán, who painted only about a dozen examples, there were very few Spanish artists who painted still lifes until the late 1610s and early 1620s; it took time for the novel concept to develop into a popular art form that would support the careers of Alejandro de Loarte (cat. 53) and Juan van der Hamen (cats. 55, 56, 63).[105] Van der Hamen's oeuvre, which consisted of many different

painting sizes and levels of complexity within compositions, reflected a diverse clientele; there were a variety of tastes and economic means in the open market.

Another factor that brought about a change in clientele for artists was the inflation of titles and favors granted by the king, which produced more collectors than had ever existed. Before Philip III money and titles were held by a tiny sector of the population—at the end of the sixteenth century there were only eighteen dukes, thirty-eight marquises, and forty-three counts.[106] Within the first year of his reign, Philip III had already bestowed more than fifty habits in the three knighthood orders, Santiago, Calatrava, and Alcántara, more than his father had done in ten years.[107] Philip III was liberal in rewarding his favorite, as we know, but also many members of Lerma's family, other well-connected noblemen, and hidalgos (lesser nobility). Even the servants of noblemen had opportunities to elevate their social status and become rich—the best known example is Lerma's secretary Rodrigo de Calderón, who became the count of Oliva and marquis of Siete Iglesias, built a splendid burial chapel in Valladolid, and became a collector of note.[108]

Members of this newly formed privileged class were eager to follow Lerma's example in ostentatious show and collecting as a manifestation of their status, and suddenly another arena opened up for the artists of the time. Collectors ranged from court administrators and well-off household servants to new and old titled noblemen. Demand caused some artists to expand their workshops; Tristán and Orrente each hired four apprentices. In noble and urban residences, the *galeria de retratos* (portrait gallery) became a standard feature, made popular by Philip III's revised portrait gallery at El Pardo and the regal example in Lerma's Madrid palace, listed in an inventory of 1607. Before his death in 1608, Pantoja and to a greater extent Bartolomé González, along with lesser-known portraitists such as Antonio Ricci and Santiago Morán, were called upon to supply portraits for the growing number of these private galleries, which typically included portraits of the monarchs, often the duke of Lerma, and notable members of the collector's own family. Although we do not know how many workshop assistants González employed, we can guess by the vast number of extant portraits attributed to him.[109] For the king alone, González was commissioned to make seventy-five portraits between 1608 and 1617, and another commission of sixteen in three years from 1609 to 1612. By comparison, Velázquez could take up to one year to complete a single portrait.

Another significant change in society was a new sense of individualism. Despite the religious atmosphere, a new secular spirit was evolving at the same time, based on developments in the empirical sciences. Artists and writers were challenged to closely describe nature as they saw it with their own eyes, without following conventions. The result was the naturalism seen in all the arts during this period, from still-life painting to the specificity of descriptive language in *Don Quijote*.[110] We also begin to see artistic self-referencing. By creating a character in *Don Quijote* who is a reader and collects books on chivalry, Cervantes reflected on his own artistic discipline (see Laura Bass's essay in this volume).[111] In *Diálogos de la pintura*, Carducho's characters are a painter and his pupil;

Palomino wrote that Vicente "was fortunate in gathering a whole school of followers."[112] Perhaps another reflection of this growing sense of self appears in artists' increasing sense of professional autonomy. In a self-congratulatory gesture, Carducho includes in the *Diálogos* the successful *memoria* written to the king by painters and writers in defense of removing the sales tax (*alcábala*) from works of art; and art criticism in Spain really begins with Padre Sigüenza's history of El Escorial.

This is the time that the first self-portraits were made by Spanish artists (figs. 14, 15, 17, 19, 23, pp. 43–74) and there also are many more informal portraits of artists' family and friends. Poets are immortalized, including Góngora by Velázquez (cat. 17) and Lorenzo van der Hamen by his brother Juan (cat. 15), and religious orders celebrated their own writers and noted scholar theologians. Based on the likeness of a cenotaph in the Dominican church of San Esteban in Salamanca, Jesús Urrea identified the sitter in Maino's realistic *Portrait of a Monk* (cat. 16) as Fray Pedro de Herrera, who was appointed *Catedratico jubilado de Prima* at the University of Valladolid by Philip III and worked for both Bernardo de Sandoval y Rojas and Lerma.[113] Maino, also a Dominican monk and member of the court as drawing master for Prince Philip (IV), would have had ample opportunity to paint the friar, as he was one of the most famous living members of his order. In comparison to formal portraiture, artists painting such informal works were free to realize their own conceptions.

The social world of the artist in seventeenth-century Spain was affected by the presence of foreign artists trained elsewhere who visited, such as Peter Paul Rubens and Orazio Borgianni; or those who came to settle, such as Pompeo Leoni and El Greco; Vicente Carducho's brother, Bartolomé; Cajés's father, Patricio; Angelo Nardi; and G. B. Crescenzi. From Rubens, the Italians, and El Greco, artists working under Philip III acquired a sense of entitlement and learned to resent the traditionally low social status of artists in Spain, where they were considered in a category just above that of artisans.[114] As Antonio Feros explains in his essay in this volume, artists traditionally belonged to the *menores* class, because they used their hands and paid taxes. By Philip III's time, however, artists were struggling to get out of or stay in the *medianos* class.

One's place in the social strata depended upon the patronage system institutionalized in Philip III's government, which was based on favoritism, and patronage became a fact of life and a necessary key to success. Artists competed at court for an open post of *pintor del rey*, or a place in Lerma's "public gallery," or for favor with the wealthy archbishop of Toledo. Cajés, for example, tried unsuccessfully for a royal household post to supplement his wages as *pintor del rey*.

It is a paradox, therefore, that while society offered new possibilities to artists in Spain, artists also suffered under the hierarchical structure of Spanish society, which according to Bernard Vincent had "never been more exclusive."[115] There was an obsession with lineage (noble blood), which was needed in times of liberal distribution of royal *mercedes* (awards) and ever growing membership in the knighthood orders, and with proving *limpieza de sangre* (clean blood, without taint of Jewish or Moorish ancestry, and with no family ties to a New Christian,

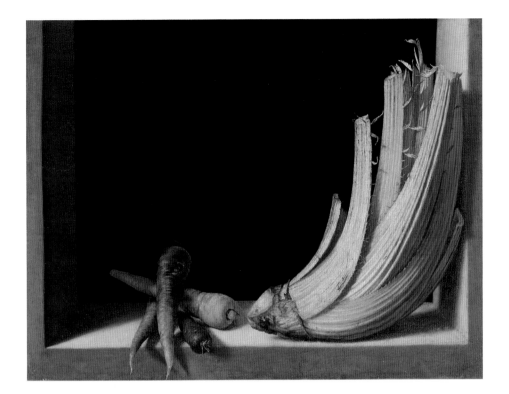

51
Juan Sánchez Cotán
Still Life with Cardoon and Carrots, about 1602
Oil on canvas, 24¹³⁄₁₆ x 32¹⁄₁₆ in. (62 x 82 cm)
Museo de Bellas Artes de Granada

a *converso,* or a *morisco*). We know that Maino and Sánchez Cotán were required
to go through the *limpieza de sangre* process to be accepted into their respective
religious orders. In 1609 the government began to expel the *moriscos* remaining in
the country, thus putting an end to the multiculturalism that had characterized
Spanish society for centuries. It would have a devastating economic effect, touch-
ing all aspects of life.

In Valencia the *moriscos* were mainly tenant farmers for aristocratic land-
holders, and highly valued for their hard work; in Castile they were the small
craftsmen and manual laborers, such as blacksmiths, shoemakers, muleteers, and
basket makers.[116] One hundred years had passed since Moors had been forced into
converting, but the *moriscos* of the late sixteenth and early seventeenth centuries
continued to retain their traditions and belief system; although baptized, they
shunned the rituals of the Catholics and continued to openly proclaim their
adherence to Islam. The horn calling the Muslim to prayer five times a day could
be heard in some parts of Spain, and Arabic diet, language, and dress were main-
tained,[117] all of which strengthened the fear that the *moriscos* would join the forces
of Islam in the East to win back Spain, which had been under Moorish rule for
eight centuries until the successful Christian reconquest in 1492.

The duke of Lerma owned land in Valencia, which had the highest concen-
tration of *moriscos,* and at first he opposed the expulsion of this highly valued
labor force. In 1599 Philip III ordered the archbishop of Valencia, Juan de Ribera,
to keep pressing ahead with the publication of a catechism for the newly convert-
ed, but by 1601 the archbishop was writing to the king urging expulsion as the

only solution to the problem. In 1605 it was discovered that the *moriscos* had planned an uprising in Valencia, with French and Algerian participation. In 1609 the edict was issued, which Philip III signed on the same day as the truce with the Netherlands, perhaps to divert attention from what was perceived in some quarters as a humiliating defeat. Archbishop Juan de Ribera had convinced the crown that an expulsion needed to be carried out for the health of the kingdom, which was in danger because Philip III had made peace with the heretics.

It was definitely the one black mark on the otherwise holy career of Juan de Ribera (beatified in 1796, canonized in 1960). Three hundred thousand *moriscos* were forced to leave for France and North Africa; ten thousand to twelve thousand lost their lives resisting expulsion. The population decreased by 23 percent, and the loss of the labor force created a severe economic recession in all of Spain. Economically, the situation was bad to begin with; inflation indicators (such as the price of grain, which jumped from 350 maravedises in 1595 to 1,401 maravedises in 1598)[118] reflected the national economic crisis facing Philip III and Lerma when the reign began. Philip II had declared bankruptcy in 1596; Philip III would follow in 1607. The poor economic situation led to more poverty, creating conditions ripe for the plague to take hold, which it did in 1599–1606.

For artists, low pay gave way to eternal postponements; the crown's coffers were empty, and artists' needs were not high on the list. To address their low social status, artists unsuccessfuly attempted to form an academy in 1603 and again in 1606.[119] A number of artists formed a common voice in protest of the crown's unfair evaluation of their work at El Pardo. As previously mentioned, Vicente Carducho and others clamored for painting to be elevated in status. Although they complained about lowly tasks and payments in arrears, however, these artists knew that they fared better under Philip III than they would have under Philip II, who preferred to import artists from abroad for his projects and bestowed favors upon only a few.

It was during the upheaval of the explusion that the Lerma-led government began to fall apart. Calderón, like numerous other favorites of Lerma, abused his privileges and was convicted of corruption. The fall of the duke's favorites—primarily Franqueza, Ramírez del Prado, and Calderón—and the ascent in 1618 of those in the faction that overthrew Lerma (headed by his own son) were horrific and unsettling; all living at the time were "witness to the most radical conflicts between factions in the modern history of Spain."[120] About 1611 Lerma began to divest himself of his collection, mostly to his religious foundations. He seems to have stopped acquiring paintings altogether. His last great building project, the urban complex in Lerma, was finished in 1617, one year before his fall from power. Cardinal Bernardo de Sandoval y Rojas died in 1618. The two great patrons were gone.

A Philip III Style?

During the reign of Philip III, style was integrated into the social fabric of a changing court culture and religious and social practices and values in the midst of transformation. In a society in a "constant state of instability,"[121] style can hardly be heterogeneous or constant; it will shift by necessity. In this transitional period, artists experimented, borrowing from the past (e.g., Tristán from El Greco in the *Adoration of the Shepherds,* cat. 23) and the present (Maino from Caravaggio and followers in the *Adoration of the Magi,* cat. 21), in an attempt to devise a new visual language to communicate the special interests and varied (and sometimes disparate) tastes and needs of the Church, monarchy, and new collectors. It may seem inconceivable that González's Caravaggesque *Rest on the Flight into Egypt* (cat. 25), for example, belongs to the same hand as the formulaic portraits of the infantes (cat. 10). The notion of an historical progression of style can hardly serve if, in 1603, a painter who produced sophisticated, progressive pictures in the novel genre of still life (cats. 50–52) would later paint a *Virgin of the Immaculate Conception* almost medieval in character (cat. 46), especially given the heightened naturalism with which Velázquez treated the same subject at roughly the same time (cat. 48).

With styles changing according to the tastes of patrons, it is impossible to detect a linear stylistic development within the work of certain artists, like Luis Tristán, who appears to have selectively borrowed from several stylistic sources (from El Greco to Caravaggio). In response to the social conditions in which they found themselves, artists of this time undoubtedly accepted out of financial need commissions that required them to paint in a manner not their own, or that required them to eschew the newest trends.

There are common traits, however, that allow us to identify a work of this period. One of these is eclecticism, the acceptance on the part of both the patrons and the artists of the existence of a diversity of styles, techniques, and conceptions, appearing simultaneously. To create a clear distinction between the monarchs and the favorite, and between this king and his father, for example, royal portraiture adopted a peculiar combination of iconic Elizabethan style and certain elements of naturalism. The efficacy of Pantoja's formal vocabulary of retrospection and modernity, meanwhile, is proven by the stubborn adherence to it in all royal portraits throughout the reign, until the duke of Lerma lost power. Only then could the portraitist Pedro Antonio Vidal unmask the king, dress him in somber clothes, and represent him in an illusionistic space (fig. 52), paving the way for Velázquez's portraits of Philip IV (see fig. 2, p. 18).

A commingling of forward-looking trends with archaic compositions also benefited the second generation of Spanish reformers who wished to express the "holy fervor" of the times and reinforce their Catholic credentials.[122] Knowing that his patrons favored subjects with the strong character and intent of devotional paintings, Francisco Ribalta produced innovative masterpieces of deep and sin-

cere emotion (cats. 39, 40, 44) by combining "modern" stylistic traits—the monumentality of the figure within the frame, correct and particularized drawing of anatomy, realistic rendering of details and textures of objects, and tenebrism—with the archaic content and form of decades-old Flemish engravings.[123]

In the reign of Philip the Pious, the rugged, irreverent Caravaggio was not fashionable, but it is only partly true that this was the case because Spanish artists understood Caravaggio's works superficially or through copies alone.[124] Their rejection or personal adaption of the Caravaggesque style was positive and intentional, as these artists and their patrons sought to express a uniquely national art form. This is evident in the secular works as well; Velázquez may have been inspired by Flemish prints, but he created a distinctly Spanish kind of *bodegón*.

Perhaps because the mystical movement that spread over the rest of Europe in the thirteenth and fourteenth centuries bypassed Spain, that country's first experience with mysticism was expressed in the emotional intensity often achieved by painters and sculptors of this time. As in Spanish literature and in the practice of Spain's own mystics, who were now officially accepted by all and becoming internationally famous, a personal intimacy with God and the saints emerged. Until this reign, there were few Spanish saints, and popular devotional subjects were not widespread. Now, all around them, on their own land, miracles abounded to prove to the people of Spain the sainthood of a great number of their religious figures. In their own language, authors and clerics guided the people to a new, fervent, and personal identification with God, which Spanish artists such as Velázquez (cat. 22) often visualized by "secularizing the transcendental."[125]

The patronage of local artists by the duke of Lerma and Philip III, as well as the powerful archbishops of Toledo and Valencia, had far-reaching consequences for the arts in Spain. For the first time in Spanish society, a substantial number of artists found adequate employment in Spain to keep them working there. This court's choice to use local artists paved the way for Velázquez's career at court, and allowed for the formation of a local school, which was the basis for the development of Spanish art of the Golden Age. Without the stimulus that forced the artists of Philip III to fight for a better position in society, one could argue that Velázquez under Philip IV would never have been so bold as to seek higher and better-paid appointments in the royal household or, finally, membership in the Order of Santiago.

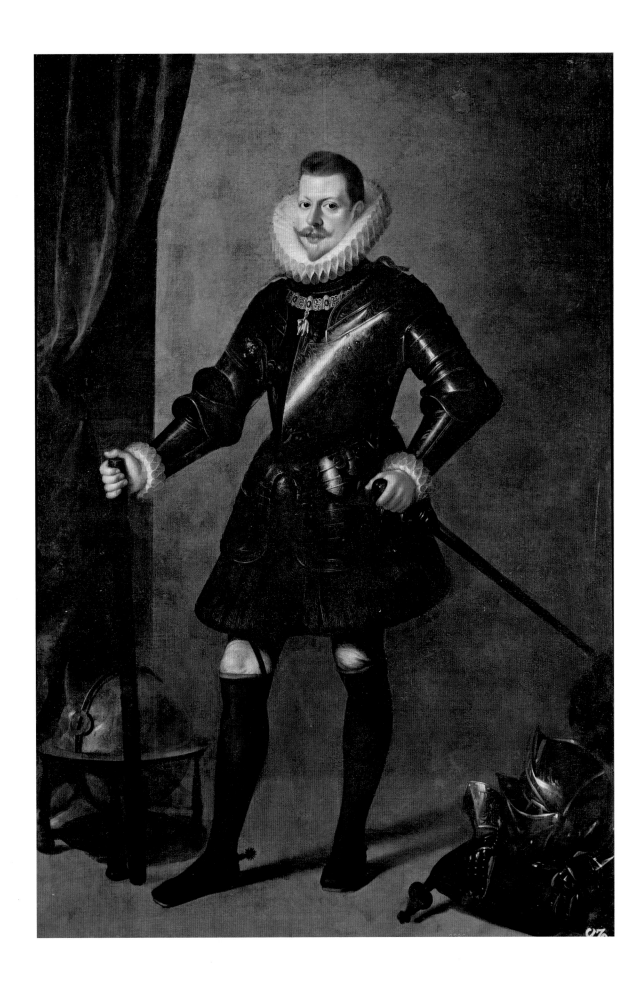

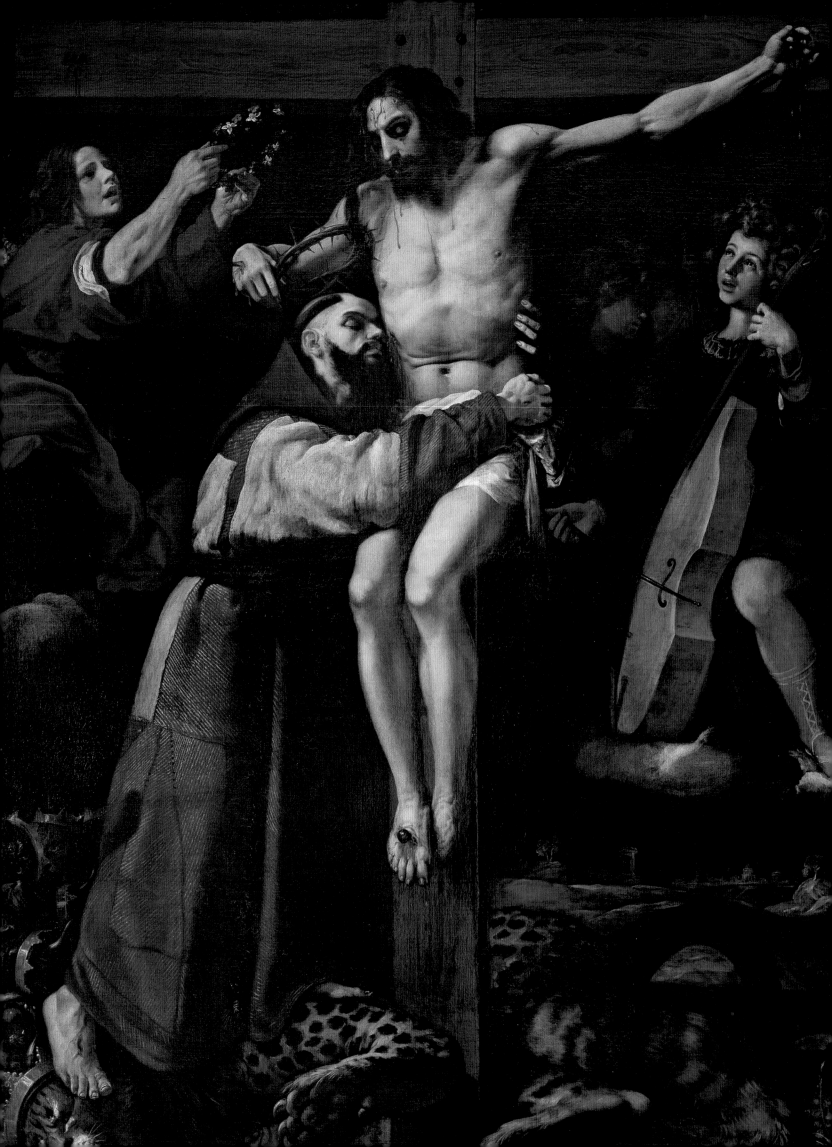

Images of Power and Salvation

ROSEMARIE MULCAHY

As Philip III lay on his deathbed in the royal Alcázar of Madrid, in March 1621, he could not banish the remorse he felt for his failings as a king. In spite of the assurances offered by his Dominican confessor, the Inquisitor General Fray Luis de Aliaga, he feared death and judgment. The crucifix that he held was the same one that his father and grandfather Philip II and Charles V had held when they lay dying. The body of Madrid's patron, Blessed Isidore the farm laborer, was carried in procession to the royal chapel in a public display of prayer for the soul of the dying king. Our Lady of Atocha, patroness of the city, was also carried to the palace. The Spanish royals had special devotion to this Virgin since the time of Charles V, and the king had assumed patronage of her chapel in 1602, making it the most splendid in Madrid. He kept her image at the head of his bed and wore a small version in ivory close to his heart. Now he asked her to help him, to be his advocate in the heavenly court in his hour of greatest need, reminding her of all he had done to have her Immaculate Conception officially declared a mystery of faith. He also called on Isidore—whose bones he believed had saved him from death two years earlier—whose beatification he had secured in 1619 and for whose canonization he had worked tirelessly. The king was desperately calling in favors from his spiritual representatives before God.[1]

In the king's bedchamber members of religious orders outnumbered courtiers, evidence of the powerful position they occupied as spiritual—and temporal—intermediaries. Among those who came to give spiritual solace was the prior of the Escorial and the Guardian of the Capuchin monastery at El Pardo. The royal preacher, the Jesuit Jerónimo de Florencia, tried to assuage the king's feelings of doubt and remorse. Readings from religious texts brought some consolation; among the books that the king asked to be brought from his oratory was a text on a good death (*Avisos de buen morir*) and a book of hours of the Virgin. The venerable Simón de Rojas of the monastery of the Holy Trinity, and soon to be beatified, read from the Passion of Saint John. Together they recited the 30th Psalm, "in manos tuas Domine comendo spiritu," which seemed to comfort him. As the end drew near, Diego de Guzmán, his chaplain and chief almoner, administered the last rites. When the time came to prepare his body for burial, it was dressed not in regal finery but in the rough, woolen cloth of the habit of Saint Francis, which had been brought by the

general of the Franciscans, Fray Benigno de Génova. The Hapsburg monarchy had special devotion to the Blessed Sacrament, and now, in an extravagant display of religious fervor, the Sacrament was exposed for public veneration on the altars of churches, monasteries, and convents throughout the kingdom. No fewer than thirty thousand masses were said for the salvation of the king's soul.

In the decades after Philip III's death, his biographers portrayed him as virtuous and pious, almost a saint. Of his piety there can be little doubt. In his first address to the Council of State, he presented himself as the faithful heir of his ancestors as a champion of the Catholic faith, which he promised to defend even if it meant the loss of all his kingdoms. His father, in his instructions to his son in preparation for kingship, stressed the necessity of God's help for good government: "to maintain these realms in this Catholic Religion, in justice, obedience and peace."[2] The connection between religion and government was seamless. The Church provided the structure for the expression of this contract with God, through elaborate ritual presided over by the secular clergy and the religious orders. The gospels, the life of the Virgin and of Christ, and the exemplary lives of the saints were familiar subjects for the Catholic faithful. The message of salvation was central: God the Father sent his only son, Jesus, to redeem the world from sin by the sacrifice of His death on the cross and Resurrection. This long tradition combined with nationalism—as a result of centuries of confrontation with Islam, and from the mid-sixteenth century with Protestantism—was seen as a holy crusade. The Protestant attack on the use of religious imagery only intensified the fervor of Spanish Catholics toward visual representation of their beliefs. It also helps to explain the overwhelming predominance of religious subject matter in Spain during this period.[3]

The drive to create an absolute monarchy had begun under Philip II. The continuation of this process during the reign of Philip III can be seen in the preponderance of ideologies, images, and rituals designed to help justify the sacred foundations of the Catholic monarchy. The royal chronicler Gil González Dávila is at pains to trace the antiquity of the foundation of the city of Madrid—although Philip II had established the court there only in 1561. What is clear from his history is the desire to show the Catholic monarchy in a continuum that goes back to early Christian times, thereby consolidating its legitimacy and its God-given right to rule. There is considerable emphasis on Spanish saints, who are seen as the most potent form of representation before the divinity: "the saints on earth and in heaven are the true fathers of the fatherland (*patria*), our representatives in the court of heaven, and the best vassals of the kings." To ensure their continued services it was advisable that "as good kings, they not only reward the services of their vassals in life, but also in death, approving their deeds with titles and renown, as though they were living."[4] During his reign Philip backed vigorous campaigns for the canonization and beatification of Spanish saints: two hundred martyrs of the Order of Saint Benedict (1603), Juan de Sahagún (1603), Raymundo de Peñafort (1605), Ignatius Loyola (1609), Luis Beltrán (1613), Teresa of Avila (1614), Tomás de Villanueva (1618), Pascual Baylon (1618), Francis Xavier (1619), and Isidore the farm laborer (1619).

As argued throughout this catalogue, the new reign was characterized by the ostentatious display of wealth. There was lavish spending on buildings and furnish-

ings, court spectacle, and religious pomp and ceremony.[5] During the first two decades of the seventeenth century, in Madrid alone sixteen new religious houses were established. Philip's young and pious queen, Margaret of Austria, established several important religious foundations, which, after her death, were brought to fruition by her husband: the Descalzas Reales in Valladolid, the Unshod Augustinian convent of La Encarnación in Madrid, and the Jesuit College in Salamanca. The king had his architect, Juan Gómez de Mora, undertake the construction and renovation of three religious foundations near the royal palace: La Encarnación, already mentioned; the Unshod Franciscan monastery of San Gil; and Santo Domingo el Real. He also founded the Capuchin monastery of Santa María de los Angeles at El Pardo and began work on the royal mausoleum at El Escorial. The duke of Lerma, the prime minister, the aristocracy, and members of the court, indeed anyone of means with social or political aspirations, also sought to obtain the patronage of a religious institution. To point out that it may have been politic to do so is not to undervalue the very real desire on the part of these new patrons to ensure a favored place in the afterlife.

The reform of the Catholic Church that took place in the second half of the sixteenth century as a result of the Council of Trent was consolidated about 1600. There was a new emphasis on the Sacraments as the means of salvation, in particular the celebration of the Mass where the Eucharist, in the form of bread and wine, represents the body and blood of Christ who died on the cross for the redemption of mankind. Confession achieved a new importance as the means whereby the sinner could achieve the state of grace necessary for the reception of the Eucharist. According to tradition, the House of Austria linked the good fortune and prosperity of the dynasty to their devotion to the Eucharist. This involved self-examination of sin, leading to contrition, confession, and absolution. These spiritual concerns are reflected in the art and subject matter of the period, most strikingly in the monumental *retablos*, or altarpieces, that fill the high-altar area in Spanish churches of the late sixteenth to eighteenth centuries. *Retablos* were usually constructed in wood, polychromed and gilded, rising in two or three tiers, and crowned with a Calvary group, the central niche above the altar table and tabernacle displaying a carved or painted image of the sacred event or saint to which the church is dedicated. Scenes from the life of Christ, the Virgin, or the saints usually fill the other spaces. The *retablo* by Vicente Carducho and Anton de Morales for the convent of Corpus Christi (Las Carboneras) and the altarpiece in the church of Las Huelgas Reales, Valladolid, by Gregorio Fernández, both still in situ, are important examples (fig. 53).[6]

The articles on art issued at the last session of the Council of Trent in December 1563 ("Decree on the invocation and veneration of relics of saints, and on sacred images") were a response to the Protestant attack on religious images. They were very vague, however, and merely codified the kind of criticisms leveled against the use of indecent or erroneous imagery by theologians.[7] The influence of Trent on art in Spain was more general than specific. Sacred images had to be orthodox and decorous, but within these parameters artists seem to have had considerable artistic freedom. Of far more influence on Spanish art of the Golden

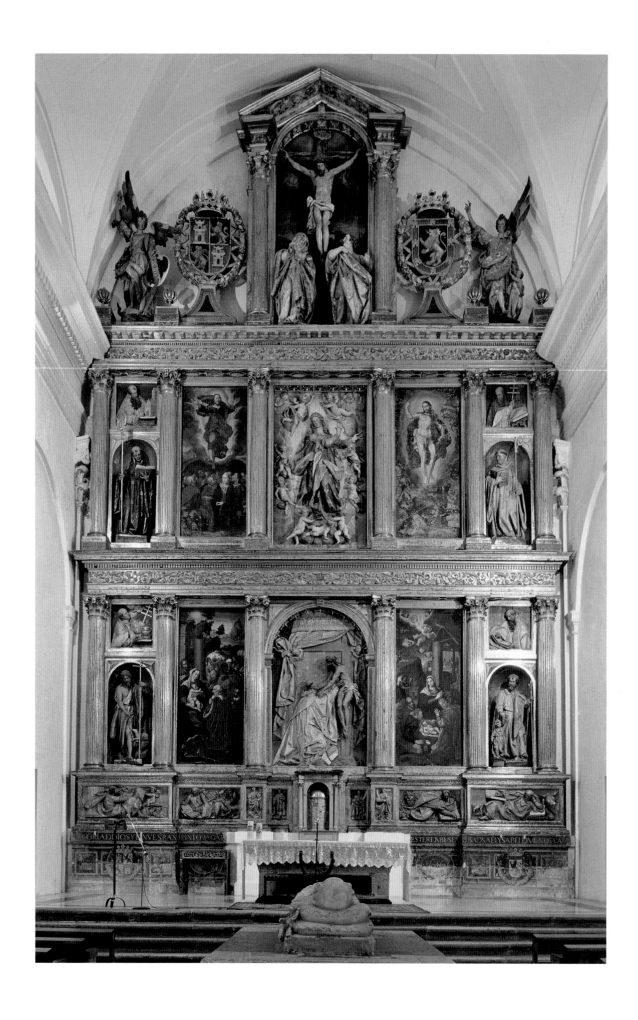

Age were the spiritual writers, mystics, and religious reformers of outstanding ability, such as John of the Cross, Teresa of Avila, Peter of Alcántara, Ignatius of Loyola, Francis Xavier, and Luis de Granada. Until the end of the sixteenth century the visual arts lagged behind literature in its ability to express emotion, exaltation, and realism. Religious literature was unflinching in its realistic descriptions of the Passion. Rarely before 1600 do we find in art anything to equal the brutal realism of Fray Luis de Granada's (1504–1588) description of the body of Christ, covered with "bruises, scratched to the bone, the blood streaming in rivulets everywhere, revealing the white bone under the bloodied flesh."[8] The *Revelations of Saint Bridget of Sweden* (1303–1373), in which she describes her mystic visions of the Passion (IV, ch. 70), had a profound and long-lasting influence on Christian spirituality in Spain. Like Luis de Granada, her descriptions were much more shocking and realistic than representations by painters or sculptors: "He was crowned with thorns. The eyes, ears and beard were dripping blood; his jaw was extended, the mouth partly open, the tongue bleeding, the stomach shrunken touching his back, as though he had no intestines."

Spiritual writers recommended the use of images as an aid to prayer. Juan de Avila, in his celebrated treatise *Audi Filia,* advises looking at scenes of the Passion as a stimulus to the imagination.[9] When Teresa of Avila (1515–1582) recalled her vision of the Resurrected Christ she compared it to a painting:

> Sometimes I thought that what I could see was nothing more than a painting; but on many other occasions it was obviously Jesus Christ himself; much depended on how clearly he wanted to reveal himself to me. Sometimes when the clarity was not very strong, it did seem to me that I might be looking at a painting, but a painting quite different from those here on earth, even the very best.[10]

This seems to suggest that the divine is attracted by a representation of itself. The importance of love in achieving mystic union with Christ is central to Teresa's spirituality, which is rooted in the practical and everyday: "In my opinion, mental prayer is nothing else but friendly conversation, frequently talking alone with Him whom we know loves us."[11] Saint John of the Cross did not believe in the necessity for images, but such was the weight of belief in their efficacy that the Carmelites issued prints that seemed to contradict his writings. One of these shows what is referred to as the miracle of Segovia, a miraculous dialogue that occurred while John was praying before a painting of Christ carrying the cross, and the painting spoke to him. The image was widely disseminated through prints by the celebrated Wierix brothers of Antwerp (fig. 54).[12] Interestingly, the subject is reminiscent of the altarpiece by Titian in Philip II's private oratory at the Escorial.

Saint Ignatius of Loyola's (1491–1556) *Spiritual Exercises,* first published in Rome in 1548 and widely practiced due to the outstanding role of the Jesuits in education, opened up to the laity the possibility of an active spiritual life through a strict program of self-examination, prayer, and penitence. Few books have had such an influence on Christian asceticism. The exercises (structured in the form of a four-week retreat) involve the use of the senses in stimulating the imagination to mentally re-create sacred events and persons in their settings ("the com-

53
Gregorio Fernández
High altarpiece of Las Huelgas Reales, 1613–14
Polychromed wood and oil on canvas
Monasterio de las Huelgas Reales, Valladolid

B. IOANNES A CRVCE *Carm.*^{tar.} *excalceat. primus Parens, mysticæ Theologiæ sublimis Doctor et scriptor: diuinorum patiens. Segobiæ hæc cum Dño familiariter verba habuit.*

Anton. Wierx fecit et excud.

position of place"). The aim was to use the "three powers of the soul"—memory, understanding, and will—to enter into conversation with God. This method not only encouraged the use of imagery, it also influenced the growth of realism, which is so characteristic of Baroque art, by encouraging a desire to re-create not just an historical event but something present. The method is particularly effective in relation to the Passion of Christ, as the retreatant tries to imagine in great detail the sufferings that Christ endured, and thereby be moved to greater sorrow for his sins. "This is the gift proper to the Passion: Sorrow in company with Christ in His sorrow, being crushed with the pain that crushed Christ, tears and a deep-felt sense of suffering, because Christ suffered so much for me" (Third week, second contemplation).

Interest in meditation was so pervasive that the act itself became a subject of paintings. *Christ at Calvary* (cat. 27), by the court painter Vicente Carducho, is one of the most affecting images of this theme. Christ is shown seated on a rock, sad eyes downcast in reflection, arms folded in calm resignation, as he contemplates his imminent crucifixion. The slender body bears the signs of his torture—there is a very prominent wound on the shoulder and knee, as described in one of Saint Teresa's visions; the crown of thorns, the ropes around his neck and wrists, the prominently placed basket containing the implements of the crucifixion, the wooden planks all incite the imagination of the viewer. Christ is strongly illuminated, yet the location is only dimly suggested; the Virgin is but a shadowy figure in the background. A painting of the same subject by his associate and fellow Florentine Eugenio Cajés (cat. 28) emphasizes the meekness and vulnerability of Christ. The similarity in their composition suggests that the image was in demand. Images of the Passion were by far the most widespread form of religious art, especially the Crucified Christ, as the visual representation of the means of salvation and the fundamental image of the Christian faith. Not surprisingly, the Jesuits commissioned some of the most impressive sculptures of the period—notably, Juan de Mesa's *Crucified Christ*, commissioned in 1620 for the confraternity of priests of the Jesuit House (Casa Profesa) in Seville (now in the students' chapel of the University of Seville). The slender, lacerated body of Christ, with the head dropped forward and the eyes closed, is an image that conveys a great sense of resolution and peace.[13]

Perhaps the most spiritually exalted images are those painted by El Greco. He was the only artist of his generation to have developed a style with which to represent the spiritual. While his contemporaries were in pursuit of realism, his flamelike figures, lit by an unreal light, defied earthly gravity and reached heavenward in spiritual ecstasy. His interpretation of the Crucifixion for the *retablo* of the Seminary of the Incarnation in Madrid shows Christ as triumphant, as God rather than man, as part of the cosmos rather than earthbound (fig. 55). Even his closest disciple, Luis Tristán, could not imitate El Greco's highly intellectual style. Tristán's *Crucified Christ with the Virgin and Saint John* (cat. 30) shows the emaciated, twisted body of the dead Christ illuminated by a harsh light against a dark, threatening view of Toledo. The Virgin and Saint John are emotional, distraught, and real. One of the great masterpieces of European art is the *Christ of Clemency*

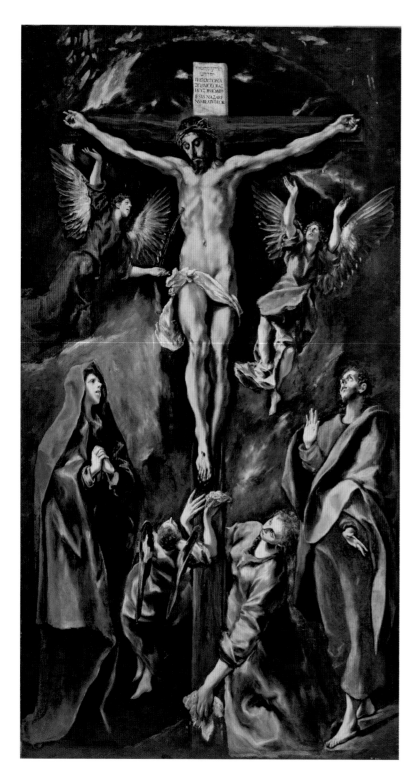

55
El Greco
Crucifixion, 1596–1600
Oil on canvas, 122 13/16 x 66½ in. (312 x 169 cm)
Museo Nacional del Prado, Madrid

56
Juan Martínez Montañés
Christ of Clemency, 1603
Polychromed wood
Seville Cathedral

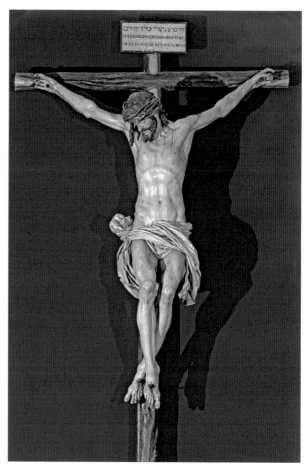

(Seville Cathedral) by the Sevillian sculptor Juan Martínez Montañés, a friend and colleague of Pacheco and Velázquez (fig. 56). Commissioned in 1603 by a canon of Seville Cathedral, Mateo Vázquez de Leca, for his private chapel, it now hangs in its own chapel in the cathedral. From the contract of April 5, 1603, we know that it was conceived as though Christ is speaking to the viewer. Christ was "to be alive, before he had died, with the head inclined towards the right side, looking to any person who might be praying at the foot of the crucifix, as if Christ Himself were speaking to him and reproaching him because what he is suffering is for the person who is praying; and therefore the eyes and the face must have a rather severe expression, and the eyes must be completely open."[14] In fact, the expression on Christ's face is one of compassion. The image works as a vehicle for intimate conversation between the sinner and Christ; one might even say that the sculpture achieves its potential only when it fulfills this devotional function.

This concept of Christ communing with a human being reflects the highly personalized spirituality of the time. The most exalted form of mystical ecstasy aspired to physical union. An engraving by Hieronymus Wierix (before 1619) shows Christ reaching down from the cross to embrace a Jesuit (fig. 57).[15] The same visionary experience was propagated by the Franciscan Order whose piety, like that of the Jesuits, is centered on the Passion. Francisco Ribalta's *Saint Francis Embracing the Crucified Christ* (cat. 40) shows a scene of great tenderness. The saint lays his lips close to the bleeding wound in Christ's side, thereby drawing attention to the Holy Blood of salvation. Originally the painting was placed on a side altar of the church of the Capuchin monastery of Sangre de Cristo (Blood of Christ) in Valencia. The seven huge cats, crowned with gold and writhing at the saint's feet, symbolize his contempt for worldly glory and rejection of the seven mortal sins. Christ places the crown of thorns on the head of the saint, whose hands and feet already bear the wounds of the stigmata. The stigmatization, said to have occurred at Mount Alverno in 1224 as recorded by Saint Bonaventura, founded the Franciscan myth of the first instance in the history of Christian spirituality of a person being marked with the signs of the Passion of Christ. This gave the order great spiritual authority. The theme of mystical union goes back to Bernard of Clairvaux's commentaries on the Song of Songs: "How good you are, Lord, to the soul who looks for you. You go before it, You embrace it, You treat it like a spouse, You are its Lord." This allegorical commentary very quickly becomes a biographical account included in the 1599 *Flos Sanctorum* of Ribadeneyra.

Perhaps the most emotive manifestation of public piety was directed toward the *Cristo Yacente*, or the Supine Christ: Christ's dead body lying on a sheet. The theme relates iconographically to the Pietà, Lamentation, and Entombment, which were widespread in art from medieval times. In Spain representations of the body of Christ in isolation became popular during the last quarter of the sixteenth century. The body of Christ in the tomb is discussed in great detail in the devotional literature, particularly in Ludolph of Saxony's widely read *Vita Christi*, a medieval source that was reprinted repeatedly during the sixteenth to eighteenth centuries. According to Ludolph, the sepulchre was like an altar where the host is consecrated: "The mind should be like the grave that had held Christ, and we too should

bury Him in our mind and steadfastly watch over Him, just as He was guarded in the closed tomb after His death."[16] At the court of Philip III this devotion increased in popularity and achieved its finest artistic expression in the work of the great sculptor Gregorio Fernández. *The Supine Christ* (about 1609), considered to be the first of several, was commissioned by the duke of Lerma for the Dominican church of San Pablo in Valladolid, of which he was a generous benefactor (fig. 58). The lean, muscular body of Fernández's Christ has the beauty of a classical sculpture. The exaggerated thorax accommodates a receptacle to house the Eucharist. The head is raised on two pillows, the eyes closed, and the mouth slightly open. The left leg is slightly raised and the head turned to the right to position the figure for optimum viewing in its place under the altar table. The lustrous finish of the polychrome gives the figure a remarkably lifelike appearance. It has a serene beauty in spite of the signs of the Passion, which are relatively restrained.[17] The church was the setting for the major religious ceremonies of the court during its residence in that city (1601–6). Lerma established his funerary chapel in the chancel, with provision for burial in the crypt below. The royal sculptor Pompeo Leoni (d. 1608) was engaged to make kneeling bronze portraits of Lerma and his wife, Doña Catalina de la Cerda, for either side of the high altar (fig. 28, p. 86). He donated a magnificent tabernacle, and for the fiesta of Corpus Christi he commissioned a sumptuous portable platform (*andas*) and monstrance.

The platform was also used to carry the *Supine Christ* in procession. The Lerma family had a particular devotion to the dead Christ, commissioning several other versions of the subject, including one for the Franciscan convent of Santa Clara in the ducal town of Lerma, where it still remains. The latter is of the reliquary type, with an opening in the side to contain a relic of the Holy Blood donated by Queen Margaret. This image derives from the custom of placing the Holy Sepulchre, in the form of a glass casket containing the body of Christ, below the altar table during the liturgy of Holy Week so that it could be seen and venerated. In some images the thorax was transformed into a reliquary in which the Eucharist was reserved from Maundy Thursday to Easter Saturday; the body of Christ and the Eucharist are as one.[18]

The *Supine Christ* is closely associated with the Spanish monarchy, an early example being the superb polychrome sculpture attributed to Gaspar Becerra in the Descalzas Reales in Madrid, a convent of Franciscan nuns founded by Juana of Austria, sister of Philip II.[19] Philip III commissioned a *Supine Christ* for the Capuchin monastery of Nuestra Señora de los Angeles at the royal site of El Pardo, of which he and the queen were patrons. In 1615 the image was carried in solemn procession to be placed in a casket beneath the altar in its own chapel, where it became the only devotion in the monastery, as all other brotherhoods and confraternities were forbidden. The body, of classical proportions, is only lightly marked with the wounds of the Passion. The sculptor used new techniques

58
Gregorio Fernández
The Supine Christ, about 1609
Polychromed wood, 80 11/16 x 25 9/16 x 27 9/16 in.
(205 x 65 x 70 cm)
Monastery of San Pablo de Padres Dominicos,
Valladolid

to achieve greater realism: the eyes are of glass, the teeth of ivory, and resin is used to simulate the blood and water that flowed from the wound in the side caused by the lance of Longinus. A similar image was commissioned from the sculptor, most probably by the king, for the Augustinian convent of La Encarnación, which the queen had founded shortly before her death in 1611 and which her husband dutifully brought to completion. He took part in the splendid ceremonial of the installation of the nuns in their new convent in 1616.[20]

Philip III had a particular devotion to Christ at the column, one of the most emotive themes for private meditation. The Gospels relate how Pontius Pilate, governor of Jerusalem, bowed to the demands of the mob and delivered Christ to be scourged and crucified (Matthew 27:26). Spiritual writers, both medieval and modern, dwelt on this scene from the Passion. The king commissioned a painting of the subject in 1617 from his painter Vicente Carducho, for his private oratory in the Capuchin church at El Pardo. The previous year he had commissioned Juan de Roelas to paint the *Flagellated Christ Contemplated by the Christian Soul* for the inauguration of the royal convent of La Encarnación. This painting originally had an inscription: "Soul, suffer for me, as you have done this to me,"[21] which gives a useful insight into the mechanisms by which these images functioned. The king would have been familiar with the painting of the same subject in the upper cloister of the royal monastery of El Escorial by Juan Fernández de Navarrete "el Mudo" (about 1538–1579). This work is described at considerable detail by Fray José de Sigüenza in his history of the royal foundation, published in 1605. Sigüenza was a most perceptive critic and he ends his description with an explanation of how the image functioned as a devotional work: "Whoever looks at such a vivid representation and is not heartbroken, and does not dissolve in tears and ponder the gravity of his sins, must be harder than the marble to which this meek, humble and most obedient lamb is tied."[22] The more emotion a work of art could summon up, the greater its power as a spiritual aid.

A magnificent polychromed wood sculpture representing *Christ at the Column* by Gregorio Fernández (fig. 40, p. 97), also in La Encarnación, was commissioned either by Philip III or by the prioress Mariana de San José. The sculpture was installed in a chapel in the cloister on the side along which the king passed to his *tribuna,* or private gallery, which adjoined the church. The body of Christ is idealized and shown in an elegant pose, one leg crossed in front of the other, the upper body slightly turned in the opposite direction (*contrapposto*). His hands are tied to a short column, similar to the relic venerated in Santa Prasseda in Rome. This elegant variation on classical sculpture, which seeks to make the figure viewable in the round, is characteristic of Mannerism and the work of Giambologna, who in early-seventeenth-century Spain was considered the greatest living sculptor. This style was ideally suited to figures designed to be carried in procession. The glass eyes and false lashes intensify the expression, and the many wounds— an enormous one on the back—are made more realistic by the incorporation of other materials, such as granules of cork to simulate coagulated blood.[23] Luis Muñoz, biographer of the Venerable Mariana de San José, describes the sculpture and admires the same qualities that a modern-day viewer might admire:

It cost many prayers in the making, and the result is successful: the eyes and the expression of the face is admirable, and the fresh wounds, in particular on the back, shoulder and knee. The body is so perfect that one can feel the sockets of the bones, the nerves and veins; only the arteries need to pulsate. This image alone could make the name of Gregorio Fernández, the famous sculptor of Valladolid.[24]

The emphasis on the wounds of Christ relates to the widespread existence of brotherhoods and confraternities dedicated to the devotion of the Holy Wounds.[25]

It is evident that sculpture had a much greater emotional impact on the faithful than painting. The modern-day viewer, understandably, may recoil from such brutal imagery, but the contemporary viewer would have been exposed to actual scenes of flagellation during Holy Week. The Portuguese traveler Pinheiro da Veiga, an acute observer of the celebrations and rituals in Valladolid during 1605, was greatly impressed by the scale, order, and solemnity of the processions. The largest of these, which followed the route from the monastery of San Francisco to the royal palace, from where it was observed by the king, had more than three thousand participants (more than one thousand members of the penitential brotherhood and two thousand flagellants). It took three hours to pass. Pinheiro was shocked by the brutality and excess of the flagellation, which drew large quantities of blood.[26]

As a counterbalance to so much sorrow and tears, the Joyful Mysteries of the liturgical calendar were also celebrated and represented in art. One of the most popular was the Annunciation to the Virgin, or the Incarnation, where the Archangel Gabriel, God's messenger, announces that Mary will bear a child. "Hail Mary full of grace, the Lord is with thee, and blessed is the fruit of thy womb, Jesus." This scene provided opportunities for artists to show their skills in conveying beauty, color, and movement.

As ever, El Greco had a most original approach to this traditional subject. His *Annunciation* (cat. 19) for the high altarpiece of the Augustinian Seminary of the Incarnation, known as the Colegio de Doña María de Aragón, is a tour de force of dazzling color, light, and movement. The flamelike figures soar upward, and there is no division between the earthly and heavenly spheres. During his later years, El Greco developed a new and daring technique with which to portray sacred subjects. His paintings for the seminary are informed by the spiritual writings of its founder, the Blessed Alonso de Orozco (1500–1591); the centrally placed burning bush as a symbol of the purity of the Virgin, instead of the more traditional pot of lilies, is evidence of this.[27]

Vincente Carducho's interpretation of the subject is in complete contrast to El Greco, but then every other painter was; no one followed El Greco's daring experiments. Carducho's *Annunciation* for the high altarpiece of the royal monastery of La Encarnación (1616) (fig. 42, p. 100) shows an altogether more solid rendering of the Virgin and the Archangel and displays Florentine values of drawing, composition, and anatomy; the style is elegant and courtly. God the father, accompanied by a host of angels, sends down the dove of the Holy Spirit through a swirl of cloud and golden light. Here, the heavenly sphere invades the earthly. Both of these religious institutions were within a stone's throw of each

other and were patronized by the court. The fact that they could encompass such a wide range of artistic expression suggests that painters enjoyed considerable freedom in matters of style.

There are revealing indications of change in the manifestation of majesty, in the appearance of a form of portraiture, *a lo divino,* in which members of the royal family become participants in sacred events. This seems to have been introduced by Queen Margaret, perhaps following a fashion in her native Austria, as well as in Florence, the adopted city of her sister, Grand Duchess Maria Maddalena von Hapsburg de' Medici. In 1603 the prolific royal painter Juan Pantoja de la Cruz was commissioned to paint a pair of canvases for the queen's private oratory in the royal palace in Valladolid, an *Adoration of the Shepherds* and a *Birth of the Virgin.* In the latter the principal protagonist is the queen's mother, Maria of Bavaria, who is shown bathing the newborn infant, while her daughters are in attendance. Childbirth was a major concern for the royal succession. Maria had reared fifteen children, and Margaret also had fulfilled her expected role; she was to die after giving birth to her eighth child. In the companion piece Margaret (who was born on Christmas Day), Philip, and his brothers-in-law, in the guise of shepherds, pay homage to the newborn Christ. The participation of the king in religious ceremonies, such as the *mandato,* when on Holy Thursday he washed the feet of twelve poor men, in imitation of Christ at the Last Supper, and the adoration of the cross on Good Friday, before which he pardoned prisoners condemned to death, transformed him into an actor in a sacred drama. The Adoration of the Magi is a subject closely associated with kingship. Philip II began a tradition of offering three chalices each year to the Church on the feast of the Epiphany (January 6). Fray Juan de San Jerónimo, chronicler of the early years of El Escorial, describes the ceremony, which took place during High Mass.[28] The king, kneeling on a red velvet cushion on the steps of the high altar, received from his chief almoner the gilded silver chalices containing gold, frankincense, and myrrh. Having reverently kissed the paten on which they reposed, he then presented them one by one to the prior of the monastery. Ceremonies such as these provided for the public display of the contract between the monarchy and the Catholic Church.

In *Queen Margaret and Princess Ana as the Annunciation,* by Juan Pantoja de la Cruz (fig. 59), the royals assume primary roles, in a way that would have been unthinkable during the previous reign; Philip II kept a strict division between the divine and the human. By portraying the Virgin with the features of the queen in a painting that celebrates the Virgin's conception of the Savior, the continuity of the monarchy appears to be sanctified. In his funeral oration the royal preacher Fray Hortensio Félix Paravicino, so vividly portrayed by El Greco (cat. 12), refers to her steadfast support for religious institutions, her generous almsgiving, and her assiduous attendance at religious ceremonies. He addresses her, "You are the living temple of the Incarnation, for the grace and love of the Holy Spirit," and compares her to the Virgin of the Apocalyptic vision of Saint John. Paravicino's highly rhetorical and metaphor-laden language uses the conceit of the queen as builder of the convent (temple) of the Incarnation (Annunciation) and as Holy Queen and mother.[29]

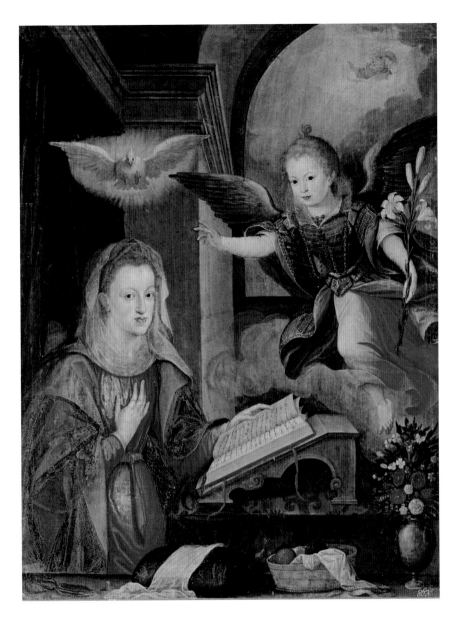

59
Juan Pantoja de la Cruz
*Queen Margaret and Princess Ana
as the Annunciation,* about 1605
Oil on canvas, 59¹³/₁₆ x 45¼ in. (152 x 115 cm)
Kunsthistorisches Museum, Vienna

The Descalzas Reales in Madrid was an important center of spirituality and political influence. Since its foundation in 1557 by Juana of Austria, it had been greatly favored by the royal family; Queen Margaret often stayed at the convent while the king was absent from Madrid. It provided a place of retreat for royal women, the most formidable being Doña Juana's older sister, the empress Maria (1528–1603), who returned to Spain and took up residence in the convent in 1582 after the death of her husband, Maximilian II. Her youngest daughter took the vows of a Franciscan nun, as Margaret of the Cross (1567–1633), and lived in the convent.[30] The Descalzas was probably the model that inspired Queen Margaret to found the Augustinian convent of La Encarnación in 1611. However, she died that same year; the convent was brought to completion by her husband and was to be her most enduring monument. The convent was enriched by many gifts, from the royal family and other benefactors, of liturgical vessels and vestments, reliquaries,

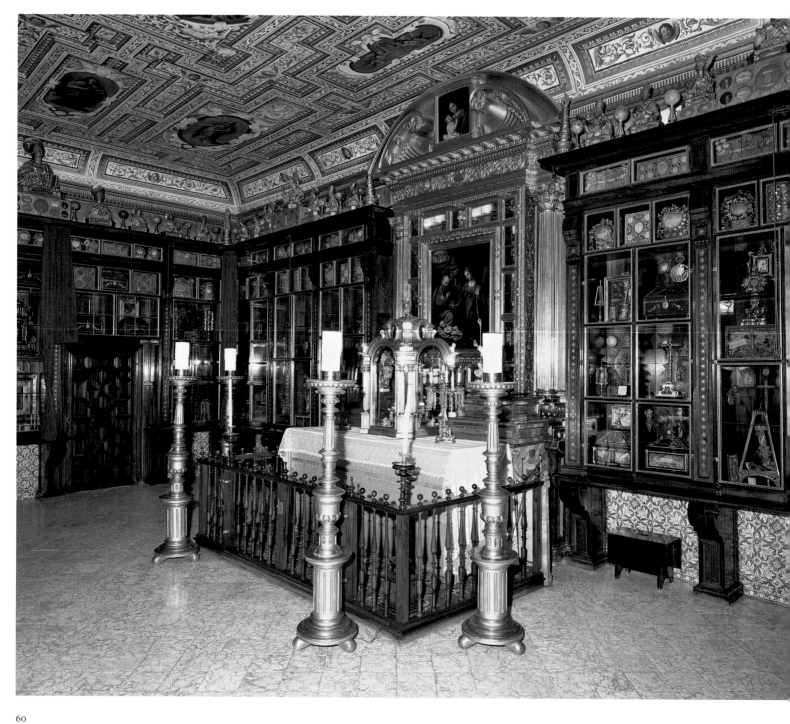

60
Reliquary room
Convento de la Encarnación, Madrid

and works of art. Designed by the royal architect Francisco de Mora, the convent was linked to the palace by a raised corridor to facilitate frequent visits by the royal family. The paintings for the high altarpiece of the church, dedicated to the Annunciation, and the lateral altars, dedicated to Saints Philip and Margaret, where masses were said for the founders and day and night a nun prayed before the Blessed Sacrament for the increase of the Catholic Faith and the prosperity of the kings of Spain, were commissioned from Vicente Carducho.[31] Although little is known of her collection, the queen had the reputation as a connoisseur of fine paintings. Florence was a major source of works of art. For reasons of state, the grand duke of Tuscany, Ferdinando I, was anxious to please the Spanish monarchy, and for reasons of family ties, Grand Duchess Maria Maddalena was eager to help. Orazio de la Rena, of the Tuscan delegation in Madrid, reported that the best possible gifts that the grand duke could send to the queen would be fine paintings to adorn her oratory.[32] In 1607 eight small paintings on copper representing the life of the Virgin were ordered from eight distinguished Florentine painters for the queen's oratory.[33] In 1611 more than thirty paintings were sent from Florence for the Franciscan convent of the Descalzas Reales in Valladolid, which Queen Margaret had founded during the stay of the court in that city.[34] These included fine works by Giovanni Bilivert, Pompeo Coccini, Valerio Manucelli, and Mateo Rosselli, but the rest were of mediocre quality. Another major interest was relics, which she avidly sought out. Relics were requisites of power, and their collection was driven by a belief in the need to rescue them from destruction by heretics. Philip II had amassed seven thousand at El Escorial, and his daughter, Juana of Austria, had assembled in the Descalzas Reales the most splendid *camarín*, or reliquary room.[35] The magnificent reliquary room in La Encarnación, built and assembled after Margaret's death, contains many precious reliquaries and small paintings, some of which undoubtedly belonged to her (fig. 60).[36] Somewhere between a relic and a painting is the miraculous image. The one most sought after, during the reigns of Philip II and Philip III, were copies of the image of the *Annunciation* from the church of Annunziata in Florence, which was believed to have been painted by divine intervention. Examples still survive in El Escorial, the Descalzas Reales, and La Encarnación.[37]

The most popular and widespread devotion by far was that to the Blessed Virgin Mary, who was seen as the most powerful intercessor. Although the royal family was an important driving force in the adoption of Marian devotions, both traditional and new, these images were repositories of the expectations and hopes of the people and gave them a sense of communal identity.[38] In Madrid the Virgin of Almudena was greatly venerated as an image that had been hidden from the Muslims and miraculously found in the walls of the Alcázar after the reconquest. But the most famous of all was the Virgin of Atocha in the Dominican monastery, which was under royal patronage.[39] A print by Juan de Courbes in which the arms of the city and the image of the Virgin of Atocha are combined shows the importance given to her protective role (fig. 61). The Marian devotion most closely associated with Spain is the Immaculate Conception, the belief that the Virgin Mary was conceived without stain of Original Sin. Although the Council of Trent did

61
Juan de Courbes
Virgin of Atocha, engraving in *Teatro de las grandezas de la villa de Madrid,* 1623, by Gil González Dávila
Biblioteca Nacional de España, Madrid

not support the doctrine, it continued to grow; the Franciscans and the Jesuits were its most active promoters, against the initial resistance of the Dominicans. Queen Margaret's Franciscan confessor, Francisco de Santiago, was instrumental in obtaining royal support for the cause.[40] The real impetus, however, came from Seville with the idea of establishing a royal committee to further the campaign to have the Immaculate Conception declared church dogma.

Against this background the church authorities began a vigorous propaganda campaign in Seville to mobilize popular support. Fiestas and processions, masses and sermons were effective vehicles for showing collective fervor for the doctrine; it is likely that the generous indulgences granted to participants stimulated public response (forty days were deducted from the torments of purgatory for hearing mass during the fiesta). The salutation *Ave Maria purísima. Sin pecado concebida* (Hail Mary most pure. Conceived without sin) became widespread, and is still used today in convents. The painter and cleric Juan de Roelas, in *Seville Honors the Immaculate Conception in 1615* (fig. 62), left a rare visual record of the impressive procession that he witnessed on June 29 of that year. An inscription describes the event: "all the people of Seville came to the cathedral from where they went out singing 'Everyone in general/in a clamorous cry, Elect Queen/declares that you are conceived/without original sin': Franciscans, Carmelites, Benedictines, Trinitarians, Capuchins, Third Order, plus 20,000 secular clergy, Knights of Santiago, Alcántara, Calatrava, dukes, counts, marquises, clergy and students of the university." The painting contains a history of the doctrine in the form of excerpts from the writings of those who defended the Immaculate Conception. This elaborate type of painting seems to have come into being as part of the propaganda campaign; another example is the *Allegory of the Immaculate Conception,* attributed to Roelas, in the Museo Nacional de Escultura, Valladolid.[41] Commemorative portraits were commissioned of some of the principal promoters of the campaign. The best known of these is Francisco Pacheco's *Virgin of the Immaculate Conception with Miguel del Cid* (cat. 45). Cid was an ardent defender of the Immaculist doctrine and author of the popular couplet quoted above. The Virgin is shown in the traditional manner as the woman of the Apocalypse of Saint John (Revelation 12:1), standing on the moon, clothed by the sun, and crowned by stars. Her symbols, taken from the Song of Songs and the Marian litanies, are set in a Sevillian landscape with a view of the city. Close in time, but artistically distant, is Velázquez's interpretation of the subject (cat. 48). Although the iconography is traditional, the representation of the Virgin is revolutionary in its naturalism. He drew inspiration from the celebrated polychromed wood sculpture of Juan Martínez Montañés, who was influential in creating a Sevillian prototype (cat. 47). She is a young girl, evidently painted from life, and the golden radiance and brilliant white clouds that surround her create the atmosphere of a cosmic vision. In this work Velázquez explores the relationship between vision and painting, a technical problem that was discussed by his master, Francisco Pacheco, in his treatise *Arte de la pintura.* The companion to this painting, *Saint John the Evangelist on the Island of Patmos* (National Gallery, London), portrays the saint in the process of recording his vision. The two paintings can be read as a dual

62
Juan de Roelas
Seville Honors the Immaculate Conception in 1615, 1616
Oil on canvas, 141¾ x 91 in. (360 x 231 cm)
Museo Nacional de Escultura, Valladolid

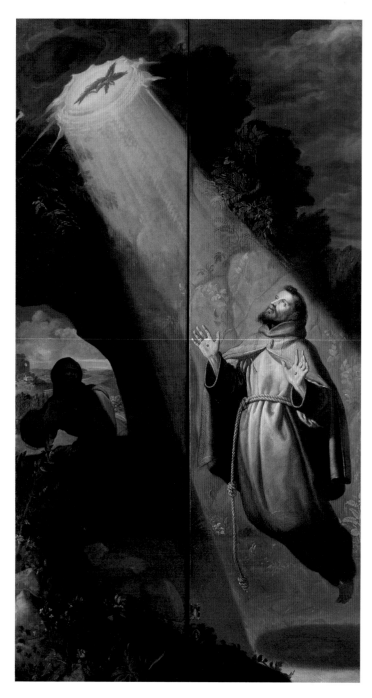

63
Vicente Carducho
The Stigmatization of Saint Francis, 1604–6
Reliquary doors; polychromed wood and
oil on canvas, 179⅛ x 85 in. (455 x 216 cm)
Museo Nacional de Escultura, Valladolid

work, which shows the progression of one representa-
tion to the other, the written text transformed into pic-
torial image.[42]

Visions are frequently represented in the art of
the early seventeenth century. The intervention of the
divine in the lives of saints strengthened their reputation
within Christian society. There was a surge of interest on
the part of the religious orders in propagating images
of their founders and illustrious members that showed
them as specially favored by God. The Franciscans and
the Jesuits were particularly adept in this regard. The
fact that the founders of the Dominicans, Jesuits, and
Mercedarians were Spanish was a source of national
pride. For the Franciscans, the prestige of national fig-
ures linked to the movement, such as Diego de Alcalá,
to whom the monarchy had special devotion, and Pedro
de Alcántara, who was so influential in this vigorous
and particularly Spanish reform, led to a very wide-
spread acceptance of the order by the nobility. The king
assumed patronage of the Capuchin monastery at El
Pardo and of the Franciscans of San Gil in Madrid. The
duke of Lerma, ever ready to emulate the monarchs,
took on the patronage of the Unshod Franciscans in
Valladolid in 1601. He provided a site for the monastery
of San Diego de Alcalá next to his own palace, from
which he could attend religious ceremonies from his
private gallery (*tribuna*), which communicated with the
church. He spared no expense on the church's decora-
tion, which contrasted with the austere, small-scale
architecture required by the rule of the order. The finest
court artists were engaged for the project: the architect
Francisco de Mora, the sculptor Pompeo Leoni, the
painters Bartolomé and Vicente Carducho, and the
master carpenter Juan de Muñiátegui all worked on
the high altarpiece, which was dedicated to San Diego.
Two large reliquary cupboards of classical design, the
Annunciation and the *Stigmatization of Saint Francis*
(fig. 63), flanked the high altar, in emulation of the
basilica of El Escorial.[43] Relics brought added prestige to
the patron and also attracted donations for the upkeep
of the monastery. Vicente Carducho's painting of Saint
Francis, on the outer door, shows the moment when the
saint received the stigmata. Illuminated by a beam of
golden light, the saint levitates with palms raised, clear-
ly showing the wounds of the Passion. His expression,

as he looks up to the source of divine radiation, is one of spiritual ecstasy. Carducho shows himself as a master in the representation of intensely felt spirituality. He literally takes this to new heights—levitation becomes mystical flight—in his altarpiece for the Venerable Third Order of Saint Francis in Madrid (cat. 38), of which he was an active member and in whose habit he was buried. The saint is shown almost on a level with the crucified Christ, and there is an intense spiritual communication between them. With arms outstretched, he is both receiving and showing his wounds. Saint Dominic, in his manual on prayer, considered this position to have been inspired by Christ on the cross and to be the gesture that would facilitate levitation.[44]

In his ducal town of Lerma, the prime minister built convents and monasteries for Franciscan, Carmelite, Cistercian, and Dominican communities, as well as a splendid collegiate church. As in Valladolid, the Dominican monastery of San Blas (fig. 79, p. 288) was connected to his palace by a passage. Lerma was covering his spiritual bets; in his will he made provision for no less than twenty thousand masses to be said in the religious institutions of which he was patron. When the ducal complex was inaugurated in October 1617, it was described as "the happiest, most famous and celebrated fiestas that the world has seen."[45] One of Lerma's closest associates and henchman, Rodrigo Calderón, count of Oliva (1570–1621), tried to emulate the patronage and art collecting of his political master. He founded the Dominican convent of Portacoeli in Valladolid and gave part of his palace for its construction. The large church has a magnificent high altar and lateral altarpiece of colored marble, imported from Genoa. The paintings of the high altar, dedicated to the life of the Virgin, as well as the lateral altars, which are dedicated to Saints Dominic and Francis, are by Orazio Borgianni (about 1575–1616), a painter whose style of using strongly contrasting light and shade influenced Spanish painters.[46] Destined as a funerary chapel, marble effigies of Calderón, his wife, and his parents kneel in perpetual adoration of the Eucharist. This grand demonstration of patronage symbolizes the combination of magnificence and piety, the worldly and the spiritual that is so characteristic of Philip III's reign. In 1621 Don Rodrigo was executed for rampant corruption, but he went to the scaffold a repentant sinner, his body lacerated by self-inflicted punishment.[47]

The campaign for the canonization of Ignatius Loyola, Francis Xavier, Teresa of Avila, and Isidore the farm laborer created new standardized images and iconography. Series of engravings of the lives of the saints were issued, and these, along with literary sources, served as inspiration for artists. The Jesuit Order took great care to reproduce images that were as true to life as possible. For Ignatius, they worked from a copy of his death mask, as well as a portrait based on it by the court painter Alonso Sánchez Coello (d. 1588). The description by the saint's biographer, Pedro de Ribadeneyra (1526–1611), was an important source: bald, aquiline nose, serious expression, eyes glistening with tears.[48] Martínez Montañés shows him this way in the expressive head, which was commissioned for the church of the Jesuit house (the Anunciación) in Seville for the fiestas to celebrate Loyola's beatification in 1610. Montañés provided the head and hands only, which are carved in wood and polychromed by Pacheco. The figure consists of a simple

armature, conceived to be dressed (*imagen de vestir*). Even the images fully carved in the round by Gregorio Fernández in Valladolid were dressed on festive occasions. His *Saint Ignatius of Loyola* (cat. 42), shown wearing the black soutane and cloak of the order and holding the book of its *Constitutions*, would have been dressed in black velvet, richly embroidered in silver and gold.

The beatification in 1614 of Teresa of Avila, who opened the first monastery of the Carmelite Reform in Avila in 1562, generated numerous images to adorn the altars of the Carmelite Order. From his renowned workshop in Valladolid, Gregorio Fernández supplied sculptures that were to define the representation of the saint for generations. The earliest known example belongs to the convent of Nuestra Señora del Carmen de Extramuros in Valladolid (cat. 41). Teresa appears lost in spiritual contemplation, looking heavenward as though seeking divine inspiration, a raised pen in one hand and an open book in the other. The rich polychrome of the heavy draperies of her habit and veil is a more permanent reminder of the finery with which she was adorned for her fiestas, when her garments were studded with precious gems.[49]

Saint Isidore (d. about 1172) was a saint of the people who combined the virtues of industriousness and piety. He was invoked as the celestial patron of Madrid and of workers and laborers. Representations of the saint emphasize his humble earthly status yet exalted spiritual life. Juan van der Hamen portrays him experiencing a miraculous vision, while angels take over his work at the plow (National Gallery of Ireland). The monumental figure, rendered with strongly contrasting light and shade, has a great sense of immediacy and realism. This quest for verisimilitude is characteristic of much of the religious art of the early decades of the seventeenth century. Painters such as Bartolomé Carducho, Pantoja de la Cruz, Bartolomé González, Pedro Orrente, and Francisco Ribalta all responded to the growing demand for more "real" images. Tenebrism and the observation of nature were important tools in this new development.[50]

After years of Spanish pressure on the Vatican, finally, in 1622, the four Spanish saints—Ignatius Loyola, Francis Xavier, Teresa of Avila, Isidore the farm

laborer—as well as Filippo Neri, were canonized in Rome by Gregory xv. Philip iii, who had so vigorously promoted their cause, had not lived to see the joyful celebrations that exploded throughout the peninsula. He would have been gratified to see his young heir Philip iv reap the benefits of this spectacular beginning to his reign. In Madrid fiestas were organized by the city authorities, the Jesuits, and the Carmelites.[51] The body of Saint Isidore, contained in a silver-and-gold casket and mounted on a triumphal cart, was accompanied by Philip iv, grandees, and members of the court through streets decorated with costly hangings and strewn with aromatic herbs and flowers. Sculptures of the Jesuit saints were carried on silver biers: Francis Xavier dressed in black velvet embroidered in silver and gold, held a spray of lilies, the stem made of emeralds and the flowers made of pearls; Saint Ignatius, dressed in a similar way, held in his right hand the name of Jesus (IHS), the insignia of the order, made of diamonds and pearls. Monumental altars adorned the processional route. Some rose higher than the adjacent buildings, such as the two seventy-foot-tall pyramids with gilded statues on top representing Saint Teresa and the prophet Elijah, constructed by the Carmelite Order. Manuel Ponce, an official reporter, lamented his difficulty in giving an adequate account of the splendor of the occasion: the transformation of church interiors with rich fabric hangings, and the adornment of altars, both inside and on the streets, with paintings, sculptures and reliquaries, silver vessels, embroideries and jewels, braziers, incense and flowers, and all kinds of illuminations. This demonstration of religious belief and piety was very much part of a rich culture that celebrated both the sacred and the profane. Dance and music were important elements; every procession began with the Dance of the Giants. There were representations of the four elements, the four continents, the signs of the zodiac, the seven planets, naval battles, poetry, and fireworks.

In this desire to know and represent the world, both real and supernatural, artists played an important role. Those who dealt with religious subjects were held in great esteem; in the words of Lope de Vega, they were "heaven-sent divine imitators."[52]

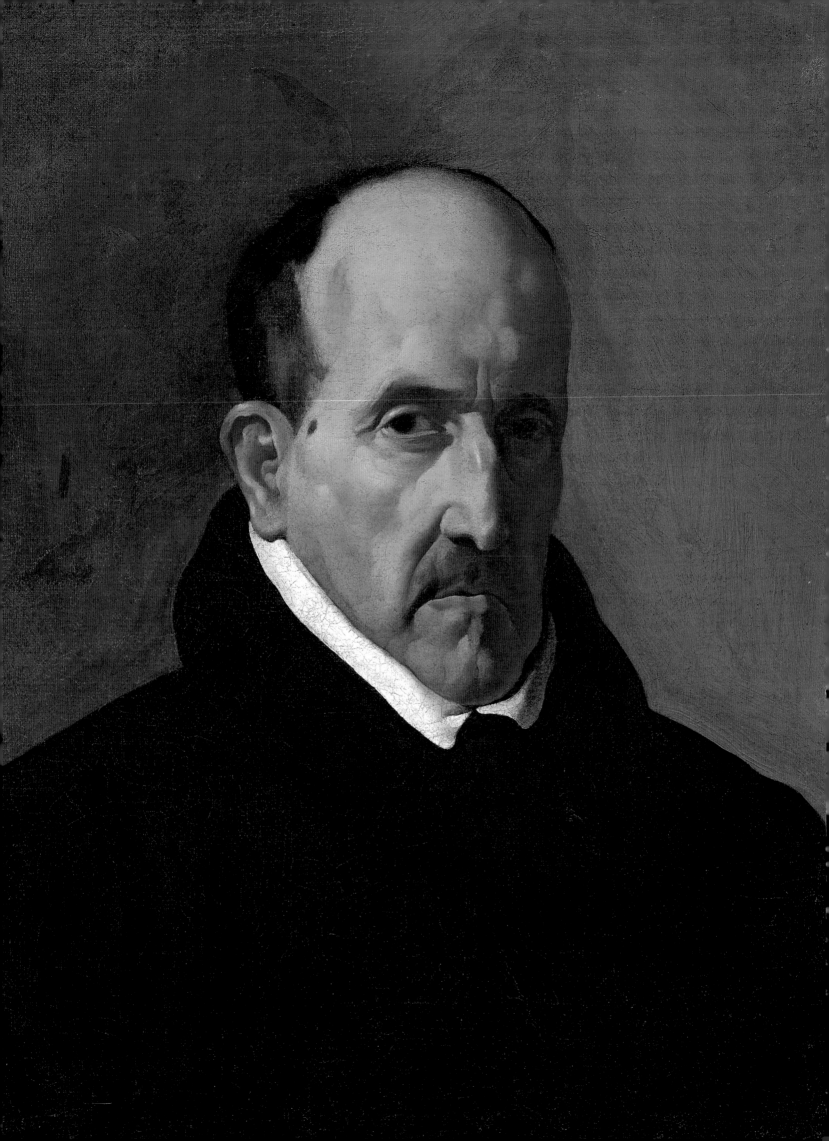

The Treasury of the Language:
Literary Invention in Philip III's Spain

LAURA R. BASS

In his imprimatur to Sebastián de Covarrubias's *Tesoro de la lengua castellana o española* (Treasury of the Castilian or Spanish Language) (1611), the first dictionary of Spanish ever published, Philip III's royal chronicler Pedro de Valencia proclaimed it most fitting that a work dedicated to the "propriety, purity, and elegance" of the language should be written at the moment of its greatest efflorescence ("en el momento en que más florece").[1] While the term Golden Age would not be applied to this period until the eighteenth century, Valencia's words spoke beyond the level of mere rhetoric to a keen consciousness of the achievements of Spanish lettered culture during the reign of Philip III. This culture encompassed writings ranging from histories that chronicled Spain's past and present to descriptions of important celebrations (*relaciones de fiesta*); to religious works such as saints' lives and sermons; to treatises on good government and proper conduct; to Spanish-language grammars and dictionaries, such as that of Covarrubias; and, of course, to novels, dramas, and poetry—the types of works that fall under the modern rubric of literature.

Without question, the reign of Philip III marked one of the richest and most innovative periods in Spanish literary history. The same years in which El Greco produced some of his most daring and original paintings and Diego Velázquez launched his artistic career, Miguel de Cervantes (1547–1616) published his masterpiece *Don Quijote de la Mancha* (part 1, 1605; part 2, 1615) (fig. 64); Lope de Vega (1562–1635) penned the bulk of his best-known plays; and Luis de Góngora (1561–1627) (cat. 17) revolutionized Castilian verse in his famous *Fábula de Polifemo y Galatea* (Fable of Polyphemus and Galatea) (1612) and *Soledades* (Solitudes) (1613, 1614). If these authors are generally known for their respective achievements in prose narrative, drama, and poetry, their creative talents expanded to other genres as well.

Though vastly different in personality, background, and literary output, the three most emblematic writers of Philip III's Spain share one fundamental quality— the brilliant inventiveness of their work. As in the visual arts, authors were expanding on the precept of *imitatio*, the imitation of the classics, and putting greater emphasis on *inventio*, which entailed not only the refashioning of established models but also the creation of new ones. Although novelty (*novedad*) was still a culturally suspicious category (Covarrubias defined the term as "Something new or unaccustomed to [that] tends to be dangerous because it brings change from old

ways"),[2] Spain's great writers cultivated it with pride. In the prologue to his *Novelas ejemplares* (Exemplary Novels) (1613), Cervantes declared himself the first to write novellas in Castilian; more exactly, he claimed to be the first "to novelize" (*novelar*), employing a neologism that itself reinforced the innovative nature of his collected stories. As broadcasted in the almost redundant title, the *New Art of Making Plays in These Times* (*Arte nuevo de hacer comedias en este tiempo*) (first presented in about 1606 but published in 1609), Lope de Vega flaunted the unprecedented novelty of the theater formula he had perfected even as he famously deprecated its appeal to a paying public (*el vulgo*). In the dedication of a sermon he wrote to the memory of Philip III's wife, Queen Margaret, the erudite court preacher Fray Hortensio Félix Paravicino (cat. 12)—variously celebrated and censored for his innovative, gongorist oratory—cast himself as a literary Christopher Columbus for daring to discover new worlds within the Castilian language.[3] And although in his lifetime Góngora's "new poetry" (*nueva poesía*) earned him many an enemy, it soon won out as the dominant mode of poetic discourse in seventeenth-century Spain and Spanish America.

Social and Material Contexts

In accordance with standard historiography, this literary efflorescence has struck many a scholar as a paradox. If, in terms of politics and the visual arts, the reign of Philip III has traditionally been thought to pale in comparison to those of his father and his son (see Sarah Schroth's essay in this volume), the achievements of its greatest writers are beyond dispute. Yet, in the light of reevaluations of the period that bring into view its tremendous cultural vitality, the creative expansiveness of Spanish literature in the first decades of the seventeenth century ceases to be so paradoxical. The brilliance of a Cervantes, Lope, or Góngora comes into focus not only as a matter of individual genius but also as a product of a society ripe for genius as a prized cultural value. Moreover, the lives and work of writers become increasingly appreciated not merely as parallel to those of artists but as intersecting with them in a shared culture of intellectual and artistic promotion and production.

For its alleged decline, the Spain that Philip III inherited was quite possibly the most educated society in all of Western Europe.[4] It was certainly more educated than it had ever been in its own history—or would be for centuries to come; indeed Castile had more university students in 1600 than it would in 1900. Between the reign of the Catholic kings in the latter part of the fifteenth century and Philip III's succession to the throne, the number of universities had increased from six to thirty-three, spurred on by the monarchy's growing demand for a bureaucratic elite of magistrates, councilors, and statesmen, collectively knows as *letrados*.[5] With the rise in university education came an expansion in the secondary school system of *colegios* or *escuelas de gramática* dedicated to the teaching of Latin. For its part, primary instruction brought literacy in Castilian to increasing numbers of children from traditionally uneducated classes, not only in urban centers but also in small towns and even many villages.[6] Overall, some 20 percent of the population could read, and in seventeenth-century Madrid and Toledo that

EL INGENIOSO
HIDALGO DON QVI-
XOTE DE LA MANCHA,

*Compueſto por Miguel de Ceruantes
Saauedra.*

DIRIGIDO AL DVQVE DE BEIAR,
Marques de Gibraleon, Conde de Benalcaçar, y Baña-
res, Vizconde de la Puebla de Alcozer, Señor de
las villas de Capilla, Curiel, y
Burguillos.

Año, 1605.

CON PRIVILEGIO,
EN MADRID, Por Iuan de la Cueſta.

Vendeſe en caſa de Franciſco de Robles, librero del Rey nſo ſeñor.

64
Title page of Miguel de Cervantes Saavedra,
*El ingenioso hidalgo Don Quixote de la
Mancha* (Madrid, 1605)
The Hispanic Society of America, New York

number reached 40 to 50 percent.[7] Literacy was by no means limited to men, for if few women beyond the aristocracy learned how to write, many were taught how to read. In Lope de Vega's 1613 comedy *La dama boba* (Lady Simpleton), which is set in Madrid, the simpleton title character is given a remedial lesson in the ABCs by a private tutor just as she is about to get married, making clear that reading was a requisite skill among daughters of well-to-do urban families.

Spain's education revolution from the late fifteenth through the sixteenth centuries went hand in hand with the rise of printing, which first arrived in the early 1470s. By 1520 printing presses had been set up in every market town and city. Initially, Madrid was not one of them; a secondary town until its establishment as Philip II's capital in 1561, it got its first printing press in 1566. By 1600, however, it had become home to the most important presses in Castile.[8] The important Aragonese printing industry was concentrated in Zaragoza and Barcelona, made famous in part two of *Don Quijote de la Mancha* when the knight and his squire visit a Barcelonese printing shop.

What kinds of works did the printing industry make available to Spain's increasingly large literate population—as well as to those who could not read on their own but still shared in print culture through the widespread practice of group reading aloud?[9] Using numbers of editions as an index, studies of bestsellers show that the most popular texts in the period do not necessarily correspond to what we have come to think of as the great works of Spanish Golden-Age literature.[10] To be sure, many of the most popular books in the seventeenth century remain classics to this day. These include Francisco de Rojas's novel in dialogue *Celestina* (first published anonymously in 1499) about the eponymous go-between and the ill-fated young lovers Calixto and Melibea; Jorge de Montemayor's pastoral romance *La Diana* (1559?); and Mateo Alemán's 1599 picaresque sensation *Guzmán de Alfarache*. But with *Guzmán* we begin to appreciate differences between modern preferences and those of seventeenth-century readers: judging from its thirty-nine editions in the period, this moralizing novel was even more widely read than the most famous title in all of Spanish literary history, Cervantes's *Don Quijote*, which came out in two dozen editions. Another bestseller in its own day is a work that is only recently regaining its place in the Golden-Age Spanish literary canon: Ginés Pérez de Hita's historical novel about Moorish Granada, *Guerras civiles de Granada* (part 1, 1595; part 2, 1609). First published in the years leading up to the 1609–14 expulsion of the *moriscos* (Muslim converts to Christianity), the novel was reprinted thirty-five times, revealing an ongoing cultural preoccupation with Spain's Muslim past well after the last *moriscos* had been expelled. From Christian Granada came the most popular book of all during the Spanish Golden Age—the Dominican friar and mystic Luis de Granada's *Libro de la oración* (Book of Prayer). Edited more than one hundred times between 1554, the year of its first printing, and 1679, this voluminous work epitomized the impassioned spirituality of Counter-Reformation Catholicism and, along with the writings of other sixteenth-century mystics and theologians (e.g., John of the Cross, Teresa of Avila, and Ignatius of Loyola), informed religious expression in the paintings of the period. Indeed, the majority

of books bought and sold in sixteenth- and seventeenth-century Spain were religious in nature, ranging from expensive liturgical volumes in Latin to inexpensive devotional works easily accessible to lower-class readers.[11] It is also important to mention the multiple types of cheaply available ephemera, including sheets of religious songs and prayers; secular poems, ballads, and jokes; accounts of current events (*relaciones de suceso*); and reading primers and catechisms.

As in other parts of Europe, the printing industry in Spain was subject to monarchical and ecclesiastical control. First instituted in 1502 in the Kingdom of Castile was a system of prepublication regulation that required approval by civil and Church authorities before works could be printed and sold.[12] Another layer of censorship affected books already licensed for printing or in circulation. Introduced in 1520 in the wake of the Protestant Reformation and strengthened during the reign of Philip II, this type of a posteriori control fell to the hands of the Inquisition, which was in charge of compiling and enforcing indexes of prohibited and expurgated titles and of monitoring printers' shops, booksellers, and points of entry and exit. As stated in Philip II's 1558 legislation on the subject, there was a need to prohibit the publication and importation of books that contained "heresies, errors, and false, suspicious doctrines" (*heregías, herrores, y falsas doctrinas sospechosas*), as well as those that treated "idle and indecent matters that set bad examples" (*materias vanas, deshonestas y de mal ejemplo*).[13] This broadly encompassing language notwithstanding, in actual practice what most concerned book censors in the period were issues pertaining to Church doctrine and institutions. For students and scholars of Spanish Golden-Age literature, it is noteworthy that the vast majority of titles included in the indexes of prohibited and expurgated books treats religious themes, while a mere 1 percent corresponds to profane works.[14] Even when the anonymous picaresque novel *Lazarillo de Tormes* (first published in 1554) appeared in the famous 1559 Valdés Index (named for Fernando de Valdés, the inquisitor general who compiled it), the problem was largely its satirical treatment of the clergy.[15] To be sure, the effects of imaginative literature and the theater on behavior and morality were widely debated, and some of the greatest writing of the period was fueled by those debates.[16] Nonetheless, it was not until a 1625 ban on the publication of novels and plays in Castile that the state clamped down on these kinds of works as part of a larger campaign of social reform spearheaded by the count-duke of Olivares.[17] Such an effort to limit literary activity in the early years of the reign of Philip IV is testament to how much it had flourished during the reign of his father.

Writers and Patrons

As for the leading writers of Philip III's Spain, they were products, as well as producers, of the twin revolution in printing and lay education. The son of a barber-surgeon, Cervantes received a humanist education at the preuniversity level; perhaps more important, he was also very much an autodidact, an avid reader (like the myriad readers who would fill the pages of *Don Quijote de la Mancha*) of all manner of books and manuscripts. Mateo Alemán, author of *Guzmán de Alfarache*, was the son of a surgeon of Jewish *converso* origin; he stud-

ied with the humanist Juan de Mal Lara in his native Seville and went on to study medicine at the University of Salamanca and the University of Alcalá. The son of an artisan, Lope attended the Jesuit college in Madrid and later the University of Alcalá (and possibly also the University of Salamanca). In contrast to the Renaissance ideal of an aristocrat poet (Garcilaso de la Vega is the quintessential example), all three of these authors were from the middle classes and wrote for a broad reading—and, in the case of Lope, play-going—public. With the commercial success of their work, they typified the still-emergent professional writer of the late sixteenth and seventeenth centuries.[18]

However, the growing literary market did not displace—in fact, it arguably encouraged—the continued cultivation of more elite authorial practices, as exemplified by the case of Luis de Góngora. The son of a noble family of Córdoba and prebendary of the cathedral from 1585, he did not write for the literary market, and except for several poems and one play that appeared in contemporary anthologies, the bulk of his work remained unpublished during his lifetime. His *letrillas* and *romances* (both popular verse forms) enjoyed broad oral transmission, and his major works were widely copied, making him the only poet of his age whose writings, in manuscript form, were commercially exploited by booksellers.[19] He himself, however, penned his most ambitious and difficult *Polifemo* and the *Soledades* for a narrow audience of intellectuals and aristocrats, taking great care to control their reception by initially distributing them among the most select readers. Only toward the end of his life did a desperate need for money— and the urging of no less than the count-duke of Olivares—impel Góngora to gather his writings for print, a project that he did not live to fulfill.[20]

Even the more professional writers did not enjoy independent means or status. The majority devoted good parts of their lives to other occupations— Cervantes, for example, had been a soldier and a tax collector before his first major literary success, and Alemán held such posts as auditor for the royal treasury and judge charged with inspecting a mercury mine. It was also common for authors to seek employment in the service of noblemen and grandees to supplement their incomes (usually insufficient) from writing; finance the publication of their works; and, perhaps most important, elevate their social standing. Lope de Vega is a notorious case in point; as a youth, he worked for a series of noble families and, even after establishing himself as a successful commercial playwright, served as secretary to aristocrats ranging from the fifth duke of Alba to the sixth duke of Sessa, for whom he ghostwrote adulterous love letters over a span of twenty-five years.[21] While only a small percentage of authors enjoyed the steady support of powerful patrons, most obsessively sought it; the record of that obsession is the dedications invariably included in the preliminaries of their works.[22]

If there is any single factor that most contributed to the flourishing literary culture of the Spain of Philip III, it was the elaborate system of patronage that developed at his court with his royal favorite, the duke of Lerma, at the helm. Adopting a phrase from a contemporary chronicle, Harry Sieber has described that system as a "magnificent fountain" of favors channeled by Lerma and those close in his circle.[23] As Sarah Schroth shows in her essay in this catalogue, Lerma's

aim was to create a new, ostentatiously splendorous court in contradistinction to the famously austere court of Philip II. Writers were enlisted to compose plays performed in public celebrations, to chronicle those celebrations in *relaciones de fiestas*, and to pen sermons exalting the monarchy's providential mission.

The patronage system did not only account for specific civic and religious commissions, however. Part of a larger economy of prestige, it fueled literary production more generally, attracting writers to Spain's centers of power and privilege where they competed for favors. When the court moved to Valladolid in 1601, writers quickly followed. It was in Valladolid, for instance, that Cervantes finished the first part of *Don Quijote* in 1604, dedicating it to the duke of Béjar. Once the court moved back to Madrid permanently in 1606, all major writers spent significant periods of time there, drawn to the city's multiple venues for the expression of literary talent—theaters, public festivals, literary academies (*academias literarias*). Not unique to Madrid (Valencia, Zaragoza, and Seville all boasted of important *academias*), these salons were generally held in the homes of noblemen, which allowed writers to make important contacts and establish their literary credentials, while also enhancing the cultural capital of their patrons.[24]

The hierarchical structure of the patronage system did not mean that writers were necessarily servile. In the case of the most talented ones, it certainly did not stifle creativity. To the contrary, dependence was coupled with rivalry, propelling authors to showcase, beyond their worthiness of favor from illustrious patrons, their own superior genius. Perhaps nowhere is this dynamic more eloquently articulated than in Góngora's verse dedication of his first *Soledad* to the duke of Béjar (the same Béjar who had figured as Cervantes's dedicatee for the first part of *Don Quijote*). Rehearsing the Renaissance competition between arms and letters, Góngora extols the aristocrat's power to subdue nature through the hunt, only to call him to set aside his spear and yield before his, the poet's, art.[25]

Writers and Artists

The lives of writers of the caliber of Lope de Vega and Góngora and artists such as El Greco and Velázquez did not just overlap in time and place; they shared common conceptions of their respective arts as well as social aspirations. In terms of aesthetic theory, this intersection of literature and painting was rooted in the well-known Horatian precept *ut pictura poesis* (as is painting so is poetry). On the literary side, the concept of the sister arts informed what Frederick de Armas has described as a "writing for the eyes," which included the practice of ekphrastic poetry (i.e., poems dedicated to the description of paintings); the use of painting terminology, like *sombras* (shadows) and *visos* (appearances), to describe visual experience in words; poetic reflections on the nature of vision and its connection to knowledge and desire.[26] On the artistic side, the Horatian simile contributed to an emphasis on the rhetorical and persuasive value of the visual, important in post-Tridentine religious painting, as well as its narrative capacities, most obvious in history and mythological works. It also served painters in their ongoing effort to elevate their status from that of artisans to artists.

In seventeenth-century Spain professional painters were still battling for social and legal recognition of their art as precisely that—an art rather than a trade. By 1600 this battle had been won in Italy where painting was considered equal to poetry, which, for its part, was accepted as a liberal art.[27] The fact that painters in Spain, like silversmiths or carpenters, continued to be classified as craftsmen stemmed in part from the prolongation of the guild system that regulated their training and production and in part from a cash-strapped treasury's investment in subjecting their works to the sales tax known as the *alcábala*.[28] Legitimizing the nobility of painting as a fundamentally intellectual (as opposed to merely mechanical) vocation thus became a major concern of artists and art theorists. It fueled the developing subgenre of the self-portrait; the burgeoning of art treatises; the formation of circles of artists, writers, and aristocrats such as Pacheco's famous academy in Seville; and, most obvious, the numerous lawsuits painters fought against the royal treasury. Painters drew on the support of writers in these various endeavors. For instance, the poets Juan de Arguijo, Francisco de Rioja, and Juan de Jáuregui (who was also an amateur painter) were regular members of Pacheco's academy, which Lope de Vega also attended during his stays in Seville.[29] Writers, including Lope, also provided verses to crown each of the dialogues in Vicente Carducho's treatise *Diálogos de la pintura*. Among other authors, Lope de Vega and Pedro Calderón de la Barca, the most famous dramatists of seventeenth-century Spain, lent their eloquence to the defense of painters in their legal battles over the taxation of their works, Lope in the late 1620s and Calderón as late as 1677.

Just as painters drew on the art of writers to ennoble their profession, writers benefited from the art of painters in the enhancement of their own fame. Indeed, their relationships often came full circle: artists immortalized men of letters in portraits; poets celebrated artists in words. The examples of El Greco and Fray Hortensio Félix Paravicino are paradigmatic. The Toledan painter created a masterpiece of psychological depth in his portrait of the orator-poet (cat. 12); in an ingenious recasting of literary commonplaces, Paravicino extolled that portrait as so lifelike that he must wonder whether his soul lives more in the body painted by the artist or the one created by God.[30] Portraits of authors could also lead to forms of mock ekphrasis; as we will see below, such is the case of Cervantes's ironic description of a likeness Juan de Jáuregui supposedly painted of him, placed at the beginning of his prologue to the *Novelas ejemplares*.

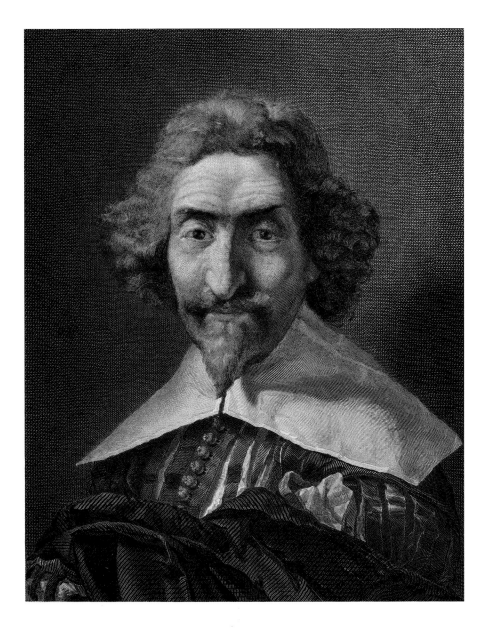

65

Abraham Bauvier (after Diego Rodríguez de Silva y Velázquez)

Cervantes

Engraving, image 7 ⅜ x 5 ⅞ in. (18.7 x 14.9 cm), platemark 13 ½ x 10 in. (34.3 x 25.4 cm)

Museum of Fine Arts, Boston

Miguel de Cervantes

Soldier, Captive, Tax Collector

Of the major writers of Philip III's Spain, none is as universally famous as Miguel de Cervantes (fig. 65). As one of the most influential authors of all time, he is often invoked alongside William Shakespeare (it is a great coincidence of literary history that they share the same recorded date of death), and his masterpiece, *Don Quijote de la Mancha*, has as much of a place in the canon of world literature as it does in that of the Spanish Golden Age. Yet Cervantes belonged very much to his own time and place, which his work brilliantly captured and critiqued.

His was a long and dramatic life that began in 1547 in the Castilian university town and center of Spanish Renaissance Humanism, Alcalá de Henares.[31] Little is known about his childhood beyond the fact that a series of misfortunes propelled

his family to make several moves—first to Valladolid, then to Córdoba, next to Seville, and finally, in the late 1560s, to Madrid. It was in Spain's newly established court capital that his writings first appeared in print, among them four poems that the humanist López de Hoyos included in a 1569 volume commemorating Queen Isabel of Valois's death. It was also apparently in these years that Cervantes devoured the chivalric romances (*libros de caballería*) that he would parody decades later in *Don Quijote de la Mancha.*

Supposedly fleeing prosecution for injuring a man in a duel, Cervantes left Madrid for Rome in 1569. He spent two years in Italy, absorbing its culture and art in ways that would influence his entire literary career.[32] Heroic adventures and trials also awaited him in Italy. As a recently enlisted soldier in the Spanish army, he fought in the great naval victory against the Turks at Lepanto in 1571. There he lost use of his left hand from a blunderbuss wound, which decades later he would proudly brandish as a "beautiful" reminder of his participation "in the greatest and most memorable event that past centuries have ever seen or those to come may hope to see."[33] Making his way back to Spain in 1575, he was captured by Berber corsairs and held in captivity in Algiers for five years. He would reenact the trauma of those years in two plays, *El trato de Argel* (The Traffic of Algiers) (1581–83) and *Los baños de Argel* (The Prisons of Algiers) (1609–10), and fictionally rework it in the Captive's tale in *Don Quijote* (1: 39–42).[34]

Ransomed by Trinitarian friars, Cervantes returned to Spain in 1580 and settled in Madrid. The heroic decade of the 1570s gave way to his first period of serious literary production. Quite fittingly, one of the principal products of this transition was his four-act drama of national heroism and sacrifice *El cerco de la Numancia* (The Siege of Numantia) (1581–87) depicting the Celtiberian town of Numantia's lengthy resistance to and final collective suicide before Scipio's army in 133 B.C.

Cervantes's other major literary achievement from this period, and, indeed, his first real publication, is *La Galatea* (1585), a pastoral romance in verse and prose. Peopled with shepherds and shepherdesses who discourse about love in every poetic form in vogue, *La Galatea* has often been dismissed as a mere exercise in imitation. However, its juxtaposition of diverse literary modes offers a reflection on the possibilities of language and the perspectival nature of human experience, anticipating his later masterpiece *Don Quijote.*[35]

Don Quijote's (Step) Father

Two full decades would intervene between the publication of *La Galatea* and the first part of *Don Quijote,* more than ten years of which Cervantes spent in Andalusia employed, first, as a commissary charged with requisitioning food supplies for Spain's doomed Armada expedition against England (1588) and, later, as a tax collector. Neither of these jobs won him any glory; to the contrary, they brought him opprobrium and even time in jail. Still, the very misfortunes and hardships of this period were crucial in shaping Cervantes's mature literary production, accounting for the growing sense of disillusionment and irony characteristic of his oeuvre.

Cervantes originally titled his great novel *El ingenioso hidalgo Don Quijote de la Mancha* (The Ingenious Gentleman Don Quijote of La Mancha). His chosen epithet

is rich in ambiguity. For contemporaries, *ingenio* (variously translated into English as "wit," "genius," or "ingenuity") referred to an innate intelligence—a kind of inherent capacity for generating new ideas or, in extreme cases, imagined falsehoods.[36] Precisely in the ambiguity of *ingenioso*, the epithet captures the work's essential artistic complexity. This is a book about a fifty-year-old man who goes mad from reading too many romances of chivalry and reinvents himself as a knight, written by a man, also in his fifties, who creates a new literary genre—the modern novel, fashioned out of the narrative and poetic traditions (chivalric, pastoral, and Byzantine romance; the epic; the picaresque novel) he has mastered through his own avid reading.[37] Among other things, it is a book about artistic creation and self-invention and the relationship between the two.

In this aspect, it is noteworthy that Cervantes takes his cues from contemporary painting practice. Thus, for example, Don Quijote justifies his imitation of Amadís de Gaula and Orlando in the Sierra Moreno episode through an analogy to the training of painters: "I say, too, that when a painter wishes to win fame in his art, he attempts to copy the original works of the most talented painters he knows; this same rule applies to all important occupations and professions that serve to embellish nations."[38] Painting once again provides the analogy for a discussion of originals and copies when, toward the end of part two, Don Quijote and Sancho discover the existence of Alonso Fernández de Avellaneda's fraudulent imitation of their adventures, published in 1614 before Cervantes had a chance to finish his own second part. A fascinating discussion ensues about who should rightfully be permitted to tell Don Quijote's story. Don Juan, a reader familiar with the unauthorized sequel, proposes an order be issued so that no one "dare to deal with the affairs of the great Don Quijote, except Cide Hamete, just as Alexander the Great ordered that no could dare paint his portrait except Apelles," to which Don Quijote replies: "Retráteme el que quisiere; pero no me maltrate" (Let him who will paint me, but let him not abuse me).[39]

It has often been said that Cervantes's great novel brings into confrontation the two main aesthetic currents of his time—the exalted intellectualism epitomized by El Greco and the realistic naturalism introduced in Spain by Francisco Ribalta and perfected by Velázquez.[40] This polarity is present in the juxtaposition of the main literary forms out of which *Don Quijote*, especially part one, is built. From the idealistic vein of Spanish Golden-Age literature, the chivalric romance provided the novel's most obvious intertext. Like many forms of the popular media today, novels of chivalry also had vociferous opponents—humanists, theologians, and literary theorists (especially Alonso López Pinciano, author of the 1596 *Philosophia antigua poética* [Ancient Poetic Philosophy]) who decried their supposedly pernicious effects on morals and violation of Aristotelian precepts of logic and verisimilitude. Cervantes echoed contemporary literary debates in key dialogues interspersed throughout part one, but it was in his parody of the language and commonplaces of books of chivalry that he made his most original and memorable contribution to literary theory. A vehicle for literary criticism, his parody also offered up ideological critique, exposing the obsolescence of heroic fervor in what he saw as an age of mechanized warfare and military decline.

From the opposite, indeed anti-idealist spectrum of contemporary literature, the other main narrative influence on *Don Quijote* was the picaresque novel. Characterized

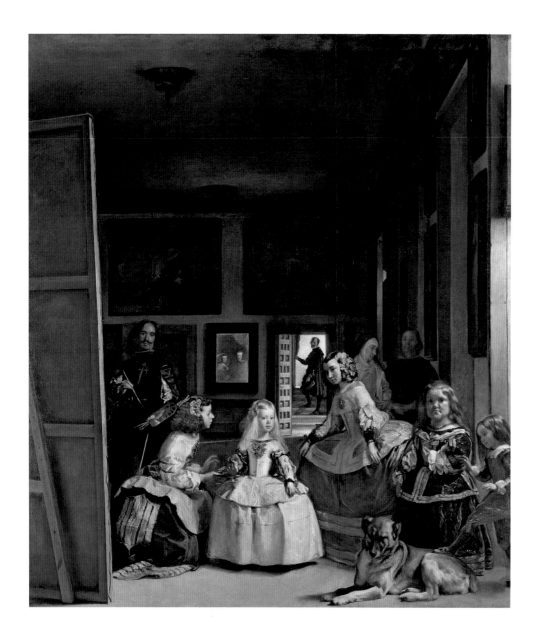

66
Diego Rodríguez de Silva y Velázquez
Las Meninas, 1656
Oil on canvas, 126⅜ x 110⅛ in. (321 x 281 cm)
Museo Nacional del Prado, Madrid

by a boldly, bitingly realistic depiction of low-life existence and social corruption, the genre was the literary equivalent of the Spanish *bodegón*, especially in the form of kitchen and tavern scenes, whose vogue it may well have encouraged.[41] While it originated in the anonymous *Life of Lazarillo de Tormes* (1554), the picaresque reached full form in Mateo Alemán's 1599 bestseller *The Life of Guzmán de Alfarache*, which inspired, in quick succession, a spate of continuations and variations, including Alemán's sequel (1604) and Francisco de Quevedo's *La vida del Buscón* (The Swindler) (composed in 1604; published in Zaragoza in 1626). Scholars have related the explosion of these narratives of social marginalization in the early years of Philip III's reign to a pervasive atmosphere of disillusionment (so-called *desengaño*) following such key events as the 1588 defeat of the Armada, the monarchy's declaration of bankruptcy in 1595, and famine and plague in 1596. *Guzmán* in particular is closely associated with the spirit of reform that inspired

the famous *arbitristas* (projectors) to pen their countless tracts and treatises on the causes and cures of Spain's putative decline; it is known, for instance, that Alemán maintained correspondence with Cristóbal Pérez de Herrera, author of the 1598 *Discursos del amparo de los legítimos pobres y reducción de los fingidos* (Discourses on the Protection of the Legitimately Poor and Control of the Pretend Ones).[42] With its focus on social mobility and the trappings of honor and privilege, the genre has also been tied to the duke of Lerma's establishment of a court society obsessed with status, lineage, and wealth.[43]

Cervantes's interest in the picaresque stemmed in no small part from his own contact with the more unseemly social types and realities that constituted the genre. A disillusioned former soldier, he was all too well aware of the impossibility of his hero's chivalric fantasies of maidens, fortress keepers, and towering castles, and he employed his literary genius to bring them into crashing and crushing juxtaposition against the picaresque world of prostitutes, thieves, and lowly inns. He did not merely incorporate the picaresque into his novelistic universe, however; he also critiqued and reinvented it, most obviously in the galley slaves episode (1: 22). The episode radically eschews the didacticism of the picaresque (especially evident in *Guzmán*) by rendering Don Quijote's condemnation of the state's disciplinary practices in terms at once eloquently reasoned and practically absurd. Moreover, Cervantes satirizes the normative autobiographical format of this genre when Ginés de Pasamonte—condemned to the galleys like his literary antecedent Guzmán—announces that he is writing the story of his life, but that it will not be finished until his life itself is finished.

In poking fun at Pasamonte's authorial ambition, Cervantes sheds light on his own authorial project and its deliberate eschewal of narrative totality and control. That refusal is evident from the famous prologue to part one in which the author invokes the authority of tradition only to undermine it, and, at the same time, denies his own authorial claim over his text by declaring, in an ingenious twist on a literary commonplace, that he is merely Don Quijote's stepfather and not his father. Within the body of the novel, he further relinquishes authorial command by creating a narrator whose story is based on translations of a fragmented manuscript written by a presumably unreliable Arab historian Cide Hamete.

In part two of *Don Quijote* (1615), the textual layering becomes ever more complicated, as Don Quijote and Sancho encounter various characters who have read the first volume of their adventures and are eager not only to comment on them but also to re-create them. References to external literary models thus give way to a vertiginous play of self-reflexivity that is often compared to Velázquez's great painting *Las Meninas*, in which the artist boldly includes a portrait of himself at work on the large canvas (visible only from the back) within the painting (fig. 66). But where Velázquez shows himself as the painter of his own image, as well as of every other portrait in the painting, including the reflection of the king and queen in the mirror, in the second part of *Don Quijote* the would-be knight is no longer the sole author of his self-creation or the illusions he imposes on the world (e.g., turning inns into castles and windmills into giants). Instead he finds himself the protagonist of chivalric fictions fabricated by others, including Avellaneda who had published his apocryphal sequel to the original novel in 1614.

NOVELAS
EXEMPLARES
DE MIGVEL DE
Ceruantes Saauedra.

DIRIGIDO, A DON PEDRO FERNAN-
dez de Castro, Conde de Lemos, de Andrade, y de Villalua,
Marques de Sarria, Gentilhombre de la Camara de su
Magestad, Virrey, Gouernador, y Capitan General
del Reyno de Napoles, Comendador de la En-
comienda de la Zarça de la Orden
de Alcantara.

Año 1613.

Cõ priuilegio de Castilla, y de los Reynos de la Corona de Aragõ.
EN MADRID, Por Iuan de la Cuesta.
Vendese en casa de Frãcisco de Robles, librero del Rey nro Señor.

Even before the specter of this real-life usurper intrudes in the fiction (2: 59), Cervantes peoples it with other readers and reinventors of the first volume. Not least among these are the decadent duke and duchess who transform their palace into a chivalric set from which they script a series of cruel pranks with Don Quijote and Sancho assigned their usual roles. The aristocratic couple's transformation of the world into a stage exemplifies the overall Baroque aesthetic that critics have long identified as characteristic of part two. Here, it is important to add that in theatricalizing his novel within the fiction of the second, Cervantes was alluding to its theatricalization in real life. Indeed, their story was so popular that almost immediately following its publication, Don Quijote and Sancho had started appearing as characters in masques and festivals performed throughout the Spanish world. Moreover, in the ostentatious excess of the scenes staged in the ducal palace (like the one featuring the flying wooden horse Clavileño), Cervantes was no doubt offering a biting critique of the culture of spectacle that Lerma had made so defining of Philip III's court.

Novelist and Playwright

After *Don Quijote de la Mancha*, Cervantes's most celebrated work by far is his volume of twelve long stories, *Novelas ejemplares* (Exemplary Novels) (fig. 67). Cervantes published this collection in 1613; by that point in his life he had been living in Madrid for seven years, active in literary academies, widely admired following the success of the first part of *Don Quijote*. His oft-cited prologue to the collection reveals his proud awareness of his status as a writer. It does so most obviously in the author's self-declaration as the first to write novels in Castilian. Cervantes's prologue further advertises his authorial pride through its teasing engagement in the ancient *pictura-poesis* rivalry. At the outset, he alleges that he would have preferred to begin his book with a frontispiece portrait engraving based on a likeness painted of him by the poet and artist Juan de Jáuregui. Despite speculations that Cervantes may have been referring to a portrait now housed in the Real Academia Española de la Lengua, there is no evidence that Jáuregui ever in fact painted the famous author; moreover, the reference to a real-life portrait is most likely one of those cases of the author's hallmark irony.[44] Certainly ironic is his claim that a frontispiece image would have saved him the bother of writing his prologue, for while he laments the absence of an engraving, he clearly prefers his role as the author of his own verbal self-portrait, cast as a mock ekphrasis of the supposed real one:

> This man you see here, with aquiline face, chestnut hair, smooth, unwrinkled brow, joyful eyes and curved though well-proportioned nose; silvery beard which not twenty years ago was golden, large moustache, small mouth, teeth neither small nor large, since he has only six, and those are in poor condition and worse alignment; of middling height, neither tall nor short, fresh-faced, rather fair than dark; somewhat stooping and none too light on his feet; this, I say, is the likeness of the author of *La Galatea* and *Don Quijote de la Mancha*.[45]

Cervantes has layered his self-description with epistemological pentimenti, aiming toward precision only to backtrack with qualifiers that betray the fundamental elusiveness of his task. For its humorous self-deprecation and equivocation, however, his verbal portrait is boldly defiant, flouting the pretensions of writers like his rival Lope de Vega who never missed a chance for aggrandizing visual self-display. Master of paradox, Cervantes declared his authorial pride through an apparent commitment to self-effacement in its most literal sense: aside from the Real Academia Española likeness identified as his but of dubious authenticity, there is no portrait of this great writer taken from life. He left us instead the portraits he painted with the ironic detachment of his own pen.

As for the *Novelas ejemplares* themselves, the very title of the collection announces their daring originality. As scholars have noted, it is an inventive oxymoron: a direct rendering of the Italian *novella*, the still relatively recent term *novela* was associated with bawdy, licentious stories in the manner of medieval *fabliaux*, while the adjective "exemplary" recalled the didactic probity of medieval *exempla*.[46] Bringing the two terms together, Cervantes sought to elevate the status of a disreputable narrative form. Exactly what lessons he intended his stories to exemplify, however, is famously ambiguous.

The heterogeneous pairing that constitutes the volume's title is matched in the heterogeneity of its stories, with their generic crossings and disruptions. "The Illustrious Kitchen Maid" is an obvious case in point, with a title, as paradoxical as that of the collection as a whole, that advertises its hybrid blending of the high-born world of romance with the lowly register of the picaresque. The author's resistance to the confines of genre brilliantly mirrors the impulses of the story's male protagonists—two young men from noble families who run away to join a band of *pícaros*, lured by the freedom of the underworld life. A similar mirroring of generic experimentation with storyline is found in "Rinconete and Cortadillo," whose eponymous heroes also take up crime as an escape from social constraints, while Cervantes draws on the picaresque only to break away from the limitations of its first-person point of view. By far the most revolutionary of the *Novelas ejemplares* is the last in the collection, "The Colloquy of the Dogs," whose satiric reuse of diverse literary forms (pastoral romance, love poetry, the picaresque) is surpassed only in *Don Quijote*.[47] As recent scholarship has emphasized, the generic diversity and hybridity of the novellas is the formal counterpart to all kinds of other crossings and confusions—of gender (as in "The Two Damsels"), geography ("The Spanish English Lady"), ethnicity ("The Little Gypsy Girl"), and class ("The Illustrious Kitchen Maid")—and the larger crises (social, political, and religious) they signal.[48]

While *Quijote* and the *Novelas ejemplares* established Cervantes's undisputed status as the greatest author of prose narrative of the age, he never gave up his pursuit of the other major genres. His most sustained engagement with poetry is found in *El viaje del Parnaso* (Journey to Parnassus) (1614), an adaptation of a 1582 Italian poem of the same title. Written entirely in tercets, this burlesque epic relates Cervantes's travels by mule to the mountain of fame and immortality where he and Spain's good poets battle it out against the poetasters. The journey allows him

to survey the vast and uneven landscape of Golden-Age poetic production and to reflect on his own place in the Spanish Parnassus.

As for drama, Cervantes once again tried his hand at this art form starting in the late 1590s, writing new plays and revising earlier ones. Although he never managed to sell any to theater companies, he was sufficiently proud of these works to publish them in a 1615 collection appropriately titled *Ocho comedias y ocho entremeses nunca representados* (Eight Comedies and Eight Interludes Never Performed). By far the most well-crafted and conceived of the *Ocho comedias* is the last, *Pedro de Urdemalas* (Pedro the Great Pretender),[49] whose ingenious, protean title character Cervantes based on a trickster from Spanish folklore. A number of dramas set in the Islamic world vow to Cervantes's persistent interest in Christian-Muslim contact and issues of religious identity and conversion, explained both by the indelible mark that his own five-year captivity left on him and by the impression made on him by debates surrounding the *morisco* expulsion, which took place in the very period in which he wrote these dramas. The majority of the interludes are small masterpieces that employ farcical humor to mock social pretension, government corruption, ignorance, and the obsession with honor and blood purity.

Already an old man of sixty-six when he published *Ocho comedias y ocho entremeses*, Cervantes remained vigorous in his literary ambition. In his dedication of this volume to the count of Lemos, he anxiously anticipated being able to offer him the second part of *Don Quijote*, followed by the Byzantine novel *Los trabajos de Persiles y Segismundo* (The Trials of Persiles and Segismundo), and two other works. He was only able to fulfill his promise for *Don Quijote*; but the "great *Persiles*," as he referred to it in the dedication, was important enough that he managed to finish it before his death, leaving the charge of its posthumous publication to his wife. Conceived by the author as his crowning achievement, *Persiles* narrates a semiallegorical pilgrimage from northern Barbarian lands to Christian Rome, interpreted variously as ideologically in line with Counter-Reformation values or as a critique of Spain's imperial project. Showcasing the intertwining of literature and art, paintings play an important role in the work's structure (particularly in book 3), mirroring and affecting its complex plot.

Lope de Vega
Playwright

"Fénix de los Ingenios" (Phoenix of Creative Geniuses) and "Monstruo de la Naturaleza" (Monster of Nature), as he was called by his contemporaries, Lope de Vega was the most prolific, wide-reaching writer of his time. To posterity his name is almost synonymous with Spain's *comedia nueva* (new theater). Performed in public playhouses known as *corrales de comedias*, the paradigmatic *comedia* was a play in three acts characterized by its combination of multiple verse forms, comic and tragic elements, high- and lowborn characters, and both learned and popular registers. Though not the outright inventor of the *comedia* (he learned much from the Spanish and Italian theater companies active on the peninsula from the 1550s on), Lope endowed it with the definitive form that would last a hundred years,

influencing dozens of playwrights in Spain and dramatists abroad.[50] In the words of Ezra Pound, "Whatever be the intrinsic merit of Lope's work: he gave Spain her dramatic literature, and from Spain Europe derived her modern theater."[51] Thematically, his theater ranged from history plays, peasant-honor dramas, romantic comedies (usually referred to as cloak-and-sword plays), *autos sacramentales* (one-act religious allegories performed for Corpus Christi), *comedias de santos* (plays about saints' lives), and mythological dramas. His sources were likewise multiple: historical chronicles and legends, popular ballads, hagiographies, Italian *novelle*. In terms of volume, Lope's level of production was nothing short of staggering: he left to posterity some 350 plays, though he most likely wrote a still more impressive total of 600–700.[52]

While such output could not ensure consistent quality, Lope applied his consummate skill as a poet and instinct for the stage to produce a host of masterful works. Of several accomplished romantic comedies, by far the most sophisticated is *El perro del hortelano* (The Dog in the Manger) (1613–15), about a countess's vacillations between her love for her secretary and her sense of duty to her social rank.[53] The happy ending is crafted by the clownish servant who invents a new identity for his master as the long-lost son of a nobleman. When the secretary's "natural nobility" (*nobleza natural*) forces him to confess the truth to the countess, she responds that society has no trouble accepting such falsehoods and entreats the audience to silent complicity.[54] The very artistry of the play, especially evident in its employment of no fewer than nine sonnets, reinforces its thematic preoccupation with artifice in social life, and the blatantly fabricated ending denaturalizes aristocratic privilege. Of his famous peasant-honor dramas, the most well-known and frequently performed is *Fuenteovejuna* (1612–14), which dramatizes the murder by villagers of their tyrannical overlord in 1476 and their subsequent pardon by the Catholic monarchs. Arguably more accomplished in its poetic craftsmanship is Lope's first foray into this subgenre, *Peribáñez y el comendador de Ocaña* (1605), in which the juxtaposition of traditional Castilian verse forms and Italianate meters underscores the dramatic conflict between peasants and aristocrats.[55] In the vein of tragedy, his most lyrically evocative play is *El caballero de Olmedo* (The Knight from Olmedo) (1620?), based on a refrain from a popular ballad about the assassination of a nobleman. Undoubtedly, his dramatic masterpiece is *El castigo sin venganza* (Punishment without Revenge) (1631), which borrows from a novella by Bandello to build a powerful tragedy of paternal love and adulterous incest.

Although most renowned today for his success as a playwright, for much of his career Lope himself had ambivalence toward his main occupation. The innovative and commercial nature of the *comedia nueva* made it a suspect genre in the eyes of many an intellectual and nobleman and hence a liability to his social aspirations. The clearest expression of that ambivalence is his *Arte nuevo de hacer comedias en este tiempo* (New Art of Making Plays in These Times), which he presented at the Academia de Madrid in about 1606, probably at the behest of the count of Saldaña, himself an advocate for the new theater. This famously contradictory manifesto at once flaunted the dramatist's classical credentials and flouted the authority of tradition in favor of that of his contemporary public.

In an effort to secure fame as a serious writer worthy of elite protection, Lope also cultivated the more prestigious genres of his day—the pastoral romance, the epic, collections of Petrarchan and devotional verses, among others.[56] The establishment of the court of Philip III and the duke of Lerma provided a particularly strong impetus to his literary and social ambitions.[57] As early as 1598 he dedicated to the future king his epic poem *La Dragontea* celebrating the death two years earlier of Spain's enemy Francis Drake. The end of the poem announces his authorial positioning (which would never be fulfilled) for an appointment as royal chronicler, "I, sir, will tell your praises while the sun continues to shine" (*[Y] y yo, Señor, tus alabanzas diga/mientras el Sol su elíptica prosiga*).[58] As Sarah Schroth notes in her essay in this volume, the year after Philip III's inheritance of the throne, Lope participated in his wedding entourage as secretary to the marquis de Sarría (future count of Lemos) and recorded those celebrations in a two-canto poem *Fiestas de Denia* (1599). A decade later he dedicated to Philip his most ambitious epic, *Jerusalén conquistada* (Jerusalem Conquered) (1609), an attempt to surpass Tasso's *Gerusalemme liberata* by rewriting the Third Crusade as a quest headed by Philip III's ancestor Alfonso VIII. Once again, Lope used his poetic art not only to praise the king but also to assert his own indispensability as an author.

Most emblematic of Lope's paired literary and courtly ambitions were his contributions to the canonization campaign of Madrid's rustic holy patron Isidro *labrador* (Isidore the farm laborer).[59] The choice of a humble farmer as the city's patron saint may seem incongruous to its recent establishment as the court center of the world's most powerful monarchy. In fact, though, the promotion of this laborer who had spent most of his life (1070–1130) in the service of a powerful landowner just outside Madrid quite literally grounded the young capital in a sacral geography.[60] Solicited by the Dominican friar spearheading the campaign, Lope's first major contribution to it was *El Isidro* (1599). This ten-canto poem, appropriately composed of traditional Castilian *quintillas* (stanzas of five lines), connected the life and miracles of the saint to the history of Madrid. About the same time, Lope composed a hagiographic play known as *San Isidro Labrador*. Active for more than a half century, the campaign for Isidore received renewed impetus when Philip III fell seriously ill in 1619; taken to the king's sickbed, Isidore's holy image supposedly cured him. Isidore's beatification was celebrated in 1620, followed by his canonization two years later. Lope de Vega contributed to the festivities with two more plays and a leading role in poetic jousts honoring the saint. As Elizabeth Wright has argued, especially in his 1599 poem, he deliberately linked his labor as a court poet to Isidore's occupation as laborer of the land.[61] Invoking the ancient analogy of poetry and painting, he also compared his authorial identity to that of an artist.[62]

Lope and the Visual Arts

Of the major writers of his generation, no one had a greater affinity for artists than Lope de Vega.[63] That affinity was in no small part the product of his upbringing as the son of a master embroiderer (himself the son of a silversmith) who, along with countless other skilled craftsmen, had flocked to Madrid to help build Philip II's new court capital. An esteemed member of his guild (he served as *bordador de la Reina*), Félix de Vega belonged to a milieu of upwardly mobile artisans and painters committed to ensuring fine educations for their sons. Javier Portús mentions, for example, the case of Pedro Gutiérrez, a tapestry maker employed by Philip II whose son Gaspar Gutiérrez de los Ríos trained as a lawyer and went on to pen the *Noticia general para la estimación de todas las artes* (General Information for the Appreciation of All the Arts) (1600), the first writing of its kind in Spanish to defend the nobility of arts traditionally considered mechanical.[64] From a similar background, Lope de Vega also became a great advocate for artists, and painters above all.

Although he did not contribute to contemporary art theory in as systematic a way as Gutiérrez de los Ríos or the more well-known Francisco Pacheco and Vicente Carducho, Lope did offer one theoretical statement on painting in his contribution to Carducho's and Cajés's defense before the treasury in the late 1620s. Along with the declarations of several other legal and literary minds who supported the painters' cause, Lope's testimony was published in 1629 with a full title that duly acknowledged his intellectual prestige, *Dicho y deposición de Frey Lópe Félix de Vega Carpio, del hábito de S. Iuan, celebrado en el mundo por su ingenio, que está en los autos desta causa* (Statement and Deposition of Fr. Lope Félix de Vega Carpio, Order of San Juan, Honored in the World for His Genius, Which Has Been Offered in Support of This Cause).[65] For the most part, his arguments were typical of defenses of painting: beginning with the ancient *deus pictor* topos (God, the painter of the universe and of man in his image and likeness), he marshaled classical and Church authorities to establish the venerability of this art throughout the ages; turning to his own times, he invoked the Tridentine affirmation of the respect due to holy images and gave examples of how the Spanish Hapsburgs have always honored painters. On a more personal note, meant to prove the royalty's esteem not only for painters but also skilled artisans (like his own father and grandfather), he recalled hearing his parents say that during the royal entrance of Isabel of Valois to Madrid, "every tradesman had been ordered to the festivities, including soldiers and the officers with their flags and their drums and their guns, but only painters, embroiderers, and silversmiths were excepted."[66] Lope also managed to pepper his statement with his wit, arguing that since the Virgin Mary "never had to pay the debt" of original sin, so, too, should those who paint her image be free from paying taxes.[67]

Beyond this legal statement, Lope's esteem for painters is reflected throughout his literary oeuvre. In contrast to Cervantes, who seems to have had little

contact with the painters of his age and rarely mentions them in his work, Lope counted several among his friends and made the celebration of their art a frequent subject of his poetry. The artists he praises in his verse include: Diego de Urbina (an important painter at the court of Philip II whose daughter, Isabel de Urbina, Lope abducted and married in 1588); Felipe de Liaño (a highly skilled creator of portrait miniatures in the Madrid of the late sixteenth century and also apparently a close friend of the writer); Juan Pantoja de la Cruz (whom he must have known); Francisco Ribalta (whom Lope may have met when he traveled to Valencia as part of the entourage that followed Philip III on his wedding trip to that city); Francisco Pacheco (whose intellectual circle the author frequented as a resident in Seville between 1602 and 1604); and Vicente Carducho, Eugenio Cajés, Juan van der Hamen, and Juan Bautista Maino (all painters who dominated the artistic scene in Madrid in the 1620s and to whom Lope was closely connected).[68] Many of Lope's poems in praise of artists employ well-worn commonplaces: Spain's modern painters rival Apelles and Zeuxis; they bring envy to Nature in their creative powers; they make the dead seem living. But even if their metaphors are not always original, they offer eloquent testament to the author's active participation in a culture of mutually reinforcing artistic production and social promotion. Cited by Ronni Baer in her essay in this volume, his *Jerusalén conquistada* poem in praise of Pacheco's skill with both brush (*pincel*) and pen (*pluma*) is a case in point. As Lope himself would later explain in his dedication to Pacheco of his play *La gallarda toledana*, in which he reprinted the poem, he originally composed it in gratitude to the artist-writer for having included his portrait among those of the learned elite immortalized in his *Libro de retratos*.[69] For his part, Pacheco reinforced his admiration for Lope by offering a prologue to *Jerusalén* in which he celebrated the author's vast literary production, emphasizing his genius (*ingenio*) and artistry with words (*artificio de sus letras*).[70] Lope would again pay homage to Pacheco by including him (along with several other artists and some three hundred authors) among the *ingenios* honored in his lengthy poem *Laurel de Apolo* (1630).[71] But where most of the other painters are mentioned together in the ninth *silva*, Pacheco appears among the Sevillian poets praised in the second.[72]

Lope's literary reflections on art are by no means limited to references to specific painters. Overall, his work reveals a profound interest in the nature of visual representation, and his drama, especially, makes frequent use of paintings as the focal point of action and thematic exploration. Even a seemingly incidental mention of a portrait in the comedy *La dama boba* (Lady Simpleton) (1613) has important cultural implications: when the dimwitted title character complains that her father has betrothed her to a man with no legs (she has only seen him in a half-length portrait painted on a small card), the playwright comments on portraiture as a learned form of visual signification indispensable in urban social commerce.[73] In a more serious vein, *La quinta de Florencia*

(The Tuscan Villa) explores the dangerously seductive power of pictures of nudes, as the nobleman's lust for a Venus painted by Michelangelo leads him to rape a peasant girl who resembles her.[74] *Peribáñez y el comendador de Ocaña* also reflects on the connection between painting and desire. Madly in love with Peribáñez's beautiful young wife, the overlord commissions a painter to secretly sketch her portrait, a large canvas copy of which Peribáñez discovers in a painter's studio in Toledo where he has taken a statue of their village patron saint for repair. Dramatically, the portrait functions to alert the husband of his rival's dishonorable intentions and take action (by murdering him) before he fulfills them. Thematically, the juxtaposition between the likeness of the woman commissioned by the comendador and the religious sculpture cared for by the villagers foregrounds the contrast between aristocratic excess and peasant piety central to the drama's ideological workings.[75]

That piety is directed to another devotional image as well—that of the Virgin del Sagrario, patroness of Toledo, whose feast-day procession brings together the villagers and their king, Enrique III. As the central axis of the drama, Toledo brims with cultural significance. Lope composed *Peribáñez y el comendador de Ocaña* in 1605 while residing in the city,[76] in a period, coinciding with the court's relocation to Valladolid, in which Toledo was vying to reclaim its traditional status as Spain's political and spiritual capital.[77] We know that the dramatist lent his pen to Toledo's cause on another occasion—a 1605 poetic competition celebrating the birth of the new prince, the future Philip IV, which took as its theme the city's privileged connection to the monarchy and its claim as the rightful home of the court.[78] Analogous to his Isidore plays that contributed to the beatification of the saint and the exaltation of Madrid, *Peribáñez* also participated in the project of Toledo's promotion. Although the painter in the play is not identified, his busy studio and ability to work in diverse genres pay homage to the city's importance as a center of artistic activity. A speech by Enrique III bestows yet more explicit honor on Toledo and its magnificent cathedral, reminding audiences of its preeminence as the most powerful archbishopric in Spain.[79] Above all, the Virgin del Sagrario, venerated by monarch and peasants alike, crowns the drama's exaltation of Toledo as the heart of Spain. In the same years when Lope wrote this drama, construction of the costly chapel dedicated to her in Toledo Cathedral had already begun. Though the dramatist would not be involved in the festivities celebrating its completion in 1616, his play had already promoted the cult of her "sovereign image."

68
Portrait de Lope de Vega in *El peregrino
en su patria* (Seville, 1604)
Biblioteca Nacional de España, Madrid

Lope's Own Image

Not only the writer of his generation who most admired the visual arts, Lope de Vega also took greatest advantage of them to construct his own image. From contemporary sources, we know that at least twenty-five portraits of the author were made during his lifetime; of those, more than a dozen survive to this day.[80] Among the earliest was the drawing by Pacheco that Lope acknowledged in his dedication of *La gallarda toledana.* In the form of frontispiece engravings, other early portraits reveal his authorial pride and social pretensions. One of the most grandiose was published in his 1604 novel of adventure *El peregrino en su patria* (The Pilgrim in His Homeland) (fig. 68). Portraying him in the fashionable ruff (*lechuguilla*) of a courtier, the portrait is framed by an ornamental cartouche

beneath which hangs a coat of arms with nineteen towers falsely claiming a noble descent from the legendary hero Bernardo del Carpio; the Latin inscriptions surrounding the portrait allude to the envy that comes with fame, while the laurel-wreathed skull above assures the security of fame beyond the grave.[81] Another aggrandizing image, the anonymous frontispiece illustration of *Jerusalén conquistada* depicts the author as stoic sage (fig. 69), his portrait bust resting on a pedestal with an inscription declaring his agelessness (*Aetatis su ae nichil*). Positioned at the entryway of a triumphal arch inscribed with the name of Philip III, his dedicatee, the portrait bust fashions the poet as a pillar of the monarchy.[82] Pacheco's laudatory prologue to *Jerusalén* mentioned above opens as a gloss on this portrait, "Esta es la efigie de Lope de Vega Carpio, a quien justissimamente se concede lugar entre los ho[m]bres emine[n]tes, y famosos de nuestros días" (This is the likeness of Lope de Vega Carpio, to whom a place among the eminent and famous men of our day is most justly accorded). One might suspect that it was precisely this frontispiece and accompanying text that Cervantes satirized in the false ekphrasis that begins the prologue to the *Novelas ejemplares*.

Lope's later portraits are superior in both artistic quality and sensibility. None surpasses the copper engraving made by Pedro Perret and published in *Triunfos divinos, con otras rimas sacras* (Divine Triumphs, with Other Sacred Verses) (1625) (fig. 70). Already over sixty years old, in clerical garb (he had been ordained as a priest in 1614), the sitter is portrayed with an exquisite balance of detail and simplicity and psychological incisiveness. In the medium of painting, the best extant portrait of the author is one attributed to Eugenio Cajés. Housed today in the Fundación Lázaro Galdiano in Madrid, it was probably owned by his longtime patron the duke of Sessa.[83] Most striking about this portrait of the nearly seventy-year-old author is the double display of the Cross of Malta. A fulfillment late in life of his pursuit of ennoblement through his literary art, this honor had been bestowed upon him by Pope Urban VIII in 1627 in gratitude for having made him the dedicatee of his drama *La corona trágica* (The Tragic Crown) about Queen Mary Stuart.

The last identified likeness of Lope is found in Vicente Carducho's painting *Death of the Venerable Odón* (1632) (fig. 71). The two had apparently been friends since the early 1620s, when Carducho's name begins to appear in Lope's writing.[84] As we have seen, later in the decade the author offered his support on behalf of Carducho and Cajés in their legal defense against the Royal Treasury. Lope also reserved a place for Carducho in his *Laurel de Apolo*. Once again, he celebrated Carducho's art in the poem he wrote for the *Diálogos de la pintura* extolling the power of painting as nothing short of divine.[85] The admiration was entirely mutual; among the several *ingenios* whom Carducho extols in the *Diálogos* for their ability to "paint" with words, Lope receives particularly lavish praise as renowned creator of drama and poetry, including the very *Laurel de Apolo* that summoned Carducho to the pinnacle of Parnassus.[86] *Death of the Venerable Odón* offers visual testament to the friendship between the painter and the writer, for Carducho places an aged Lope, his face shown in profile, immediately behind a portrait of himself kneeling in prayer.

69
Portrait of Lope de Vega in *Jerusalén conquistada* (Madrid, 1609)
Biblioteca Nacional de España, Madrid

70
Pedro Perret, *Portrait of Lope de Vega* in *Triunfos divinos, con otras rimas sacras* (Madrid, 1625)
Biblioteca Nacional de España, Madrid

71
Vicente Carducho
Death of the Venerable Odón, 1632
Oil on canvas, 135¹³⁄₁₆ x 124¹⁄₁₆ in.
(345 x 312 cm)
Museo Nacional del Prado, Madrid

73
Portrait of D. Luis de Góngora in *Obras de Luis de Góngora* (Chacón manuscript, 1627)
Biblioteca Nacional de España, Madrid

72
Juan de Courbes
Portrait of Luis de Góngora, in José Pellicer de Ossau y Tovar, *Lecciones solemnes a las obras de Don Luis de Góngora y Argote* (Madrid, 1630)
Biblioteca Nacional de España, Madrid

Luis de Góngora: The Poet and Painters

In the same years that Lope de Vega was developing a friendship with Carducho, his greatest poetic rival, Luis de Góngora, was painted by Carducho's own competitor, Diego Velázquez (cat. 17). Along with El Greco's portrait of *Fray Hortensio Félix Paravicino* (cat. 12), Velázquez's *Luis de Góngora y Argote* is one of the most incisive likenesses of a writer from seventeenth-century Spain. The Sevillian artist executed this portrait in April 1622, during his first visit to Madrid. At the time, the sitter was sixty-one years old and had been living in the city since 1617. A native and resident of Córdoba for most of his life, Góngora had a long love-hate relationship with the court,[87] but his arrival in 1617 looked promising, bolstered by an appointment as royal chaplain. Unfortunately, Madrid let him down, and he was faced with financial hardship as well as the devastating loss of powerful supporters such as Rodrigo Calderón, executed in October 1621, and the count of Villamediana, assassinated in August of the following year. As Jonathan Brown has put it, "The young Velázquez sensed the sad truth of this great, but isolated genius and recorded it without giving an inch."[88]

Velázquez portrayed Góngora at the behest of his father-in-law Francisco Pacheco, who presumably planned to make a drawing after it for inclusion in his *Libro de retratos.*[89] In keeping with Pacheco's format for his portraits of illustrious poets, the artist originally depicted his sitter crowned with a laurel wreath, but subsequently painted it out.[90] We do not know why he made that alteration. At the very least, it rendered the image more consonant with the painted bust portraits of intellectuals being cultivated at the time, as in Juan van der Hamen's series of *hombres ilustres* (illustrious men), which included a lost portrait of Góngora.[91] Velázquez's simplified version of the portrait is also very much in keeping with his own developing naturalistic aesthetic—the "modesty" (*modestia*) that Pacheco would claim Rubens admired in the artist's work.[92] As a portraitist, Velázquez most notably cultivated that aesthetic in his paintings of Philip IV. An "enemy of flattery," as Brown has called him, Velázquez eschewed ornamentation to better construct the inherent grandeur of his royal sitter.[93] In the portrait of Góngora, the deletion of the laurel wreath put the poet's towering intellect into sharper relief; as one of Spain's most brilliant minds, he needed no adornment. As so often in the period, the relationship between artist and writer was mutually reinforcing. Velázquez's portrait paid homage to the great poet and served as the model for the engraving of the author, by French-born artist Juan de Courbes, published in José Pellicer de Ossau y Tovar's *Lecciones solemnes a las obras de Don Luis de Góngora y Argote* (fig. 72). At the same time, the portrait helped establish the painter's own fame at court.[94]

Yet a more explicit manifestation of Góngora's mutual support for artists is the encomiastic sonnet "Hurtas mi vulto" (You Steal My Figure), which he wrote in response to the portrait that Juan van der Hamen y León painted of him in 1620 for the artist's series of illustrious men.[95] In the sonnet, Góngora builds on the *topos* of the portraitist as Prometheus, the rebellious god who stole fire from Zeus to enliven a clay figure.[96] Thus, the poet celebrates the artist's "divine" theft,

his ability to animate the canvas ("rival of [the god's] clay" [*émulo del barro*]) with the sitter's living spirit (*espíritu vivaz*); so alive is the canvas that it "thirstily drinks" (*sediente bebe*) the painter's colors. As if addressing the artist in the very moment of sitting for his portrait, the poet exhorts him to continue in his "noble theft" (*hurto noble*), confident of the imperishability of the final product. His hopes, however, were partly defrauded: the Van der Hamen original did not survive. Nevertheless, a drawing based on it (fig. 73) is still preserved in the famous Chacón manuscript of the poet's collected works, *Obras de D. Luis de Góngora*.[97]

Without a doubt, the poet's greatest tribute to a painter is his 1614 epitaph-sonnet to El Greco. Although Góngora's precise relationship to the Toledan artist is unknown, it is likely that he counted him among the many friends and acquaintances he had in Toledo, a city he greatly admired and visited on several occasions. He most loudly sang its praises in his only finished *comedia, Las firmezas de Isabel* (The Constancy of Isabel) (1610), which is set in the "Imperial City," and includes a more than fifty-verse-long encomium to its cultural and architectural splendor (both civil and ecclesiastical), as well as to its most eminent citizens— above all, the duke of Lerma's uncle, Archbishop Bernardo de Sandoval y Rojas.[98] Góngora's verbal eulogy of Toledo has been rightfully compared to El Greco's magnificent paintings of the city,[99] and if El Greco's name is not mentioned there, certainly the epitaph-sonnet offers eloquent testimony to the poet's admiration for its most illustrious painter:

> This in elegant form, oh wayfarer,
> a hard key of shining porphyry
> denies to the world the softest brush
> ever to give spirit to wood, life to linen.
>
> His name, deserving of even greater breath
> than the trumpets of Fame could ever blow,
> makes the surface of this grave marble illustrious.
> Venerate it and continue on your way.
>
> Here lies the Greek. Nature inherited
> Art, Art skill, Iris colors,
> Phoebus light, Morpheus shadows.
>
> May this great tomb, despite its hardness
> soak up tears and aromas sweat
> by the funereal bark of the Sabaean tree.[100]

The quatrains function as an apostrophe to a passerby, commanding him to pause at the marble tomb whose hardness denies the world its softest brush—a metonym for the painter—and pay it tribute. Beginning with the stark declaration, "Here lies the Greek," the first tercet functions as the epitaph proper. Employing the conceit of the reading of a will and a series of personifications, the poet enumerates the artist's bequests to nature, to the visible world, and to art itself.[101] El Greco does not so much compete with nature as contribute to its own artistry— endowing, for instance, the rainbow with new colors. Similarly, the poet does not so much rival the painter as use his verbal art to build on his legacy and immor-

talize his name. In the first quatrain, he celebrates the painter's ability to give life to wood and canvas, employing the graceful alliteration *leño/lino* (wood/linen, i.e., canvas) to capture the fluid movement of his brush. In the final tercet, the poet himself strives to enliven an inanimate surface, the stone on which he has inscribed his epitaph, imploring it to "soak up the tears" of mourning and "sweat the aromas" of frankincense.

The Poet's Art

It is no accident that Góngora applied his poetic art to eulogize that of El Greco, for he must have identified with the painter who had drawn almost as much censure for his daring originality as he had admiration. By the time he penned the epitaph-sonnet, Góngora had become both famous and infamous as the most audacious poet of his age for his cultivation of linguistic difficulty and extravagantly wrought artistry.

Góngora's poetic career began in the 1580s.[102] He dedicated his first period of production, which spanned from that decade through the early years of Philip III's reign, to the emulation and reinvention of both Castilian and Italianate verse forms. In the former category, he gave new life (as did his rival Lope de Vega) to the traditional *romance* (ballads of lines of eight or six syllables in assonant rhyme). He also refashioned another popular lyric form, the *villancico*, into playful, often bitingly satirical and sophisticated *letrillas* (poems of short verses organized in stanzas with a repeated *estribillo*, or refrain). The early Góngora is perhaps most famous as a master of the sonnet.

Indeed, his best-known sonnets display the dazzling ornamentation that is one of the poet's hallmarks. These are poems meant to outdo their predecessors with ingeniously novel conceits that revel in their own artifice. Góngora's rewriting of Garcilaso's famous *carpe diem* sonnet "Mientras por competir con tu cabello" (While to compete with your hair) (itself based on the classical "Collige, virgo, rosas") is the classic case in point. The poem makes rivalry its explicit theme from the very first lines, "While to compete with your hair,/gold burnished in the sun gleams in vain" (*Mientras por competir con tu cabello/oro bruñido al sol relumba en vano*). Just as the lady's beauty triumphs over gold, lilies, carnations, and crystal, the poet's imitation surpasses the original, dethroning in the process the host of Petrarchan commonplaces upon which it drew.

The brilliant artifice of the sonnets is often built of precious gems and imported luxury goods, their exoticism accentuated verbally by the profusion of imported Latinisms. Lavish references to sapphires, emeralds, diamonds, mother-of-pearl, Indian ivory, and Arabian silk make them the verbal equivalents of the duke of Lerma's *camarín*, with its glittery display of rare objects. It is not just the poems' mention of such objects that dazzles, however; it is also the ingenuity and complexity of the conceits fashioned from them. Such is the case for "Prisión del nácar era articulado" (Prison of jointed mother-of pearl) in which extravagant metaphors and hyperbaton (the radical rupture of normal word order) make the meaning of the poem as hard to extract—but ultimately as marvelous—as the precious metals and stones encrusted within it.[103]

"Cornucopias of poetic tribute to beauty," in the words of Mary Gaylord, Góngora's most characteristic sonnets are also, similar to Baroque *vanitas* paintings, reminders of its fugacity and false allure.[104] The lady's beauty in "While to compete with your hair" does not just fade; it and she herself turn into "earth, smoke, dust, shadow, nothingness" (*en tierra, en humo, en polvo, en sombra, en nada*). Hiding between the red lips of "The sweet mouth that invites to taste" (*La dulce boca que a gustar convida*) is a serpent (i.e., tongue and also biblical allusion) waiting to discharge its poison. And yet in his sonnets memorializing Queen Margaret of Austria, the mutability of beauty ultimately gives way to an image of rebirth. Thus, for example, one of the three poems he wrote in 1611 for the catafalque erected for the queen in Córdoba concludes with an image of rebirth as "the dark shell of a *Margarita* [the queen's name was a kind of a pearl]/who, a ruby in charity, in faith a diamond,/is reborn in a new Sun, a new Orient."[105]

Góngora's notoriously difficult style and aesthetic preoccupations came to full fruition in *La fábula de Polifemo y Galatea* and the *Soledades*, which first circulated in manuscript form in 1613–14. The former is a reworking of Ovid's story of Acis and Galatea (*Metamorphoses*, 13), in which the beautiful nymph Galatea is wooed both by the handsome youth Acis and by the hideous Cyclops Polyphemus. When Acis wins her love, Polyphemus turns mad with jealousy and hurls a boulder at his rival to kill him; in the end, Acis is transformed into a river at the foot of Mt. Etna in Sicily. This story of rivalry and metamorphosis could not have been better suited to Góngora's poetic project, committed as it was to surpassing literary models by refashioning—indeed, metamorphosizing—them.[106] This is what he did to Ovid's tale. In sheer extension, Góngora's poem of 504 verses is three times longer than the original; that those verses are organized into *octavas reales* (octaves), a heroic meter, underscores his poetic ambition. At the level of content, Góngora amplified the story's inherent tensions through the creation of bold contrasts between ugliness and beauty, darkness and light, idyllic eroticism and violent passion. Those contrasts are wrought into the poem not only thematically but also stylistically, with verses of beautiful balance and proportion poised among tortuous uses of hyperbaton.[107] Artistically, Góngora exploited the theme of metamorphosis to fashion richly dense verbal conceits able to capture nature's own abundant creativity (e.g., almonds produced of "the heavenly liquid [i.e., Zeus's sperm] recently coagulated")[108] and exquisite artifice (e.g., a "shady canopy" of a cliff, "green blinds" of ivy, a "carpet" [of soft grass] woven of the "silks" of Spring).[109] Góngora also departed from his source in terms of narrative voice. In Ovid, Galatea relates her story with a few interruptions from a third-person narrator. In Góngora, the nymph is silent. Instead, the poet-narrator speaks, but for the thirteen stanzas that he cedes to Polyphemus's famous song to Galatea. The giant's thunderous voice accompanied by his untuned pipes produces a monstrous music but also some passages of beautiful verse. His song thus becomes a figure for his creator's own poetics of both shocking disproportion and lyric beauty.

More ambitious in scope than *Polifemo* is Góngora's *Soledades*, originally

intended as a four-book poem, of which only the first was finished and a fragment (albeit a lengthy one) of the second. The syntactic difficulty and metaphorical density (even opacity) of the *Polifemo* are also salient characteristics of the *Soledades*. Formally, however, they are radically different, replacing the ordered *octavas* of the first poem with irregular *silvas* (which combine seven- and eleven-syllable lines lacking fixed rhyme-scheme or stanzic structure). Etymologically related to the word *selva* (jungle), this meandering form is well-suited to the story, about the wanderings of a shipwrecked youth through a rustic landscape. On his way, the lonely pilgrim meets up with mountain folk, goatherds, villagers, fishermen, and, later, an aristocratic hunting party. One of the most notable sections of the first *Soledad* is a tragic-epic in miniature about Portugal's and Spain's global conquests. Recounted by an old man who lost his own son to a shipwreck, this passage reveals the poet's deep ambivalence toward Spain's imperial project—his celebration of heroism, on the one hand, and condemnation of New World greed, on the other.[110] But if Góngora was ambivalent about the economic and human costs of empire, he took great pride in having elevated Castilian to the stature of the imperial language par excellence: in his own words, "[A]t the cost of my labor, our language has arrived at the perfection and sublimity of Latin."[111]

Góngora made that claim in response to an anonymous "friend" (probably Lope de Vega) who wrote a letter attacking the *Soledades* for their babelic confusion. Such attack was common; along with *Polifemo*, this audacious poem unleashed a virulent polemic. Even his friend Pedro de Valencia had strong objections. Góngora had sent these texts to him for initial review in 1613. The royal chronicler, who had two years earlier celebrated the "purity and propriety" of Castilian in his imprimatur to Covarrubias's dictionary, decried Góngora's new poetry for violating the "inherent beauty and natural greatness" (*belleza propia i grandeza natural*) of the language.[112] Góngora's enemies (including Francisco Quevedo) went further, labelling his style *culterano* (cultured) in a purposeful echo of the Castilian word *luterano* (Lutheran) that branded the Cordoban poet's style as heretical.

But Góngora also had defenders and followers. Not least among them was Fray Hortensio Félix Paravicino, who applied the poet's putatively heretical language to an oratory meant to heighten the impact of its religious messages through effects of surprise and wonder. Born in Madrid in 1580, he began preaching about 1605, though his first published sermon dates to 1616 when the archbishop of Toledo, Bernardo de Sandoval y Rojas, invited him to participate in the festivities celebrating the dedication of the Virgin del Sagrario chapel.[113] In 1617, shortly after Góngora was granted the title of *capellán real* by Philip III, Paravicino was appointed *predicador real* (royal preacher). Like Góngora, he also had his share of detractors. Nonetheless, the friar-intellectual immortalized by El Greco continued to dazzle the court and the royal family with his daring rhetorical novelty until his death in 1633. Fifteen years later Baltasar Gracián would celebrate *lo ingenioso* (the ingeniousness) of his ideas and *lo bizarro* (the splendor) of his speech.[114]

Epilogue: Heroic Audacity

The innovative genius that characterizes the narrative, drama, poetry, and even oratory of the Spain of Philip III, as well as the sheer generic expansiveness of the authors who excelled in these literary forms, cannot be considered an anomaly, or even a mere coincidence. Literature flourished not in ironic disjunction with some supposed era of decline but rather as the result of the opportunities opened to writers by the convergence of—and productive tensions between—a vital commercial market for books and plays and a competitive culture of court patronage. As we have seen, unprecedented levels of literacy, achieved through a century-long expansion in education, had given rise to a broad reading public with an insatiable thirst for books. That public, including readers who consumed literature by listening, reached its maturity precisely during the reign of Philip III, when genres popular in the sixteenth century were ripe for renovation and even deconstruction.

Especially in the area of narrative literature, no one was better prepared to experiment with established models and create new ones than Cervantes, with his particular combination of brilliant literary gifts and extraordinary life experience. Of the major authors of his generation, none had lived anything as heroic as Lepanto or traumatic as five years of Algerian captivity. No other had traveled as far and wide. Though Lope spent periods of his life in cities other than Madrid, the Spanish capital was really his home, and Góngora was above all a Cordoban poet. Only Cervantes had spent ten years traveling outside the peninsula between Italy and North Africa, followed by a peripatetic decade in Andalusia, before finally settling in Madrid.

Compared to these other literary giants, he was a relative outsider. For all their disappointments at court, Lope and Góngora were able to insert themselves more fully within the circuits of patronage and power; we need only recall, for example, that Lope, as secretary to the marquis of Sarría, was a member of the retinue that accompanied Philip III on his lavish nuptials, or that Góngora was honored with an appointment as royal chaplain. Cervantes never worked for a noble household or secured an important office—one of his greatest frustrations was a series of failed petitions in the 1590s to a post in the royal administration of the Indies. Only in the last period of his life did he find a steady patron, the count of Lemos, to whom he dedicated all his works published between 1613 and 1616. Yet, Cervantes's choice of his dedicatee was tinged with irony; Lemos had greatly disappointed the writer when he failed to include him among the literary coterie he took to Italy as viceroy of Naples in 1610, a fact Cervantes recalled in a gibe he made comparing the viceroy to the emperor of China in the 1615 dedication of *Don Quijote*.[115] Rather than stymie his creativity, Cervantes's frustrations fueled it. It has often been said that had he realized his ambition for an administrative career in the Indies, he never would have written *Don Quijote*. More obvious, his disappointments contributed to an ongoing preoccupation with the nature and contingencies of authorship and authority. His was an authorial identity constructed in constant tension with the very figures of authority whose support he coveted but never fully secured.

As extraordinary as Cervantes's life was, however, he has too often been cast as a lone critic of a homogenizing Spain steeped in orthodoxy.[116] Such a Spain is itself a reductive construct, for in fact there were multiple voices of dissent regarding official policies and constant debates concerning the country's social and economic woes. Cervantes's genius lay in his ability to capture those voices and the ideological complexity of his times by bringing into radical juxtaposition the main literary forms of his day and the multiple perspectives—linguistic, social, and ideological —they encoded.

Born and raised in Madrid almost immediately upon its establishment by Philip II as the capital of Spain, Lope de Vega was well positioned to build a literary career that straddled the city's double nature as *corte* (court) and *villa* (town). He was not yet twenty years old when Madrid's first public playhouses opened (El Corral de la Cruz in 1579, El Corral del Príncipe in 1581), but he would soon become the preeminent playwright of his day, perfecting a theatrical formula ideally suited to the cultural needs of an exploding urban populace. Although he is remembered less as the author of a work like *Jerusalén conquistada* than *Fuenteovejuna*, as we have seen in fact he was as much a court poet as a commercial playwright, endowed with a combination of genius and social ambition that allowed him to exploit every available literary venue of his day. If scholars have frequently projected onto Cervantes the image of an antiestablishment writer, in Lope de Vega they have often seen a propagandistic defender of monarchy whose works for the stage in particular served to promote Spanish Old Christian values. Lope certainly drew from Spain's rich ballad tradition, its legends, and historical chronicles to create a national theater and a collective identity around it; yet plays like *El caballero de Olmedo* dramatize the tragic costs of exclusionary practices, and numerous political dramas critique kingship rather than glorify it.[117] Moreover, as a literary form that flouted the classical rules, the *comedia nueva* he perfected was anything but conservative.

Lope has also often been taken as the antithesis of Luis de Góngora. While Góngora's poetic idiom stood out for its artistic difficulty and alleged foreignness, Lope's verse was considered natural, quintessentially Castilian, and he was especially celebrated for his seemingly spontaneous *romances* (ballads) and homespun lyric poems. But he also wrote more complex poetry, eventually even imitating Góngora's difficult style, and naturalness was itself a pose, one of the many faces of the most protean of the writers of his generation.[118] As the multiplicity of his portraits makes clear, Lope de Vega was the author most obsessed with his own image.

As for Góngora himself, although he had been writing poetry since the 1580s, it was the establishment of Philip III's court that created the cultural and social conditions that pushed him to become the radically innovative poet for which he is most famous. While motivated by official business on behalf of Córdoba's cathedral chapter, Góngora's first visit to the court at Valladolid in 1603 inspired in him new literary ambitions, and he began to write verses that won the favor of, and often celebrated, many a grandee. The canonization of his poetry also began during that visit when the poet Pedro Espinosa made him the writer most heavily represented in his anthology *Flores de poetas ilustres* (Flowers of Illustrious Poets)

(Valladolid, 1604). It was either during or immediately after a later trip to court (relocated in Madrid) in 1611 that Góngora first saw, hot off the press, the collected works of another Cordoban poet, Luis Carrillo y Sotomayor, whose *Fábula de Acis y Galatea* (Fable of Acis and Galatea) inspired Góngora's own, more daring version of the Ovidian story. The social stakes in this courtly game of literary one-upmanship were high: not incidentally, Góngora dedicated his *Polifemo y Galatea* to the count of Niebla, the same aristocrat Carillo y Sotomayor had chosen as his dedicatee.[119] And as we saw above, it was at court where Góngora would first have that poem circulate along with the *Soledades*, launching, to his surprise, the most bitter literary polemic of the day. Although Góngora's so-called new poetry was attacked for its supposed violence to the Castilian language, within a year of his death he was canonized as no less than the Spanish Homer.[120]

The idea of national literatures is a modern concept that emerges in tandem with the rise of the nation-state. Yet, it was already being forged in the early modern period—less in the sense of competition among nations than between the present and the classical past, as the vernacular languages and literatures consciously competed with those of ancient Greece and Rome. Nowhere was that competition more pressing than in Spain, the largest imperial power in Europe from the late fifteenth century until the end of the Thirty Years' War in 1648. As many a student of Golden-Age Spanish literature has heard, it was no accident that the first Spanish grammar, Nebrija's *Gramática castellana* (1492), was published the same year that Columbus discovered America (also the same year as the expulsion of the Jews and the reconquest of Granada); in Nebrija's famous words, "Language is the handmaiden of empire" (*[S]iempre la lengua fue compañera del imperio*).[121] Yet, it would take another hundred years for Spanish—or, more exactly, Castilian—literature to fully come into its own. For despite Spain's rise to unparalleled political power in the sixteenth century, authors still carried a sense of cultural belatedness, especially in relation to Italy, large portions of which belonged to the Spanish crown.

While it was well on its way to being redressed in such monumental works as Fernando de Herrera's commentary on Garcilaso de la Vega (1580), that sense of belatedness was only surpassed during the reign of Philip III when Sebastián de Covarrubias affirmed the necessity of a Spanish dictionary not only for the benefit of the "Spanish nation" (*la [nación] española*) but also for all those nations "anxious to learn our language" (*que con tanta codicia procuran deprender nuestra*

lengua); Cervantes proudly declared himself the first to "novelize" in Castilian without relying on imported models; Lope boasted a theater newly molded to the temperament of the Spanish people that would, in turn, influence the shape of theater in the whole of Europe; and Góngora claimed to have elevated Castilian to the "perfection and sublimity of Latin" through his poetic labor.[122] These authors wrote in often virulently competing idioms within their native language, contributing to debates about what was proper or improper, natural or foreign to it, but each knew that he was giving shape to literary forms that had nothing to envy Greece, Rome, or Italy.

It might be argued—and has often been assumed—that the literary achievements of Philip III's Spain were ahead of those made in the realm of the visual arts. With a wide range of venues open to their work and relatively few constraints on its content (save for the case of religious subjects), Spain's writers were able to create a literature of tremendous formal and thematic originality and variety. Trained in a more tightly controlled guild system and largely dependent on commissions, with the art market still quite new, painters were more limited in their opportunities for expansion. Despite the cultivation of new genres such as the *bodegón* and the broadening of portraiture beyond the royalty and aristocracy, religious subjects and formal portraiture dominated, and the focus of innovation was more technical than thematic. But we should keep in mind that the very medium of images in contrast to that of words created less demand for local painters to apply their talents to subject matters well covered by Northern and Italian imports (e.g., genre paintings and mythological themes)—after all, *ut pictura poesis* notwithstanding, pictures do not require the same kind of linguistic translation as poems, plays, or novels.

Moreover, for the undeniable differences between literary and artistic production in the Spain of Philip III, socially and intellectually writers and painters saw themselves as sharing fundamental interests and goals. Their shared aspirations can perhaps best be summed up with reference to two characters from classical mythology—Icarus and Prometheus. In early-seventeenth-century Spain, Icarus's wings were frequently equated with the writer's pen (*pluma*, "feather"), the fire of Prometheus with the animating spirit painters gave to figures on the canvas. And what was emphasized in these analogies was not the crushing fate that befell the young man and the Titan but rather their heroic audacity.

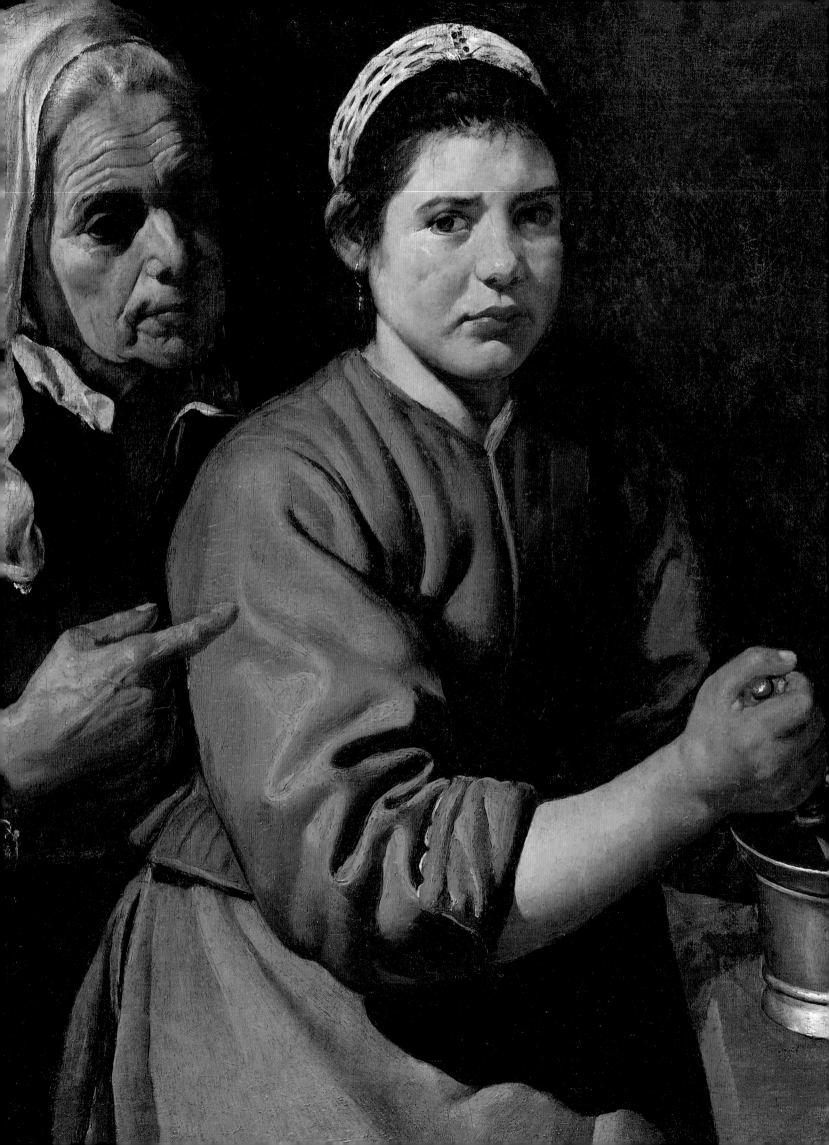

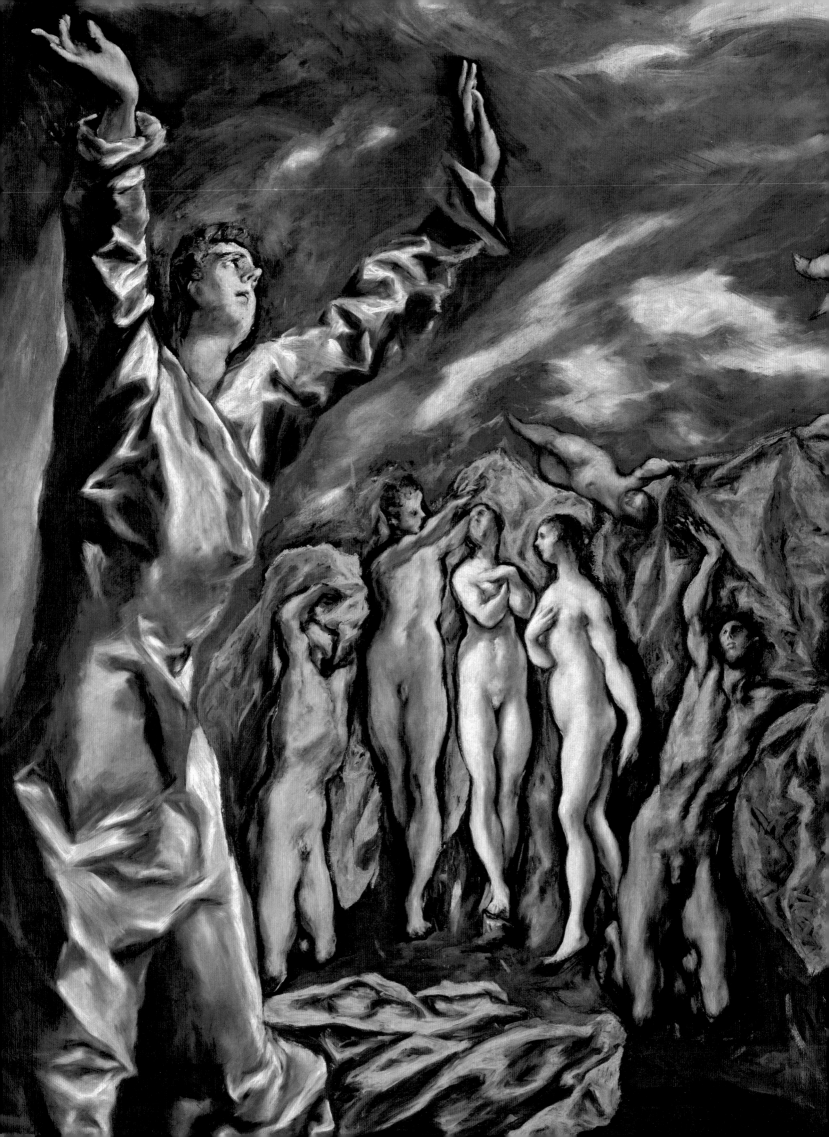

Late El Greco

At the beginning of the reign of Philip III, El Greco's client base was expanding beyond Toledo and its environs.[1] In 1596 he signed a contract to produce seven large paintings for the main altarpiece of the Augustinian seminary in Madrid known as the Colegio de Doña María de Aragón. According to the scholar Richard Mann, "El Greco probably considered his work at the seminary to be the most prestigious and important commission of his career," bringing him "closer to achieving the status of a court artist than at any other time."[2] This was El Greco's first large-scale commission in Madrid and was responsible, in part, for creating a new market for him; not only the intellectual elite in Toledo but now courtiers in Madrid, more liberal than those who attended Philip II, were among his clientele.

In 1600 the paintings for the altar were delivered and installed to great acclaim; the *Annunciation* (cat. 19) was the central panel.[3] The assessments of the altarpiece made by the court artists Bartolomé Carducho and Pantoja de la Cruz indicate just how much El Greco's peers esteemed his achievement: the altarpiece was valued at nearly 6,000 ducats, a vast sum that was more than the artist had ever received. The paintings for the first time exhibit El Greco's mystical late style, in which figural proportions, the treatment of space, light, and colors, and the interpretation of subject reached new heights of originality—"the Greek's extravagant style," as Palomino called it. It was this bold style and frantic, expressionist paint application that most appealed to the avant-garde painters who rediscovered him in the late nineteenth century; Millet, Degas, and Ignacio Zuloaga all collected his work.[4]

El Greco enjoyed a freedom in his late career that allowed him to make daring works as never before. This period, generally dated between 1600 and his death at age seventy-three in 1614, took place entirely during the reign of Philip III. It was a busy time for the artist. Gone were the earlier constraints placed upon him for his lack of doctrinal correctness. El Greco's output increased dramatically; the elevated peer evaluations of the paintings for the Colegio de Doña María de Aragón, the presence of his work in the collection of the powerful duke of Lerma, and his positive relationship with the archbishop of Toledo, Cardinal Bernardo de Sandoval y Rojas, are some of the factors responsible for the greater demand for his works.

In 1603 El Greco moved into more spacious quarters to accommodate a larger workshop; he rented twenty-four rooms and the main hall in the palace of the marques of Villena. In the first decade of Philip III's reign, Luis Tristán, Pedro Lopez (about 1575–1623), the Flemish engraver Diego de Astor (1585–1650), and possibly Pedro Orrente entered El Greco's studio.[5] His twenty-year-old son, Jorge Manuel, began to play a larger role in the workshop and in his father's business affairs. For the first time, El Greco had the time and support to experiment with new types of pictures in addition to the commissioned altarpieces and portraits that had been his primary source of income.

El Greco returned to painting small devotional pieces toward the end of his career. As far as we know, he had never painted a small-scale crucifixion before he made the *Christ on the Cross* (cat. 2), a work that came to light only in the 1990s. By encouraging intimate contact with the viewer, it reflects the changes in devotion that came about as a result of Saint Ignatius's *Spiritual Exercises* and Saint Teresa's use of images as an aid to individual prayer.

El Greco clearly delighted in providing an opportunity for a close-up inspection of his

lively application of paint and artistic skill. The tiny, nervous brushwork seen in the delicate edging of the cloth of purity and the economy of means used to convincingly portray the three fleeting soldiers on horseback in the midground are different than similar elements in El Greco's larger-scale crucifixions. Made with a smaller brush, the rapid and fainter touch reveals supreme confidence and great manual dexterity.

Painted about 1597–99, the *View of Toledo* (cat. 4) represented a totally new subject for El Greco, a cityscape, though not in the strict sense of the word. El Greco's painting of his adopted home is an abstracted and reconstructed view, which includes an emotional landscape—more interpretive than documentary.[6] Views of the city of Toledo appear frequently in the backgrounds of El Greco's pictures, especially in the late period, as in the *Christ on the Cross* (cat. 2), *Saint Martin and the Beggar* (cat. 1), and *Laocoön* (cat. 6). But only twice did El Greco use the city as the sole subject for a painting: this *View of Toledo* and his *View and Plan of Toledo* (Museo de El Greco). El Greco may have been responding (in his unique way) to the passion for collecting maps and cityscapes that came into its own in the sixteenth century and became quite fashionable during the reign of Philip III. The duke of Lerma had a total of sixty-three maps and cityscapes, and in *Teatro de las Grandezas*, published in 1623, González Dávila described the "mapas de muchas ciudades de España, Italia y Flandes" installed in the Alcázar.[7] The king's interest in this type of image can be surmised because he ordered Julio Semin to clean and restore three paintings of Flemish cities for the *pasadizo* connecting the royal palace to the convent of La Encarnación.[8]

El Greco's *View of Toledo* and the *View and Plan of Toledo* may have been owned by one of the first people in Spain to take an interest in the pursuit of map collecting, El Greco's friend and patron Pedro de Salazár de Mendoza.[9] A resident of Toledo, Salazár de Mendoza was well known at the court of Philip III. He wrote the chronicle of the Sandoval family for the duke of Lerma, as well as other genealogies of the Spanish noblemen, and authored an important history of Toledo. He was appointed administrator of the Hospital Tavera in Toledo and was responsible for commissioning El Greco to design the high altar of the chapel there, for which the artist made the extraordinary *Vision of Saint John* (cat. 5).

One of the earliest appearances of the visionary landscape of Toledo in the background of a religious painting occurs in El Greco's *Saint Martin and the Beggar* (cat. 1). The painting, made for one of the side altars of the chapel of Saint Joseph in Toledo,[10] was commissioned in 1597 by the heir of the founder, Martín Ramírez, and was dedicated to his name saint.[11]

The view of the city of Toledo in the background, as well as the saint's sixteenth-century armor and naturalistically rendered horse, which seems to stride out of the canvas into the viewer's space, made the famous tale of charity more relevant to El Greco's contemporaries. El Greco thus fulfilled one of the goals of the Catholic Reformation; he also anticipated Velázquez's more direct approach of bringing the sacred figures down to earth so that the viewer could easily identify with them (see, in particular, his use of a local Sevillian girl as the Virgin in *The Immaculate Conception* [cat. 48]). When Rubens made his way to the court in Valladolid in 1603, he might have passed through Toledo and seen *Saint Martin and the Beggar*, which was still a relatively new work. Similar pictorial conceits appear in the *Equestrian Portrait of the Duke of Lerma* (cat. 11): a monumental white horse and rider; a pose to show control of the horse, who performs a difficult maneuver; the viewpoint from below; and a landscape in the far distance seen through the horse's legs. It may also be that both artists were working with the same sources in mind (Il Pordenone [1483/4–1539], who worked in Venice), but that fact does not detract from the up-to-date quality of El Greco's image.[12]

In his late period, El Greco invented a new iconography for Saint Jerome (cat. 3), whose cult of devotion increased when Luther refused to accept the Vulgate, the Latin version of the Bible that Jerome had translated.[13] The first-century saint is usually depicted in his cell writing, referring to his vast biblical learning, or in the wilderness as a penitent, affirming the sacrament of penance. El Greco instead created a devotional portrait of this Doctor of the Church. He adopted the three-quarter-length format of sixteenth-century Venetian portraiture but removed the figure from a narrative context, placing him against a black ground and endowing him with an intent gaze, as he had done for the *Apostolado* (cat. 33).[14] El Greco at once created a devotional picture and "portraitized" Saint Jerome. The monumental figure taking up most of the can-

vas, the pose of the sitter standing at a table and turned toward the viewer, the placement of the hands, the large book, the interrupted action, and the direct, almost stern gaze are virtually identical to the portrait of a living sitter he painted about the same time, thought to be Francisco Pisa, the famous historian in Toledo (cat. 13).

Without a halo or other saintly attributes, El Greco presented to the viewer a hauntingly true-to-life image of Jerome's body ravaged by asceticism. The unkempt beard references his time as a hermit in the wilderness. El Greco also portrayed the saint as an elderly scholar, his intellectual endeavor emphasized by the way in which he compares marginal notes, marked by his thumb, with the text in a large book.[15] The three versions of El Greco's portrait of Saint Jerome that were created during the reign of Philip III signified the success of this new iconographical type. Such an image reflected the preaching of the second-generation reformers to identify personally and intimately with the sacred figures of the past.

In the *Vision of Saint John* (cat. 5), El Greco "pushed to an extreme the iconographic originality" of his late period.[16] So exceptional is the painting, in fact, that the identification of the subject is still in question. A small version of the painting was described in the 1614 inventory of the artist's studio as "Saint John the Evangelist witnessing the Mysteries of the Apocalypse";[17] the opening of the fifth seal by the Lamb of God (Revelation 6:9–11) revealed to Saint John "the souls of them who were slain for the word of God . . . And white robes were given to every one of them." El Greco omitted important details from the account, and added others, such as the yellow and green draperies that are not in Saint John's description.[18] Although the picture was never finished, has been cut down, and is badly damaged in areas, it remains "the best testimony we have of the visionary heights of El Greco's late style."[19] El Greco had the freedom to invent a new vision because of the support of his friend and patron Pedro Salazár de Mendoza, who commissioned the painting as one of the altarpieces for the chapel in the Hospital Tavera.

In contrast to the elongated figures in the *Vision of Saint John*, the figures in the *Laocoön* (cat. 6) are rendered closer to the Greek canon of proportions and seem to have been inspired by classical sources. El Greco drew the subject, figural types, and expressions of horror from the famous ancient sculptural group *Laocoön and His Sons*, which was unearthed in Rome in 1506. He may have derived the falling body of Laocoön from the *Wounded Gaul* (Museo Archeologico, Venice), and the *Fallen Giant* (Museo Nazionale, Naples) is similar in pose to the dead son.[20] But the strange colors and flickering light and the juxtaposition of a Homeric tale with the city of Toledo make the *Laocoön* as visionary and otherworldly as the *Vision of Saint John*.

Laocoön illustrates the tale of the fate of the Trojan priest who warned Troy against accepting the gift of a huge wooden horse from the Greeks in honor of Minerva: "I fear the Greeks, even when bearing gifts" (Virgil, *Aeneid* 2.49). After uttering this speech, which angered Minerva, snakes came from the sea and attacked Laocoön and his sons. El Greco, however, did not follow Virgil's description of the event; the erudite artist combined several different ancient accounts and invented others, reinterpreting the gruesome death in his own terms.[21]

The father falls in an awkward, ungraceful pose, while the son on the left could be a muscled dancer, a snake as his hoop, except for the horrible mouth and fangs of the sea serpent about to bite into his naked waist. Two figures on the right calmly witness the horrific event. They have been variously called Paris and Helen, Adam and Eve, Poseidon and Cassandra—El Greco left their identities ambiguous (although recent restoration, which revealed a fifth leg and third head, suggests that the artist was not quite finished with the work). The tiny wooden horse in the background is a surreal image, alive and moving not toward Troy but toward the walls of Toledo, identified by the Visagra gate. As in other late works, El Greco imagined the mythological event taking place in his own adopted city. This might have been intended as a message to his contemporaries, encouraging them somehow to identify with the figures or to see in the classical subject a meaning that applied to a current historical situation.

Why El Greco painted the *Laocoön* and for whom has never been satisfactorily explained. Three paintings of the subject were in the artist's studio at the time of his death. From a contextual viewpoint, it would seem reasonable to posit that the picture referred at least on some level to one of the primary problems in the government of Philip III—the system of favoritism and the inevitable bribery resulting from it—

sponsoring a reaction similar to the cry "fear the Greeks . . . bearing gifts." It might also allude to the possible fate of those who dared to speak out against the practice by the duke of Lerma or the king. Situating the Trojan horse in front of the walls of Toledo, where the Archbishop Bernardo de Sandoval y Rojas was agitating against the corruption of the Lerma faction, would have brought home the lesson of the legend to contemporary Toledans.

El Greco's purpose in painting the *Laocoön*, however, might have been purely artistic, a vehicle to show off his brilliant ability for inventive narrative and his knowledge and grasp of classical text and image. The painting would thereby be evidence of El Greco's lifelong attempt to change the Spanish attitude toward painting as mere craft to an understanding of it as an intellectual endeavor. If accepted as such, the Spanish artist would be worthy of elevation to a higher social standing. Without documentation, however, the meaning of the painting remains ambiguous. Like the young Velázquez, soon to come on the scene, El Greco probably sensed a virtue in ambiguity.

El Greco's mastery of medium and uniqueness of mind, in addition to his individualism and commitment to asserting the painter's right to proper remuneration, impressed his contemporaries. The admiration of Carducho and Pantoja was reflected in the generous sum they awarded him for his paintings for the *colegio*. He was the teacher of Luis Tristán and a debtor of Sánchez Cotán. Contrary to the myth of the great El Greco as outside the mainstream, his bold pictures with new themes became part of contemporary artistic vocabulary. His portraits, especially the heads, were highly influential; Velázquez owned three of them. El Greco introduced the *Apostolado* to Spanish art, and the conceit of the "portraitized" saint. Although very different from the tradition that would culminate in Velázquez's painting of *The Immaculate Conception* (cat. 48), he was among the first to create an image of the theme (parish church of San Nicolás de Bari, now stored in the Museo de Santa Cruz, Toledo). He invented a new iconography for the depiction of Saint Francis (cat. 37). Rubens's *Equestrian Portrait of the Duke of Lerma* might have been a courtly Baroque answer to El Greco's *Saint Martin and the Beggar*. His erudition and litigiousness likely provided a model for Vicente Carducho. No longer can we consider him a solitary genius isolated in Toledo.

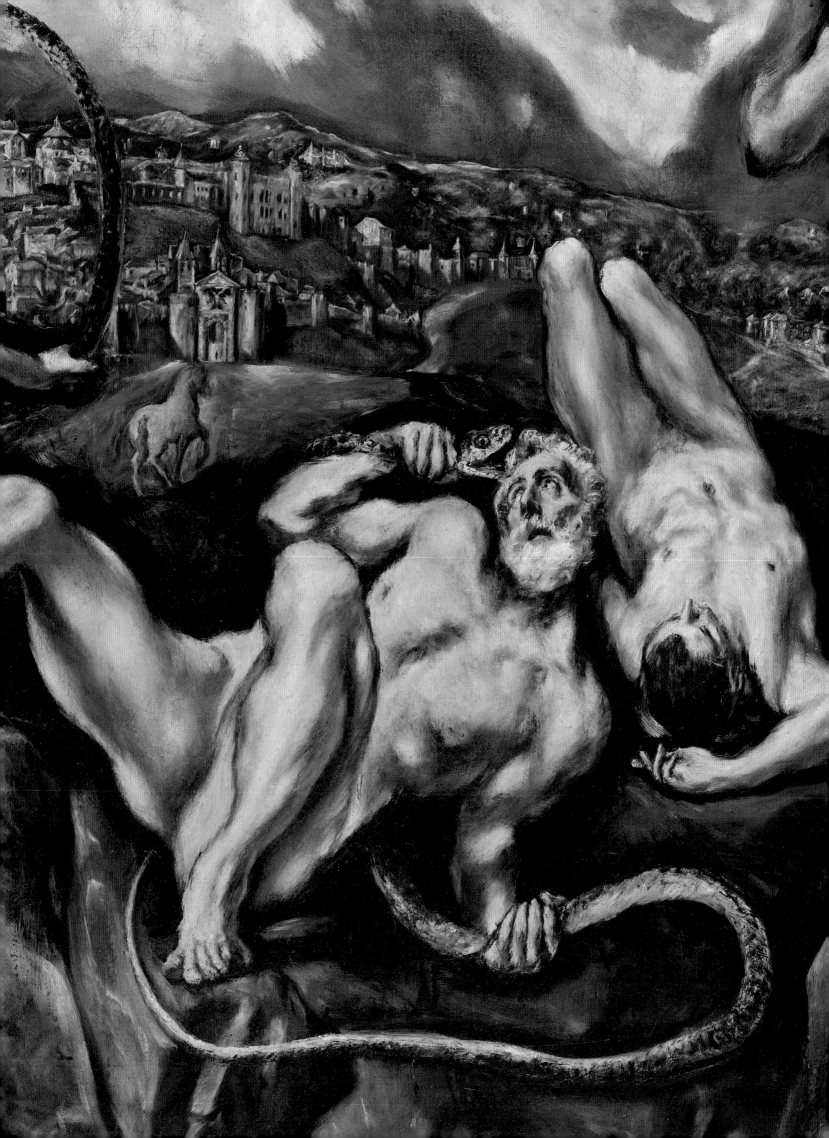

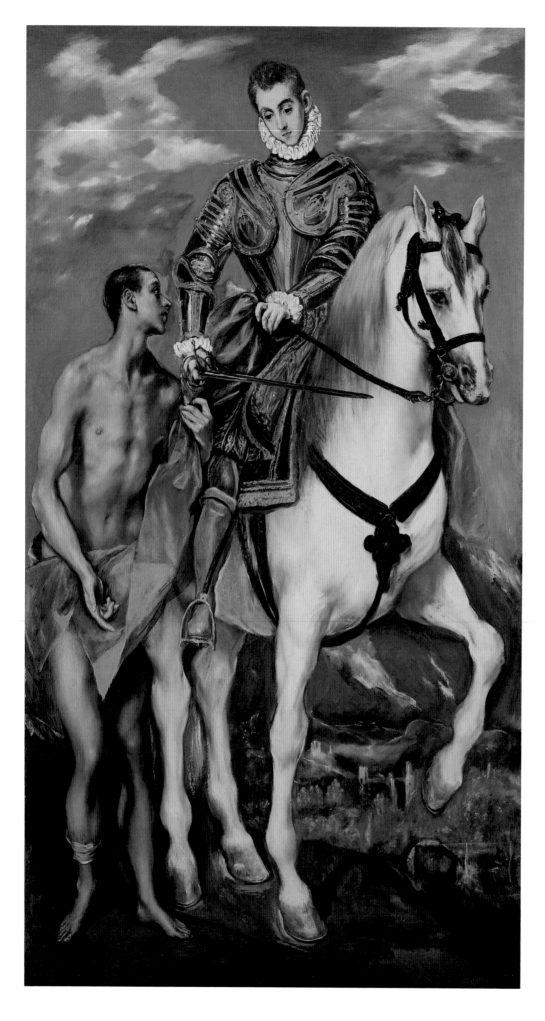

Catalogue 1
EL GRECO
Saint Martin and the Beggar, about 1597–99
Oil on canvas with wooden strips attached
at bottom
76³⁄₁₆ x 40⁹⁄₁₆ in. (193.5 x 103 cm)
National Gallery of Art, Washington, DC

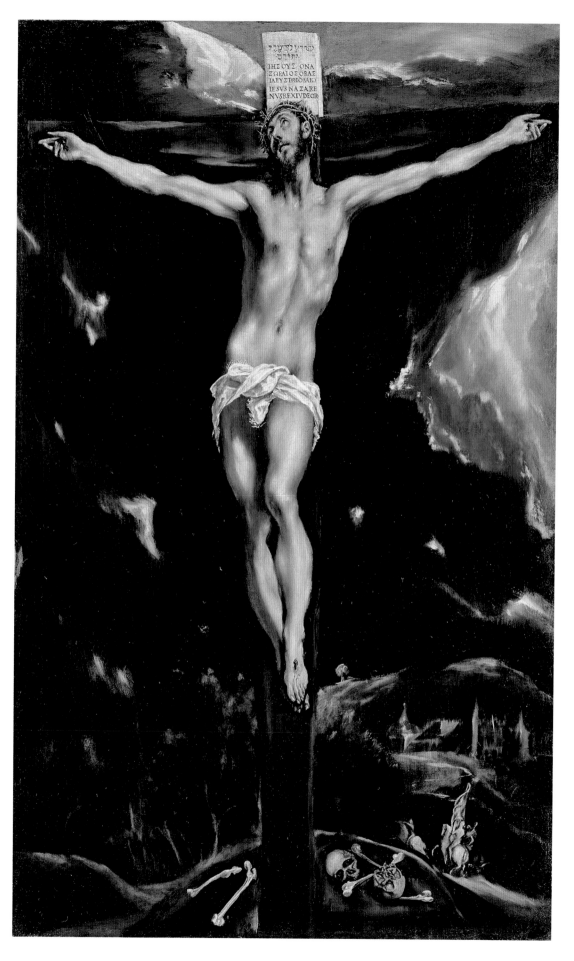

Catalogue 2
EL GRECO
Christ on the Cross, about 1600–10
Oil on canvas
32½ x 20⁵⁄₁₆ in. (82.6 x 51.6 cm)
The J. Paul Getty Museum, Los Angeles

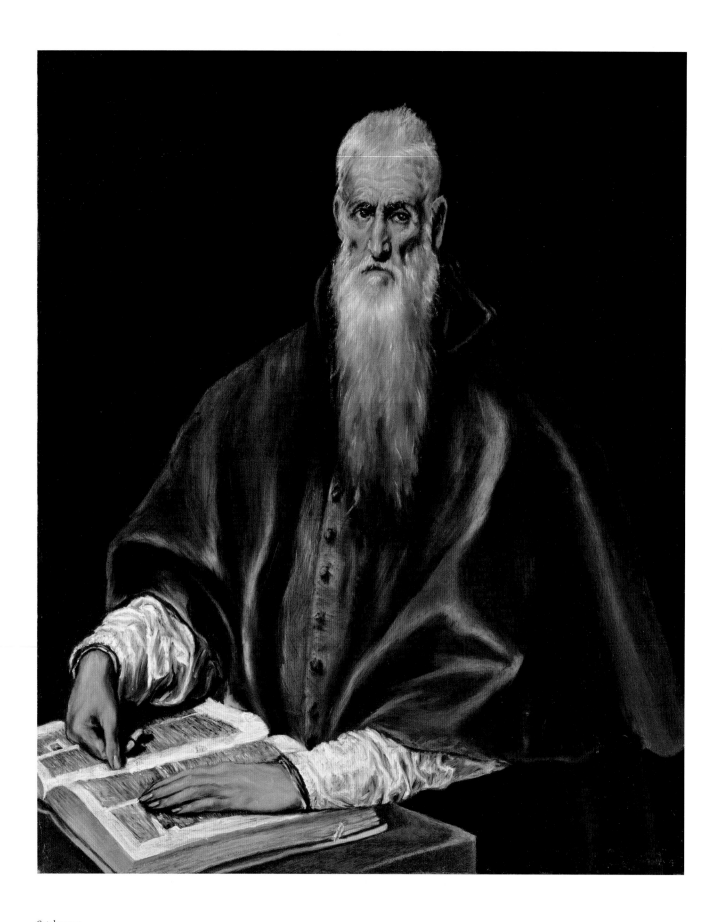

Catalogue 3
EL GRECO
Saint Jerome as Scholar, about 1610
Oil on canvas
42½ x 35⅟₁₆ in. (108 x 89 cm)
The Metropolitan Museum of Art, New York

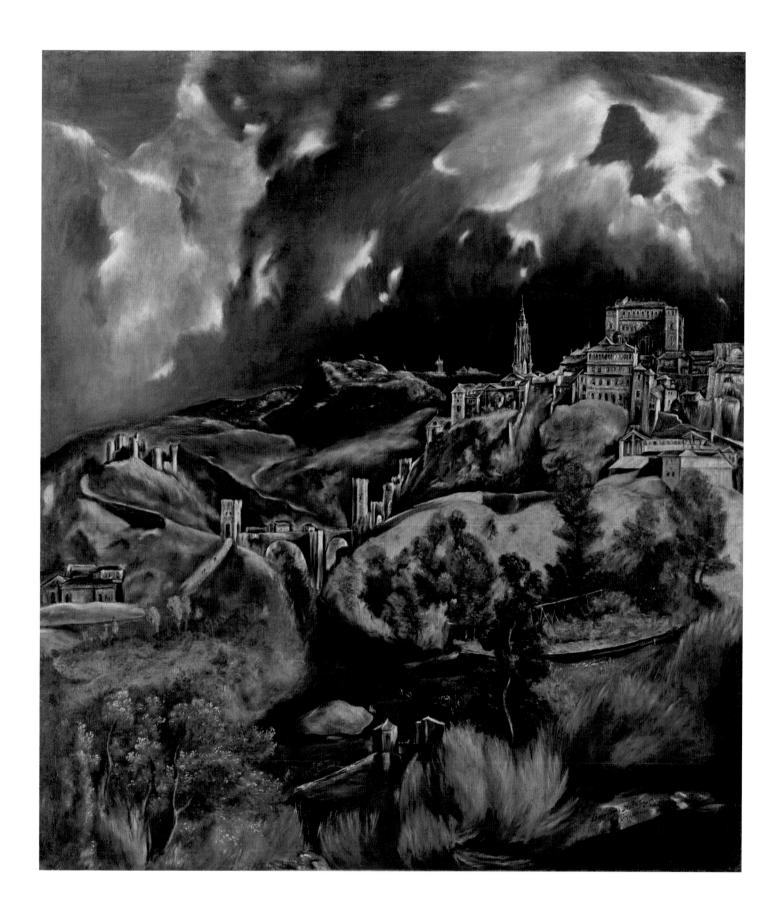

Catalogue 4
EL GRECO
View of Toledo
Oil on canvas
47¾ x 42¾ in. (121.3 x 108.6 cm)
The Metropolitan Museum of Art, New York

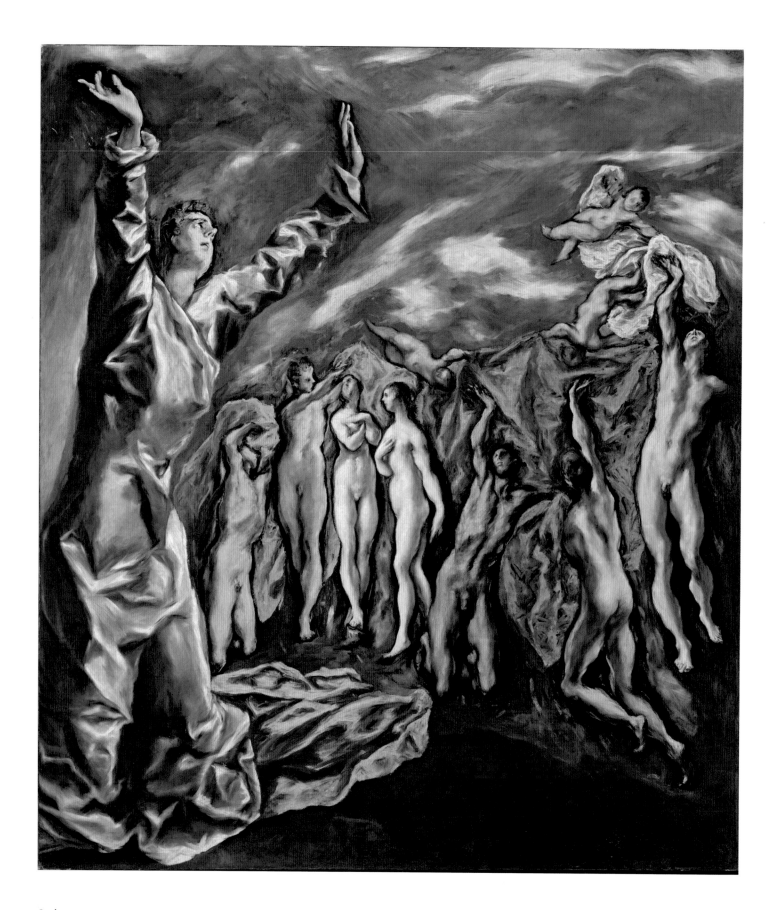

Catalogue 5
EL GRECO
The Vision of Saint John, 1608–14
Oil on canvas
87½ x 76 in. (222.3 x 193 cm); with added strips 88½ x
78½ in. (224.8 x 199.4 cm)
The Metropolitan Museum of Art, New York

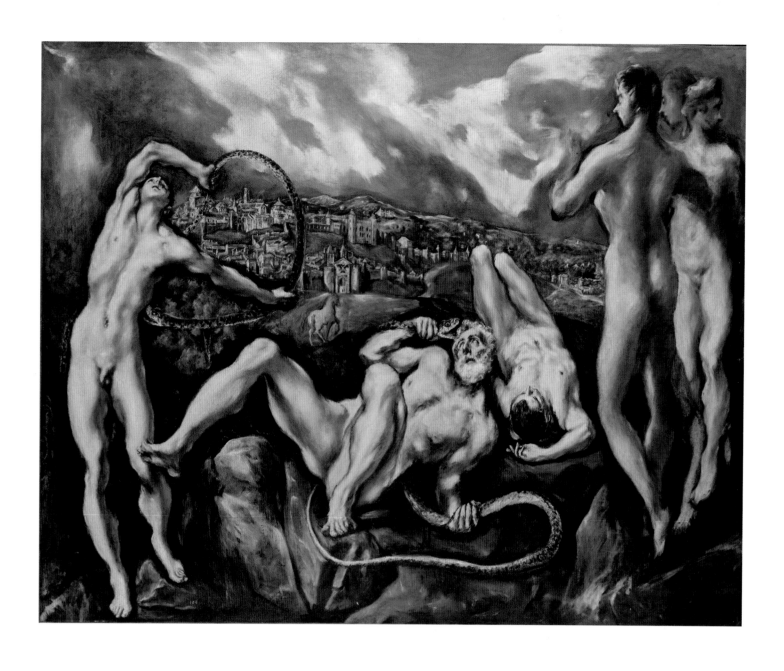

Catalogue 6
EL GRECO
Laocoön, about 1610–14
Oil on canvas
54⅛ x 67⅞ in. (137.5 x 172.4 cm)
National Gallery of Art, Washington, DC

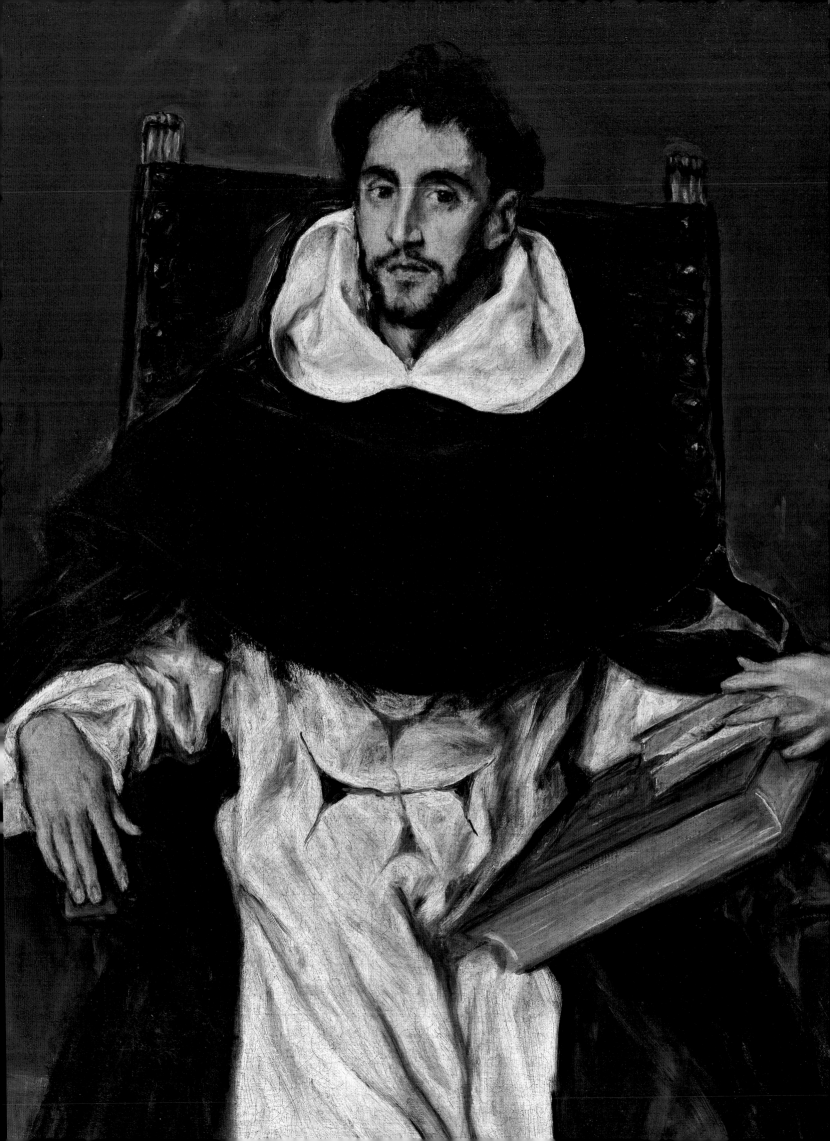

Portraiture

The royal portraits of Spanish monarchs in *El Greco to Velázquez: Art during the Reign of Philip III* were not intended to portray specific personalities—this would have violated notions of decorum and the strict etiquette of the Spanish Hapsburg court—but rather were purposely designed to convey carefully conceived images that reflected the politics and taste of the court. They had to be unique and identifiable, tied to past traditions of representation, but distinct, not to be confused with a previous ruler or ruler of another state. Copies of these portraits were made and disseminated to the various kingdoms on the Iberian Peninsula and the culturally disparate areas under Spanish control in Europe and the Americas, intended as propagandistic expressions of Philip III's intellectual and political ideas. Beyond this, there was a clear desire to invoke an image of richness and magnificence, a display of ostentation—the new style of grandeur that was such an important component of Philip III's public identity.

Juan Pantoja de la Cruz was the principal court portraitist from the time of the death of his master, Alonso Sánchez Coello, in 1588 until his own death in 1608. The royal portraits by Pantoja included in this exhibition display the artist's unique style, one that combines the realistic precision of Antonis Mor's Flemish tradition and the painterly manner of Titian with modern effects of naturalistic light. Pantoja's *King Philip III of Spain* (cat. 7), the first formal portrait of Philip as king, was painted about 1601, the year that Spain began its long and bloody siege against the Dutch rebels at Ostend. Philip is depicted in armor holding a general's baton, although he was never on the battlefield.[1] Being portrayed in armor for an official image was a time-honored tradition in Hapsburg state portraiture from the time of Philip III's ancestor the

Holy Roman emperor Maximilian I (1459–1519).[2] The type of armor chosen by Philip III, however, departs from earlier representations by reflecting sumptuousness rarely displayed in a Spanish royal portrait.[3] The armor is highly embellished with relief figures and embossed gilded bands of richly damascened decoration that nearly obscures the "blued" steel breastplate and other areas.[4]

Compared with the portrait of his father, which depicts Philip II in the armor he actually wore in the battle of Saint Quentin (see fig. 1, p. 17), Philip III's armor is "spectacular body jewelry."[5] The white collar and cuffs in Philip II's portrait, worn to protect the neck and wrists from rubbing against the steel, are replaced in Philip III's image by the newest fashion, an oversized starched ruff and wide cuffs.

Pantoja's portrait of *Queen Margaret of Austria* (cat. 8) alludes to her royal status: the chair of red velvet behind her, the floor-length skirt of stiff luxurious material with matching jacket (especially tailored to her pregnant condition), and an overdress with round sleeves and jeweled borders. The queen holds a costly lace handkerchief in her left hand, resting the other on top of the head of a favorite court dwarf, Doña Sophia.[6]

Many of these symbolic elements can be seen in *Isabella Clara Eugenia and Magdalena Ruiz* painted by his teacher Sánchez Coello (fig. 74). However, Pantoja is careful to make an image that distinguishes the official portraits of Philip III's court from those of the previous reign even while following traditions of female state portraiture in Spain. As in Philip III's portrait, Pantoja's painting of Queen Margaret embodies the contemporary taste for opulence. She is wearing more jewels than Isabella Clara Eugenia—at least thirty-two are sewn into the

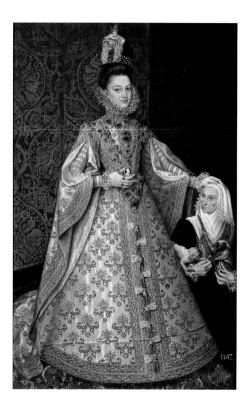

74
Alonso Sánchez Coello
Isabella Clara Eugenia and Magdalena Ruiz, 1580
Oil on canvas, 81½ x 50¹³⁄₁₆ in.
(207 x 129 cm)
Museo Nacional del Prado, Madrid

border of her outer coat—and the settings of gold and garnet in her necklace are larger. The cloth of her outfit is more intricately worked; the sheen on the front of her dress suggests that the small geometric patterns were all hand-stitched with gold thread. Margaret's starched lace ruff is so large that it completely frames her face, hiding her neck and reaching to the top of the back of her head.[7] We can see in the queen's portrait that the outlandishly large ruffs were so heavy they required the support of a silver plate. The fashion for these enormous, costly *cuellos de lechuguilla* (little lettuce collars) symbolizes the extravagance of the reign of Philip III.[8]

The royal portraits of Pantoja exhibit a striking archaism, a "strange mixture of ceremonialism and realism."[9] Compared to Sánchez Coello's portrait of Isabel Clara Eugenia, in which the stiff dress material is modeled to give the appearance that it bends and moves, Pantoja chose to eliminate volume-defining and modeled folds in Margaret's dress, flattening her form.[10] The space is limited, like a stage; the background is dark, like a devotional painting. The color scheme is reduced.

The king's and queen's faces, moreover, are almost abstract. They are illuminated by a frontal light that is brighter and flatter than the lighting used for the rest of the figures. An unbroken line around the faces does not allow the heads and ruffs to sink into space; detached from the ground, the faces are isolated by white "frames" (the ruffs).[11] The individual features of the king and queen are almost completely idealized—the eyebrows are perfect thin arches; the catchlights of the eyes, a device usually employed by portraitists to animate the face, are tiny and uniform. Pantoja set these idealized features in a vividly whitened face where bones, wrinkles, and surface imperfections are not depicted. The face has the hard and artificial look of a mask. These same qualities are to be found in his depictions of the royal children as well (cat. 9).

These powerful official images contained all the ingredients necessary to convey a clear and effective message of authority and grandeur. The efficacy of Pantoja's solution, his formal vocabulary combining retrospection and modernity, is proven by the stubborn adherence to it in the majority of royal portraits painted even after his death in 1608. The portraitists of the royal family continued to paint their sitters in all their finery, with flat silhouettes and masklike faces, as is evident in

Bartolomé González's portrait of a pair of the royal children (cat. 10).

And while Pantoja employed the same format for his 1602 official portrait of the king's sole favorite, the duke of Lerma (fig. 75), that he used for his images of the king, Philip III's subjects would never have mistaken it for a depiction of a member of the royal family. The duke's features are individualized and recognizable (including his lazy left eye). His face is not washed out by a bright frontal light or disguised by a white mask. Lerma is approachable, of this world, flesh and bones, while the king and queen are otherworldly, invisible, hidden behind a mask, part of an abstract archaic design, inaccessible. The half-armor and other iconographical elements of kingship refer to Lerma's unprecedented role as alter ego of the king, but the naturalistic manner of portraying his facial features, achieved through a forceful play of light and shadow that creates volumetric form, separates the official image of the favorite from that of his monarch.

Pantoja's "official" image of Lerma would be used by Peter Paul Rubens when the latter set out to paint the great *Equestrian Portrait of the Duke of Lerma* (cat. 11). The court itinerary proves that Rubens never actually had a sitting with the duke but had to travel to Lerma's hunting lodge in Ventosilla to "copy" Lerma's features from Pantoja's official portrait image.[12]

Rubens's splendid life-size depiction shows the duke dressed in parade armor, subtly controlling a magnificent white steed, which seems about to step out of the canvas and into the viewer's space. Scholars have noted the similarity of this painting to El Greco's *Saint Martin and the Beggar* (cat. 1), which Rubens may well have seen in Toledo on his way from Alicante.[13] Formalistically, the differences are more telling: in Rubens's painting, the eyes of the horse and his proudly posed mount meet our gaze head on, and the body of the horse is entirely visible, showing off the painter's command of space and perspective. The animal has been turned slightly to the right, while the duke has just pulled on the bit, causing the horse to swing its neck around and its curled mane to fly into the air, bringing dynamic movement to the composition. The artist is developing a greater freedom of expression, a loosening of his brushwork as a result of his study of Italian art while at the Mantuan court.

The choice of an equestrian portrait would have immediately called to mind images of Roman emperors, at the time popular in paint-

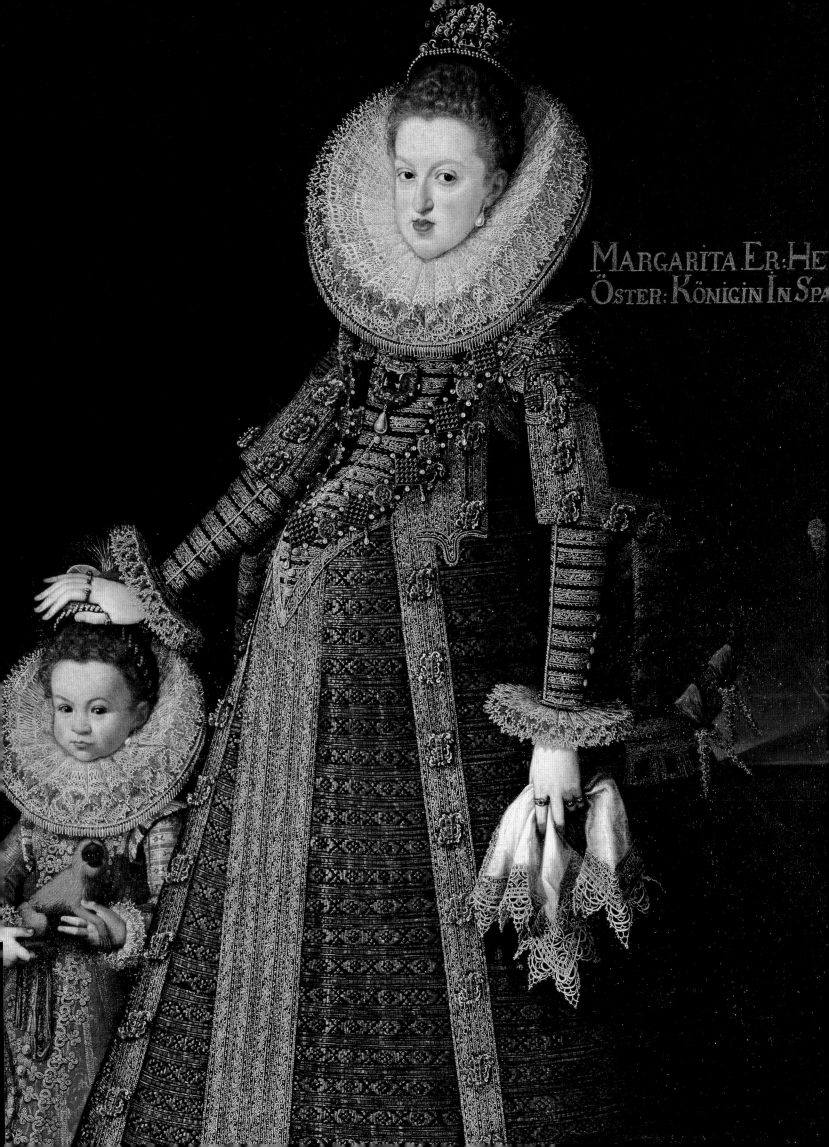

MARGARITA ER: HE[
ÖSTER: KÖNIGIN IN SPA[

75
Juan Pantoja de la Cruz
*Francisco Gómez de Sandoval y Rojas,
Duke of Lerma,* 1602
Oil on canvas, 80½ x 40 in.
(204.5 x 101.5 cm)
Palacio Pilatos, Seville

ings, sculptures, and prints. As a symbol of power and control, the Roman emperor portrait held a particular fascination for many "favorites" of the Spanish kings who historically sought out examples for their private collections.[14] Lerma had more than any of them.[15]

As in Pantoja's *King Philip III of Spain,* there is military action in the background of Rubens's portrait, and in this case it has a double meaning. The painting fulfilled the need to commemorate yet another spectacular favor granted to Lerma by his king, his appointment as commander-general of the Spanish Cavalry. The king announced this honor in March, only two weeks before Rubens arrived on the Iberian shore.[16] It must have created much gossip at court; traditionally the king himself or a member of his immediate family held the post.[17] While Rubens was in Valladolid awaiting an audience with the duke, restoring the gifted paintings that became water damaged during his passage, and composing for Lerma his own *The Philosophers Democritus and Heraclitus* (see fig. 38, p. 95), the king and members of the court traveled to Burgos to participate in the official ceremony in which Lerma reviewed the troops in his new capacity for the first time.[18] In his grand painting, Rubens created a narrative of the event: with the cavalry behind him, Lerma, high in the saddle, proudly holds his general's baton and skillfully guides his elaborately bridled horse in the *passage,* or controlled trot, the equestrian exercise that would have been used to review the troops.[19] Rubens's image helps to construct the identity of one born to help his king rule, whose background, traced by El Greco's friend and patron Pedro Salazar de Mendoza (about 1550–1629) to the Aragonese king Alfonso V the Magnanimous (1416–1458), made him deserving of the status afforded by the position.[20]

The nonroyal portraits by El Greco and Luis Tristán in the exhibition have an immediacy and intimacy of presentation lacking in the more official images, and the informal bust portraits by Juan van der Hamen and Juan Bautista Maino are even further removed from the abstract, idealized regal visages. One would expect Van der Hamen's *Portrait of Lorenzo van der Hamen y León* (cat. 15), his elder brother, to be both casual and familiar. Lorenzo, an ecclesiastic who was also a scholar and historian, was one of the most respected men of letters of Madrid in his day and a

friend of both Quevedo and Lope de Vega.[21] The portrait probably originally formed part of the series of twenty portraits of "Illustrious Men" inventoried in Van der Hamen's studio after his death. It exhibits a lively and fluid touch that implies his comfort with the sitter; the confident naturalism suggests that it was taken from life.[22]

Maino's *Portrait of a Monk* (cat. 16) has been plausibly identified as the Dominican Fray Pedro de Herrera.[23] Herrera served as the royal censor, examining all books dedicated to the king. He was also connected to the duke of Lerma, who had been a patron of the Dominican Order in Spain since 1603. Herrera recorded the inauguration of the Sagrario in the Toledo Cathedral, the published account of which was commissioned by Archbishop Bernardo de Sandoval y Rojas, and the events surrounding the installation of the Blessed Sacrament in San Pedro in Lerma, commissioned by the duke of Lerma.

Maino used a modern format for the informal portrait, a small canvas with a bust-length figure against a dark ground, concentrating all attention on the head and facial features with the clothing merely sketched in. The portrait has a sympathetic and spontaneous quality emphasized by the sitter's sidelong glance. In contrast to similar images by El Greco, Maino's portrait is more naturalistic, the modeling in light and dark capturing every nuance of the face and its bone structure. The artist also attended to details: the effect on the skin of the raised left brow, the wrinkles around his eyes, the stubble of short white and black beard hairs. Maino's conception of his sitter is quite different from Tristán's, whose monk's piercing gaze arrests that of the viewer (cat. 14). By extending the composition to three-quarter length, Tristán emphasizes the sitter's voluminous cape. Books and a table suggest both occupation and setting. The handling of paint is also different; Tristán's is both more schematic and liquid, and the sitter's hair has been treated more as a mass and less as individual strands.

In his portraiture, Tristán paid homage to his master, El Greco. The practice of making portraits of lower-ranking members of society (that is, not royalty, high clerics, or noblemen but, as here, ordinary members of the clergy), was brought to Spain by El Greco, who imported the practice from Italy, where the sense of the individual had a long history. The compo-

sition of Tristán's *Portrait of a Carmelite* is the same as that used by El Greco for his *Portrait of an Ecclesiastic* (cat. 13), which is perhaps a depiction of the Toledan historian Francisco de Pisa. El Greco had not used this format since his time in Venice and Rome in the 1570s. The style of portrait, based on late Titian types, was presumably more expensive than the heads or busts he had earlier produced for his Toledan clients. The luxurious fur and velvet clothing worn by the sitter is both a further indication of his status and an expression of the new style of grandeur dominating Spanish culture during the period. Most striking, of course, is El Greco's manner of painting. Jagged, lightning strokes of white describe both material and light; layers of successive aureoles of paint in the background activate the sitter and imply his presence. There is nothing smooth or still in this incisive portrait.

Fray Hortensio Félix Paravicino (cat. 12), depicted by El Greco in this arresting portrait, was one of the most eloquent poets and orators of his generation. Known in Madrid for his brilliant and complex sermons, he was appointed royal preacher to Philip III in December 1617. He counted such diverse figures as Góngora, Lope de Vega, and Quevedo as friends and admirers.[24] Although there is no information about the relationship between the preacher and the painter, Paravicino's regard for El Greco is clear in the sonnet he wrote praising the portrait, which begins, "O Greek divine! We wonder not that in thy works/The imagery surpasses actual being." According to contemporary sources, Paravicino kept this portrait in his cell.[25]

For the painting, El Greco borrowed the sixteenth-century format of the full-length seated ecclesiastical figure made famous by Raphael and Titian and already adopted by the latter for portraits of lower ecclesiastics. Despite its superficial similarities to earlier portraits, *Paravicino* brilliantly illustrates the daring originality of El Greco's late period. The chair is positioned so that the sitter's body faces the viewer directly, facilitating the preacher's intensely concentrated gaze and creating an artistic challenge in the rendering of frontal perspective. The Spanish leather chair back breaks up and animates the background; its height is the same as the preacher's eyebrows, creating a line that emphasizes the intelligent dark eyes and frames the face below. El Greco's

unique style is evident in the handling of the drapery, where long animated strokes cascade into the viewer's space. The lively technique implies movement, notwithstanding the sitter's stillness.

According to Palomino, Velázquez "in his portraits imitated Dominico Greco, because his heads were such that they could never be sufficiently praised."[26] Velázquez owned three portraits by El Greco, and although they have not been identified, they must have had an impact on the younger artist.[27] For his portrait of *Luis de Góngora y Argote* (cat. 17), however, Velázquez was surely influenced by his teacher Francisco Pacheco. For his *Libro de retratos*, a book of drawings of famous Sevillians, Pacheco made portraits in black and red chalk (some from prints, some from descriptions, some from memory, but most from sketches) of more than 150 ecclesiastics, poets, and other eminent figures. Among these is the *Portrait of a Poet* (cat. 18), which at some point was cut out and separated from the book. This was the bust format adopted by Van der Hamen for his series of "Illustrious Men," and it would be the format chosen by Velázquez for his painting of the celebrated Cordoban poet and clergyman Góngora. The laurel wreath, which indicates his status as a poet, originally encircled Góngora's head but is now only visible in X-rays of the painting. Velázquez preferred to convey his sitter's distinction through characterization rather than attribute.

Pacheco recounts that, at his request, in 1622 Velázquez traveled to Madrid and painted Góngora from life, most likely for use in his *Libro de retratos*. Although "there was not an opportunity [for the young artist] to paint the king and queen"[28] while there, the portrait of Góngora, which must have been shown to people interested in advancing Velázquez's position at court, was very celebrated. The depiction, similar in its disposition and coloring to portraits of humanists El Greco painted in Toledo, is very different in style. Góngora's neck is swathed in the black bulk of his body, his head emerging from his white cleric's collar in flat broad planes of flesh-colored tones enlivened by pink. The dramatic play of light and dark, the intensity of his gaze, the downturned lips, and the creased furrow of his brow characterize this disillusioned and sickly giant of Spanish literature.

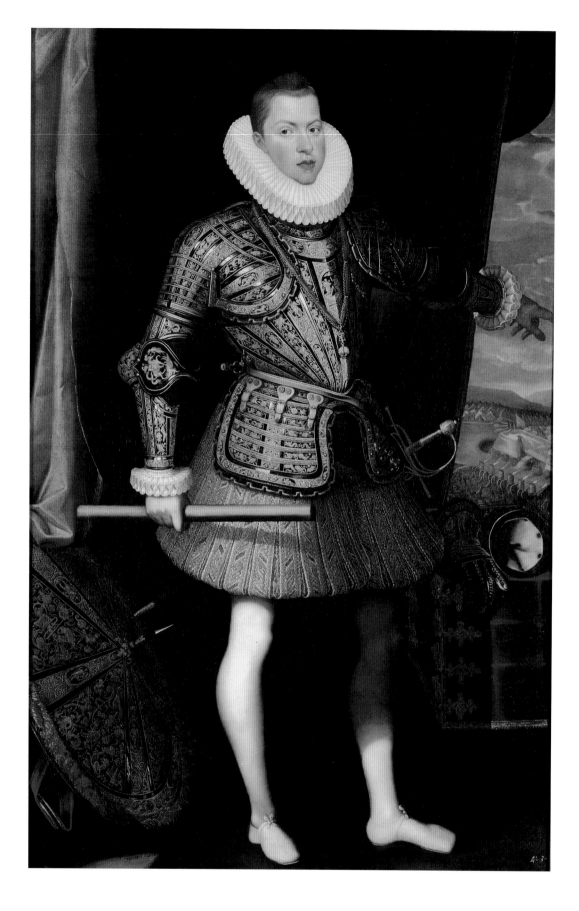

Catalogue 7
JUAN PANTOJA DE LA CRUZ
King Philip III of Spain, about 1601–2
Oil on canvas
69 5/16 x 45 11/16 in. (176 x 116 cm)
Kunsthistorisches Museum, Vienna

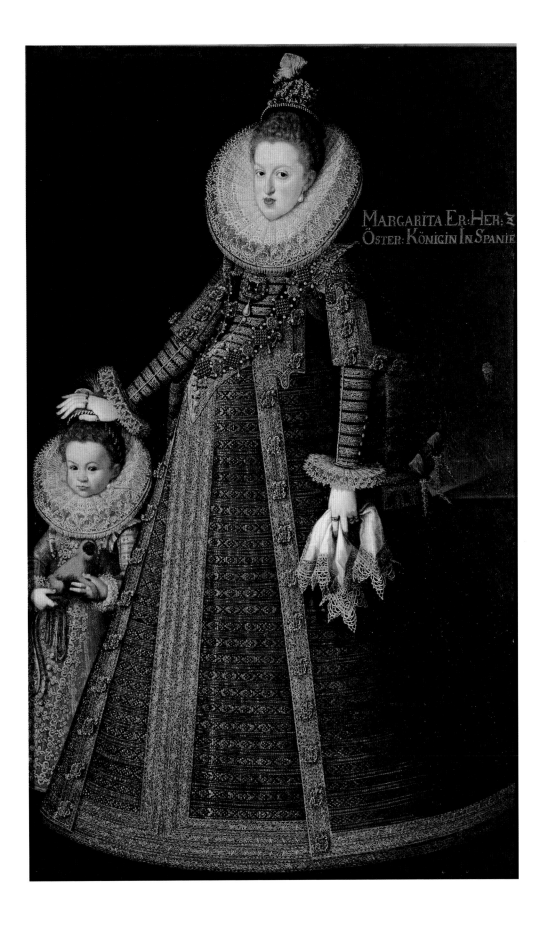

Catalogue 9
JUAN PANTOJA DE LA CRUZ
Portrait of Philip IV and Ana, 1607
Oil on canvas
46½ x 48¾ in. (118 x 124 cm)
Kunsthistorisches Museum, Vienna

Catalogue 10
BARTOLOMÉ GONZÁLEZ
Portrait of Alfonso "el Caro" and Ana Margarita,
about 1613–14
Oil on canvas
48 13/16 x 38¾ in. (124 x 98.5 cm)
Instituto de Valencia de Don Juan, Madrid

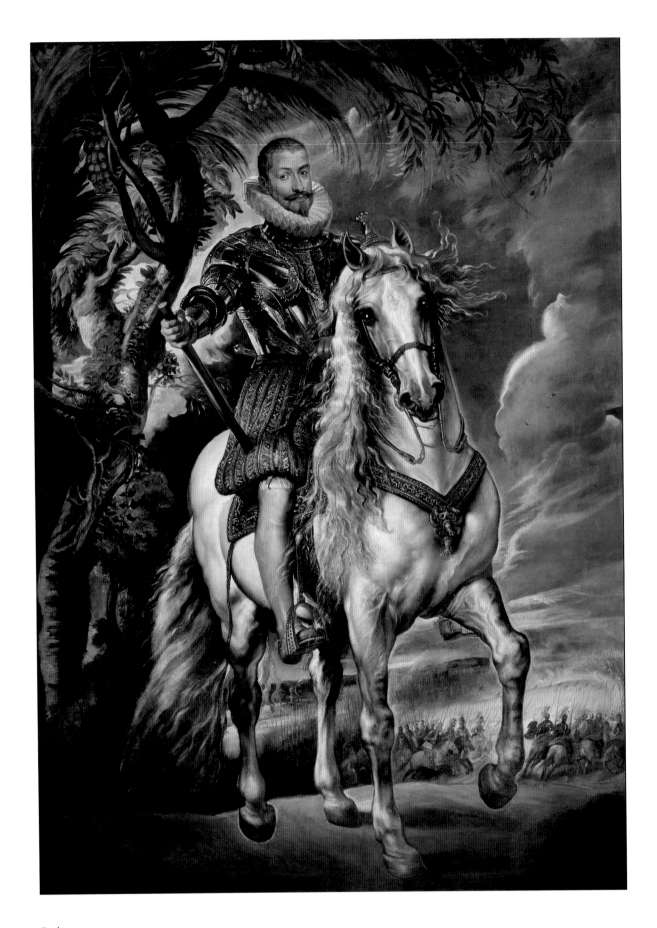

Catalogue 11
PETER PAUL RUBENS
Equestrian Portrait of the Duke of Lerma, about 1603
Oil on canvas
111 7/16 x 78 3/4 in. (283 x 200 cm)
Museo Nacional del Prado, Madrid

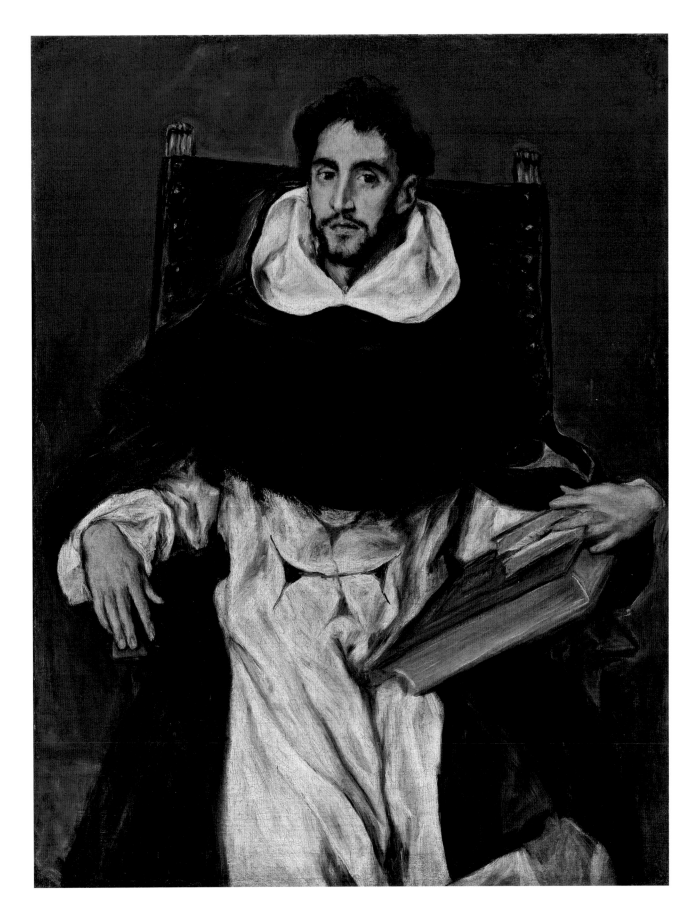

Catalogue 12
EL GRECO
Fray Hortensio Félix Paravicino, 1609
Oil on canvas
44⅛ x 33⅞ in. (112.1 x 86.1 cm)
Museum of Fine Arts, Boston

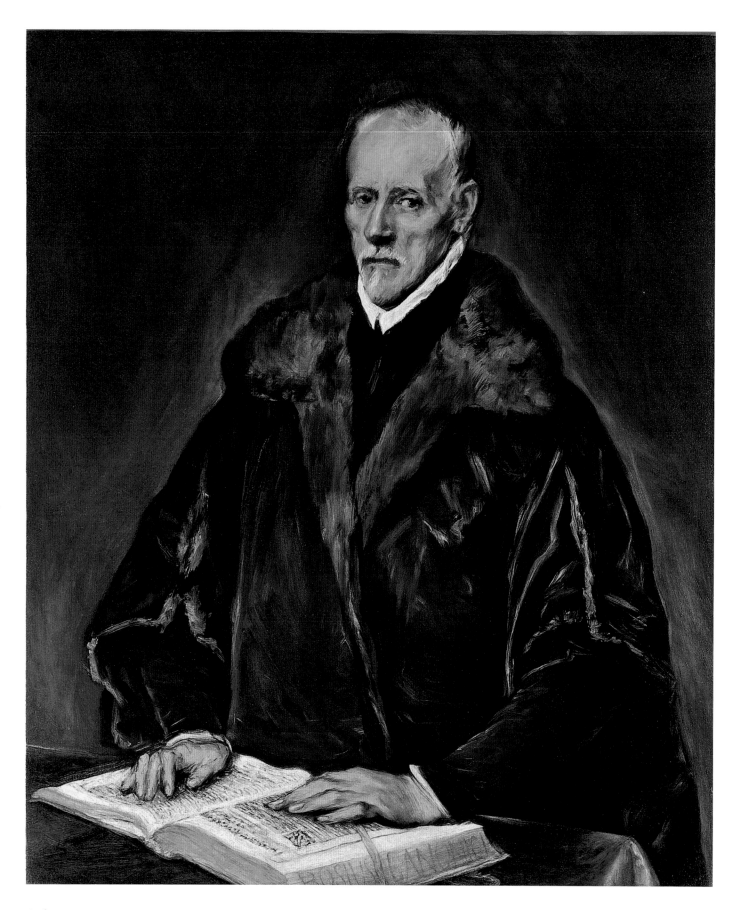

Catalogue 13
EL GRECO
Portrait of an Ecclesiastic, about 1610–14
Oil on canvas
42⅛ x 35½ in. (107 x 90.2 cm)
Kimbell Art Museum, Fort Worth, Texas

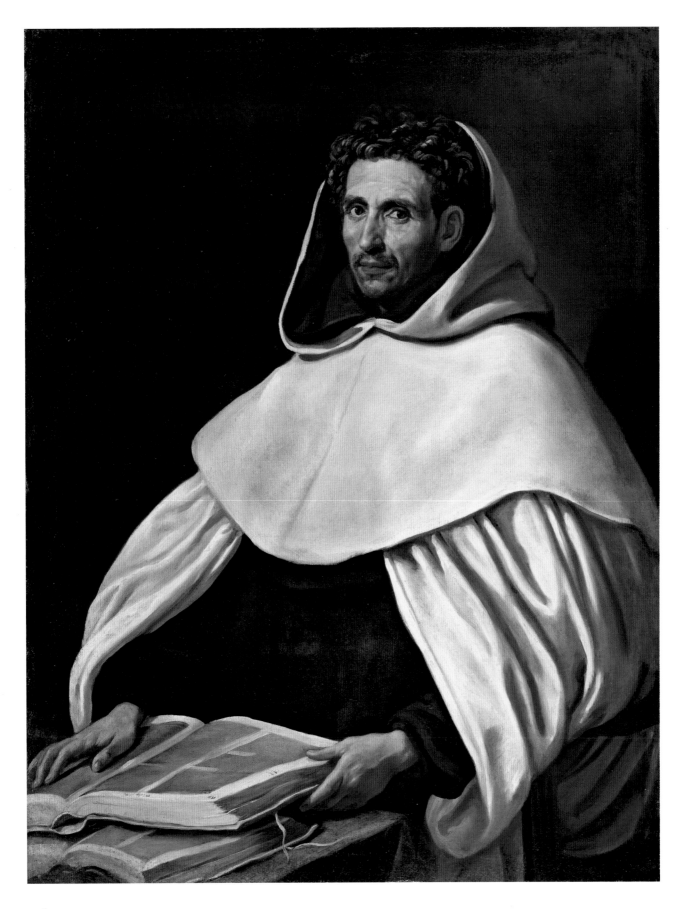

Catalogue 14
LUIS TRISTÁN
Portrait of a Carmelite
Oil on canvas
43 5/16 x 33 1/16 in. (110 x 84 cm)
Museo Nacional del Prado, Madrid

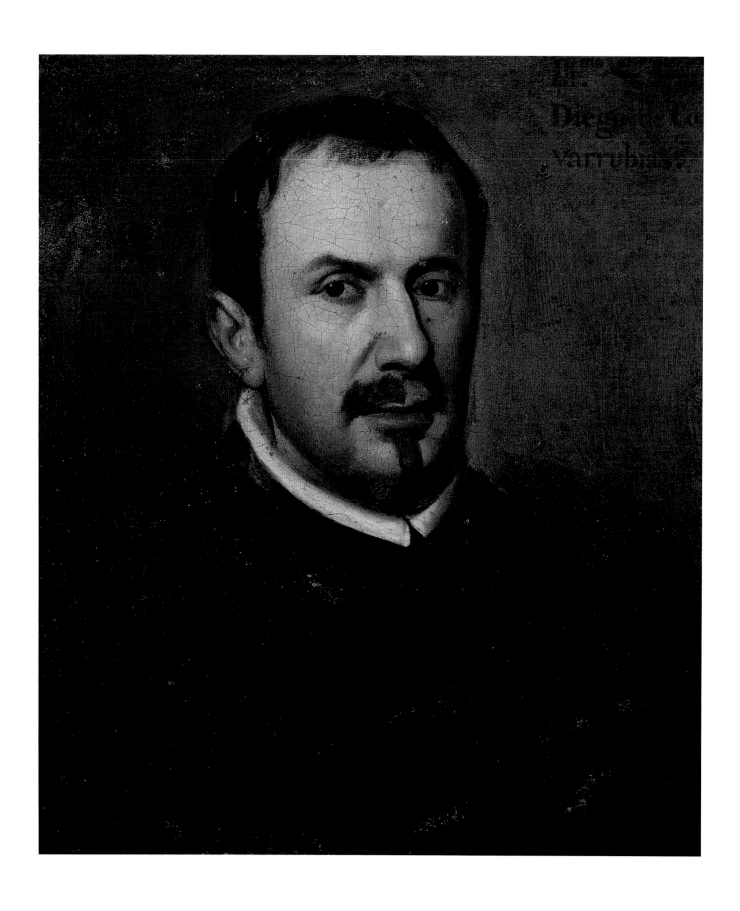

Catalogue 15
JUAN VAN DER HAMEN Y LEÓN
Portrait of Lorenzo van der Hamen y León, about 1620
Oil on canvas
21 9/16 x 16 13/16 in. (54.8 x 42.7 cm)
Instituto de Valencia de Don Juan, Madrid

Catalogue 16
JUAN BAUTISTA MAINO
Portrait of a Monk
Oil on canvas
18½ x 13⅛ in. (47 x 33.3 cm)
Ashmolean Museum, University of Oxford

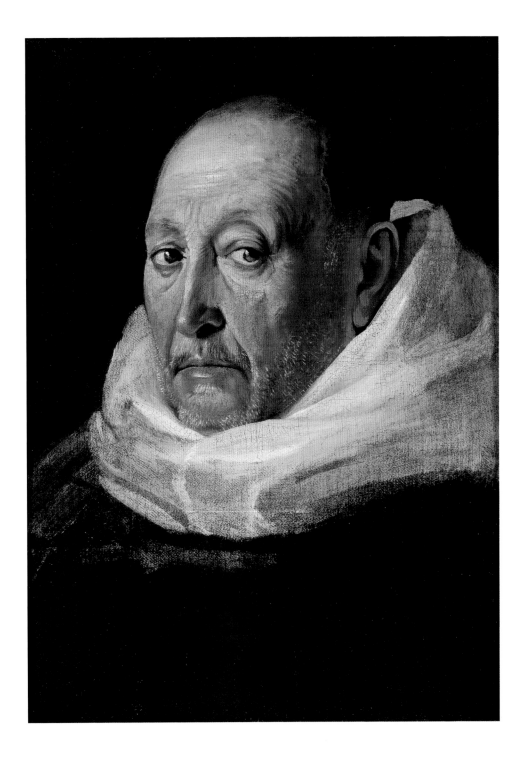

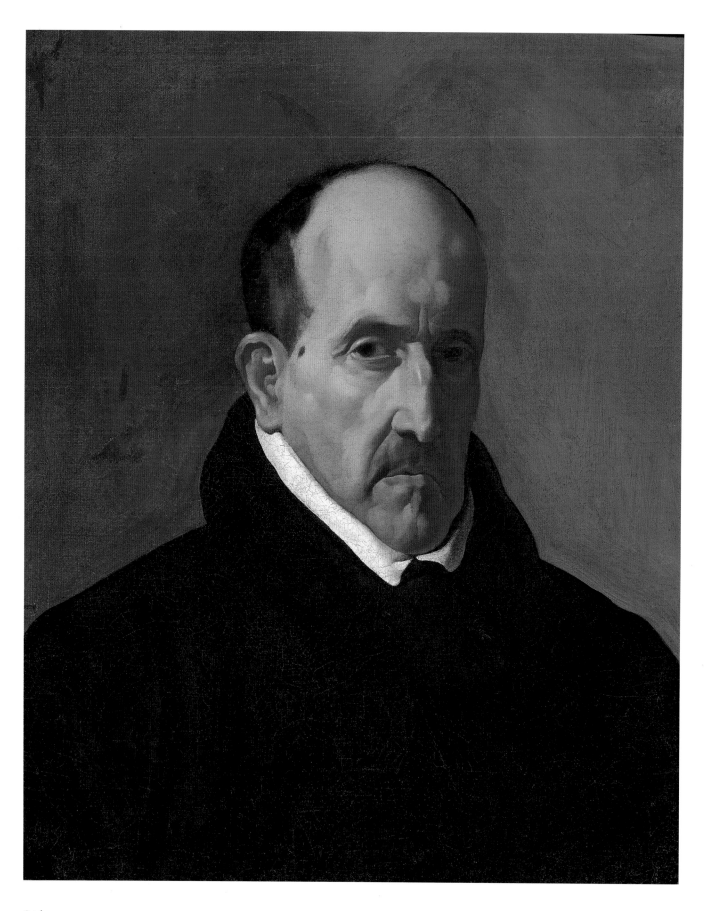

Catalogue 17
DIEGO RODRÍGUEZ DE SILVA Y VELÁZQUEZ
Luis de Góngora y Argote, 1622
Oil on canvas
19¾ x 16 in. (50.2 x 40.6 cm)
Museum of Fine Arts, Boston

Catalogue 18
FRANCISCO PACHECO
Portrait of a Poet
Black and red chalk over wash
7¼ x 5⅞ in. (18.4 x 14.9 cm)
Biblioteca Nacional de España, Madrid

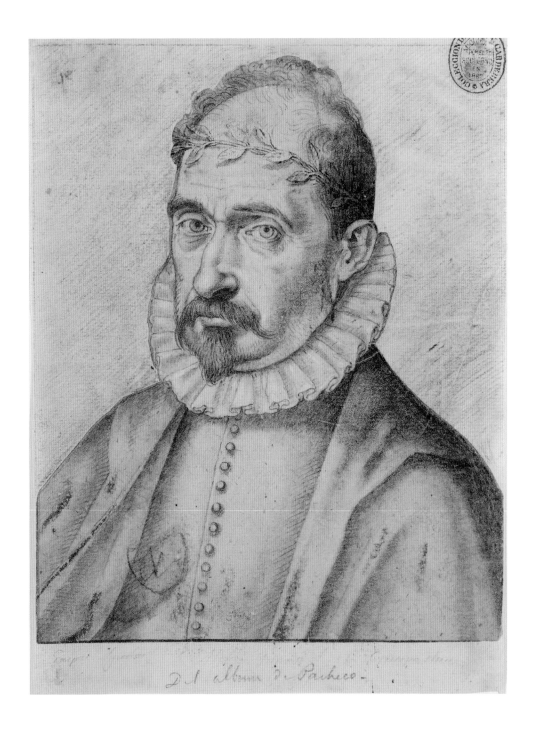

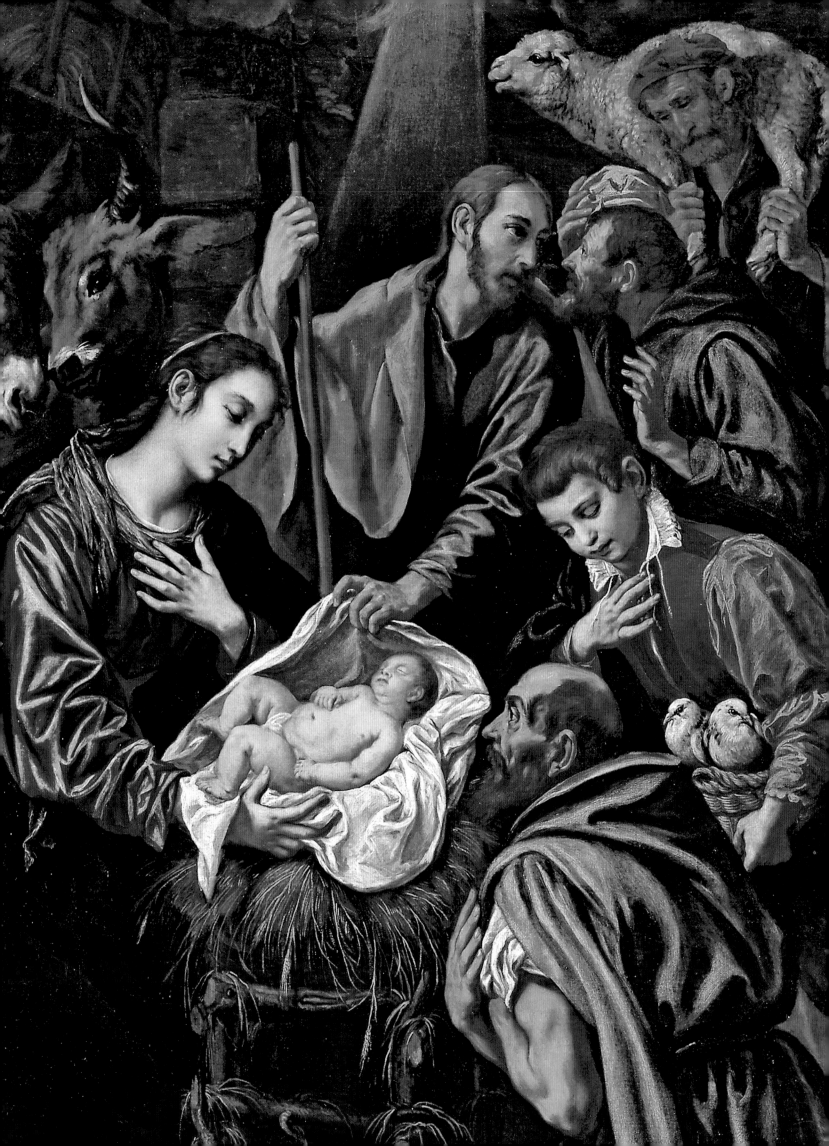

Religious Institutions and Private Patrons

One important factor in the study of Spanish art and culture is the "profound religious ethos which is all-pervasive, including the non-conformist strain, struggling for expression within and beyond the limits of orthodoxy."[1] In the seventeenth century the Catholic Church consisted of orders (monasteries and convents); the secular parish churches, which belonged to a diocese; and grand cathedrals, the centerpieces of the dioceses, whose bishops and archbishops, most often members of the aristocracy or the royal family, were appointed by the king. There were also churches, hospitals, and other such facilities for the poor and sick, run by confraternities (independent brotherhoods of lay people) who maintained their own institutions. The type of institution, its location, and its economic health determined the nature of the artistic programs it sponsored.[2] The cloistered order of the Carthusians in Granada, for example, commissioned the conservative *Immaculate Conception* from the lay brother of their order, Sánchez Cotán (cat. 46); whereas the Jesuits, who were based in Rome but had missions all over the world, were the patrons of Velázquez's progressive, Caravaggesque *Adoration of the Magi* (cat. 22), of about the same date. While a couple of the works in this exhibition were produced for a cathedral or a hospital, most of them were monastic commissions from the Augustinian, Dominican, Jesuit, and Hieronymite orders, intended for their churches and private spaces. Scale and subject matter suggest that others may have been made for private collectors.

El Greco's *Annunciation* (cat. 19), the *Adoration of the Magi* by Maino (cat. 21), and Tristán's *Adoration of the Shepherds* (cat. 23) once functioned as parts of *retablos mayores* (high or main altarpieces), elaborate architectural structures with paintings and sculpture that were located behind the altars where the Mass was celebrated.[3] The *retablo mayor* was usually the main decoration of a parish or convent church, the focal point at the end of a long central nave that terminated in a flat or slightly curved apse. The multipart altarpiece, standing out brightly in the dim church interior and filling the apse from floor to ceiling, created a spiritual ambience and illustrated the sacred stories and mysteries of the Church to serve as a guide to prayer for the faithful. The grandest and most influential example is found in the church of El Escorial (fig. 76), completed about 1592, with gilt bronze statues by the Milanese sculptors Leon and Pompeo Leoni, enormous red and green jasper framework columns with classical orders, and paintings by the Italians Federico Zuccaro (1540/41–1609) and Pellegrino Tibaldi (1527–1596).

In the Catholic Reformation of the seventeenth century, altarpieces often featured scenes from the life of Christ that referred to the main feasts of the liturgical calendar: the Nativity and the Adoration of the Shepherds (Christmas); the Adoration of the Magi (Epiphany); the Resurrection (Easter); and the Descent of the Holy Ghost (Pentecost). Subjects from the life of the Virgin Mary were also appropriate for a *retablo mayor* as Mary was held to be the Immaculate Temple or Tabernacle of Christ. The altarpiece could be devoted to the saint to which the church was dedicated, or whose relics the altar enshrined. As in the church of El Escorial, the saint's martyrdom was often featured in the central panel, surrounded by scenes from the life of Christ and the Virgin; these images were meant to encourage the religious to model their lives after the exemplary lives depicted.

A simple Crucifixion scene often surmounted the structure of the *retablo mayor*, as if the sacrifice of Christ were the epitome of all themes, with its message of the salvation of mankind through Christ's death on the cross. Although its original setting is unknown, Tristán's *Crucified Christ with the Virgin and Saint John* (cat. 30) might well have occupied this position; the plasticity of the figures and the gestures of Mary and John echo the sculptural groups that Gregorio Fernández made for several high altars.

76
Retablo mayor, Real Monasterio de
San Lorenzo de El Escorial, Madrid

The centerpiece El Greco made for the
Colegio de Doña María de Aragón, his only
retablo mayor in Madrid,[4] consisted of six or
seven large pieces arranged in two rows;[5] the
Annunciation occupied the central position
in the lower register. The artist followed the
orthodox requirements of representing the
sacred theme of the Annunciation in many
respects: he rendered the scene at night; gave
the archangel Gabriel a human form, decently
dressed and not in flight; and depicted the
Virgin, clothed in red with a blue mantle, her
head covered, on her knees in front of an open
book on a stand.[6]

By featuring a band of musical angels in
the Gloria above the scene, however, El Greco
departed from the traditional rendering of the
subject, which normally showed God the Father
in this position. The divergence suggests that
there might have been a programmatic dictate
by the patron to incorporate details from the
Blessed Alonso Orozco's writings.[7] Orozco had
had a vision of the Annunciation in which a
host of angels played music just at the moment
of the Incarnation. El Greco devoted the top
third of his composition to Orozco's vision.
He painted the angels playing contemporary
instruments, the same instruments a seven-
teenth-century worshiper might have known
and perhaps heard in church. The angel on the
left conducts from a book of music, while four
angels play stringed instruments and are accom-
panied by an angelic flutist. The presence of the
handheld harpsichord, viola da gamba, harp,
and Spanish lute (played by the central angel
with its back to us) refers to the progressive
musical accomplishments of the time. These
included the writing of polyphonic works in
the new Baroque idiom by one of the greatest
composers of the age, Mateo Romero (1575–
1647), a Fleming who lived at the court of
Philip III from an early age,[8] and by Tomás
Luís de Victoria (1548–1611), the native of Avila
who brought back to Spain the new style of the
great Italian Counter-Reformation composer
Giovanni Pierluigi de Palestrina.[9]

El Greco's angelic musicians may therefore
allude to the new practice at the court of Philip
III, where instruments were now allowed dur-
ing Mass to accompany the traditional five or
six voices.[10] The king's favorite, the duke of
Lerma, was probably behind this change in
practice; recent evidence reveals that the duke,
an important patron of progressive music of
the time, was responsible for introducing the
violin to Spain.[11]

Another assault on the orthodox mode of
representing the Annunciation is the absence of
the traditional lily, which has been replaced by a
highly unusual symbol: a bush with flames, cen-
tered between Mary and the archangel Gabriel,
just above Mary's sewing basket. This is a refer-
ence to Orozco's unorthodox belief that the
Burning Bush (the form assumed by God when
He called Moses to lead the Israelites out of
Egypt [Exodus 3:2–5]) miraculously reappeared
at the moment of conception as a symbol of the
Virgin Birth.[12] According to Orozco, the fire of
God's spirit, in the form of the Holy Spirit, was
"enflamed by intense love" as He descended
upon Mary like the flames of the Burning Bush,
with "leaves that experienced fire but did not
burn" (Exodus 3:5). In spite of the fiery love
raining down on her, Mary did not burn but
remained pure, a not-so-subtle allusion to the
vow of chastity preached by Orozco to the semi-
narians, and taken by Doña María de Aragón at
the age of eleven.

The central position of the *Annunciation* is
rather unusual for a monastic altarpiece. Vicente
Carducho's painting of the same subject appears
in the main retable at the nearby convent of La
Encarnación, founded by Queen Margaret and
Philip III (fig. 42, p. 100). The specific dedica-
tion of both reform Augustinian institutions—the
male seminary (the proper name of which was
Colegio de Nuestra Señora de La Encarnación)
and the royal female convent—was to the Virgin
of the Incarnation. The *retablo mayor* in both
cases reflected the Catholic Reformation's
renewed passion for the cult of Mary.

Juan Bautista Maino's *Adoration of the
Magi* (cat. 21) came from the *retablo mayor* in
the Dominican monastery of San Pedro Mártir
in Toledo. It was commissioned by the friars
in 1612; before completing the work, Maino
had taken steps to become a noviate in the
Dominican Order. The four scenes of the altar-
piece—the Adoration of the Shepherds, the
Adoration of the Magi, the Resurrection, and the
Pentecost ("Las cuatro Pascuas," as it was called
in contemporary documents)—refer to impor-
tant Catholic sacraments: Communion (taking
the body and blood of Christ in the form of
bread and wine), Ordination (conferment of
priesthood), and Confirmation (profession of
faith). The last two take place on the Feast of
the Pentecost, when the Holy Spirit was made
manifest in the tongues of fire, giving the apos-
tles power to speak and spread the word. The
function of the altarpiece then was to confirm
the importance of the Sacraments and to em-
phasize the preaching mission of the Dominicans.

Maino developed a masterful commingling
of styles that he adapted from modern painters
in Rome: rich drapery stuffs of sumptuous color

and material from Orazio Gentileschi, and the use of real-life models for the sacred figures and tenebrism from Caravaggio. Florentine influence can also be detected in its sweet, tender religious expression and certain stylistic elements found in a work of the same subject by Gregorio Pagani (1558–1605) (Santo Spirito, Florence).[13]

The Adoration of the Magi, the second important moment in the depiction of the life of Jesus after his birth, usually occupies the lower left register of seventeenth-century Spanish altarpieces. It depicts the "wise men from the east" who were led by a star to the new king of the Jews bearing gifts of gold, frankincense, and myrrh (Matthew 2:11). The gifts were symbols alluding to Christ's kingship, divinity, and humanity. Saint Augustine specified that gold, represented in Maino's painting by the large covered chalice in the foreground, was for tribute; frankincense, which sweetened the air, represented Christ's sacrifice; and myrrh, an embalming herb, stood for His death.[14] In Maino's painting, a large, perfectly formed baby raises its little arm in benediction as Caspar bows down in submission. This is the gesture of benediction given by the priest, as Christ's representative on earth, when the Eucharist is consecrated, at the end of the Mass, and in the administration of other sacraments. The congregation would have recognized that the kings were clothed in contemporary dress, that the sacred figures had faces like their own, and that the gesture of benediction echoed that of the priest.

Luis Tristán's *Adoration of the Shepherds*, signed and dated 1620, was first seen and praised by Palomino in the convent of the Jerónimas de la Reina in Toledo. It too came from a *retablo mayor* dedicated to "Las cuatro Pascuas."[15] As opposed to Maino's older and wiser baby, Tristán portrayed Jesus as a newborn child, sound asleep. He is a small and vulnerable human being protected by his parents. In a rare iconographical detail, it is the earthly father who holds the white cloth covering the baby, an expression of the growing devotion in Spain to Saint Joseph.[16] Below the manger is the sacrificial lamb with its feet bound, an allusion to God's only son, the Lamb of God, who would be sacrificed to bring man salvation. Tristán conceived of the scene naturalistically, and many of his figure types were based on real-life models. Nevertheless, the artist also turned to pictorial precedents. The boy on the right of the manger holding two doves is a direct quotation from Bassano, as is the red-hatted repoussoir figure at lower left. The dirty feet of the kneeling shepherd is a motif adopted from Caravaggio's famous *Madonna of the Pilgrims* in San Agostino, which Tristán surely

visited while in Rome, while the figure itself and the treatment of flickering light pay homage to his teacher, El Greco.

The naturalism in Velázquez's *Adoration of the Magi* (cat. 22), made for the novitiate chapel in the Jesuit monastery in Seville, is vastly different than Tristán's. There are no references to past artists here; Velázquez re-created a time-honored theme in completely human and contemporary terms. It is at first difficult to recognize the figures on the Virgin's right as the Three Kings. They are usually shown in sumptuous, colorful clothing, but here Velázquez eschewed exotic dress and used figures he might have seen on the streets of Seville for his models. The painting is a good example of the artist's ability to translate the divine into human terms, an idea espoused by the Jesuit founder Ignatius Loyola in his *Spiritual Exercises*, which every novice had to learn and practice.

Historically, the theme of the Adoration of the Magi had special meaning to the Spanish kings. As Rosemarie Mulcahy has pointed out in her essay in this volume, the Feast of the Adoration (the Epiphany) was celebrated in a special ceremony by Philip II, in which he gave chalices with gold, frankincense, and myrrh to the prior of the monastery of El Escorial, thereby making explicit the connection between the king and the Catholic Church. At a moment when the health of the monarchy and the notion of kingship were at stake, the image may have taken on additional significance for Philip III's subjects. During this king's reign, the theme was especially common; most of the artists painted at least one depiction of it.

Joachim and Anne Meeting at the Golden Gate (cat. 20) by Eugenio Cajés has been identified as the only surviving work from the "altar of the Guardian angel," which was located in the second side chapel on the left in the church of the Shod Augustinians in Madrid (San Felipe el Real), where Cajés himself was buried.[17] A contract, dated September 1604, commissioned the sculptor Juan de Porres and Cajés to make an altarpiece with five paintings of "histories of the Christ child and Joachim and Ana" for the chapel belonging to the proctor Pedro de Cercito.[18] Palomino reported that a fire in 1718 destroyed much of the church (including the *retablo mayor*, also by Cajés, of the *Martyrdom of Saint Philip*), although the *Meeting at the Golden Gate* survived.[19]

Palomino praised Cajés as "one of the most outstanding painters of this court" and singled out the *Meeting at the Golden Gate* as "an excellent picture and one of his best."[20] It exhibits the soft, almost blurred and idealized facial types that Cajés developed early in his career,

undoubtedly as a result of his intimate familiarity with the gauzy sfumato of Correggio's *Leda and the Swan* and *Rape of Ganymede*, paintings given by Philip III to his cousin Rudolf of Prague.[21] Cajés's exposure to the "moderns" in Rome and elsewhere, including Cavaliere d'Arpino, who was painting the dome of Saint Peter's, would have reinforced his late Mannerist style, evident here in the elongated figures that are elegantly draped in heavy cloth, the folds of which seem of greater interest to Cajés than the definition of form underneath.[22] The bright color juxtapositions indicate that he also admired paintings by Federico Barocci. However, the charming concetto of the descending angel who joins Anne with Joachim departs from late Mannerism into nascent naturalism and is related in feeling to Cajés's tender depiction of Saint Julian in the act of basket weaving (cat. 43).

The story was derived from the apocryphal Protoevangelium. After twenty years of marriage, Joachim and Anne remained childless. Joachim, refused at the temple because sterility was thought to be a curse by the Jews, went into exile while Anne stayed in Jerusalem. The angel Gabriel appeared to both saying that they were to become the parents of a special child blessed by God; they were then reunited at the Golden Gate in Jerusalem.[23] Cajés framed his composition with two gilt corners and flat pilasters behind the figures, which allude to this gate. In the fifteenth century it was popularly believed that Mary was conceived at the moment of the chaste embrace; sometimes, therefore, the image was associated with an Immaculatist program. Cajés added the unusual motif of the angel who puts his right hand on the head of Joachim and his left on that of Anne to join together the parents of the Virgin Mary. Jusepe Martínez claimed that "the delicacy of the clouds he painted with celestial scenes were unsurpassed by ancient and modern artists alike."[24]

As a rule, altarpieces in Spanish cathedrals, the sites of the grandest religious ceremony and pomp, were often quite large and impressive; chapels within the cathedral were used as family burial sites for well-endowed and well-connected citizens. Pedro Orrente's enormous *Martyrdom of Saint Sebastian* was commissioned by Diego de Covarrubias (d. 1608), the king's *procanciller* (prochancellor) of Aragón, for the altar in the chapel of Saint Sebastian in the Cathedral of Valencia, where he and his wife were to be buried.[25] The picture has always been greatly admired; for the art historian Pérez Sánchez, it is "one of the most beautiful nude youths in the history of Spanish art." He noted that the intense illumination that gives the figure its sculptural character is derived from Bassano.[26] The angels flying in to crown the saint with a laurel wreath show the artist's familiarity with the works of Caravaggio, which he must have seen during his time in Italy.

Palomino mentioned this work, adding that the first design or sketch for it was in the upper cloister of the convent of the Unshod Carmelites in Madrid.[27] The autograph replica on a smaller scale in the Descalzas Reales (cat. 32) could be the work Palomino cited, as some of the early religious members of this Unshod Franciscan convent had close ties to Gandia (Valencia).[28]

There are no other known preliminary oil paintings by Orrente, and the smaller *Saint Sebastian* appears to be a finished work. Perhaps the artist was following the example of El Greco's studio in creating a reduced version of a large altarpiece, or it might have been ordered by one of the Valencian nuns at the Descalzas Reales as a memento of an important image from her hometown.

The little-known *Resurrection* (cat. 31) by the court portraitist Juan Pantoja de la Cruz originally came from the Hospital General in Valladolid. It was undoubtedly commissioned by the duke of Lerma, the great patron of this institution; the painting is dated 1605, when the court was still in Valladolid and Lerma was at the height of his power. Its immense size suggests that it may have been an altarpiece for the hospital's chapel, or, as in the case of Vicente Carducho's *Stigmatization of Saint Francis* in the Hospital of the T.O.R. in Madrid (cat. 38), it may have hung on a cloister wall or in some other common area. The Resurrection was an appropriate subject for a hospital, for, as Saint Paul explained, the significance of the miracle was a promise of salvation: "just as Christ has arisen from the dead through the glory of the Father, so we may walk in newness of life. For if we have been united with Him in the likeness of His death, we shall be so in the likeness of His Resurrection also" (Romans 6:4–5). Pantoja's *Resurrection* would have functioned as a visual reminder of hope to the dying for an everlasting life.

The artist envisioned Christ risen from his tomb in the middle of the night. The dramatic play of supernatural light effects in the profound darkness alludes to Christ's power and glory and the Resurrection as a state of transcendence.[29] The Victor Triumphant emits a powerful light; it forms a supernatural aureole around Him and causes reflections in the metal armor and weapons of the soldiers. Pantoja is at pains to show the cast shadow of Christ's long banner pole on His foot, healed and whole. Pantoja's choice of a night scene with

its Bassano-like effects and the Florentine body type of Christ reflect the duke of Lerma's taste. For the artist, this commission offered an opportunity to establish his reputation as a history painter as well as a portraitist.

The *Vision of Father Simón* by Ribalta (cat. 44) might have functioned as a street altar in Valencia, many of which were erected after Simón's death, or it could have been intended for a private collection, since the Cathedral of Valencia ordered three copies of Ribalta's image as gifts (for the king, the pope, and the duke of Lerma). Collectors during the reign of Philip III often commissioned religious subjects from local artists for their residences and hung the paintings among secular works on their walls or in private oratories. Spanish palace architecture of the early seventeenth century often featured a small room on the second story that overlooked the altar of an adjoining conventual church or monastery patronized by the palace owner. This cell-like space functioned as a private chapel for him and his family, while the chapel below served the religious and secular community. Established by Philip II at El Escorial, the tradition was also practiced by Lerma in all of his residential complexes.

Because of its intimate scale and subject matter, Cajés's *Nativity* (cat. 24) is an example of a devotional picture meant for a private residence. The same is probably true for Tristán's *Holy Family* (cat. 26), a painting whose domesticity would have been more appropriate for a less public setting. Such tender depictions might also have hung in the interior spaces of convents. Similarly, the subject of González's *Rest on the Flight into Egypt* (cat. 25) is rarely found in large altarpieces. It too depicts the intimate engagement of the sacred figures with one another. Because of its basic human subject that would have been familiar to all, it was a powerful tool for private contemplation and silent prayer. These images indicate the painters' knowledge of the "humanized" Holy Family images current in Italian Baroque art.[30]

Christ at Calvary by Cajés (cat. 28) has been identified as the painting described by Palomino in the corner of the cloister of the Augustinian seminary in Madrid (Colegio de Doña María de Aragón), where El Greco had been responsible for the main altar.[31] The contemplative subject was appropriate for the young seminarians taking meditative walks around the cloister. It depicts Christ moments before the Crucifixion, contemplating his fate. Not described in scripture or other religious texts, *Christ at Calvary* represents a type of devotional painting without historical narrative that invited meditation on the Passion of Christ.

This is true of Roelas's *Christ with the Cross* (cat. 29) as well. Vicente Carducho's near-identical treatment of *Christ at Calvary* (cat. 27) speaks to the success of the image. Perhaps the version by Cajés was seen by a private or monastic patron who then asked Carducho to paint the same subject (or vice-versa), or perhaps they were commissioned by the same patron, who wished to compare the different styles of these two contemporary painters to the king.

In both works, Christ is resigned to His fate, meek in posture, with head bowed. His hands are bound, like the sacrificial lamb in Tristán's *Adoration of the Shepherds*, alluding to Christ's identification as the Agnus Dei (lamb of God). The incredible sorrow and empathy the image conveys encourage the viewer to meditate on his own sins for which this Man, whose humanity is perfectly clear, was sacrificed. Cajés and Carducho paint a vivid picture to evoke the kind of empathetic emotion from the viewer that Ignatius Loyola was after—like the anguished figure of Mary in the background, we are there as witnesses at the moment Christ contemplates His own grueling way to the cross, suffering and dying for the salvation of man. The figure is monumental, filling the canvas and illuminated by a strong, focused light that reveals a vulnerable, exposed body with wounds that are all too real. The rough ropes and instruments of the passion inside the basket are given the attention of objects in a still life. Like the practitioner of the *Spiritual Exercises*, Cajés and Carducho translated into paint a scene so moving that the viewer could assume the state of mind necessary to contemplate the Passion:

> "In the Passion the proper thing to ask for is grief with Christ suffering, a broken heart with Christ heartbroken, tears, and deep suffering because of the great suffering that Christ endured for me . . . I will . . . arouse myself to sorrow, suffering and deep pain, frequently calling to mind the labors, burdens, and sufferings that Christ our Lord bore from the moment of His birth up to the mystery of His Passion, which I am now contemplating."[32]

Cajés and Carducho reinforce this theme of the *Spiritual Exercises* by picturing Christ Himself in the act of contemplating his own suffering, perhaps as a form of prayer to God the father.

The religious works created during the reign of Philip III attempt to express the sacred in human terms. The sincere and simple piety that resonates in these paintings would later find expression in the works of the artists of the Spanish Golden Age, especially those of Zurbarán and Murillo.

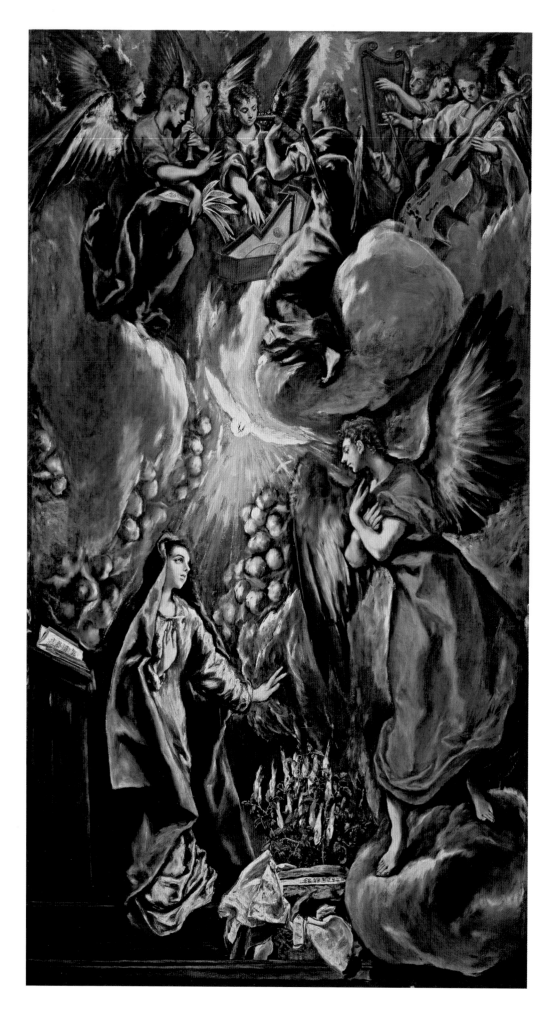

Catalogue 19
EL GRECO
Annunciation, about 1596–1600
Oil on canvas
124 x 68½ in. (315 x 174 cm)
Museo Nacional del Prado, Madrid

Catalogue 20
EUGENIO CAJÉS
Joachim and Anne Meeting at the Golden Gate,
about 1605
Oil on canvas
107 1/16 x 56 5/16 in. (272 x 143 cm)
Museo de la Real Academia de Bellas Artes
de San Fernando, Madrid

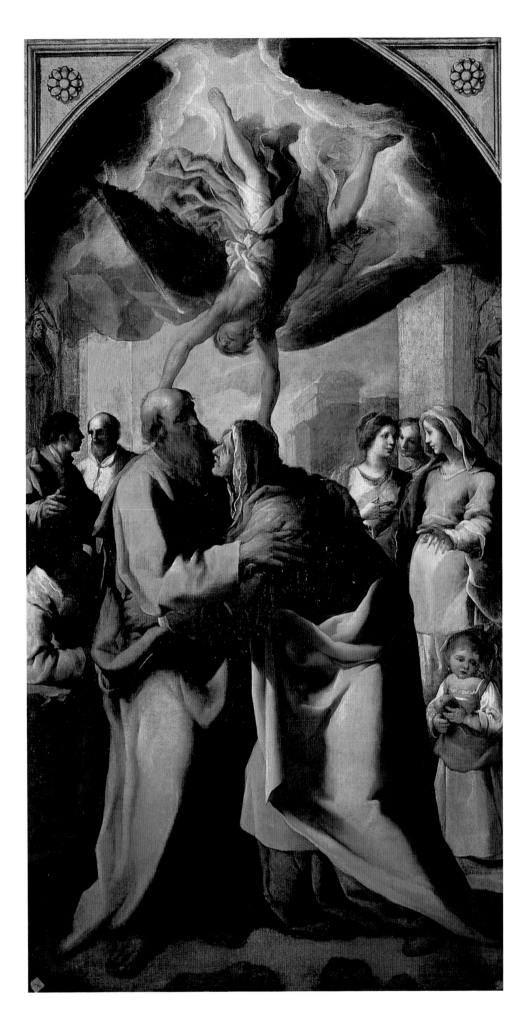

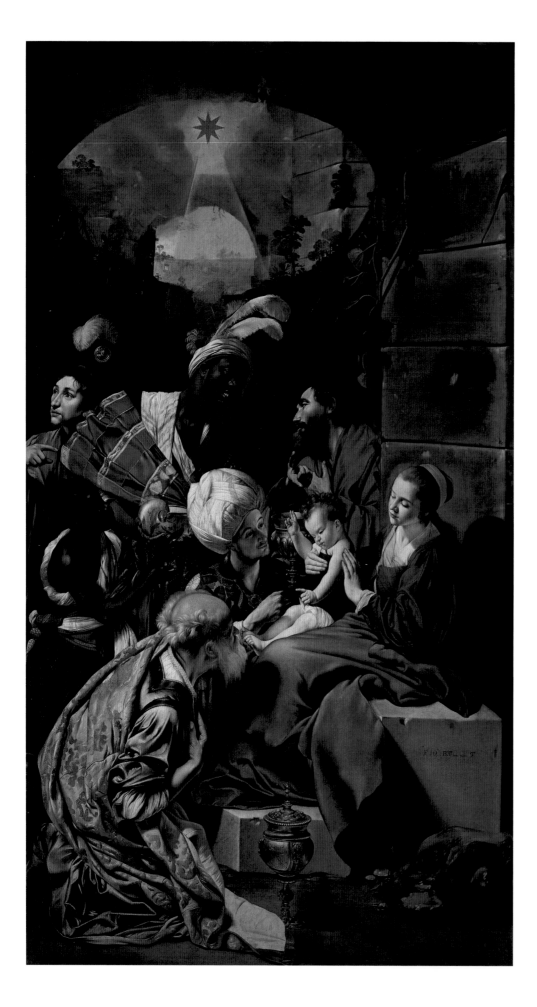

Catalogue 21
JUAN BAUTISTA MAINO
Adoration of the Magi, 1612
Oil on canvas
124 x 68½ in. (315 x 174 cm)
Museo Nacional del Prado, Madrid

Catalogue 22
DIEGO RODRÍGUEZ DE SILVA
Y VELÁZQUEZ
Adoration of the Magi, 1619
Oil on canvas
79 15/16 x 49 3/16 in. (203 x 125 cm)
Museo Nacional del Prado, Madrid

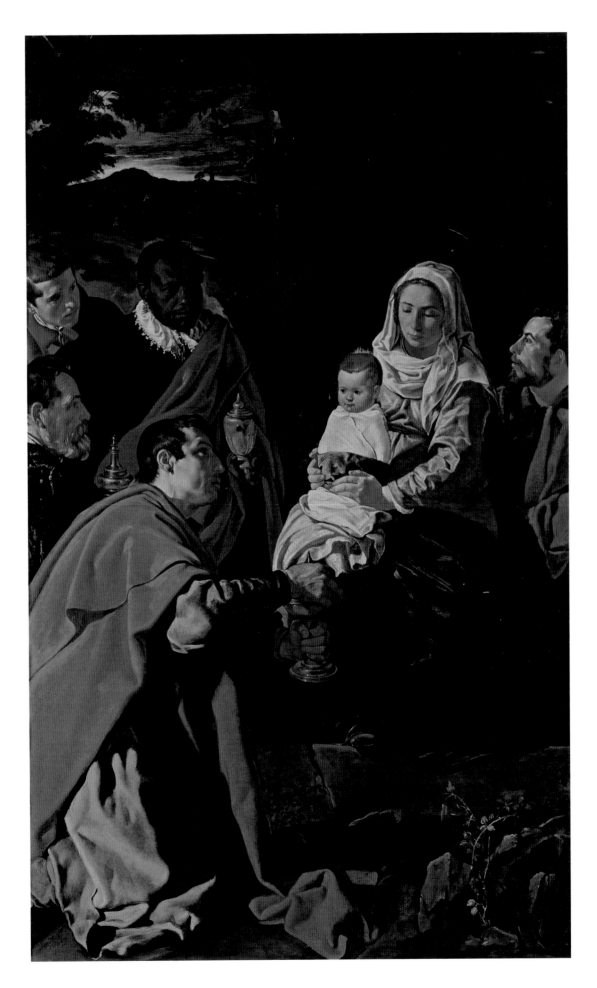

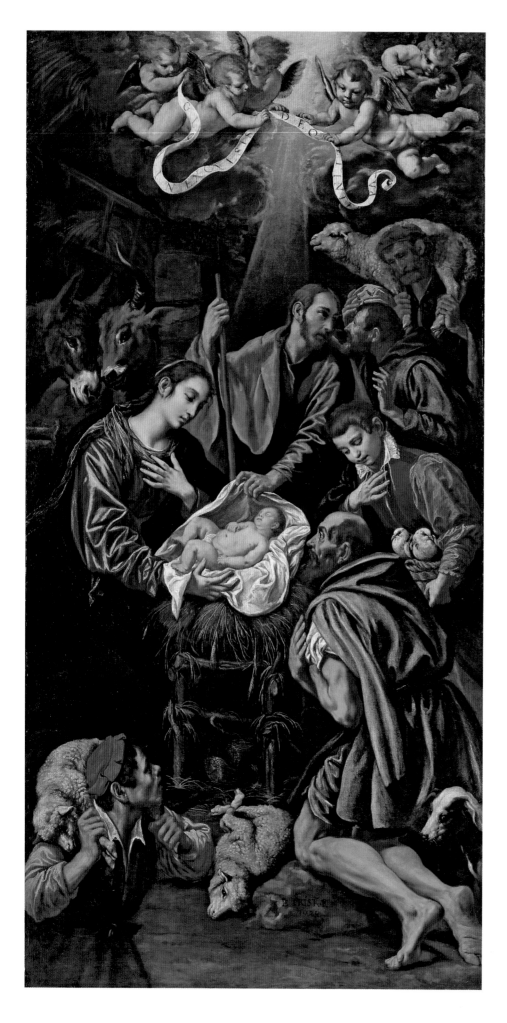

Catalogue 23
LUIS TRISTÁN
Adoration of the Shepherds, 1620
Oil on canvas
91¾ x 45¼ in. (233 x 115 cm)
Fitzwilliam Museum, Cambridge

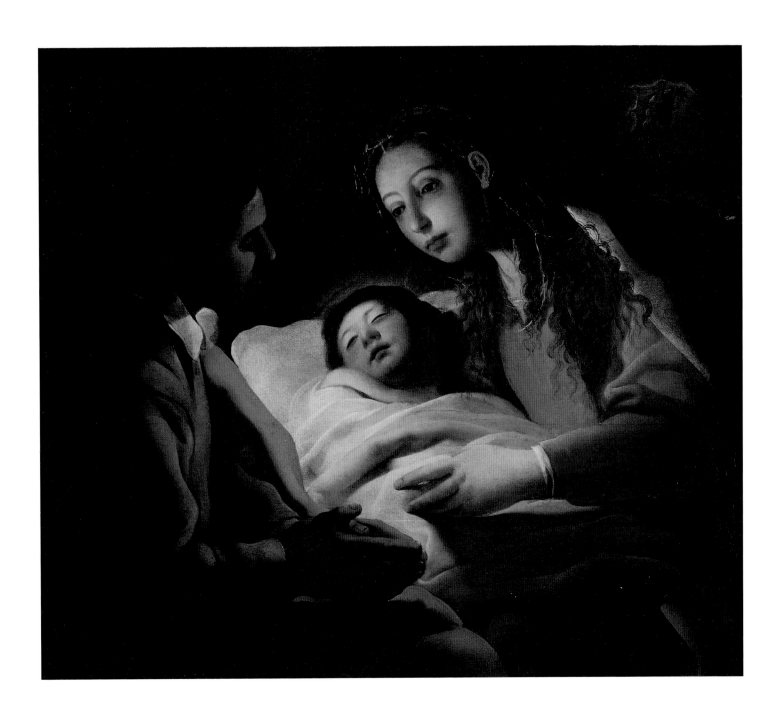

Catalogue 24
EUGENIO CAJÉS
Nativity, 1610
Oil on canvas
27⅝ x 31⁹⁄₁₆ in. (70.2 x 80.2 cm)
Plácido Arango Collection

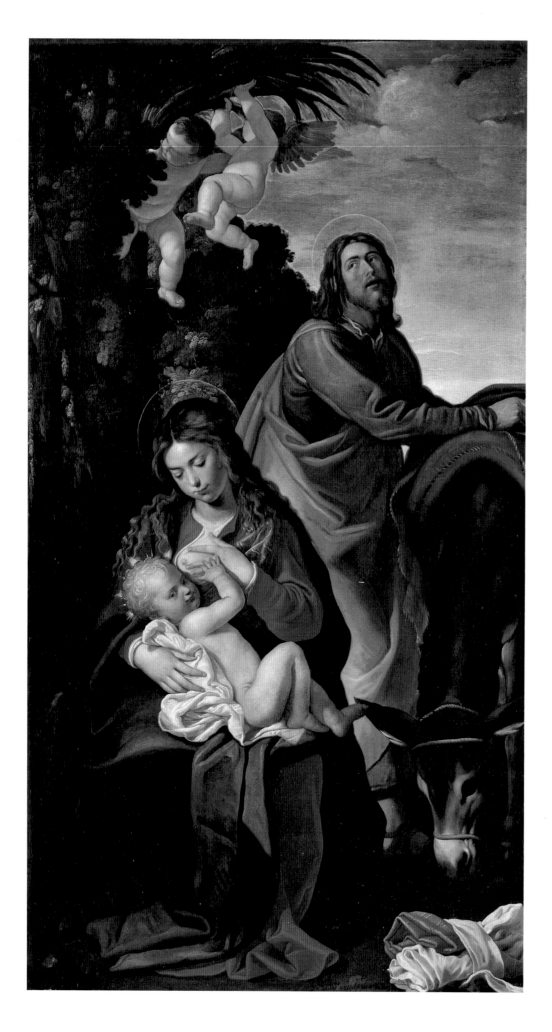

Catalogue 25
BARTOLOMÉ GONZÁLEZ
Rest on the Flight into Egypt, 1627
Oil on canvas
61 x 34⅝ in. (155 x 88 cm)
Museo Nacional del Prado, Madrid

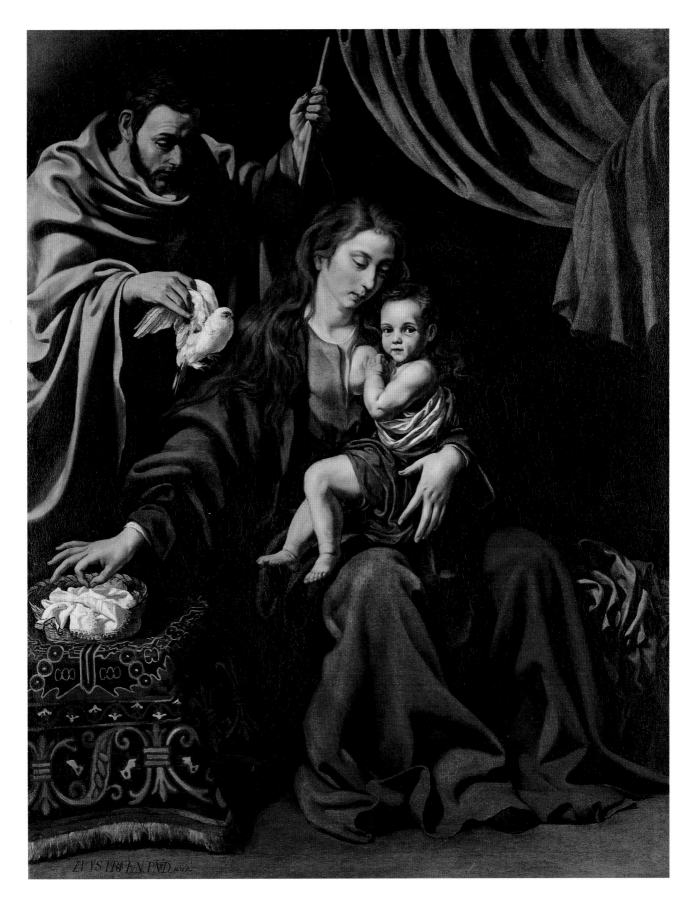

Catalogue 26
LUIS TRISTÁN
The Holy Family, 1613
Oil on canvas
56 x 43 in. (142.2 x 109.2 cm)
Minneapolis Institute of Arts

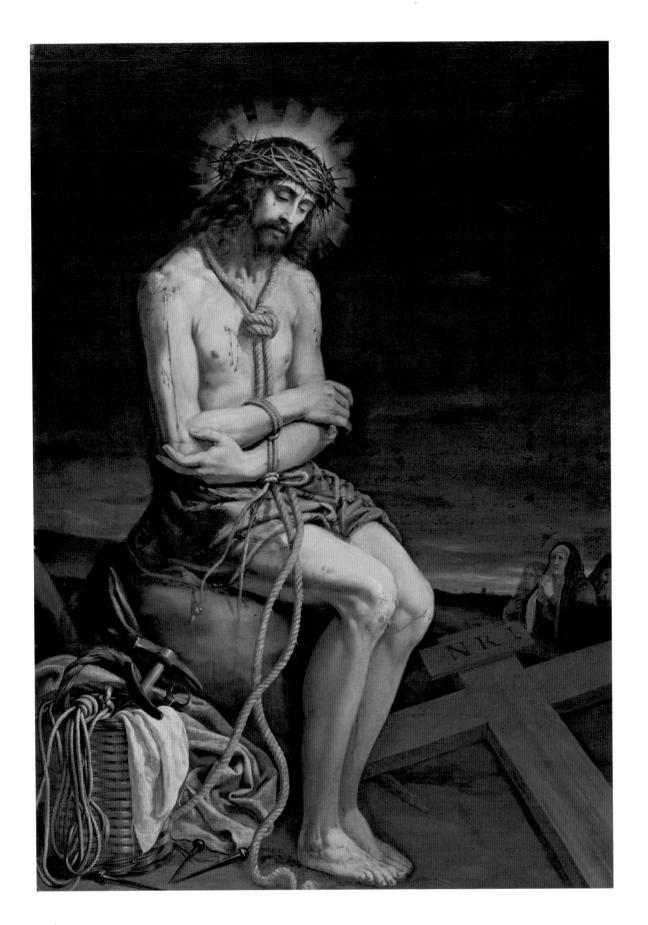

Catalogue 27
VICENTE CARDUCHO
Christ at Calvary
Oil on canvas
64¼ x 45 in. (166 x 116.7 cm)
Private Collection, Madrid

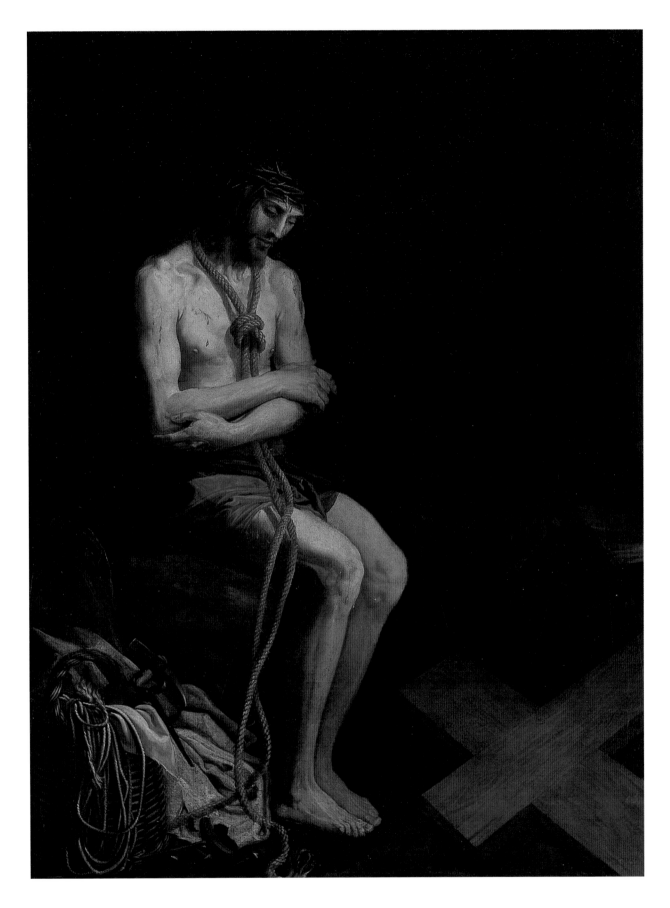

Catalogue 28
EUGENIO CAJÉS
Christ at Calvary, about 1615
Oil on canvas
77 9/16 x 58 11/16 in. (197 x 149 cm)
Museo Nacional del Prado, Madrid

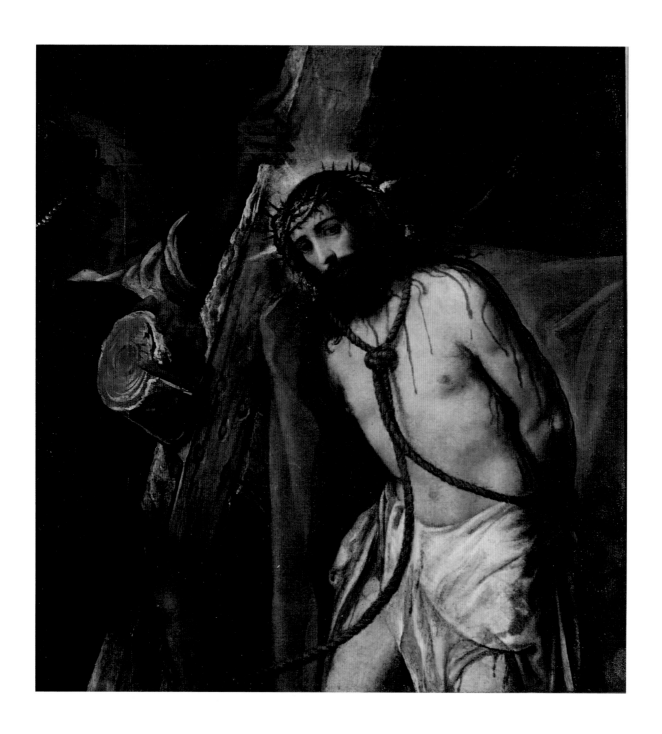

Catalogue 29
JUAN DE ROELAS
Christ with the Cross, about 1620–24
Oil on canvas
48 1/16 x 45 1/4 in. (122 x 115 cm)
Museo de Bellas Artes de Seville

Catalogue 30
LUIS TRISTÁN
Crucified Christ with the Virgin
and Saint John, about 1613
Oil on canvas
93�5/₁₆ x 61 in. (237 x 155 cm)
Plácido Arango Collection

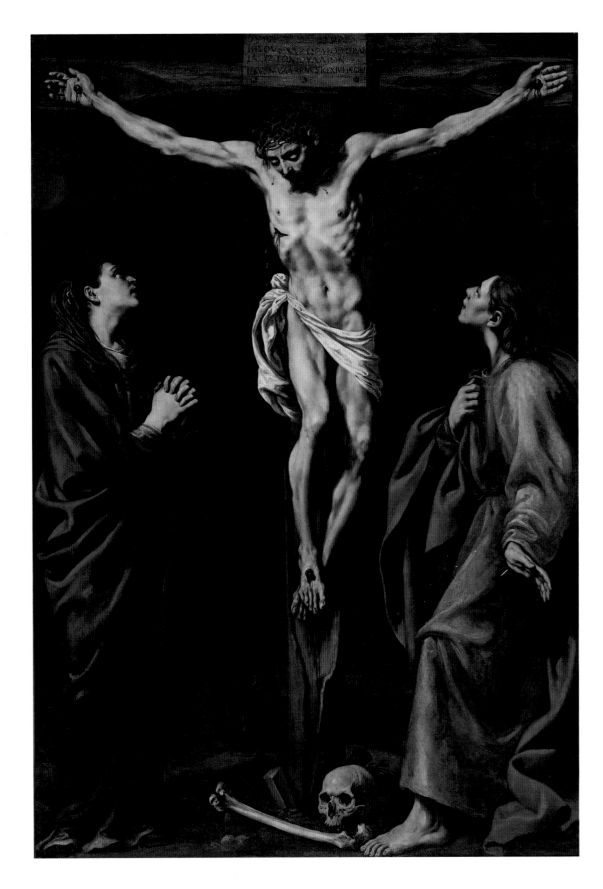

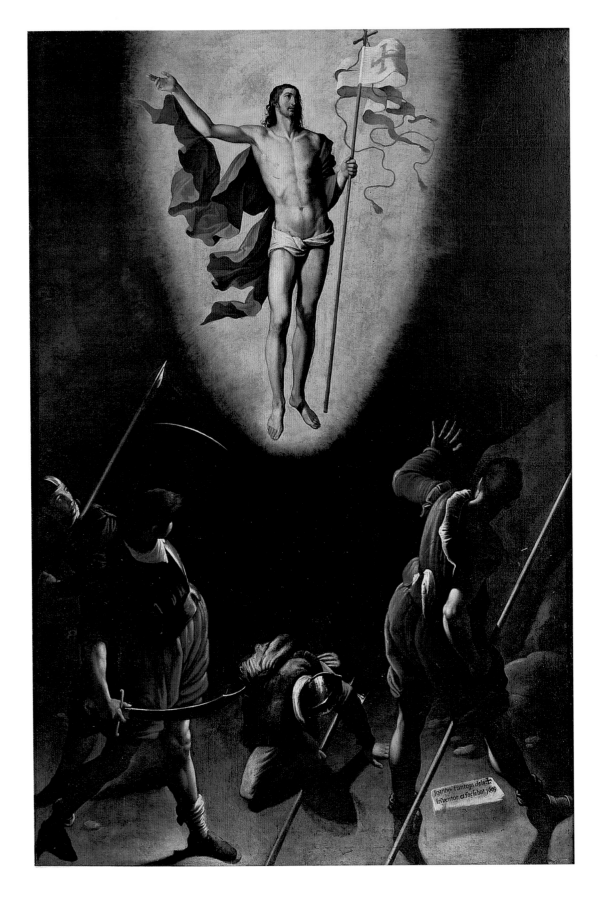

Catalogue 31
JUAN PANTOJA DE LA CRUZ
Resurrection, 1605
Oil on canvas
98⁷⁄₁₆ x 68⁷⁄₈ in. (250 x 175 cm)
Diputación de Valladolid

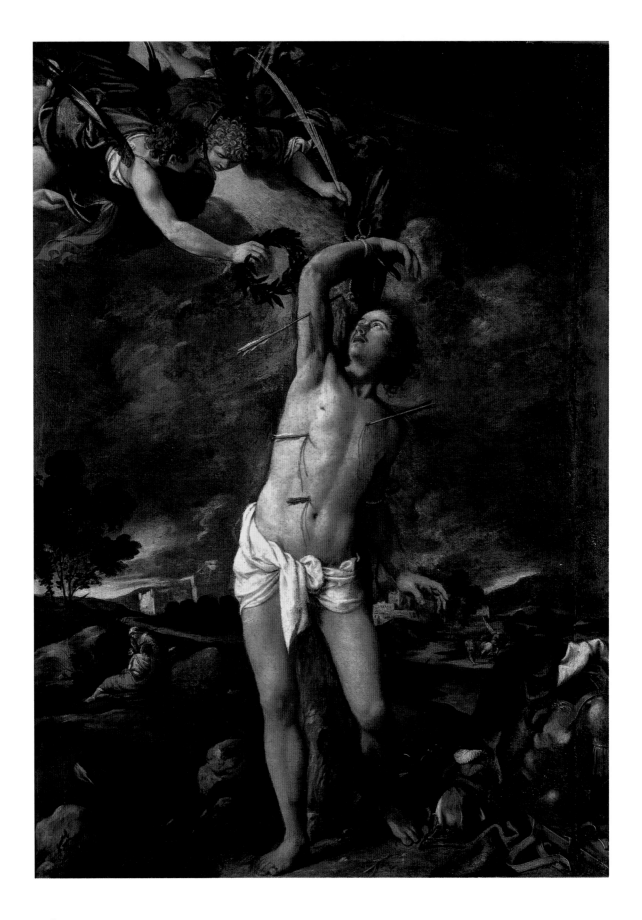

Catalogue 32
PEDRO ORRENTE
Martyrdom of Saint Sebastian, after 1606
Oil on canvas
64³⁄₁₆ x 48¹³⁄₁₆ in. (163 x 124 cm)
Monasterio de las Descalzas Reales, Madrid

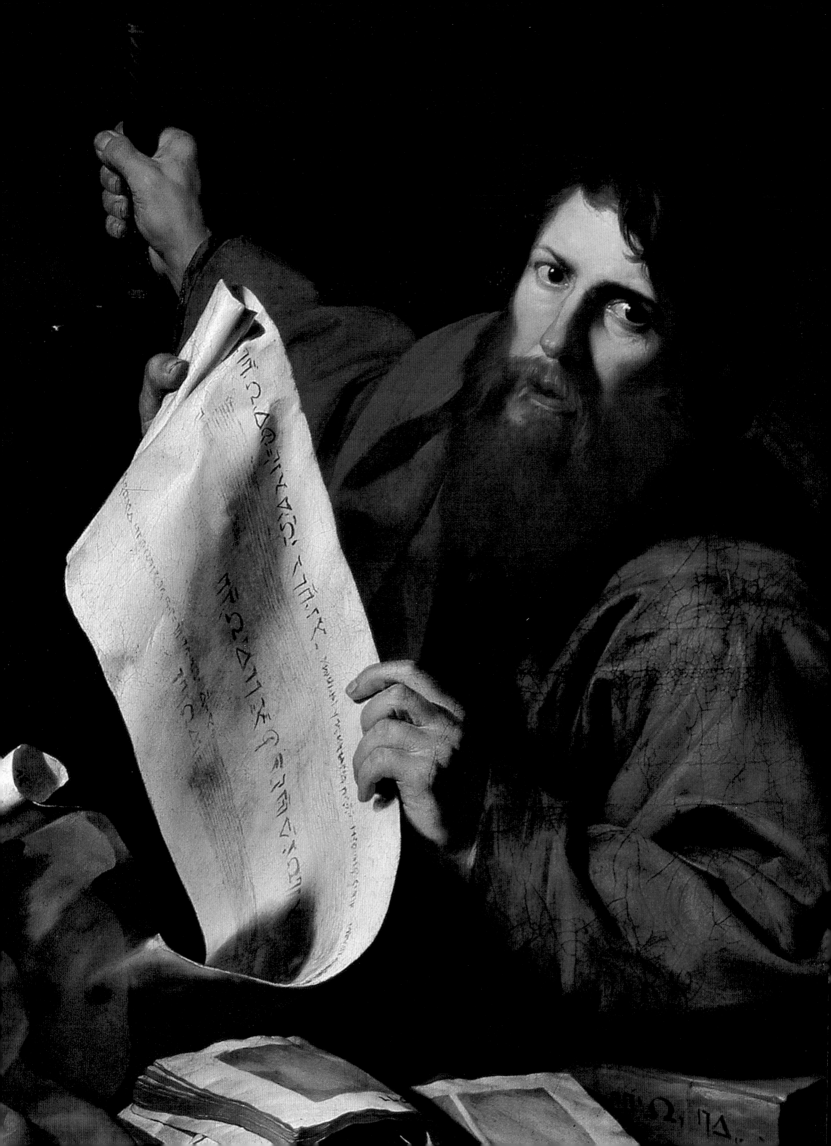

Apostolado

An important manifestation of the cult of saints in the reign of Philip III can be seen in El Greco's painting of *Saint James* (*Santiago el Mayor*) (cat. 33), the patron saint of Spain, and Velázquez's *Apostle Thomas* (cat. 35), which belong to the same iconographical type: they are part of an *Apostolado*, a set of thirteen individual canvases representing Christ and the twelve apostles. Ribera's *Saints Peter and Paul* (cat. 34) also exemplifies the theme, which honors the first followers of Christ as separate individuals, each holding the symbol that identifies him.

The new theme of the *Apostolado* reflected the Catholic Reformation program aimed at honoring the apostles' labor of spreading the word of God through preaching and writing.[1] The series also affirmed the Post-Tridentine tenants of Faith and Good Works, the sacrament of Ordination, and the importance of missionary efforts.[2] For Spanish bishops and archbishops struggling against papal and royal control by Philip III and the duke of Lerma, it had added significance; as successors of the apostles they could maintain that they possessed divine authority.[3]

El Greco was the first artist in Spain to paint an *Apostolado* and the first to conceive of the *Apostolado* theme as a series of easel paintings that are presented as portraits.[4] The earliest *Apostolado* by El Greco is the series still in the sacristy of the Cathedral of Toledo, where it was seen by Palomino and Ponz. Evidence suggests that it was commissioned by the archbishop of Toledo, Cardinal Bernardo de Sandoval y Rojas, about 1600.[5] El Greco's initial attempt was successful; he received at least five commissions for *Apostolados* in his last years.[6] The master had obviously hit upon an effective pictorial strategy to meet the demands for an important Catholic Reformation subject.

The *Saint James* (cat. 33) belongs to what was undoubtedly El Greco's last *Apostolado*; it was first recorded in 1837, when the parish priest of San Lucas in Toledo gave the set to the Asilo de los Pobres de San Sebastián, housed in the Hospital de Santiago in Toledo.[7] The other twelve from this series are also in the Museo del Greco. They are usually dated 1610–14 and are in varying states of completion. The freedom of execution and fragmentary brushwork indicate that they were among the last paintings El Greco worked on before his death. The artist was probably fulfilling a specific commission from a church or well-endowed religious institution because the cost of thirteen canvases by his hand would have been prohibitive for most individuals and too costly to have been made for the open market.[8]

The subject itself dates back to the eleventh century, when individual apostles with their defining attributes were first seen as sculptural decoration in French Gothic church portals; it subsequently spread to Spain, where the "Puerta de los Apostoles" became a common and long-standing feature in church architecture. The main portal of the western facade of the Toledo Cathedral, in fact, is adorned with large statues of twelve standing apostles with their attributes. Engravings, etchings, and woodcuts representing the twelve individual apostles were made by all the great Northern printmakers of the fifteenth and sixteenth centuries and were widely circulated, providing another ready source for artists.[9]

Unlike the earlier examples, however, El Greco treated the apostles as individuals, not as idealized types, so he did not stress identifying attributes. For example, Saint James is not shown as a pilgrim with pilgrim's hat and staff, a reference to his famous shrine at Santiago de Compostela in northern Spain, the end of the pilgrimage route since medieval times. In traditional iconography, a scallop shell is often attached to the hat or on his clothing, a reference to the legend that the apostles crossed the sea to bring the body of James back to Spain, where he is said to have preached. In the painting, El Greco omitted this attribute. El Greco's Saint James holds only a roughly carved wooden stick, which is shorter than any staff found in earlier representations of the saint.

For his earliest *Apostolado*, El Greco borrowed from portraiture to recast the first-century follower of Christ as a human type from his own world. The three-quarter length figure and dimensions of the canvas were the formats used in contemporary portraiture, as were the elegant frozen gesture and turned head that give the apostle a sense of arrested

motion. Saint James is portrayed as a youngish man, with individualized features—a very long nose, wide-open dark eyes, a high forehead with receding hairline, a sparse moustache, and thin beard with a few wiry, curling hairs. El Greco created a "portrait" of Saint James; in his subsequent *Apostolado*, the apostle would be recognizable by these features and this gesture.

El Greco also combined portraiture with pictorial strategies derived from devotional painting— the indefinite setting that eliminates any narrative context; the up-close presentation of the figure; and the strong frontal illumination that does not penetrate into the dark background.[10] This approach, meant to evoke empathy in the viewer, no doubt appealed to the taste of his patrons, as did the devotional paintings of Luis de Morales so favored by the Sandovals (Bernardo, like Lerma, owned one). El Greco transformed the images of Saint James and the other apostles into devotional portraits intended for private mental prayer.

The most exciting passages in *Saint James* are the beautiful face and the unfinished areas. El Greco paid close attention to the rendering of the face, which is the most finished part of the canvas. By contrast, the left hand and left side of the open-collar shirt are the least finished areas and give us insight into the great painter's working method at the end of his career. In the section around the elbow of the left arm, for example, we can see how El Greco began the composition. To define the crook of the elbow and the resulting fold of drapery, El Greco used a relatively large brush to rapidly apply a few bold black lines directly onto the canvas, which had been primed with a rich terracotta brown. Another black line is visible above the shoulder, forming the shape of the upper shoulder and neck. These few strokes were all that were needed to indicate the figure and its placement on the canvas. Rather than working from dark to light, he applied his thick white paint for the highlights first and ended by using the ground for deepest shadow. Not enough is known of the actual practices of the workshop to say with assurance what the next step would have been, but it is likely that El Greco started the paintings with the idea that at some point his workshop would take over and finish them for the client.[11]

If El Greco was the first to "portraitize" his apostle-saints, depicting them as ordinary humans, Velázquez brought the concept to its inevitable conclusion. Velázquez's *Apostle Thomas* (cat. 35) is an actual portrait of a man playing the role of the apostle, a type of depiction he knew, from reputation and copies, to have been used to great acclaim by Caravaggio. In fact, some believe the Orléans

Apostle Thomas is the most Caravaggesque of Velázquez's paintings.[12] It was painted in Seville not more than eight or nine years after El Greco painted the *Saint James* and may have belonged to a complete *Apostolado* that Ponz saw in the Carthusian monastery of Nuestra Señora de las Cuevas there.[13]

The young Velázquez's representation of the apostle could not be more different from El Greco's. Here is a recognizable boy from the streets of Seville, whose face and thin moustache appear in other of Velázquez's early works. Pacheco wrote that his son-in-law often paid boys to pose for him so that he could learn to imitate nature by studying it. Velázquez does not disguise his model's rustic appearance, nor does he use the red and blue colors or carpenter's square that are usual in images of Saint Thomas. Instead, we are given clues to his identity by the lance he holds, the weapon of his martyrdom, and the book he props up (awkwardly) on his knee, which relates to his mission to India. His mouth is open and his forehead wrinkled (in doubtful recognition or surprise?), a possible allusion to Saint Thomas's act of incredulity. By means of a strong directed light and a model taken from life, Velázquez brings the ethereal and spiritual portrayals by El Greco down to the gritty earth.

Ribera painted his *Saints Peter and Paul* (cat. 34) about 1616, when he had just arrived in Naples from Rome. If this is the picture described in El Escorial in 1657, it may have been purchased by the Neapolitan viceroy, the duke of Osuna, and sent back to Spain with his other paintings by Ribera, which were later gifted to Philip IV. Ribera's depiction of Saint Peter conforms to other conventional representations of him—a balding man with white hair and full beard. And the attributes are the traditional ones: Peter is identified by his keys, one of gold signifying his power in heaven and one of silver signifying his power on earth, and Paul by his sword. But Ribera's conception of Saint Paul, based on a real-life model, is a new type. Usually depicted as an old man with a long, flowing beard, here Paul is young, with brown hair and a reddish beard and mustache.

The subject of the disputation of the saints is rare, and Ribera may have modeled his picture on a famous painting by Guido Reni. As in several of his other works, Ribera resorts to pseudo-Greek characters for the text of the scroll, as he does for the binding of the closed tome and the lettering at the top of the open book's page. The sharp fall of light from the upper left, which unifies and dramatizes the composition, is indebted to Caravaggio, but Ribera's handling of paint is more impasted and physically expressive.[14]

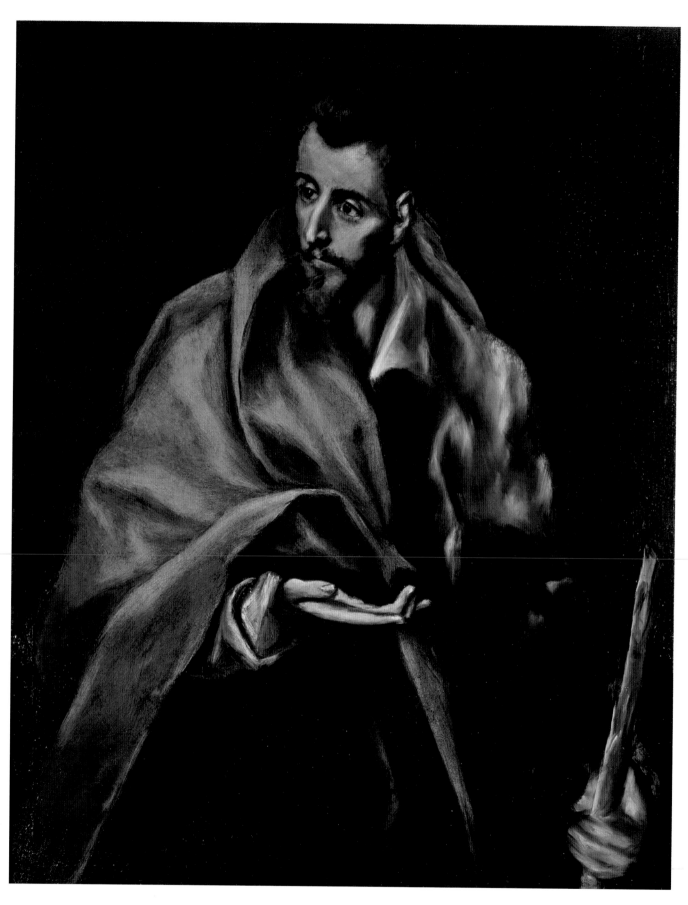

Catalogue 33
EL GRECO
Saint James (Santiago el Mayor), about 1610–14
Oil on canvas
39½ x 31⅝ in. (100.4 x 80.4 cm)
Museo del Greco, Toledo

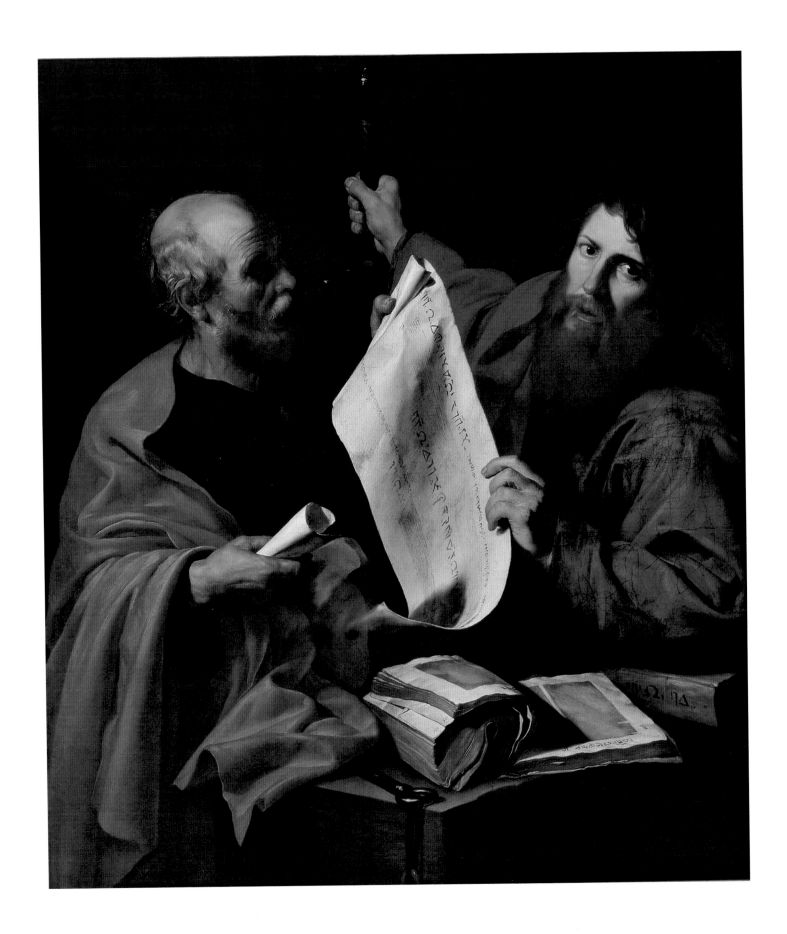

Catalogue 34
JUSEPE DE RIBERA
Saints Peter and Paul, about 1616
Oil on canvas
49⅝ x 44⅛ in. (126 x 112 cm)
Musée des Beaux-Arts de Strasbourg

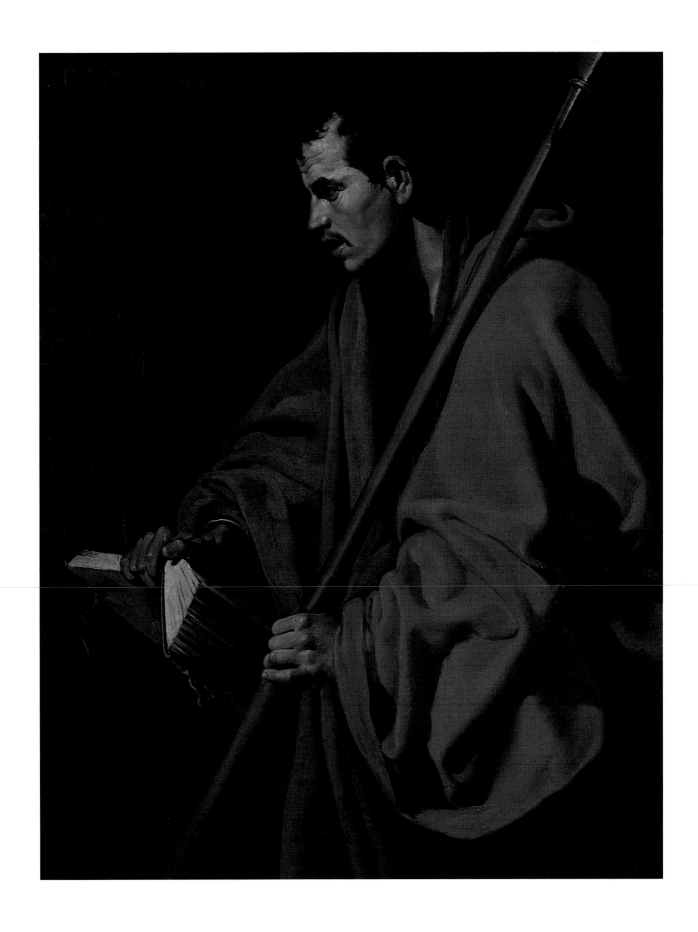

Catalogue 35
DIEGO RODRÍGUEZ DE SILVA Y VELÁZQUEZ
Apostle Thomas, 1622
Oil on canvas
41⁵⁄₁₆ x 33⁷⁄₁₆ in. (105 x 85 cm)
Orléans, Musée des Beaux-Arts

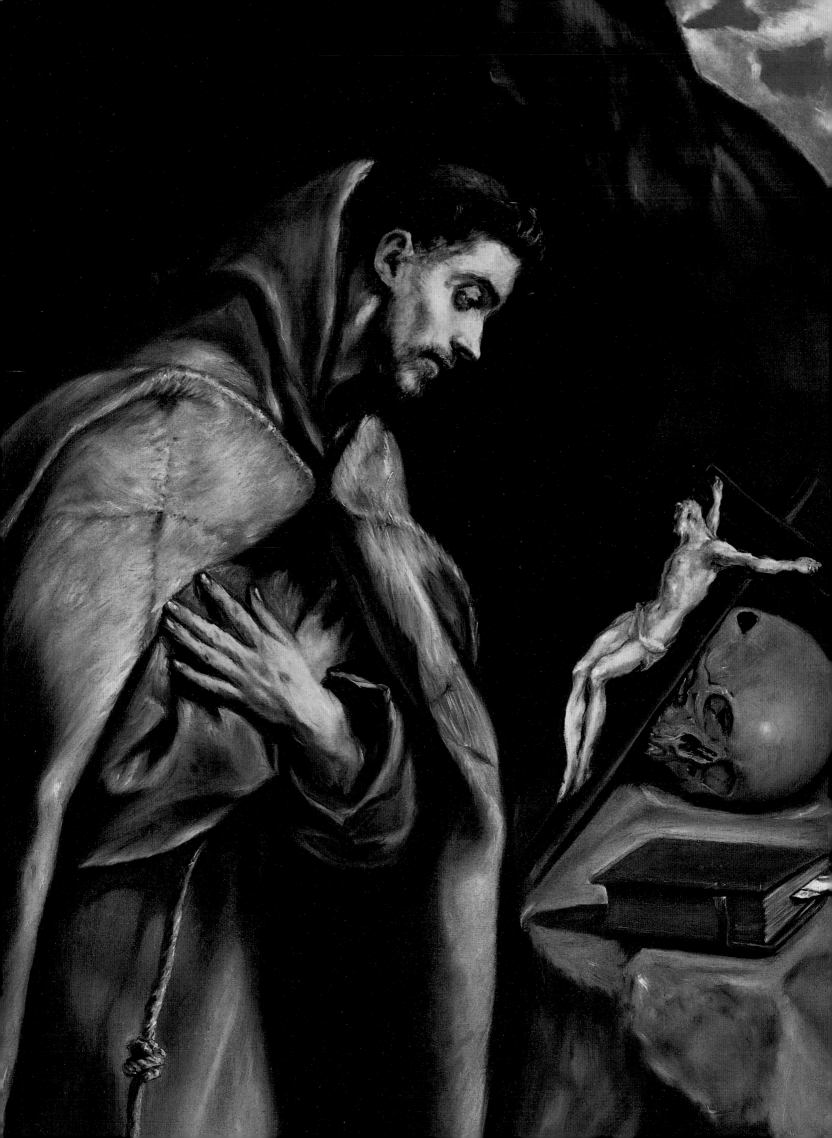

Saint Francis

Francesco di Bernardone was born in 1181 in Assisi, Italy, the son of a rich merchant. As a young man, he rejected the ease and luxury his background afforded him to follow a life of extreme poverty and service to the poor, the sick, and the lepers in Assisi. He attracted a group of followers who lived with him in huts or caves in the countryside; their aim was to imitate the life of Christ, living without money, land, or possessions of any kind. In 1209 Francis added teaching to his mission and wrote the primitive rule of the order, which required absolute poverty. The growing numbers of followers led Pope Honorius III to issue a bull officially approving the order of the "Friars Minor" in 1223.

In his last years, exhausted after his intense apostolic activities, Francis retreated into the wilderness to devote his life to meditation on the sufferings of Christ. He was rewarded in 1224 with the signs of the crucified Christ on his body —actual wounds mysteriously appeared on both feet and hands and on his right side—becoming the first saint to receive the stigmata of the Passion.[1] He died in 1226 at the age of forty-five and was canonized almost immediately in 1228.

Throughout the next two centuries, various branches of the Franciscan order were established, observing Saint Francis's strict rule with varying degrees of loyalty. By the mid-sixteenth century, the Franciscans numbered more than 100,000, making it by far the largest of all religious orders. In the context of the Catholic Reformation, Saint Francis's "rigorous asceticism, meditational practices, and spiritual union with Christ in the stigmatization made him an important example of post-Tridentine spirituality."[2]

As Mulcahy and Schroth have pointed out in their essays in this volume, devotion to Saint Francis and support of the Franciscan orders were particularly strong during the reign of Philip III. During the period of the Spanish Catholic Reformation, many new reform Franciscan monasteries and convents were created, and branches of the Franciscan Order were to be found in most regions of the Iberian Peninsula. The Capuchin Order came to Spain in 1585 with the aid of Archbishop Juan de Ribera;[3] Philip III built a monastery for that order near El Pardo (decorated with paintings by Bartolomé González and a *Supine Christ* by Gregorio Fernández [compare fig. 58, p. 133]). Other reformer branches begun in Spain were the Descalzas (Unshod) Friars Minor or Recollects, patronized by the duke of Lerma and characterized by their return to the primitive rule, and the Alcantarians, begun by Saint Teresa's friend, San Pedro de Alcántara, whose strict observance was one of the most extreme in the history of the order.[4]

In the late sixteenth century representations of Saint Francis changed from depictions of a humble poet, benevolent man of charity, or gentle friend of the animals to a figure of the contemplative penitent rapt in prayer or in some form of ecstasy.[5] El Greco was one of the first artists in Europe to develop the new Franciscan iconography of the saint as a penitent, conforming to the spirit of the first- and second-wave reformers in Spain; the Council of Trent recommended that "artists portray Saint Francis more simply to encourage a contemplative attitude conducive to daily meditation."[6] Paintings of Saint Francis by El Greco were generally made for religious houses or private patrons (the duke of Lerma among them), as an aid to devotion and prayer. They visualize the importance of the sacrament of penance and private individual prayer, also stressed by Saint Teresa in the *Castillo Interior*.[7]

El Greco painted no other saint as frequently or inventively as Francis; scholars have accepted 135 paintings belonging to ten iconographical types, six of which belong to the artist's activity during the reign of Philip III.[8]

In *Saint Francis Venerating the Crucifix* (cat. 37), dating about 1596,[9] the saint is depicted kneeling, with hands crossed over his chest in a gesture of veneration (similar to the gesture of the Archangel Gabriel in El Greco's *Annunciation* [cat. 19]). His head and neck are slightly bowed toward a sculpted image of Christ on the cross, at which the saint intently gazes in contemplative meditation. The other objects on the rock are a skull[10] and a Bible or breviary with a piece of paper marking the office of the day.[11] The setting of a rocky cave is a reference to Mount Alverna, where Francis retreated and received the stigmatization. The ivy, which appears in other paintings by El Greco of hermit saints, is a symbol of ascendant virtue.[12]

According to Pacheco, El Greco was the best painter of Saint Francis in his day "because he conforms best to what the histories say."[13] El Greco's rendering of Saint Francis was faithful to the physical characteristics of Francis described in the biographies[14] and a portrait in Venice thought to have been made from life. Pacheco advised that the saint should be portrayed as "of medium stature, more short than tall, proportioned and round head, face a little long, full forehead, small black eyes, black hair for beard and head, symmetrical and delicate nose, small ears, happy and benign face, not white, more *moreno*, even teeth, thin and delicate complexion," adding, "and his spirit should seem more of heaven than of the earth."[15]

Indeed, El Greco followed this description closely, painting the saint as "era de muy pocas carnes" (having little meat on his bones) and, more important, by capturing the spiritual presence of the man as described in *Arte de la pintura*.[16] El Greco clearly relied on the same orthodox sources that Pacheco used for his 1648 publication. The artist's iconographical innovations influenced his contemporaries, which contradicts again the stereotype of El Greco as an isolated genius who had no impact on his fellow artists.

El Greco's pupil, Luis Tristán, reversed his master's composition and chose to depict Saint Francis at a different moment, after the stigmatization and in a more fervent state of meditation that has produced actual ecstasy (cat. 36). His open book, foreshortened head

looking upward into an unworldly light (the blue sky and white clouds in the upper right show the "real" sky), and gesture suggest a moment of enlightenment or divine apparition. It is a less quiet moment, far more dramatic and theatrical. Tristán's exposure to Caravaggio and his followers in Rome sometime between 1606 and 1612 allowed him to bring his master's representations of Saint Francis up to date. The illumination is more sensational, with sharper contrasts of light and dark, than the more even lighting of the figure in El Greco's picture. Tristán used a live model for the head, emphasizing the wrinkles in the neck and face, and realistically depicted the wound—a gaping hole edged with freshly dried blood—on the back of Francis's hand, both evidence of Caravaggesque naturalism.

In contrast to El Greco, Tristán placed the attributes between the viewer and the saint and gave them a utilitarian purpose that lessens their abstract symbolic qualities. A plain wooden cross marks a page in the open book, while the skull's position on the edge of the book holds open the pages.

Vicente Carducho also captured the feeling of being carried away by an ecstatic experience in his rendition of the stigmatization of Saint Francis, envisioning this union with Christ as a state of pure rapture (cat. 38).[17] It is hard not to connect Carducho's innovative representation of the stigmatization with the popular spiritual writings of his time. Indeed, Saint Teresa, who was closely associated with Franciscan spirituality and guided by the Franciscan authors Francisco de Osuna and Pedro de Alcántara, described the "flight of spirit" she experienced when praying: "It is as if the higher part [of the body] were carried away, and the soul [were] leaving the body."[18] In her autobiography, Saint Teresa made vivid a state of rapture that could well explain Carducho's unusual depiction: "You see and feel it as a cloud, or a strong eagle rising upwards and carrying you away on its wings. I repeat it: you feel and see yourself carried away, you know not wither."[19]

About 1620 Francisco Ribalta was commissioned to paint *Saint Francis Embracing the Crucified Christ* (cat. 40) for a side altar in the monastery of Sangre de Cristo (Blood of Christ) in Valencia.[20] One of the first Capuchin

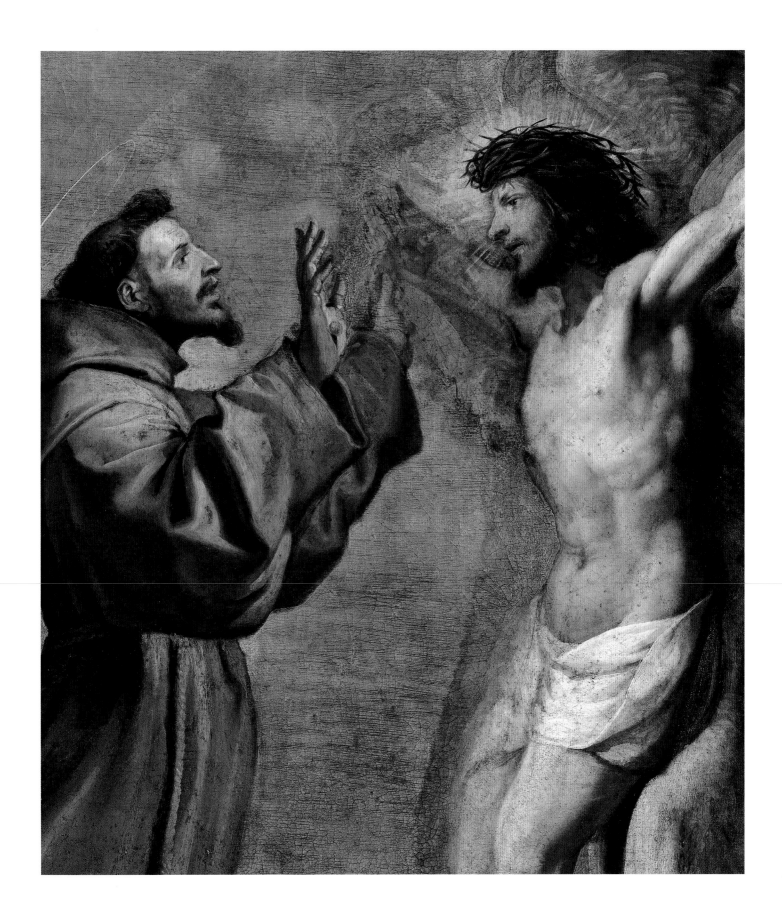

establishments in Spain, it was founded in 1596 with the support of the archbishop of Valencia, Juan de Ribera.[21] The subject of the crucified Christ embracing the saint, who puts his lips near the blood flowing from Christ's side, illustrates the specific devotion to which the Valencian monastery was dedicated, and the unusual subject suggests that the Capuchins may have provided Ribalta with a printed source for the composition.[22]

The subject as depicted by Ribalta does not correspond to written descriptions of the life and miracles of the saint and is entirely without precedent in painted depictions. It is an imagined vision that Francis could have had during his meditations on the sufferings of Christ. Not unlike a contemporary practitioner of Ignatius Loyola's *Spiritual Exercises*, it is possible that Francis here identifies with Christ's suffering, placing himself at the scene of the Crucifixion by forming a mental-prayer image of Christ's painful wounds. Seemingly overcome with emotion, he embraces the body of Christ, who in turn embraces him. Christ recognizes Francis's sincere longing and grants the saint's wish of equal suffering by taking the crown of thorns off his own head and extending it toward the saint.[23] The leopard, an animal associated with Africa, could refer to the recent expulsion of the *moriscos* from Spain, an event championed by Archbishop Ribera, whose spiritual fervor is reflected in this work.[24] It may also represent the areas to which the Capuchins were being sent as missionaries.

It is possible that Ribalta's *Ecstasy of Saint Francis: The Vision of the Musical Angel* (cat. 39) was made for another Capuchin foundation in or around Valencia.[25] The subject, taken from Saint Bonaventure's life of Saint Francis (the biography preferred by the Capuchins), shows the miraculous appearance of an angel sent by God to play comforting music to the saint on his sickbed. The sheep beside the bed alludes to Saint Francis as the lamb of God. Brother Leo, silhouetted against a background of divine light that he doesn't see, continues to read and still needs a candle to light his text. His lack of awareness establishes "his location outside the realm of mystical experience."[26]

The setting so naturalistically described by Ribalta reflects the strict observance of the primitive rule of Saint Francis. The bed consists only of a wooden plank, on top of which is a thin straw mat and rough wool blanket. There is a single pillow, one set of rosary beads, a flask of water (symbolic of priestly purity), and a basket for collecting alms. It is a humble cell, completely unadorned except for a wooden cross and a print of the Crucifixion on the wall. Ribalta's attention to these and other realistic details (note the bony foot of Saint Francis and the muscular forearm of the angel playing the lute) and his skillful use of tenebrism, which beautifully describes the long shadow of the lute player's fingers on the face of his instrument, owe something to Caravaggio or one of his followers.[27]

The popular devotion to Saint Francis is skillfully and inventively expressed by the artists working during the reign of Philip III in the artistic centers of Madrid, Valencia, and Toledo. These images of Saint Francis demonstrate the range of creativity at this time, and directly relate to the conception and portrayal of the saint by Zurbarán and Murillo.

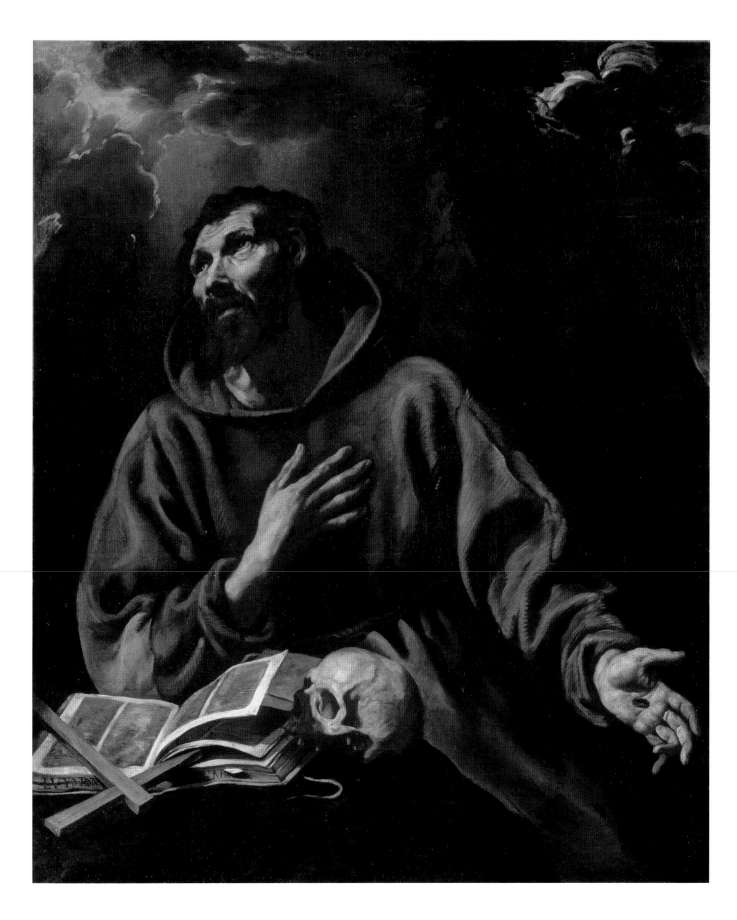

Catalogue 36
LUIS TRISTÁN
The Vision of Saint Francis of Assisi, 1600−25
Oil on canvas
49 ³⁄₁₆ x 40 ¹⁵⁄₁₆ in. (125 x 104 cm)
Musée du Louvre, Paris

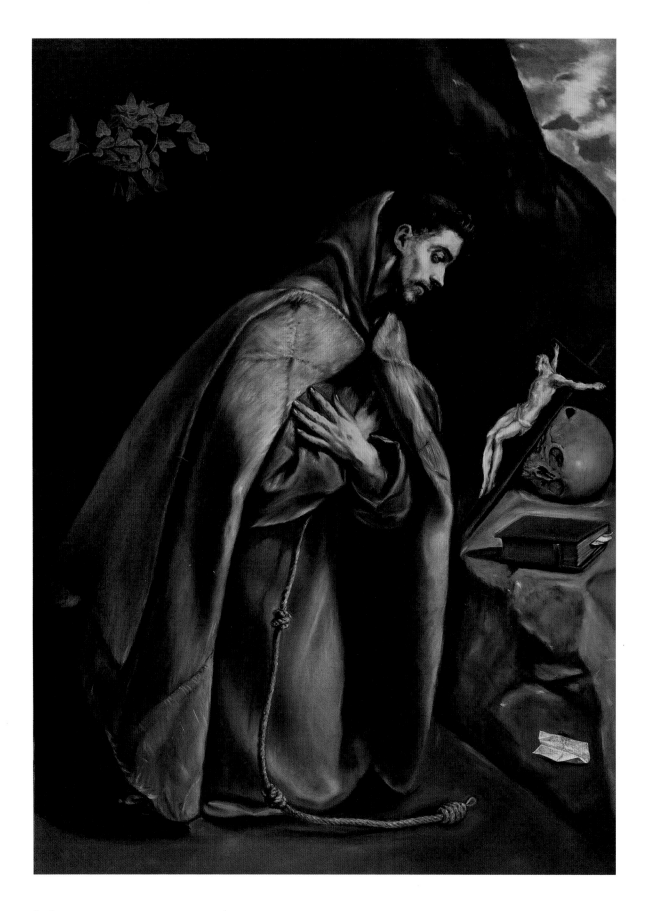

Catalogue 37
EL GRECO
Saint Francis Venerating the Crucifix, about 1596
Oil on canvas
58 x 41½ in. (147.3 x 105.4 cm)
Fine Arts Museums of San Francisco

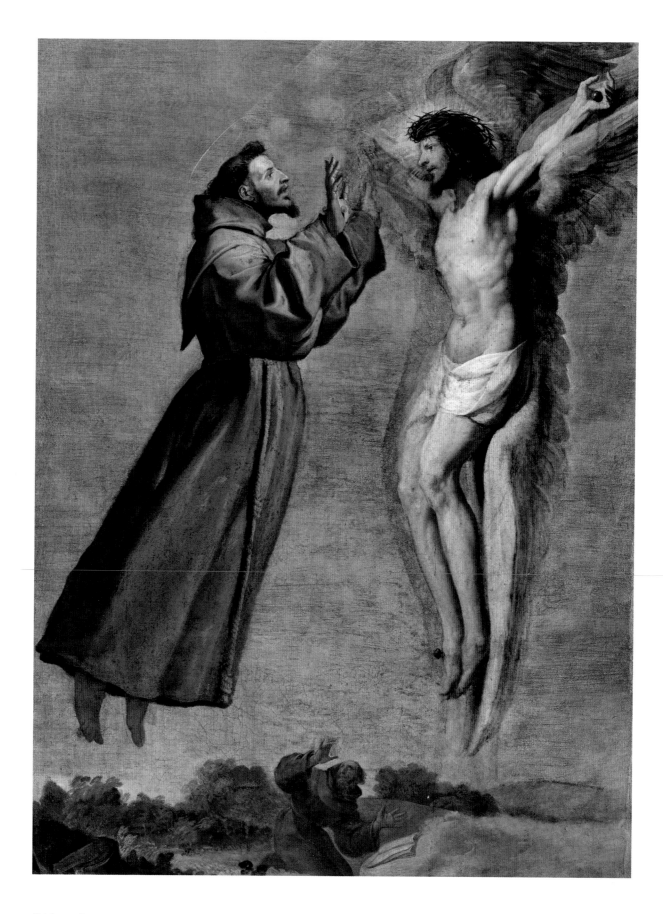

Catalogue 38
VICENTE CARDUCHO
The Stigmatization of Saint Francis
Oil on canvas
61 x 44½ in. (155 x 113 cm)
Hospital de la V.O.T. de San Francisco de Asis, Madrid

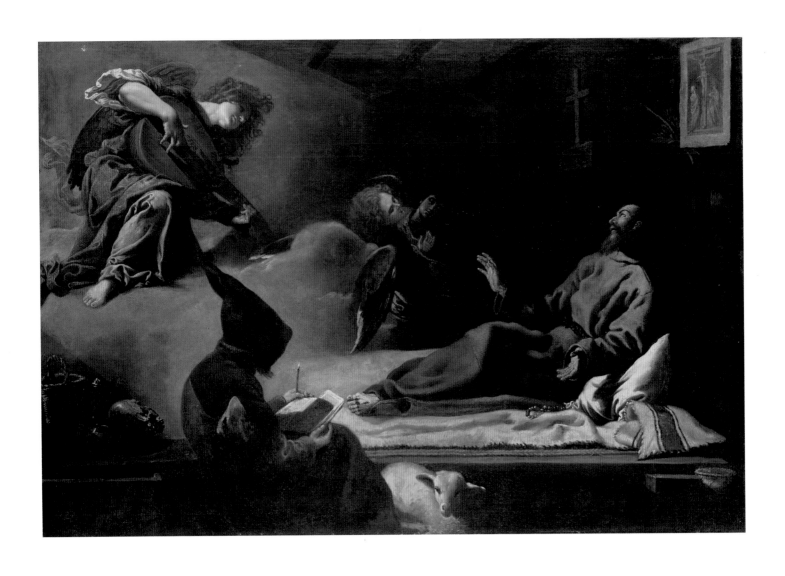

Catalogue 39
FRANCISCO RIBALTA
The Ecstasy of Saint Francis of Assisi: The Vision of the Musical Angel, about 1620–25
Oil on canvas
42½ x 62¼ in. (108 x 158.1 cm)
Wadsworth Atheneum Museum of Art, Hartford, CT

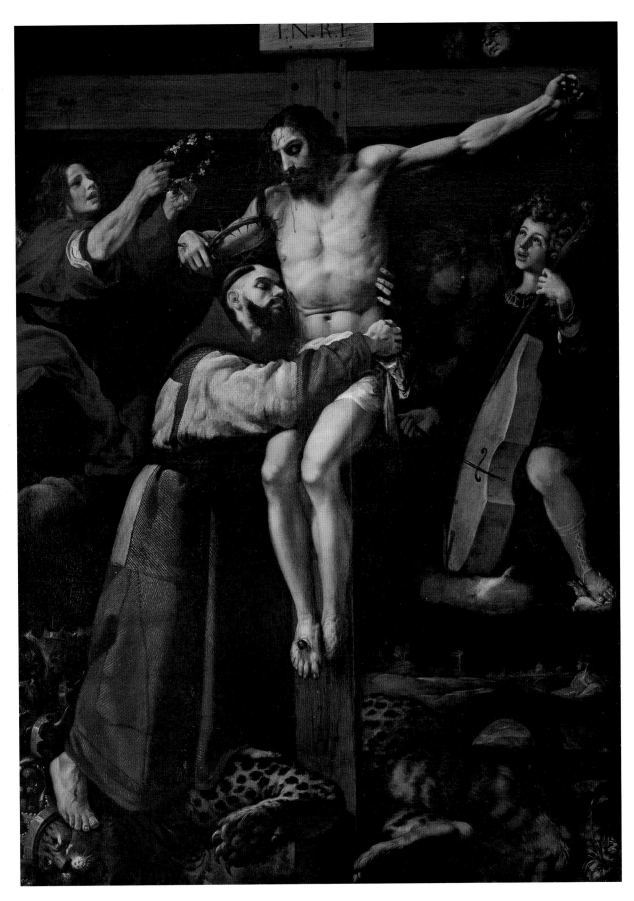

Catalogue 40
FRANCISCO RIBALTA
Saint Francis Embracing the Crucified Christ, about 1620
Oil on canvas
91⁵/₁₆ x 67⁵/₁₆ in. (232 x 171 cm)
Museo de Bellas Artes de Valencia

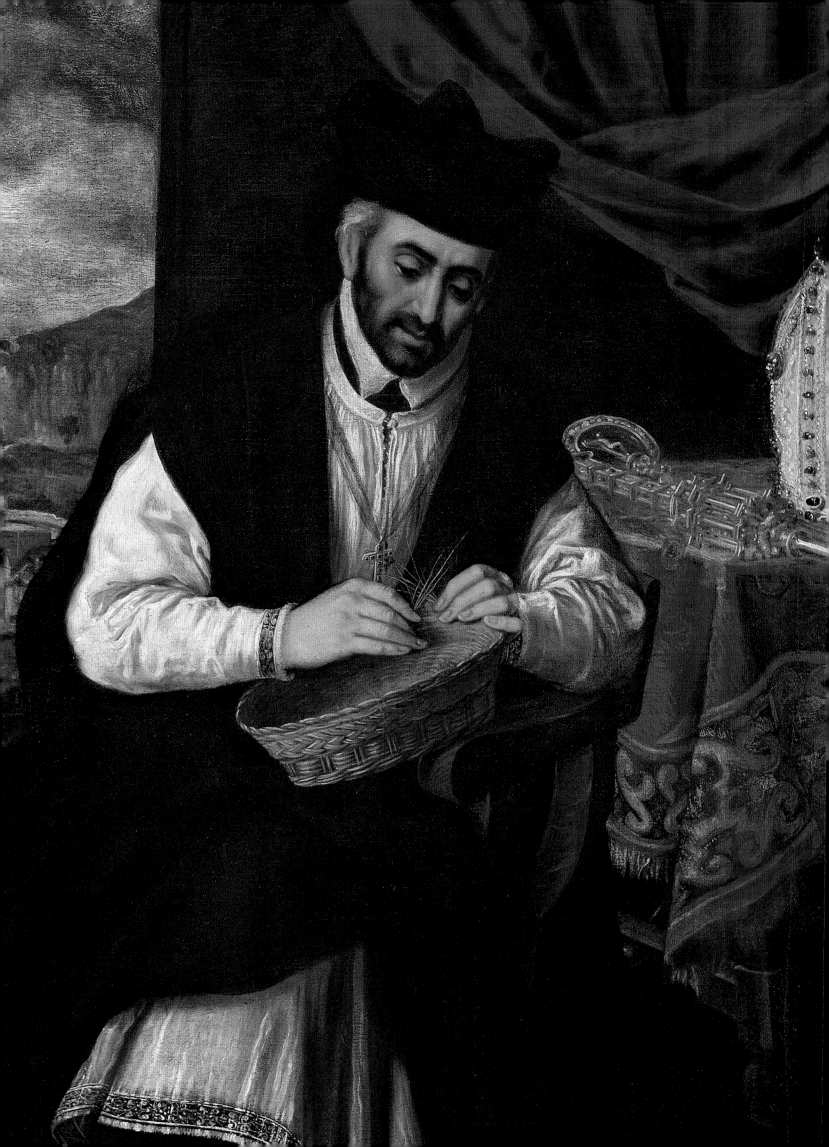

Spanish Saints

When Pope Gregory xv canonized four Spanish saints in 1622 (Teresa, Ignatius Loyola, Francis Xavier, and Isidore), the second-generation reformers who had worked so hard for their recognition were rewarded. Canonization (the papal declar-ation of sainthood) is a long and drawn-out process; it was necessary to prove that the holy person had independently verified visions of God, an uncorrupt body after death, and performed miracles, among other require-ments. There was an intense effort made by the faithful to gather documentation of these won-drous acts during the reign of Philip iii. Both popular and royal support were enormous, and the regions of Spain that were home to these blessed persons worked the hardest to advance such claims—sometimes with success, sometimes not.

Local authorities were well aware that pilgrim-ages made to the native towns, burial places, and visionary sites of the new saints could potentially improve the economy of both local governments and religious institutions. A visual record of the saint-citizen was important to this impulse, and that image had to be powerful, memorable, and effective in communicating the story of the saint.

This task fell to the artists of the reign of Philip iii. The iconic Spanish image for the Blessed Teresa of Avila was created by one of the great sculptors of the period, Gregorio Fernández. For his life-size wooden polychrome statue *Saint Teresa of Avila* (cat. 41), made soon after her beat-ification in 1614, Fernández depicted the Blessed Teresa as a down-to-earth figure, a Castilian woman with large, beautifully carved hands and very plain features, whose flesh tones, created by a painter rather than the sculptor, seem real. Teresa would not have approved of the fancy habit she wears; for this commission, Fernández left behind the austere world of the previous reign, when she actually lived, and entered into the grander one of Philip iii. In this work the sculptor did not ideal-ize Saint Teresa; instead, he created a posthumous portrait in the round.

Teresa de Ahumada y Cepeda came from Jewish ancestry. Her father, Alonso de Cepeda, from Toledo, was an open *converso* (converted Jew) who was forced to flee the imperial city under the intolerant Archbishop Francisco Jimenez de Cisneros (1436–1517), a major sup-porter of the expulsion of the Jews from Spain in 1492. Alonso and his family moved to Avila, his sons scattered to North Africa and the New World, and his daughter, Teresa, who was born in 1515, entered the Carmelite convent in Avila at age twenty, against the wishes of her father.

There is a significant story Teresa later recounted about her childhood, which explains her devotion to images as a visual aid to prayer. Upon learning of her mother's death as a young girl, Teresa ran crying into the Cathedral of Avila, "como yo commence a entender lo que había perdido, afligida fuime a una imagen de Nuestra Señora y supliquela fuese mi madre, con muchas lagrimas" (as I began to realize what I had lost, with anguish I went to an image of Our Lady and begged her to be my mother, with many tears).[1]

About 1538 Teresa began to practice individ-ual prayer and meditation on her own, and from the 1540s until 1560 experienced a series of divine revelations and visions during her "visits from God." Dissatisfied with the laxity of her order and wishing to return to the original (primitive) rule, Teresa founded a reformed movement, the Unshod Carmelite Order. She learned to use her formidable diplomatic and persuasive writing skills to win approval for building new convents all over Spain; in a period of twenty years, she personally opened seventeen convents (and helped her co-reformer, the poet Saint John of the Cross, to open fifteen monasteries). She was a prolific writer: the *Camino de Perfección*, *Meditaciones sobre los cantares*, and *Libro de la vida* were among

her many tracts. Her spiritual methods, visions, and writings made her suspect; in 1576 she was denounced to the Inquisition of Seville but survived with the strong support of Cristóbal Rojas y Sandoval, the duke of Lerma's uncle. She died on October 4, 1582, at the age of sixty-seven.

The process of her canonization began as early as 1591, and it had royal support. In 1586 Empress Maria, Philip III's aunt, had been given a copy of Teresa's last autobiographical manuscript, which had earlier been condemned and never published, and the empress let it be known that it was her desire to have it printed. In 1588, when Teresa's last writings were finally published, Philip II ordered the original manuscript in her hand to be deposited in El Escorial. It was Teresa's role as a spiritual writer, therefore, that was valued most by the Catholic Reformation in Spain. God called Teresa to write.

This was the aspect of the saint that Fernández emphasized in his representation of her. The sculptor depicted Teresa in the act of writing, thus establishing an original iconography for her representations in Spain (which is worlds apart from Bernini's later Italian Baroque conceit in his sculpture in Santa Maria della Victoria, Rome, that spectacularized one of her visions). Fernández's image of Teresa, poised looking upward, with an open book and a pen held high in the air, is based directly on her writings in which she often calls to God for help, as in the opening lines of *Castillo interior o las moradas*: "My sisters, I am here today asking our Lord to speak for me, because I have not hit upon a thing to say or know how to begin to fulfill this obedience."[2]

To teach her reform Carmelite nuns to pray, she often borrowed images from the domestic world as metaphors for the internal world:

> Consider our soul as a castle made of one diamond or very clear crystal . . . consider that this castle has many rooms: some are above, others below and to the side; and in the center and the middle of all of them is the most essential, that is where the most secret things between God and the soul take place...the door to enter the castle is prayer and consideration.[3]

Teresa's practical nature and the domestic references she frequently used in her writings contributed to the taste for religious scenes told in human, everyday terms (the Holy Family images by Cajés and Tristán come to mind [cats. 24, 26]), and some believe her writings also inspired Juan Sánchez Cotán to create paintings of simple fruits and vegetables as a way to focus meditation on God's presence in everyday life (cats. 50–52).

Fernández was also responsible for establishing an iconography for the soon-to-be canonized Ignatius of Loyola (cat. 42). The sculptor depicted him as the visionary soldier-leader of the missionary order of the Society of Jesus (Jesuits), the order closest to the heart of the duke of Lerma, whose maternal uncle, Francisco Borja, followed in Ignatius's footsteps as third general of the order.

Born Iñigo López de Loyola in 1491 in the Spanish province of Guipuzcoa, the future founder of the Jesuits began his life in the conventional manner of the youngest son of an aristocratic family—he served as a page in the court of Ferdinand and Isabella and then became a soldier. During his military career, he was badly wounded; he spent his recuperation reading the Castilian translation of the *Vita Christi*, the famous *Imitatio Christi*, and the popular *Flos sanctorum* (Lives of the Saints). These texts led to his conversion to the life of an ascetic. According to his biography, he had a vision of the Virgin with her Son, which filled him with loathing for his former life, especially his carnal desires. The experience deeply marked him, and from that moment he began a life of poverty, fasting, meditation, and service to the poor, just as Saint Francis had done two centuries before.

Ignatius, however, was living in the time of the Protestant Reformation and soon realized that his calling was to teach Catholics to exercise reason in spiritual matters, to act as their spiritual guide. To this end, he studied Latin and philosophy at the Universities of Alcalá and Salamanca between 1524 and 1527. At this time Ignatius distributed to some of his companions an early version of his *Spiritual Exercises* (eventually published in Rome in 1548), which immediately brought him under suspicion by the religious authorities. He was arrested by the Inquisition in 1526 and finally fled to Paris in 1527 to avoid persecution.

Ignatius continued his studies at the University of Paris, where he met a group of men who joined him to form the Company of Jesus, with Ignatius as the first general. This terminology, as well as his insistence on the vow of obedience, discipline, and political ability, drew upon his military background; his strict training would contribute to the great effectiveness of the order. The Society of Jesus received official sanction from Pope Paul III in 1540 and

developed into "the international cornerstone of the Counter-Reformation's educational mission."[4] The society was the first true "teaching order" in the Catholic Church, and because of the learning of its members, it had an open relationship with cultures of the "other" encountered throughout the world by the Jesuit missionaries.[5]

Endowing Ignatius with a purposeful striding posture, Fernández portrayed the former soldier-turned-militant as a man of action in a religious worldwide drama, with "a burning desire to heal the wounds of faith at home and abroad."[6] The lifelike portrait quality of Ignatius's head was required by the sculptor's Jesuit patrons; when Ignatius died in Rome in 1556, a death mask was made from which prints and paintings for Jesuit houses around the world could be generated, so that images of Ignatius would remain true to life. Fernández's sculpture succeeds in capturing the intelligent spiritual guide who "fired the will by moving the imagination and the heart" as expressed in the *Spiritual Exercises*, his treatise that stressed methodological prayer and was addressed to everyone.[7]

Saint Julian, bishop of Cuenca (about 1113?–1208), the subject of Eugenio Cajés's painting (cat. 43), is not a well-known figure, nor was he included in the *Flos sanctorum* published in the 1590s and 1600s. All we know is that he taught at the University of Palencia, became a desert hermit, and was appointed the second bishop of Cuenca in 1190, only thirteen years after it had been taken from the Moors. The initial processes for his canonization may have taken place during the time of the great first-generation reformer Gaspar de Quiroga (1512–1594), who was bishop of Cuenca (r. 1572–77) and supported a program of religious reform there.[8] For the purposes of canonization, Julian's body was disinterred, taken from Cuenca, and indeed found to be uncorrupted.

Eugenio Cajés's domesticated image of Saint Julian, who had been canonized as recently as 1594, depicts the twelfth-century bishop as the artist's contemporary. Reflecting the down-to-earth spiritual quality of Saint Teresa's writings, Cajés conceived of his painting as a large-format portrait of the saint weaving a basket, with a distant view of a landscape behind. Although the painting is undated, it is quite close in style and composition to the artist's *Portrait of Cisneros* (Ministry of Education, Madrid), signed and dated 1604. For these paintings Cajés drew on two traditional portrait types. He depicted the sitters full-length, seated in chairs, a type estab-

lished by Raphael in his *Portrait of Julius II* (National Gallery, London) and used by El Greco about this time for *Fray Hortensio Félix Paravicino* (cat. 12). Second, he placed the sitters beside an open window, a compositional device popularized by Titian and his compatriots.[9] Cajés could have seen such paintings during his travels in Italy, but the royal collection in Madrid also had a superb example: Titian's *Portrait of Empress Isabella* of 1548 (Museo Nacional del Prado).

In 1599 Bartolomé de Segura, a poet living in Cuenca, published *Del nacimiento, vida y muerte de glorioso Confessor San Julian Segundo Obispo de Cuenca*.[10] The seventh canto "paints a living portrait" of the saint based on an unknown print. Cajés might have had access to either the book or the print, because he seems to have illustrated the poet's words, who described Julian as "the opposite of vain and haughty/ humble, affable, kind." Later Segura recounted that Julian miraculously healed plague victims who touched the baskets he made with his own hands.

By treating Saint Julian's image so naturalistically, Cajés shared the impulse to "portraitize" his saint, just as El Greco was doing to great effect in his *Apostolados* (see cat. 33). Cajés gave the saint individualized features and included telling details, such as his unshaven face and white hair sticking out of his simple priest's biretta. Still-life elements, such as the bishop's crosier on the table and the intricate weave of the baskets, have been painstakingly observed. The humanized representation of a holy person involved in a mundane activity, characterized by psychological accessibility and a "mood of poetic innocence,"[11] can be compared to the domestic holy scenes by certain Caravaggesque painters, especially those of Carlo Saraceni (see fig. 48, p. 109), whose works were hung close to Cajés's in the Sagrario in the Toledo Cathedral. Like many of his contemporaries, Cajés stylistically kept one foot in the past while dipping the other into the more "modern" waters of naturalism.

The overarching stylistic quality of the images of saints created during the reign of Philip III was naturalism—a sense of the saint as a living person, fully present and breathing, with whom the viewer could identify. These portraitlike images brought the saints down to earth so that the faithful could recognize in themselves something of the qualities and virtues that made these individuals so special to God and worthy of emulation.

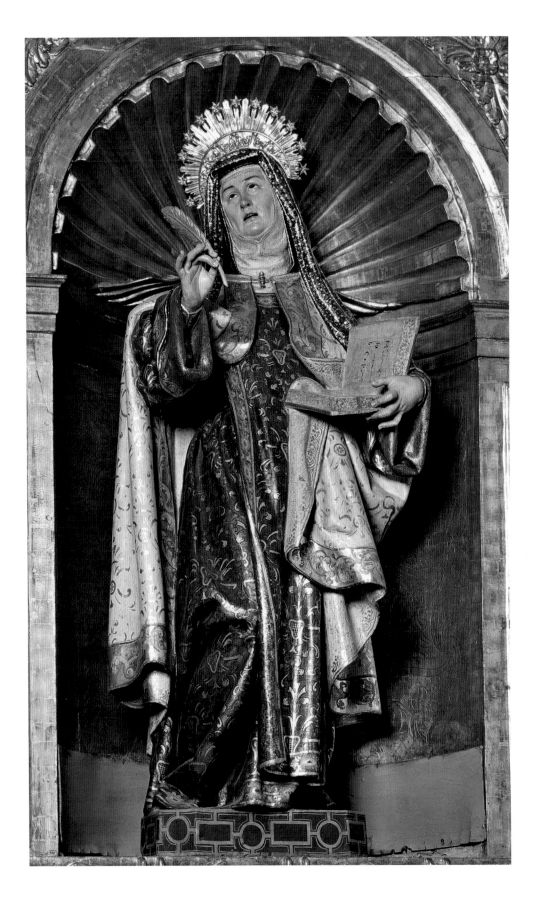

Catalogue 41
GREGORIO FERNÁNDEZ
Saint Teresa of Avila, about 1614
Polychrome wood
H. 63 in. (160 cm)
Santuario de Nuestra Señora del Carmen
de Extramuros, Valladolid

Catalogue 42
GREGORIO FERNÁNDEZ
Saint Ignatius Loyola, about 1622
Polychrome wood
H. 60⅝ in. (154 cm)
Iglesia de San Miguel y San Julián,
Valladolid

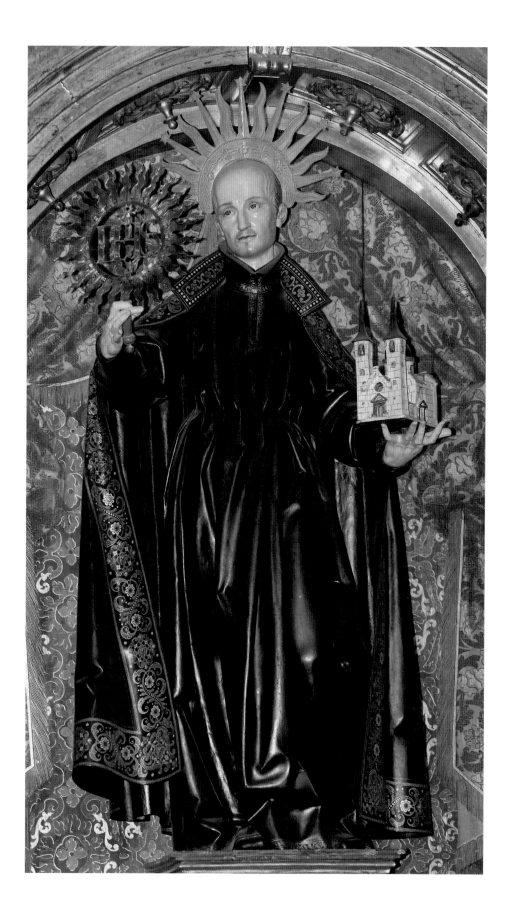

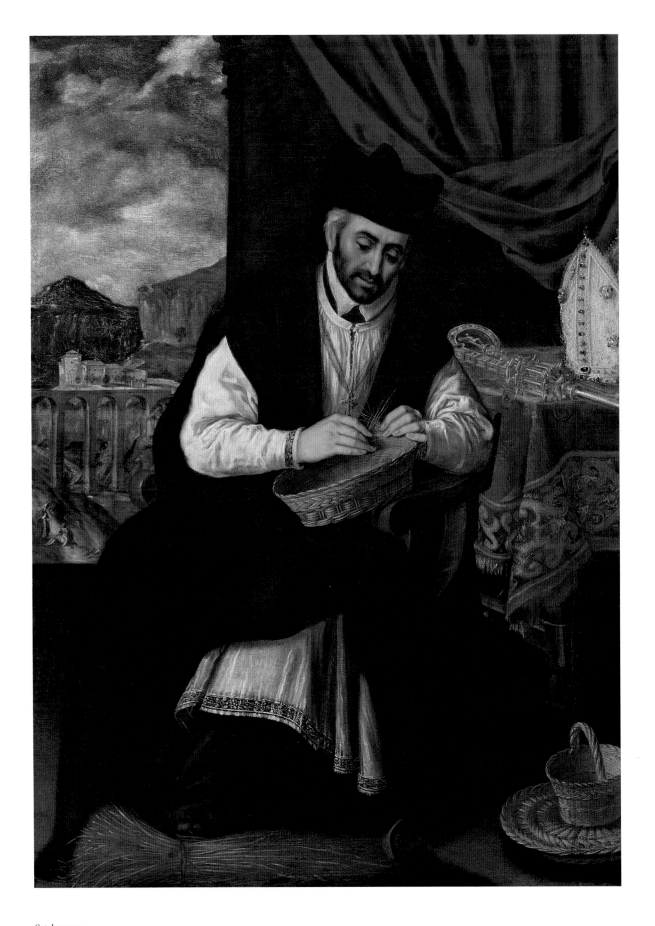

Catalogue 43
EUGENIO CAJÉS
Saint Julian, Bishop of Cuenca
Oil on canvas
65½ x 46⅜ in. (166.4 x 117.8 cm)
Stirling Maxwell Collection, Pollok House, Glasgow

Catalogue 44
FRANCISCO RIBALTA
Vision of Father Simón, 1612
Oil on canvas
83 x 43½ in. (210.8 x 110.5 cm)
The National Gallery, London

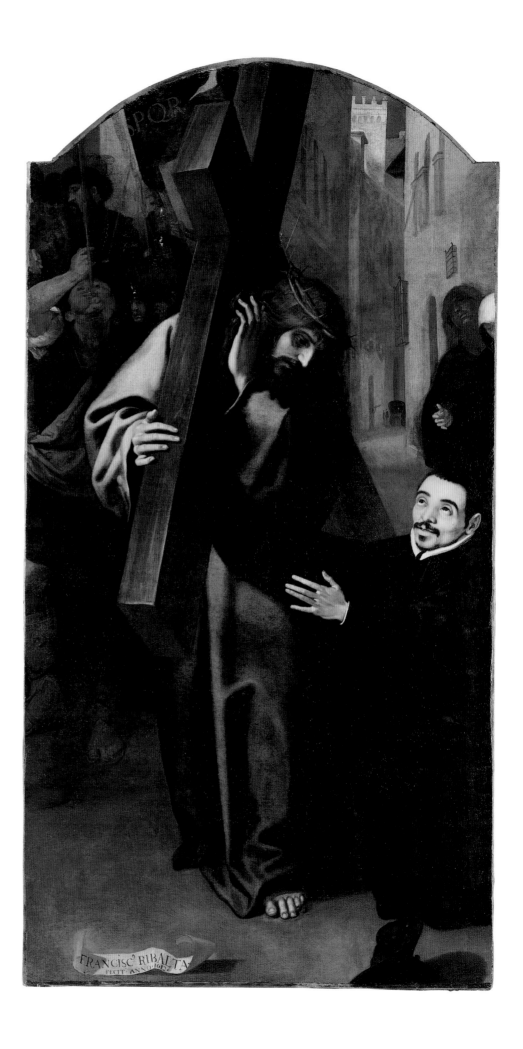

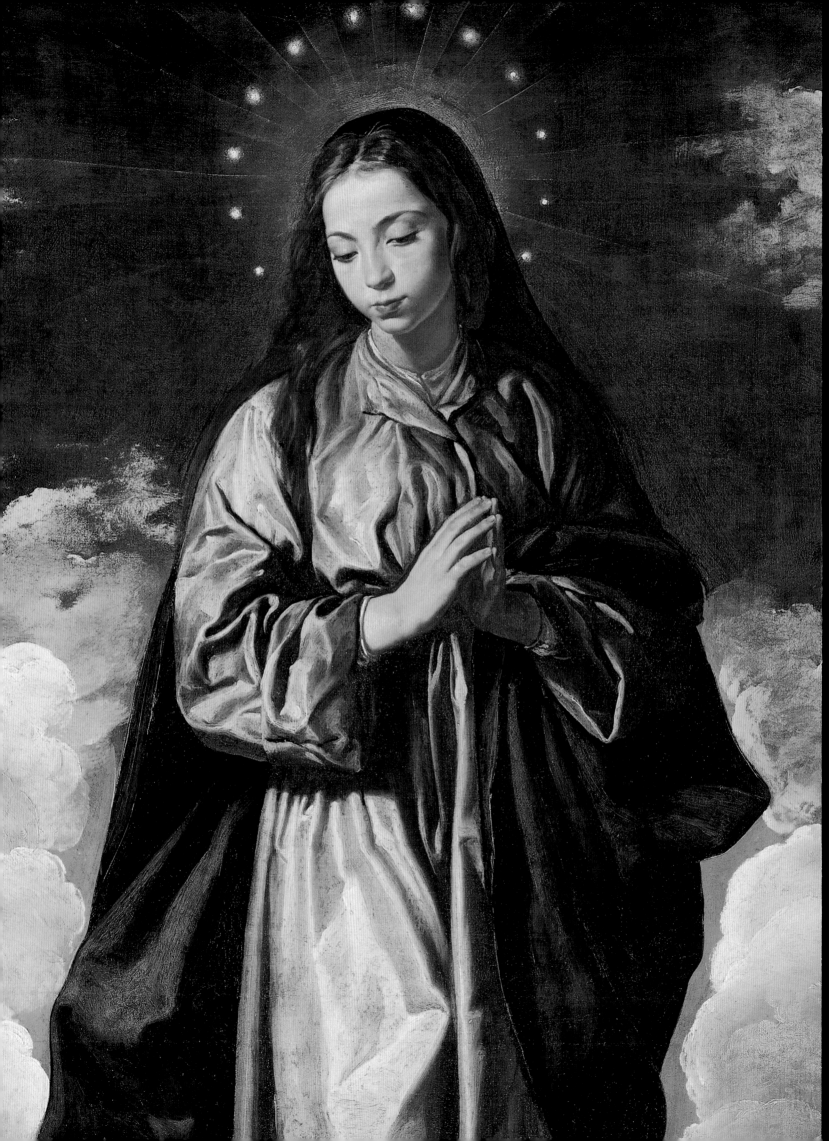

The Immaculate Conception

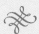

Todo el mundo en general
A voces Reina escogida
Diga que sois cocebida
Sin pecado original

Everyone in general
In a clamorous cry, Elect Queen
Declares that you are conceived
Without original sin

Miguel del Cid, the author of the popular refrain that was sung during the passionate processions honoring the Virgin of the Immaculate Conception in seventeenth-century Seville, is immortalized in Francisco Pacheco's painting of 1619 (cat. 45). The poet, who died in 1612, is pictured holding a printed copy of his verse that "became the rallying cry of popular piety" in Seville,[1] especially after a Dominican monk in 1613 dared to preach against the city's dearly held belief. As the "Elect Queen" referred to by Cid, Pacheco gave his *Inmaculada* a gold crown in addition to the crown of stars, moon, and sunlight derived from Saint John's vision of the Apocalyptic Woman: "And a great sign appeared in heaven: A woman clothed with the sun, and the moon under her feet, and on her head a crown of twelve stars: and being with child, she cried travailing in birth" (Apocalypse 12:1–2). After the Council of Trent, the iconography of the Immaculate Conception usually combined this tradition with attributes of the Marian litanies symbolizing her incorruptible purity: the rose, the cedar, the ship, and the tower of David (which Pacheco imagines as the Tower of Gold in Seville) taken from the description of the bride in the Song of Solomon, who is *tota pulchra*: "Thou art all fair my love; there is no spot in thee" (Song of Solomon 4:4–15).[2]

Although supported by Philip III and fiercely believed in by the Spanish people, the Immaculate Conception of Mary (not to be confused with

that of the Christ, whose conception was unquestionably considered immaculate) was a theologically complex and controversial doctrine open to debate. Indeed, it was not until 1854 that the Roman Catholic Church proclaimed the doctrine as dogma, an article of faith.[3]

There was never any doubt that Mary, chosen as the Mother of God, was born without sin. The issue lay in her conception, since, as Saint Augustine argued, original sin is passed on by the concupiscence of the parents. The Maculists, who relied on the teachings of Saint Thomas Aquinas (d. 1274) and were led by the Dominican Order, believed that Mary, like all of us, was conceived with sin but that God sanctified her in the womb of her mother. The Immaculists, on the other hand, argued that the Supreme Being could make the soul of Mary spotless at the time of conception. The Franciscan Duns Scotus (d. 1308) refined the Immaculists' argument: Mary did not have a soul at the time of conception. When God bestowed a soul upon her eighty days after she was conceived (the end of her nonvegetative state in the womb), it was one free from original sin.

During the reign of Philip III, the subject of the *Inmaculada* became extremely popular. In 1606 the Virgin appeared to the Franciscan confessor of Queen Margaret, Francisco de Santiago, prophesizing an imminent increase in the popular veneration of her as the Virgin Immaculate.[4] Undoubtedly with the backing of the pious Margaret, the Franciscan pressed Philip III until the king promised to lend his powerful support to the cause. In 1616 Philip III established a royal *junta* of theologians and prelates to study the question of the Immaculate Conception with the mission of asking the pope to pronounce the doctrine as dogma, or, at least, to silence those who were against it.

Reflecting the heightened effort to spread the cult of the Immaculate Conception, churchmen

of the Spanish Catholic Reformation organized celebrations to stir public enthusiasm, while religious institutions (with the exception of the Dominicans) commissioned painters and sculptors to make her image. The Jesuit Order, with its interest in using art as a teaching tool, commissioned a series of prints designed by Martin de Vos and engraved by the Wierix family that widely dispersed the standard iconography of the Immaculate Conception.[5] In addition, a beautiful image by Cavaliere d'Arpino (Academia Real de Bellas Artes de San Fernando, Madrid) was sent by the Jesuits from Rome to decorate the Jesuit college in Seville, where it was immediately influential.[6]

One of the earliest images of the *Inmaculada* in Seville is by the most important sculptor of the day, Juan Martínez Montañés (cat. 47). In 1606 he was commissioned to make an image of the Immaculate Conception for the parish church of El Pedroso, a village in the foothills of the Sierra Morena, where it remains today.[7] He imagines her as a young girl with flowing hair, eyes downcast, hands held together in prayer, with a bent knee, standing in contrapposto upon a crescent moon, the only attribute identifying her as the *Inmaculada*. Diego Velázquez's image of 1618–19 (cat. 48) must have been inspired by the Montañés sculpture, which he could have known. In Veláquez's painting Mary is three-dimensional and lifelike, depicted as a very young girl with loose hair and in the same posture as that used by Montañés. As in the sculpture, the drapery in the painting is also long and completely covers the Virgin's feet.[8] Velázquez departs from Pacheco's hieratic and rigid figure, possibly using his sister, Juana (b. 1609), as a live model, or "a simple Sevillian girl whose demure expression endows her with a sincerity absent from Pacheco's respectful rendition."[9] Whoever the model was, as Baticle observed, "[i]n her person, Velázquez has evoked the qualities of innocence, humility, and piety befitting the Purisima."[10]

Velázquez was commissioned to paint his *Inmaculada* by the Unshod Carmelites in Seville. The painting likely is a pendent to the *Vision of Saint John on Patmos*; if so, she would be the "vision" John recorded of the woman in the sun. Velázquez interpreted this vision naturalistically, situating the figure so that her form, which almost obsures the sun, is subtly outlined by light that surrounds and "clothes" her. The symbols of Mary's litanies are incorporated into the landscape below. In a departure from convention, the moon is conceived as a full moon rather than the traditional crescent.

The naturalism of Velázquez's image can be fully appreciated when it is compared to the nearly contemporary *Virgin of the Immaculate Conception* by Juan Sánchez Cotán (cat. 46), who painted this work for the Carthusian monastery in Granada around 1617–18. Sánchez Cotán's *Inmaculada* leaves nothing out; every attribute is crowded into the composition, along with new symbols, including the dove of the Holy Spirit and the full and crescent moons in the sky. While some of the Immaculist attributes are incorporated into the landscape, the irises, roses, and lilies arranged along the bottom edge of the canvas function as a still life, an illusion of real flowers placed on the altar before the image. The artist limited his palette to four colors—blue, yellow, white, and pink—which contributes to the strange impact of the work. The unusual birth-canal-shaped mandorla surrounding the Virgin is undoubtedly a reference to her conception and birth without sin. For an artist who contributed to the birth of naturalism in Spain with his still-life paintings, this *Virgin of the Immaculate Conception* is highly retrograde, like a medieval manuscript image en-larged to over-life-size.

These images of the Immaculate Conception were roughly contemporary with a decree issued in 1617 by Pope Paul V that prohibited preaching against the Immaculate Conception; this was interpreted as a great victory for the cause and was celebrated in Seville for days. Philip III also wished to hold a sumptuous public procession, but the papal nuncio in Madrid reminded the king that the pope wished for no public demonstrations. Philip III had to content himself with a private one inside the Descalzas Reales. The Spanish patron of the Dominicans, the duke of Lerma, turned his back on the Maculists; Lerma was planning to build a cathedral in Madrid dedicated to the Immaculate Conception of Mary.[11] He also presented a letter from the king to the Dominicans gathered in Our Lady of Atocha, asking them to preach in defense of the Immaculate Conception.[12]

On his deathbed Philip III claimed that his biggest regret was that he was unable to convince the pope to make the Immaculate Conception dogma, "for the glorification of Our Lady."[13]

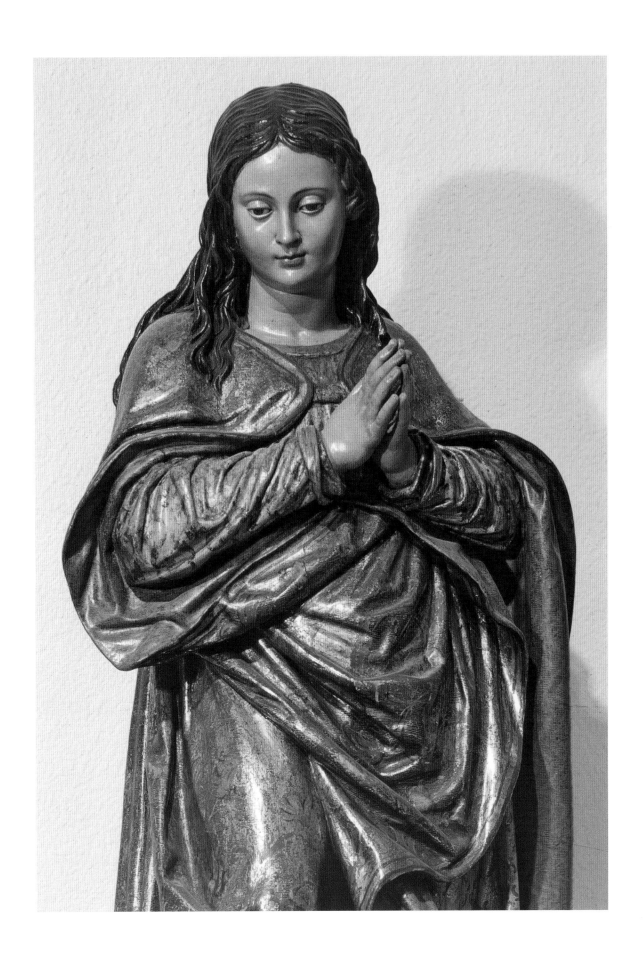

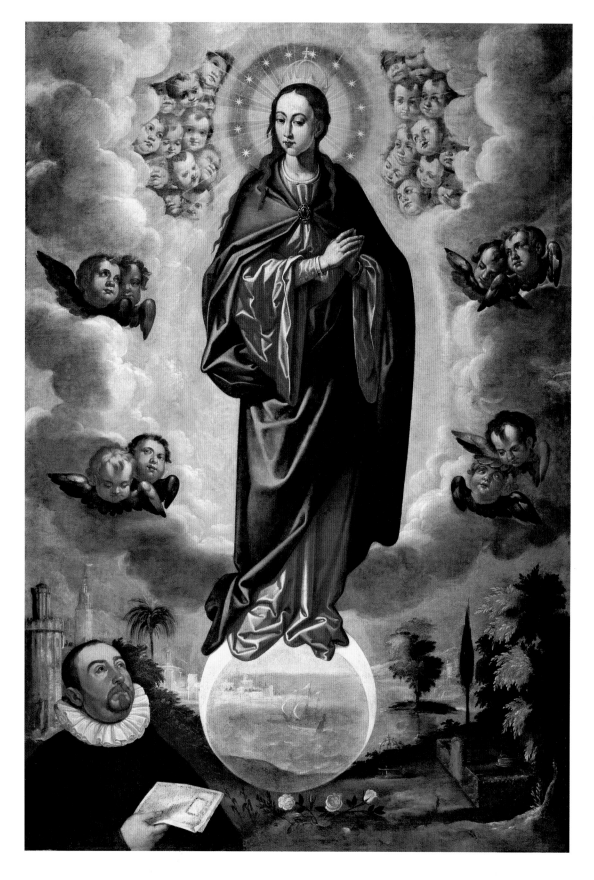

Catalogue 45
FRANCISCO PACHECO
*Virgin of the Immaculate Conception
with Miguel del Cid*, 1619
Oil on canvas
63 x 42 $^{15}/_{16}$ in. (160 x 109 cm)
Cathedral of Seville

Catalogue 46
JUAN SÁNCHEZ COTÁN
Virgin of the Immaculate Conception,
about 1617–18
Oil on canvas
102⅜ x 70 1/16 in. (260 x 178 cm)
Museo de Bellas Artes de Granada

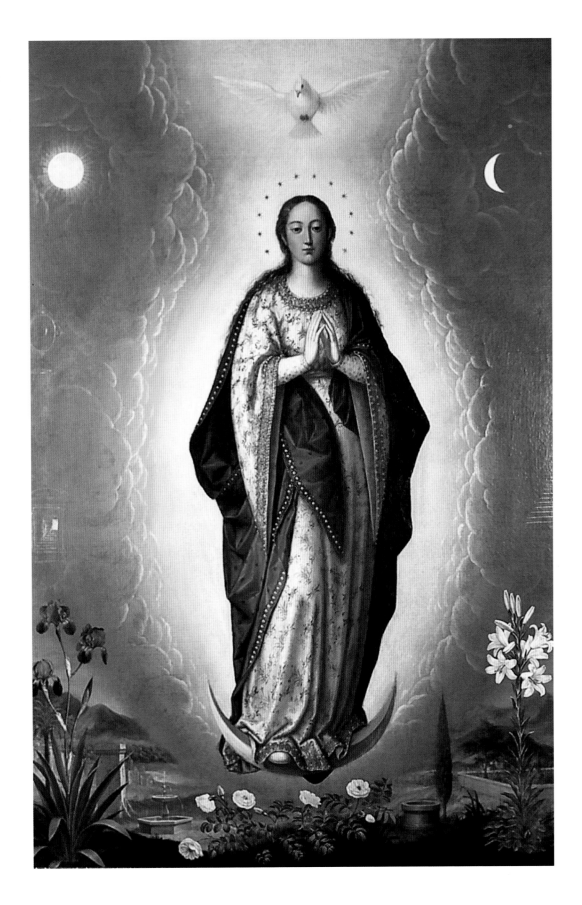

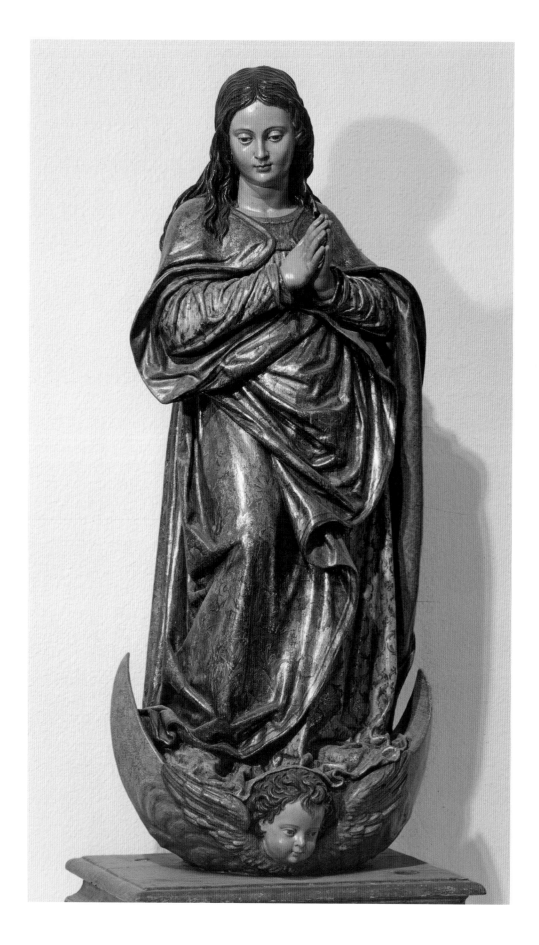

Catalogue 47
JUAN MARTÍNEZ MONTAÑÉS
Virgin of the Immaculate Conception, about 1606–8
Polychrome wood
52¾ x 20⅞ x 16¹⁵⁄₁₆ in. (134 x 53 x 43 cm)
Nuestra Señora de la Consolación, El Pedroso

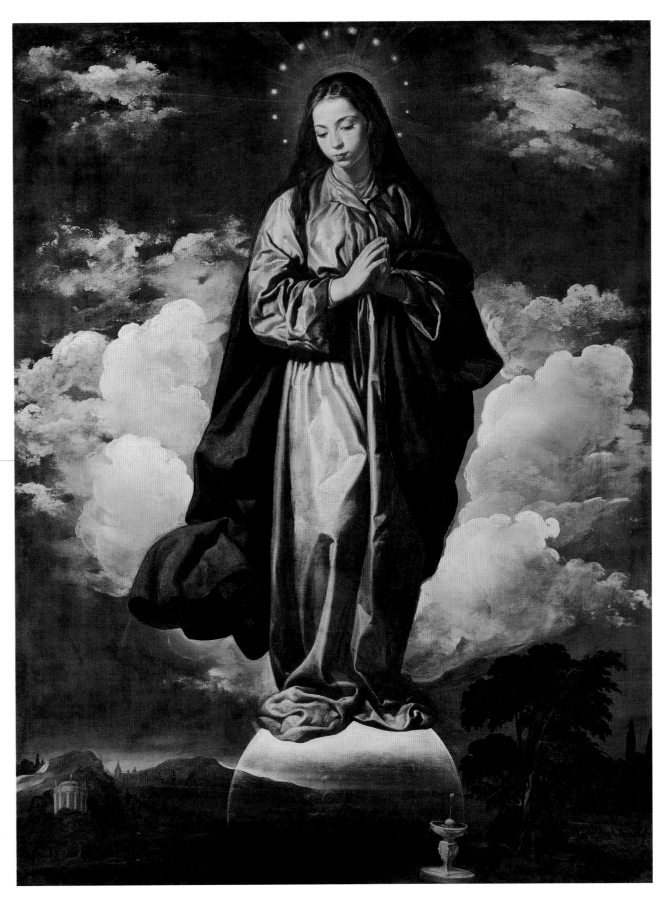

Catalogue 48
DIEGO RODRÍGUEZ DE SILVA Y
VELÁZQUEZ
The Immaculate Conception, 1618–19
Oil on canvas
53⅛ x 40 in. (135 x 101.6 cm)
The National Gallery, London

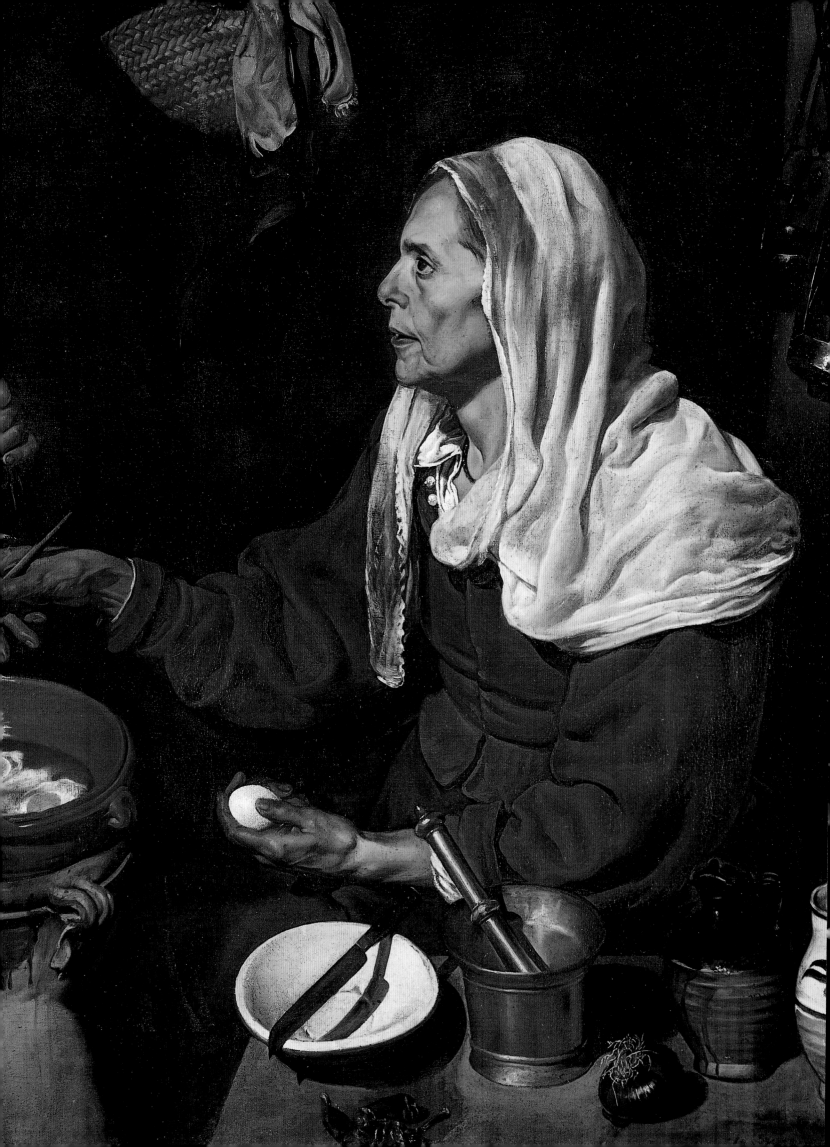

Still Life and the *Bodegón*

Spanish painters during the reign of Philip III created some of the earliest and most sophisticated manifestations of a genre that was entirely novel at the time.[1] The still-life painting did not exist before the 1590s; the concept of a picture depicting inanimate objects without a narrative content was known only from descriptions by Pliny and others of long-lost ancient examples, such as the often-repeated story (referred to in their treatises by both Vicente Carducho and Francisco Pacheco) of a painting of grapes by the Greek artist Zeuxis that appeared so real that a bird flew down to peck at them. Late-sixteenth- and early-seventeenth-century artists, therefore, painted the first still lifes since antiquity, and clearly one of their motivations was to measure themselves against the legendary skill of the ancients: to faithfully imitate nature in order to fool the eye. The same concept (*engañar*) is frequently seen in the literature of the period.

Artists of all eras have painted fruits and arrangements of objects and foodstuffs, but only as accessories in historical or religious depictions. Truly independent easel paintings of still lifes (*lienzo de frutas*) suddenly appeared about the same time in Spain, Italy, The Netherlands, and Germany. The simultaneous emergence of still life throughout Europe is still not completely explained; the discovery of and interest in ancient texts, the fascination with the Italian tradition of the grotesque (festoons and swags of fruits, flowers, and birds), the challenge of illusionism, the growth of empirical science and natural history, the interest in creating and collecting secular subjects, and the embracing of an everyday experience as an alternative mode of expression all seem to have contributed to the development of the genre.[2]

The Spain of Philip III was in the forefront of this development, another example of the keen interest in naturalism and experimentation that

characterized the reign. The earliest *recorded* still lifes in Europe were made by Blas de Prado; unfortunately, we know little about this artist. In 1593, while passing through Seville on his way to serve the sultan in Morocco "by order of the king,"[3] Blas de Prado showed Pacheco some "very well-painted" *lienzos de frutas*.[4]

Peter Cherry recently attributed the charming *Plate of Pears* (cat. 49) to Blas de Prado and dated the picture about 1595–1600.[5] *Plate of Pears* has been compared to the work of the Lombard painters experimenting with still life about the same time, Ambrogio Figino (1550–about 1608) and Fede Galizia (1578–1630). The modest scale and simple arrangement of fruit in a single container (bowl, plate) are the pictorial schema used in both the *Plate of Pears* attributed to Blas de Prado and the *Plates of Fruit* by Galizia, which is signed and dated 1602. The close political relationship between Spain and Milan (under Spain's control) would have facilitated exchange; contemporaries reported that works by Figino and Galizia had been sent to Spain, and a still life by a Lombard painter was among the possessions of Juan de Mendoza, marquis of Hinojosa, governor of Milan until 1615.[6] The Spanish and Lombard artists probably influenced one another.

Plate of Pears is a more complex painting than it at first seems, one in which the artist set high expectations for himself. Ten or eleven small yellow pears are carefully arranged on a metal plate. The artist closely studied the shape and color of the fruit, and he has attempted to paint the pear from every conceivable angle. The reflective surface of the plate allowed the artist to try his hand at creating a mirrored surface; it is a lesson in naturalistic illumination. To show where the metal catches the light, the artist placed white highlights along the left edge, and he gave the composition depth by adding a cast shadow

underneath it. Another challenge was making the dark stems visible against the dark background, which the artist successfully achieved by light. Their curving shapes create a rhythm across the surface and give the composition additional height.

Cherry remarked that the *Plate of Pears* brings to mind the still life owned by the duke of Lerma in 1603, described as "un platillo (little plate) de frutas."[7] The duke had other still lifes in his collection;[8] he was among the educated elite who collected them, when still life was still new.[9]

Pacheco tells us that Blas de Prado was responsible for teaching this genre to Juan Sánchez Cotán, the "pupil . . . who before becoming a religious of the Carthusians in Granada, had much fame" for his still lifes.[10] The artist's fame was built on his inventive approach, seen in the San Diego *Still Life with Quince, Cabbage, Melon, and Cucumber* (cat. 51). It predates 1603, when it appeared in the inventory of Sánchez Cotán's possessions as he left his native Toledo to become a lay brother in the Carthusian order.[11] Its early date, brilliant composition, and unflinching naturalism have given this picture an element of modernity still striking after four hundred years.

The main conceit of the artist is ingenious: hanging a dense quince and a heavier cabbage from delicate strings (that could never have supported the cabbage), and arranging them, with mathematical precision, together with a melon and cucumber to create a composition based on a graceful hyperbolic curve. The originality of the painting is heightened by the choice of common vegetables and fruits, placed in a simple window setting, with intense light hitting the realistically rendered objects without penetrating the pitch-black background. The emptiness of the black background is as much a part of the composition as anything else and, as a void, is given tremendous weight. Beginning with the quince, each of elements seems to come out a little farther into the viewer's space.

Many have puzzled over the niche or window in such a still life, suggesting it may represent a *cantarero*, an architectural element in Spanish houses situated to receive cross ventilation, where food was placed so it would not spoil.[12] Others define it as a *despensa*, a niche in the cellar that served the same function.[13] The artist himself referred to the niche as a "window," as we know from an entry in the artist's inventory: "Un lienzo emprimado para una ventana"

(a primed canvas for a window). From this we learn that the windows were painted first onto Sánchez Cotán's canvases after they had been primed; after that basic compositional framework had dried, he added the still-life elements on top. The window served as a pictorial device. The Varez Fisa still life (cat. 50) provides further proof of the artist's method. The paint has become transparent in the pinkish cardoon (a winter vegetable in the thistle family), so that the line forming the window ledge underneath is now visible.

"If a single painting could be chosen to help define the seventeenth-century usage of the word *ingenio* and its adjective *ingenioso*, it ought to be this one," Jordan wrote about the San Diego picture. "It reveals that quality of mind and imagination intended to dazzle by its brilliance, its cleverness and originality."[14] Perhaps, but Sánchez Cotán's painting has an undeniable hushed stillness and mysteriousness, which become even more pronounced in *Still Life with Cardoon and Carrots* (fig. 51, p. 117), Sánchez Cotán's last still life, found after his death in the Granada chapterhouse where he lived out his life. These qualities, together with the fact that the artist became a monk, have invited numerous religious interpretations of the still lifes over the years.[15] While specific religious symbolism may not have been intended by the artist, it seems unlikely that Sánchez Cotán's still lifes, especially the ones that emphasize the empty blackness, were completely devoid of spiritual content. Given the religious fervor of the time, which clearly had a personal impact on Sánchez Cotán (a successful artist who gave up everything), it is hard to believe that he did not have thoughts about the genre as a glorification of God's humble creations and gifts to man.[16] Felipe Ramírez's later adaptation of a Sánchez Cotán composition with obvious religious symbolism (fig. 77) would seem to support the view that some seventeenth-century audiences read Sánchez Cotán's still lifes as more than a mere interest in naturalism or an intellectual competition with the ancients.

In *Still Life with Game Fowl* (cat. 52), Sánchez Cotán repeated the composition of the San Diego still life, adding three birds and a duck. The reuse of certain motifs was a common practice by Sánchez Cotán. The artist balanced the movement of the hyperbolic curve by placing the birds in a steady planar progression toward the front of the picture plane. Further balance was provided by putting the strange

fruit in the lower left, which has been identified as a *chayote*, a variety of *cucurbit* or squash, native to Latin America.[17] This inclusion demonstrates an interest in natural history, and perhaps was also a reference to the foreign missionaries responsible for writing such histories.

The still life from the Varez Fisa collection, *Still Life with Fruit and Vegetables* (cat. 50) is quite different from the other extant works. The favorite motif, the cardoon, is not propped up against the window frame but now lies vertically on the stone surface. The distance between the hanging objects is more regular and exists in the same plane, which suggests that it may be the earliest effort by the artist.[18] This arrangement solidifies the strong intersecting lines of the composition, and there is a decidedly baroque flourish in the choice and painting of the curling shapes of the escarole and cabbage, which communicates a sense of lightness and playfulness.

Sánchez Cotán had few followers; not until the 1620s did still life blossom into a specialty for artists. His pictorial devices and the appropriation of the cardoon as a still-life element by others, however, are proof of his long-lasting influence. In Juan van der Hamen's *Still Life with Sweets*, which is signed and dated 1621 (cat. 54), for example, objects are also arranged along a stone ledge against a black void. But instead of humble fruits, vegetables, and game, Van der Hamen painted expensive dessert items: a stack of two round wooden boxes of marzipan, with a glass jar of cherry preserves on top, and a glazed ceramic vessel for honey with a silver spoon.[19] A subtle play of shapes and textures skillfully imitated, it was originally in the archbishop's palace in Granada, where his brother Lorenzo (whose portrait Van der Hamen painted [cat. 15]), served as chaplain of the royal chapel from 1650 until 1665.

In *Still Life with Sweets* (cat. 56), signed and dated 1622, the subject is also Spanish delicacies, a leitmotif for the artist. Here he depicted plates of *turrones*, a mixture of honey and pine nuts with almonds and hazelnuts. The fancy Venetian wine goblet is a tour de force in the representation of reflections on glass. William Jordan sees this as one of Van der Hamen's boldest compositions: "The daring interplay of bold primal shapes in this painting were undertaken at great risk of failure, so fine is the line between the representational and abstract in these particular forms. But few paintings reveal so clearly the architectonic aims of the artist as he subtly manipulates those shapes."[20]

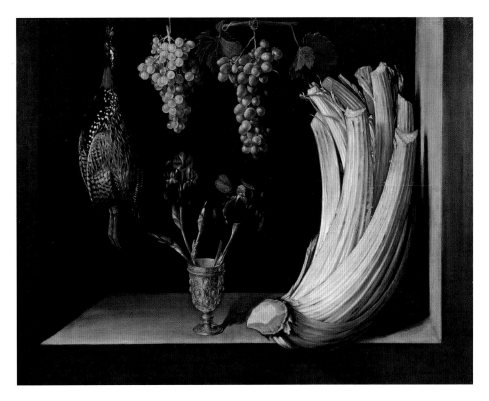

Juan van der Hamen was able to make a long and illustrious career as a painter of still lifes (although he badly wanted recognition for his portraits and religious pictures), as Alejandro Loarte might have done if he had lived longer. Loarte's painting of about 1624, *Still Life with Fruit Bowl* (cat. 53), pays homage to the great master, but also reveals that taste had changed in twenty years. The symmetry and decorative lushness of this work appealed to wider audiences. Peter Cherry's exhaustive archival work has shown that about 1615 an active market for still-life painting began and grew throughout the seventeenth century. The development of a market for still-life painting and its new popularity among non-noble classes reflected the changing society, one which emphasized individuality and innovation. A competitive and lively market allowed the artist to create works from his own imagination, for money and on spec, an alternative to religious and portrait commissions. The rise in popularity of such images is also connected to the growth of collecting, and indicates that taste was expanding among high-ranking court officials who wanted to imitate collections previously formed by a higher social class.[21]

77
Felipe Ramírez
Still Life with Cardoon, Francolin, Grapes and Irises, 1628
Oil on canvas, 28 x 36³⁄₁₆ in. (71 x 92 cm)
Museo Nacional del Prado, Madrid

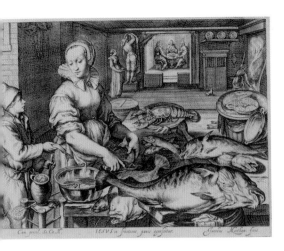

78
Jacob Matham (after Pieter Aertsen)
Kitchen Scene with Supper at Emmaus, about 1603
Engraving, image 9⅛ x 12¹³⁄₁₆ in. (23.2 x 32.5 cm);
platemark 9¹¹⁄₁₆ x 13 in. (24.6 x 33 cm)
Museum of Fine Arts, Boston

Bodegón means tavern or humble public place where food and drink are served. It was first used in Spain in the sixteenth century as a term for genre paintings imported from Flanders and Italy, usually depicting servants preparing a meal or market sellers, which were sometimes imbued with base connotations.[22] Although Spanish *bodegones* came out of this pictorial tradition, the young Velázquez made the genre his own; the dignity and restraint found in them separate his works from any source.[23]

Like still life, its practice was compared to ancient precedents. In *Arte de la pintura*, Pacheco cited Pliny on the Greek artists Dionysius, who made "ordinary and comic things," and Pieraikos, the painter of "humble things like barber-shops, stalls, meals and similar things."[24] Velázquez's *Old Woman Cooking Eggs* (cat. 62) was signed and dated 1618 by the nineteen-year-old soon after he completed his apprenticeship with Pacheco. Velázquez was trying something new for a Spanish artist, the figural equivalent of the still life: using everyday life as a subject.[25] The well-educated young man was certainly competing with the ancients, whom he had studied in Pacheco's academy.

"Well then," asks Pacheco after discussing the Greek examples, "are *bodegones* not worthy of esteem? Of course they are when they are painted as my son-in-law paints them, rising in this field so as to yield to no one . . . they are deserving of the highest esteem . . . he hit upon the true imitation of nature."[26] Velázquez captured a lifelike sense of the two figures. These people and all the humble objects surrounding them seem to exist before our eyes in real time. Was a Greek artist capable of representing egg whites the moment their texture and color are transformed in the broth?

Pachecho discussed the *bodegón* in chapter 7 of *Arte de la pintura*, entitled, "On the Painting of Animals or Birds, Fish Markets and *Bodegones* and on the Ingenious Invention of Portraits Made from Life." For Pacheco, all of these subjects offered the painter an opportunity to perfect *fuerza y relieve*, as he explained, "if the picture from nature possesses relief and force, it appears round like a solid volume and lifelike and deceives the eye as if it were coming out of the picture."[27]

Before mentioning his son-in-law, he praised paintings by Bassano, "the best imitator of animals,"[28] whose lively naturalism also captured the texture of copper kettles and different glasses, as well as human figures of all ages. Velázquez, Orrente, and even Ribera knew the work of Jacopo Bassano and his sons and were aware of the taste in Spain for their pictures, which emphasized naturalism and everyday life and may have influenced these painters, especially in the upward tilt of objects in space, the reflected light on utensils, the bird's-eye view, and the mood of introspection among the self-absorbed workers.[29]

Bassano has come up time and again in our discussions of the development of naturalism in the period of Philip III. Paintings by Bassano, like those of El Greco, were less appreciated in the previous reign (the historian of El Escorial, Padre Sigüenza, made the dismissive remark that there were too many Bassanos in El Escorial to record or talk about), which may explain why their influence on Spanish painting appeared only now.

Pacheco wrote that Pedro Orrente mastered the type of painting introduced to Spain by the Bassano family, "although his style differs from theirs."[30] Orrente spent time in Italy between 1604 and 1612, reportedly studying with one of Jacopo's sons, Leandro. When he returned to Spain, Orrente fulfilled collectors' demands for paintings by Bassano by imitating their subject matter and naturalistic models.

In Pacheco's and Velázquez's world, Orrente's *Jacob Conjuring Laban's Sheep* (cat. 57) would have been admired for the same reasons as a painting of a *bodegón* or a portrait from life: for "strength and relief," for the successful imitation of animals, and for the original and naturalistic interpretations of biblical stories. The painting demonstrates Orrente's close observation of sheep in nature. He captured their flocking behavior (including their confusion about which way to head when separated) and the sheep's timid manner, except at the feeding trough, where three of the seven have been head-butted out of the way. Orrente mastered the realistic rendering of the texture of the fleece, even the wavy lines of the crimp of the wool.

Although Orrente is called the "Spanish Bassano," his painting has a monumentality and true naturalism that places it in the world of the international Baroque. His figure and composition are closer in style to an Italian *bodegón* or to the close inspection of nature seen in independent still-life paintings.

Orrente returned from Italy about the same time as Maino and Tristán, and his *Martyrdom of Saint Sebastian* (cat. 32) is painted in Caravaggio's manner. As Pacheco singled out Orrente for praise, it seems plausible that his student Velázquez, in starting his career by painting *bodegones*, would have paid attention

to a work like this—the burst of light in a darkened sky, the planar arrangement of objects, the intimacy of the scene, and the tactile rendering of objects are also found in Velázquez's early works.[31]

It has long been established that Velázquez's *Kitchen Scene with Christ in the House of Martha and Mary* (cat. 59) was based on Jacob Matham's (1571–1631) engraving after Pieter Aertsen (1508–1575) (fig. 78). Flemish prints were plentiful in Seville, whose large community of Flemish merchants imported, owned, and sold such pictures. But Velázquez goes far beyond the earlier source by breathing air and life into the subject. Although beautifully sketched, the religious scene visible through the window was secondary to Velázquez—all the focus is on the foreground action and the table, which is tilted up to display the artist's technical proficiency in painting eggs (defined by dozens of brushstrokes in graduated tones of white and other colors); crinkly, dry garlic and red pepper; scaly fish; and shiny metal and glazed ceramic. The female figures in the foreground were taken from life and probably represent not the Martha and Mary who appear in the biblical story behind them but contemporary embodiments of the *vita activa* and *vita contemplativa*.[32]

The Kitchen Maid (cat. 60) by Velázquez is a version of an almost identical picture now at the National Gallery of Dublin, except that there is no religious scene in the background. The reason for omitting the religious component in the Chicago version is unknown (technical examination has found no evidence that it has been painted over or scraped from the canvas), but, without it, all that remains is the foreground figure and an exquisite still life. The mysterious figure, an African or a Moor, stares blankly at the pot, or is lost in deep thought—we cannot tell. Velázquez's interest in natural appearances and subject matter imbued with ambiguity dates from these early *bodegones*.

As far as we know, the *bodegones* in Madrid collections were all imported. The duke of Lerma owned nine *bodegones*; one is identified as Flemish, another from Italy, and similar entries appear in many other inventories of the period.[33] We know that the court artist Juan Pantoja de la Cruz, who worked for Lerma, painted three "*bodegones* de Italia," in the 1590s, a description suggestive of the kitchen scenes by the best-known painter of the genre in Italy, Vincenzo Campi (fig. 79). This sort of *bodegón* was referred to simply as "la cocina" (the kitchen). Despite their popularity, Vicente Carducho

loathed them—he remained true to the classical Italian idea that the artist must use his intellect and skill to improve upon nature rather than imitate it.

In Toledo, Alejandro Loarte was one of the few to try his hand at painting *bodegones*. His *Market Scene with Poultry Sellers* (private collection, Madrid), signed and dated 1626, was set in the Zocodover Plaza in Toledo, and he made four small works that combine the *cocina* tradition with still life, probably inspired, as Velázquez was, by the Flemish "inverted" still-life paintings by Aertsen or prints after them. Loarte's *Birds with Kitchen Scene* (cat. 58) shows three large foul in the foreground, their beaks hanging from hooks on a wooden beam. They take up two-thirds of the composition, while in the background we see a slice of contemporary life, rather than a biblical scene. A hunter presents two birds to the mistress of the house, her well-dressed, well-fed child beside her. In the kitchen behind them, a fire is being prepared to roast the fowl, while a boy in tattered clothes waits outside the kitchen, hoping to receive food or alms. Like the religious *bodegones* of Velázquez, Loarte's still lifes have moralizing subjects but are easily read, without Velázquez's hint of irony or ambiguity. "The young artist [Velázquez] understood, perhaps intuitively," Carr informed us, "that remaining indefinite about what is going on in his pictures would intrigue and allow the viewer a greater role in interpretation."[34]

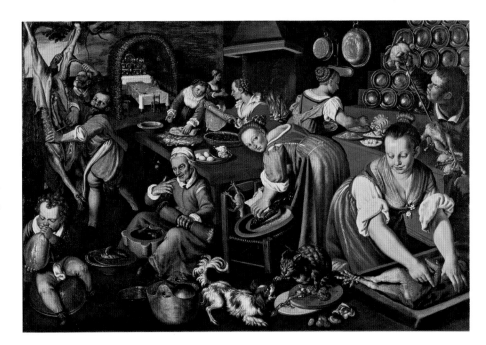

79
Vincenzo Campi
The Kitchen, second half of 1580s
Oil on canvas, 57 1/16 x 86 5/8 in. (145 x 220 cm)
Pinacoteca di Brera, Milan

Catalogue 49
ANONYMOUS
Plate of Pears, about 1595–1600
Oil on canvas
9 1/16 x 12 13/16 in. (23 x 32.5 cm)
Naseiro Collection, Madrid

Catalogue 50
JUAN SÁNCHEZ COTÁN
Still Life with Fruit and Vegetables, about 1602
Oil on canvas
27⅜ x 38 in. (69.5 x 96.5 cm)
Varez Fisa Collection, Spain

Catalogue 51
JUAN SÁNCHEZ COTÁN
Still Life with Quince, Cabbage, Melon, and Cucumber,
about 1600
Oil on canvas
27¼ x 33½ in. (69.2 x 85.1 cm)
San Diego Museum of Art

Catalogue 52
JUAN SÁNCHEZ COTÁN
Still Life with Game Fowl, about 1600
Oil on canvas
26 11/16 x 34 15/16 in. (67.8 x 88.7 cm)
The Art Institute of Chicago

Catalogue 53
ALEJANDRO DE LOARTE
Still Life with Fruit Bowl
Oil on canvas
32¹⁄₁₆ x 42½ in. (81.5 x 108 cm)
Plácido Arango Collection

Catalogue 54
JUAN VAN DER HAMEN Y LEÓN
Still Life with Sweets, 1621
Oil on canvas
14¹⁵⁄₁₆ x 19⁵⁄₁₆ in. (38 x 49 cm)
Museo de Bellas Artes de Granada

Catalogue 55
JUAN VAN DER HAMEN Y LEÓN
Still Life (Plate with Bacon, Bread, and Wine), about 1621
Oil on canvas remounted on wood
14 9/16 x 16 15/16 in. (37 x 43 cm)
Musées royaux des Beaux-Arts de Belgique, Brussels

Catalogue 56
JUAN VAN DER HAMEN Y LEÓN
Still Life with Sweets, 1622
Oil on canvas
22 13/16 x 38 3/16 in. (58 x 97 cm)
The Cleveland Museum of Art

Catalogue 57
PEDRO ORRENTE
Jacob Conjuring Laban's Sheep, about 1612–22
Oil on canvas
39 x 52 in. (99.1 x 132.1 cm)
North Carolina Museum of Art, Raleigh

Catalogue 58
ALEJANDRO DE LOARTE
Birds with Kitchen Scene
Oil on canvas
19 11/16 x 27 9/16 in. (50 x 70 cm)
Granados Collection, Madrid

Catalogue 59
DIEGO RODRÍGUEZ DE SILVA Y VELÁZQUEZ
Kitchen Scene with Christ in the House of Martha
and Mary, probably 1618
Oil on canvas
23⅜ x 40¾ in. (60 x 103.5 cm)
The National Gallery, London

Catalogue 60
DIEGO RODRÍGUEZ DE SILVA Y VELÁZQUEZ
The Kitchen Maid, about 1618–20
Oil on canvas
21⅝ x 40¹⁵⁄₁₆ in. (55 x 104 cm)
The Art Institute of Chicago

Catalogue 61
JUSEPE DE RIBERA
The Sense of Taste, about 1614–16
Oil on canvas
44¹³⁄₁₆ x 34¾ in. (113.8 x 88.3 cm)
Wadsworth Atheneum Museum of Art,
Hartford, CT

284

Catalogue 62
DIEGO RODRÍGUEZ DE SILVA Y VELÁZQUEZ
An Old Woman Cooking Eggs, 1618
Oil on canvas
39 x 50⅜ in. (99 x 128 cm)
National Gallery of Scotland, Edinburgh

Catalogue 63
JUAN VAN DER HAMEN Y LEÓN
Still Life with Sweets and Pottery, 1627
Oil on canvas
33⅛ x 44⅜ in. (84.1 x 112.7 cm)
National Gallery of Art, Washington, DC

The *Camarín* and the Duke of Lerma's Pictures

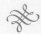

The duke of Lerma purchased his Madrid property in 1602, only one year after the court had relocated to Valladolid.[1] Located on the southeast edge of the city, on the Paseo del Prado, the property was referred to as "La Huerta del Prior" after its former owner, Don Hernando de Toledo, a onetime prior and distinguished member of Philip II's court. Although the palace and gardens on the property are no longer extant, three archival sources allow us to partially reconstruct their contents.[2] According to the 1605 inventory made while the building was still under construction, the most significant features of Lerma's Madrid palace were its extensive gardens, decorated with twenty-four marble busts or heads of ancient Roman emperors on jasper and marble pedestals, and its *camarín*, meticulously described in unusual length and detail. This *camarín* exemplifies the reign's interest in creating an impression of splendor.

In the first dictionary of the Spanish language, published during the reign of Philip III in 1611, its author Covarrubias defined the *camarín* as "a *retrete* [a small storage room or closet] where the ladies have their porcelains, earthenware pots, glass and other curiosities." Lerma's impressive *camarín* in Madrid may have provided the prototype for this particularly Spanish type of collector's cabinet; as we know from other inventories of the period, *camarines de barros y vidrios* (jars and glassware) were popular at the time.[3] In Luis de Góngora's sonnet entitled "To the Count of Villamedia, Celebrating His Taste in Diamonds, Paintings and Horses," the poet included in his praise the count's *camarín*; another such *camarín* was lauded by Lope de Vega in his sonnet "To Juan Infante de Olivares."[4] Furthermore, it is probably not coincidental that a still-life painter such as Juan van der Hamen, in his *Still Life with Sweets and Pottery* from 1627 (cat. 63), included interesting pieces of glass and ceramics, like those described in Lerma's *camarín*, among the fruits and courtly treats he depicted. Indeed, the unusual stepped composition Van der Hamen invented for his still lifes may be tied to the *camarín* tradition; the painter has arranged his objects on three ledges, a compositional device that recalls the five *grados* (stepped shelves) used by the duke of Lerma to display the objects in his *camarín*.

Lerma's *camarín*, which must have measured about fifteen to twenty feet square, contained an astounding number of items: 847 glittering objects, where Venetian glass was juxtaposed with fancy Catalan glass, and Chinese export ware was contrasted with native Talavera majolica, New World pottery, and Spanish and Portuguese redwares and lusterware. The intention was to impress the visitor by creating an ostentatious display of luxury items, while at the same time proudly promoting Iberian and Portuguese goods (comparing them favorably to foreign examples), a form of cultural nationalism appropriate to the isolationist impulse of the reign.

Although the inventory does not have enough detail to identify specific pieces that belonged to the duke, the description of shapes, colors, sizes, and place of origin allows for the identification of representative objects that once formed the collection.[5] The largest category was Chinese porcelain, including both blue-and-white and polychrome wares suggestive of contemporary Ming porcelain from the reign of Wanli (1573–1620); *Kinran de*-type wares, identified by their overglazes of colored enamels and gilded decoration; and a small number of bowls mounted in metal. Chinese porcelain was widely collected in the sixteenth and seventeenth centuries; Lerma's interest in it was to some extent

80
Convent of San Blas

a reflection of prevailing taste. Second in size was glass: 233 pieces from Venice and Barcelona, described as "curiosities of different makes and sources, some gilded, some green, great and small." Then came Iberian ceramics: one hundred examples of red pottery described as from Lisbon, Granada, and Badajoz; several pieces of majolica from Talavera; and a small number of lusterwares, presumably contemporary productions. In addition the *camarín* contained fourteen shells, one mounted in metal.

The preponderance of Chinese export ware reflected the wide-ranging cultural interests of the duke of Lerma. His perspective was undoubtedly influenced by his close relationship to the Jesuit Order; their far-flung missionary activity was an essential part of their attempt to strengthen the faith at home and abroad. Collecting foreign ceramics and glass and juxtaposing them with native ware on the five shelves, therefore, may have had a religious as well as a cultural and political motive.

Lerma seems to have collected pictures for a similar reason: to dazzle the visitor by an overwhelming, precedent-setting number of pictures by both well-known European artists and local Spanish painters. As far as we know, the duke inherited few paintings,[6] although among them must have been the works his mother acquired in 1504 at the sale of Queen Isabella's goods: ten tiny precious Flemish panels from the altarpiece commissioned by the queen from Juan de Flandes and Michel Sitow.[7] And yet by 1603 Lerma had amassed a collection of 488 paintings, including masterworks by Titian (1), Rubens (3), the Bassano family (29 originals and 17 copies), Alessandro Allori (1), Luca Cambiaso (1), Hieronymus Bosch (5), Frans Pourbus (1), and the Spanish artists Francisco Ribalta (1), Antonio Ricci (11), and Vicente Carducho (3). Copies after well-known works by Raphael, Titian, Veronese, Dosso Dossi, and others were also found among the paintings that decorated Lerma's ducal quarters in the royal palace in Valladolid.[8] Only three years later the collection had nearly doubled in size: 890 paintings were now hung on the walls of the fourteen rooms fashioned by the duke within the royal palace. Next to the palace, in the monastery and church of San Diego that Lerma built for the Unshod Franciscans, another eighty-two paintings were recorded in 1606.[9]

Lerma's riverside pleasure palace in Valladolid, La Huerta de la Ribera, boasted a total of 631 paintings in 1606, among them Rubens's *Equestrian Portrait of the Duke of Lerma* (cat. 11). When the court moved back to Madrid from Valladolid, the duke sold La Huerta de la Ribera and all of its contents to King Philip III; by arranging for his acquisitions to enter the royal collection, Lerma cleverly (and rightly, as it turns out) ensured that his legacy as favorite and collector would be preserved. Even though Philip IV and his own favorite, the count-duke of Olivares (Lerma's archenemy), would give away some of the masterpieces from La Huerta de la Ribera (such as Giambologna's fountain sculpture of *Samson and a Philistine* [fig. 30, p. 88], and Veronese's *Mars and Venus* [fig. 33, p. 90], gifted to the Prince of Wales), the Lerma provenance had been established.[10]

About 1606, when Madrid again became the city of the court, Lerma moved into his new ducal palace, the Quinta del Prior, with its marvelous *camarín*, antique marble garden sculpture, and paintings. By August 1607 a modest 315 portraits and religious pictures were housed there, valued at 124,143 reales. Despite Cabrera de Cordoba's claim that Lerma was building "one of the best and most costly houses" ever made,[11] it seems clear that the duke was reacting to the charges of corruption against members of his political circle by decorating the walls in a slightly less grand manner and by giving away works by the hundreds to religious institutions in Valladolid, Madrid, and Lerma. Nevertheless,

the Quinta del Prior was home to Titian's *Salomé* (fig. 36, p. 94) and original works by Cambiaso, Antonis Mor (fig. 81), and Pantoja de la Cruz.

Meanwhile, for the hunting lodge in Ventosilla, the duke purchased another seventy-seven works on the theme of saints and hermits in the wilderness, an appropriate subject for his country residence. At least, these were the works there in 1605. A few years later many works from Lerma's Madrid palace were transferred to Ventosilla, a common habit with Lerma, who would create special installations of pictures gathered from his other residences when he was hosting an important event for the royal family.

The most spectacular event planned by the duke of Lerma involving the hosting of the royals, and one of the most impressive and lavish of the whole reign, took place in the village of Lerma over a two-week period in October 1617. The excuse was to celebrate the transportation of the Blessed Sacrament to the newly consecrated Collegiate church of San Pedro, which had been completely rebuilt on a grander scale, refurnished, and restaffed by the duke.[12] The duke also intended to introduce the court to the newly completed urban complex in Lerma designed by Juan Gómez de Mora—a monumental ducal palace with extended buildings forming a unified, spacious *plaza mayor*, and six monasteries and convents, all connected to the ducal palace by various *pasadizos*. Lerma was well aware of the growing faction at court led by his son, the duke of Uceda, who was plotting to overthrow him; perhaps the lavish care he took in the preparations for the royal visit was a last-ditch effort to regain the king's confidence. Documents record that thirty cartloads of pictures, furniture, silver, tapestries, and other luxury goods were brought from Madrid to create a most impressive environment.

The monk Pedro de Herrera (cat. 16), authored a detailed account of each activity during the fourteen days of *comedias*, bullfights, masques, fireworks, religious processions, and liturgies, and recorded all of the attendees, including not only the royal family and their households but all of the principals of the court and councils, as well as members of religious orders, ambassadors, and relatives of the duke, notably the archbishop of Toledo, Bernardo de Sandoval y Rojas.

By this time, however, the duke of Lerma's picture collection, numbering at its peak at least two thousand paintings, had largely been dispersed, and some of his greatest masterpieces, such as Fra Angelico's *Annunciation* (fig. 29, p. 87) and Rubens's *Equestrian Portrait of the Duke of Lerma* (cat. 11), had been given to his churches or sold to the king. For the 1617 festivities Lerma took care to create a special place for Philip III and his family to view the events—the *pasadizo* connecting his ducal palace to the Franciscan convent of Las Clarisas became an elongated picture gallery hung with ninety-six works, dominated by maps and city views. Philip III would later use the same theme to decorate the *pasadizo* he had built between the royal palace in Madrid and the church of La Encarnación.

The treasured pictures that the duke kept for himself—El Greco's *Saint Francis* (cat. 37), Titian's *Salomé* (fig. 36, p. 94), Jacopo Bassano's *Gloria* (Museo Nacional del Prado), and a previously unrecorded *Ecce Homo* by Tintoretto, as well as portraits of family members and ecclesiastical figures —were among the 173 paintings crowded in his "cell" that overlooked the altar of San Blas, the Dominican convent next to the ducal palace (fig. 80). The ducal palace in Lerma also had a *camarín*, but by this time it contained paintings, a shift in taste toward the Baroque concept of a private picture collection[13] and a model for the later, more famous picture collections formed during the reign of Philip IV.

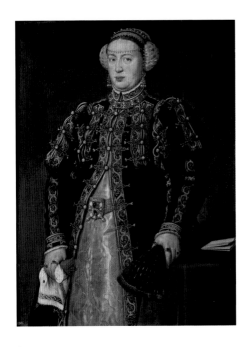

81
Antonis Mor
Catherine of Austria, Wife of John III of Portugal, 1552
Oil on panel, 42⅛ x 33⅛ in. (107 x 84 cm)
Museo Nacional del Prado, Madrid

Biographies

Biographies

THE FOLLOWING BIOGRAPHIES of the artists in the exhibition, arranged alphabetically and, within each artist, chronologically, are based on documentary evidence. The starting point and an indispensable source was the pioneering work of Angulo Iñiguez and Pérez Sánchez on the artists of the Madrid and Toledo schools (1969 and 1972 respectively) and Valdivieso and Serrera on the artists of the Seville school (1985) in the Historia de la pintura española series. Their work has been corrected, updated, gathered together, and, for the most part, published in English here for the first time. Wherever possible, the original citation of the source material has been checked, although original documents have not.

Eugenio Cajés

1574 (January 10): Baptized (Mazón de la Torre 1971, 415); born in Madrid to Casilda de la Fuente and Tuscan painter Patrizio Cascesi (Patricio Cajés) (Pérez Pastor 1914, 137).

1598: Married Felipa Manzano, daughter of one of the king's carpenters (Ceán Bermúdez 1965, 1: 301; Agulló y Cobo 1978, 36–39).

1599: Knew Juan Pantoja de la Cruz by this date, from whom he borrowed money in January (50 reales) (Sánchez Cantón 1947, 100) and in April (2 ducats) (Angulo Iñiguez and Pérez Sánchez 1969, 221); Pantoja referred to him in his first will as a "carver of ivory" (Kusche 1964, 231).

1599 (August 25): Named godfather at the baptism of Laurencio, son of Franciso de Pineda, painter, and María López (Agulló y Cobo 1978, 129).

1601 (July 18): Received commission from the accountant Ochoa de Urquiza, an official of the Casa de Contratación in Seville, to work with his father Patricio on a retable for the church of the town of Esquino in Vizcaya (Pérez Pastor 1914, 88).

1602 (December 3): Commissioned by Fray Pedro de Madrano, of the Order of the Trinitarians, resident in Madrid, for four paintings in oil (Nativity, Adoration of the Magi, Purification, Circumcision) to be completed in ten months, all of which were to be by the hand of Cajés; each picture was to cost 300 reales (Pérez Pastor 1914, 96).

1602 (December 26): Transferred the execution of the Circumcision and Purification commissioned by Fray Pedro de Madrano to Luis de Carvajal. However, two days later the two artists agreed to execute the four paintings jointly (Pérez Pastor 1914, 95–6).

1603 (June 22): Document authorizing a delegation of the Academia de San Lucas (Eugenio and Patricio Cajés, Antonio Ricci, Luis de Carvajal, Orazio Borgianni) to petition the king for his support (Brown 1986–87, 178).

1604: Signed Portrait of Cisneros as "Academicus Matriti" (Angulo Iñiguez and Pérez Sánchez 1969, 222).

1604 (August 19): Was paid 1,500 reales by the king for copies of Correggio's Ganymede and Leda (Pérez Pastor 1914, 107).

1604 (September 7): Commissioned with the sculptor Juan de Porres for a retable of the Holy Infant of La Guardia for the chapel of Pedro de Cercito in the monastery of San Felipe el Real, Madrid. The paintings were to be executed by the hand of Patricio or Eugenio Cajés and the price would be set by valuation (Pérez Pastor 1914, 108). Joachim and Anne Meeting at the Golden Gate (cat. 20) was originally part of this retable (Angulo Iñiguez and Pérez Sánchez 1969, 229).

1604 (September 20): Took on Francisco de Aguilera as an apprentice (Pérez Pastor 1914, 109).

1604 (October 23): Received commission for the painting and gilding of four pictures for the retable for the chapel of San Segundo in Avila Cathedral (Pérez Pastor 1914, 110).

1605: Signed Saint Michael (Fall of the Rebel Angels) (Statens Museum for Kunst, Copenhagen) (Angulo Iñiguez and Pérez Sánchez 1969, 250).

1605 (January 9): Valued the goods of Don Francisco de Rojas, marquis de Poza, with Orazio Borgianni and Juan de Soto (Pérez Pastor 1914, 111).

1605 (February 4): Received 130 ducats from Don Pedro de Tablanes, archdeacon of Avila, for the paintings he was executing for the altarpiece of the chapel of San Segundo in Avila Cathedral (Pérez Pastor 1914, 111).

1605 (April 7): Settlement with the sculptor Juan de Porres over paintings for the altarpiece for the Cercito chapel in the monastery of San Felipe el Real, Madrid, commissioned the previous year; Porres empowered Cajés to collect 200 ducats on his behalf for the work done (Pérez Pastor 1914, 112).

1606 (February 24): Agreed to paint an Annunciation for Doña Juana Dormer, the duchess of Feria, at the price of 2,400 reales (Pérez Pastor 1914, 116).

1606 (April 1): Contracted with the duchess of Feria for two side altarpieces, one of Saint Joseph and one of Saint Anthony, for the chapel of Santa Marina in Zafra (Extramadura). The price was set at 1,500 reales (Pérez Pastor 1914, 117; Angulo Iñiguez and Pérez Sánchez 1969, 232).

1607: Contracted for pictures for El Pardo, with his father, Bartolomé and Vicente Carducho, Francisco López, Juan de Soto, Francisco de Carvajal, Julio César Semín, Fabrizio Castello, Pedro de Guzmán, and Jerónimo de Mora (Martín González, "Arte y artistas" 1958, 133).

1609: Celebrated in Lope de Vega's Jerusalén libertada (Angulo Iñiguez and Pérez Sánchez 1969, 214).

1609 (February 24): Document between Pantoja's heirs and Francisco López for the latter to finish Pantoja's part of the work left incomplete at his death in the gallery of the king's living quarters in El Pardo; Cajés agrees with Guzmán and Mora about the extent of Pantoja's work left undone and

López's role in finishing it, and states that he (Cajés) is thirty-four years old (Saltillo 1948, 10).

1610: Signed the Nativity (cat. 24).

1610 (December 29): Valued the paintings left by Francisco de Mora, aposentador mayor (chief chamberlain) of the palace (Pérez Pastor 1914, 133).

1611 (July 19): Received 200 ducats from Diego Ruiz de Tapia for the Martyrdom of Saint Agueda and for two other paintings for the sepulchre of Diego Páez de la Fuente, in the monastery of San Felipe el Real, Madrid (Pérez Pastor 1914, 137).

1611 (October 26): With his father made an account of what they had received for gilding, fresco painting, and stucco work in the galería de la reina (Queen's Gallery) and the sala de audiencias (audience room) in El Pardo (Cuerpo de Archiveros 1874, 439–40; according to Martín González, "Arte y artistas" 1958, 137, only Patricio was named in the appraisal as the painter of the frescoes; see Carducho 1979, 331: "Patricio Cajés designed, painted and executed the stucco work in the galería de la Reina").

1612 (April 13): Accepted fifteen-year-old Julián de Pascual, son of Juan Pascual of Cuenca, as an apprentice for ten years (Pérez Pastor 1914, 140).

1612 (May 4): Transferred his share of the work for the altarpiece of Ocaña to the gilder and estofador Gaspar Cerezo (García Rey 1932, 140).

1612 (August 11): Valuation of paintings in El Pardo by Pedro Juan de Tapia and Antonio Morales on the part of the king and by Lorenzo de Aguirre and Alonso Maldonado for Carducho, Cajés, and others; Cajés's work in fresco and gilding of the vault of the audience room amounts to 31,238 reales; total valuation was 556,880 reales (Martín González, "Arte y artistas" 1958, 134, 137 n. 34).

1612 (August 12): Named pintor del rey (painter to the king), in place of his father, at a salary of 50,000 maravedíes, and would be paid for his works according to their appraised value or agreed-upon price (Sánchez Cantón 1916, 72).

1612 (September 30): New valuation of paintings in El Pardo by Pedro Orfelín de Poultiers, of Zaragoza, for 278,512 reales (Martín González, "Arte y artistas" 1958, 134).

1613: Signed Pentecost (Adanero collection, Madrid) (Angulo Iñiguez and Pérez Sánchez 1969, 223).

1613 (September 12): Undertook to paint for Pedro Rens a Saint Francis Appearing to Pope Nicolas IV similar to the one he had executed for the monastery of San Francisco, Madrid (Pérez Pastor 1914, 144).

1614 (May 25): Requested the king to honor the first valuation of the work at El Pardo; on November 22 an inquiry was begun into whether Lorenzo de Aguirre and Pedro de Tapia were in communication with the painters regarding the valuation amount and to establish that Orfelín was an honorable person; no agreement was reached (Martín González, "Arte y artistas" 1958, 134–36).

1614 (October 3): Vicente Carducho authorized him to negotiate the contract for the work, cost, and conditions of painting and gilding the Capilla del Sagrario in the Toledo Cathedral, which they would both execute, and that had already been commissioned by Don Bernardo de Rojas y Sandoval, the archbishop of Toledo; Cajés signed the contract in Toledo on October 27 (Pérez Pastor 1914, 147; Volk 1977, 367–69).

1614 (October 31): His and his wife's houses on the calle de Baño, worth 2,500 ducats, put up as collateral as part of the contract with Carducho for work in the Sagrario in the Toledo Cathedral (Saltillo 1947, 611).

1615: With Carducho executed paintings in oil and fresco in the Sagrario in the Toledo Cathedral. Their work was settled at 6,500 ducats (Ceán Bermúdez 1965, 1: 249–302).

1615 (February 18): With Carducho signed a contract in Toledo for the main retable of the church of the royal monastery of Nuestra Señora de Guadalupe, Guadalupe (Cáceres). They agreed to deliver the works within a two-year period and would be paid according to a final appraisal, minus the 400 ducats they received at the start of the work (Marías 1978, 423).

1615 (June 26): Another valuation for work at El Pardo, this time with Orfelín for the king and Francisco Esteban and the sculptor Alonso de Vallejo for the painters; final result of the litigation is unknown (Martín González, "Arte y artistas" 1958, 137).

1615 (August 29): With Carducho requested an appraisal of the work in the Sagrario and named Francisco Granelo as their judge; the cathedral representative, Canon Garay, named as his valuator Juan Bautista Maino, who was established in Toledo in the monastery of San Pedro Mártir (Marías 1978, 423).

1615 (September 9): With Carducho asked for final payment for their work in the Sagrario. On September 18 they were paid 6,500 ducats, an amount that did not coincide with the appraised estimate of 8,200 ducats (Pérez Sedano 1914, 88; Volk 1977, 143).

1616: Signed *Saint Leocadia* for the church of Santa Leocadia in Toledo (Angulo Iñiguez and Pérez Sánchez 1969, 249).

1616 (March 12): With the sculptor Alonso López Maldonado and the architect Mateo González agreed to execute an altarpiece for a pillar in the monastery of La Victoria, Madrid (Pérez Pastor 1914, 152).

1616 (July 6): Valued the paintings of the main retable and side altarpieces in the convent of La Encarnación, Madrid, on the part of Vicente Carducho (Pérez Pastor 1914, 154, 160).

1617: Signed *Saint Michael* (duke of Infantado collection, Madrid) (Angulo Iñiguez and Pérez Sánchez 1969, 250).

1618: With Carducho finished painting the high altarpiece for the Hieronymite monastery of Nuestra Señora de Guadalupe, Guadalupe. They were paid 2,000 ducats (Ceán Bermúdez 1965, 1: 302; Ponz 1947, 607). Cajés painted *Pentecost*, *Resurrection*, and *Assumption* (Angulo Iñiguez and Pérez Sánchez 1969, 228).

1618 (January 28): In Guadalupe was authorized by Carducho to collect 325 ducats for paintings executed for the main chapel of the monastery there (Volk 1977, 164).

1618 (March 3): With Bartolomé González valued, as painter of His Majesty but on the part of Roelas, three canvases painted (by Roelas) for the king (Moreno Villa 1937, 263–67).

1619: Signed the *Annunciation* from the altarpiece for the Church of Asunción de Nuestra Señora of Algete (Madrid) (Angulo Iñiguez and Pérez Sánchez 1969, 227); signed *Christ Awaiting Crucifixion* for the convent of Nuestra Señora de la Concepción, Madrid (Angulo Iñiguez and Pérez Sánchez 1969, 224, 242).

1620: Signed *Annunciation* (monastery of Santo Domingo el Antiguo, Toledo) (Angulo Iñiguez and Pérez Sánchez 1969, 224).

1620: Painted *San Isidro* for the provisional high altar made by Alonso Carbonell for the monastery of Nuestra Señora de la Merced, Madrid (Ceán Bermúdez 1965, 1: 235; Angulo Iñiguez and Pérez Sánchez 1969, 224).

1620 (December 1): On the part of Felipe Dirksen appraised the portrait of Philip III painted in Lisbon; Bartolomé Gonzalez valued the work on the part of the king (Moreno Villa 1936, 264–65).

1621: With Carducho and Julio César Semín decorated the catafalque of Philip III in San Jerónimo el Real, Madrid, with coats of arms and skulls (Martín González, "Arte y artistas" 1958, 133).

1621 (March 10): With Jerónimo López, on the part of His Majesty, numerous portraits painted by Bartolomé González for the king (Moreno Villa and Sánchez Cantón 1937, 157).

1621 (November 11): Contracted with Alonso Carbonell for the high altar and two side altarpieces for the main chapel of the monastery of Nuestra Señora de la Merced, Madrid. They agreed to execute this commission within five years for 12,000 ducats (Cervera Vera 1948, 299–300).

1622: Was celebrated in Lope de Vega's *Relación de la Fiesta de la Canonización de San Isidro.*

1622 (March 20): Contracted with Diego de Baeza and Ginés Carbonell for the *estofado* and gilding of the main and side altarpieces for the monastery of Nuestra Señora de la Merced, Madrid (Pérez Pastor 1914, 167).

1622 (August 6): Asked the sculptor Tomás Martínez de la Puente for the return of 370 reales that he had advanced him for a wooden model that was not to his taste (Pérez Pastor 1914, 168).

1622 (October 18): Received 1,375 reales for an *Annunciation* that the king commissioned for the convent of La Encarnación, Madrid, according to a document from the *oficio de guardajoyas* (treasury) (Tormo y Monzó 1917, 186–87).

1624 (January 18): New contract with Ginés Carbonell regarding the *estofado* and gilding of the altarpiece of the monastery of Nuestra Señora de la Merced, Madrid (Cervera Vera 1948, 301).

About 1625: Valued an image of *Nuestra Señora de la Expectación* by Pacheco (Pacheco 1956, 2: 46–48).

1625: With Carducho and González commissioned to paint companion pieces to Velázquez's equestrian portrait of Philip IV (no longer extant) (Brown 1986, 111–12).

1627: Royal competition for *Expulsion of the Moriscos from Spain by Philip III* among Cajés, Carducho, Angelo Nardi, and Velázquez. Juan Bautista Maino and Giovanni Bautista Crescenzi were the judges; Velázquez won the competition (painting no longer extant) (Palomino 1987, 146).

1627 (August 25): Asked to resume, together with Alonso Carbonell, the interrupted work on the altarpiece of the monastery of Nuestra Señora de la Merced, Madrid (Cervera Vera 1948, 301–2).

1627 (December 1): Named to a committee of three (with Carducho and Velázquez) to appoint a successor to González as *pintor del rey*; the position was suppressed (Brown 1991, 138).

1628: Signed the *Immaculate Conception* for the Augustinian convent in Salamanca (Angulo Iñiguez and Pérez Sánchez 1969, 225).

1628 (April 4): Contracted with Doña Ana Bernaldo de Quirós for a painting of the *Assumption of the Virgin* for the retable in her chapel in the parish church of Santa María Magdalena, Torrelaguna (Madrid), at the price of 5,000 reales. The architecture of the retable was entrusted to Alonso Carbonell (Saltillo 1951, 128).

1628 (September 4): Requested position of *ujier de cámara* (usher of the chamber), which, although authorized by the king, he did not receive (Sánchez Cantón 1914, 300).

1629: Signed the *Assumption of the Virgin* for the parish church of Santa María Magdalena, Torrelaguna (Angulo Iñiguez and Pérez Sánchez 1969, 225, 231); signed the *Descent from the Cross* (Museo Casa de Oquendo, San Sebastián) (Angulo Iñiguez and Pérez Sánchez 1969, 242).

1629: Repeated the petition for the position of *ujier de cámara* with the same negative result (Sánchez Cantón 1914, 300–1).

1630: Signed the *Martyrdom of Saint Philip* for the retable of Saint Philip commissioned for the chapel founded by Doña Petronila de Pastrana in 1626 in Santa María Magdalena, Torrelaguna (Angulo Iñiguez and Pérez Sánchez 1969, 225, 231).

1630: Lope de Vega, in *Laurel de Apolo*, raised Carducho and Cajés to the "beautiful top" of Parnassus (Angulo Iñiguez and Pérez Sánchez 1969, 214).

1630 (June 10): Contracted, with Pedro Orrente, for a screen for the Capilla de los Reyes Nuevos in the Toledo Cathedral (Marías 1978, 422).

1630 (September 11): Commissioned for the *Adoration of the Magi* for the Toledo Cathedral; the price of the painting was settled at 3,350 reales (García Rey 1929, 431). According to Palomino, this work was done in competition with Orrente, who painted a *Nativity* (Palomino 1947, 863).

1631: Signed *Saint Isabel* and *Saint Engracia* for the church of San Antonio de los Portugueses, Madrid (Angulo Iñiguez and Pérez Sánchez 1969, 226, 248).

1631 (February): Asked for a pay increase; the king responded that it was not the time to raise salaries (Justi 1953, 236; Angulo Iñiguez and Pérez Sánchez 1969, 225).

1631 (November 3): Received 11,000 reales for the *History of Agamemnon* for the Alcázar, Madrid. Pedro Nuñez valued the painting (Ceán Bermúdez 1965, 1: 302).

1632: With Nardi valued the paintings by Carducho in the Charterhouse of El Paular (Madrid) (Ponz 1947, 875).

1632 (January 12): Contracted anew for the *estofado* and gilding of the altarpiece for the monastery of Nuestra Señora de la Merced, Madrid (Cervera Vera 1948, 302; Angulo Iñiguez and Pérez Sánchez 1969, 225).

1633 (January 11): With Carducho and on the part of the painters, obtained exemption from the *alcábala* (sales tax) (Palomino 1947, 161).

1634: Valued pictures by Collantes and Acevedo for the Buen Retiro (Caturla 1960, 336).

1634: Contributed two paintings for the Hall of Realms in the Buen Retiro (Angulo Iñiguez and Pérez Sánchez 1969, 253–55).

1634 (August 20): Account made on state of the altarpiece for the monastery of Nuestra Señora de la Merced, Madrid, which was complete but for which Cajés had not yet been paid (Cervera Vera 1948, 303).

1634 (August 21): Received partial payment for the paintings he was executing for the Buen Retiro (Caturla 1960, 352).

1634 (October 8): Received payment for the completed altarpiece of the monastery of Nuestra Señora de la Merced, Madrid (Ceán Bermúdez 1965, 1: 235; Angulo Iñiguez and Pérez Sánchez 1969, 225, point out that Ceán erroneously gave the date as 1624).

1634 (December 13): Signed last will and testament, naming his three daughters and wife as heirs. The witnesses were Juan Cardosso, Simón de Orja, and the painter Juan Gutiérrez. In this document he listed payments owed by the king, including his salary for six or seven years and final compensation for the paintings for the Buen Retiro (Agulló y Cobo 1978, 36–39).

1634 (December 15): Died in his house on the calle del Baño (Pérez Pastor 1914, 173–74).

Vicente Carducho

About 1576: Born in Florence (Martí y Monsó 1898–1901, 279: Carducho is declared as "more or less" twenty-nine years old in July 1605; 280: declared to be thirty in 1606; also corresponds to the inscription on Carducho's portrait engraved by Perret, dated 1614, which gives the age of the sitter as thirty-eight years old. Arguing for a birth date of 1578: Simón Díaz 1947, 252: referred to as fifty in 1628; Palomino 1987, 96, says he died at age seventy in 1638).

1585: Came to Spain with his brother Bartolomé, whom he accompanied to El Escorial (Ceán Bermúdez 1965, 1: 245–46).

1597 (December 9): Served as godfather to his niece Catalina (Zarco-Bacas y Cuevas 1932, 298).

1599: Worked on triumphal arches erected for the royal entry of Queen Margaret into Madrid, according to his own testimony of July 7, 1606 (Martí y Monsó 1898–1901, 280).

1601 (May 19): In Madrid authorized the notary Alonso de Carmona to collect debts owed to him (Pérez Pastor 1914, 87; Volk 1977, 59).

1602: First appeared in the account books of the Palace of Valladolid. He is mentioned in reference to payment for the gold leaf he used in the works for the *camarín* of the duke, the oratorio of the duchess, and the quarters of the count of Fuensaldaña (Martí y Monsó 1898–1901, 605).

1602 (August 16): Summary of payments (156,200 maravedíes) from the duke of Lerma for works in the monastery of San Pablo, Valladolid (Volk 1977, 298).

1603: Mentioned in Valladolid as working for the palace. The account books show that he was paid for the *Holy Spirit* and for the painting and gilding of chests in the palace; he subcontracted the decorative work to the painters Jusepe de Porras and Ambrosio de Caro and received 700 reales to pay them (Martí y Monsó 1898–1901, 606).

1603 (September 26): Assisted with and signed the inventory of the duke of Lerma's paintings taken by his brother Bartolomé (Schroth 1990, 22–23).

1603 (December 7): In Valladolid acted as godfather to his niece Luisa, daughter of Bartolomé (Martí y Monsó 1898–1901, 625).

1604 (February 23): Receipt of 1,600 maravedíes from Tomás de Angulo, treasurer of the duke of Lerma, for works done in Lerma (Volk 1977, 299).

1605 (January 1): In Valladolid acted as godfather to his niece María, daughter of Bartolomé (Martí y Monsó 1898–1901, 625).

1605 (February 16): Received payments for gilding and painting the balconies and window grilles of the duke of Lerma's house (Volk 1977, 301).

1605 (July): Acted as a witness to a legal proceeding that took place in Valladolid concerning the dispute over payment owed to Bartolomé Carducho and Pompeo Leoni for works made for the entrance of Queen Margaret into Madrid. Vicente is declared as "bicencio carducho pintor de 29 años poco mas o menos." The litigation against the *ayuntamiento* (city council) of Madrid was settled in favor of the painters on November 19, 1605 (Martí y Monsó 1898–1901, 279).

1605 (July 13): Received 20,944 maravedíes from Tómas de Angulo, treasurer of the duke of Lerma,

for paintings and expenditures made in Valladolid in the service of the duke of Lerma at the time of the *alarde general*, festivities in honor of the English delegation who came to Valladolid for the ratification of the peace treaty signed at Whitehall the previous year (Pérez Pastor 1914, 113; Volk 1977, 301).

1605 (August 11): Receipt of payment for 5,049 maravedíes from Tomás de Angulo for the monastery of San Diego, Valladolid (Pérez Pastor 1914, 113–14; Volk 1977, 303).

1605 (October 17): Received a partial payment of 1,000 reales from the duke of Lerma for the gilding and *estofado* of the retables in the monastery of San Diego, Valladolid (Pérez Pastor 1914, 185).

1605 (November 22): Received 9,982 maravedíes from the duke of Lerma for gilding and blackening the screens in the church of the monastery of San Diego, Valladolid (Pérez Pastor 1914, 185; Volk 1977, 301).

1606: Signed *Stigmatization of Saint Francis* (fig. 63, p. 142) and *Annunciation* (both Museo Nacional de Escultura, Valladolid) for the retable of the monastery of San Diego, Valladolid (Angulo Iñiguez and Pérez Sánchez 1969, 121).

1606 (January 4): Received 2,000 reales from the duke of Lerma for paintings (probably for the main altar) made for the monastery of San Diego, Valladolid (Pérez Pastor 1914, 185; Volk 1977, 134, 302).

1606 (March 14): Received 200 ducats for painting, gilding, and *estofado* of the side altars and retables of the two small chapels in the monastery of San Diego, Valladolid (Volk 1977, 304).

1606 (June 11): Received payment for painting a gallery in La Huerta de la Ribera, the recreational palace of the duke of Lerma, located outside Valladolid (Martí y Monsó 1898–1901, 610).

1606 (July 7): "Vicencio Florentino" (surely Carducho) declared that he is thirty years old and that he worked on the triumphal arches for the entrance of Queen Margaret from their beginning to the end in 1599 (Martí y Monsó 1898–1901, 280).

1606: Returned from Valladolid with the court to Madrid (Ceán Bermúdez 1965, 2: 246).

1606 (November 24): Among the signatories of an agreement with the monastery of San Bartolomé de la Victoria, Madrid, for space to house an academy of painters (Pérez Pastor 1914, 119; Brown 1998, 82).

1607: Contracted (with other artists including Eugenio Cajés) for paintings for El Pardo (Martín González, "Arte y artistas" 1958, 133–34; according to Brown 1998, 82, the decoration was completed in 1612).

1608: Married Doña Francisca de Benavides (Pérez Pastor 1914, 125).

1608 (August 21): Received 1,500 reales for the painting, retouching, and blackening of the catafalque that was made for the funerary rites of the archduchess Maria Anna of Bavaria (mother of Queen Margaret) in San Benito, Valladolid, as well as escutcheons for the banner and archducal crown (Pérez Sánchez 1976, 296).

1609 (January 28): Named *pintor del rey* on the death of his brother, with the same salary (Ceán Bermúdez 1965, 1: 247).

1609 (April 18): Received 500 ducats from the duke of Lerma as payment for paintings (Pérez Pastor 1914, 127).

1610: Signed the *Preaching of Saint John* for the Basilica of San Francisco el Grande, Madrid (Real Academia de Bellas Artes de San Fernando, Madrid) (Angulo Iñiguez and Pérez Sánchez 1969, 171–72).

1610 (December 1): Was paid 1,000 reales by Garei Mazo de la Vega, treasurer of the duke of Lerma, for paintings ordered by the duke for the convent of Madre de Dios, Lerma, and for the monastery of San Diego, Valladolid (Pérez Pastor 1914, 133).

1611 (March 15): Signed contract with the prior of the Hieronymite monastery of El Parral, Segovia, for two side altarpieces for the main chapel, which was under patronage of the duke of Escalona (Lozoya and Vera 1962, 385).

1611 (March 15): Received final payment from the duke of Lerma for the paintings executed for the convent of Madre de Dios, Lerma, and the central panel of *San Diego* for the retable in the monastery of San Diego, Valladolid (Volk 1977, 304).

1611 (October 26): Submitted invoice for the painting and gilding in the *capilla real* (royal chapel) of El Pardo for a total of 405,550 maravedíes (Cuerpo de Archiveros 1874, 439).

1611 (December 11): Paid 85 ducats to Antonio de Haro toward the rental of houses at the corner of calle de Lobo and calle de los Guertos (Pérez Pastor 1914, 138).

1612 (August 11): Valuation of paintings in El Pardo by Pedro Juan de Tapia and Antonio Morales on the part of the king and by Lorenzo de Aguirre and Alonso Maldonado for Carducho, Cajés, and others; Carducho's work in fresco and gilding of the vault of the *capilla real* was valued at 27,764 reales (10,894 for *los estuques* [stucco and cartouche decoration]), and his work in fresco and gilding of the vault of the *galería del mediodía* (South Gallery) was valued at 124,818 reales (38,740 for *los estuques*); total valuation was 556,880 reales (Martín González, "Arte y artistas" 1958, 134, 137–38 n. 34).

1612 (September 30): New valuation of paintings in El Pardo by Pedro Orfelín de Poultiers, of Zaragoza, for 278,512 reales (Martín González, "Arte y artistas" 1958, 134).

1612 (November 7): Acted as guarantor to his widowed sister-in-law in the contract between her and Antonio de Herrera regarding the stucco work for El Pardo left undone at Bartolomé's death (Pérez Pastor 1914, 142).

1613 (August 7): Obligated to pay the treasurer of the condestable of Castile 4,683 reales for a six-panel tapestry from Brussels (Pérez Pastor 1914, 144).

1613 (September 6): Royal *cédula* (decree) granting 2,200 reales in partial payment for a painting of the *Annunciation* for the retable for the high altar of the church of the convent of La Encarnación, Madrid (Tormo y Monzó 1917, 187).

1614 (March 9): Received commission for the paintings for the main and side retables (*Annunciation, Saint Philip, Saint Margaret* respectively) for La Encarnación, Madrid (Volk 1977, 321–22).

1614 (April 21): Living in houses on the calle del Prado, obligated to pay, with the painter Lorenzo de Aguirre, 3,087 reales to the merchants Domingo Martel and Matías López for 252 skeins of gold and silver thread from Milan (Pérez Pastor 1914, 146).

1614 (May 25): Requested the king to honor the first valuation of the work at El Pardo; on November 22

an inquiry began into whether Lorenzo de Aguirre and Pedro de Tapia were in communication with the painters and to establish that Orfelín was an honorable person; no agreement was reached (Martín González, "Arte y artistas" 1958, 134–36).

1614 (June 3): Obligated to repay within the year the 1,200 reales he had borrowed from Francisco Chacón de Padilla (Pérez Pastor 1914, 146–47).

1614 (July 21 and 25): Documents regarding the valuation of the retable for the hospital of Nuestra Señora del Rosario, Briviesca, commissioned by Don Juan Fernández de Velasco (1550–1613), fifth condestable of Castile, on February 18, 1613 (Volk 1977, 365; Cruz Yábar 1996, 191–92).

1614 (October 3): Authorized Cajés to negotiate the work, cost, and conditions of painting (in fresco) and gilding the Sagrario in the Toledo Cathedral, which they would both execute; the contract was signed by Cajés in Toledo on October 27 (Pérez Pastor 1914, 147; Volk 1977, 367–69).

1614 (October 31): Put up as collateral houses on the calle del Prado as part of the contract signed with Cajés for the decoration of the Sagrario in the Toledo Cathedral (Saltillo 1947, 611).

1615: With Cajés painted frescoes and canvases for the Sagrario in the Toledo Cathedral. Their work was settled at 6,500 ducats (Ceán Bermúdez 1965, 1: 249, 302).

1615 (February 18): With Cajés signed a contract in Toledo for the main retable of the church of the monastery of Nuestra Señora de Guadalupe, Guadalupe (Cáceres). They agreed to deliver the works within a two-year period and would be paid according to a final appraisal, minus the 400 ducats they received at the start of the work (Marías 1978, 423).

1615 (June 26): Another valuation for work in El Pardo, this time with Orfelín for the king and Francisco Esteban and the sculptor Alonso de Vallejo for the painters; final result of the litigation is unknown (Martín González, "Arte y artistas" 1958, 137).

1615 (August 29): With Cajés requested an appraisal of the work in the Sagrario and named Francisco Granelo as their judge; the cathedral representative, Canon Garay, named as his valuator Juan Bautista Maino, who was established in Toledo in the monastery of San Pedro Mártir (Marías 1978, 423).

1615 (September 9): With Cajés asked for final payment for their work in the Sagrario. On September 18 they were paid 6,500 ducats, an amount that did not coincide with the appraised estimate of 8,200 ducats. (Pérez Sedano 1914, 88; Volk 1977, 143).

1615 (December 12): With his wife authorized the collection of income that the marquis of Alcañices bestowed on Don Francisco de Benavides, the artist's father-in-law (Pérez Pastor 1914, 151).

1616 (July 6): The paintings, gilding, and *estofado* of the retables for La Encarnación, Madrid, were appraised by Cajés, Juan de Roelas, and Juan Gómez at 37,580 reales (Pérez Pastor 1914, 154). The *Annunciation, Saint Philip,* and *Saint Margaret,* the central paintings of the three retables, were signed in this year (Angulo Iñiguez and Pérez Sánchez 1969, 107).

1617: Signed the *Last Supper* for the refectory of La Encarnación, Madrid (Angulo Iñiguez and Pérez Sánchez 1969, 157).

1617 (August 9): With Santiago Morán valued numerous portraits painted by Bartolomé González of the royal family. These values were included in an inventory presented by González to the king for payment (Moreno Villa and Sánchez Cantón 1937, 153).

1617 (October 11): Account made of paintings executed for the monastery of the Capuchins at El Pardo; valuations by Juan de Roelas (Martín González, "Arte y artistas" 1958, 131–33).

1618: With Cajés finished painting the high altarpiece for the Hieronymite monastery of Nuestra Señora de Guadalupe, Guadalupe. They were paid 2,000 ducats (Ceán Bermúdez 1965, 1: 302; Ponz 1947, 607). Carducho painted the *Annunciation, Adoration of the Magi,* and *Adoration of the Shepherds* (Ceán Bermúdez, 1965, 1: 253; Volk 1977, 43).

1618: Participated in the partition of the goods of Bartolomé Carducho and Gerónima Capello, as executor to his sister-in-law's estate and guardian of their children (Pérez Pastor 1914, 160).

1618 (January 28): Authorized Cajés, who was in Guadalupe, to collect 325 ducats for paintings executed for the main chapel of Nuestra Señora de Guadalupe, Guadalupe (Volk 1977, 164).

1618 (May 21): New appraisal of paintings for the retables for La Encarnación, Madrid; was granted an additional 94,398 reales (Volk 1977, 153, 323–25).

1619: With Cajés worked on the altarpiece for the parish church of the Asunción de Nuestra Señora, Algete (Madrid); signed the *Annunciation* and the *Nativity* (Angulo Iñiguez and Pérez Sánchez 1969, 87).

1619: Hearing and litigation over the payment due for paintings for El Pardo (Volk 1977, 308–10).

1619 (October 8): Transfer of the remainder of work for the altarpiece of the church of San Sebastián, Madrid, from Antonio de Lanchares to Carducho (Pérez Pastor 1914, 162; Volk 1977, 326–28).

1620 (August 5): Received payment for the paintings for the main retable of Nuestra Señora de Guadalupe, Guadalupe (Volk 1977, 363–64).

1621: With Cajés and Julio César Semín decorated the catafalque of Philip III in San Jerónimo el Real, Madrid, with coats of arms and skulls (Martín González, "Arte y artistas" 1958, 133).

1621: Lope de Vega included a poem (in *octavas reales*) in praise of Carducho in *La Filomena* (Rosell 1950, 480a).

1622: Signed the *Crucifixion* (Cuenca Cathedral) (Volk 1977, 172).

1622 (August 18): Valued the pictures owned by the late Don Alonso de Vargas (Pérez Pastor 1914, 168).

1623 (January 13): Continued litigation over payment due for the decoration of El Pardo (Volk 1977, 311–12).

1624: Signed the small *Annunciation* for the refectory of the convent of Las Descalzas Reales, Madrid (Angulo Iñiguez and Pérez Sánchez 1969, 153; Volk 1977, 156).

1624 (May 2): Received final payment for the main retable of the church of San Sebastián, Madrid (Volk 1977, 306–7).

1625: Signed *Pentecost* (ex-collection Serafín García de la Huerta, Madrid [d. 1839], present location unknown) (Angulo Iñiguez and Pérez Sánchez 1969, 160); signed *Beata Mariana de Jesús* (Almería Cathedral) (Angulo Iñiguez and Pérez Sánchez 1969, 173).

1625: With Cajés and González commissioned to paint companion pieces to Velázquez's equestrian portrait of Philip IV (no longer extant) (Brown 1986, 111–12).

1625 (August 12): Received payment for canvases painted prior to 1617 for the monastery of the Capuchins at El Pardo (Martín González, "Arte y artistas" 1958, 133).

1625 (December 24): Royal authorization for payment of 1,000 reales to lengthen, widen, and add to three canvases, two of which are by Titian, for the new *salón* in the Alcázar. The payment does not actually take place until April 26, 1626 (Moreno Villa 1933, 113).

1625–27: Made a brother and judge of the Venerable Third Order of Saint Francis (V.O.T.) (Palomino 1987, 96).

1626 (August 29): Received commission for fifty-six paintings for the Charterhouse of El Paular (Madrid) (Ceán Bermúdez 1965, 1: 247, 252).

1627: Royal competition for *Expulsion of the Moriscos from Spain by Philip III* among Cajés, Carducho, Angelo Nardi, and Velázquez. Juan Bautista Maino and Giovanni Bautista Crescenzi were the judges; Velázquez won the commission (painting no longer extant) (Palomino 1987, 146).

1627 (December 1): Named to a committee of three (with Cajés and Velázquez) to appoint a successor to González as *pintor del rey;* the position was suppressed (Brown 1991, 138).

1628: Testified in Nardi's lawsuit, giving his age as fifty years (Simón Díaz 1947, 252).

1628 (February 8): Contracted for the main retable for the church in Valdehermoso (Volk 1977, 370–72).

1628 (June 16): Continued litigation over the unpaid work executed for El Pardo in 1607 (Volk 1977, 312–17).

1628 (October 20): Received 500 ducats for paintings for the Charterhouse of El Paular (Volk 1977, 329).

1629: Repaired paintings in the *galería* of the Alcázar and other works in the west wing of the palace for 6,070 reales, which still had not been paid in 1631 (per document addressed to the king in 1631) (Martín González, "Sobre las relaciones" 1958, 63; Angulo Iñiguez and Pérez Sánchez 1969, 188).

1630: Signed *Saint Gonzalo with Saint Francis and Saint Bernard* (probably the same picture cited by Ponz 1947, 38, and Ceán Bermúdez 1965, 1: 254, as in the convent of Constantinopla, Madrid) (Gemäldegalerie, Dresden) (Angulo Iñiguez and Pérez Sánchez 1969, 169); signed the *Guardian Angel (Ángel de la Guarda)* for the Ermita del Ángel, Toledo (in situ) (Angulo Iñiguez and Pérez Sánchez 1969, 176).

1630 (April 9): Account of payments received for the decoration of El Pardo (Volk 1977, 318–20).

1630 (July 15): Signed first will; witnesses were Joan Bautista García de Riberas, Joan Martínez, Domingo García de Biescas de la Bega, and Andrés Ruiz Legias (Caturla 1968–69, 151–60). There were two codicils to the first will: one dated August 17, 1630 (169–70), and the second dated December 7, 1630 (170–72).

1631: Signed the *Vision of Saint Anthony of Padua* (Hermitage, St. Petersburg) and the *Vision of Saint Francis with the Immaculate Conception* (Szépművészeti Múzeum, Budapest) for the side

altarpieces of the monastery of San Gil, Madrid (Angulo Iñiguez and Pérez Sánchez 1969, 108, 118); signed the *Martyrdom of Saint Barbara* for the main altarpiece of the monastery of Santa Bárbara, Madrid (Angulo Iñiguez and Pérez Sánchez 1969, 108, 112); signed the *Holy Family with Saints Joachim and Anne* (Museo Nacional del Prado, Madrid) (Angulo Iñiguez and Pérez Sánchez 1969, 108, 156).

1632: Signed thirteen paintings in the cycle for the Charterhouse of El Paular (Angulo Iñiguez and Pérez Sánchez 1969, 134–41); signed *Saint Joseph and Christ Child* (Musée des Beaux Arts, Narbonne) (Angulo Iñiguez and Pérez Sánchez 1969, 171).

1632 (April 3): Received partial payment of 500 ducats for the cycle at the Charterhouse of El Paular (Volk 1977, 177).

1632 (May 4): Received commission for the main retable of the monastery of the Unshod Trinitarians, Madrid, at the price of 800 ducats and obligated to finish by the feast day of the Trinity in the next year (Pérez Pastor 1914, 172; Volk 1977, 338–39).

1632 (August 10): Signed contract with conditions for the decoration of the retable for the church of San Antonio de los Portugueses, Madrid (Volk 1977, 349–52).

1633: *Diálogos de la pintura* published in Madrid.

1633 (January 11): With Cajés and on the part of the painters obtained exemption from the *alcábala* (sales tax) (Palomino 1947, 161).

1633 (August 6): Petition concerning the retable of San Antonio de los Portugueses (Volk 1977, 354).

1633 (October 3): With Velázquez named to value certain portraits of the king, the royal family, and other royal personages and to declare which pictures could be sold (Herrero-García 1936, 67).

1634 (July 29): Received 4,400 reales for the battle paintings executed for the Hall of Realms in the Buen Retiro (Caturla 1960, 352). The *Seige at Rheinfelden* and *Liberation of the City of Constance* were signed in this year (both Museo Nacional del Prado, Madrid).

1634 (July 29): Authorized Francisco Bartolini of Alicante to collect the outstanding payments for the retable for the monastery of the Unshod Trinitarians; a receipt from the monastery is issued that same day (Volk 1977, 341–42).

1634 (August 19): Authorized Domingo and Francisco Bartolini again to collect money owed by the monastery of the Unshod Trinitarians, Madrid (Volk 1977, 343).

1634 (August 27): Was asked by the Venerable Third Order of Saint Francis (V.O.T.), Madrid, to show the altarpiece design for their chapel. The retable was executed in 1635–36 by artists other than Carducho (Pérez Pastor 1914, 173; Volk 1977, 285–86, for discussion).

1634 (November 23): Signed contract with conditions with the Unshod Trinitarians, Madrid, regarding the fourteen paintings in the cycle of the lives of Saint John of Mata and Saint Felix of Valois (Volk 1977, 340).

1634 (December 2): Received 500 reales from the church of San Antonio de los Portugueses, Madrid (Volk 1977, 353).

1635 (January 27): Received 200 ducats in partial payment of the 700 ducats owed for the main

retable of the monastery of the Unshod Trinitarians, Madrid (Volk 1977, 242, 344).

1635 (April 13): Signed second will; witnesses were Domingo de Paz, Juan de Mier, Alonso Martínez, Manuel de la Cruz and Francisco de Traspuerto (Caturla 1968–69, 160–68). This will specified that he should be buried in the habit of Saint Francis, of whose Venerable Third Order of Penitence he was a member, in the church of the Unshod Carmelites in Madrid in the part of the chapel where his wife is buried, if possible (Caturla 1968–69, 161). There is a codicil to the second will, dated November 14, 1638, which states that Carducho was ill in bed (Caturla 1968–69, 172–76).

1636 (January 29): Received 2,000 ducats for pictures for the Charterhouse of El Paular (Volk 1977, 330).

1637: Signed *Saint Ines* (Palacio Diputación, Albacete) (Angulo Iñiguez and Pérez Sánchez 1969, 170).

1638 (January 8): Document regarding the outstanding payments for Carducho's work in the Charterhouse of El Paular (Volk 1977, 332–35).

1638 (July 3): Received payment for work in the Charterhouse of El Paular (Volk 1977, 336–37).

1638: Died and, as a member of the Venerable Third Order of Saint Francis, was buried in the crypt of the old chapel of the order (Palomino 1987, 96).

El Greco (Domeniko Theotokopoulos)

1541: Born in Candia, Crete (Bray and Oliver 2004, 32: in a document dated October 31, 1606, the artist gave his age as sixty-five. In 1582, acting as interpreter in the trial of a Greek boy in Toledo, he stated that he was a native of the "town of Candia," capital of Crete).

1563 (September 28): First recorded as a master painter in a document issued by the duke of Candia (Bray and Oliver 2004, 32).

1566 (June 6): Acted as a witness in the sale of a house, signing himself as *maistro Menegos Theotokópoulos, sgourafos* (Master Domeniko Theotokopoulos, master painter) (Bray and Oliver 2004, 32).

1566 (November 5): Named as a representative in the mediation of a dispute against the Venetian patrician Luca Miani, who bore the honorary title of Camerlengo of the Serenissima in Candia from 1561 to 1564 (Bray and Oliver 2004, 32).

1566 (December 26): Obtained permission to sell "a *Passion of Christ* executed on a gold background" in a lottery. A day later two artists assessed its value at 70 ducats (Bray and Oliver 2004, 32).

1568 (August 18): Living in Venice, gave a series of drawings to Manolis Dakypris to give to the Cretan cartographer Giorgio Sideris, called Calapodas (Bray and Oliver 2004, 32).

1570: Arrived in Rome, probably via Padua, Verona, Parma, Bologna, Florence, and Siena (Bray and Oliver 2004, 32).

1570 (November 16): Recommended by Giulio Clovio to his patron Cardinal Alessandro Farnese and asked to place the artist under his protection and give him temporary lodging in the Palazzo Farnese (Bray and Oliver 2004, 33).

1572 (July 6): Wrote to Cardinal Farnese to protest about being thrown out of his palace in Rome (Bray and Oliver 2004, 33).

1572 (September 18): Admitted to the Guild of Saint Luke, registering as "Dominico Greco," the first record of the artist calling himself by this name; by the end of the year he had opened a workshop and had an assistant (Bray and Oliver 2004, 33).

1575: Painted the portrait *Vincenzo Anastagi* to commemorate his appointment to the office of Sergente Maggiore of the Castel Sant'Angelo in Rome (Bray and Oliver 2004, 33).

1576 (October 21): In Madrid; listed in the records of the Royal Almoner, where he appealed for financial aid (Bray and Oliver 2004, 34).

1577: Signed the *Assumption of the Virgin* (Art Institute, Chicago) for Santo Domingo el Antiguo (Bray and Oliver 2004, 34).

1577 (July 2): In Toledo received a payment on account for the *Disrobing of Christ*, commissioned through Diego de Castilla, dean of the canons of Toledo Cathedral (Bray and Oliver 2004, 34).

1577 (August 8): Signed a contract with Diego de Castilla to provide eight pictures for the new church of Santo Domingo el Antiguo, six for the main altar and one each for the side altars (Bray and Oliver 2004, 34).

1578: Birth of Jorge Manuel, El Greco's son (Bray and Oliver 2004, 34; per Brown 1982, 18, shortly after his arrival in Toledo, El Greco formed a relationship with Jerónima de las Cuevas, with whom he lived thereafter but never married).

1579 (July 15): Met with Canon García de Loaisa Girón before a notary for the valuation of the *Disrobing of Christ* for Toledo Cathedral; after a dispute concerning the valuation, an arbitrator set the price at 317 ducats on July 23 but the artist refused to deliver the painting until he was satisfied with the price (Bray and Oliver 2004, 34).

1579 (September 22): Church of Santo Domingo el Antiguo was dedicated; all of the paintings for the retables were finished and installed by this date (Bray and Oliver 2004, 34).

1579 (September 23): Canon García de Loaisa Girón appeared before the magistrate of Toledo and requested that El Greco immediately deliver the *Disrobing of Christ* to the cathedral as security against the 150-ducat advance the artist had received (Bray and Oliver 2004, 34).

1580 (April 25): Philip II ordered the Prior of El Escorial to provide El Greco with materials to enable him to carry out the commission "made some time ago" for the *Martyrdom of Saint Maurice* for one of the chapels of the church of El Escorial (Bray and Oliver 2004, 34).

1580 (May 11): With his chief assistant Francisco Prevoste received an advance of 200 ducats for the *Martyrdom of Saint Maurice*; on September 2 they received another 200 ducats (Bray and Oliver 2004, 34).

1581 (December 8): The dispute over payment for the *Disrobing of Christ* was settled at 200 ducats, in addition to the 150 ducat advance (Bray and Oliver 2004, 35).

1582 (May–December): Acted as an interpreter at nine court hearings for Micael (*sic*) Rizo Calcandil a seventeen-year-old servant from Athens who was accused of heresy by the Inquisition in Toledo (Bray and Oliver 2004, 35).

1582 (November 16): Delivered the *Martyrdom of Saint Maurice* to El Escorial in person; Philip II did not like the painting and ordered it removed (Bray and Oliver 2004, 35).

1584: Received a small payment for designing a frame for the *Disrobing of Christ* (Bray and Oliver 2004, 35).

1585 (July 9): Signed a contract with the new warden of Toledo Cathedral, Juan Bautista Pérez, to build the gilt wood frame with sculptural decoration he had designed for the *Disrobing of Christ* (Bray and Oliver 2004, 35).

1585 (September 10): Signed a lease to rent three apartments in the ancient palace of the marquis de Villena, where he continued to live until at least 1590 and again from 1604 onward (Bray and Oliver 2004, 35).

1586 (March 18): Commissioned to paint the *Burial of the Count of Orgaz* for the parish church of Santo Tomé, to be completed by Christmas of that year (Bray and Oliver 2004, 35).

1587: Provided two wooden arches decorated with wooden sculpture painted to imitate marble and with monochromatic paintings depicting scenes from the life of Saint Leocadia for the triumphal procession into Toledo of the saint's relics, which were enshrined in the cathedral on April 26 (Bray and Oliver 2004, 35).

1587 (February 20): Frame for the *Disrobing of Christ* was valued without incident at just over 570 ducats (Bray and Oliver 2004, 35).

1588 (May 30): The archbishop's council ruled that the first appraisal (1,200 ducats) of the *Burial of the Count of Orgaz*, completed in the spring of that year, should stand and ordered payment to the artist within nine days; El Greco appealed this decision in favor of the second appraisal of 1,600 ducats but finally accepted the settlement (Bray and Oliver 2004, 36).

1588 (July 1): With Prevoste sent paintings of *Saint Peter* and *Saint Francis* to agents in Seville, possibly for export to the Americas (Bray and Oliver 2004, 36).

1589 (December 27): Signed contract for continued payment of his apartments in the palace of the marquis de Villena; this document described him as resident of Toledo (Bray and Oliver 2004, 36).

1591 (February 14): Received a commission for the paintings of the high altar of the church of San Andrés in Talavera la Vieja (Toledo); he completed the paintings, which must have been executed largely by assistants, by the summer and received 300 ducats for the work (Bray and Oliver 2004, 36).

1591 (November 26): Authorized Prevoste to act on his behalf in discussions relating to a commission for an altarpiece for the monastery of Nuestra Señora de Guadalupe, Guadalupe (Cáceres) (Bray and Oliver 2004, 36).

1595 (August 28): Received commission for a tabernacle in the church of the Hospital de San Juan Bautista (also known as the Tavera Hospital), Toledo, through Pedro Salazar de Mendoza, the canon of Toledo Cathedral (Bray and Oliver 2004, 36).

1596 (December 17–21): Signed various documents for a contract with the royal council of Castile for the retable and paintings for the high altar of the church of the Augustinian Colegio de Doña María de Aragón, Madrid (see fig. 55, p. 130); El Greco was to receive a total of 2,000 ducats in advance against the final price to be determined by appraisal (Bray and Oliver 2004, 36). The *Annunciation* (cat. 19) was originally the central painting of the altarpiece (Bray and Oliver 2004, 55).

1597 (April 16): Received commission for the high altar of the royal monastery of Nuestra Señora de Guadalupe, Guadalupe, at the price of 16,000 ducats (never executed) (Bray and Oliver 2004, 37).

1597 (May 24): With Prevoste sent works to agents in Seville for sale again (Bray and Oliver 2004, 37).

1597 (November 9): Contracted with Martín Ramírez de Zayas, professor of theology at the University of Toledo, to paint three altarpieces for his private family chapel of San José (Saint Joseph), Toledo (Bray and Oliver 2004, 37); one of the side altarpieces was *Saint Martin and the Beggar* (cat. 1) (Davies et al. 2003, 164).

1598: Obtained an injunction against the estate of Doña María de Aragón for 1,000 ducats he was owed as part of the 2,000 ducat advance agreed in 1596 (Bray and Oliver 2004, 37).

1599 (June 22): Injunction against the estate of Doña María de Aragón was lifted (Bray and Oliver 2004, 37).

1599 (December 13): Paintings for the chapel of Saint Joseph, Toledo, were valued; after an initial challenge, Ramírez agreed to pay the full price of 2,850 ducats, 500 of which went to Juan Sánchez Cotán for an unspecified claim (Bray and Oliver 2004, 37).

1600 (July 12): Paintings for the Colegio de Doña María de Aragón transported from Toledo to Madrid (Bray and Oliver 2004, 37).

1600 (August): Paintings for the Colegio de Doña María de Aragón assessed by Juan Pantoja de la Cruz acting for the colegio and Bartolomé Carducho for El Greco; the artist was to receive nearly 6,000 ducats for the paintings, retable designs, and sculptures (Bray and Oliver 2004, 37).

1600 (December 12): Luis Pantoja Portocarrero acknowledged receipt of rent from El Greco, indicating that the artist had moved to new lodgings in Toledo (location unknown) (Bray and Oliver 2004, 37).

1601 (June): Following problems with the payment for the paintings for the Colegio de Doña María de Aragón, El Greco's agent attempted to collect 500 ducats directly from the tax collector in Illescas (Toledo), who owed this amount to the estate (Bray and Oliver 2004, 37).

1603: Luis Tristán entered El Greco's studio as an apprentice, remaining there until 1606 (Bray and Oliver 2004, 38).

1603: Jorge Manuel appeared in documents as his father's assistant and business partner for the first time (Bray and Oliver 2004, 37).

1603 (January 7): With Jorge Manuel witnessed a document issued by Fray Sabba of the Order of Saint Basil in Macedonia granting a Greek resident in Toledo permission to raise funds in the bishopric of Cuenca to free six friars of the monastery of Santa María de Yberia from the Turks (Bray and Oliver 2004, 37).

1603 (February 3): Received payment for *Saint Bernard*, the altarpiece for the Franciscan College of St. Bernardino; the total price for the work was approximately 275 ducats, and final payment was made on September 10, 1604 (Bray and Oliver 2004, 37).

1603 (April 7): Authorized Jorge Manuel to inspect the proposal for a new altarpiece for the Hospital de la Caridad, Illescas (Toledo) (Bray and Oliver 2004, 37).

1603 (June 18): With Jorge Manuel received the commission for the Hospital de la Caridad, Illescas, including the design for the retable and the provision of sculptures and paintings; contract stipulated that the altarpiece should be in place by August 31, 1604 (Bray and Oliver 2004, 37).

1603 (August 20): Received an advance of 1,200 reales for the work on the retable of the Hospital de la Caridad (Bray and Oliver 2004, 37).

1603 (September 17): Jorge Manuel received a commission on El Greco's behalf to build the altarpiece of the chapel of Nuestra Señora del Prado in Talavera de la Reina (Toledo). This may never have been executed (Bray and Oliver 2004, 38).

1604 (August 5): Returned to live in the palace of the marquis of Villena, and remained there for the rest of his life (Bray and Oliver 2004, 38).

1605 (August 4): Completed work at the Hospital de la Caridad by this date; the hospital's valuators recommended the price of 2,430 ducats, which sparked a bitter dispute; a second valuation occurred on September 20, setting a price of 4,437 ducats (Bray and Oliver 2004, 38).

1605 (November 19): Hospital de la Caridad lodged complaints, saying the work had not been completed by the agreed-upon date (August 31, 1604) (Bray and Oliver 2004, 38).

1605 (December 14): Petitioned the archbishop's council, which supported the artist in the dispute with the Hospital de la Caridad, noting "the delay continues to cause me much damage and loss" (Bray and Oliver 2004, 38).

1606 (January 26): Third valuation of the work for the Hospital de la Caridad, setting a price of just over 4,835 ducats (Bray and Oliver 2004, 38).

1606 (March): Archbishop's council threatened the confiscation of Hospital de la Caridad property to pay debt. El Greco was successful in contesting payment of tax on proceeds from the Illescas commission (Bray and Oliver 2004, 38).

1606 (August 25): With Jorge Manuel commissioned by Juan Bautista de Ubeda and his brother to execute an altarpiece for their family chapel in the parish church of San Ginés, Toledo, at the price of 1,000 reales (Bray and Oliver 2004, 38).

1606 (November 7): Jorge Manuel received a commission on El Greco's behalf for the main and side altarpieces for the parish church of San Martín de Montálban, Toledo (Bray and Oliver 2004, 38).

1607 (March 17): The paintings for the Hospital de la Caridad were valued at 2,093 ducats; El Greco agreed to accept this price (Bray and Oliver 2004, 38).

1607 (April 29): Granted power of attorney to Prevoste (Bray and Oliver 2004, 39).

1607 (May 29): Granted power of attorney to Jorge Manuel, confirming his predominant role in the workshop (Bray and Oliver 2004, 39).

1607 (December 11): Received commission to complete the altarpiece for the chapel of Isabel de Oballe in the parish church of San Vicente, Toledo, left unfinished at the death of Alessandro Semini; on December 12 the city council voted to accept El Greco's proposal for the altarpiece and to pay him 1,200 escudos (1,280 ducats) with an advance of 400 ducats (Bray and Oliver 2004, 39).

1608 (August 13): Stated that the work on the altarpiece for the Oballe chapel, San Vicente, was much advanced, but not finished (Bray and Oliver 2004, 39).

1608 (November 16): Received commission for the main and side altarpieces for the Hospital de San Juan Bautista (Hospital of Saint John the Baptist), Toledo, to be delivered within five years with advances of 1,000 ducats per annum; the *Vision of Saint John* (cat. 5) was painted for one of the side altars (Bray and Oliver 2004, 39).

1611: Received visit from Francisco Pacheco (Pacheco 1956, 1: 370; 2: 8).

1611 (August 12): With Jorge Manuel negotiated a postponement of back rent payment with the agents of the marquis of Villena; at the same time signed a lease on the property for another year (Bray and Oliver 2004, 39).

1611 (November 19): Received commission, with Jorge Manuel, to provide a monument for the funerary celebrations in Toledo Cathedral for Margaret of Austria ordered by Philip III (Bray and Oliver 2004, 39); the monument was praised in a sonnet by Fray Hortensio Félix Paravicino, whose portrait El Greco had painted about 1609 (cat. 12).

1612 (August 26): With Jorge Manuel purchased a family burial vault in the church of Santo Domingo el Antiguo, Toledo. As payment El Greco was to build the altar and retable at his own expense (Bray and Oliver 2004, 39).

1613 (April 17): Stated that the retable for the Oballe chapel in San Vicente was complete and requested a valuation (Bray and Oliver 2004, 39).

1614 (March 31): "Confined to his bed," affirmed his Catholic faith; unable to make a will, he gave power of attorney to Jorge Manuel to make his testament, arrange his burial, and pay his debts. He made Jorge Manuel his universal heir and named as his executors Luis de Castilla, dean of Cuenca Cathedral, and Fray Domingo Banegas, a Dominican monk in San Pedro Mártir (Bray and Oliver 2004, 40).

1614 (April 7): Died in Toledo; buried in Santo Domingo el Antiguo (Bray and Oliver 2004, 40).

1614 (July 7): Inventory of El Greco's possessions made by Jorge Manuel (Bray and Oliver 2004, 40).

1614: Praised in Luis de Góngora y Argote's sonnet, "A Funeral Lament to El Greco," which was published in 1627.

Gregorio Fernández

1576: Born in Sarria (Lugo), son of the wood carver Gregorio Fernández (Bartolomé 1999–2000, 155; Urrea 1999–2000, 17).

1605 (May): In Valladolid, participated with Milán Vimercado on the decoration of a *templete* erected in the *salón de fiestas* of the royal palace for the baptism of the future Philip IV (Bartolomé, 1999–2000, 155); on May 11 he received 200 reales in partial payment for the work, and on May 28 he received an additional 270 reales (Martí y Monsó 1898–1901, 393).

1605 (November 6): Baptism of his son Gregorio in the parish church of San Ildefonso, Valladolid (Bartolomé 1999–2000, 155); date of the sculptor's marriage to María Pérez Palencia unknown (Urrea 1999–2000, 18).

1606 (June 11): Agreed to execute the sculptural group of *Saint Martin and the Beggar* for the church of San Martín, Valladolid, to be finished by December of that year at a price of 500 ducats (García Chico 1940–46, 2: 154–55; Bartolomé 1999–2000, 155).

1606 (October 26): Contracted for sculptures (nine large and nine small figures) for the retable of the high altar of the church of San Miguel, Valladolid (no longer extant), at the price of 4,280 reales (Martí y Monsó 1898–1901, 394–95; Bartolomé 1999–2000, 155).

1607 (October): Baptism of his daughter Damiana in the parish church of San Ildefonso, Valladolid (as October 11 in Urrea 1999–2000, 19; as October 21 in Bartolomé 1999–2000, 155).

1608 (May 5): Valued busts of Don Antonio Cabeza de Vaca and Doña María de Castro, the work of Pedro de la Cuadra (Bartolomé 1999–2000, 155).

1608 (November 24): Acquired guardianship of fifteen-year-old Manuel Rincón, orphan of Francisco Rincón (García Chico 1940–46, 2: 147–49; Bartolomé 1999–2000, 155).

1608 (December 6): Received Manuel Rincón as apprentice (García Chico 1940–46, 2: 149–52; Bartolomé 1999–2000, 155).

1609 (March 28): Contracted Francisco de Molledo and Pedro de Roda for the polychromy of the sculpture of *San Antolín* for the high altarpiece of the Cathedral of Palencia (Bartolomé 1999–2000, 155).

1610 (June 5): Alonso de Mondravilla, sculptor, affirmed having valued in the presence of Fernández the alabaster busts of the Nelli family (Bartolomé 1999–2000, 155).

1610 (June 20): Death of his son Gregorio, who was buried in San Ildefonso, Valladolid (Bartolomé 1999–2000, 155).

1610 (July 3): Commission received by Cristóbal and Francisco Velázquez for the assembly of a retable for the confraternity of Santa María la Real de la Misericordia, Valladolid, the sculpture of which had to be by Fernández (García Chico 1940–46, 2: 156–58; Bartolomé 1999–2000, 155).

1610 (November 17): Testified in a petition for payment brought by Miguel de Oviedo on behalf of the deceased Francisco Sobrino against the parish church of San Ildefonso; Fernández stated that he was thirty-four years old more or less (García Chico 1940–46, 2: 152; Bartolomé 1999–2000, 155).

1611 (June 8): Rented a house, livery stable, and garden outside the Puerta del Campo, property of Pedro de Salcedo (García Chico 1940–46, 2: 153–54; Bartolomé 1999–2000, 155).

1611 (August 13): Contract for the high altarpiece for the parish church in Nava del Rey (Valladolid) awarded to Francisco Velázquez with the condition that the sculpture would be by Fernández (Bartolomé 1999–2000, 155).

1611 (October 4): Acted as godparent, with his wife, to Juan de Castaño, son of Agustín de Castaño and Magdalena de Basoco (Bartolomé 1999–2000, 155).

1611 (December 20): Contracted for the sculptures for the tabernacle of the high altarpiece of the church of Nuestra Señora de la Asunción, Tudela de Duero (Valladolid) (Bartolomé 1999–2000, 155).

1612 (April 14): The guild of *pasamaneros* (passementerie manufacturers) offered to pay for the *paso*

of *Sed Tengo* for the penitential confraternity of Jesús Nazareno, Valladolid (Bartolomé 1999–2000, 155).

1612 (May 7): In his will the joiner Juan de Muñiátegui recognized the debt of 1,350 reales remaining from a loan from Fernández, in addition to the amount owed for the sculpting of the work for Don Rodrigo Calderón and that for Villaverde (García Chico 1940–46, 2: 158–59; Bartolomé 1999–2000, 155).

1612 (August 14): Received 50 ducats from the guild of *pasamaneros* (Bartolomé 1999–2000, 155).

1612 (September 13): Valued the goods of Juan de Muñiátegui (Bartolomé 1999–2000, 155).

1612 (October 7): Witnessed the marriage of Ana María de Juni, granddaughter of Juan de Juni and widow of Juan de Muñiátegui, to Benito Chamoso (Bartolomé 1999–2000, 155).

1612 (December 10): Appeared as executor of Juana Martínez, widow of Isaac de Juni (Bartolomé 1999–2000, 155).

1613 (February 22): Contracted to execute the sculptures for the high altarpiece of the church of San Pablo, Valladolid (Bartolomé 1999–2000, 155).

1613 (April 15): Contracted for the sculptures for the main retable of the convent of Santa María la Real de las Huelgas, Burgos (fig. 53, p. 127) (García Chico 1940–46, 2: 160–66; Bartolomé 1999–2000, 155).

1613 (April 19): Received 4,500 reales as partial payment for the retable of Las Huelgas (García Chico 1940–46, 2: 166; Bartolomé 1999–2000, 155).

1613 (June 21): Acted as guarantor to the architect Cristóbal Velázquez in the contract for the two side reliquary retables for the Jesuit Casa Profesa, Valladolid; the sculptures in the retables were commissioned from Fernández (García Chico 1940–46, 2: 168–70; Bartolomé 1999–2000, 155).

1613 (October 18): Modified the designs of the reliquary retables for the Jesuit Casa Profesa (Bartolomé 1999–2000, 155).

1614 (March 5): Received another payment for the retable of Las Huelgas (García Chico 1940–46, 2: 166–67, as March 25; Bartolomé 1999–2000, 155).

1614 (March 9): Contracted for the *Cristo Yacente* for the Capuchin monastery at El Pardo (Bartolomé 1999–2000, 155).

1614 (May 23): Gave a receipt of payment to Father Gaspar Suárez for the sculpture of *Saint Ignatius of Loyola* for the Jesuit seminary in Vergara (Guipúzcoa) (Bartolomé 1999–2000, 155).

1614 (July 24): Received final payment for the retable of Las Huelgas (Bartolomé 1999–2000, 155).

1614 (November 22): Contracted with the confraternity of La Pasión for four figures (Christ, Simon the Cyrenian, and two executioners) for the *paso* of *Christ Bearing the Cross* (Bartolomé 1999–2000, 155).

1615 (May 12–23): Acquired houses that belonged to Isaac de Juni (Bartolomé 1999–2000, 155).

1615 (July 15): Contracted for nine sculptures for the duke of Lerma for the high altarpiece of the Colegiata de Lerma, Burgos (García Chico 1940–46, 2: 171–72; Bartolomé 1999–2000, 155).

1615 (November 5): Acted as best man at the wedding of his disciple Manuel de Rincón and Ana María Martínez de Espinosa (Bartolomé 1999–2000, 155).

1616 (March 22): Received payment for the reliquary busts of the Fathers of the Church and the rest of the work realized for the Shrine of the Jesuit Casa Profesa (Bartolomé 1999–2000, 156).

1616 (June 16): With his wife acknowledged the Niño de Castro family as inheritors of the *censo* (annuity) assessed on the houses that had been acquired from the heirs of Juni (Bartolomé 1999–2000, 156; Bosarte 1804, 194–95, as June 15).

1616 (June 29): Received 500 reales from the church of San Andrés, Segovia, for his work on the high altarpiece (Bartolomé 1999–2000, 156).

1616 (July 22): Received 416 reales for the retable figures for the church of San Andrés, Segovia (Bartolomé 1999–2000, 156).

1616 (December 19): Received another 244 reales in final payment for the retable figures for San Andrés, Segovia (Bartolomé 1999–2000, 156).

1617 (February 21): Urged by the Jesuits in Valladolid to deliver the "worshipping" busts of the counts of Fuensaldaña and was conceded a new deadline (Bartolomé 1999–2000, 156).

1617 (May 22): Payment ordered to twenty-eight men who carried the new *paso* of the *Pietà* from Fernández's house to the church of Las Angustias, Valladolid (Bartolomé 1999–2000, 156) (García Chico 1940–46, 2: 172, says payment was ordered on March 22).

1617 (November 28): Fernández's statue of the *Virgin of the Immaculate Conception* is mentioned in the agreement between the monastery of San Francisco, Valladolid, and the confraternity of La Inmaculada Concepción (Bartolomé 1999–2000, 156).

1617 (November 28): Received payment from the parish church of San Lorenzo, Valladolid, for the pedestal for the relic of San Lorenzo and to mend a broken statue for the procession on the feast day of Corpus Christi (Bartolomé 1999–2000, 156).

1618 (October 18): Appeared among the members of the confraternity of La Inmaculada Concepción of the monastery of San Francisco (Bartolomé 1999–2000, 156).

1618 (November 13): Contracted with the countess of Triviana regarding the retables for the monastery of Nuestra Señora de la Concepción, Vitoria (Bartolomé 1999–2000, 156).

1618 (November 18): Received 400 reales from the convent of the Unshod Carmelites, Valladolid (Bartolomé 1999–2000, 156).

1619 (January 27): Received 220 reales for a sculpture of *Saint Teresa* for the convent of the Unshod Carmelites, Valladolid (Bartolomé 1999–2000, 156).

1620 (May 26): Received final payment for the "worshipping" busts of the counts of Fuensaldaña for the Jesuit Casa Profesa (Bartolomé 1999–2000, 156).

1620 (May 29): Contracted for a statue of the *Virgin of the Immaculate Conception* for the confraternity of La Vera Cruz, Salamanca; the document stipulated that this sculpture should look like one made for the monastery of San Francisco (García Chico 1940–46, 2: 175–76; Bartolomé 1999–2000, 156).

1620 (September 12): Valued the sculptures in the estate of Ana María de Juni following her death (Bartolomé 1999–2000, 156).

1620 (November 30): The confraternity of Niños Expósitos in Valladolid gave specifications for the three figures of the Holy Family commissioned from Fernández (Bartolomé 1999–2000, 156).

1621 (January 3): Bernardo de Salcedo, parish priest of San Nicolás, Valladolid, delivered Fernández's sculpture of *Ecce Homo* to the confraternity of Santísimo Sacramento y Ánimas of that church (Bartolomé 1999–2000, 156).

1621 (June 1): Sponsored Bernardo de Rincón, son of Manuel and grandson of Francisco, who also wanted to be a sculptor (Bartolomé 1999–2000, 156).

1621 (June 19): Delivered the *Virgin of the Rosary* ordered by the confraternity of La Virgen del Rosario to Don Antonio del Río, alderman of the church in Tudela de Duero (Valladolid) (Bartolomé 1999–2000, 156).

1621 (July 16): Marriage contract between his daughter Damiana and Miguel de Elizalde, a sculptor employed in Fernández's studio (Bartolomé 1999–2000, 156).

1621 (July 28): Received various amounts from the countess of Triviana for the retables for the monastery of La Concepción, Vitoria (García Chico 1940–46, 2: 179–80; Bartolomé 1999–2000, 156).

1621 (August 26): Contracted for the group of *Saint Isabel and the Beggar* for the convent of Santa Isabel, Valladolid, in which it was stipulated that Fernández would carve, paint, and *estofar* the image of the saint (García Chico 1940–46, 2: 178; Bartolomé 1999–2000, 156).

1621 (September 3): Juan de Angulo, sculptor from Vitoria, authorized his son Juan to enter into a contract with Fernández (Bartolomé 1999–2000, 156).

1621 (September 22): Marriage ceremony of Damiana Fernández and Miguel de Elizalde (Bartolomé 1999–2000, 156).

1621 (November 13): Pedro de Fuertes, painter, was paid for the polychromy of the *Crucifix* for the parish church of San Pedro Apóstol, Zaratán (Valladolid) (Bartolomé 1999–2000, 156).

1621 (November 16): Designated executor in the testament of the joiner Diego de Basoco (Bartolomé 1999–2000, 156).

1621 (December 15): With the joiner Francisco Velázquez appeared as guarantor of Diego de Basoco in the assembly of the retable for the Colegiata de Ampudia, Palencia (Bartolomé 1999–2000, 156).

1622: Purchased a tomb in the monastery of Nuestra Señora del Carmen, Valladolid (Bartolomé 1999–2000, 156).

1623 (May): Out of friendship for the ill Pedro de la Cuadra, sent two craftsmen to finish an escutcheon for the upper cloister of the monastery of the Shod Order of Mercy (la Merced Calzada), Valladolid (Bartolomé 1999–2000, 156).

1623 (June 13): Received 13,853 reales for the sculptures for the retables of the monastery of La Concepción, Vitoria (García Chico 1940–46, 2: 179–80).

1623 (June 16): Contracted for the *paso* of the *Descent from the Cross* for the confraternity of La Vera Cruz, Valladolid (García Chico 1940–46, 2: 180–81; Bartolomé 1999–2000, 156).

1623 (December 4): In Vitoria signed the preliminary contract for the high altarpiece of the parish church of San Miguel (Bartolomé 1999–2000, 156).

1623 (December 21): Received 440 reales as partial payment for *Saint Joseph* for the convent of the Unshod Carmelites, Valladolid (Bartolomé 1999–2000, 156).

1624 (March 2): Juan de Maseras, joiner, received payment for a retable commissioned by Don Antonio de Camporredondo y Río for the church of the monastery of the Unshod Carmelites, Valladolid, for which Fernández made the relief of the *Baptism of Christ* (García Chico 1940–46, 2: 189–91; Bartolomé 1999–2000, 156).

1624 (August 2–23): Correspondence between the Carmelite friar Juan de Orbea and Don Juan López de Isasi regarding the retables for the Franciscan convent of Eibar (Guipúzcoa) for which Fernández made the sculpture (Bartolomé 1999–2000, 156).

1624 (August 24): In Valladolid signed the definitive contract for the retable for the church of San Miguel, Vitoria (Bartolomé 1999–2000, 156).

1624 (November 20): Together with Francisco Velázquez, appeared as guarantor to Cristóbal and Juan Velázquez in the contract to realize the assembly of the high altarpiece of the Cathedral of Plasencia (Cáceres) (García Chico 1940–46, 2: 182–83; Bartolomé 1999–2000, 156).

1625 (May 4): In Plasencia (Bartolomé 1999–2000, 156).

1625 (May 7): The *cabildo* of the Plasencia Cathedral accepted Fernández's conditions regarding the execution in three years of the sculptures for the high altarpiece (Bartolomé 1999–2000, 157).

1625 (June 28): Contracted with the *cabildo* of the Plasencia Cathedral to carve the sculptures for their altarpiece. Listed his guarantors and submitted information concerning his economic security (García Chico 1940–46, 2: 183–84; Bartolomé 1999–2000, 157).

1625 (June 28): In the name of Manuel de Rincón and his wife, gave authorization to collect the interest of a *censo* in Madrid (García Chico 1940–46, 2: 193; Bartolomé 1999–2000, 157).

1625 (September 30): Was paid 2,330 ducats by the *cabildo* of the Plasencia Cathedral for the sculptures for their retable (García Chico 1940–46, 2: 186).

1626 (April): Finished the *Virgin of the Immaculate Conception* for the Astorga Cathedral (León) (Bartolomé 1999–2000, 157).

1626 (May 24): Finished four sculptures for the retable of Santo Domingo in the monastery of San Pablo, Valladolid (Bartolomé 1999–2000, 157).

1626 (June 5): Accepted his godson Juan Castaño, orphan of the sculptor Agustín Castaño, as apprentice (Bartolomé 1999–2000, 157).

1627: Executed the *Virgin of the Quinta Angustia* for the chapel of the Cárdenas family in the monastery of San Francisco, Valladolid (now in San Martín) (Bartolomé 1999–2000, 157).

1627 (March 20): Received 600 reales for a *Christ* that the countess of Triviana presented to the convent of Santa Clara, Carrión de los Condes (Palencia); received another 1,050 reales for this work on March 30 (Bartolomé 1999–2000, 157).

1627 (August 16): Signed the first contract for the retable for the sanctuary of Nuestra Señora de Aránzazu (Guipúzcoa) (García Chico 1940–46, 2: 194–96; Bartolomé 1999–2000, 157).

1628 (January 4–8): Valued the prints and sculptures in the inventory of the goods of the countess of Triviana (Bartolomé 1999–2000, 157).

1628 (February 19): Received payment for the sculpture of *San Marcelo* for the church of San Marcelo, León (García Chico 1940–46, 2: 198; Bartolomé 1999–2000, 157).

1628 (July 14): With the joiner Juan Velázquez agreed to execute a retable for the cleric Alonso de Vargas, resident of Braojos de la Sierra (Madrid) (Bartolomé 1999–2000, 157).

1628 (November 23): The monastery of the Unshod Carmelites, La Bañeza (León), ratified the contract signed by Fernández for a sculptural group of the *Pietà* (Bartolomé 1999–2000, 157).

1629: Contracted for *Virgin of the Immaculate Conception* for the confraternity of La Concepción in Ciudad Rodrigo (Salamanca) (Bartolomé 1999–2000, 157).

1629 (January 13): Acted as a witness to the delivery of the retable of the *Baptism of Christ* to the monastery of the Unshod Carmelites, Valladolid (Bartolomé 1999–2000, 157).

1629 (June 20): Accepted guardianship of Isabel de la Cruz Miranda (García Chico 1940–46, 2: 193; Bartolomé 1999–2000, 157).

1629 (June 28): With his wife acted as guarantors to the monastery of the Unshod Carmelites, Valladolid (Bartolomé 1999–2000, 157).

1629 (September 29): Named executor by Francisca Hernández, who left a legacy to his wife María (Bartolomé 1999–2000, 157).

1629 (December 28): Letter from Fray Juan de Orbea to Juan López de Isasi in which the former stated that Fernández had been paid for the side altarpieces for the Franciscan convent, Eibar (Guipúzcoa) (Bartolomé 1999–2000, 157).

1630 (May 16): With Andrés Solanes commissioned for a *paso* for the confraternity of La Piedad, Valladolid (Bartolomé 1999–2000, 157).

1630 (October 17): Received 561 reales from Don Antonio de Camporredondo y Río in final payment for the retable of the *Baptism of Christ* for the monastery of the Unshod Carmelites (García Chico 1940–46, 2: 192–93; Bartolomé 1999–2000, 157).

1630 (October 27): Reported to the *cabildo* of the Cathedral of Plasencia on the sculptures he had executed for the retable of their high altar (García Chico 1940–46, 2: 186–88; Bartolomé 1999–2000, 157).

1631 (July 1): Contracted for a *Crucifixion*, to be finished within two and a half months, for the chapel of Antonio de Valderas in the church of San Marcelo, León (García Chico 1940–46, 2: 199; Bartolomé 1999–2000, 157).

1632 (February 16): Received partial payment for the *Virgin of the Immaculate Conception* made for Don Antonio de Camporredondo y Río, destined for the monastery of the Unshod Carmelites, Valladolid (Bartolomé 1999–2000, 157).

1632 (April 9): Authorized collection of what was owed to him for the retable of the *Saint Johns* for the parish church in Nava del Rey (Valladolid) (Bartolomé 1999–2000, 157).

1632 (August 17): Reimbursed 1,000 reales for his trip to Vitoria to install the retable in the parish church of San Miguel (Bartolomé 1999–2000, 157).

1632 (November 8): Juan Velázquez, joiner, authorized Fernández to collect 3,580 reales owed for the retable of the parish church in Nava del Rey (García Chico 1940–46, 2: 159–60).

1633 (June 28): Contracted with the convent of Santa Teresa, Avila, for sculptures *Saint Teresa at the Feet of Christ* and *Virgin del Carmen* (Bartolomé 1999–2000, 158).

1634 (January 7): With his son-in-law Juan Francisco de Iribarni, contracted to execute figures for the retable of the main chapel of the monastery of Nuestra Señora de Aniago, Valladolid (García Chico 1940–46, 2: 207–9; Bartolomé 1999–2000, 158).

1635 (September 2): Referred to by Philip IV as "the most highly skilled sculptor in my kingdoms" (regarding authorization of the delivery of the sculpture of *Saint Michael* to the Colegiata de San Miguel Arcángel, Alfaro [La Rioja]) (Bartolomé 1999–2000, 158).

1636 (January 22): Died and was buried in the monastery of Nuestra Señora del Carmen, Valladolid (Bartolomé 1999–2000, 158).

Bartolomé González

1564: Born in Valladolid (Palomino 1947, 828).

1606: Came to Madrid from Valladolid, when the court returned to that city (Palomino 1947, 828).

1608: Began to work for Philip III (Ceán Bermúdez 1965, 2: 206; Moreno Villa and Sánchez Cantón 1937, 137).

1609 (November 27): Entered into a contract with Pantoja de la Cruz's daughter Mariana and son-in-law to complete the unfinished portraits for El Pardo (Pérez Pastor 1914, 129).

1611 (November 27): Signed marriage contract with Juliana López del Rincón, daughter of the court painter Francisco López (Pérez Pastor 1914, 138).

1612: Received commission from Philip III for full-length portraits of his children for El Pardo (Kusche 1999, 125–26, with no document or source given).

1614 (November 23): Signed marriage contract with Ana de Nava at which time an inventory was taken of his estate, worth 25,777 reales; sixteen paintings were mentioned, eight of which were copies (Cherry 1993, 3).

1617 (August 9): Document listing the seventy-five portraits made by González for the king from January 1, 1608, until the end of August 1617, witnessed and valued by Vicente Carducho and Santiago Morán. Some of these paintings were sent to Flanders, Germany, Poland, and the court at Graz and eleven were executed for El Pardo (Moreno Villa and Sánchez Cantón 1937, 137–53).

1617 (August 12): Named *pintor del rey* on the death of Fabricio Castello over Juan de Roelas, with a salary of 6,000 maravedíes (Ceán Bermúdez 1965, 2: 207); in a document dated August 30, 1617, his salary is given as 72,000 maravedíes annually (Azcárate 1970, 50).

1617 (October 11): Account made of paintings executed by González, Jerónimo de Cabrera, and Vicente Carducho for the monastery of the Capuchins at El Pardo; González's works included a *Virgin with Angels* valued at 200 ducats and a *Saint Francis Comforted by a Musical Angel* valued at 70 ducats; valuations made by Juan de Roelas (Martín González, "Arte y artistas" 1958, 131–33).

1618 (March 3): On behalf of the treasurer Hernando Despejo appraised three canvases executed by Juan de Roelas for the king. Eugenio Cajés valued the works on the part of Roelas (Moreno Villa 1936, 263–65).

1619 (December 31): Received 400 reales in partial payment for the life-size painting he made of Philip III entering Lisbon; he received final payment in 1626 (Azcárate 1970, 50).

1620: Received commission for six paintings of the siblings of Queen Margaret, at the price of 2,400 reales, to be put in the "galeria de la princesa nuestra señora" in the Alcázar, Madrid. González is paid in full by 1625 (Azcárate 1970, 50).

1620 (December 1): On the part of the treasurer Hernando Despejo appraised a portrait of Philip III painted in Lisbon by Felipe Dirksen. Eugenio Cajés valued the painting on the part of Dirksen (Moreno Villa 1936, 264–65).

1621: Signed *Saint John the Baptist* (Szépmüvészeti Múzeum, Budapest) (Camón Aznar 1978, 24).

1621 (March 10): Document listing the sixteen additional portraits made by González for the king beginning in 1619 witnessed and valued by Eugenio Cajés and Jerónimo López (Moreno Villa and Sánchez Cantón 1937, 153–57).

1622 (June 2): Report and bill for restoration work on Michiel Coxcie's copy of the Ghent altarpiece commissioned by Philip II (Sánchez Cantón 1947, 163).

1625: With Carducho and Cajés commissioned to paint companion pieces to Velázquez's equestrian portrait of Philip IV (no longer extant) (Brown 1986, 111–12).

1626 (April 1): Acted as a witness to the will of the painter Jerónimo López Polanco (Agulló y Cobo 1978, 88–89).

1627: Signed *Rest on the Flight into Egypt* (cat. 25) (García de Wattenburg 1969, 25).

1627 (October 8): Signed his last will and testament in which he requested burial in the parish church of San Ginés, Madrid, where his parents and siblings were already buried (Agulló y Cobo 1978, 72).

1627 (November 1): Died and buried in the parish church of San Ginés, Madrid (Cherry 1993, 1 n. 2).

1627 (November 8): Inventory of his studio made by his widow (Cherry 1993, 3, 6–7).

1629 (April 5): Antonio Lanchares valued the paintings and materials in González's studio; mention is made of copies of paintings by Orrente (landscape), Ribera (*Saint Peter*), and Caravaggio (*Ecce Homo*) (Cherry 1993, 5, 7–9).

Juan van der Hamen y León

Because of the large number of signed and dated paintings by this artist, only those in the present exhibition are included in the chronology.

1596 (April 8): Baptized in the parish church of San Andrés, Madrid, son of Juan van der Hamen from Brussels, *arquero del rey*, and Dorotea Bitman Gómez de León from Toledo (Jordan 1967, 2: 175; document now destroyed).

1608 (December 10): With his brother Lorenzo witnessed an obligation of Juan de Peba, farmer, to supply wheat to Matías Martínez, both parishioners of San Andrés (Cherry 1991, 457; 1999, 481).

1610 (December 9): With his brother Pedro witnessed their brother Lorenzo, "cleric of lesser orders," give power of attorney to their father so he could collect pensions due Lorenzo by the archbishops of Coria and Plasencia (Cherry 1991, 457; 1999, 481).

1615 (March 7): Petition acceded to by the vicar general of Madrid allowing Van der Hamen to marry Eugenia de Herrera immediately, without posting

the customary wedding banns (Jordan 1967, 2: 182–83); married seventeen-year-old Eugenia de Herrera in the parish church of San Ginés, Madrid (Cherry 1991, 458; 1999, 481).

1615 (November 22): Marriage to Eugenia de Herrera confirmed in the parish church of San Sebastián, Madrid (Cherry 1991, 458; 1999, 481).

1616 (May 23): Baptism of his son Francisco in the parish church of Santa Cruz, Madrid (Cherry 1991, 458; 1999, 481).

1619 (September 10): Received 100 reales from Philip III for a still life of fruit and game for the South Gallery of El Pardo (Jordan 1967, 2: 184; Cherry 1991, 458; 1999, 482).

1621: Signed *Still Life with Sweets* (cat. 54) (Jordan 2005, 83).

1621 (August 30): Apparently bought a painting of *Nuestra Señora del Pópolo* (9 reales), a primed canvas, and two easels at the studio auction of the deceased painter Juan Rodríguez (Cherry 1991, 459; 1999, 482).

1622: Signed *Still Life with Sweets* (cat. 56) (Jordan 2005, 79).

1622 (January 1): Joined the royal guard of the Archers (Cherry 1991, 459; 1999, 482).

1622 (April 5): Baptism of his daughter María in the parish church of Santiago, Madrid (Jordan 1967, 2: 184–85).

1622 (April 29): Living on the calle de Santiago in the house of Joan d'Espinosa, silversmith, testified concerning the sale of houses on the calle de San Pedro that belonged to Diego de Alfaro, deceased tailor, husband of his sister-in-law, Juana de Herrera. Swore that he knew Alfaro and Juana since 1615 and that he was twenty-four years old, more or less (Cherry 1991, 459; 1999, 482).

1622 (May 24): Juana de Herrera, widow of Diego de Alfaro, returned to Van der Hamen four fruit still lifes that had not been paid for and that had been inventoried in her husband's house (Cherry 1991, 459; 1999, 482).

1623 (May): Was commissioned to paint a deathbed portrait of Doña Juana de Aragón, duchess of Villahermosa, who had died in childbirth on May 3 (Jordan 2005, 129); the oil sketch for this portrait was recorded in the inventory of the artist's studio taken after his death (Jordan 1967, 2: 193).

1623 (June 29): Baptism of his daughter Ana María (Cherry 1999, 482).

1624 (October 26): Accepted seventeen-year-old Antonio Ponce, son of Antonia de Villalobos, widow of Francisco Ponce, as an apprentice for a period of three years, from the beginning of September (Cherry 1991, 460; 1999, 482).

1625: Dated the paintings for the cloister of the convent of La Encarnación, Madrid (fig. 18, p. 57) (Cherry 1999, 482).

1625 (June 2): Buried his mother-in-law, Leonor Clara de Barrionuevo, widow of Francisco de Herrera, in an act of charity in the parish of San Ginés, Madrid (Cherry 1991, 460; 1999, 482).

1626 (July 28–August 1): Painted the portrait of Cardinal Francesco Barberini during the visit of the papal legate to Madrid (Cherry 1991, 460; 1999, 482).

1627: Signed *Still Life with Sweets and Pottery* (cat. 63) (Jordan 2005, 190).

1627 (August 17): With Vicente Carducho valued the collection of paintings (almost exclusively religious) of the late Doña Luisa Manrique, duchess of Nájera (Cherry 1991, 461; 1999, 483).

1627 (November 5): Solicited the position of *pintor del rey*, vacated by the death of Bartolomé González (Jordan 1967, 2: 185–86).

1627 (November 23): Valued a small group of paintings and nearly sixty maps owned by Moisés Bartolomé Sebastián, deceased Valencian priest sent to Madrid to realize steps in the process of beatification of the *siervos de dios* Mosén Francisco Jerónimo Simó (Father Simón) and Father Antonio Sobrino (Jordan 1967, 2: 185–86).

1628 (February 15): Valued the small number of paintings from the estate of Juan de Soria, deceased royal official (Cherry 1991, 461; 1999, 483).

1628 (May 10): Valued the paintings from the estate of Rafaela de Velasco, deceased widow of Leandro Hurtado, *regidor* (alderman) and *veedor y contador de las obras reales* (royal overseer and accountant) (Cherry 1991, 461; 1999, 483).

1628 (August 17): Valued the picture collection of the late Don Pedro de Fonseca, marquis of Orellana (Cherry 1991, 461; 1999, 483).

1629 (August 18): Received first payment for three paintings of festoons of flowers, fruit, and putti for the royal palace (Jordan 1967, 2: 260, 268).

1629 (September 1): As cessionary of Gabriel López, *ujier de cámara*, authorized Pedro del Baños(?) to obtain 800 reales from Captain Tomás de Cardona, *maestro de cámara*, and Don Juan de Barrionuevo Peralta, *pagador de las caballerizas* (Jordan 1967, 1: 16–17; Cherry 1991, 462; 1999, 483).

1630 (February 25): Valued religious paintings and images belonging to the late Bernarda de Alfaro, deceased widow of Juan de Atriba, *criado de su Majestad* (Cherry 1991, 462; 1999, 483).

1630 (July 24): Valued the religious painting, print, and alabaster image of the Virgin in the dowry of Isabel de Agramonte, daughter of Francisco de Agramonte, who was in the service of Prince Filiberto, for her marriage to the doctor Manuel Fernández de Riofrío (Cherry 1991, 462; 1999, 483).

1630 (December 22): Payment ordered to Van der Hamen for three or four paintings and other decorative painting for the gallery of the Cardinal Infante Don Fernando in the Alcázar, for the agreed upon price of 100,980 maravedíes; final payment was received on August 16, 1631 (Jordan 2005, 264–65).

1631 (February 3): Named to value the few religious paintings of Francisco de Aldrete, late goldsmith. The valuation was carried out after Van der Hamen's death by the painter Domingo de Carrión (Cherry 1991, 462; 1999, 483).

1631 (March 28): Died at home on the calle de los Tinteros (Jordan 1967, 2: 187).

1631 (April 4): Inventory of the estate of Van der Hamen, drawn up by his widow (Jordan 1967, 2: 188–212).

1631 (April 14): Valuation of the estate of Van der Hamen, with his studio contents valued by the painters Pedro Núñez del Valle and Angelo Nardi (Jordan 1967, 2: 213–40).

Alejandro de Loarte

1595–1600: Probable birth date of the artist, son of the painter Jéromino de Loarte; probably trained with his father (Jordan 1985, 94–95).

1619 (June 24): Lived from this date for a year with María del Corral in rented quarters in a house on the calle de los Gitanos in Madrid, which was part of María's dowry (Cherry 1991, 438; 1999, 467).

1619 (June 27): Married María del Corral in the parish church of San Sebastián, Madrid. María was the young widow of Gaspar Carrillo, court notary (Cherry 1991, 438; 1999, 467).

1619 (October 16): Signed the dowry contract, valued at 12,851 reales, in which he described himself as a painter resident in Madrid and the son of Jerónimo de Loarte (Cherry 1991, 438; 1999, 467).

1619 (October 30): Marriage to María del Corral confirmed in the parish church of San Sebastián, Madrid (Cherry 1991, 438; 1999, 467).

1620 (August 2): Valued religious paintings in the estate partition of Antonio de Heredia, *maestro de postas* (Cherry 1991, 439; 1999, 467).

1622: Signed the *Miracle of the Loaves and Fishes* that was in the refectory of the monastery of Los Mínimos, Toledo. Was probably working in Toledo by this date (Cherry 1991, 439; 1999, 467).

1623: Signed *Still Life with Game and Fruit* (Fundación Santamarca, Madrid) (Cherry 1991, 439; 1999, 467).

1624: Signed *Still Life with Basket of Grapes and Fruit* (Plácido Arango Collection, Madrid) (Cherry 1991, 439; 1999, 467); signed *Fall of Manna* (Museo Nacional, Havana) (Cherry 1999, 47 n. 83); signed *Ship of the Eucharist* for the parish church of Santa Maria, Los Yébenes (Toledo) (Cherry 1991, 60; 1999, 37).

1624 (February 13): Living in Toledo, accepted Francisco de Molina, son of Franciso de Molina, priest of the Cathedral of Toledo, as *oficial* (journeyman) for a year and a half. He received 190 reales to house and feed Molina but paid him wages (Cherry 1991, 439; 1999, 467).

1624 (May 7): Acted as guarantor in the joiner Francisco Fernández's guardianship of his twelve-year-old nephew Juan de Sevilla Villaquirán. At the same time the boy became Loarte's apprentice for six years. Received 30 ducats for his education but was not responsible for his lodging or care (Cherry 1991, 439; 1999, 467).

1625: Signed the *Kitchen Still Life* (Varez-Fisa Collection, Madrid) (Cherry 1991, 439; 1999, 468).

1625 (May 14): Contracted with the *licenciado* Gaspar Alvárez to paint *Martyrdom of Saint Catherine* for the chapel of Saint Catherine in the parish church, Bórox (Toledo) (still in situ), to be finished before the end of July 1625. Was to receive 550 reales for the work (Cherry 1991, 440; 1999, 468).

1625 (May 23): Accepted Eugenia de Olmedo, the fifteen-year-old daughter of the painter Juan de Olmedo, as an apprentice for two and a half years (Cherry 1991, 440; 1999, 468).

1626: Signed *Market Scene with Poultry Sellers* (private collection, Madrid) (Cherry 1991, 440; 1999, 468); signed *Saint Bartholomew Cures the Daughter of King Polimius* (Bishopric of Huesca) (Cherry 1999, 47 n. 86).

1626 (September 24): Contracted with the painter Félix de Melgar, who was over twenty-five years old, for the latter to work as an *oficial* in the artist's studio for two years. Agreed to house and support Melgar in addition to paying him 100 ducats for two years' service (Cherry 1991, 440; 1999, 468).

1626 (December 9): Signed last will and testament in Toledo (Cherry 1991, 440; 1999, 471–73); executors were his wife and Pedro Orrente, who was also living in Toledo (Jordan 1985, 95).

1626 (December 13): Died (Cherry 1991, 440; 1999, 468).

1626 (December 17): His widow had an inventory taken of his goods (Cherry 1991, 441; 1999, 468).

1626 (December 27): Félix de Melgar contracted to finish *Immaculate Conception* and *Christ Child* left incomplete at Loarte's death. He agreed to deduct this work from the sum of 159 reales he owed Loarte's widow for a suit of clothes (Cherry 1991, 441; 1999, 468).

1627 (February 25): Valuation of Loarte's goods; Diego de Toro Testillano named to value the workshop of the painter (Cherry 1991, 442; 1999, 468).

1627 (March 5): Partition of Loarte's estate; all goods were inherited by his widow (Cherry 1991, 442; 1999, 469).

Juan Bautista Maino

1581 (October 15): Baptized (Cortijo Ayuso 1978, 289); born in Pastrana (Guadalajara) to the Milanese Juan Bautista Maino and the Portuguese Doña Ana de Figueredo, who was in the service of the princess of Eboli (Marías 1976, 469; Pérez Sánchez 1997, 114 n. 2).

1608 (January 24): Paid 2,000 maravedíes for taxes imposed on houses bought by his father (Junquera 1977, 135–36).

1611 (March 8): Received 200 reales for painting (*de lo que pinta*) in the cloister of the Toledo Cathedral (Zarco del Valle 1916, 362; Brown 1998, 88, says that he restored a fresco there; compare document of May 18, 1611).

1611 (March 15): Authorized Fray Rodrigo de Portillo, of the Order of Saint Francis in Milan, to settle his accounts in that city with the administrators of his goods. He stated that he is over twenty-five years old and signed the document "Mayno" (Harris 1935, 338).

1611 (May 18): Received 600 reales (to complete the 800 reales for the commission) for restoring the *Circumcision* (*el quadro dela circunçion*) in the cloister of Toledo Cathedral (Zarco del Valle 1916, 362; see document of March 8, 1611).

1611 (October 20): Received commission to paint *Saint Ildefonso* on canvas for the new sacristy of the Toledo Cathedral (not realized) (Pérez Sedano 1914, 89); the next day Maino received an advance of 400 reales for the painting (Zarco del Valle 1916, 362).

1612 (January 29): Received an advance of 200 ducats for the high altarpiece for the church of the Dominican monastery of San Pedro Mártir, Toledo (Marías 1978, 425).

1612 (February 14): Received commission for the high altarpiece for the church of the monastery of San Pedro Mártir, which he was to complete in eight months (Harris 1935, 338).

1612 (September 19): Investigations began into his family, to establish his *limpieza de sangre* (lasted until June 17, 1613); during this time was a Dominican novice at the monastery of San Pedro Mártir, Toledo (Marías 1976, 469).

1613 (June 20): Judged to be an old Christian and pure of blood by the ecclesiastical authorities of Toledo (Marías 1976, 469).

1613 (July 27): Professed as a Dominican monk in the monastery of San Pedro Mártir; signed the document "Maino" for first time instead of "Mayno" (García Figar 1958, 8).

1614 (August 28): Appeared as a professed friar for the first time in a document related to San Pedro Mártir (Harris 1935, 339).

1614 (December 28): Received final payment for the retable for the church of San Pedro Mártir (Marías 1978, 425).

1615 (February 14): Authorized by the prior and brothers of San Pedro Mártir to request in the name of the monastery the goods he inherited from his father (Harris 1935, 339).

1615 (September 4): Valued the paintings for the Sagrario of the Toledo Cathedral by Eugenio Cajés and Vicente Carducho on behalf of the cathedral representative, Canon Garay (Marías 1978, 423).

1619: Referred to as the painting master of Prince Philip (the future Philip IV) and as resident in Lisbon in a document authorizing him to sell houses in that Portuguese city inherited by his mother (Agulló y Cobo 1994, 65–66).

1620: Appeared as witness in a litigation brought by painters against gilders who wanted to establish a *colegio*, to be able to give decrees, and to name overseers; living in the Colegio de Atocha, Madrid, testified on behalf of the painters, saying that the labor of the gilder was in no way artistic nor did it entail any study (Pérez Sánchez 1997, 119).

1621: Document directing Fray Diego de la Fuente, Fray Antonio de la Natividad, and Maino to go to Rome to procure the removal of the vicar general from reformed monasteries in Portugal (Pou y Martí 1917, 253; Urrea 1991, 296, says that only Fray Antonio went according to a letter of June 8 signed by Philip IV).

1621 (April 5): Letter from Philip IV, signed by the king's secretary Jorge de Tovar, to the Spanish ambassador in Rome, the duke of Alburquerque (*sic*), regarding the prompt execution of a papal bull for 200 ducats of pension for Maino (Urrea 1991, 296–97).

1626: Living in the Dominican monastery of Santo Tomás in Madrid; signed a deed of patronage (*una escritura de Patronato*) given to the count-duke of Olivares (Martínez Escudero in Allende-Salazar and Sánchez Cantón 1919, 206–7).

1627: With Giovanni Battista Crescenzi judged Velázquez winner of competition for *Expulsion of the Moors from Spain* over Eugenio Cajés, Vicente Carducho, and Angelo Nardi (Pacheco 1956, 1:157–59, but with no year; Harris 1935, 334–35).

1628: Two paintings by Maino appeared in the inventory of the canon of Granada, Don Juan de Matute: *Magdalene in the Desert* and "Santa María de la Mayor" (Barrio Moya 1991 in Pérez Sánchez 1997, 114 n. 3).

1628: Unveiling of the altar of *Santo Domingo in Soriano*, painted by Maino, in the *sala capitular* (chapter house) of the monastery of Nuestra Señora de Atocha, Madrid (María de los Hoyos 1963 in Pérez Sánchez 1997, 115 n. 5).

1630: Lope de Vega included Maino in his praise of artists in *Laurel de Apolo* (silva IV): *Y con pincel divino,/Juan Bautista Mayno,/a quien el arte debe/aquella acción que las figuras mueve* (And with a divine brush/Juan Bautista Maino/to whom art owes/that effect which makes figures move) (Pérez de Guzmán y Gallo 1914, 58).

1632 (April 26): Valued the paintings of the deceased Toledan count of Añover de Tajo, Don Luis Lasso de la Vega (Pérez Sánchez 1997, 115).

1633: Signed the modification of the 1626 deed of patronage given to the count-duke of Olivares (Martínez Escudero in Allende-Salazar and Sánchez Cantón 1919, 207).

1635: Diego de Covarrubias published a collection of eulogistic verse, *Elogios al palacio real del Buen Retiro* (dedicated to the count-duke of Olivares); three sonnets praise *Recapture of Bahía*: Gabriel de Roa, who assures us that Maino was the first master who ever succeeded in painting light and sound; Andres de Balmaseda describes his "pencils of diamond"; and Doña Anna Ponce de León says that figures were painted by his brush more effectively than they could be cast in bronze (Stirling-Maxwell 1891, 2: 501–2).

1635 (March 26): Received 550 reales for *Recapture of Bahía* (fig. 12, p. 38) (Museo Nacional del Prado) (Caturla 1960, 347–48).

1635 (June 16): Received the rest of the payment for *Recapture of Bahía* (Caturla 1960, 348).

1636 (January 30): Valued paintings in the estate of Don Francisco Díaz Romero, a member of the Consejo de Su Majestad and the king's *alcalde de casa y corte*, in Madrid (Agulló y Cobo and Baratech Zalama 1996, 64).

1636 (February 6): Contracted for six paintings (four scenes from the life of the Virgin and two Old Testament scenes) for the retable for the chapel of the count of Castrillo in the monastery in Espeja (Burgos), at the price of 600 ducats (Pérez Sánchez 1997, 117).

1638 (April 14): Resident in the Colegio de Atocha, Madrid, acted as a witness for the defense in the Inquisition trial against Isabel de Briñas, who was accused of eighty-two crimes against the faith, including performing miracles and having visions, and was expelled from Toledo and Madrid on September 28, 1640; Maino executed a portrait of Isabel that was said to have been used by the daughter of the count of Villalba as a curative amulet (Pérez de Guzmán y Gallo 1914, 61–72).

1639 (October 4): Resident in the Colegio de Santo Tomás, Madrid, called as a witness in the ratification of the testimony in the case against Isabel de Briñas (Pérez de Guzmán y Gallo 1914, 66).

1649 (April 1): Died in the monastery of Santo Tomas, Madrid, where he was buried in the chapel of Nuestra Señora (Martínez Escudero in Allende-Salazar and Sánchez Cantón 1919, 206–7).

Juan Martínez Montañés

1568 (March 16): Baptized in the parish church of Santo Domingo de Silos in Alcalá la Real (Jaén), son of Juan Martínez, an embroiderer, and Marta González (López Martínez, *Retablos* 1928, 45 n. 2).

1587 (June 11): Dowry settlement for his marriage to Ana de Villegas, daughter of the joiner Juan Izquierdo and the deceased Catalina de Villegas (López Martínez 1932, 227).

1587 (June 22): Married Ana de Villegas in the church of San Vicente, Seville, the parish in which the sculptor lived (López Martínez, *Retablos* 1928, 45 n. 2).

1588 (December 1): Examined by the sculptors Gaspar de Águila and Miguel Adán; obtained license to practice sculpture and to open his own shop as master sculptor (López Martínez 1929, 267–68).

1589 (June 8): Rented a house in the Plazuelas del Campanario in the parish of La Magdalena, Seville, for two years at the price of 75 ducats per year (López Martínez 1929, 268–69).

1589 (June 8): Commissioned by Gaspar de Peralta for a stone relief of the *Last Supper* to be completed in six months at the price of 110 ducats, with an additional 10 ducats if the work pleased the beneficiary of the church, Francisco de Medina (Bago y Quintanilla 1927, 167–70).

1589 (July 28): Received commission for a statue of *Our Lady of Belén* to be completed in twenty-four days at the price of 25 ducats; the coats of arms of Rodrigo Ponce de León, duke of Arcos, and his wife, Teresa de Zúñiga, were painted on the base of the statue (López Martínez 1949, 247–48; Proske 1967, 12–13).

1590: Worked for the convent of Santa Teresa according to the archives of that community (Serrano y Ortega 1898 in Proske 1967, 142 n. 58).

1590 (February 2): Accepted Ambrosio Tirado, minor, as an apprentice for six years (López Martínez 1932, 227–28).

1590 (May 12): Received commission for *Virgin and Christ Child* for the chapel of the confraternity of Nuestra Señora del Rosario in the monastery of Santo Domingo in Alcalá de los Gazules (Cádiz) to be delivered in August of that year and at the price of 400 reales (López Martínez, *Retablos* 1928, 35).

1590 (July 4): Received commission from the Dominican monk Fray Cristóbal Nuñez for eight statues of *Our Lady of the Rosary* to be sent to Dominican monasteries in Chile; the value would be determined upon completion by four appraisers (López Martínez, *Retablos* 1928, 36).

1590 (July 19): Received commission for a statue of *San Diego*, destined for the church in Ayamonte (Huelva), from Fray Cristóbal de Atienza; this work was to be like the one carved for the Franciscan monastery in Cádiz (Hernández Díaz 1939 in Proske 1967, 16 n. 58).

1590 (August 27): Contracted for a *Crucifixion* carved from cypress ordered by Alonso Antunes of Portalegre, Portugal; Cervantes served as a witness to the document (Proske 1967, 15).

1590 (November 12): Received commission from the cleric Nicolás Monardes for a carved ivory crucifix, to be finished within three months at the price of 120 ducats (López Martínez 1932, 228).

1590 (November 29): Accepted Alonso Díaz as an apprentice for a period of five years, beginning on December 1 (López Martínez 1932, 228).

1591 (January 25): Received commission from Luis Martín de Caseres, resident in the Indies, and Baltasar de Montemayor of Seville for a *Saint Francis*, to be finished by the end of February at a cost of 20 ducats on account and 220 reales when finished (López Martínez 1932, 228).

1591 (June 8): Contracted to make a tabernacle for the altar of the Crucifixion for the "second church"

of the Hieronymite monastery of San Isidoro del Campo, Seville (López Martínez 1932, 228–29); the work was to be finished within three months, put up, and then removed for gilding at the price of 200 ducats (López Martínez 1930 in Proske 1967, 143 n. 69). On June 17 hired the joiner Andrés de Ortega to execute the carpentry from his plans (López Martínez, *Retablos* 1928, 79).

1591 (June 28): Contracted with Juan Sánchez for a statue of *San Diego* for the monastery of San Diego, Seville, to be completed in two months at the price of 43 ducats (López Martínez 1932, 229).

1591 (July 2): Was ordered by the painter Alonso Vázquez to carve *Christ on the Cross* and finish it in two months at the price of 15 ducats with an additional 200 reales if the painter was pleased (López Martínez 1932, 229).

1591 (August 2 or 3): Accused of murdering Luis Sánchez and imprisoned (Proske 1967, 19).

1592: Lived on the calle de los Tiros in the parish of San Lorenzo, Seville (Proske 1967, 141 n. 39).

1592 (April 13): With the painter Sebastian de Barahona contracted for figures of *Saint John the Baptist* and *Saint John the Evangelist* ordered by the confraternity of El Dulce Nombre de Jesús of the monastery of San Pablo, Seville; the sculptures were to be gilded and finished in *estofado* (López Martínez 1932, 229–30).

1592 (September 19): Commissioned to make a *Crucifixion* of unpainted cypress on a cross of ebony inlaid with another wood for Cristóbal Suárez de Ribera; Francisco Pacheco acted as guarantor (López Martínez 1929, 269).

1592 (October 11): With his wife entered the confraternity of El Dulce Nombre de Jesús as *hermanos de luz* (carried candles in the Holy Week processions); received a life membership because he had given the brotherhood a statue of the *Mater Dolorosa* (González de León 1852 in Proske 1967, 20 n. 74).

1593 (January 23): With Gaspar Núñez Delgado solicited the contract for a retable for the chapel of the Vizcaínos in the monastery of San Francisco, Seville (López Martínez, *Arquitectos* 1928, 227–28).

1593 (September 20): Pardoned by the widow of Luis Sánchez in the death of her husband after she received payment of 100 ducats from the sculptor's wife (López Martínez 1929, 270–71).

1594 (January 21): Contracted by Diego de la Fuente for a retable of the *Stigmatization of Saint Francis* for his chapel in the monastery of San Francisco, Seville, at the price of 180 ducats (López Martínez 1929, 271); received final payment by May 5 (López Martínez 1929, 272).

1594 (December 30): With the architect Juan de Figueroa appraised the retable of *Saint Catherine of Siena* made by Gerónimo de Guzmán for the convent of Regina Coeli, Seville, at 260 ducats (López Martínez 1932, 230).

1595 (February 20): Acted as guarantor to Jacques Bauzel in the contract with the *licenciado* Hernando de Mayorga for a wooden retable to be finished within five months and at the price of 72 ducats (López Martínez 1932, 230).

1595 (May 17): Contracted with Pedro Cornielles (*sic*) of Gibraltar for a statue of *San Ginés* in pinewood to be finished in two and a half months and to be paid by valuation; the painter Alonso Vázquez agreed to paint, gild, and *estofar* the sculpture (López Martínez 1932, 230).

1596 (May 18): Authorized Diego Felipe Rogero to collect all debts owed to the sculptor (López Martínez 1932, 230–31).

1596 (September 2): Authorized Diego Felipe Rogero to collect money owed by Antonio Cordero de Tapia of Villamartín for an image of the *Christ Child* (López Martínez 1932, 231).

1597 (August 9): Was authorized by the architect Juan de Oviedo y de la Bandera to draw up a joint contract for the retable for the convent of Santa Clara, Llerena (Badajoz), and to bind him to a half share in any other contracts for retables he might wish to undertake (López Martínez 1929, 74; Proske 1967, 31–32, as the first record of the collaboration between the two).

1597 (August 19): Contracted with the glove makers Lucas Chamorro and Gabriel Ramírez for a polychrome sculpture of *Saint Christopher* to be finished by the beginning of May 1598 at the price of 110 ducats (López Martínez 1932, 231).

1598 (January 24): With Diego López Bueno appraised a retable by the joiner Francisco de Vergara at 371 ducats (López Martínez 1932, 231).

1598 (February 16): With Juan de Oviedo agreed to take over the contract for a retable for the convent of Santa Clara, Llerena, originally commissioned from Diego Daza and Jacques Bauchel (Bauzel) on January 11 (López Martínez 1932, 231–32).

1598 (March 2): Contracted with Sebastian Fernández, parishioner of the church of San Miguel, for two processional figures, *Our Lady of the Incarnation* and *Saint Michael Vanquishing the Devil*, to be delivered by the end of April at the price of 70 ducats (López Martínez 1932, 232).

1598 (May 20): Contracted for ten wooden tabernacles, two larger than the rest, to be sent to the Dominican monasteries of the Nuevo Reino de Granada (now Colombia) by order of Philip II (Pulido Rubio 1943 in Proske 1967, 27 n. 101).

1598 (June 13): With the joiner Diego López Bueno contracted for a retable for the convent of Nuestra Señora de la Limpia Concepción, Panamá, to be completed within nine months at the price of 1,236 ducats; on August 4 with López Bueno commissioned the polychromy and gilding from the painter Gaspar Ragis at the price of 300 ducats (López Martínez 1932, 232–33).

1598 (September 29): Modeled two statues, *Seville* and *Loyalty*, for the arcade designed to flank the catafalque of Philip II ordered for Seville Cathedral and designed by Juan de Oviedo y de la Bandera, sixteen symbolic figures of virtues for the second and third stories of the structure and *Saint Lawrence* for the third story (Proske 1967, 23–24).

1598 (December 2): With Juan de Oviedo appraised a retable made by Diego López and Pedro de Mora for a chapel endowed by Bernabe Minuche in the church of San Miguel, Seville, at 10,880 reales (López Martínez 1932, 233).

1599 (January 4): Provided wooden maces to be carried in the procession of city officials from the marquis of La Algaba's house to the Plaza de San Francisco for the proclamation ceremony of Philip III, for which he received 500 reales in partial payment on November 13, 1598 (Gestoso y Pérez 1899–1909, 3: 149–50; Proske 1967, 25–26).

1599 (February 19): Contracted for twelve tabernacles, two larger than the rest, with royal arms to be sent to the Augustinian monasteries in the provinces of Quito, Popayán, and the Nuevo Reino de Granada ordered by Philip II the previous year (Pulido Rubio 1943 in Proske 1967, 27–28 n. 103).

1599 (May 8): With Pedro de la Cueva valued two coats of arms and two sculptures executed by Andrés de Ocampo for the convent of Regina Coeli, Seville, at 398 ducats (López Martínez 1932, 233).

1599 (June 2): Acted as guarantor to the joiner Artus Jordán in a contract with the confraternity of El Santísimo Sacramento for two retables for the confraternity's chapels in the church of San Salvador, Seville (López Martínez 1932, 234).

1599 (September 6): With his wife acted as godparent to a son of Rodrigo de Esquivel (López Martínez 1927, 211).

1600 (August 9): With Diego López received a payment of 436 ducats in settlement of the retable for the convent of Nuestra Señora de la Limpia Concepción, Panamá (López Martínez 1932, 235).

1601 (February): Contracted for five gilded tabernacles for the province of Santa Cruz, Isla de España (Pulido Rubio in Hernández Díaz 1927, 108).

1601 (June 18): Acted as godfather to a daughter of Blas Camacho (López Martínez 1927, 211).

1601 (July 6): Contracted for five tabernacles ordered for Franciscan monasteries in Venezuela by royal *cédula* (Pulido Rubio 1943 in Proske 1967, 28 n. 104).

1601 (September 25): Awarded contract for five tabernacles to be sent to Santo Domingo for use in Dominican monasteries; they were to be delivered to Don Francisco Duarte on November 20 at the price of 500 ducats apportioned by the king (Proske 1960, 84).

1601 (October 1): Acted as guarantor for painters Juan and Diego de Salcedo in the contract for the retable for the church of Santa María, Villamartín (Cádiz) (López Martínez 1932, 203).

1601 (October 1): With Juan de Oviedo and Gaspar de Águila contracted for the architecture and sculpture for the main retable of the church of San Miguel, Jerez de la Frontera (Cádiz), to be completed in six years (López Martínez 1932, 235–36).

1601 (December 31): With his wife bought houses on the calle de la Muela, parish of La Magdalena, from Juan Ponce de León (López Martínez 1932, 236).

1602 (January 24): With the painter Vasco Pereira contracted with Doña Mencía de Aguilar and Geronima de Sant (*sic*) Martín, nuns in the convent of La Limpia Concepción in the parish of San Juan, Seville, for a retable for the altar of Saint John the Evangelist to be finished by the end of June for the sum of 600 ducats; acted as guarantor to Vasco Pereira in the contract for the gilding, painting, and *estofado* of this retable (López Martínez 1932, 236–37).

1602 (January 28): On the part of the sculptor Diego López, valued the retable made for the main chapel of the monastery of the Shod Trinitarians outside of Seville; Andrés de Ocampo appraised the work on behalf of the monastery (López Martínez 1932, 237–38).

1602 (March 8): With Juan de Oviedo authorized the priest Francisco de Cervantes and Captain Cristóbal de Ayala, resident of Osuna, to collect money owed for the retable for the main altar of the collegiate church at Osuna (López Martínez 1932, 238).

1602 (November 29): Received 37,400 maravedíes from Don Lorenzo de Ribera for the materials and execution of a tabernacle for the high altar of the convent of La Encarnación, Seville (López Martínez 1932, 238; Proske 1967, 31).

1602 (December 31): With his wife purchased houses on the calle de la Muela in Seville (López Martínez 1932, 238).

1603 (April 5): Received commission from Mateo Vázquez de Leca, archdeacon of Carmona, for the *Christ of Clemency* (fig. 56, p. 130) for his chapel at the price of 300 ducats (Hazañas y la Rúa 1918, 236–39).

1604 (January 27): With Juan de Oviedo contracted for the retable for the convent of Santa Clara, Cazalla de la Sierra (Seville) (López Martínez, *Retablos* 1928, 37–40); provided models for the retable but subcontracted the actual carving to Francisco de Ocampo on March 18 (López Martínez 1932, 239–40).

1604 (February 9): Contracted for thirteen tabernacles made of ebony in various sizes requested by Fray Melchor Delgado de Torreyra of the Franciscan Order in Nueva Granada and approved by royal *cédula* (Pulido Rubio 1943 in Proske 1967, 30 n. 116).

1604 (March 16): Subcontracted eight of the thirteen tabernacles ordered for the Franciscans in Nueva Granada to the joiner Artus Jordán at the price of 150 ducats (López Martínez 1932, 238–39).

1604 (May 5): Received 100 ducats for a sculpture of *Saint Jerome* from Juan de Uceda, with whom he had agreed the previous year to gild, polychrome, and supply the missing sculptures for the retable for the convent of Santa Clara, Llerena (López Martínez 1932, 240).

1604 (August 25): As "sculptor and architect" agreed to make a retable for a niche and altar in the tomb of Pedro de Cárdenas Sotes, *familiar* of the Inquisition, in the chapel of Las Ánimas in the monastery of San Francisco, Seville (López Martínez, *Retablos* 1928, 40–42); in a contract dated October 17, 1605, Francisco Pacheco acted as guarantor to the sculptor and agreed to supply the paintings and polychromy for the retable (López Martínez 1949, 252).

1604 (October 29): With the painter Gaspar Ragis and the silversmith Blas Camacho received payment (180 ducats to the sculptor) for statues of *Saint Honorius*, *Saint Eutychius*, and *Saint Stephen*, patron saints of Jerez de la Frontera, ordered by the city (López Martínez, *Retablos* 1928, 42–43).

1604 (December 22): Contracted with the painter Gaspar Ragis for the painting, gilding, and *estofado* of thirteen tabernacles by the end of February 1605 (López Martínez 1932, 240–41).

1605: Received commission from the guild of ship carpenters in Seville for a group of Saint Joseph holding the Christ Child by the hand, carved in the round, for their confraternity in the monastery of Nuestra Señora de la Victoria, Triana (Seville) (Proske 1967, 38); on March 21 contracted with Gaspar Ragis to gild and polychrome the statue of Saint Joseph by Good Friday (Hernández Díaz 1928, 162).

1605: Commissioned by Don Diego González de Mendoza for the main retable of the monastery of Santo Domingo de Portacoeli, Seville, at the price of 1,000 ducats; the polychromy was contracted to Francisco Pacheco in November at a price of 7,000 reales (López Martínez 1949, 255).

1605 (April 21): Contracted with Gaspar Ragis to paint and gild a bust of *Saint John the Baptist* by May 20 (López Martínez 1932, 241).

1605 (August 23): With Francisco Pacheco contracted with Doña Francisca de León, widow of the physician Francisco Díaz, for a retable for her chapel in the Colegio de El Ángel de la Guarda, Seville (López Martínez 1932, 241–43).

1605 (September 28): Accepted thirteen-year-old Pedro Sánchez of Antequera as an apprentice for a period of six years (López Martínez, *Retablos* 1928, 43–44).

1605 (October 10): Contracted for three tabernacles to be sent to the Dominican monasteries at La Habana (the island of Margarita) and the monastery of Santo Tomás, San Juan (Puerto Rico) (Pulido Rubio 1943 in Proske 1967, 31 n. 119).

1606 (April 29): Received final payment for the *Christ of Clemency* made for Mateo Vázquez de León, including 600 reales and two *cahices* of wheat in addition to the agreed-upon 300 ducats (Hazañas y la Rúa 1918, 244–45).

1606 (May 9): Contract for the retable for the Saint Catherine chapel in the parish church of Santa María de Consolación, El Pedroso (Seville), to be completed in eight months at the price of 580 ducats (López Martínez 1949, 259–60); this retable was commissioned in collaboration with Francisco Pacheco (Davies and Harris 1996, 154). The principal sculpture of this retable is the *Virgin of the Immaculate Conception* (cat. 47).

1606 (May 13): Paid the muleteer Juan de Nebra 10 ducats for bringing Francisco de Villegas from Toledo to become an apprentice (Hernández Díaz 1928, 163).

1606 (June 7): With the joiner and architect Pablo de Castillo contracted for a retable for the high altar of the monastery of San Francisco, Huelva, ordered by Captain Andrés Garrocho; was solely responsible for the relief of the *Purification of the Virgin* (López Martínez 1932, 244–45). Pacheco was contracted for the painting and gilding of the framework and sculpture (Hernández Díaz 1927, 148–52).

1606 (August 30): Contracted with Pedro de Ocaña, representative of the confraternity of El Santísimo Sacramento of the Seville Cathedral, for a statuette of the *Christ Child* (in situ) to be delivered within four months at the price of 1,300 reales (López Martínez 1932, 245–46).

1606 (September 22): Received 434 reales from Pedro de Ocaña, majordomo of the confraternity of El Santísimo Sacramento, as the second payment for the statuette of the *Christ Child* (López Martínez 1932, 246).

1607 (January 4): Commissioned by Francisco Galiano of Lima, Peru, for a retable dedicated to Saint John the Baptist for the convent of La Concepción, Lima (Sancho Corbacho 1928, 227–30).

1607 (September 4): Received 175,124 maravedíes from Gabriel de León according to an order of payment signed by Don Francisco Duarte, of the royal council in the Indies, on May 20, 1605 (López Martínez 1932, 246).

1607 (November 7): Signed apprenticeship contract with Juan de Mesa for a period of three years, although he had already entered Montañés's studio in May 1606 (Hernández Díaz 1928, 128–30).

1608 (June 20): Began work on the retable dedicated to Saint Albert commissioned by Miguel Jerónimo, milliner and parishioner of Santa María la Mayor, for the Colegio del Santo Ángel de la Guarda, Seville; the sculpture was finished by October 4, 1609, and Pacheco was contracted the next year for the polychromy (López Martínez 1949, 261–63).

1609 (February 7): As cessionary of Gaspar Suárez de la Puente and his sister Doña Inés, executors and heirs of Doña Juana de la Puente, received 5,000 maravedíes from Don Sebastián de Casaus (López Martínez 1932, 246–47).

1609 (March 16): As "sculptor and architect," contracted with the *licenciado* Lucas Pérez for a retable to be placed on a pillar above an altar near his burial site in the church of San Ildefonso, Seville; the work was to be completed in five months at the price of 250 ducats (López Martínez 1932, 247–48).

1609 (September 22): Contracted anew for the retable for the church of San Miguel, Jerez de la Frontera (Esteve Guerrero 1927, 290).

1609 (November 16): Contracted with Fray Juan Bautista, procurator of the monastery of San Isidoro del Campo in Santiponce (Seville), for a retable for the high altar of the church to follow the design already drawn by the sculptor; the work was to be completed within a year and a half at the price of 3,500 ducats (Bago y Quintanilla 1928, 50–57).

1610 (January 29): With the painter Juan de Uceda contracted with the convent of Santa María del Socorro, Seville, for a retable of Saint John the Baptist to be finished by the saint's feast day in 1611 for the sum of 1,1775 ducats (López Martínez 1932 248–49).

1610 (March 16): As "sculptor and architect" received commission for the framework, sculpture, gilding, and painting of a retable for the altar of the Saint Catherine chapel in the church of Nuestra Señora de la Consolación, Cazalla de la Sierra (Seville), and for an iron screen to be placed in front of the altar; the work was to be completed by October at the price of 400 ducats (López Martínez 1932, 249–50).

1610 (July 3): Received 850 reales from the priest Diego Gómez de Ortego as partial payment for the retable for the church of Nuestra Señora de la Consolación (López Martínez 1932, 250).

1610 (July 20): With Juan de Oviedo acted as a guarantor to the painter Diego de Salcedo and his wife Doña Micaela de Sandoval in the lease of houses (López Martínez 1932, 250).

1610 (July 28): With Francisco Pacheco contracted with the broker Hernando de Palma Carrillo and his son *licenciado* Juan Carrillo de Palma for the painting, gilding, and *estofado* of a retable for their altar and burial site in the church of the convent of Santa Isabel, Seville (Rodríguez Marín 1923, 46–48).

1611 (August 1): Authorized the attorney Juan Luis Quintilla to represent him in all matters (Gestoso y Pérez 1899–1909, 1: 225).

1612: Acted as a witness for the process of beatification of Hernando de Mata, a Sevillian priest; testified that he had known Father Mata for twelve or fifteen years (Pedro de Jesús María 1663 in Proske 1967, 80 n. 253).

1612 (March 7): Accepted fourteen-year-old orphan Juan Gregorio of Granada as an apprentice for a period of five years (López Martínez 1932, 251).

1612 (June 3): With Félix de Oviedo acted as a guarantor to Juan de Oviedo in the lease of houses (López Martínez 1932, 251).

1612 (August 20): Contracted for the sculpture, painting, gilding, and *estofado* of the retable for the Franciscan monastery of Nuestra Señora de Gracia, Villamanrique (Seville), ordered by the Marchioness Beatriz de Zúñiga y Velasco at the price of 1,200 ducats (Hernández Díaz 1928, 164–68); on August 11 acted as guarantor to Diego López Bueno to whom the framework of the altarpiece was contracted (Hernández Díaz 1928, 140–43).

1613 (August 20): With his wife granted a dowry of 1,000 ducats to their daughter Catalina, five years old (López Martínez 1932, 251).

1613 (August 28): His wife Ana de Villegas was buried in the church of the monastery of San Pablo, Seville, in the parish of La Magdalena, after having made her will on August 20 (López Martínez 1932, 251–52).

1613 (December 10 and 11): Signed revised contract for the retable for the church of San Miguel, Jerez de la Frontera (Esteve Guerrero 1927, 286–92, 319–26, 341–49).

1614 (April 10): Granted letter of dowry to his second wife, Doña Catalina de Sandoval, daughter of Diego de Salcedo and Doña Micaela de Sandoval (López Martínez 1932, 252).

1614 (April 28): Married Catalina de Sandoval, having obtained dispensation from the pope (López Martínez 1932, 252).

1614 (June 14?): Asked the city of Seville to ratify the earlier decree absolving sculptors from sharing the tax levied on the carpenters (Gestoso y Pérez 1899–1909, 1: 226).

1614 (July 14): Hired former apprentice Francisco de Villegas as an assistant (López Martínez, *Retablos* 1928, 45).

1614 (September 19): Return of the apprentice Alonso Albarrán to the sculptor's studio after the boy left before the term of the original contract was finished (López Martínez 1932, 252).

1615: Became a *cofrade benemérito* (distinguished brother) in the confraternity of El Dulce Nombre de Jesús, Seville (López Martínez 1943, 13).

1617 (April 10): Acted as a witness in the marriage of Juan de Oviedo y de la Bandera and Doña Inés de Alarás (López Martínez 1932, 253).

1617 (August 3): Received 3,262 reales from Doña Ana Pinelo, a nun in the convent of Nuestra Señora de la Concepción, Lima, for sculptural work for the convent (López Martínez 1932, 253).

1617 (November 22): Authorized Pedro Gutiérrez to collect 30 ducats in rent from the weaver Antonio Sánchez (López Martínez 1932, 253).

1618 (March 3): Authorized Father Juan Bautista Vero, procurator of the Jesuit College in Córdoba, to collect from the sculptor Felipe Vázquez de Ureta 414 reales owed for the completion of a commission (López Martínez 1932, 253).

1618 (May 8): Contracted with Pedro de Gúzman, executor of the will of Fernando Portocarrero, for a retable frame for the altar and burial site in the deceased's chapel in the parish church, Benacazón (Seville); this retable was to be a repetition of the one above the tomb of the venerable Father Francisco de Mata in the convent of La Encarnación, Seville (López Martínez 1932, 253–54).

1618 (June 28): Authorized Pedro de la Rosa to file suit against Antonio Sánchez and Pedro Gutiérrez over the 65 ducats owed in rent (López Martínez 1932, 254).

1618 (July 1): Authorized Pedro de la Rosa to appear before a notary in Cádiz to collect 65 ducats owed by Antón Sánchez for houses rented in Seville (Agulló y Cobo 2005, 188).

1618 (September 30): With Juan de Uceda acknowledged the delay in the work on the retable of Saint John the Baptist for the convent of Santa María del Socorro, Seville, and promised to finish the retable in a year and a half (López Martínez 1932, 254–55).

1618 (December 31): Received 1,392 reales from Cristóbal Sánchez Zorrilla of Peru, on behalf of Doña Ana Pinelo of the convent of La Concepción, Lima, in settlement of the contract for the retable (López Martínez 1932, 255).

1619 (July 18): With Francisco Pacheco and Juan de Uceda appraised a portrait by Domingo de Caraballo at 100 ducats (López Martínez 1932, 255).

1619 (September 13): Gave a receipt for 1,432 reales to the Jesuit priest Fabian López for a statuette of the *Virgin of the Rosary* for the priest Juan López de Vozmediano of Lima (Bago y Quintanilla 1928, 59–61).

1619 (December 30): Received 410 pesos from Gaspar de Rojas on behalf of Juan Martínez de Belasco of Portobello, Peru (López Martínez 1932, 255).

1620 (January 3): Contracted with the priest Juan López Boz Mediano (Vozmediano), resident of Lima, for a statue of the *Virgin of the Rosary* to be completed in seven months at the price of 2,232 reales (Bago y Quintanilla 1928, 60).

1620 (January 4): Drew up architectural plans for a cloister to be built at the Carthusian monastery in Jerez de la Frontera (López Martínez, *Retablos* 1928, 48).

1620 (August): Contracted with the customhouse officer Juan Peñate de Narváez for a retable dedicated to Saint John the Baptist for the patron's chapel in the Augustinian convent of San Leandro, Seville (Muro Orejón 1930 in Proske 1967, 93–94 n. 303).

1621 (March 3): In the name of Juan de Oviedo sold a slave at the price of 80 ducats (López Martínez 1932, 256).

1621 (April 2): Contracted for a *Saint Sebastian*, ordered by Juan Bernal of Santa Olalla (Huelva), to be finished six days before Corpus Christi at the price of 40 ducats (Bago y Quintanilla 1932, 56–57).

1621 (April 10): Authorized Francisco Gómez, notary from Sanlúcar de Barrameda (Cádiz), Pedro de la Rosa, joiner, and Mateo de León to collect from Juan Baptista González 17,000 reales, the outstanding balance of the price of 2,000 ducats for *Christ Child* and *Virgin of the Immaculate Conception* (López Martínez 1932, 256).

1621 (April 29): Contracted for statues of the *Virgin and Child* and *Saint John the Baptist* for two small retables (commissioned in 1617 and 1618) made for the lay brothers' choir in the royal Carthusian monastery of Santa María de la Cuevas outside Seville (Bago y Quintanilla 1927, 177–78).

1621 (November 4): Gave a receipt for 6,000 reales for the retable of Saint Joseph commissioned for the chapel of Juan Peñate de Narváez in the con-vent of San Leandro, Seville (López Martínez, *Retablos* 1928, 48).

1621 (November 6): Contracted for the main retable for the convent of Santa Clara, Seville, to be finished in two years; was to be paid 4,500 ducats of the total price of 6,000 ducats (López Martínez, *Retablos* 1928, 48–53). Contract was cited by Francisco Pacheco in his 1622 complaint against Montañés for infringing upon the rights of the painters' guild, "A los profesores del arte de la pintura" (Sánchez Cantón 1923–1941, 5: 267–74).

1622 (January 18): Received 500 ducats in partial payment for the retable for the convent of Santa Clara, Seville (López Martínez 1932, 256).

1622 (January 25): Authorized Francisco Alvárez de Castro to collect from Rodrigo de Almansa, guarantor of the abbess of the convent of Nuestra Señora del Socorro, Seville, the remaining 450 ducats owed for the retable executed for the convent (López Martínez 1932, 249).

1622 (December 16): Received 500 ducats from Doña Francisca de Santillana, abbess of the convent of Santa Clara, Seville, in partial payment of the retable he was making (López Martínez 1932, 256).

1623 (January 25): Authorized Gaspar Jiménez to collect money owed by Juan Bautista Pasajero of Peru (López Martínez 1932, 257).

1624 (March 13): Signed the contract for the main retable of the convent of San Clemente el Real, Seville, at the agreed-upon price of 22,000 ducats (López Martínez 1932, 257–61); the work was never carried out (Proske 1967, 110).

1624 (March 30): Received 500 ducats from the abbess of the convent of Santa Clara, Seville, in partial payment of the retable for the main chapel of the convent (López Martínez 1932, 261).

1624 (June 12): Gave 100 ducats to Doña Catalina de Mendoza, a maid who wished to be a nun in the convent of Santa Paula, Seville, but did not have the money to enter (López Martínez 1932, 261).

1625 (December 9): Authorized Francisco de Aguirre to collect 2,000 reales from Diego Ramos of Jerez de la Frontera owed him according to a contract signed on November 30 (López Martínez 1932, 261–62).

1626 (April 4): Named guardian of Miguel de Salcedo, who was "less than twenty-five years old and more than sixteen years old," son of the deceased Diego de Salcedo (López Martínez 1932, 262).

1626 (May 25): Commissioned to carve the missing figures for the main retable for the church of Santiago, Alcalá de Guadaira (Seville), within three years and at the price of 1,300 ducats (López Martínez, *Retablos* 1928, 152–54).

1626 (July 2): Authorized the painter Baltasar Quintero to collect 200 ducats from the convent of Santa Clara, Seville, owed to the sculptor by virtue of the litigation over the price of the retable (López Martínez 1932, 262).

1627 (July 18): Contracted for a group of *Saint Anne and the Virgin* for the Carmelite convent of Santa Ana, Seville, to be finished by the saint's feast day (Sancho Corbacho 1931, 71–73).

1628: Designed two reliquaries, ordered by Juan Bautista de Mena and made by Alonso Sánchez of Seville (according to contract of May 25), for the retable of Nuestra Señora de los Desconsolados in the monastery of the Shod Trinitarians outside of Seville (López Martínez, *Retablos* 1928, 120–21).

1628 (February 4): Contracted with Doña Jerónima de Zamudio, widow of Francisco Gutiérrez de Molina, for a retable for her chapel dedicated to the Immaculate Conception in the Seville Cathedral; the document stipulated that the work must be finished by the end of May 1629 and that the sculptor would receive 500 ducats to begin (and would receive up to 1,200 ducats as he progressed) but the overall price would be determined by an appraisal (López Martínez, *Retablos* 1928, 154–56). Pacheco was contracted to polychrome the retable on February 5 (Rodríguez Marín 1923, 51–53).

1628 (March 20): Commissioned by Captain Baltasar Becerra, acting on behalf of Martín Sánchez, chaplain of the convent of La Concepción, Lima, for two figures of angels, one playing a bugle and the other a flageolet, to be finished by December (López Martínez, *Retablos* 1928, 55–56).

1628 (August 26): Obligated to repay 500 ducats to Juan Baptista de Mena (López Martínez 1932, 262).

1632 (June 8): Accepted Josephe Martínez de Castaño as an apprentice in his studio (López Martínez 1932, 262).

1632 (June 23): Contracted for an addition to the retable made for the chapel of Fernando Portocarrero in the parish church in Benacazón (originally commissioned in 1618) (Bago y Quintanilla 1927, 180–87).

1632 (July 5): Contracted for the retable for the church of San Lorenzo, Seville, to be finished within three years and at the price of 6,000 ducats (López Martínez 1932, 135).

1632 (July 10): Named guardian of Martín Pérez, the twelve-year-old son of the deceased Ginés Pérez; placed the boy as an apprentice to the joiner and architect Luis de Figueroa (López Martínez 1932, 262).

1632 (July 21): Received 4,050 reales, collected by means of lawsuit, due him from the first contract for the retable for the chapel of Fernando Portocarrero in the parish church in Benacazón (López Martínez, *Arquitectos* 1928, 96).

1632 (October 9): Contracted for a group of *Saint Anne and the Virgin* for the altarpiece for the chapel of the Carmelite Colegio de San Alberto, Seville, endowed by Francisco Bernardino Palacios; the sculpture was to be finished by May 1633 at the price of 600 ducats (Muro Orejón 1927, 209–10).

1632 (November 27): Contracted Baltasar Quintero to gild and polychrome the figures in the retable of Saint John the Evangelist carved for the convent of San Leandro, Seville (López Martínez 1932, 262).

1633 (March 8): Asked for permission to repair and remake statues, finished by Diego de Velasco in 1589 for the retable of the church of Santiago, Alcalá de Guadaira, that were heavily damaged (López Martínez, *Retablos* 1928, 56–58).

1633 (September 24): Received 6,000 reales in partial payment for the retable for the high altar of the church of San Lorenzo, Seville (López Martínez 1932, 262).

1633 (November 10): Received 1,860 reales for the sculptures made for the retable of the church of Santiago, Alcalá de Guadaira; received another 3,740 reales in December (López Martínez 1932, 263).

1634 (March 10): Received 100 ducats as partial payment toward the agreed-upon price of 400 ducats for a statue of *Saint Bruno* for the Carthusian monastery of Santa María de las Cuevas, Seville (Bago y Quintanilla 1928, 66).

1634 (November 28): Received 200 ducats from the heirs of Doña Isabel de Montemayor in settlement of the retable for the parish church of San Lorenzo (López Martínez 1932, 263).

1635 (June 14): Authorized his wife Catalina de Salcedo to make his will, indicating that he should be buried in their vault in the monastery of San Pablo, Seville, or if elsewhere, in the parish church of the city where he died (López Martínez 1932, 263).

1635 (August 6): In Madrid authorized by the sculptors' guild of Seville to plead before the king or any other official council any cases that involved the guild, especially regarding the tax levied against their profession (López Martínez, *Arquitectos* 1928, 96).

1636 (February 7): Received payment for a portrait bust of Philip IV (now lost) in the form of a royal order entitling the sculptor to send a 600 ton merchant ship with the Indies fleet (Proske 1967, 122).

1637 (January 7): Began carving the principal statue of *Saint John the Evangelist* for the retable (for which Alonso Cano was architect) dedicated to the saint for the convent of Santa Paula, Seville (López Martínez, *Retablos* 1928, 143–44, 156–57).

1638 (January 2): With Luis de Figueroa, Gerónimo Velázquez, and Martín Moreno authorized Alonso Cano to protest before the royal council in Madrid the inclusion of sculptors in the *alcábala* levied on the carpenters (López Martínez 1932, 264).

1638 (March 7): Contracted to carve the central figure of *Saint John the Baptist* for the retable dedicated to the saint in the convent of Santa Paula (López Martínez, *Retablos* 1928, 96–97).

1638 (April 15): Commissioned by Alonso de Nobela, *maestrescuela* of Cádiz Cathedral and vicar of the churches of Medina Sidonia, and Fernando de Flores Román of Seville for three sculptures of saints to be finished within a year (López Martínez 1932, 264–65).

1638 (August 5): Received 400 ducats from Cristóbal de Contreras, a cloth merchant, as partial payment of the 580 ducats agreed upon with Contreras and Don Luis de Villegas for a relief commissioned for Villegas's chapel in the convent of Santa María de la Pasión, Seville (López Martínez 1932, 265).

1638 (October 8): Commissioned to carve four reliefs and four figures of saints for the retable for the church of San Miguel, Jerez de la Frontera (Sancho Corbacho 1931, 80–82).

1639 (March 22): Signed a receipt for 400 ducats that he had received at various times to pay for his expenses in Madrid (Sancho Corbacho 1931, 73–74).

1639 (May 7): Received 500 ducats from the *licenciado* Andrés Gómez de Esquivel, curate of the church at Castilleja del Campo and executor of the will of the *licenciado* Juan Valetín de Tobar, majordomo of the parish church of San Lorenzo, Seville, for the retable of the main chapel of San Lorenzo, Seville (López Martínez 1932, 265).

1639 (August 5): Fray Juan de Salcedo received 1,531 reales from an agent of Don Gaspar Alonso de Guzmán, duke of Medina Sidonia, on the sculptor's behalf (López Martínez 1932, 265).

1639 (September 5): Received 22,560 reales (of the assessed retable value of 32,000 reales) from Pedro Martín López, majordomo of the church of San Lorenzo (López Martínez 1932, 266).

1640: Asked for exemption from a tax due to lack of property or funds (Gestoso y Pérez 1899–1909, 1: 225–26).

1640 (March 16): Commissioned for a *Crucifixion* from the Franciscan monk Gaspar de Azeves (López Martínez, *Retablos* 1928, 157).

1640 (July 13): Finished a *Crucifixion* and readied it for delivery to Dr. Luis de Betancourt y Figueroa, prosecutor in the Inquisition tribunal in Lima (López Martínez, *Retablos* 1928, 59).

1640 (September 28): Collected, as creditor, a percentage on a loan demanded by the king on the gold and silver brought by the fleet of the marquis of Cardeñosa in 1637 (López Martínez, *Retablos* 1928, 59).

1641 (April 19): Transferred the contract for the carving of additional figures for the retable for San Miguel, Jerez de la Frontera, to José de Arce (López Martínez, *Retablos* 1928, 59–60).

1641 (August 23): Commissioned for a statue of *Saint Peter* from Francisco Cordero, parish priest at Cilleros, and Juan Cordero, a mason from Seville (Sancho Corbacho 1931, 74; Proske 1967, 134, as his last recorded commission).

1643 (February 15): Obligated to pay 6,103 reales in settlement of accounts he had with Captain Roque de Lora Santa Gadea, an agent of Cardinal Spinosa (López Martínez 1932, 266).

1644 (April 15): With Don Pedro Lorenzo, majordomo of the church of San Miguel, Jerez de la Frontera, agreed to settle the dispute over payment of the retable executed for the church at 1,700 ducats (López Martínez 1932, 267).

1645 (July 4): Rented houses he owned in La Rabeta to Diego Cortés de Abila at the price of 60 reales per month; a new lease was drawn up on May 8, 1646 (López Martínez 1932, 267).

1645 (October 5): Transferred his share of the work on the retable for the church of San Lorenzo, Seville, to Felipe de Ribas (López Martínez 1932, 133–35).

1646 (June 18): Died and was buried in the church of Santa María Magdalena, Seville (López Martínez 1932, 268).

1648 (September 19): Document signed by Montañés and presented (posthumously) to the tribunal of the Casa de Contratación regarding the portrait bust of Philip IV he made to be sent to Florence and his claim to a vessel promised by Philip IV in response and payment for this service (Ceán Bermúdez 1965, 3: 86).

1658: Montañés's widow was sent a bar of silver from Portobello with a value of 1,008 pesos as a result of her selling a license for a vessel (Ceán Bermúdez 1965, 3: 89).

Pedro Orrente

1580 (April 18): Baptized in the church of Santa Catalina, Murcia (López Jiménez 1960, 166); son of fabric-shop owner Jaume, native of Marseilles, and Isabel de Jumilla from Murcia (López Jiménez 1961, 74).

1600 (September 3): In Toledo contracted with Pedro Sánchez Delgado, painter and resident of Toledo, to restore and execute paintings for the retable for the hermitage of Nuestra Señora del Saz, Guadarrama (Madrid) (García Rey 1929, 432).

1604 (December 18): Jerónimo Castro, of Murcia, agreed to give the painter's father 200 reales by the end of February 1605 in payment for a *San Vidal* painted by Orrente (López Jiménez 1962, 62).

1605 (August 27): In Venice "Pietro Orrente, painter, native of Murcia" (identified thus by Daniel de Nys) authorized Gasparao Manart in Rome to receive from Ferrante Frigerio "73 écus 14 sous 6 deniers" in accordance with a letter of exchange of October 25, 1602, from Giovanni Battista Paravicino of Alicante (Brulez 1965, 558).

1612: Signed the *Blessing of Jacob* (Pitti Palace, Florence) (Angulo Iñiguez and Pérez Sánchez 1972, 250).

1612: Married María Matamoros, daughter of Esteban García Matamoros and Isabel Martínez, parishioners of San Nicolás, Murcia. She brought to the marriage clothing and goods valued at 3,766 reales and a dowry of 1,000 ducats. He brought another 1,000 ducats and various rich fabrics (López Jiménez 1962, 63).

1612 (January 31): In Murcia, authorized the painter Angelo Nardi, resident at the court of His Majesty, to collect from Pedro Pérez Carrión, silversmith and resident of Madrid, a painting of *Saint Catherine Martyr* or its price of 20 ducats in reales (López Jiménez 1962, 62).

1614: With his brother Patricio appeared as owner of his father's house in the parish of Santa Catalina, Murcia (López Jiménez 1962, 63).

1616: In Valencia signed *Martyrdom of Saint Vincent* (whereabouts unknown) (Orellana 1930, 119).

1617 (November 4): In Murcia received 1,500 reales for the painting of *Saint Leocadia* for the Toledo Cathedral, a special commission from Cardinal Sandoval y Rojas (Pérez Sedano 1914, 89, 129; Zarco del Valle 1916, 324).

About 1620: Either stayed in or visited Cuenca, where he took on as a disciple Cristóbal García Salmerón (Ceán Bermúdez 1965, 3: 275; Angulo Iñiguez and Pérez Sánchez 1972, 229 [undocumented]).

1622 (October 17): Contracted with the confraternity of Nuestra Señora de la Concepción in Murcia for the main altarpiece for the confraternity's chapel (López Jiménez 1964, 197 n. 1).

1624: In Murcia applied for an appointment as *familiar* (lay collaborator) of the Holy Office of the Inquisition (Morales y Marín 1977 in Benito Doménech 1987, 260).

1625 (June): Tried to secure the commission for the altarpiece for the Chapel of the Rosary in Santo Domingo, Murcia, which was eventually awarded to Juan de Alvarado and Juan López Luján (López Jiménez 1964, 172; Angulo Iñiguez and Pérez Sánchez 1972, 251).

1626 (December 9): In Toledo named as executor of the will of Alejandro de Loarte (Méndez Casal 1934, 191).

1627 (January 24): In Toledo took Juan de Sevilla, son of the Toledan sculptor Juan de Sevilla Villaquirán and Jerónima de Aguilar, as an apprentice for a period of five years (García Rey 1929, 431).

1627 (May 11): With his wife María authorized Diego Martínez de Villalta to sell the hacienda in Comarja, bordering the town of Algavía, that María inherited from her parents (García Rey 1929, 432–33).

1627 (December 20): With his wife named godparent to a daughter of Jorge Manuel Theotokopoulos (San Román y Fernández 1910, 223–24).

1629 (June 8): In Toledo commissioned by the monastery of San Francisco, Yeste (Albacete), for five paintings for a retable to be completed by Christmas day of that year at the price of 200 ducats (García Rey 1929, 433–34); in a related document dated April 25 Orrente is referred to as "pintor de su majestad" (García Rey 1929, 434).

1629 (June 20): With his wife named godparent to a son of Jorge Manuel Theotokopoulos (San Román y Fernández 1910, 224–25).

1630 (June 10): With Eugenio Cajés contracted for a screen for the Capilla de los Reyes Nuevos in Toledo Cathedral (Marías 1978, 422).

1630 (October 21): Payment of 3,350 reales ordered to the artist for a *Nativity* for the Capilla de los Reyes Nuevos in Toledo Cathedral (García Rey 1929, 431).

1631 (May 20): In Toledo granted Don Francisco Gómez de Asprilla, secretary to His Majesty (to whom he owed money), and Alonso Sánchez Hurtado the authority to collect 700 reales owed him by Madrid resident Doña Lorenza de Silva; transferred the money to Gómez de Asprilla to settle his own debt (García Rey 1929, 431, 433).

1631 (May 23): Contracted for the painting, gilding, and *estofado* of the altarpiece of the convent of San Antonio de Padua, Toledo (García Rey 1929, 435).

1632 (February 28): In Valencia accepted Juan de Toledo, son of Jerónimo de Toledo, *maestro del arte de la seda* (silk worker) and inhabitant of Toledo, as an apprentice for seven years to learn the art of painting; testified to by Juan de Sevilla (apprenticed to Orrente in 1627) (López Azorín 2006, 68).

1633 (February): Granted appointment as *familiar* of the Holy Office of the Inquisition in Murcia (Pérez Sánchez 2007); dispatch from the Inquisition referred to him and his wife as "vecinos de Espinardo," residents of a small town neighboring Murcia (Benito Doménech 1987, 260).

1634 (January 5): Agreed with Don Diego de Vich y Mascó to paint and gild the altarpiece of the main chapel of the church of the Hieronymite convent and monastery of Nuestra Señora de la Murta, Alzira (Valencia), for 300 libras (López Azorín 2006, 69).

1634 (January 13): Paid Doña Jerónima Bou y de Boyl 32 libras and 10 sueldos as *conductor* of a house in the parish of San Esteban, Valencia (López Azorín 2006, 69).

1634 (June 2): As painter and tenant of the house of Señor de Toga in the parish of San Esteban in Valencia, paid Antonio Picó of Valencia 24 libras toward the 48 owed for works executed in that house (López Azorín 2006, 69).

1634 (October 18): Authorized Gabriel de la Os, majordomo of the count of Albatera and administrator of his goods, to collect in his (Orrente's) name the debts owed to him (López Azorín 2006, 69).

1635 (January 16): Authorized the *licenciado* priest Gabriel de la Hos (Os), majordomo of the count of Albatera and resident of Murcia, to sell the houses and land that he inherited from his sister Sor Leonor Barrio y Orrente in the city of Murcia (López Azorín 2006, 69).

1635 (February 7): Paid Jacobo Tensa of Valencia 6 libras and 6 sueldos as *conductor* of the house of Don Francisco Carroz, Señor de Toga, in the parish of San Esteban (López Azorín 2006, 69).

1635 (February 13): Accepted as apprentice thirteen-year-old Pablo Puntons for seven years (López Azorín 2006, 70).

1635 (August 7): Paid Doña Jerónima Bou y de Boyl, widow, 15 libras for half a year's rent for her house in the parish of San Esteban in Valencia (López Azorín 2006, 70).

1635 (October 26): As guardian of the minor Isabel Casilda Matamoros authorized to sell her property in Murcia (López Azorín 2006, 70).

1635 (November 10): Petitions against him to settle rent owed on their house waived by Don Pedro Carroz and his wife (López Azorín 2006, 70).

1635 (November 18): Receipt of sale from his nephew Father Fray Nicolás Gamir of a *censo* for property in Murcia for 143,420 maravedíes (López Azorín 2006, 70).

1635 (November 26): Collected 66 libras and 10 sueldos from Ildefonso Sebria, a farmer in Alzira (López Azorín 2006, 70).

1635 (December 31): Named Melchor Merique, citizen of Alzira, as his proxy to appear before the notary of Alzira for the publication of the will of his sister Elionora Barria (*sic*), a professed nun in the convent of Santa Lucia, Alzira (Valencia) (López Azorín 2006, 69).

1636 (March 6): Received by the order of Don Diego Vich, Señor de la Baronía de Llaurí, through Diego Donau, 50 libras for his share of the altarpiece made for the monastery of Santa María de la Murta, Alzira (López Azorín 2006, 70–71).

1636 (April 1): Collected 67 libras and 10 sueldos from Ildefonso Cebriá (Sebria) on account of the 135 libras owed for his share of the altarpiece for the monastery of la Murta (López Azorín 2006, 71).

1636 (December 2): Testified before Francesco Morales, the notary of Valencia, regarding Pablo Puntons who had been imprisoned (López Azorín 2006, 71).

1636 (December 21): Collected 115 libras, 9 sueldos, and 2 dineros owed by various residents of Villajoyosa (Alicante) because of a change in property worth 400 libras to Don Jéronimo Villarasa Castellsens (López Azorín 2006, 71).

1637 (February 22): Received 27 libras from Pedro Banil, a farmer from Valencia, for the extension of the lease of 24 *cafisadas* of land in Meliana (Valencia) (López Azorín 2006, 71).

1637 (April 8): Authorized Señor Racionero Jaime of the Cathedral of Cartaxena (Murcia) to act as his proxy in the collection of the amount owed him by Gaspar de Rocafull y Boyl, count of Albatera, and his son Ramón de Rocafull for a property transaction on behalf of Juan de Villarasa Castellsens (López Azorín 2006, 71).

1637 (June 17): Juan de la Puente, farmer in Valencia, put his fourteen-year-old daughter, Magdalena de la Puente, in the service of Orrente's house for eight years (López Azorín 2006, 71).

1637 (August 25): As *padre de los pobres* of the parish of San Andrés, Valencia, collected from Francisco Figuerola 3 libras and 11 dineros owed for the pension for the poor (López Azorín 2006, 71).

1638: In Murcia where he owned two houses in the Plaza de Vidrieros and one in the Plaza Mayor (López Jiménez 1962, 63).

1638 (April 14): Received 26 libras and 3 dineros from Jacobo Llorensa, a farmer from Villajoyosa (Alicante), in settlement of a debt (López Azorín 2006, 72).

1638 (June 16): Rented a house in the parish of San Lorenzo, Valencia, from Melchor de Figuerola, Caballero de Montesa y de San Jorge de Alfama and Señor de Náquera, for five years at the price of 86 libras per year (López Azorín 2006, 72).

1638 (July 12): In Valencia valued with J. J. Espinosa paintings that Urbano Fos painted for the altarpiece of the Sagrario in the church of Santa María, Castellón (Olucha Montíns 1987, 108–9).

1639: The painter Lorenzo Suárez was contracted to complete the altarpiece of the Franciscan monastery of La Concepción, left unfinished by Orrente when he left Murcia (Sánchez Moreno 1952–53, 425).

1639 (February 15): Named Nicolas Juste, a Valencian notary, as his procurator for judicial and ecclesiastical matters (López Azorín 2006, 72).

1639 (September 18): Sold two mules to Pedro Perales, a farmer from Guadasuar (Valencia), for 130 reales (López Azorín 2006, 72).

1640 (June 8): Received 40 libras from Francisco Bernial de Alboraya in partial payment toward the other 250 owed for property reasons; witnessed by the painter Pablo Pontons (Puntons) (López Azorín 2006, 72).

1641 (August 2): Named Jacobo Gasot, Valencian notary, as his procurator (López Azorín 2006, 72).

1642 (June 18): Named Heronimo Carranza, a soldier in Valencia, as his procurator in order to collect money and for judicial matters (López Azorín 2006, 72).

1644 (February 16): In Murcia his nephew and guarantor Gaspar Coronel paid 1,864 reales on behalf of the artist, "resident of Valencia," to Lorenzo Suárez to settle the account regarding the retable for the confraternity of La Concepción (Sánchez Moreno 1952–53, 421).

1645 (January 17): Drew up his will in Valencia before the notary Juan Fita (Tramoyeres Blasco 1916, 92–93; López Jiménez 1959, 74–75, for document in Catalan).

1645 (January 19): Died in Valencia and was buried in the parish of San Martín the next day (Tramoyeres Blasco 1916, 92).

Francisco Pacheco

1564 (November 3): Baptized in Sanlúcar de Barrameda (Cádiz) (Rodríguez Marín 1923, 35).

1583 (March 2): Admitted to the confraternity of Nazareno de Santa Cruz en Jerusalén, Seville (Asensio 1886, 15; Valdivieso and Serrera 1985, 34).

1585 (March 11): Designated as "francisco pacheco pintor de ymagineria" in a document for the rental of a house from Francisco Vázquez on the calle de los Limones in Seville (López Martínez 1932, 192).

1586 (August 7): Authorized his brother Pedro López to collect debts in his name (López Martínez 1929, 178).

1589: Signed *Christ Carrying the Cross* (whereabouts unknown), his earliest known signed and dated work (Valdivieso and Serrera 1985, 26).

1589 (November 24): Accepted eleven-year-old Agustín de Sojo in his workshop as apprentice (López Martínez 1929, 178).

1590: Signed *Virgin of Belén* (Granada Cathedral) (Valdivieso and Serrera 1985, 34).

1592 (April 10): Contracted with Father Gabriel de Alarcón of the Jesuits in Marchena (Seville) for the execution of three paintings (*Saint Michael Archangel, Penitent Magdalene,* and *Saint Vincent Ferrer*) (Rodríguez Marín 1923, 38–40).

1592 (December 2): Contracted with Doña Mencía de Morales for a retable for the chapel of Gonzalo de Vallarubia in the parish church of Santa María, Guadalcanal (Seville) (López Martínez, *Arquitectos* 1928, 229).

1593: Consulted the Dominican Fray Juan de Espinosa and the Jesuit Father Juan de Soria regarding the iconography for the decapitation of Saint Paul (Pacheco 1956, 1: 268; Brown 1978, 54).

1593 (October 24): In Seville attested that he and his brothers Pedro López and Mateo Pérez were legitimate sons of Juan Pérez and Leonor de Ríos and were old Christians. On October 30 his brother Juan Pérez testified in the town of Trigueros that he and Pacheco were legitimate sons of Juan Pérez and Leonor de Ríos (a native of Trigueros) and that all were old Christians (Rodríguez Marín 1923, 40–41).

1593 (December 29): Received the dowry (262,500 maravedíes) of his future wife María Ruiz; an inventory of the painter's goods was made (López Martínez 1929, 179–82).

1594: Painted four banners for the New Spain fleet and one for the Tierra Firme fleet (Pacheco 1990, 492–93).

1594 (January 17): Married María Ruiz de Páramo (López Martínez 1929, 182).

1594 (July 27): Received 166 reales for the appraisal of the painted and gilded works for the main and side altarpieces of the convent of Santa Paula, Seville, executed by Alonso Vázquez (López Martínez 1932, 214).

1594 (October 30): Authorized Bernabé Caviedes to collect payment in his name for the painting of the royal banner for the New Spain fleet (López Martínez 1929, 182).

1595 (March 20): Received partial payments for the retable for the chapel of García Díaz de Villarubia in the parish church of Santa María, Guadalcanal (López Martínez 1929, 183).

1595 (August 1): With other local painters empowered Vasco Pereira to represent them in litigation opposing the tax to be levied on the profession of painting (López Martínez 1929, 188–89).

1596 (May 19): Accepted twelve-year-old Lorenzo Lozano in his workshop as an apprentice for six years (Rodríguez Marín 1923, 43).

1597: Signed *Saint John the Baptist* (Nuestra Señora de las Nieves, Bogotá) (Valdivieso and Serrera 1985, 36).

1598: With other painters participated in the creation of the catafalque of Philip II, erected in Seville Cathedral (Pacheco 1956, 1: 247).

1598 (February 7): Appeared as a guarantor to the painter Diego Gómez in a contract for a *monumento* for the monastery of Nuestra Señora del Carmen, Seville (Álvarez Márquez 1981, 241).

1599: Began writing *Libro de descripción de verdaderos retratos de ilustres y memorables varones* (Asensio 1886, 35).

1599: Signed *Christ with Saint John the Baptist and Saint John the Evangelist* (parish church, Carabanchel [Madrid]) (Valdivieso and Serrera 1985, 80); painted *Saint Francis* and *Saint Anthony* for two side altarpieces in the Franciscan monastery in Lora del Río (Seville) (Asensio 1886, 15).

1599 (January 27): With the carver Diego López contracted for the execution of a sculpted and painted altarpiece for the church in Cortés to be finished in six months at the price of 400 ducats (Hernández Díaz 1928, 137).

1599 (July 31): The *cabildo* (municipal council) of Seville summoned Pacheco and six other painters in order to elect *alcaldes veedores del oficio de pintor de imaginería* (overseers of the painting of sacred images); they would elect Vasco Pereira and Francisco Bravo on August 2 (Valdivieso and Serrera 1985, 36).

1599 (October 5): The election of Francisco Bravo was contested, so the painters elected Juan de Saucedo (Valdivieso and Serrera 1985, 36).

1600: Began work on the six paintings for the main cloister of the monastery of the Shod Order of Mercy (la Merced Calzada), Seville, commissioned by Fray Juan Bernal (Asensio 1886, 97; Pacheco 1956, 2: 76).

1601 (March 7): With Diego Gómez, *pintores de imaginería* (painters of sacred images), received the transfer of the commission, originally given to Antonio de Arfian and his son, to paint, prime, and gild the altarpiece for the church of San Martín, Niebla (Huelva) (López Martínez 1932, 193).

1601 (March 12): Agreed to execute three paintings (*Holy Family with Saint John the Baptist in Saint Joseph's Workshop, Baptism of Saint John,* and *Christ on the Cross*) in collaboration with Juan de Bustinza (Rodríguez Marín 1923, 43–44).

1601 (March 20): Information on the *limpieza de sangre* of Pacheco and his brothers Juan, Pedro, and Mateo is registered in Seville (Rodríguez Marín 1923, 44–45).

1601 (August 4): With Miguel Vázquez, *pintores de imaginería,* appraised certain paintings in the house of the *correo mayor* (royal postmaster) Hernando Ruiz de Medina (López Martínez 1932, 194).

1601 (November 2): Receipt of 60 ducats from Juan de Bustinza for paintings contracted that year. Two of the paintings had been delivered and the third, the *Holy Family,* was to be finished by the beginning of January 1602 (Rodríguez Marín 1923, 45).

1602: Signed *Saint John the Baptist* (now lost) (Valdivieso and Serrera 1985, 37; Asensio 1886, 98, as in the collection of Juan de Olivar in the palace of the duke of Alba in Seville).

1602 (February 17): Signed the drawing *Saint Jerome* (Galleria degli Uffizi, Florence) (Sánchez Cantón 1930, 3: pl. 194; Valdivieso and Serrera 1985, 37).

1602 (June 1): Baptism of his daughter Juana in the church of San Miguel, Seville (Gallego y Burín 1960, 214).

1602 (November): Signed a drawing of a Mercedarian (Academia de San Fernando, Madrid) (Sánchez Cantón 1930, 3: pl. 194; Valdivieso and Serrera 1985, 37).

1603: Received commission from Don Fernando Enríquez de Ribera, third duke of Alcalá, to paint the ceiling of the *camarín* in the Casa de Pilatos, Seville, with the *Apotheosis of Hercules* (Pacheco 1956, 2: 22).

1604 (April 9): Signed the preparatory drawing for the *Apotheosis of Hercules* for the ceiling of the Casa de Pilatos; this same year he also signed the pictorial ensemble (Sánchez Cantón 1930, 3: pl. 195; Valdivieso and Serrera 1985, 37).

1604 (August 22): Signed the drawing for the *Fall of Phaeton* for the ceiling of the *camarín* of the Casa de Pilatos (Sánchez Cantón 1930, 3: pl. 196; Valdivieso and Serrera 1985, 37).

1605 (August 23): With Juan Martínez Montañés contracted for the painting, gilding, and *estofado* of the altarpiece for the chapel of Doña Francisca de León in the Colegio del Ángel de la Guarda, Seville (López Martínez 1932, 241–43).

1605 (October 17): With Montañés contracted for an altarpiece for the chapel of the Brotherhood of San Onofre in the monastery of San Francisco, Seville. The work was commissioned by Don Pedro Cárdenas, *familiar del Santo Oficio* and member of the brotherhood (López Martínez 1949, 248–53).

1605 (November): Commissioned by González de Mendoza for the execution of the gilding, *estofado,* and painting of an altarpiece for the church of the monastery of Santo Domingo de Portacoeli, Seville. Juan Martínez Montañés was contracted for the architectural design, carving, and sculpture for the retable (López Martínez 1949, 253–57).

1606 (February 21): Signed the drawing of the *Last Communion of Saint Peter Nolasco* (Sánchez Cantón 1930, 3: pl. 197, Valdivieso and Serrera 1985, 38).

1606 (February 28): With Juan de Uceda agreed to the carving, sculpting, and painting of an altarpiece for the monastery of San Diego, Seville (Rodríguez Marín 1923, 45–46).

1606 (August 28): Obliged to paint, gild, and *estofar* the altarpiece commissioned by Andrés Garrocho for the main chapel of the church of San Francisco, Huelva. The sculptures were commissioned from Juan Martínez Montañés (López Martínez 1949, 259).

1608: Signed *Saint Ines* (Museo Nacional del Prado) that was originally part of the retable of Doña Francisca de León in the Colegio del Ángel de la Guarda, Seville (Valdivieso and Serrera 1985, 60).

About 1609: Praised in Lope de Vega's *Jerusalén conquistada.*

1609 (December 22): Cancelled his work on the altarpiece for the monastery of Portacoeli, Seville (López Martínez 1949, 257).

1609 (December 22): Presented a statement to the treasurer's office of the count of Niebla regarding the materials needed to execute works in the count's palace in Seville (Valdivieso and Serrera 1985, 38).

1610: Repaired a triptych, which he estimated was over 130 years old, owned by Don Pedro de Sandoval (Pacheco 1956, 2: 172); polychromed *Saint Ignatius* sculpted by Juan Martínez Montañés for the Jesuit Casa Profesa (Sánchez Cantón in Pacheco 1956, 1: xl).

1610 (July 28): With Montañés contracted for the painting, gilding, and *estofado* of the altarpiece for the altar and sepulchre of Hernando de Palma Carrillo in the church of the convent of Santa Isabel, Seville (Rodríguez Marín 1923, 46–48).

1610 (September 1): Obliged to gild, paint, and *estofar* the altarpiece and sculpture of Saint Albert for the chapel of Miguel Jerónimo in the church of Santo Ángel, Seville, in six months and at the price of 300 ducats (López Martínez 1949, 263).

1610 (September 17): Contracted for the labor of painting, gilding, and *estofado* of the altarpiece of Saint John the Baptist for the convent of San Clemente, Seville (Muro Orejón 1932, 107–10).

1610 (October 17): Appeared as a guarantor of Diego López Bueno in a contract for the main retable for the church in San Juan del Puerto (Huelva) (López Martínez 1929, 127–28).

1611: Traveled to Córdoba, Toledo, Madrid, El Pardo, and El Escorial (Pacheco 1990, 36).

1611: Signed the *Last Communion of San Ramón Nonnato* (Bowes Museum, Barnard Castle). This work was part of the *History of the Order of Mercy*, a cycle of paintings executed with Alonso Vázquez for the monastery of the Shod Order of Mercy (la Merced Calzada), Seville (Valdivieso and Serrera 1985, 62–64); signed a *Crucifixion* for Nuestra Señora de Consolación, El Coronil (Seville) (Valdivieso and Serrera 1985, 76).

1611 (September 22): Signed contract accepting the apprenticeship of Diego Velázquez (Rodríguez Marín 1923, 48–50).

1611 (October 29): With Juana de Salcedo and Diego Gómez contracted to execute paintings for the catafalque erected in Seville on the occasion of the funerary honors of Queen Margaret of Austria (Sancho Corbacho 1928, 240–41).

1611 (December 24): Appeared as a guarantor in the contract committing Juan and Diego de Salcedo to the gilding and *estofado* of the retable of the church of San Martín, Seville (Sancho Corbacho 1928, 248).

1612: Painted *Saint Ignatius* for the main staircase in the Colegio de San Hermenegildo, Seville (Pacheco 1956, 358).

1612 (November 12): Signed the drawing *Saint Lucy* (Galleria degli Uffizi, Florence) (Valdivieso and Serrera 1985, 39).

1613: Signed *Saint Gregory and Saint Ambrose* (in situ) for the retable of Saint John the Baptist commissioned for the convent of San Clemente, Seville, in 1610 (Valdivieso and Serrera 1985, 53).

1613 (September 6): Authorized the cleric Dr. Juan del Busto to appear in his name before the king and the royal council to seek privileges ("cierta gracia e merced") in royal service; also empowered Busta to present written testimony and to collect money owed him (López Martínez 1928, 88–89).

1614: Signed *Christ Crucified* (Instituto Gómez Moreno, Madrid) (Valdivieso and Serrera 1985, 77).

1614 (May 14): With other painters, including Juan Sánchez Cotán, authorized Pedro Suárez to begin litigation against the assessment of the *alcábala* on their works made by Miguel Guelles and Miguel Gonsales (two officials in the painters' guild) (López Martínez 1932, 195).

1615: Signed *Christ Crucified* (Teresa López Doria collection, Madrid) (Valdivieso and Serrera 1985, 77).

1615 (October 1): Signed the drawing *Saint Ines* (Galleria degli Ufizzi, Florence) (Valdivieso and Serrera 1985, 39).

1616: Painted *Christ Served by Angels* (Musée de Goya, Castres) destined for the refectory of the convent of San Clemente, Seville; painted *Saint Sebastian Attended by Saint Irene* for the Hospital de San Sebastián in Alcalá de Guadaira (Seville)

(this work was destroyed in 1936) (Pacheco 1956, 2: 280, 327; Valdivieso and Serrera 1985, 39–40).

1616 (July 16): Named by the *ayuntamiento* (city council) of Seville as *alcalde veedor del oficio de pintor* (overseer of the art of painting) (Asensio 1886, 17).

1616 (August 17): Alonso Cano entered his workshop as an apprentice (Bago y Quintanilla 1928, 95).

1616 (December 16): Requested a copy of the contract signed in 1592 with Doña Mencía de Morales for a retable for a chapel in the church of Santa María, Guadalupe, with the intention of bringing suit over details in the document (López Martínez, *Arquitectos* 1928, 230).

1617: Signed *Saint Francis* (Antonio González Nicolás collection, Seville) (Valdivieso and Serrera 1985, 40).

1617 (March 14): As *alcalde veedor del oficio de pintor* for the city of Seville, granted Velázquez a *carta de examen* (certificate of examination) (Bago y Quintanilla 1928, 5).

1617 (June 12): Contracted for the painting, gilding, and *estofado* of the Sagrario del Retablo for the parish church of San Lorenzo, Seville (Morales 1981 in Valdivieso and Serrera 1985, 40).

1618 (March 7): Named by the Tribunal of the Inquisition as *veedor de pinturas sagradas* (overseer of sacred paintings) (Pacheco 1956, 2: 194).

1618 (April 23): Daughter Juana de Miranda married Diego Velázquez (Asensio 1886, 26).

1619: Signed *Virgin of the Immaculate Conception with Miguel del Cid* (cat. 45) (Conferencia Episcopal Española 2005, 204).

1619: Received visit at his workshop of the duke of Alcalá; the viewing of *Christ Crucified with Four Nails* led to the polemic over the *Título de la Cruz* between the duke and Francisco de Rioja (Pacheco 1990, 29).

1619 (April 26): Receipt for 290 ducats for a painting for Garcitello Osario, resident of the Canary Islands (Bago y Quintanilla 1928, 97).

1619 (May 2): Swore to renounce claims to a salary for the title of *pintor del rey* (Bago y Quintanilla 1928, 95–96).

1619 (July 13): Signed letter of examination in favor of Francisco Herrera the Elder (Martínez Ripoll 1978, 259).

1619 (July 18): Valued a painting by Domingo de Carvallo (Valdivieso and Serrera 1985, 40 [not in López Martínez, 1932, 225]).

1620: Signed *Baptism of Christ* painted on marble that was in Los Toribios, Seville (no longer extant) (Asensio 1886, 101; Pacheco 1956, 1: xlii).

1620: Gave receipt of payment to the carver Eugenio Ortiz for goods that he had sent to a relative in New Spain (Valdivieso and Serrera 1985, 41 [not in Sancho Corbacho 1928, 653]).

1620 (January 24): Named valuator of a painting by Miguel Guelles for the church of Nuestra Señora de las Angustias, Ayamonte (Huelva) (Sancho Corbacho 1928, 272).

1620 (July 18): At his request an auction of his deceased brother's goods is held (López Martínez, *Retablos* 1928, 89).

1621: Signed *Virgin with the Portrait of Vázquez de Leca* (private collection, Seville) (Valdivieso and Serrera 1985, 69).

1622 (March 17): Received money from Doña Constanza of Araos as the administrator of a trust instituted by Doña Mencía Sánchez of Bayas (Cuéllar Contreras 1982 in Valdivieso and Serrera 1985, 41).

1622 (April 14): Authorized by Velázquez to collect debts in his (Velázquez's) name (López Martínez, *Retablos* 1928, 89).

1622 (May 18): In Velázquez's name rented houses on the calle del Patio in Seville to Juan Vázquez of Sigüenza (López Martínez, *Retablos* 1928, 89–90).

1622 (July 14): Agreed to execute nine paintings for the altarpiece for the main chapel of the monastery of Santo Domingo, Málaga, at the price of 200 ducats (López Martínez, *Retablos* 1928, 90).

1622 (July 16): Finished the brief treatise on the antiquity and honor of the art of painting and its comparison with sculpture (*A los profesores del Arte de la Pintura*) (Asensio 1886, L).

1623: Accompanied Velázquez on his definitive journey to Madrid (Asensio 1886, 27).

1623: Signed the *Annunciation* (Rectorate of the University of Seville) (Asensio 1886, 96).

1623 (January 4): Received a partial payment of 800 reales for the nine paintings that he was making for the monastery of Santo Domingo, Málaga (Bago y Quintanilla 1928, 97).

1623 (July 7): Received commission for an altarpiece of the Immaculate Conception for the chapel of Doña Isabel de Montemayor in the parish church of San Lorenzo, Seville (Muro Orejón 1935, 65).

1624: Signed the *Immaculate Conception* (in situ) from the retable for San Lorenzo (Valdivieso and Serrera 1985, 55).

1624 (July 5): Authorized the cleric Diego Arias to collect in his (Pacheco's) name 500 reales from the book printer Diego Pérez (López Martínez 1929, 184).

1624 (October 20): Resident in Madrid was empowered by the painter Francisco López to collect 30 ducats inherited from Juana López from her executor Diego Velázquez (López Martínez 1932, 190).

1624 (December 27): With the painter Francisco Varela commissioned by Juan Bautista de Mena of Seville for fourteen paintings (twelve apostles, Christ, and Virgin); declared that he had received 600 reales from de Mena through Juan Martínez Montañés (Muro Orejón 1935, 67).

1625: Juan Gómez de Mora, *maestro mayor del rey*, commissioned the painting and gilding of *Nuestra Señora de Expectación* for the countess of Olivares at the price of 2,000 reales; Cajés valued it at 500 ducats (Pacheco 1956, 2: 46–48).

1625 (July 30): Signed the *Knight of the Order of Santiago* (Williams College Museum of Art, Williamstown) (Valdivieso and Serrera 1985, 112).

1626 (March 7): In Madrid Velázquez solicited on Pacheco's behalf the title of royal painter (Gallego y Burín 1960, 225).

1626 (July 8): While at court in Madrid, empowered Luis de Lupica in Seville to deal with the matter of a house he had rented to the Hospital de Amor de Dios (Rodríguez Marín 1923, 50).

1627 (March 27): Authorized Francisco and Luis Ortiz to collect a debt from Cristóbal Pérez in Lima (López Martínez, *Arquitectos* 1928, 135).

1627 (March 27): Empowered Alonso de la Fuente to collect payment from Sebastián Martínez Botello of Cartagena for twenty-five pictures that had been delivered in 1614. In both documents designated as *pintor de masonería* (López Martínez, *Arquitectos* 1928, 135).

1627 (August 3): Authorized by Velázquez and his wife (who were in Madrid) to sell houses they owned in Seville near the Alameda de Hercules (López Martínez, *Arquitectos* 1928, 210–11).

1627 (September 26): Received commission for the execution of half of the work of gilding, *estofado*, and painting of the main altarpiece for the church of San Miguel, Jerez de la Frontera (Cádiz) (López Martínez, *Arquitectos* 1928, 41).

1628: Signed and dated *Mystical Marriage of Saint Ines* (Museo de Bellas Artes, Seville) (Valdivieso and Serrera 1985, 91).

1628 (February 5): With Baltasar Quintero commissioned by Doña Jerónima de Zamudio for the painting, gilding, and *estofado* of an altarpiece of the *Immaculate Conception*, coats of arms, and the gilding of the screen for her chapel in the Seville Cathedral (Rodríguez Marín 1923, 51).

1628 (May 9): Leased a house on the Alameda de Hercules in Seville (López Martínez, *Arquitectos* 1928, 136).

1629 (January 19): With Pablo Legot, Alonso Cano, and Francisco Fernández Llera formed a partnership to execute the painting, gilding, and *estofado* of the main altarpiece of the parish church of San Miguel, Jerez de la Frontera (Hernández Díaz 1929, 41).

1629 (January 22): Received the Portuguese Juan Ribero as an apprentice (López Martínez, *Arquitectos* 1928, 136).

1629 (March 23): As a witness signed the conditions for the execution of the retable for the brotherhood of Los Maestros Pintores for the church San Antonio Abad, Seville (Sancho Corbacho 1928, 291–92).

1629 (May 4): With Baltasar Quintero made a second contract for the work commissioned by Doña Jerónima Zamudio for her chapel in Seville Cathedral (López Martínez 1949, 265–66).

1630: Lope de Vega published a poem in praise of Pacheco in his *Laurel de Apolo*.

1630: (March 9): Signed the *Immaculate Conception* (Baron of Terrateig collection, Valencia) (Valdivieso and Serrera 1985, 66).

1631 (May 15): Authorized Rafael de Contreras in Santo Domingo to collect money and other things that were bequeathed to Pacheco by the painter Urbano Martín Blanco (López Martínez, *Arquitectos* 1928, 136).

1631 (September 22): With Juan del Castillo revoked the authorization given to Pablo Legot to collect 2,000 ducats for the work on the retable for the church of San Miguel, Jerez de la Frontera (López Martínez, *Arquitectos* 1928, 137).

1631 (November 1): Visited the *camarín* of the duke of Alcalá (Pacheco 1956, 2: 58).

1632 (February 27): Gave receipt of payment to Doña Jerónima de Zamudio for 17,000 reales for his share of the work for the decoration of her chapel in the Seville Cathedral (López Martínez 1949, 265–66).

1632 (May 31): Visited the Charterhouse in Seville (Pacheco 1956, 2: 35).

1632 (November 2): Signed the drawing of the *Virgin and Child* (formerly in the Boix collection) (Sánchez Cantón 1930, 3: pl. 201; Valdivieso and Serrera 1985, 44).

1633 (February 12): With Francisco Fernández de Llera granted Juan del Castillo the power to collect in his name the amount owed him for the painting, gilding, and *estofado* of the main altarpiece for the church of San Miguel, Jerez de la Frontera (López Martínez, *Arquitectos* 1928, 137).

1633 (November 22): With Juan del Castillo and Francisco Fernández de Llera authorized Alonso de Alarcón to collect in his name the last third of the amount owed for the altarpiece for the church of San Miguel, Jerez de la Frontera (López Martínez, *Arquitectos* 1928, 136–38).

1634: Painted *Presentation of the Virgin in the Temple* for the convent of Puerto de Santa María (Pacheco 1956, 2: 225); signed *San Fernando Entering Seville* (Seville Cathedral) (Valdivieso and Serrera 1985, 87).

1634 (April 27): Received payment from the *cabildo* of the Seville Cathedral for *San Fernando Entering Seville* (Gestoso y Pérez 1889–92, 3: 279; despite the document published by Gestoso y Pérez, Valdivieso and Serrera 1985, 44, assert that the date of payment should be 1633).

1635 (July 18): Commissioned by Miguel del Cid to paint an altarpiece for his chapel in San Francisco de Paula, Seville (López Martínez, *Arquitectos* 1928, 138).

1635 (July 30): Signed a drawing in the Kupferstichkabinett, Berlin (Pacheco 1956, 1: xlvi).

1635 (December 7): With Juan de Castillo authorized Fray Juan Vazquez to collect the remaining maravedíes owed for the altarpiece of San Miguel, Jerez de la Frontera (López Martínez, *Arquitectos* 1928, 139).

1636 (May 10): With Juan del Castillo valued the gilding and polychromy by Francisco Terron of the *monumento* of Holy Week for the parish church of San Pedro, Seville (Dabrio González 1975, 193–94).

1637: Signed *Saint Michael Archangel* (Church of San Alberto, Seville) (Valdivieso and Serrera 1985, 97).

1638: Signed *Flagellation* (private collection, Madrid) (Valdivieso and Serrera 1985, 45).

1638 (January 24): Signed the manuscript of *Arte de la pintura* (Pacheco 1956, 2: 433).

1639: Signed *Virgin of the Immaculate Conception* that was owned by Don Ignacio Galindo of Seville (now lost) (Asensio 1886, 99; Valdivieso and Serrera 1985, 45).

1639 (May 10): Made last will and testament in Seville (Salazar 1928, 157–60).

1641 (December 24): Asked for a license for the printing of *Arte de la pintura* (Valdivieso and Serrera 1985, 45).

1644 (November 27): Buried in the church of San Miguel, Seville (Gallego y Burín 1960, 256).

1649: *Arte de la pintura* was published in Seville by Simón Fajardo (Asensio 1886, 31).

Juan Pantoja de la Cruz

Because of the large number of signed and dated royal portraits by this artist, only those in the present exhibition are included in the chronology.

1553: Born, based on the declaration that he was fifty-three years old on July 7, 1606 (Martí y Monsó 1898–1901, 280).

1587: Married Francisca de Huertos in Madrid (dowry contracts dated March 29 and April 2, in Kusche 1964, 221–24).

1588: Signed his first portrait (Sánchez Cantón 1947, 110).

1590: In Valladolid assured his sister's dowry for her marriage (Martín González 1973, 461).

About 1590: In Simancas, where he had friends and family; made a Book of Hours, mentioned in his will of 1599, for Francisco Aguado, "oficial mayor de los Archivos de Simancas," who was the brother of his brother-in-law (Kusche 1964, 28); according to a drawing with descriptive text, he was engaged to paint thirteen portraits of Castilian kings for cupboard doors as part of the decoration project of the royal archives of Simancas (unrealized) (Plaza 1935, 259–62: "A probable date for the document is 1590 since in this year the part of the building that corresponds to the rooms and cupboards in the drawing was being built, and the death of the secretary Mateo Vázquez, in whose home Pantoja lived according to the document, occurred on May 4, 1591. This supposition is also confirmed by the fact that in a document dated August 18, 1590 a system of bronze doors for the cupboards is rejected in favor of paintings, which seems to refer to the decorative project related to our document").

1592: Made three *bodegones de Italia* (Italian still lifes) per his will of 1599 (Sánchez Cantón 1947, 102).

1595 (March 23): Receipt of payment from Antonio de Paredes for two religious paintings and an additional 24 reales for two small portraits copied from a devotional manuscript (Pérez Pastor 1914, 67).

1596: From this time, acted in the official capacity as *pintor de la cámara*, succeeding his master Alonso Sánchez Coello (Kusche 1996, 137; see Kusche 1964, 224–25, for account book of Francisco Guillaumas, the *maestro de cámara*, where Pantoja is mentioned as in the employ of the king in 1596 and 1597).

1597: Mentioned in the account book of the *maestría de la cámara* (as "pintor de su Majestad") regarding work for the funeral rites of the Infanta Doña Catalina Micaela (Kusche 1964, 226).

1597 (February 4): Sold a house on the calle de las Fuentes, Madrid, to the painter Santiago Morán (Pérez Pastor 1914, 71).

1597 and 1598: Mentioned in the account book of the *maestría de la cámara* (as *pintor del rey*) regarding the painting of the royal arms on church candles for the feast of Candlemas for the Infanta Isabel Clara Eugenia (Kusche 1964, 226).

1598: Received two payments for four escutcheons painted on the ceiling of the church of the Colegio de Doña María de Aragón, Madrid (Pérez Pastor 1914, 76).

1599 (January 8): Contracted with Don Juan Mingo for the painting and gilding of the altarpiece for the capilla del convento de Mercenarios, Madrid (Pérez Pastor 1914, 76–77).

1599 (January 15): Commissioned to paint a retable for the Hospital de la Misericordia, Madrid (Sánchez Cantón 1947, 105; Kusche 1964, 229, for testament)

1599 (January 23): Lent Eugenio Cajés 50 reales (Sánchez Cantón 1947, 100).

1599 (July 23): Made first will. In a codicil dated the same day he recorded his salary as 30,000 maravedíes (Pérez Pastor 1914, 79; Kusche 1964, 227–34, for document).

1599 (December 21): Another codicil added to the will (Pérez Pastor 1914, 81).

1600 (January 18): With Alonso Vallejo received commission for an altarpiece for the church of San Agustín outside of Madrigal de las Altas Torres (Avila) (Pérez Pastor 1914, 92).

1600 (May 26): Contracted with the sculptor Miguel González for the tabernacle and altarpiece for the main church in Valdeconcha (Guadalupe) (Pérez Pastor 1914, 83).

1600 (July): Appraised paintings and other devotional works of art in the estate of Philip II, including the Casa del Tesoro (Sánchez Cantón 1956–59, 10: 17–29; 11: 244–52).

1600 (August 23): On behalf of the Colegio de Doña María de Aragón, Madrid, appraised El Greco's altarpiece for just under 6,000 ducats (García Chico 1940–46, 3: 290; Brown 1982, 103–5).

1600 (October 8): Accepted seventeen-year-old Cristóbal López as an apprentice (Pérez Pastor 1914, 84).

1601: Signed *Saint Augustine* and *Saint Nicolas of Tolentino* (both Museo Nacional del Prado, Madrid) executed for the Colegio de Doña María de Aragón (Kusche 1964, 175–76).

1601 (October 6): Appraised the three triumphal arches made by Luis de Carvajal, Fabricio Castello, and Bartolomé Carducho in 1599 for the entry of Queen Margaret into Madrid. On behalf of Carvajal and Castello, valued the work at 34,300 reales (Pérez Pastor 1914, 89).

1602: Mentioned by Lope de Vega in *Hermosura de Angélica* (Kusche 1964, 10).

1602 (September 15 and 16): Ceded the work on the retable for the church of San Augustín outside of Madrigal de las Altas Torres to his colleague Alonso Vallejo because he was occupied with works for the king (Pérez Pastor 1914, 92).

1602 (September 23): In Valladolid signed the marriage contract of his daughter Mariana (Martí y Monsó 1898–1901, 525–26).

1603 (October 2): With Luis de Carvajal and Mateo de Paredes received commission for the painting of the main altarpiece for the church of Santa María, Ocaña (Toledo) (García Rey 1932, 139).

1604: Commissioned to paint thirty-five portraits for the new gallery, intended to be a pictorial genealogy of the house of Austria, in El Pardo, and for the stucco and fresco painting on the ceiling, which he shared with Francisco López (Kusche 1964, 34–35; 1999, 121).

1604 (October 30): Received payments (546,212 and 76,750 maravedíes) for unidentified works executed for Philip III in 1602 (Kusche 1964, 235–36).

1605: Signed the *Resurrection* for the church of the Hospital General de la Resurrección in Valladolid (cat. 31) (Martí y Monsó 1898–1901, 626, with the erroneous date of 1609; Beroqui in Agapito y Revilla 1922, 83).

1605 (January 31): Appraised the inventory of works left in Valladolid by the deceased painter Diego de la Puente (Martí y Monsó 1898–1901, 626).

1605 (December 23): Valued an altarpiece by Pedro de Oña in the church of Santa María, Medina de Rioseco (Valladolid) (García Chico 1940–46, 3: 256–57).

1606 (June 10): With Bartolomé Carducho signed the contract to paint, gild, and *estofar* the high altarpiece of the main chapel of the monastery of San Agustín, Valladolid (this commission not realized) (Martí y Monsó 1898–1901, 611–13).

1607: Signed *Portrait of Philip IV and Ana* (cat. 9) (Kusche 1964, 160–61).

1607 (March 21): Signed a contract for portraits for the *sala de retratos* in El Pardo, which he was obligated to finish by the end of April 1608 (Martín González, "Arte y artistas" 1958, 134).

1607 (May 15): Received 3,000 reales from Andrés Laredo y Vergara, treasurer to the duke of Lerma, for four portraits commissioned by the duke: two of the king and queen and two of the ducal pair (Pérez Pastor 1914, 120).

1607 (December 6): Received 1,900 reales from Andrés Laredo y Vergara for two portraits commissioned by the duke of Lerma (Pérez Pastor 1914, 611).

1608: Petitioned Philip III for payment of an outstanding bill for works in the service of the king (Kusche 1964, 257).

1608 (October 7): Second will (Pérez Pastor 1914, 124).

1608 (October 26): Died; buried in the Franciscan Church of Saint Ginés, Madrid (Sentenach 1912, 114).

1608 (November 3): Inventory taken of his household goods and workshop (Kusche 1964, 258); public auction of his estate held in this month (Kusche 1964, 263–64).

1608 (November 19): In the account of Pantoja's debtors, Francisco Ribalta was listed as owing "un escudo de oro" (400 maravedíes) (Sánchez Cantón 1947, 100).

1609: Lope de Vega mentioned him in *Jerusalén conquistada*.

1609 (February 24): His heirs entered into a financial agreement with Francisco López regarding the artist's unfinished work in the joint commission to decorate a room in El Pardo (Pérez Pastor 1914, 126).

1609 (March 5): Agreement between his children and Francisco López to finish the paintings for El Pardo left incomplete at the artist's death (Pérez Pastor 1914, 126).

1609 (November 27): His daughter Mariana and son-in-law entered into a contract with Bartolomé González to complete the portraits for El Pardo (Pérez Pastor 1914, 129).

1610 (April 29): Inventory and division of the goods that belonged to him and his wife, Francisca de Guertos (Pérez Pastor 1914, 131).

1610 (May 7): Settlement between Francisco Guillaumas, *maestro de la cámara*, and Pantoja's children regarding the unfinished retable for the chapel of Nuestra Señora de la Asunción in the convent of San José, Avila (Pérez Pastor 1914, 131).

1612: His heirs submitted invoices for unpaid works executed in royal service by the artist from 1600 to 1608; these paintings were appraised at 17,604 reales (twenty-four pictures ordered by Queen Margaret), 14,953 reales (fifteen works ordered by Philip III), and 2,275 ducats (thirty-five portraits for El Pardo) (Aguirre, "Documentos I" 1922, 17–21; Aguirre, "Documentos II" 1922, 270–73; 1923, 201–5).

Francisco Ribalta

1565 (June 2): Baptized in Solsona (Lérida in Catalonia) (Lloréns Solé 1951, 93).

About 1571–73: At some point during this period the Ribalta family moved to Barcelona (Lloréns Solé 1951, 85). Family vineyard was sold on March 25, 1571, and family house on the calle de Castillo in Solsona was sold on August 27, 1573 (Lloréns Solé 1951, 100–1).

1581 (June 8): With his siblings named as his parents' heirs in a document granting power of attorney to his older brother Juan to sell a family vineyard in Borina (Lloréns Solé 1951, 92).

1582: In Madrid signed *Preparations for the Crucifixion* (The State Hermitage Museum, St. Petersburg) (Tormo y Monzó 1916, 27).

1591 (December 23): Contracted for the *Annunciation* for the jurist Matías Romano Cuello, a member of the court, at the price of 10 ducats and to be completed within two months. The preparatory drawing was supervised by the painter Blas de Prado (Maldonado 1970, 5).

1596 (May 28): In Madrid acted as a witness to the signing of a legal document drawn up by Gaspar de Velasco, secretary to the king, and his wife Inés de Paz (Maldonado 1970, 6).

About 1596–97: Married Inés Pelayo; their son Juan was born in Madrid (Darby 1938, 27 n. 27, 234).

1599 (February 12): Declaration of Francisco Noguer, a Barcelona businessman who acted on various occasions as agent for the Ribalta family, of a debt of 40 libras owed to the painter, by then resident in Valencia. Noguer restated the debt as 47 libras in a subsequent document dated June 21, 1599 (Ainaud de Lasarte 1947, 349–50; Benito Doménech 1988, 36).

1599 (April): Living on the calle de Renglóns enrolled in the confraternity of La Virgen de los Desamparados, Valencia (González Martí 1928, 161).

1601 (February 12): Living on the calle de Nuestra Señora de Gracia, death of his infant son is recorded in the book of the parish church of San Martín, Valencia (González Martí 1928, 161).

1601 (March 20): Living on the calle Sans, the death of his wife, Inés Pelayo, is recorded in the book of the parish church of San Martín, Valencia, where she was buried (González Martí 1928, 161).

1601 (October 3): Received payment for the price of blue pigment used to "paint and retouch" the fresco of the *Martyrdom of Saint Andrew* by Bartolomé Matarana in the sanctuary of the Colegio de Corpus Christi, Valencia (Benito Doménech 1980, 125, 139).

1601 (October 5): Served as guarantor in the contract for the painting and gilding of the altarpiece of the main chapel of the church of the Colegio de Corpus Christi by Bartolomé Matarana (Boronat y Barrachina 1904, 285–88).

1602: Mentioned by Lope de Vega in *Hermosura de Angélica*.

1602 (December 28): Employed by Pedro Juan Esquerdo to paint two portraits of Fray Domingo Anadón, almoner of Santo Domingo (Thomás Miguel 1716 in Darby 1938, 229).

1603: Signed the *Martyrdom of Santiago* and *Santiago Matamoros* for the altarpiece of the parish church of Santiago Apóstol, Algemesí (in situ) (Valencia) (Darby 1938, 230).

1603 (February 26): In Valencia received payment for two paintings (*Presentation of the Virgin* [now lost] and *Christ Child* [possibly the painting in The Colegio de Corpus Christi, Valencia]) made for the Patriarch Juan de Ribera's *casa de estudios* in Burjasot (Valencia) (Boronat y Barrachina 1904, 37).

1603 (March 21): Payment of 30 reales to Ribalta's shop boy for three days' work on the main altarpiece of the Colegio de Corpus Christi (Boronat y Barrachina 1904, 294).

1603 (May 2): Received payment for a portrait of *Bishop Don Miguel de Espinosa* to be used as a model for Bartolomé Matarana's fresco in the chapel of Nuestra Señora de la Antigua in the church of the Colegio de Corpus Christi (Boronat y Barrachina 1904, 37).

1604 (August 31): Received 12 libras for a painting presented by Canon Miguel Vicente Molla of the cathedral to the Colegio de Corpus Christi for one of the altars in the main chapel (Boronat y Barrachina 1904, 37–38).

1604 (November 20): Residing in Algemesí was reimbursed for a journey to Valencia for the purpose of planning the retable of Saint Vincent Ferrer for a side chapel in the Colegio de Corpus Christi (Boronat y Barrachina 1904, 38).

1604 (December 13): Payment made to a courier who carried letters from the patriarch to the artist in Algemesí (Boronat y Barrachina 1904, 38).

1605 (January 24): Payment made to a second courier who carried letters from the patriarch to the artist in Algemesí (Boronat y Barrachina 1904, 38).

1605 (February 8): Received 210 libras for *Christ Appearing to Saint Vincent Ferrer* (Robres and Castell 1943, 214); this painting was placed on the main altar of the chapel of Saint Vincent Ferrer (formerly dedicated to the two Saint Johns) in the Colegio de Corpus Christi (in situ) (Benito Doménech 1980, 131–32).

1605 (November 8): Received 60 reales for a painting of Christ made for the Capuchin Friars of Alcira (Valencia) by order of the patriarch (Boronat y Barrachina 1904, 38).

1605 (December 16): Received 110 reales, 70 reales for two portraits of *Fray Francisco del Niño Jesús* and 40 reales for a portrait of *Pope Paul v* executed for the patriarch (Boronat y Barrachina 1904, 38–39).

1606 (February 11): Received 400 libras for the *Last Supper* for the high altar of the church of the Colegio de Corpus Christi (in situ); he agreed to finish the painting to the satisfaction of the marquis de Malpica, nephew of the patriarch (Boronat y Barrachina 1904, 39).

1606 (February 13): Received 100 reales for the portrait of *Sister Agullona*, an Augustinian nun venerated by the patriarch, made for her sepulchre (Boronat y Barrachina 1904, 39); this painting is a copy of a work by the artist from about 1600 (Benito Doménech 1980, 125).

1607 (September 15): Commissioned by the silversmiths' guild to complete within four years the painting, gilding, and *estofado* of the altarpiece (nine paintings) dedicated to Saint Eligius in the parish church of Santa Catalina, Valencia (Rodríguez Roda 1944, 330–33).

1607 (October 19): Mentioned in an excerpt from the minutes of a meeting of the Colegio de Pintores of Valencia in which was recorded the reelection of officers; he was to be a councilor (*consejero*) (Tramoyeres 1911, 291–93).

1607 (October 29 and 30): Appraised a retable painted by Juan Sariñena for the *generalidad* (government) of Valencia (Martínez Aloy 1909–10, 87; Kowal 1981, 242–43, for record).

1607 (November 3): Received payment from the *generalidad* of Valencia for his part in the valuation of Sariñena's retable (Kowal 1981, 244).

1608 (November 19): Listed in the account of Juan Pantoja de la Cruz's debtors as owing "un escudo de oro" (Sánchez Cantón 1947, 100).

1610: Record of payment for painting and gilding the retable of the parish church of Algemesí (Belda Ferre 1908 in Darby 1938, 232–33).

1610 (May 8): Received payment for clay (*arcila de Torrente*) acquired from the mason Guillem Roca (Benito Doménech 1980, 127, 140).

1610 (June 20): Received 80 reales for work done on the retable of Saint Eligius in Santa Catalina, Valencia (Rodríguez Roda 1944, 335).

1610 (July 9): Received payment for the *Nativity* atop the main altarpiece of the Colegio of Corpus Christi (above the *Last Supper*) and other works there (Robres and Castell 1943, 215).

1611 (January 28 and December 17): Received payments for work done on the retable of Saint Eligius in Santa Catalina, Valencia (Rodríguez Roda 1944, 335–37).

1612: Living on the calle de Ruzafa with his son Juan and household servants appeared in the book of communicants of the parish of San Martín, Valencia (González Martí 1928, 164).

1612: Signed the *Vision of Father Simón* (cat. 44) (Darby 1938, 233).

1612 (December 5): Received payment for decorative works executed for Don Joaquín Real, regent of the chancellery (Tramoyeres 1917, 97).

1613 (January 24): Received 60 libras for three pictures of Padre Francisco Jerónimo Simó (Father Simón), ordered by the *cabildo* of the Valencia Cathedral, to be sent to Pope Paul v, King Philip iii, and the duke of Lerma (Talón 1918, 203).

1615: Was ill during this period; his eighteen-year-old son Juan executed and signed *Preparation for the Crucifixion* (Museo Provincial de Bellas Artes, Valencia) (Orellana 1930, 109).

1615 (November 30): Received payment for posthumous portraits of Archbishop Juan de Ribera and his father Don Perafán de Ribera, duke of Alcalá, for the library of the Colegio de Corpus Christi, Valencia. Acknowledged receipt of 24 libras on December 16, 1615 (Robres and Castell 1943, 216; Benito Doménech 1980, 141).

1616 (August 16): Acknowledged receipt of 45 libras from the *cabildo* of the cathedral for the portrait of Thomas of Villanueva (Talón 1918, 202).

1616 (September 5): Mentioned in testimony given before the tribunal (*jurados*) of Valencia by a witness hostile to Colegio de Pintores (Tramoyeres 1911, 452).

1616 (September 27–October 29): Appeared in the roll book of the Colegio de Pintores of Valencia (Tramoyeres 1911, 515).

1616 (October 23): Mentioned in minutes of a meeting of the Colegio de Pintores held for the reelection of officers; Ribalta was one of the *mayorales* (Tramoyeres 1911, 524–25).

1617 (February 11): Mentioned in minutes of a meeting of the Colegio de Pintores held for the purpose of voting on a proposed assessment (Tramoyeres 1911, 526).

1617 (June 13): In a document of goods received as part of the dowry of Doña María de Andosilla Larramendi in her marriage to Francisco Calvo, two paintings by Ribalta are listed: a copy after a *Savior* by Raphael and an image of *Nuestra Señora del Pópulo* (Maldonado 1970, 6).

1617 (June 22–July 13): Among the members of the Colegio de Pintores who petitioned the king for support of the organization; replied to by the regent Don Lucas Pérez Manrique (manuscript found and copied by the count of Viñaza, who asserted that the original was in the Archivo General de Simancas [where it no longer exists]; see Viñaza 1894, 294–96; Tramoyeres 1911, 461–62).

1618 (January 1): Elected *baciner de pobres* (a position that required collecting and distributing alms each Saturday and warm clothing on All Saint's Day) for the parish church of San Andrés, Valencia (Benito Doménech and Vallés Borrás 1989, 146).

1618 (January 18): Appealed the position of *baciner de pobres*, since it would demand a certain dedication and expense (Benito Doménech and Vallés Borrás 1989, 146).

1618 (February 17): Answered in writing the series of questions that had been posed by Martí de Sent Climent, representative of the parish of San Andrés, on February 14 (Benito Doménech and Vallés Borrás 1989, 151).

1618 (March 23): Martí de Sent Climent took statements from other witnesses that were in favor of the election of Ribalta as *baciner de pobres* (Benito Doménech and Vallés Borrás 1989, 154).

1619: Received payment (Francisco or Juan?) for the painting of the *Savior* for the high altar of the parish church in Jérica (Valencia) (Pérez Martín 1935, 306).

1619 (March 2): Juan Castellví, lieutenant general for the governor, settled suit brought by the church of San Andrés by stating that the artist had to serve and administrate the office of "obrer menor de pobres" for the year 1619 and had to pay a penalty of 100 libras (Benito Doménech and Vallés Borrás 1989, 155).

1620: Record of a *Last Supper* (no longer extant), executed for the refectory of the Capuchin convent of La Sangre de Cristo, outside Valencia (*Noticias curiosas sobre los conventos de Capuchinos de la Provincia de Valencia*, unpublished manuscript in the Biblioteca Municipal of Valencia in Darby 1938, 238).

1622 (November 13): Street altar erected with a painting by the artist in the parish of Saint Martin, Valencia (*Cosas evangudes en la ciutat y regne de Valencia* 1934 in Kowal 1985, 190).

1623: Inventory of goods made by Angelo Nardi on the occasion of his wedding, including a debt owed him by Ribalta (Kowal 1981, 267).

1625–27: Account of the work undertaken for the Charterhouse of Portacoeli near Bétera (Valencia), including *Christ Embracing Saint Bernard* and an altarpiece of sixteen paintings by him and his close collaborators (Tramoyeres 1917, 98–99; Benito Doménech 1988, 46).

1628 (January 13): Died suddenly of a stroke of apoplexy (Tramayores 1917, 95).

1628 (January 14): Buried in the church of the Santos Juanes, Valencia (Tramoyeres 1917, 95) where his son Juan, who had died on October 9, 1628, was also interred (Darby 1938, 19 n. 3).

Jusepe Ribera

1591 (February 17): Baptized in Játiva, son of Simón Ribera, shoemaker, and Margarita Cuco (Viñes 1923 and Mateu y Llopis 1953 in Finaldi, "Documentary Appendix" 1992, 231).

1610: In Parma received commission for a *Saint Martin and the Beggar* (no longer extant) from a lay confraternity of the church of San Prospero (according to an unpublished two-volume manuscript by Enrico Scarabelli-Zunti entitled "Documenti e memorie di belle arti parmigiane dall'anno 1068 all'anno 1851" (2: 159): "In the sixteenth century, this small church [of San Prospero] had three altars, one of which was maintained by a lay confraternity [that] in 1610 commissioned from the painter Giuseppe Ribera, known as Lo Spagnoletto, who was then in Parma to study the works of the immortal Allegri, that stupendous altarpiece which shows Saint Martin dividing his cloak to cover a poor man's nakedness. The young and almost unknown artist was paid only 109 lire (*sic*) and one soldo for the picture, when today it would be worth thousands!"; see Finaldi, "A Documentary Look" 1992, 6 n. 2).

1611 (June 11): In Parma received payment for the *Saint Martin and the Beggar* ("L.209.s" recorded in a note in an eighteenth-century manuscript; see Cordaro 1980 in Finaldi, "Documentary Appendix" 1992, 232).

1613 (October 27): In Rome received an invitation from the Accademia di San Luca to attend a meeting in which the subject of discussion was the Accademia's church (Hoogewerff 1913 in Finaldi, "Documentary Appendix" 1992, 232).

1614 (April 6): With Guido Reni, Ottavio Leoni, and other academicians "Joseph Riviera Hyspanus" committed to contribute the considerable sum of 100 ducats to a fund for the construction of the church of the Accademia di San Luca, in Rome (Gallo 1998 in Lange 2003, 265–66).

1615 (April): Was in Rome with one of his brothers ("Girolamo fratello di Giuseppe") (Chenault 1969 in Finaldi, "Documentary Appendix" 1992, 232).

1616 (March): Was still in Rome with his younger brother Juan ("Giovanni suo fratello") (Chenault 1969 in Finaldi, "Documentary Appendix" 1992, 232).

1616 (May 7): Paid 2 scudi to the Accademia di San Luca (Hoogewerff 1913 in Finaldi, "Documentary Appendix" 1992, 232).

1616 (July 21): In Naples received payment for *Saint Mark* for Marcantonio Doria (Delfino 1986 in Lange 2003, 272).

1616 (October 8): Received 9 ducats from Don Fernando de Aragón for a painting (Lange 2003, 272: "A d[o]n fernando d'Aragon D. nove per essi à Giuseppe rivera pintor del e[xcelenti]a d[iss]e per una pittura fatta per suo ser[viti]o").

1616 (November 10): Marriage contract with Caterina Azzolino y India (Delfino 1987 in Finaldi, "Documentary Appendix" 1992, 234).

1616 (between November 11 and December 25): Married Caterina Azzolino y India in the church of San Marco dei Tessitori, Naples (Salazar 1894 in Finaldi, "Documentary Appendix" 1992, 234).

1617 (August 18): Received 100 ducats for painting banners for four of the duke of Elma's (Lerma's?) galleys (Nappi 1990 in Finaldi, "Documentary Appendix" 1992, 234).

1617 (August 31): Received 50 ducats as final payment of the 300 ducats owed for painting banners for four of the duke of Elma's (Lerma's?) galleys (Nappi 1990 in Finaldi, "Documentary Appendix" 1992, 234).

1617 (September 16): Authorized Gaspar Belaver to settle the account between the artist and David de Leon in Rome (Lange 2003, 275).

1617 (November 7): Dowry of Caterina Azzolino, wife of the painter, ratified (Finaldi, "Documentary Appendix" 1992, 234).

1617 (December 9): "Gio de Rivera" (Jusepe or, less likely, his brother Juan, who was also a painter) referred to in a document as having received 50 ducats from Bernardo Farardo for *Saint Augustine* (Finaldi, "Documentary Appendix" 1992, 234–35, made available by Eduardo Nappi).

1618 (January 23): Referred to in a letter from the Tuscan agent in Naples, Cosimo del Sera, to the grand duke Cosimo II's secretary, Andrea Cioli (Parronchi 1980 in Finaldi, "Documentary Appendix" 1992, 235).

1618 (February 8): Paid 150 ducats to the painter Giovanni Bernardino Azzolino, his father-in-law (Nappi 1990 in Finaldi, "Documentary Appendix" 1992, 235).

1618 (February 12): Received 300 ducats, drawn on a military account, from Apparitio d'Orive, secretary to the duke of Osuna, viceroy of Naples (Nappi 1990 in Finaldi, "Documentary Appendix" 1992, 235: "Alia Cassa Militare D.300. E per essa al presidente Apparitio d'Orive per spese secrete del servitio di Sua Maestà dei quali n'ha da dar conto. E per esso a Giuseppe de Ribera di sua volontà").

1618 (February 13 and 20): Letter from Cosimo del Sera to Andrea Cioli, indicating that the artist was to paint a picture for the grand duke of Tuscany, Cosimo II (Parronchi 1980 in Finaldi, "Documentary Appendix" 1992, 235).

1618 (March 6): Del Sera informed Cioli that work had not begun on the picture for the grand duke yet because the artist was painting a *Crucifixion* for the vicereine of Naples (Parronchi 1980 in Finaldi 1991, 445–46, with corrected transcription).

1618 (April 12): Del Sera informed Cioli that the work for the grand duke would be finished by the end of May (Parronchi 1980 in Finaldi, "Documentary Appendix" 1992, 235).

1618 (August 11): Received 300 ducats from Azzolino in accordance with the dowry agreement (Ferrante 1979 and Nappi 1990 in Finaldi, "Documentary Appendix" 1992, 236, with corrected transcription per Lange 2003).

1618 (October 13): Received payment from Vincenzo Vettori, the Tuscan agent in Naples, for *Martyrdom of Saint Bartholomew* (Nappi 1990 in Finaldi, "Documentary Appendix" 1992, 236, with minor corrections per Lange 2003).

1618 (October 26): Received 50 ducats from the Tuscans Capponi and Del Sera for an unidentified painting (Nappi 1990 in Finaldi, "Documentary Appendix" 1992, 236).

1618 (December 11): Praised highly in a letter from Lodovico Carracci in Bologna to Ferrante Carlo, the Roman collector (Bottari and Ticozzi 1822 in Finaldi, "Documentary Appendix" 1992, 289).

1619 (August 13): Paid part of the annual sum he owed for a house he had acquired in the Strada di Santo Spirito (Nappi 1990 in Finaldi, "Documentary Appendix" 1992, 236).

1619 (October 26): Acquired stone and paid for work on his house in the Strada di Santo Spirito (Nappi 1990 in Finaldi, "Documentary Appendix" 1992, 236).

1619 (November 7): Received payment for three paintings of evangelists for Marcantonio Doria (Delfino 1984 in Finaldi, "Documentary Appendix" 1992, 236, with minor corrections per Lange 2003).

1620 (March 23): Received payment for a *Guardian Angel* and *Pietà* for Marcantonio Doria (Delfino 1984 in Finaldi, "Documentary Appendix" 1992, 237).

1620 (April 3): Borrowed 100 ducats from Azzolino (Nappi 1990 in Finaldi, "Documentary Appendix" 1992, 237).

1620 (July 4): Paid 50 ducats to the Della Trinità brothers, from whom he had bought a house (Nappi 1990 in Finaldi, "Documentary Appendix" 1992, 237).

1620 (August 26): Received from Lanfranco Massa the balance of 20 ducats for the *Guardian Angel* for Marcantonio Doria, which already had been delivered; borrowed 30 ducats from Massa (Nappi 1990 in Finaldi, "Documentary Appendix" 1992, 237; Delfino 1984 in Lange 2003, 282).

1620 (September 12): His brother-in-law Gabriele Azzolino sold *Saint Bartholomew* to the Florentine Vincenzo Vettori (Nappi 1990 in Finaldi, "Documentary Appendix" 1992, 237).

1620 (October 2): Received payment from the Tuscans Capponi and Del Sera for *Saint Jerome in the Desert* (Delfino 1984 in Finaldi, "Documentary Appendix" 1992, 237).

1620 (October 5): Received payment for some paintings executed for the Florentine Vincenzo Vettori (Delfino 1986 in Finaldi, "Documentary Appendix" 1992, 237–38).

1620 (October 26): Received payment for three paintings of apostles for Vincenzo Vettori (Delfino 1984 in Finaldi, "Documentary Appendix" 1992, 238).

1620 (November 3): Received 20 ducats for two paintings of apostles; information repeated in another letter of November 5, 1620 (Nappi 1990 in Finaldi, "Documentary Appendix" 1992, 238).

1620 (November 10): Received 20 ducats owed him by Vincenzo Vettori (Nappi 1990 in Finaldi, "Documentary Appendix" 1992, 238).

1620 (November 18): Received payment for two "heads" for Vincenzo Vettori (Delfino 1986 in Finaldi, "Documentary Appendix" 1992, 238).

1621 (September 13): Received payments for unspecified works (Nappi 1990 in Finaldi, "Documentary Appendix" 1992, 238).

1621 (September 20): Received 40 ducats from the convent of Trinità delle Monache, Naples, to acquire pigments for a painting he was to make for the church (Nappi 1988 in Finaldi, "Documentary Appendix" 1992, 238).

1621 (October 14): Received payment from Pier Capponi for two paintings; reiterated in letter of January 21, 1622 (Nappi 1990 in Finaldi, "Documentary Appendix" 1992, 238).

1622 (March 27): Notary's record (probably the marriage contract of Elivra Azzolino, Caterina's sister, and the physician Michele Adott, childhood friend

of Ribera's brother Juan) indicating that Ribera paid an annual sum of 14 ducats to his father-in-law (Prota-Giurleo 1953 in Finaldi, "Documentary Appendix" 1992, 238–39).

1622 (July 23): Received payment from Princess Squillace for some unspecified works (Nappi 1990 in Finaldi, "Documentary Appendix" 1992, 239).

1623 (May 15): Received payment from Princess Squillace for a painting (Nappi 1990 in Finaldi, "Documentary Appendix" 1992, 239).

1623 (June 3): Received payment for a painting (*Pietà*), which he was to execute for Marcantonio Doria (Nappi 1990 in Finaldi, "Documentary Appendix" 1992, 239).

1623 (July 1): Acted as a witness to the marriage of Luca Castaldo and Anna Melone (Salazar 1895 in Finaldi, "Documentary Appendix" 1992, 239).

1623 (July 7): Received final payment from Lanfranco Massia for the *Pietà* for Marcantonio Doria (Nappi 1990 in Finaldi, "Documentary Appendix" 1992, 239).

1623 (July 12): Received payment from Giovan Battista and Orazio de'Medici (Nappi 1990 in Finaldi, "Documentary Appendix" 1992, 239).

1625: Met Jusepe Martínez, the painter from Saragossa (Martínez 1988, 98–100); acted as a witness to Baldassare Cañizal's (Cannizzaro) marriage to Giulia Cognone (Prota-Giurleo 1953 in Finaldi, "Documentary Appendix" 1992, 240).

1626: Cared for the children of his recently widowed sister-in-law Anna (née Azzolino) Biancardo in his house (Prota-Giurleo 1953 in Finaldi, "Documentary Appendix" 1992, 240–41).

1626 (January 19): As a witness signed the marriage contract of Giovanni Dò, a painter from Játiva who had been in Naples for about three years, to Maria Grazia de Rosa (Prota-Giurleo 1951 in Finaldi, "Documentary Appendix" 1992, 240); witnessed their marriage on May 3, 1626 (Salazar 1895 in Finaldi, "Documentary Appendix" 1992, 240).

1626 (January 29): Admitted to the Order of Christ in a ceremony held at Saint Peter's, Rome (Chenault 1976 in Finaldi, "Documentary Appendix" 1992, 240).

1626 (February 15): In Naples declared himself a member of the "Congregazione della Beata Vergine die Sette Dolori" in the church of the Santo Spirito di Palazzo and requested to be buried there in the chapel of the Madonna Santissima del Rosario (Finaldi 1995 in Lange 2003, 290).

1626 (April 16): Will of the Sicilian painter Gabriele Testa in which he bequeathed 7.30 scudi owed to him by Ribera to the "Congregatione Nativitatis Beate Virginis" in San Lorenzo in Lucina, Rome (Lange 2003, 291).

1626 (August 8): Received 20 ducats from Princess Squillace for a painting she had commissioned from him (Nappi 1990 in Finaldi, "Documentary Appendix" 1992, 241).

1627 (January 18): Baptism of his son Antonio Simone (Salazar 1894 in Finaldi, "Documentary Appendix" 1992, 241).

1627 (April 13): The chapter of the Colegiata of Osuna, near Seville, expressed gratitude to the duchess of Osuna, Catalina Enríquez, for the gift of ten paintings including Ribera's *Crucifixion*, still in Osuna (Rodríguez-Buzón Calle 1982 in Finaldi, "Documentary Appendix" 1992, 241).

1627 (October 2): Received payment for *Martyrdom of Saint Andrew* (Delfino 1985 in Finaldi, "Documentary Appendix" 1992, 241).

1628 (November 25): Baptism of his son Jacinto Tomás (Salazar 1894 in Finaldi, "Documentary Appendix" 1992, 241).

1630 (April 22): Baptism of his daughter Margarita (Salazar 1894 in Finaldi, "Documentary Appendix" 1992, 242).

1630 (December 20): Received payment from the procurator of the count of Monterrey for two paintings (Nappi 1990 in Finaldi, "Documentary Appendix" 1992, 242).

1631 (July 17): Baptism of his daughter Anna Luisa (Salazar 1894 in Finaldi, "Documentary Appendix" 1992, 243).

1634 (May 9): Baptism of his son Francisco Antonio (Salazar 1894 in Finaldi, "Documentary Appendix" 1992, 243).

1634 (before June 24): Received payment from King Philip IV for works (*Satyr*, *Venus and Adonis*, two of *las furias* (*Ixion* and *Sisyphus*), and two from the fable of Adonis) from his secret account for the decoration of the Buen Retiro, Madrid (Finaldi, "Documentary Appendix" 1992, 243).

1634 (October 3): Postscript to a letter from the duke of Alcalá to his agent in Naples, Sancho de Céspedes, with instructions for the commission of a *Madonna* from Ribera and for the acquisition of a painter's mannequin (Saltillo 1940–41 in Finaldi, "Documentary Appendix" 1992, 243–44).

1636 (October 9): Baptism of his daughter María Francesca (Salazar 1894 in Finaldi, "Documentary Appendix" 1992, 244–45).

1638: Called *insigne pintor* (celebrated painter) and father identified as shoemaker in genealogy of the artist that was sent by the notary of the Holy Office in Játiva to the inquisitor general (San Petrillo 1953 in Finaldi, "Documentary Appendix" 1992, 245).

Between 1651 (August 31) and 1652 (September 3): Petitioned Philip IV to grant a benefice to his daughter Margarita, recently widowed (Prota-Giurleo in Finaldi, "Documentary Appendix" 1992, 251).

1652 (September 3): Died in Naples (Salazar 1896 in Finaldi, "Documentary Appendix" 1992, 253).

Juan de Roelas

About 1568: Earliest birth date if Roelas was "over twenty-five years old" as stated in a document of 1594; born in Flanders (Fernández del Hoyo 2000, 26, as "of Flemish origin").

1594 (March 8): Living in Valladolid he and his father were obliged to pay back a loan of 300 reales to Juan Fernández, *racionero* (prebendary) of the church in Palencia (Fernández del Hoyo 2000, 25).

1594 (June 16): With his father rented a house on the calle de los Baños for a period of four years; in the document he is designated as being over twenty-five years old (Fernández del Hoyo 2000, 26).

1597: Signed the print of the *Elevation of the Cross* (Angulo Iñiguez 1925, 104).

1598 (May 28): In Valladolid appraised the paintings left at the death of Doña Luisa Enríquez, daughter of Doña Francisca Enríquez de Almansa, marchioness of Poza and widow of Don Francisco de Fonseca y Ayala, Señor de Coca y Alaejos (Fernández del Hoyo 2000, 26).

1598 (December 26): Along with other artists, brought a complaint against the University of Valladolid for unpaid paintings (four figures, six *jeroglyphicos*, and a large coat of arms) executed for the funerary monument for Philip II (Martí y Monsó 1898–1901, 235).

1599 (May 7): With other artists petitioned Antonio Aras, the majordomo of the University of Valladolid, for final payment for his work on the tomb of Philip II (Martí y Monsó 1898–1901, 235).

1601: Mentioned in the accounts of the duke of Lerma as having been paid for various coats of arms that had been realized for the church and convent of San Pablo, Valladolid (Martí y Monsó 1898–1901, 602).

1602 (February 9): Acquired houses situated outside the Puerta del Campo in the Acera de Santispíritus that had belonged to the sculptor Juan de Juni and were sold by Juana Martínez, widow of Isaac de Juni, son of Juan; later reneged on the purchase (Martí y Monsó 1898–1901, 416).

1603 (January): From this time appeared in the account book of the church of Santa María de la Nieves, Olivares (Seville), as chaplain of the church ("Documentos varios" 1927, 78).

1604: Executed the majority of the paintings for the high altar of the Jesuit Casa Profesa, Seville (Valdivieso and Serrera 1985, 118 [undocumented]).

1606 (March): Recorded for the last time in the accounts of the chaplains of Olivares, in which he had appeared uninterrupted since 1603 ("Documentos varios" 1927, 78).

1607 (October 22): The *cabildo* of Las Palmas Cathedral wrote to its dean, resident in Seville, about the purchase of the artist's *Saint Anne* (Montero 1933 in Valdivieso and Serrera 1985, 130).

1608 (September 9): Received from Father Juan, superior of the Colegio de San Gregorio in Seville, partial payment for the painting of *Saint Gregory*; full payment was rendered this same year (Angulo Iñiguez 1929 in Valdivieso and Serrera 1985, 131).

1609 (February 9): Praised in letter sent by the *cabildo* of Las Palmas Cathedral to the rector of the Jesuits regarding payment for *Saint Anne*, intended as an altarpiece for the cathedral (Montero 1933 in Valdivieso and Serrera 1985, 131).

1609 (May 23): With Juan de Salcedo and Vasco Pereira received commission for the gilding, painting, and *estofado* of the high altarpiece of the church of El Salvador, Seville (López Martínez, *Retablos* 1928, 116).

1609 (September 16): Received 3,000 reales from the Seville Cathedral for *Saint James at the Battle of Clavijo* and *Pietà* (Gestoso y Pérez 1889–92, 2: 539).

1609 (September 22): Received 200 ducats from Antonio Quirós de Perea in exchange for the royal appointment of governor for life of the Casa de la Moneda in Seville, a post held at that time by Antonio's father, Andrés (Cuéllar Contreras 1982 in Valdivieso and Serrera 1985, 131).

1609 (September 24): Delivered to Antonio Quirós de Perea a royal document extending the time of the governorship of Andrés de Perea of the Casa de la Moneda (Cuéllar Contreras 1982 in Valdivieso and Serrera 1985, 131).

1611: Acted as chaplain of the Church of El Salvador, Seville; asked for a substitute as he was ill (Gestoso y Pérez 1912, 59).

1611 (September 10): Drew up a will in Seville (Valdivieso and Serrera 1985, 131).

1612: Received payment from the Hospital de San Bernardo (de los Viejos), Seville, for the *Vision of Saint Bernard* commissioned for the *sala de cabildos* of the hospital (Angulo Iñiguez 1925, 107–9).

1612: Executed a *Liberation of Saint Peter* for the brotherhood of Sacerdotes Beneficiados de San Pedro, Seville; Roelas was admitted to this brotherhood (Valdivieso and Serrera 1985, 118–19, 170).

1612 (March 12): Received commission from the *licenciado* Gabriel de Torres Nieto of the Colegio del Salvador for *Christ at the Column* at the price of 400 reales (Sancho Corbacho 1928, 250).

1612 (April 21): Living in the parish of San Vicente in Seville, leased half of a house owned by the Hospital de San Bernardo (de los Viejos) (López Martínez 1932, 202).

1613 (August 16): As *clérigo presbítero* contracted for the design, gilding, and painting (including the central painting of the *Death of Saint Isidoro*) of the retable for the church of San Isidoro, Seville (Bago y Quintanilla 1928, 69).

1614 (December 30): Received a receipt of payment and settlement from the joiner Miguel Bovis for the altarpiece for the church of San Isidoro (Bago y Quintanilla 1928, 78).

1615: Painted the *Holy Spirit* for the Hospital del Espíritu Santo, Seville (Valdevieso and Serrera 1985, 125).

1615 (June 29): Participated in Seville in the procession in honor of the Immaculate Conception, according to inscriptions on his painting of the subject in the Museo Nacional de Escultura, Valladolid (fig. 62, p. 141) (Valdivieso and Serrera 1985, 131–32).

1616: Painted *The Flagellated Christ Contemplated by the Christian Soul* and *Christ on the Mount of Olives* for Philip III for La Encarnación, Madrid (Valdivieso and Serrera 1985, 158).

1616 (April 28): Receipt of payment to the majordomo of the church of San Isidoro for *Death of Saint Isidoro* painted for the high altarpiece of the church (Bago y Quintanilla 1928, 79).

1616 (July 6): As *clérigo presbítero pintor* valued (with the assistance of Juan Gómez de Mora, overseer of the king's works) the paintings of an altarpiece made by Vicente Carducho for the church of the royal convent of La Encarnación, Madrid, on behalf of the king; Eugenio Cajés valued it on behalf of Carducho (Pérez Pastor 1914, 153–54).

1617 (July 1): In Madrid requested the position of *pintor del rey*, vacated on the death of Fabricio Castello; the position was granted to Bartolomé González (Mayer 1911, 218).

1617 (October 11): Bartolomé González, Jerónimo Cabrera, and Vicente Carducho made a list of paintings, appraised by Roelas, executed for the monastery of the Capuchins at El Pardo (Martín González, "Arte y artistas" 1958, 132).

1618: With Eugenio Cajés revalued the paintings made by Vicente Carducho for the high and side altarpieces of the convent of La Encarnación, Madrid (Pérez Pastor 1914, 160).

1618 (March 3): In Madrid Bartolomé González, on behalf of the king, and Eugenio Cajés, on the part

of the artist, valued three paintings executed by Roelas in 1616 for Philip III; asked for payment and on August 30 he was granted a decree of discharge for the amount owed (Moreno Villa 1936, 262).

1619 (July 12): Designated as royal chaplain, received 500 ducats from the treasurer Don Fernando de Novela on behalf of Don Manuel Alonso, eighth duke of Medina-Sidonia, for the paintings for the monastery of the Unshod Order of Mercy, Sanlúcar de Barrameda (Cadíz) (Valdivieso 1978, 301).

1619 (October 29): In Madrid received another 500 ducats as payment for the paintings ordered for the monastery of the Unshod Order of Mercy, Sanlúcar de Barrameda (Valdivieso 1978, 301).

1621: Appeared in the Mass books of the chaplains of the church of Olivares (Seville) ("Documentos varios" 1927, 78).

1624 (June 22): In Olivares authorized his sister Catalina de Roelas of Seville to collect payment from Don Antonio de Loaysa, resident of Granada, for a painting of *Saint Leocadia* ("Documentos varios" 1927, 78).

1624 (October 10): Received 400 reales to purchase necessary materials for the pictorial series commissioned for the monastery of the Unshod Order of Mercy, Sanlúcar de Barrameda (Valdivieso 1978, 301).

1624 (November): Received an additional 3,600 maravedíes for materials necessary for the painting of the altarpieces for the monastery of the Unshod Order of Mercy, Sanlúcar de Barrameda (Valdivieso 1978, 301).

1624 (December 17): Received 8,400 maravedíes as final payment (of 3,000 reales total) for the paintings for the altarpieces of the monastery of The Unshod Order of Mercy in Sanlúcar de Barrameda (Valdivieso 1978, 301–2).

1624 (December 23): Signed a receipt of payment for the paintings commissioned by the duke of Medina-Sidonia for the monastery of the Unshod Order of Mercy, Sanlúcar de Barrameda (Valdivieso 1978, 302).

1625 (April 25): Buried in the church of Olivares; named in document as prebendary ("Documentos varios" 1927, 79).

Peter Paul Rubens

This chronology covers only the painter's first trip to Spain.

1603 (March 5): Left Mantua, part of an embassy charged with delivering to the Mantuan representative in Valladolid a series of gifts from his patron, Vincenzo Gonzaga, duke of Mantua, for King Philip III of Spain and other courtiers, including the duke of Lerma. The gift included close to forty paintings, and Rubens was to contribute to the gift by adding paintings of his own if the occasion demanded (Vergara 1999, 7).

1603 (April 2): Set sail from Livorno (Vergara 1999, 7).

1603 (April 22): Arrived at Alicante as described in a letter to Jan van der Neesen (Vergara 1999, 7; Lawrence 2006, 245 n. 1).

1603 (May 13): Arrived in Valladolid (400 miles from Alicante) (Vergara 1999, 7).

1603 (May 24): Letter to Annibale Chieppio, secre-

tary of state to the duke of Mantua, in which he referred to the "many splendid works of Titian. . . ." and stated that he associated little with the local court artists, whose work he described with great contempt, condemning "the incredible incompetence and carelessness of the painters here, whose style is totally different from mine" (Vergara 1999, 9–10). Also wrote about Lerma's "knowledge of fine things" and his "particular pleasure and practice" of seeing the great works that had been assembled in the royal collection (Magurn 1991, 33).

1603 (June 14–July 6): At some point during this period painted in Valladolid *The Philosophers Democritus and Heraclitus* (fig. 38, p. 95) (Museo Nacional de Escultura, Valladolid), in substitution for *Saint John in the Wilderness* and a painting of the Virgin that were judged to have been damaged beyond repair upon their arrival in Valladolid (the former was actually restored by Rubens and presented to Lerma) (Vergara 1999, 7, 16).

1603 (July): Asked by the duke of Lerma to paint him a picture of his own invention ("di suo capriccio") (Vergara 1999, 14).

1603 (July 18): Letter from Iberti, the Mantuan representative in Valladolid, to the duke of Mantua in which he reported the duke of Lerma's desire to have Rubens remain in Spain: "If Your Highness had sent Rubens to remain in the service of His Majesty, which would have pleased him very much, I answered so as not to lose this servant" (Vergara 1999, 16, 202 n. 51).

1603 (September 15): In a letter to Chieppio referred to a "great equestrian portrait" of the duke that the artist was to paint (Vergara 1999, 14); began work on *Equestrian Portrait of the Duke of Lerma* (cat. 11) in this month (Vergara 1999, 8).

1603 (November?): Last letter from Spain written to Gonzaga's secretary of state, Annibale Chieppio (Magurn 1991, 37–38).

1603: At the end of this year, may have traveled to Valencia (Baschet 1867 in Vergara 1999, 203 n. 56).

1604: Departed from Spain in the first months of this year (Vergara 1999, 18).

1604 (June 2): Documented in Italy; has been speculated that he arrived in February, based on a Latin poem written in honor of Rubens by his brother Philip (Rooses and Ruelens 1887 in Vergara 1999, 203 n. 56).

Juan Sánchez Cotán

1560 (June 25): Baptized, the son of Bartolomé Sánchez de Plasencia and Catalina Ramos, in the parish church of Orgaz in the environs of Toledo (Cherry 1991, 434; 1999, 465).

1593 (April 21): Was authorized by artist Blas de Prado, on the day before his voyage to Morocco, to collect money owed for an altarpiece Prado had painted for the parish church in Campo de Criptana (Ciudad Real) (Cherry 1991, 434; 1999, 465).

1597 (July 4): Paid the painter Diego de Aguilar the Younger money collected from the Hospital del Rey from the sale of Aguilar's property in the parish of San Justo y Pastor (Cherry 1991, 434; 1999, 465).

1599: Painted two sundials for the courtyards of the Tavera Hospital, Toledo (Cherry 1991, 434; 1999, 465).

1599 (July 9): Living in Toledo, with the painter Pedro Sánchez Delgado authorized Blas de Prado to name them as guarantors of a contract he had signed with the church of San Salvador, Madridejos (Toledo) (Cherry 1991, 434; 1999, 465).

1599 (December 14): As one of El Greco's creditors was paid 500 ducats for an unspecified debt from the payment made by Martín Ramírez de Zayas to El Greco for work on the chapel of San José (Saint Joseph), Toledo (Cherry 1991, 435; 1999, 465).

1600 (February 9): With other painters pledged to complete the altarpieces of the high altar of San Bartolomé de la Vega in the outskirts of Toledo, commissioned from Blas de Prado in 1593 and left unfinished at his death (Cherry 1991, 435; 1999, 465).

1600 (September 10): Mentioned as one of the painters whose altarpieces for the church of the monastery of Los Mínimos, Toledo (originally commissioned from Blas de Prado in 1593), were valued (Cherry 1991, 435; 1999, 465).

1602: Signed *Still Life with Game Fowl, Fruit and Cardoon* (Museo Nacional del Prado, Madrid) (Cherry 1991, 435; 1999, 465).

1602 (March 10): Collected money due for painting and gilding the retables of the church of the monastery of Los Mínimos, Toledo (Cherry 1991, 435; 1999, 465).

1603 (August 10): Signed his will on the eve of departing Toledo; authorized Juan de Salazar and Diego de Valdivieso to administer his estate and goods and his brother Alonso Sánchez Cotán, resident of Alcázar de San Juan (Ciudad Real), to collect money owed for four paintings commissioned by Melchor de Acevedo (Cherry 1991, 435–36; 1999, 466).

1603 (August 13): Already absent from Toledo, his executor Juan de Salazar had an inventory made of the artist's goods (Cherry 1991, 436; 1999, 466).

1603–4: Was a lay brother in the monastery of the Shod Augustinians, Granada (Cherry 1991, 436; 1999, 466).

1604 (July 29): Prepared report of *limpieza de sangre* for entry into the order of the Charterhouse of Granada (Cherry 1991, 436; 1999, 466).

1604 (September 8): Professed as a lay brother in the Charterhouse of Granada (Cherry 1991, 436; 1999, 466).

1610: Was named among the most esteemed members of the Charterhouse of El Paular (Madrid) (Cherry 1991, 436; 1999, 466).

1611 (January 13): In Toledo collaborated with his nephew, the sculptor Alonso Sánchez Cantón, on a retable for the main altar of the parish church in San Pablo de los Montes (Toledo) (Cherry 1991, 436; 1999, 44 n. 3).

1612: Left the Charterhouse of Granada to go to the town of Alcázar de San Juan to intervene in a family dispute between his brother, Alonso Sánchez Cantón, his nephews, and the sculptor Ignacio García Escucha, who had been a pupil of Alonso and married his sister that year (Cherry 1991, 437; 1999, 466).

1627 (April 8): Died at the Charterhouse of Granada (Cherry 1991, 437; 1999, 466).

Luis Tristán

About 1590: Born in Toledo (birth date unknown); this is the latest date he could have been born, according to a document of March 19, 1615, in which he declares himself to be over twenty-five years old (Gómez Menor 1967, 151–52).

1603 (July 11): Served as a witness to the ratification of the contract commissioning El Greco to paint the altarpieces for the Hospital de la Caridad, Illescas (Toledo) (signed his name as Luis de Escamilla) (San Román y Fernández 1927, 164).

1603 (September 12): Appeared as a witness to a document in which El Greco authorized Francisco Pantoja de Ayala to collect partial payment for the retable for the Colegio de San Bernardino, Toledo (San Román y Fernández 1924, 9).

1604 (October 29): Served as a witness to a document in which Manuso Theotokopoulos, El Greco's brother and executor of Tomas Trechelo's will, authorized Pedro Sánchez de Mendoza to ask religious and royal councils in Toledo for an extension of Trechelo's permit to raise funds for the release of Turkish prisoners (San Román y Fernández 1927, 170).

1606 (November 7): Served as a witness to a power of attorney given by El Greco to his son Jorge Manuel Theotokopoulos to take charge of the construction of the main and side altarpieces of the parish church in San Martín de Montalbán (Toledo) (San Román y Fernández 1927, 276).

1612 (May 10): Contracted for twenty-four large and twenty-four small paintings commissioned by the councilman of Toledo, Luis Sirvendo (Pérez Sánchez and Navarrete Prieto 2001, 278–79).

1612 (October 2): Recieved 2,600 reales from the Jesuits of Toledo for twenty-four pictures of Jesuit martyrs for the Casa Profesa (Marías 1978, 421; Pérez Sánchez and Navarrete Prieto 2001, 279–80, for document).

1613: Signed the *Holy Family* (cat. 26) (Angulo Iñiguez and Pérez Sánchez 1972, 153).

1613 (November 11): Contracted for the *Last Supper* and other paintings for the monastery of Nuestra Señora de Santa María de la Sisla, Toledo (signed his name for the first time as Luis Tristán) (San Román y Fernández 1924, 9, 17–18).

1613 (December 9): With his parents promised to supply the dowry for his sister, Ursula de Escamilla, in her marriage to the painter Manuel de Acevedo (Pérez Sánchez and Navarrete Prieto 2001, 281–82).

1614 (June 14): Signed marriage contract with Catalina de la Higuera (San Román y Fernández 1924, 18–19).

1614 (June 26): Marriage to Catalina de la Higuera (Ramírez de Arellano 1920, 310).

1614 (July 7): Drew up a dowry document relating to his marriage to Catalina de la Higuera (Pérez Sánchez and Navarrete Prieto 2001, 283–84).

1615: Publication in Toledo of *De Apelatione* by Juan de Narbona with a portrait of the author engraved by Pedro Angel after a design by Tristán (Angulo Iñiguez and Pérez Sánchez 1972, 140).

1615 (March 19): With his mother, Ana de Escamilla, signed a document in which he declared himself to be over twenty-five years old, recognizing the debt of 800 reales to Juan de Rojas, curate of San Nicolás (Gómez Menor 1967, 151–52).

1615 (May 5): Received commission for the painting of the altarpiece of the parish church in Yepes (Toledo) (Gutiérrez García-Brazales 1982 in Pérez Sánchez and Navarrete Prieto 2001, 285).

1615 (July 7): Acted as guarantor of the minor Gabriel de Balderrama, *macero* (mace-bearer) of the Capilla de los Reyes Nuevos, Toledo, in a debt of 894 reales the youth owed to the clothing merchant Francisco Fernández Mazo (San Román y Fernández 1924, 19).

1615 (October 5): Leased a house on the callejón de Gaitán from Gaspar Vargas (Marías 1978, 421, with date of 1611; according to Pérez Sánchez and Navarrete Prieto 2001, 286, the date should be 1615).

1616: Signed the *Adoration of the Magi* (in situ), one of the paintings from the Yepes altarpiece (Angulo Iñiguez and Pérez Sánchez 1972, 144).

1616 (January 20): Likely appeared as a witness to the will of El Greco, written by Jorge Manuel (San Román y Fernández 1910, 199–202, as "Juan" Tristán; Marías 1997, 297, questioned whether the Juan was meant to be Luis).

1616 (June 9): With his mother owed 175 reales to Juan Gómez de la Cruz (Pérez Sánchez and Navarrete Prieto 2001, 286–87).

1616 (August 1): Signed a two-year lease on a house in the parish of San Miguel in Toledo (Gómez Menor 1967, 153).

1617 (April): Received commission for an altarpiece for the church in Cedillo (Toledo) (Gutiérrez García-Brazales 1982 in Pérez Sánchez and Navarrete Prieto 2001, 31, 288).

1617 (April 28): Appeared in the book of *oficiales* of the archbishopric of Toledo regarding the commission for a tabernacle and an altarpiece for the church of San Martín, Ocaña (Gutiérrez García-Brazales 1982 in Pérez Sánchez and Navarrete Prieto 2001, 31, 288).

1617 (June 17): Commissioned by Miguel González, a Toledan sculptor, for a *Crucifixion* to be placed in the retable of the chapel of the *licenciado* Agraz de Marquina in the church of San Martín, Ocaña (Pérez Sánchez and Navarrete Prieto 2001, 31, 288–89).

1617 (July 18): With his mother as guarantor, owed 1,887 reales to Francisco Fernández de Montemayor (Marías 1978, 421, with erroneous sum; Pérez Sánchez and Navarrete Prieto 2001, 31, 289, for document).

1618 (February 10): Appeared as his mother's guarantor in the lease to her of the tavern Mesón de la Fruta Vieja (San Román y Fernández 1924, 20).

1618 (May 25): Appeared in the book of *oficiales* of the archbishopric of Toledo regarding the commission for an altarpiece for San Andrés, Casarrubios del Monte (Gutiérrez García-Brazales 1982 in Pérez Sánchez and Navarrete Prieto 2001, 32, 290).

1618 (May 27): Leased a house in Toledo for one year (Pérez Sánchez and Navarrete Prieto 2001, 290).

1618 (May 31): Charged with raping the young virgin María Muñoz, a servant at the tavern owned by Tristán's mother (incorrectly cited by Marías 1978, 422, as a business negotiation with the girl's father, the merchant Juan Nuñez Montesinos; Pérez Sánchez and Navarrete Prieto 2001, 291, for document).

1618 (September 26): At the behest of Jorge Manuel valued the painting and gilding of the *Adoration of the Shepherds* for El Greco's sepulchral chapel in Santo Domingo el Antiguo, Toledo (San Román y Fernández 1924, 20).

1618 (September 26): Diego de Aguilar, painter, valued El Greco's altarpiece in Santo Domingo el Antiguo; he recounted that Tristán verified the work as by the hand of Domenico Greco and that he saw him paint it (San Román Fernández 1924, 21).

1619 (March 15): Received 20 ducats for the portrait of Cardinal Bernardo Sandoval y Rojas (chapter house, Toledo Cathedral) (Zarco del Valle 1916, 363).

1619 (April 15): Contracted for the apprenticeship of fourteen-year-old Pedro de Camprobín (San Román y Fernández 1924, 21–22).

1619 (May 30): Accepted Miguel de Montoya as an apprentice (San Román y Fernández 1924, 21).

1620: Signed the *Adoration of the Shepherds* (cat. 23) from the altarpiece of Las Cuatro Pascuas made for the church of the convent of Jeronimas de la Reina, Toledo (where it was seen and praised by Ponz and Ceán) (Angulo Iñiguez and Pérez Sánchez 1972, 151); signed the *Adoration of the Magi* (Szépmüvészeti Múzeum, Budapest) from the same altarpiece (Angulo Iñiguez and Pérez Sánchez 1972, 152).

1620 (July 2): Document of the transfer of houses in Toledo to the artist (Pérez Sánchez and Navarrete Prieto 2001, 294–95).

1620 (December 3): Obligated with his brother-in-law Manuel de Acevedo to execute six paintings to be signed by Tristán in partial payment of a debt to the merchant Pedro de Alcaya (Pérez Sánchez and Navarrete Prieto 2001, 295–96).

1621 (January 12): Accepted sixteen-year-old Alonso Gutiérrez de Castro as an apprentice (Pérez Sánchez and Navarrete Prieto 2001, 296).

1621 (June 2): Petitioned the *ayuntamiento* of Toledo for payment for the catafalque erected to honor the memory of Philip III, executed with Jorge Manuel (San Román y Fernández 1924, 22–23).

1621 (August 18): Settled dispute with Pedro Tirado Palomino, *racionero* of the Toledo Cathedral, over their adjacent houses (San Román y Fernández 1924, 23–24).

1622 (January 16): Accepted thirteen-year-old Bartolomé García as an apprentice (San Román y Fernández 1924, 24).

1622 (February 12): Contracted for the main altarpiece of the convent of Santa Clara, Toledo (Pérez Sánchez and Navarrete Prieto 2001, 299–302).

1622 (February 18): Accepted Mateo del Pino, son of the sculptor Juan Fernández, as an apprentice (Pérez Sánchez and Navarrete Prieto 2001, 298–99).

1623: Signed the altarpiece for the convent of Santa Clara, Toledo (Angulo Iñiguez and Pérez Sánchez 1972, 141).

1623 (October 16): Appeared as guarantor of Juan Gómez Cotán in the contract for gilding the altarpiece of the convent of Saint Ursula, Toledo (Marías 1978, 421; Pérez Sánchez and Navarrete Prieto 2001, 303–7, for document).

1623 (November 21): Admitted the young Francisco de Herrera as his pupil (Pérez Sánchez and Navarrete Prieto 2001, 303).

1624: Signed two paintings of the *Trinity* (parish church, Moral de Calatrava [Ciudad Real] and Seville Cathedral); list of his debts to Juan Francisco Bozo and Juan Domingo de Santa Ágata documented and signed by the notary public Francisco López (San Román y Fernández 1924, 27–28).

1624 (January 8): Received 300 ducats for the altarpiece for the convent of Santa Clara (San Román y Fernández 1924, 25, as recorded by the painter Diego de Aguilar in his will).

1624 (November 8): Received commission to paint the *Incarnation of the Virgin* for the confraternity of Las Ánimas del Purgatorio to be placed in the chapel of Saint Peter in the Toledo Cathedral (Pérez Sánchez and Navarrete Prieto 2001, 307–8).

1624 (November 9): Contracted with Gonzalo Marín for four canvases for an altarpiece for the church in Alameda de la Sagra (Toledo) to be finished within one year and at the price of 1,000 reales (Gómez Menor 1967, 156).

1624 (December 6): Made last will and testament in which his mother, Ana de Escamilla, was named executrix and heir; Jorge Manuel witnessed the document and signed it for him (San Román y Fernández 1924, 25–27).

1624 (December 7): Died (Pérez Sánchez and Navarrete Prieto 2001, 310); according to his will Tristán was buried in the monastery of San Pedro Mártir.

Diego Velázquez

This chronology is pertinent only to the reign of Philip III.

1599 (June 6): Baptized in the church of San Pedro, Seville, son of Juan Rodríguez de Silva and Jéronima Velázquez (Mancini 2006, 245).

1610 (December 1): Began apprenticeship to Francisco Pacheco, with whom he would live for six years (Rodríguez Marín 1923, 48).

1611 (September 17 and 27): Contract of apprenticeship to Pacheco, signed by Juan Rodríguez on September 17 and by Pacheco on September 27 (Rodríguez Marín 1923, 48–49).

1617 (March 14): Examined by Pacheco as overseer of the art of painting in Seville and accepted as "master painter of religious images, and in oils and everything related." He is licensed to practice anywhere in the kingdom, to have his own workshop, and to paint for churches and public palaces (Mancini 2006, 245).

1618: Signed *Old Woman Cooking Eggs* (cat. 62) (Mancini 2006, 245).

1618 (April): Received dowry document from Pacheco, his wife, and daughter (Morales 1999, 222; *Corpus Velázqueño* 2000, 1: 32).

1618 (April 23): Married Pacheco's daughter, Juana de Miranda (Mancini 2006, 245).

1619: Signed the *Adoration of the Magi* (cat. 22), probably executed for the Jesuits (Mancini 2006, 245).

1619 (May 18): Baptism of his daughter Francisca (Mancini 2006, 245).

1619 (between December 9 and 16): Rented houses in the district of Alameda de Hércules, which were part of his wife's dowry, to Captain Cardosi (*Corpus Velázqueño* 2000, 1: 37).

1620: Signed *Mother Jerónima de la Fuente* (fig. 7, p. 28) (Museo Nacional del Prado, Madrid) and the posthumous portrait *Don Cristóbal Suárez de Ribera* (on loan to the Museo de Bellas Artes, Seville) for the church of San Hermenegildo, Seville (Mancini 2006, 245).

1620 (February 1): Accepted his first apprentice, Diego de Melgar (Mancini 2006, 245).

1621 (January 29): Baptism of his daughter Ignacia (Mancini 2006, 245).

1621 (March 2): Rented a house in the parish of San Martín, Seville, to Pedro Sánchez (Morales 1999, 222).

1621 (July 13): Rented a house in the Alameda district, Seville, to Francisco Ramírez (Morales 1999, 222).

1622 (March 5): Authorized Pacheco to collect debts (maravedíes or goods) owed him (*Corpus Velázqueño* 2000, 1: 40).

1622 (April): Visited Madrid, accompanied by Diego de Melgar, and El Escorial for the first time; painted *Portrait of Luis de Góngora y Argote* (cat. 17) at the request of Pacheco, which, according to him, "was very celebrated in Madrid" (Bray in Carr et al. 2006–7, 144).

1622 (May 18): In Velázquez's name Pacheco rented out houses owned by the artist on the calle del Potro, Seville (Morales 1999, 222).

1623 (January 25): Back in Seville rented some houses in the Alameda district to Pedro Bastardo (Morales 1999, 222)

1623 (June 9): Appeared as witness in a document drawn up by the mother-in-law of his brother Juan (Morales 1999, 223).

1623 (July 7): Acted as guarantor for a contract signed by Pacheco to paint and gild a retable in the chapel of the Conception in the church of San Lorenzo, Seville. This is the last document in which the painter is said to be "resident in the city of Seville" (Mancini 2006, 245).

Selected Bibliography for the Biographies

Agapito y Revilla, Juan. "Juan Pantoja de la Cruz en Valladolid." *Boletín de la Sociedad Española de Excursiones* 30 (1922): 81–87.

Aguirre, Ricardo de. "Documentos relativos a la pintura en España: Juan Pantoja de la Cruz, Pintor de Cámara, i." *Boletín de la Sociedad Española de Excursiones* 30 (1922): 17–22.

———. "Documentos relativos a la pintura en España: Juan Pantoja de la Cruz, Pintor de Cámara ii." *Boletín de la Sociedad Española de Excursiones* 30 (1922): 270–74.

———. "Documentos relativos a la pintura en España: Juan Pantoja de la Cruz, Pintor de Cámara, iii." *Boletín de la Sociedad Española de Excursiones* 31 (1923): 201–5.

Agulló y Cobo, Mercedes. *Noticias sobre pintores madrileños de los siglos xvi y xvii.* Granada: Departamentos de Historia del Arte de las Universidades de Granada y Autónoma de Madrid, 1978.

———. *Documentos para la historia de la pintura española.* Vol. 1. Madrid: Museo del Prado, 1994.

———. *Documentos para la historia de la escultura española.* Madrid: Fundación de Apoyo a la Historia del Arte Hispánico, 2005.

Agulló y Cobo, Mercedes, and María Teresa Baratech Zalama. *Documentos para la historia de la pintura española.* Vol. 2. Madrid: Museo del Prado, 1996.

Ainaud de Lasarte, Juan. "Ribalta y Caravaggio." *Anales y Boletín de los Museos de Arte de Barcelona* 5 (1947): 345–413.

Allende-Salazar, Juan, and Francisco J. Sánchez Cantón. *Retratos del Museo del Prado.* Madrid: Cosano, 1919.

Alvarez Márquez, María Carmen. "Documentos de artistas sevillanos del siglo xvi en el archivo de protocolos notariales de Sevilla." *Estudis Històrics i Documents dels Arxius de Protocols* 9 (1981): 197–247.

Angulo Iñiguez, Diego. "Juan de Roelas: Aportaciones para su estudio." *Archivo Español de Arte y Arqueología* 1 (1925): 103–9.

Angulo Iñiguez, Diego, and Alfonso E. Pérez Sánchez. *Historia de la pintura española: Escuela madrileña del primer tercio del siglo xvii.* Madrid: Instituto Diego Velázquez, 1969.

———. *Historia de la pintura española: Escuela toledana de la primera mitad del siglo xvii.* Madrid: Instituto Diego Velázquez, 1972.

Asensio, José María. *Francisco Pacheco: Sus obras artísticas y literarias.* Seville: Imp. de E. Rasco, 1886.

Azcárate, José María de. "Noticias sobre Velázquez en la corte." *Archivo Español de Arte* 33 (1960): 357–85.

———. "Algunas noticias sobre pintores cortesanos del siglo xvii." *Anales de Instituto del Estudios Madrileños* 6 (1970): 43–61.

Bago y Quintanilla, Miguel de. "Aportaciones documentales." In *Documentos para la historia del arte en Andalucía.* Vol. 1. Universidad de Sevilla, Labratoria de Arte, 167–203. Seville: Facultad de Filosofía y Letras, 1927.

———. "Aportaciones documentales." In *Documentos para la historia del arte en Andalucía.* Vol. 2. Universidad de Sevilla, Labratorio de Arte, 5–104. Seville: Facultad de Filosofía y Letras, 1928.

———. *Arquitectos, escultores y pintores sevillanos del siglo xvii. Documentos para la historia del arte en Andalucía.* Vol. 5. Seville: Facultad de Filosofía y Letras, 1932.

Bartolomé, Belén. "Cronología." In *Gregorio Fernández, 1576–1636,* ed. Jesús Urrea, 155–58. Exh. cat. Madrid: Fundación Central Hispano, 1999–2000.

Benito Doménech, Fernando. *Pinturas y pintores en el real Colegio de Corpus Christi.* Valencia: Federico Doménech, 1980.

———. *Los Ribalta y la pintura valenciana de su tiempo.* Exh. cat. Madrid: Museo del Prado, 1987.

———. *The Paintings of Ribalta, 1565–1628.* Exh. cat. New York: Spanish Institute, 1988.

Benito Doménech, Fernando, and Vicente Vallés Borrás. "Un proceso a Francisco Ribalta en 1618." *Academia* 69 (1989): 145–68.

Boronat y Barrachina, Pascual. *El B. Juan de Ribera y el R. Colegio de Corpus Christi.* Valencia: Impr. de F. Vives y Mora, 1904.

Bosarte, Isidoro. *Viage artístico a varios pueblos de España.* Vol. 1. Madrid: Imprenta Real, 1804.

Bray, Xavier, and Lois Oliver. "Chronology." In *El Greco,* by David Davies et al., 32–41. Exh. cat. New York and London: The Metropolitan Museum of Art and The National Gallery, 2004.

Brown, Jonathan. *Images and Ideas in Seventeenth-Century Spanish Painting.* Princeton: Princeton University Press, 1978.

———. "El Greco and Toledo." In *El Greco of Toledo,* by Jonathon Brown et al., 75–147. Exh. cat. Toledo: Toledo Museum of Art, 1982.

———. *Velázquez: Painter and Courtier.* New Haven and London: Yale University Press, 1986.

———. "Academies of Painting in Seventeenth-Century Spain." *Leids Kunsthistorisch Jaarboek* 5–6 (1986–87): 178–85.

———. *The Golden Age of Painting in Spain.* New Haven and London: Yale University Press, 1991.

———. *Painting in Spain, 1500–1700.* New Haven and London: Yale University Press, 1998.

Brulez, Wilfrid. *Marchands flamands à Venise.* Vol. 1. Brussels: Institut historique belge de Rome, 1965.

Camón, Aznar, José. *La pintura española del siglo xvii.* Summa Artis, historia general de arte 25. Madrid: Espasa-Calpe, 1978.

Carducho, Vicente. *Diálogos de la pintura: Su defensa, origen, esencia, definición, modos y diferencias,* ed. Francisco Calvo Serraller. Madrid: Ediciones Turner, 1979.

Carr, Dawson W. et al. *Velázquez.* Exh. cat. London: The National Gallery, 2006–7.

Caturla, María Luisa. "Cartas de pago de los doce cuadros de batallas para el Salón de Reinos del Buen Retiro." *Archivo Español de Arte* 33 (1960): 333–55.

———. "Documentos en torno a Vicencio Carducho." *Arte Español* 26 (1968–69): 145–221.

Ceán Bermúdez, Juan Agustín. *Diccionario histórico de los más ilustres profesores de las bellas artes en España.* 6 vols. Madrid: Imprenta de la viuda de Ibarra, 1800. Facsimile ed., Madrid: Reales Academias de Bellas Artes de San Fernando y de la Historia, 1965.

Cervera Vera, Luis. "Arquitectos y escultores del retablo y enterramientos de la Capilla Mayor de la Iglesia del desaparecido convento de la Merced de Madrid." *Revista de la Biblioteca, Archivo y Museo del Ayuntamiento de Madrid* 17 (July 1948): 275–371.

Cherry, Peter. "Still Life and Genre Painting during the First Half of the Seventeenth Century." Ph.D. dissertation, Courtauld Institute, 1991.

———. "Nuevos datos sobre Bartolomé González." *Archivo Español de Arte* 66, no. 261 (1993): 1–9.

———. *Arte y naturaleza: El bodegón español en el Siglo de Oro.* Ed. Conchita Romero, trans. Ivars Barzdevics. Madrid: Fundación de Apoyo a la Historia del Arte Hispánico, 1999.

Conferencia Episcopal Española. *Inmaculada.* Exh. cat. Madrid: Catedral de la Almudena, 2005.

Corpus Velazqueño. Vol. 1. Madrid: Ministerio de Educación, Cultura y Deporte, Dirección General de Bellas Artes Bienes Culturales, 2000.

Cortijo Ayuso, Francisco. "El pintor Juan Bautista Maino y su familia." *Wad-al-Hayara* 5 (1978): 285–92.

Cruz Yábar, María Teresa. "El retablo de Vicente Carducho para el hospital de Nuestra Señora de Rosario de Briviesca." *Anales de Historia del Arte* 6 (1996): 191–201.

Cuerpo de Archiveros, Bibliotecarios y Anticuarios. "Seccion oficial y de noticias: Variedades." *Revista de Archivos, Bibliotecas y Museos* 1 (1874): 439–47.

Dabrio González, María Teresa. *Estudio histórico-artístico de la parroquia de San Pedro.* Seville: Diputación Provincial de Sevilla, 1975.

Darby, Delphine Fitz. *Francisco Ribalta and His School.* Cambridge: Harvard University Press, 1938.

Davies, David and Enriqueta Harris. *Velázquez in Seville.* Exh. cat. Edinburgh: The National Gallery of Scotland, 1996.

Davies, David, et. al. *El Greco.* Exh. cat. New York and London: The Metropolitan Museum of Art and The National Gallery, 2003–4.

"Documentos varios." In *Documentos para la historia del arte en Andalucía.* Vol. 1. Universidad de Sevilla, Labratorio de Arte, 77–80. Seville: Facultad de Filosofía y Letras, 1927.

Esteve Guerrero, Manuel. "San Miguel, joya jerezana." *Revista Ateneo* 4, nos. 39–41 (October–December 1927): 286–349.

Falomir Faus, Miguel. *Los Bassano en la España del Siglo de Oro.* Exh. cat. Madrid: Museo Nacional del Prado, 2001.

Fernández del Hoyo, María Antonia. "Juan de Roelas pintor flamenco." *Boletín del Museo Nacional de Escultura* 4 (2000): 24–27.

Finaldi, Gabriele. "The Patron and Date of Ribera's Crucifixion at Osuna." *Burlington Magazine* 133 (1991): 445–46.

———. "A Documentary Look at the Life and Work of Jusepe de Ribera." In *Jusepe de Ribera, 1591–1652,* by Alfonso E. Pérez Sánchez and Nicola Spinosa, 3–8. Exh. cat. New York: The Metropolitan Museum of Art, 1992.

———. "Documentary Appendix: The Life and Work of Jusepe de Ribera." In *Jusepe de Ribera, 1591–1652,* by Alfonso E. Pérez Sánchez and Nicola Spinosa, 231–55. Exh. cat. New York: The Metropolitan Museum of Art, 1992.

Gallego y Burín, Antonio, ed. *Varia Velazqueña: Homenaje a Velázquez en el iii centenario de su muerte, 1660–1960.* Vol. 2. Madrid: Ministerio de Educación Nacional, 1960.

García Chico, Esteban. *Documentos para el estudio del arte en Castilla*. 3 vols. Valladolid: Universidad de Valladolid, 1940–46.

García Figar, Fray Antonio. "Fray Juan Bautista Maino, pintor español." *Goya* 25 (1958): 6–13.

García Rey, El Commandante. "Estancias del pintor Pedro Orrente en Toledo." *Arte Español* 10 (1929): 430–35.

———. "Juan Bautista Monegro, escultor y arquitecto." *Boletín de la Sociedad Española de Excursiones* 40 (1932): 129–45.

———. "Juan Bautista Monegro, escultor y arquitecto." *Boletín de la Sociedad Española de Excursiones* 41 (1933): 204–24.

García de Wattenburg, Eloisa. *Museo de Pintura (en la antigua iglesia penitencial de La Pasión) Valladolid*. Valladolid: Museo de Pintura, 1969.

Gestoso y Pérez, José. *Sevilla monumental y artística*. 3 vols. Seville: El Conservado, 1889–92.

———. *Ensayo de un diccionario de los artífices que florecieron en Sevilla*. 3 vols. Seville: La Oficina de la Andalucía Moderna, 1899–1909.

———. *Catálogo de las pinturas y esculturas del Museo Provincial de Sevilla*. Madrid: J. Lacoste, 1912.

Gómez Menor, José. "Documentos." *Boletín de Arte Toledano* 1, no. 3 (1967): 143–58.

González Martí, Manuel. *Los grandes maestros del renacimiento*. Valencia: Editorial Arte y Letras, 1928.

Harris, Enriqueta. "Aportaciones para el estudio de Juan Bautista Maino." *Revista Española de Arte* 8 (December 1935): 333–39.

———. "Cassiano dal Pozzo on Diego Velázquez." *Burlington Magazine* 112 (1970): 364–73.

Hazañas y la Rúa, Joaquín. *Vázquez de Leca: 1573–1649*. Seville: Imp. y Lib. de Sobrinos de Izquierdo, 1918.

Hernández Díaz, José. "Documentos varios." In *Documentos para la historia del arte en Andalucía*. Vol. 1. Universidad de Sevilla, Labratorio de Arte, 93–97, 145–63. Seville: Facultad de Filosofía y Letras, 1927.

———. "Materiales para la historia del arte español." In *Documentos para la historia del arte en Andalucía*. Vol. 2. Universidad de Sevilla, Labratorio de Arte, 105–226. Seville: Facultad de Filosofía y Letras, 1928.

———. "Jerez de la Frontera, ante la historia del arte II: El retablo mayor de San Miguel." *Revista del Ateneo* 50–51 (1929): 41–42.

———. *Juan Martínez Montañés (1568–1649)*. Seville: Ediciones Guadalquivir, 1987.

Herrero-García, Miguel. "Un dictamen pericial de Velázquez y una escena de Lope de Vega." *Arte Español* 13 (1936): 66–71.

Jordan, William B. "Juan van der Hamen y León." 2 vols. Ph.D. dissertation, New York University, 1967.

———. *Spanish Still Life in the Golden Age 1600–1650*. Exh. cat. Fort Worth: Kimbell Art Museum, 1985.

———. *Juan van der Hamen y León and the Court of Madrid*. New Haven and London: Yale University Press, 2005.

Junquera, Juan José. "Un retablo de Maino en Pastrana." *Archivo Español de Arte* 50, no. 198 (1977): 129–40.

Justi, Carl. *Velázquez and His Times*. Trans. A. H. Keane. London: H. Grevel and Company, 1889.

———. *Velázquez y su siglo*. Trans. Pedro Marrades. Madrid: Espasa-Calpe, 1953.

Kowal, David M. "The Life and Art of Francisco Ribalta (1565–1628)." 3 vols. Ph.D. dissertation, University of Michigan, 1981.

———. *Ribalta y los Ribaltescos: La evolución del estilo barroco en Valencia*. Valencia: Diputación Provincial de Valencia, 1985.

Kusche, Maria. *Juan Pantoja de la Cruz*. Madrid: Editorial Castalia, 1964.

———. "La juventud de Juan Pantoja de la Cruz y sus primeros retratos: Retratos y miniaturas desconocidas de su madurez." *Archivo Español de Arte* 69, no. 274 (1996): 137–55.

———. "La nueva galería del Pardo: J. Pantoja de la Cruz, B. González, y F. López." *Archivo Español de Arte* 72, no. 286 (1999): 119–32.

Lange, Justus. *"Opere veramente di rara naturalezza": Studien zum Frühwerk Jusepe de Riberas mit Katalog der Gemälde bis 1626*. Würzburg: Ergon, 2003.

Lawrence, Cynthia. "Rubens and De Rincón in Valladolid: A Reconsideration of Rubens's First Spanish Sojourn and a New Source for the Antwerp *Raising of the Cross*." In *Munuscula Amicorum: Contributions on Rubens and His Colleagues in Honour of Hans Vlieghe*. Vol. 1, ed. K. van der Stighelen, 235–47. Turnhout: Brepols, 2006.

Lloréns Solé, Antonio. "El pintor Francisco Ribalta hijo de Solsona." *Anales y Boletín de los Museos de Arte de Barcelona* 9 (1951): 83–104.

López Azorín, María José. *Documentos para la historia de la pintura valenciana en el siglo XVII*. Madrid: Fundación de Apoyo a la Historia del Arte Hispánico, 2006.

López Jiménez, José Crisanto. "Sobre pinturas varias, una escultura y el testamento de Orrente." *Archivo de Arte Valenciano* 30 (1959): 73–76.

———. "Consideraciones en torno al arte en Orihuel." *Anales del Centro de Cultura Valenciana* 21, no. 45 (July–December 1960): 160–78.

———. "En el III centenario de la muerte de Velázquez: Hallazgo de las partidas de bautismo de Orrente y Villacis." *Archivo de Arte Valenciano* 32 (1961): 74–79.

———. "Pedro de Orrente. Noticia de mis últimas investigaciones cerca de su vida y su obra." *Arte Español* 24 (1962): 58–64.

———. "Don Nicolás de Villacis Arías, discípulo de Velázquez." *Boletín del Seminario de Estudios de Arte y Arqueología* 30 (1964): 195–210.

———. "En torno a Lorenzo Suárez y Cristóbal de Azebedo." *Archivo Español de Arte* 37 (1964): 169–78.

López Martínez, Celestino. "Testimonios para la biografía de Juan Martínez Montañés." In *Documentos para la historia del arte en Andalucía*. Vol. 1. Universidad de Sevilla, Labratorio de Arte, 211–30. Seville: Facultad de Filosofía y Letras, 1927.

———. *Notas para la historia del art: Arquitectos, escultores y pintores vecinos de Sevilla*. Seville: Rodríguez, Giménez y compañía, 1928.

———. *Notas para la historia del arte: Retablos y esculturas de traza sevillana*. Seville: Rodríguez, Giménez y compañía, 1928.

———. *Notas para la historia del arte: Desde Jerónimo Hernández hasta Martínez Montañés*. Seville: Rodríguez, Giménez y compañía, 1929.

———. *Notas para la historia del arte: Desde Martínez Montañés hasta Pedro Roldán*. Seville: Rodríguez, Giménez y compañía, 1932.

———. *El escultor y arquitecto Juan de Oviedo y de la Bandera, 1565–1625*. Discurso de ingreso en la Real Academia Sevillana de bellas artes de Santa Isabel de Hungaria. Seville: Impr. San Antonio, 1943.

———. "Homenaje al maestro escultor Martínez Montañés al cumplirse el tricentenario de su muerte." *Archivo Hispalense* 10 (1949): 241–67.

Lozoya, Marqués de, and José de Vera. "Cinco lienzos de Vicente Carducho documentados en el Museo de Segovia." *Estudios Segovianos*, no. 42 (1962): 385–90.

Magurn, Ruth Saunders, ed. and trans. *The Letters of Peter Paul Rubens*. Cambridge: Harvard University Press, 1955. Reprint, Evanston: Northwestern University Press, 1991.

Maldonado, Felipe C. R. "Francisco Ribalta: Noticias ineditas de su estancia en Madrid y de tres cuadros suyos." *La Estafeta Literaria* 455 (1970): 4–6.

Mancini, Georgia. "Chronology." In *Velázquez*, by Dawson W. Carr et al., 245–47. Exh. cat. London: The National Gallery, 2006.

Mancini, Giulio. *Considerazioni sulla pittura*. 2 vols. Ed. Adriana Marucchi and Luigi Salerno. Rome: Accademia nazionale dei Lincei, 1956.

Marías, Fernando. "Juan Bautista Maino y su familia." *Archivo Español de Arte* 49, no. 196 (1976): 468–70.

———. "Nuevos documentos de pintura toledana de la primera mitad del siglo XVII." *Archivo Español de Arte* 51, no. 204 (1978): 409–26.

———. *El Greco: Biografía de un pintor extravagante*. Madrid: Nerea, 1997.

Martí y Monsó, José. *Estudios histórico-artísticos relativos principalmente a Valladolid*. Valladolid: L. Miñón, 1898–1901.

Martín González, Juan José. "Arte y artistas del siglo XVII en la corte." *Archivo Español de Arte* 31 (1958): 125–42.

———. "Sobre las relaciones entre Nardi, Carducho y Velázquez." *Archivo Español de Arte* 31 (1958): 59–66.

———. "Un lienzo atribuible a Pantoja de la Cruz." *Boletín del Seminario de Estudios de Arte y Arqueología* 39 (1973): 459–61.

Martínez, Jusepe. *Discursos practicables del nobilísimo arte de la pintura*. Ed. Julián Gallego. Barcelona: Ediciones Bibliófilas, 1950.

———. *Discursos practicables del nobilísimo arte de la pintura*. Ed. Julián Gallego. Madrid: Akal, 1988.

Martínez Aloy, José. *La casa de la Diputación*. Valencia: Doménech, 1909–10.

Martínez Ripoll, Antonio. *Francisco Herrera "el Viejo."* Seville: Excma. Diputación Provincial, 1978.

Mayer, August L. *Die sevillaner Malerschule*. Leipzig: Klinkhardt & Biermann, 1911.

Mazón de la Torre, María. "Las partidas de bautismo de Eugenio Cajés, de Félix Castelo, del los hermanos Rizi y otras noticias sobre artistas madrileños de la primera mitad del siglo XVII." *Archivo Español de Arte* 44 (1971): 413–25.

Méndez Casal, Antonio. "El pintor Alejandro de Loarte." *Revista Española de Arte* 3, no. 4 (December 1934): 187–202.

Morales, Alfredo J. *Velázquez y Sevilla*. Exh. cat. Seville: Monasterio de la Cartuja de Santa María de las Cuevas, Salas del Centro Andaluz de Arte Contemporáneo, 1999.

Moreno Villa, José. "Cómo son y cómo eran unos Tizianos del Prado." *Archivo Español de Arte* 9 (1933): 113–16.

———. "Documentos sobre pintores recogidos en el Archivo de Palacio." *Archivo Español de Arte y Arqueología* 12 (1936): 261–68.

———. "La restauración por Bartolomé González de la copia que hizo Coxcie del políptico de Gante." *Archivo Español de Arte y Arqueología* 13 (1937): 163–64.

Moreno Villa, José, and Francisco J. Sánchez Cantón. "Noventa y siete retratos de la familia de Felipe III por Bartolomé González." *Archivo Español de Arte* 13 (1937): 127–57.

Muro Orejón, Antonio. "Documentos para la escultura sevillana." In *Documentos para la historia del arte in Andalucía*. Vol. 1. Universidad de Sevilla, Labratorio de Arte, 205–10. Seville: Facultad de Filosofía y Letras, 1927.

———. *Artífices sevillanos de los siglos XVI y XVII. Documentos para la historia del arte en Andalucía.* Vol. 4. Seville: Facultad de Filosofía y Letras, 1932.

———. *Pintores y doradores. Documentos para la historia del arte en Andalucía.* Vol. 8. Seville: Facultad de Filosofía y Letras, 1935.

Olucha Montíns, Ferrán. *Dos siglos de actividad artística en la villa de Castellon: 1500–1700 (noticias documentales).* Castelló: Diputació de Castelló, 1987.

Orellana, Marcos Antonio de. *Biografía pictórica valentina.* Ed. Xavier de Salas. Madrid: Gráficas Marinas, 1930.

Pacheco, Francisco. *Arte de la pintura.* 2 vols. Ed. Francisco J. Sánchez Cantón. Madrid: Instituto de Valencia de Don Juan, 1956.

———. *Arte de la pintura.* Ed. Bonaventura Bassegoda i Hugas. Madrid: Cátedra, 1990.

Palomino, Antonio. *Museo pictórico y escala óptica.* Madrid: L. A. de Bedmar, 1715–24. Reprint, Madrid: M. Aguilar, 1947.

———. *Lives of the Eminent Spanish Painters and Sculptors.* Ed. Nina Ayala Mallory. Cambridge and New York: Cambridge University Press, 1987.

Pérez de Guzmán y Gallo, Juan. "Mayno en un proceso de la Inquisición de Toledo." *Arte Español* 3, no. 2 (May 1914): 55–72.

Pérez Martín, José María. "Pintores valencianos medievales y modernos: Addenda." *Archivo Español de Arte y Arqueología* 11 (1935): 293–312.

Pérez Pastor, Cristóbal. *Noticias y documentos relativos a la historia y literatura española.* Memorias de la Real Academia Española. Vol. 11. Madrid: Imprenta de la Revista de Legislaciós, 1914.

Pérez Sánchez, Alfonso E. "Pintura madrileña del siglo XVII: Addenda." *Archivo Español de Arte* 49, no. 195 (1976): 293–325.

———. *Pintura barroca en España, 1600–1750.* Madrid: Cátedra, 1992.

———. "Sobre Juan Bautista Maíno." *Archivo Español de Arte* 70, no. 278 (April–June 1997): 113–25.

———. "Pedro Orrente." *Grove Dictionary of Art Online.* Oxford: Oxford University Press, 2007 <http://www.groveart.com>.

Pérez Sánchez, Alfonso E., and Benito Navarrete Prieto. *Luis Tristán, h. 1585–1624.* Madrid: Real Fundación de Toledo and Fundación BBVA, 2001.

Pérez Sánchez, Alfonso E., and Nicola Spinosa. *Jusepe de Ribera, 1591–1652.* Exh. cat. New York: The Metropolitan Museum of Art, 1992.

Pérez Sedano, Francisco. *Notas del archivo de la catedral de Toledo, redactadas sistemáticamente, en el siglo XVIII. Datos documentales inéditos para la historia del arte español.* Vol. 1. Madrid: Imp. de Fortanet, 1914.

Plaza, Angel. "Juan Pantoja de la Cruz y el Archivo de Simancas." *Boletín del Seminario de Estudios de Arte y Arqueología* 8–9 (1935): 259–62.

Ponz, Antonio. *Viaje de España.* Ed. Casto María del Rivero. Madrid: M. Aguilar, 1947.

Pou y Martí, José María. *Índice analítico de los documentos del siglo XVII. Archivo de la embajada de España, cerca de la Santa Sede.* Vol. 2. Rome: Palacio de España, 1917.

Proske, Beatrice Gilman. "Juan Martínez Montañés: A Commission for Santo Domingo." *Gazette des Beaux-Arts* 55 (February 1960): 79–94.

———. *Juan Martínez Montañés: Sevillian Sculptor.* New York: Hispanic Society of America, 1967.

Ramírez de Arellano, Rafael. *Catálogo de los artífices que trabajaron en Toledo y cuyos nombres y obras aparecen en los archivos de sus parroquias.* Toledo: Impr. Provincial, 1920.

Robres, Ramón, and Vicente Castell. "En torno a Ribalta (documentos inéditos)." *Boletín de la Sociedad Castellonense de Cultura* 18 (November–December 1943): 212–19.

Rodríguez Marín, Francisco. *Francisco Pacheco: Maestro de Velázquez.* Madrid: Tip. de la Revista de Archivos, Bibliotecas y Museos, 1923.

Rodríguez Roda, Francisco Ramón. "Los retablos de la capilla del Gremio de Plateros de Valencia." *Saitabi* (December 1944): 327–44.

Rosell, Cayetano. *Colección escogida de obras no dramáticas de Frey Lope Félix de Vega Carpio.* Madrid: M. Rivadeneyra, 1950.

Salazar, Concepción. "El testamento de Francisco Pacheco." *Archivo Español de Arte y Arqueología* 11 (1928): 155–60.

Saltillo, Marqués del (Miguel Lasso de la Vega y López de Tejada). "Efemérides artísticas madrileñas del siglo XVII." *Boletín de la Real Academia de la Historia* 120 (April–June 1947): 605–85.

———. "Efemérides artísticas madrileñas (1603–1811)." *Boletín de la Sociedad Española de Excursiones* 56 (1948): 5–42.

———. "Alonso Martínez de Espinar." *Arte Español* 18 (1951): 115–34.

San Román y Fernández, Francisco de Borja. *El Greco en Toledo.* Madrid: V. Suárez, 1910.

———. *Noticias nuevas para la biografía de Luis Tristán: Memoria presentada a la Real Academia de Bellas Artes y Ciéncias Históricas de Toledo.* Toledo: A. Medina, 1924.

———. "De la vida del Greco: Nueva seria de documentos inéditos." *Archivo Español de Arte y Arqueología* 3 (1927): 139–95, 275–339.

Sánchez Cantón, Francisco J. "Los pintores de cámara de los Reyes de España." *Boletín de la Sociedad Española de Excursiones* 22 (1914): 296–306.

———. *Los pintores de cámara de los Reyes de España.* Madrid: Fototipia de Hauser y Menet, 1916.

———. *Fuentes literarias para la historia del arte español.* 5 vols. Madrid: C. Bermejo, 1923–41.

———. *Dibujos españoles.* 5 vols. Madrid: Hauser y Menet, 1930.

———. "Sobre la vida y las obras de Juan Pantoja de la Cruz." *Archivo Español de Arte* 78 (1947): 95–120.

———, ed. *Inventarios reales: Bienes muebles que pertenecieron a Felipe II.* Archivo Documental Español. Vols. 10–11. Madrid: Real Academia de la Historia, 1956–59.

Sánchez Moreno, José. "Lorenzo Suárez y Cristóbal de Acebedo (notas para el estudio de dos pintores seiscentistas)." *Anales de la Universidad de Murcia* 11, no. 2 (1952–53): 420–44.

Sancho Corbacho, Heliodoro. "Contribución documental al estudio del arte sevillano." In *Documentos para la historia del arte en Andalucía.* Vol. 2.

Universidad de Sevilla, Laboratorio de Arte, 227–315. Seville: Facultad de Filosofía y Letras, 1928.

———. *Arte Sevillano de los Siglos XVI y XVII. Documentos para la Historia del Arte en Andalucía.* Vol. 3. Seville: Facultad de Filosofía y Letras, 1931.

Schroth, Sarah. "The Private Picture Collection of the Duke of Lerma." Ph.D. dissertation, New York University, 1990.

Sentenach, Narciso. "Los grandes retratistas en España." *Boletín de la Sociedad Española de Excursiones* 20 (1912): 46–59, 98–121, 174–89.

Simón Díaz, José. "Pleitos de Angelo Nardi." *Archivo Español de Arte* 20 (1947): 250–53.

Stirling-Maxwell, Sir William. *Annals of the Artists of Spain.* Vol. 2. London: J. C. Nimmo, 1891.

Talón, Francisco. "Dos pinturas valencianas." *Boletín de la Sociedad Española de Excursiones* 26 (1918): 202–4.

Tormo y Monzó, Elías. "La educación artística de Ribalta, padre, fué en Castilla." *Revista Crítica Hispano-Americana* 2 (1916): 19–38, 61–83.

———. "Apéndice a la visita a la clausura de la Encarnación. II: En la clausura de Santa Isabel." *Boletín de la Sociedad Española de Excursiones* 25 (1917): 180–94.

———. "La clausura de la Encarnación, de Madrid." *Boletín de la Sociedad Española de Excursiones* 25 (1917): 121–34.

Tramoyeres Blasco, Luis. "Un colegio de pintores en Valencia." *Archivo de Investigaciones Históricas* 2, nos. 4–6 (October–December 1911): 277–314, 446–62, 514–36.

———. "El pintor Pedro Orrente, ¿murió en Toledo o en Valencia?" *Archivo de Arte Valenciano* 2 (1916): 87–93.

———. "Los pintores Francisco y Juan Ribalta." *Archivo de Arte Valenciano* 3 (1917): 93–107.

Urrea, Jesús. "A propósito del pintor Juan Bautista Maino." In *Velázquez y el arte de su tiempo*, 295–97. Jornadas de Arte 5. Madrid: Editorial Alpuerto, 1991.

———. "Aproximación biográfica al escultor Gregorio Fernández." In *Gregorio Fernández, 1576–1636*, 15–41. Exh. cat. Madrid: Fundación Central Hispano, 1999–2000.

Valdivieso, Enrique. "Pinturas de Juan de Roelas para el convento de la Merced de Sanlúcar de Barrameda." *Boletín del Seminario de Arte y Arqueología de Valladolid* 44 (1978): 293–306.

Valdivieso, Enrique, and Juan M. Serrera. *Historia de la pintura española: Escuela sevillana del primer tercio del siglo XVII.* Madrid: Instituto Diego Velázquez, 1985.

Vergara, Alexander. *Rubens and His Spanish Patrons.* Cambridge and New York: Cambridge University Press, 1999.

Viñaza, El Conde de. *Adiciones al diccionario histórico de los más ilustres profesores de las bellas artes en España de D. Juan Agustín Ceán Bermúdez.* Vol. 3. Madrid: Tipografia de los Huérfanos, 1894.

Volk, Mary Crawford. *Vicencio Carducho and Seventeenth-Century Castilian Painting.* New York and London: Garland Publishing, 1977.

Zarco del Valle, Manuel R. *Documentos de la cátedral de Toledo coleccionados por Don Manuel R. Zarco del Valle. Datos documentales para la historia del arte español.* Vol. 2. Madrid: 1916.

Zarco-Bacas y Cuevas, Eusebio-Julián. *Pintores italianos en S. Lorenzo el Real de El Escorial (1575–1613).* Madrid: Talleres de E. Maestre, 1932.

Exhibition Checklist

Late El Greco

Catalogue 1
EL GRECO
Saint Martin and the Beggar, about 1597–99
Oil on canvas with wooden strips attached
at bottom, 76 3/16 x 40 9/16 in. (193.5 x 103 cm)
National Gallery of Art, Washington, DC
Widener Collection, 1942.9.25

Catalogue 2
EL GRECO
Christ on the Cross, about 1600–10
Oil on canvas, 32½ x 20 5/16 in. (82.6 x 51.6 cm)
The J. Paul Getty Museum, Los Angeles, 2000.40

Catalogue 3
EL GRECO
Saint Jerome as Scholar, about 1610
Oil on canvas, 42½ x 35 1/16 in. (108 x 89 cm)
The Metropolitan Museum of Art, New York
Robert Lehman Collection, 1975, 1975.1.146
MFA only

Catalogue 4
EL GRECO
View of Toledo
Oil on canvas, 47¾ x 42¾ in. (121.3 x 108.6 cm)
The Metropolitan Museum of Art, New York
H.O. Havemeyer Collection, Bequest of Mrs.
H.O. Havemeyer, 1929, 29.100.6
MFA only

Catalogue 5
EL GRECO
The Vision of Saint John, 1608–14
Oil on canvas, 87½ x 76 in. (222.3 x 193 cm); with
added strips 88½ x 78½ in. (224.8 x 199.4 cm)
The Metropolitan Museum of Art, New York
Rogers Fund, 1956, 56.48

Catalogue 6
EL GRECO
Laocoön, about 1610–14
Oil on canvas, 54⅛ x 67⅞ in. (137.5 x 172.4 cm)
National Gallery of Art, Washington, DC
Samuel H. Kress Collection, 1946.18.1
MFA only

Portraiture

Catalogue 7
JUAN PANTOJA DE LA CRUZ
King Philip III of Spain, about 1601–2
Oil on canvas, 69 5/16 x 45 11/16 in. (176 x 116 cm)
Kunsthistorisches Museum, Vienna, PG 9490

Catalogue 8
JUAN PANTOJA DE LA CRUZ
(Formerly attributed to Bartolomé González)
Queen Margaret of Austria, about 1603–9
Oil on canvas, 75 9/16 x 47¼ in. (192 x 120 cm)
Kunsthistorisches Museum, Vienna, PG 3139

Catalogue 9
JUAN PANTOJA DE LA CRUZ
Portrait of Philip IV and Ana, 1607
Oil on canvas, 46½ x 48¾ in. (118 x 124 cm)
Kunsthistorisches Museum, Vienna, PG 3301

Catalogue 10
BARTOLOMÉ GONZÁLEZ
Portrait of Alfonso "el Caro" and Ana Margarita,
about 1613–14
Oil on canvas, 48 13/16 x 38¾ in. (124 x 98.5 cm)
Instituto de Valencia de Don Juan, Madrid

Catalogue 11
PETER PAUL RUBENS
Equestrian Portrait of the Duke of Lerma
about 1603
Oil on canvas, 111 7/16 x 78¾ in. (283 x 200 cm)
Museo Nacional del Prado, Madrid, P03137

Catalogue 12
EL GRECO
Fray Hortensio Félix Paravicino, 1609
Oil on canvas, 44⅛ x 33⅞ in. (112.1 x 86.1 cm)
Museum of Fine Arts, Boston
Isaac Sweetser Fund, 04.234

Catalogue 13
EL GRECO
Portrait of an Ecclesiastic, about 1610–14
Oil on canvas, 42⅛ x 35½ in. (107 x 90.2 cm)
Kimbell Art Museum, Fort Worth, Texas

Catalogue 14
LUIS TRISTÁN
Portrait of a Carmelite
Oil on canvas, 43 5/16 x 33 1/16 in. (110 x 84 cm)
Museo Nacional del Prado, Madrid, P05206

Catalogue 15
JUAN VAN DER HAMEN Y LEÓN
Portrait of Lorenzo van der Hamen y León,
about 1620
Oil on canvas, 21 9/16 x 16 13/16 in. (54.8 x 42.7 cm)
Instituto de Valencia de Don Juan, Madrid,
Inv. 6008

Catalogue 16
JUAN BAUTISTA MAINO
Portrait of a Monk
Oil on canvas, 18½ x 13⅛ in. (47 x 33.3 cm)
Ashmolean Museum, University of Oxford
Bequeathed by Percy Moore Turner, 1951,
WA1951.161

Catalogue 17
DIEGO RODRÍGUEZ DE SILVA Y VELÁZQUEZ
Luis de Góngora y Argote, 1622
Oil on canvas, 19¾ x 16 in. (50.2 x 40.6 cm)
Museum of Fine Arts, Boston
Maria Antoinette Evans Fund, 32.79

Catalogue 18
FRANCISCO PACHECO
Portrait of a Poet
Black and red chalk over wash, 7¼ x 5⅞ in.
(18.4 x 14.9 cm)
Biblioteca Nacional de España, Madrid

Religious Institutions and Private Patrons

Catalogue 19
EL GRECO
Annunciation, about 1596–1600
Oil on canvas, 124 x 68½ in. (315 x 174 cm)
Museo Nacional del Prado, Madrid, P03888
MFA only

Catalogue 20
EUGENIO CAJÉS
Joachim and Anne Meeting at the Golden Gate,
about 1605
Oil on canvas, 107 1/16 x 56 5/16 in. (272 x 143 cm)
Museo de la Real Academia de Bellas Artes
de San Fernando, Madrid
MFA only

Catalogue 21
JUAN BAUTISTA MAINO
Adoration of the Magi, 1612
Oil on canvas, 124 x 68½ in. (315 x 174 cm)
Museo Nacional del Prado, Madrid, P00886

Catalogue 22
DIEGO RODRÍGUEZ DE SILVA Y VELÁZQUEZ
Adoration of the Magi, 1619
Oil on canvas, 79 15/16 x 49 3/16 in. (203 x 125 cm)
Museo Nacional del Prado, Madrid, P01166
MFA only

Catalogue 23
LUIS TRISTÁN
Adoration of the Shepherds, 1620
Oil on canvas, 91¾ x 45¼ in. (233 x 115 cm)
Fitzwilliam Museum, Cambridge, UK, M.78

Catalogue 24
EUGENIO CAJÉS
Nativity, 1610
Oil on canvas, 27⅝ x 31 9/16 in. (70.2 x 80.2 cm)
Plácido Arango Collection

Catalogue 25
BARTOLOMÉ GONZÁLEZ
Rest on the Flight into Egypt, 1627
Oil on canvas, 61 x 34⅝ in. (155 x 88 cm)
Museo Nacional del Prado, Madrid, P00718

Catalogue 26
LUIS TRISTÁN
The Holy Family, 1613
Oil on canvas, 56 x 43 in. (142.24 x 109.22 cm)
Minneapolis Institute of Arts
The William Hood Dunwoody Fund, 74.2

Catalogue 27
VICENTE CARDUCHO
Christ at Calvary
Oil on canvas, 64¼ x 45 in. (166 x 116.7 cm)
Private Collection, Madrid

Catalogue 28
EUGENIO CAJÉS
Christ at Calvary, about 1615
Oil on canvas, 77 9/16 x 58 11/16 in. (197 x 149 cm)
Museo Nacional del Prado, Madrid, P05304

Catalogue 29
JUAN DE ROELAS
Christ with the Cross, about 1620–24

Oil on canvas, 48 1/16 x 45 1/4 in. (122 x 115 cm)
Museo de Bellas Artes de Seville

Catalogue 30
LUIS TRISTÁN
Crucified Christ with the Virgin and Saint John,
about 1613
Oil on canvas, 93 5/16 x 61 in. (237 x 155 cm)
Plácido Arango Collection

Catalogue 31
JUAN PANTOJA DE LA CRUZ
Resurrection, 1605
Oil on canvas, 98 7/16 x 68 7/8 in. (250 x 175 cm)
Diputación de Valladolid

Catalogue 32
PEDRO ORRENTE
Martyrdom of Saint Sebastian, after 1606
Oil on canvas, 64 3/16 x 48 13/16 in. (163 x 124 cm)
Monasterio de las Descalzas Reales, Madrid

Apostolado

Catalogue 33
EL GRECO
Saint James (Santiago el Mayor), about 1610–14
Oil on canvas, 39 1/2 x 31 5/8 in. (100.4 x 80.4 cm)
Museo del Greco, Toledo

Catalogue 34
JUSEPE DE RIBERA
Saints Peter and Paul, about 1616
Oil on canvas, 49 5/8 x 44 1/8 in. (126 x 112 cm)
Musée des Beaux-Arts de Strasbourg

Catalogue 35
DIEGO RODRÍGUEZ DE SILVA Y VELÁZQUEZ
Apostle Thomas, 1622
Oil on canvas, 41 5/16 x 33 7/16 in. (105 x 85 cm)
Orléans, Musée des beaux-arts, Inv. 1556 A
MFA only

Saint Francis

Catalogue 36
LUIS TRISTÁN
The Vision of Saint Francis of Assisi, 1600–25
Oil on canvas, 49 3/16 x 40 15/16 in. (125 x 104 cm)
Musée du Louvre, Paris, RF240
MFA only

Catalogue 37
EL GRECO
Saint Francis Venerating the Crucifix, about 1596
Oil on canvas, 58 x 41 1/2 in. (147.3 x 105.4 cm)
Fine Arts Museums of San Francisco
Gift of the Samuel H. Kress Foundation, 61.44.24

Catalogue 38
VICENTE CARDUCHO
The Stigmatization of Saint Francis
Oil on canvas, 61 x 44 1/2 in. (155 x 113 cm)
Hospital de la V.O.T. de San Francisco de Asis, Madrid

Catalogue 39
FRANCISCO RIBALTA
*The Ecstasy of Saint Francis of Assisi: The Vision of
the Musical Angel*, about 1620–25
Oil on canvas, 42 1/2 x 62 1/4 in. (108 x 158.1 cm)

Wadsworth Atheneum Museum of Art, Hartford, CT
The Ella Gallup Sumner and Mary Catlin Sumner
Collection Fund, 1957.254

Catalogue 40
FRANCISCO RIBALTA
Saint Francis Embracing the Crucified Christ,
about 1620
Oil on canvas, 91 5/16 x 67 5/16 in. (232 x 171 cm)
Museo de Bellas Artes de Valencia, No. inv. 478

Spanish Saints

Catalogue 41
GREGORIO FERNÁNDEZ
Saint Teresa of Avila, about 1614
Polychrome wood, H. 63 in. (160 cm)
Santuario de Nuestra Señora del Carmen de
Extramuros, Valladolid

Catalogue 42
GREGORIO FERNÁNDEZ
Saint Ignatius Loyola, about 1622
Polychrome wood, H. 60 5/8 in. (154 cm)
Iglesia de San Miguel y San Julián, Valladolid

Catalogue 43
EUGENIO CAJÉS
Saint Julian, Bishop of Cuenca
Oil on canvas, 65 1/2 x 46 3/8 in. (166.4 x 117.8 cm)
Stirling Maxwell Collection, Pollok House, Glasgow

Catalogue 44
FRANCISCO RIBALTA
Vision of Father Simón, 1612
Oil on canvas, 83 x 43 1/2 in. (210.8 x 110.5 cm)
The National Gallery, London
Bought, 1913, NG2930

The Immaculate Conception

Catalogue 45
FRANCISCO PACHECO
*Virgin of the Immaculate Conception with
Miguel del Cid*, 1619
Oil on canvas, 63 x 42 15/16 in. (160 x 109 cm)
Cathedral of Seville

Catalogue 46
JUAN SÁNCHEZ COTÁN
Virgin of the Immaculate Conception,
about 1617–18
Oil on canvas, 102 3/8 x 70 1/16 in. (260 x 178 cm)
Museo de Bellas Artes de Granada

Catalogue 47
JUAN MARTÍNEZ MONTAÑÉS
Virgin of the Immaculate Conception,
about 1606–8
Polychrome wood, 52 3/4 x 20 7/8 x 16 15/16 in.
(134 x 53 x 43 cm)
Nuestra Señora de la Consolación, El Pedroso

Catalogue 48
DIEGO RODRÍGUEZ DE SILVA Y VELÁZQUEZ
The Immaculate Conception, 1618–19
Oil on canvas, 53 1/8 x 40 in. (135 x 101.6 cm)
The National Gallery, London
Bought with the aid of the National Art
Collections Fund, 1974, NG6424

Still Life and the *Bodegón*

Catalogue 49
ANONYMOUS
Plate of Pears, about 1595–1600
Oil on canvas, 9 1/16 x 12 13/16 in. (23 x 32.5 cm)
Naseiro Collection, Madrid

Catalogue 50
JUAN SÁNCHEZ COTÁN
Still Life with Fruit and Vegetables, about 1602
Oil on canvas, 27 3/8 x 38 in. (69.5 x 96.5 cm)
Varez Fisa Collection, Spain

Catalogue 51
JUAN SÁNCHEZ COTÁN
*Still Life with Quince, Cabbage, Melon, and
Cucumber*, about 1600
Oil on canvas, 27 1/4 x 33 1/2 in. (69.2 x 85.1 cm)
San Diego Museum of Art
Gift of Anne R. and Amy Putnam, 1945:43

Catalogue 52
JUAN SÁNCHEZ COTÁN
Still Life with Game Fowl, about 1600
Oil on canvas, 26 11/16 x 34 15/16 in. (67.8 x 88.7 cm)
The Art Institute of Chicago
Gift of Mr. and Mrs. Leigh B. Block, 1955.1203

Catalogue 53
ALEJANDRO DE LOARTE
Still Life with Fruit Bowl
Oil on canvas, 32 1/16 x 42 1/2 in. (81.5 x 108 cm)
Plácido Arango Collection

Catalogue 54
JUAN VAN DER HAMEN Y LEÓN
Still Life with Sweets, 1621
Oil on canvas, 14 15/16 x 19 5/16 in. (38 x 49 cm)
Museo de Bellas Artes de Granada

Catalogue 55
JUAN VAN DER HAMEN Y LEÓN
Still Life (Plate with Bacon, Bread and Wine),
about 1621
Oil on canvas remounted on wood, 14 9/16 x
16 15/16 in. (37 x 43 cm)
Musées royaux des Beaux-Arts de Belgique,
Brussels, Inv. 3864

Catalogue 56
JUAN VAN DER HAMEN Y LEÓN
Still Life with Sweets, 1622
Oil on canvas, 22 13/16 x 38 3/16 in. (58 x 97 cm)
The Cleveland Museum of Art
John L. Severance Fund, 1980.6

Catalogue 57
PEDRO ORRENTE
Jacob Conjuring Laban's Sheep, about 1612–22
Oil on canvas, 39 x 52 in. (99.1 x 132.1 cm)
North Carolina Museum of Art, Raleigh
Purchased with funds from the State of North
Carolina, 52/9/181

Catalogue 58
ALEJANDRO DE LOARTE
Birds with Kitchen Scene
Oil on canvas, 19 11/16 x 27 9/16 in. (50 x 70 cm)
Granados Collection, Madrid

Catalogue 59
DIEGO RODRÍGUEZ DE SILVA Y VELÁZQUEZ
Kitchen Scene with Christ in the House of Martha and Mary, probably 1618
Oil on canvas, 23⅝ x 40¾ in. (60 x 103.5 cm)
The National Gallery, London
Bequeathed by Sir William H. Gregory, 1892, NG1375
MFA only

Catalogue 60
DIEGO RODRÍGUEZ DE SILVA Y VELÁZQUEZ
The Kitchen Maid, about 1618–20
Oil on canvas, 21⅝ x 40¹⁵⁄₁₆ in. (55 x 104 cm)
The Art Institute of Chicago
Robert Walker Memorial Fund, 1935.380

Catalogue 61
JUSEPE DE RIBERA
The Sense of Taste, about 1614–16
Oil on canvas, 44¹³⁄₁₆ x 34¾ in. (113.8 x 88.3 cm)
Wadsworth Atheneum Museum of Art,
Hartford, CT
The Ella Gallup Sumner and Mary Catlin Sumner
Collection Fund, 1963.194

Catalogue 62
DIEGO RODRÍGUEZ DE SILVA Y VELÁZQUEZ
An Old Woman Cooking Eggs, 1618
Oil on canvas, 39 x 50⅜ in. (99 x 128 cm)
National Gallery of Scotland, Edinburgh, NG 2180
MFA only

The *Camarín* and the Duke of Lerma's Pictures

Catalogue 63
JUAN VAN DER HAMEN Y LEÓN
Still Life with Sweets and Pottery, 1627
Oil on canvas, 33⅛ x 44⅜ in. (84.1 x 112.7 cm)
National Gallery of Art, Washington, DC
Samuel H. Kress Collection, 1961.9.75

The following objects, which appeared in the exhibition but are not reproduced in the catalogue, are representative of the kinds of objects found in the camarín of the duke of Lerma. Contemporary to the reign of Philip III, these items would have appealed to collectors influenced by Lerma's taste; as far as we know, none of them belonged to the duke of Lerma.

JAR WITH BLUE-AND-WHITE DECORATION
of ducks in a lotus pond
Chinese, Ming dynasty, Wanli period (1573–1620)
Porcelain, H. 12 in., diam. 10⅝ in.
(H. 30.5 cm, diam. 27 cm)
Museum of Fine Arts, Boston
John Gardner Coolidge Collection, 46.540

JAR WITH BLUE-AND-WHITE DECORATION
of a drama scene based on the romance of the three kingdoms
Chinese, Ming dynasty, Wanli period (1573–1620)
Porcelain, H. 11¹³⁄₁₆ in., foot diam. 8¹³⁄₁₆ in.
(H. 30 cm, foot diam. 22.4 cm)
Museum of Fine Arts, Boston
John Gardner Coolidge Collection, 46.544

LARGE PLATE WITH BLUE-AND-WHITE DECORATION
of auspicious motifs
Chinese, Ming dynasty, 2nd quarter of 17th century
Porcelain, H. 22¹³⁄₁₆ in., diam. 12¹³⁄₁₆ in.
(H. 58 cm, diam. 32.6 cm)
Museum of Fine Arts, Boston
John Gardner Coolidge Collection, 46.501

PLATE WITH BLUE-AND-WHITE DECORATION
of chicken in a landscape
Chinese, late Ming dynasty
Porcelain, H. 11 in., diam. 8¼ in.
(H. 28 cm, diam. 21 cm)
Museum of Fine Arts, Boston
John Gardner Coolidge Collection, 54.1458

PORCELAIN CUP with design of eight immortals
Chinese, Ming dynasty, Wanli period (1573–1620)
Porcelain painted with underglaze blue and overglaze enamel, H. 31⅛ in., diam. 27¹⁵⁄₁₆ in.
(H. 79 cm, diam. 71 cm)
Museum of Fine Arts, Boston
Bequest of Miss Ellen Starkey Bates, 28.149

BOWL WITH BLUE-AND-WHITE DECORATION
of fish among aquatic plants (yuzao) motif
Chinese, Ming dynasty, Jiajing period (1522–66)
Porcelain, H. 3¾ in., diam. 5³⁄₁₆ in.
(H. 9.5 cm, diam. 13.2 cm)
Museum of Fine Arts, Boston
Bequest of Charles Bain Hoyt, 50.1329

INCENSE BURNER WITH BLUE-AND-WHITE
DECORATION of the eight immortals venerating the god of longevity
Chinese, Ming dynasty, Longqing period (1567–72), dated 1571
Porcelain painted with underglaze blue, H. 2⅜ in., mouth diam. 3¹⁄₁₆ in. (H. 6 cm, mouth diam. 7.8 cm)
Museum of Fine Arts, Boston
Gift of Mr. and Mrs. F. Gordon Morrill, 1979.783

LARGE BOWL WITH BLUE-AND-WHITE DECORATION
in the landscape
Chinese, late Ming dynasty, early 17th century
Porcelain painted with underglaze blue
H. 6⅛ in., mouth diam. 13¾ in.
(H. 15.6 cm, mouth diam. 35 cm)
Museum of Fine Arts, Boston
Edward Sylvester Morse Memorial Fund, 1986.236

GARLIC-HEADED VASE WITH BLUE-AND-WHITE
DECORATION of crab, fish, and shrimp
Chinese, Ming dynasty, Wanli period (1573–1620)
Porcelain, H. 21⅞ in., diam. 9¹⁵⁄₁₆ in.
(H. 55.5 cm, diam. 25.2 cm)
Museum of Fine Arts, Boston
Gift of Charles Bain Hoyt, 49.24

VASE WITH SLENDER NECK AND TWO JI-SHAPED
EARS with movable chain rings
Chinese, Ming dynasty, 14th–17th century
Porcelain, H. 21⅞ in., diam. 7½ in.
(H. 55.5 cm, diam. 19.1 cm)
Museum of Fine Arts, Boston
The John Pickering Lyman Collection. Gift of Miss Theodora Lyman, 19.976

BOWL
Chinese, Ming dynasty, about 1600
Porcelain, H. 5⅞ in., diam. 14³⁄₁₆ in.
(H. 15 cm, diam. 36 cm)
Peabody Essex Museum, Salem, Massachusetts, E83611

JAR
Chinese, Ming dynasty, Wanli period (1573–1620)
Porcelain, H. 15½ in., diam. 13 in.
(H. 39.4 cm, diam. 33 cm)
Peabody Essex Museum, Salem, Massachusetts, E83015

JAR WITH "HUNDRED BATS" DECORATION
Chinese, Ming dynasty, Wanli period (1573–1620)
Porcelain, H. 13⅜ in., diam. 11¹³⁄₁₆ in.
(H. 34 cm, diam. 30 cm)
Peabody Essex Museum, Salem, Massachusetts, E80399

KENDI IN THE FORM OF AN ELEPHANT
Chinese, Ming dynasty, about 1600
Porcelain, H. 7⅞ in., w. 7½ in., d. 3¹⁵⁄₁₆ in.
(H. 20 cm, w. 19 cm, d. 10 cm)
Peabody Essex Museum, Salem, Massachusetts, AE86475

KENDI IN THE FORM OF A FROG
Chinese, Ming dynasty, Wanli period (1573–1620)
Porcelain, H. 6⅞ in., w. 7¹⁄₁₆ in., d. 5⅛ in. (H. 17.5 cm, w. 18 cm, d. 13 cm)
Peabody Essex Museum, Salem, Massachusetts, E83882

MOUNTED CUP
Cup: Chinese, Ming dynasty, late 16th century
Mount: German (Nuremberg), about 1610
Silver marked by Peter Wiber (active 1603–41)
Porcelain and gilded silver, H. 6¾ in., diam. 4½ in.
(H. 17.1 cm, diam. 11.4 cm)
Peabody Essex Museum, Salem, Massachusetts, AE85461

EWER
Chinese, Ming dynasty, Jiajing period (1522–66)
Porcelain decorated with polychromy and gilding
H. 10 in., w. 4 in., d. 6½ in.
(H. 25.4 cm, w. 10.2 cm, d. 16.5 cm)
Anonymous Loan, TD2004.2

LARGE PLATE
Chinese, Ming dynasty, late 16th–early 17th century
Porcelain, H. 4 in., diam. 16⅛ in.
(H. 10.2 cm, diam. 41 cm)
Peabody Essex Museum, Salem, Massachusetts, AE85998

PLATE
Chinese, Ming dynasty, about 1600
Porcelain, H. 3¼ in., diam. 14¾ in.
(H. 8.3 cm, diam. 37.5 cm)
Peabody Essex Museum, Salem, Massachusetts, AE85409

LARGE PLATE
Chinese, Ming dynasty, about 1600
Porcelain, H. 3⁵⁄₁₆ in., diam. 20¹¹⁄₁₆ in.
(H. 8.4 cm, diam. 52.6 cm)
Peabody Essex Museum, Salem, Massachusetts, E84059

LARGE PLATE
Chinese, Ming dynasty, about 1600
Porcelain, H. 3⁷⁄₁₆ in., diam. 16¼ in.
(H. 8.8 cm, diam. 41.3 cm)
Peabody Essex Museum, Salem, Massachusetts, AE86428

FLASK WITH SPANISH ROYAL ARMS
Chinese, Ming dynasty, about 1600–20
Porcelain, H. 11⅝ in., w. 5⅞ in., d. 3⅛ in.
(H. 29.5 cm, w. 15 cm, d. 8 cm)
Peabody Essex Museum, Salem, Massachusetts, E82416

FIGURE OF A CRANE
Chinese, Ming dynasty, Wanli period (1573–1620)
Porcelain, H. 7⁵⁄₁₆ in., w. 2¹¹⁄₁₆ in., d. 2⅜ in.
(H. 18.5 cm, w. 6.8 cm, d. 6 cm)
Peabody Essex Museum, Salem, Massachusetts, AE86419

PLATE
Spanish (Talavera), 1600–50
Tin-glazed earthenware with colored enamel decoration, H. 1½ in., diam. 10⅜ in.
(H. 3.8 cm, diam. 26.4 cm)
Museum of Fine Arts, Boston
The John Pickering Lyman Collection. Gift of Miss Theodora Lyman, 19.1205

CUP
Portuguese (Estremoz), 16th–17th century
Red earthenware, H. 2⅞ in., diam. 3¹⁄₁₆ in.
(H. 7.3 cm, diam. 7.8 cm)
Monasterio de las Descalzas Reales, Patrimonio Nacional, Madrid, 00618471

CUP
Portuguese (Estremoz) or Mexican (Tonalá),
16th–17th century
Red earthenware, H. 4 in., diam. 2¾ in.
(H. 10.2 cm, diam. 7 cm)
Monasterio de las Descalzas Reales, Patrimonio
Nacional, Madrid, 00619092

TWO-HANDLED CUP
Portuguese (Estremoz), 16th–17th century
Red earthenware, H. 2¹⁵⁄₁₆ in., diam. 3 in.
(H. 7.5 cm, diam. 7.6 cm)
Monasterio de las Descalzas Reales, Patrimonio
Nacional, Madrid, 00619094

CUP
Mexican (Tonalá), 16th–17th century
Red earthenware, H. 3¼ in., diam. 2½ in.
(H. 8.2 cm, diam. 6.3 cm)
Monasterio de las Descalzas Reales, Patrimonio
Nacional, Madrid, 0069095

TWO-HANDLED CUP
Mexican (Tonalá), 16th–17th century
Red earthenware, H. 2¾ in., diam. 3¼ in.
(H. 7 cm, diam. 8.3 cm)
Monasterio de las Descalzas Reales, Patrimonio
Nacional, Madrid, 00619090

VESSEL
Portuguese (probably Estremoz) or Mexican
(probably Tonalá), 17th century
Red earthenware, H. 7½ in., diam. 4¹⁵⁄₁₆ in.
(H. 19.1 cm, diam. 12.5 cm)
Museo de América, Madrid, 4003

VESSEL
Portuguese (probably Estremoz) or Mexican
(probably Tonalá), 17th century
Red earthenware, H. 7 in., diam. 4⁹⁄₁₆ in.
(H. 17.8 cm, diam. 11.6 cm)
Museo de América, Madrid, 4005

DOUBLE CUP
Probably Portuguese (Estremoz), 17th century
Red earthenware, H. 13¼ in., diam. 7¼ in.
(H. 33.7 cm., diam. 18.4 cm)
Museo de América, Madrid, 4058

DOUBLE-GOURD VASE
Portuguese (probably Estremoz) or Mexican
(probably Tonalá), 17th century
Red earthenware, H. 7⅛ in., diam. 5⅝ in.
(H. 18.1 cm, diam. 14.3 cm)
Museo de América, Madrid, 4011

DOUBLE-GOURD VASE
Portuguese (probably Estremoz) or Mexican
(probably Tonalá), 17th century
Red earthenware, H. 6⅞ in., diam. 5⅝ in.
(H. 17.4 cm, diam. 14.3 cm)
Museo de América, Madrid, 4014

JUG
Portuguese (probably Estremoz) or Mexican
(probably Tonalá), 17th century
Red earthenware, H. 12⅝ in., diam. 6¾ in.
(H. 32 cm, diam. 17.2 cm)
Museo de América, Madrid, 4656

JUG
Portuguese (probably Estremoz) or Mexican
(probably Tonalá), 17th century
Red earthenware, H. 11³⁄₁₆ in., diam. 6¹¹⁄₁₆ in.
(H. 28.4 cm, diam. 17 cm)
Museo de América, Madrid, 4086

LARGE PLATE
Spanish (Valencia?), late 16th or early 17th century
Tin-enameled earthenware with luster decoration,
DIAM. 16½ in. (41.9 cm)
The Metropolitan Museum of Art, NewYork
Cloisters Fund, 1956, 56.171.72

LARGE PLATE
Spanish (Catalonia), mid-16th century
Tin-enameled earthenware with luster decoration,
DIAM. 16¼ in. (41.3 cm)
The Metropolitan Museum of Art, New York
Cloisters Fund, 1956, 56.171.140

BOWL
Spanish (Valencia), 17th century
Tin-enameled earthenware with luster decoration,
DIAM. 5¼ in. (13.3 cm)
The Metropolitan Museum of Art, New York
Gift of Henry G. Marquand, 1894, 94.4.356

BOWL
Spanish (Valencia), 16th century
Tin-enameled earthenware with luster decoration,
W. (across handles) 7 in. (17.8 cm)
The Metropolitan Museum of Art, New York
Gift of Mr. and Mrs. Arthur J. Cohen, 1976, 1976.163.12

TAZZA
Italian (Venice, Murano), 1550–99
Glass with opaque white decoration,
H. 3¾ in., diam. 7 in. (H. 9.5 cm, diam. 17.8 cm)
The Metropolitan Museum of Art, New York
Gift of James Jackson Jarves, 1881, 81.8.133
MFA only

WINEGLASS
Italian (Venice, Murano), 17th century
Glass, H. 5⅝ in., diam. 3⅝ in.
(H. 14.3 cm, diam. 9.2 cm)
The Metropolitan Museum of Art, New York
Gift of James Jackson Jarves, 1881, 81.8.98
MFA only

CRUET
Spanish (Catalonia), 17th century
Glass, H. 9⅛ in. (23.2 cm)
The Metropolitan Museum of Art, New York
Gift of Henry G. Marquand, 1883, 83.7.126
MFA only

DOUBLE-HANDLED FLASK
Italian (Venice) or the Netherlands, late 16th century
Blue glass, blown, applied, gilded, and cold-painted,
H. 17⁷⁄₁₆ in., w. 8⁷⁄₁₆ in. (H. 44.3 cm, w. 21.4 cm)
Corning Museum of Glass, 2006.3.50

CRISTALLO WINEGLASS
Italian (probably Venice), late 16th or
early 17th century
Colorless glass, H. 5¼ in. (13.4 cm)
Corning Museum of Glass, 58.3.196

TAZZA
Italian (Venice), about 1600
Colorless glass, H. 4⅛ in., rim diam. 4¹¹⁄₁₆ in.
(H. 10.5 cm, rim diam. 11.9 cm)
Corning Museum of Glass, 60.3.17

COVERED GOBLET
Italian (Venice), about 1575–1600
Colorless glass with opaque white decoration (*vetro
a filigrana*), H. 14⁹⁄₁₆ in., top diam. 4³⁄₁₆ in.
(H. 37 cm, top diam. 10.6 cm)
Corning Museum of Glass
Gift of Jerome Strauss, 67.3.42

COVERED GOBLET
Italian (probably Venice), about 1575–1625

Colorless glass with opaque white decoration
(*vetro a filigrana*), H. 13¾ in. (34.9 cm)
Corning Museum of Glass, 64.3.9

PERFUME HUMIDIFIER OR LAMP
Italian (Venice), 17th century
Colorless glass with applied blue glass handles
H. 8½ in., foot diam. 2¹¹⁄₁₆ in.
(H. 21.6 cm, foot diam. 6.8 cm)
Corning Museum of Glass, 58.3.182

ENAMELED TAZZA
Italian (Venice), first half of 16th century
Colorless soda-lime glass with gilding and poly-
chrome decoration, H. 2¹⁵⁄₁₆ in., rim diam. 10⅜ in. (H.
7.5 cm, rim diam. 26.25 cm)
Corning Museum of Glass, 51.3.117

DESSERT TRAY (SALVILLA)
Spanish (Catalonia, probably Barcelona),
about 1560–1600
Colorless glass decorated with polychrome and enam-
el, H. 2¾ in., top diam. 8⅞ in.
(H. 7 cm, top diam. 22.6 cm)
Corning Museum of Glass, 68.3.1

COVERED GOBLET (CONFITERO)
Spanish (probably Catalonia), last quarter of the 16th
century
Glass decorated with diamond-point engraving and
gilding with applied white glass decoration,
H. 10⅛ in. (25.7 cm)
Corning Museum of Glass
Bequest of Jerome Strauss, 79.3.283

BEAKER WITH TRAILED DECORATION
Probably southern Spanish, early 17th century
Colorless glass, H. 5¹¹⁄₁₆ in., rim diam. 4¹⁄₁₆ in.
(H. 14.4 cm, rim diam. 10.3 cm)
Corning Museum of Glass
Gift of The Ruth Bryan Strauss Memorial
Foundation, 79.3.885

WINEGLASS
Possibly Spanish, late 16th or early 17th century
Glass, H. 5⅜ in., diam. 4¹⁵⁄₁₆ in. (H. 13.6 cm, diam. 12.5 cm)
Corning Museum of Glass
Gift of Mrs. Yves Henry Buhler, 63.3.46

WINEGLASS
Probably Spanish, 17th century
Amber glass with applied blue glass decoration,
H. 5⅞ in. (15 cm)
Corning Museum of Glass, 65.3.42

ALBARELLO
Spanish (probably Catalonia), late 16th or
early 17th century
Colorless glass with opaque white glass decoration
(*vetro a filigrana*), H. 4½ in. (11.5 cm)
Corning Museum of Glass
Gift of George D. MacBeth, 62.3.115

COVERED RELIQUARY GOBLET
Italian (Venice) or the Netherlands, late 16th or early
17th century
Colorless glass, H. 11¼ in., foot diam. 4³⁄₁₆ in.
(H. 28.6 cm, foot diam. 10. 6 cm)
Corning Museum of Glass, 2005.3.119

PINK CONCH (*Strombus gigas*)
L. 9 in., h. 5¾ in., d. 6 in.
(L. 22.9 cm, h. 14.6 cm, d. 15.2 cm)
Peabody Essex Museum, Salem, Massachusetts

CHAMBERED NAUTILUS (*Nautilus pompilius*)
L. 7.5 in., h. 5¾ in., d. 4 in.
(L. 19.1 cm, h. 14.6 cm, d. 10.2 cm)
Peabody Essex Museum, Salem, Massachusetts

Notes

ANTONIO FEROS

Art and Spanish Society: The Historical Context, 1577–1623

1. Geoffrey Parker, *The World is not Enough: The Imperial Vision of Philip II of Spain* (Waco: Markham Press Fund, 2001).

2. Geoffrey Parker, *The Grand Strategy of Philip II* (New Haven: Yale University Press, 1998); and Anthony Padgen, *Lords of All the Worlds: Ideologies of Empire in Spain, Britain and France c. 1500–c. 1850* (New Haven: Yale University Press, 1995).

3. María Estela Lépori de Pithod, *La imagen de España en el siglo XVII: Percepción y decadencia* (Mendoza: Editorial de la Facultad de Filosofía y Letras de la Universidad Nacional de Cuyo, 1998); J. N. Hillgarth, *The Mirror of Spain, 1500–1700: The Formation of a Myth* (Ann Arbor: University of Michigan Press, 1999); and Georgina Dopico-Black, "España abierta: Cervantes y el Quijote," in *España en tiempos del Quijote*, ed. Antonio Feros and Juan E. Gelabert (Madrid: Taurus, 2004).

4. Agustín Bustamante García, *La octava maravilla del mundo: Estudio histórico sobre el Escorial de Felipe II* (Madrid: Editorial Alpuerto, 1994); Fernando Checa Cremades et al., *El Escorial: Arte, poder y cultura en la corte de Felipe II* (Madrid: Universidad Complutense de Madrid, 1989); George Kubler, *Building the Escorial* (Princeton: Princeton University Press, 1982); and Cornelia von der Osten Sacken, *San Lorenzo el Real de El Escorial: Estudio iconológico* (Bilbao: Xarait, 1984).

5. On justice in the Spanish monarchy, see Richard L. Kagan, *Lawsuits and Litigants in Castile, 1500–1700* (Chapel Hill: University of North Carolina Press, 1981); James Casey, *Early Modern Spain: A Social History* (London: Routledge, 1999), chapter 8; Tomás Antonio Mantecón Movellán, "Did Interpersonal Violence Decline in the Spanish Old Regime?" *Memoria y civilización: Anuario de historia de la Universidad de Navarra*, 2 (1999): 117–40; Juan Eloy Gelabert González, "Tiempos de borrasca: Notas sobre la violencia política en la Castilla del siglo XVII," in *Furor et rabies: Violencia, conflicto y marginación en la Edad Moderna*, ed. José Ignacio Fortea Pérez, Juan Eloy Gelabert González, and Tomás Antonio Mantecón Movellán (Santander: Universidad de Cantabria, 2002), 219–38.

6. For this and following paragraphs, see John H. Elliott, *Richelieu and Olivares* (Cambridge: Cambridge University Press, 1984); Antonio Feros, *Kingship and Favoritism in the Spain of Philip III, 1598–1621* (Cambridge: Cambridge University Press, 2000), chapters 1 and 4; and Antonio Feros, "Sacred and Terrifying Gazes: Languages and Images of Power in Early Modern Spain," in *The Cambridge Companion to Velázquez*, ed. Suzanne L. Stratton-Pruitt, (Cambridge: Cambridge University Press, 2002), 68–86.

7. Antonio Feros, "Por Dios, por la Patria y el Rey," in Feros and Gelabert, *España en tiempos del Quijote*, 61–96.

8. Feros, *Kingship and Favoritism.*

9. Richard Tuck, *Philosophy and Government, 1572–1651* (Cambridge: Cambridge University Press, 1993), 56.

10. Tuck, *Philosophy and Government*; Feros, *Kingship and Favoritism*; and Xavier Gil Pujol, "Las fuerzas del rey. La generación que leyó a Botero," in *Le Forze del Principe*, ed. Mario Rizzo, José Javier Ruiz Ibañez, and Gaetano Sabatini (Murcia: Universidad de Murcia, 2004), 2: 969–1022.

11. John H. Elliott and L. W. B. Brockliss, *The World of the Favourite* (New Haven: Yale University Press, 1999).

12. Feros, *Kingship and Favoritism*, chapters 4 and 5; Jonathan Brown and J. H. Elliott, *A Palace for a King: The Buen Retiro and the Court of Philip IV* (New Haven: Yale University Press, 2003).

13. Patrick Williams, "El auge desaforado de los Consejos," in *Felipe II (1527–1598): Europa y la monarquía católica*, ed. José Martínez Millán (Madrid: Parteluz, 1998), vol. 1.2: 975–84.

14. Feros, *Kingship and Favoritism*, chapters 9–11.

15. John H. Elliott, "Self-Perception and Decline in Early Seventeenth-Century Spain," *Past and Present*, 74 (1977): 41–61; Juan Eloy Gelabert González, "La Restauración de la República," in Feros and Gelabert, *España en tiempos del Quijote*, 197–234.

16. Martín González de Cellorigo, *Memorial de la política necesaria y útil restauración a la República de España* [1600], ed. José L. Pérez de Ayala (Madrid: Instituto de Estudios Fiscales, 1991).

17. Vicente Pérez Moreda, "The Plague in Castile at the End of the Sixteenth Century and Its Consequences," in *The Castilian Crisis of the Seventeenth Century: New Perspectives on the Economic and Social History of Seventeenth-Century Spain*, ed. I. A. A. Thompson and Bartolomé Yun Casalilla (New York: Cambridge University Press, 1994), 32–59.

18. For this and the following paragraphs, see Bernard Vincent, "La sociedad española en la época del Quijote," in Feros and Gelabert, *España en tiempos del Quijote*, 279–308.

19. Jaime Contreras and Gustav Henningsen, "Forty-Four Thousand Cases of the Spanish Inquisition (1540–1700): Analysis of a Historical Data Bank," in *The Inquisition in Early Modern Europe. Studies on Sources and Methods*, ed. Gustav Henningsen and John Tedeschi (Dekalb: Northern Illinois University Press, 1986), 100–29.

20. Helen Rawlings, *Church, Religion, and Society in Early Modern Spain* (New York: Palgrave, 2002); and *The Spanish Inquisition* (Oxford: Blackwell, 2005).

21. María Victoria López-Cordón, "La conceptualización de las mujeres en el Antiguo Régimen: Los arquetipos sexistas," *Manuscrits: Revista d'història moderna* 12 (1994): 79-108; *Historia de las mujeres en España y América Latina: El mundo moderno*, ed. Margarita Ortega et al. (Madrid: Cátedra, 2005).

22. Mantecón Movellán, "Interpersonal Violence."

23. Magdalena S. Sánchez, *The Empress, the Queen, and The Nun: Women and Power at the Court of Philip III of Spain* (Baltimore: Johns Hopkins University Press, 1998); López-Cordón, "La conceptualización de las mujeres."

24. Melveena McKendrick, *Woman and Society in the Spanish Drama of the Golden Age* (Cambridge: Cambridge University Press, 1974); and *Identities in Crisis: Essays on Honour, Gender and Women in the Comedia* (Kassel: Edition Reichenberger, 2002).

25. Pedro M. Cátedra, *Nobleza y lectura en tiempos de Felipe II: La biblioteca de Don Alonso Osorio, Marqués de Astorga* (Valladolid: Junta de Castilla y León, Consejería de Educación y Cultura, 2002); and *Invención, difusión y recepción de la literatura popular impresa (siglo XVI)* (Merida: Editora Regional de Extremadura, 2002); *Fernando Bouza Alvarez, El libro y el cetro: La biblioteca de Felipe IV en la Torre Alta del Alcázar de Madrid* (Salamanca: Instituto de Historia del Libro y de la Lectura, 2005).

26. Francisco Gómez Camacho, *Economía y filosofía moral: La formación del pensamiento económico europeo en la escolástica española* (Madrid: Síntesis, 1998), chapter 4; Anne J. Cruz, *Discourses of Poverty: Social Reform and the Picaresque Novel in Early Modern Spain* (Toronto: University of Toronto Press, 1999); and Michel Cavillac, "El Madrid 'utópico' (1597–1600) de Cristóbal Pérez de Herrera," *Bulletin hispanique*, 104, no. 2 (2002) 627–44.

27. Contreras and Henningsen, "Forty-Four Thousand Cases."

28. Juan Ignacio Gutiérrez Nieto, "La limpieza de sangre," in *Dogmatismo e intolerancia*, ed. Magdalena de Pazzis Pi Corrales and Enrique Martínez Ruiz (Madrid: Editorial Actas, 1997), 33–48; Henry Kamen, *The Spanish Inquisition: A Historical Revision* (New Haven: Yale University Press, 1998), chapter 11.

29. Davis L. Graizbord, *Souls in Dispute: Converso Identities in Iberia and the Jewish Diaspora, 1580–1700* (Philadelphia: University of Pennsylvania Press, 2004); on the remarkable life of Samuel Pallache, see also Mercedes García-Arenal and Gerard Wiegers, *A Man of Three Worlds: Samuel Pallache, a Moroccan Jew in Catholic and Protestant Europe*, trans. Martin Beagles (Baltimore: The Johns Hopkins University Press, 2003).

30. Antonio Domínguez Ortiz and Bernard Vincent, *Historia de los moriscos: Vida y tragedia de una minoría* (Madrid: Alianza Editorial 1985); Mercedes García-Arenal, "El problema morisco: Propuestas de discussion," *Al-qantara: Revista de estudios árabes*, 13 no. 2 (1992): 491–504.

31. José Ignacio Fortea Pérez, *Monarquía y cortes en la Corona de Castilla: Las ciudades ante la política fiscal de Felipe II* (Valladolid: Cortes de Castilla y León, 1990), and "Las ciudades, sus oligarquías y el gobierno del reino," in Feros and Gelabert, *España en tiempos del Quijote*, 235–78; Gelabert González, "La Restauración de la República," in Feros and Gelabert, *España en tiempos del Quijote*; Xavier Gil Pujol, "Parliamentary Life in the Crown of Aragon: Cortes, Juntas De Brazos, and Other Corporative Bodies," *Journal of Early Modern History* 4 (2003): 362–94; and Alfredo Alvar et al., *La economía en la España moderna* (Madrid: Ediciones Istmo, 2006).

32. I. A. A. Thompson, *War and Government in Habsburg Spain, 1560–1620* (London: Athlone Press, 1976); Juan Eloy Gelabert González, "Las finanzas de la monarquía hispana en tiempos de Cervantes," *Clm.economía: Revista económica de Castilla-La Mancha* 5 (2004): 95–120.

33. Raffaele Puddu, *El soldado gentilhombre* (Barcelona: Argos y Vergara, 1984); David García Hernán, *La cultura de la guerra y el teatro del Siglo de Oro* (Madrid: Silex, 2006).

34. Parker, *The Grand Strategy of Philip II*.

35. Carlos Gómez-Centurión, *Felipe II, la empresa de Inglaterra y el comercio septentrional (1566–1609)* (Madrid: Editorial Naval, 1988); and I. A. A. Thompson, "La respuesta castellana ante la política internacional de Felipe II," in *La monarquia de Felipe II a debate*, ed. Luis Antonio Ribot García (Madrid: Sociedad Estatal para la Conmemoración de los Centenarios de Felipe II y Carlos V, 2000), 121–36.

36. Bernardo José García García, *La Pax Hispánica: Política exterior del Duque de Lerma* (Louvain: University of Louvain, 1996); and Paul C. Allen, *Philip III and the Pax Hispanica, 1598–1621: The Failure of Grand Strategy* (New Haven: Yale University Press, 2000).

37. Pujol, "Las fuerzas del rey."

38. Feros, *Kingship and Favoritism*, chapter 7.

39. Allen, *Philip III and the Pax Hispanica*; and Feros, *Kingship and Favoritism*, chapter 9.

40. Feros, *Kingship and Favoritism*, chapter 9; and Rafael Benítez Sánchez-Blanco, *Heroicas decisiones: La monarquía católica y los moriscos valencianos* (Valencia: Institució Alfons el Magnànim, 2001).

41. Feros, *Kingship and Favoritism*, chapter 12.

42. On the new regime and its internal and international policies, see Elliott, *Richelieu and Olivares*.

43. On the Buen Retiro, see Brown and Elliott, *A Palace for a King*.

RONNI BAER

El Greco to Velázquez: Artists of the Reign of Philip III

This essay is dedicated to Jonathan Brown, an inspirational teacher to whom I owe my love of Spanish painting.

NOTE: *The published documentary evidence for the lives of the artists in the exhibition appears in the biographies at the end of the catalogue. The reader is referred to these biographies for unfootnoted references to dates and commissions mentioned in the text.*

1. William B. Jordan, *Juan van der Hamen y León and the Court of Madrid* (New Haven and London: Yale University Press, 2005), 29.

2. Jonathan Brown, "Introduction: El Greco, the Man and the Myths," in *El Greco of Toledo* (Toledo: The Toledo Museum of Art, 1982), 18.

3. Palomino's treatise *El museo pictórico y escala óptica*, published in 1715, was one of the most important contributions to eighteenth-century literature on Spanish art.

4. Jusepe Martínez (1600–1682), who wrote *Discursos practicables del nobilísimo arte de la pintura* about 1673 (it was not published until 1866), called him "a son of [Toledo]," and Palomino said he was "born in a village near Toledo."

5. Xavier de Salas and Fernando Marías, *El Greco y el arte de su tiempo: Las notas de El Greco a Vasari* (Toledo: Real Fundación de Toledo, 1992), 141–42. Tristán's notations also imply that his travels took him to Seville and royal sites such as Aranjuez, El Pardo, and El Escorial; see Alfonso E. Pérez Sánchez and Benito Navarrete Prieto, *Luis Tristán* (Madrid: Real Fundación de Toledo, 2001), 49–50.

6. Tristán witnessed the appointment of Jorge Manuel as proxy for his father in making altarpieces for the church in Lugarnuevo (now San Martín de Montalbán) in November 1606, and he was recorded as back in Toledo by May 1612, when he received a commission for numerous paintings for the councilman Luis Sirvendo. Fernando Marías, "Nuevos documentos de pintura toledana de la primera mitad del siglo XVII," *Archivo Español de Arte* 204 (1978): 421, published a document regarding Tristán's lease of a house on October 5, 1611, but the date has been corrected to October 5, 1615; see Pérez Sánchez and Navarrete Prieto, *Luis Tristán*, 286, document 14. The *Crucifixion* with a Tristán signature and date of 1609 published by Ismael Gutiérrez Pastor ("El Viaje a Italia de Luis Tristán," *Anuario del Departamento de Historia y Teoría del Arte* 5 [1993]: 99–104) was justifiably rejected by Pérez Sánchez and Navarrete Prieto (*Luis Tristán*, 267).

7. Jusepe Martínez, *Discursos practicables del nobilísimo arte de la pintura*, ed. Julián Gállego (Barcelona: 1950), 273.

8. Pérez Sánchez and Navarrete Prieto, *Luis Tristán*, 23 and document 4.

9. Ibid., 27.

10. Ibid., 32.

11. Ibid., 38–39.

12. Ibid., 40.

13. Ibid., 41, says January 12; document 38 says February 12.

14. Ibid., 41–42.

15. Ibid., 42–43.

16. Ibid., 42.

17. Juan Miguel Serrera, "Juan Bautista Maíno: Notas sobre el retablo de las Cuatro Pascuas," *Boletín del Museo del Prado* 10 (1989): 39. Antonio Ponz (*Viaje de España*, ed. Castro María del Ribero [Madrid: M. Aguílar, 1947], 77) praised the altarpiece as one of the very best in Toledo.

18. Antonio Palomino, *El museo pictórico y escala óptica* (Madrid: M. Aguilar, 1947), 869; Juan A. Ceán Bermúdez, *Diccionario histórico de las más ilustres profesores de las bellas artes en España*, 6 vols. (Madrid: Imprenta de la viuda de Ibarra, 1800; facsimile ed., Madrid: Reales Academias de Bellas Artes de San Fernando y la Historia, 1965), 3: 99.

19. Martínez, *Discursos practicables*, 198.

20. It is possible that Maino also went to France at this time. In his statement to the Inquisition in 1638, Maino referred to having been in the "land of the Kings of France" ("como lo ha visto hacer á los Reyes de Francia cuando á este testigo, en su tierra, le escarnecian"); A. E. Pérez Sánchez, "Fray Juan Bautista Maíno, pintor dominico," *Arte Cristiana* 82 (1994): 433; Juan Pérez de Guzmán y Gallo, "Mayno en un proceso de la Inquisición de Toledo," *Arte Español* 3 (1914): 56.

21. In *Arte de la pintura* (2 vols., ed. Francisco J. Sánchez Cotán [Madrid: Instituto de Valencia de Don Juan, 1956], 1: 175), published posthumously in 1649, Pacheco referred to Maino only as "the famous painter from the order of preachers who taught our Catholic King Philip IV how to draw when he was prince."

22. A *Portrait of a Man* in the Museo Nacional del Prado is signed "Fray Juan Bapta. Maino f."

23. Martínez, *Discursos practicables*, 199.

24. Ibid.

25. Maino's painting *Santo Domingo in Soriano* for the altar in the *sala capitular* (chapter house) of the monastery of Atocha was unveiled in 1628. Although three versions of the painting are known (Diego Angulo Iñiguez and Alfonso E. Pérez Sánchez, *Historia de la pintura española: Escuela madrileña del primer tercio del siglo XVII* [Madrid: Instituto Diego Velázquez, 1969], 314–15), Martínez (*Discursos practicables*, 200) assumed that the Atocha painting burned in a fire.

26. Martínez (ibid.) observed that Philip IV loved Maino very much, awarding him 200 ducats of silver for each year, along with other considerable contributions.

27. Jonathan Brown, *Painting in Spain, 1500–1700* (New Haven and London: Yale University Press, 1998), 48–49.

28. Despite the fact that there is no birth document for him, both his sister and his daughter were married in Valladolid, so it seems likely that he was born in that city rather than in Madrid, as asserted by Palomino. According to Jesús Urrea, there are numerous indications that Pantoja was in Valladolid between 1590 and 1606; see "Valladolid en un lienzo de Pantoja de la Cruz," *Boletín Seminario de Estudios de Arte y Arqueología* 44 (1978): 494.

29. Two portraits of the young prince Philip (soon to be Philip III) in Vienna are dated 1592 and 1594; Maria Kusche, *Juan Pantoja de la Cruz* (Madrid: Editorial Castalia, 1964), 25. The portrait of him in the exhibition (cat. 7), signed and dated 1598, was painted the year he assumed the throne.

30. This is according to the account books of Francisco Guillaumas, *maestro de la cámara* (chamberlain); it is not known when Pantoja was appointed *ayuda de cámara*, a household appointment closer to the king than a mere *pintor del rey*.

31. Richard Mann, *El Greco and His Patrons: Three Major Projects* (Cambridge and New York: Cambridge University Press, 1989), 47. My thanks go to Sarah Schroth for this reference.

32. Annotations from the account books of Francisco Guillaumas record works ordered from Pantoja by the king in 1602 that were paid for on October 30, 1604. This was the only instance during his lifetime that Pantoja was paid by the king. In 1608 Pantoja petitioned the king for money owed him. After his death later that year, the artist's heirs itemized the works he made for the queen from 1600 to 1607 and for the king from 1603 to 1608 for which they were still awaiting payment; see Kusche, *Pantoja*, 236–48.

33. Referred to in the 1607 inventory of the collection of the duke of Lerma as "good" (Alexander Vergara, *Rubens and His Spanish Patrons* [Cambridge and New York: Cambridge University Press, 1999], 16–17), and as "very good" by Iberti (Mantua's resident at the Spanish court) in a letter to the duke of Mantua (*The Letters of Peter Paul Rubens*, trans. and ed. Ruth Saunders Magurn [Cambridge, Mass.: Harvard University Press, 1955; reprint, Evanston, Ill.: Northwestern University Press, 1991], 434, letter 8, n. 1).

34. Vergara, *Rubens and His Spanish Patrons*, 14; Sarah Schroth, "Beyond the 'Identification of the Sitter': Rubens's Studies for the Equestrian Portrait of the Duke of Lerma," in *Dibujos para el retrato escuestre del duque de Lerma* (Madrid: Museo del Prado, 2001), 63.

35. Schroth, "Beyond the 'Identification of a Sitter,'" 65–66.

36. Magurn, *Letters of Peter Paul Rubens*, 435, letter 11, n. 2.

37. Ibid., 33. In 1614 Rodrigo Calderón, one of Philip III's leading courtiers and a close associate of the duke of Lerma, received from Flanders a series of paintings of Christ and the twelve apostles by Rubens. By 1618 the *Apostolado* belonged to the duke of Lerma. It is now in the Museo Nacional del Prado; see Vergara, *Rubens and His Spanish Patrons*, 20–21.

38. This idea was discussed in conversation with Sarah Schroth.

39. Jesús Urrea, "Aproximación biográfica al escultor Gregorio Fernández," in *Gregorio Fernández 1576–1636* (Valladolid: Fundación Santander Central Hispano, 1999), 21. According to Urrea, Juan de Muñiátegui, who acted as one of the guarantors of the contract, had worked with Fernández at the monastery of San Diego under the patronage of the duke of Lerma. After Muñiátegui's death at the beginning of 1612 (Fernández was executor of his estate), Fernández began to work with members of the Velázquez family.

40. The will of a Franciscan writer identified Rincón as Fernández's teacher, and an affirmation of this information was provided to the friar by the painter Diego Valentín Díaz (see fig. 16), who knew Fernández well. However, the sculptor was completely formed by the time he moved to Valladolid; he more likely entered Rincón's workshop as a journeyman; see Urrea, "Aproximación biográfica," 18. According to Urrea (21), Agustín Castaño from Palencia and Pedro Jiménez and Pedro Aldívar from Navarra were also in Fernández's workshop at the time.

41. Jesús Urrea, "Catálogo," in *Gregorio Fernández*, 94. This was the first version of the sculpture of the recumbent dead Christ; the king would have Fernández make a second version for El Pardo in 1614. San Pablo was the Lerma family burial site.

42. Urrea, "Aproximación biográfica," 25.

43. Antonio Palomino, *Lives of the Eminent Spanish Painters*, trans. Nina Ayala Mallory (Cambridge and New York: Cambridge University Press, 1987), 70.

44. J. J. Martín González, *Escultura barroca en España, 1600–1700* (Madrid: Cátedra, 1983), 68.

45. J. J. Martín González, "Gregorio Fernández," Grove Dictionary of Art online (Oxford University Press, 2007), http://www.groveart.com. According to Urrea ("Aproximación biográfica," 25), it is likely that the sculpture of the saint installed in the Jesuit church of Valladolid on November 23, 1610, to celebrate Ignatius Loyola's beatification was the work of Fernández as well.

46. J. J. Martín González, *Escultura barroca*, 43.

47. José Martí y Monsó, "Dos cartas de Francisco Pacheco," in *Estudios históricos-artísticos relativos principalmente a Valladolid* (Valladolid: L. Miñon, 1898–1901), 626. A new hospital, called La Convalencia, was established within the Hospital General in 1734; see Amalia Prieto Cantero, "El archivo del Hospital de la Resurrección de Valladolid, incorporado al Historico Provincial y Universitario," *Boletín de la ANABAD* 28, no. 4 (October–December 1978): 52. Ponz (*Viaje de España*, 974) saw the painting by Pantoja in this new hospital.

48. Maria Kusche, "La nueva galería del Pardo: J. Pantoja de la Cruz, B. González, y F. López," *Archivo Español de Arte* 72, no. 286 (1999): 121. In *La Hermosura de Angélica* of 1602, the great Spanish dramatist and poet Lope de Vega lauded Pantoja for the life and soul he was able to impart to a mute face; the writer would later praise the beauty of the artist's colors in *Jerusalén conquistada* of 1609.

49. Matías Díaz Padrón and Aida Padrón Mérida, "Miscelánea de pintura española del s. XVII," *Archivo Español de Arte* 56, no. 223 (July–September 1983): 218–19.

50. Ismael Gutiérrez Pastor, "Bartolomé González," Grove Dictionary of Art online (Oxford University Press, 2007), http://www.groveart.com.

51. Kusche, *Pantoja*, 37.

52. As cited in F. J. Sánchez Cantón, *Fuentes literarias para la historia del arte español* (Madrid: Imprenta clásica-española, 1923–41), 5: 436.

53. Ceán Bermúdez, *Diccionario*, 2: 206.

54. Palomino, *Museo pictórico*, 828.

55. Carl Justi (*Diego Velázquez and His Times* [London and Philadelphia: H. Grevel and Company and J. B. Lippincott Company, 1889], 38) mentioned that Roelas was passed over as painter to the king "in favor of the wretched portraitist B. González, portraiture being at that time the chief occupation of the Court painters."

56. According to Ceán (*Diccionario*, 2: 207), the year before he had also signed and dated the *Nativity* (then in San Francisco, Madrid) and he continued to paint such religious works until the end of his career, as is evidenced by the *Rest on the Flight into Egypt* (cat. 25), signed by him and dated 1627.

57. Peter Cherry, "Nuevos datos sobre Bartolomé González," *Archivo Español de Arte* 66, no. 261 (January–March 1993): 5, 7–9.

58. In a document of 1605, he declared himself to be "more or less" twenty-nine years old; in a document of 1606 he declared himself to be thirty. The inscription on Carducho's portrait engraved by Perret and dated 1614 gives the age of the sitter as thirty-eight years old. However, in 1628 Carducho gave his age as fifty. He wrote of himself: "My native country is the noble city of Florence, the head of Tuscany, and according to many of title, illustrious in the world; but since my education beginning from my earliest years took place in Spain, and in particular at the court of our Catholic King . . . and so I consider myself a native of Madrid"; Angulo Iñiguez and Pérez Sánchez, *Escuela madrileña*, 86.

59. Ceán Bermúdez, *Diccionario*, 1: 245–46.

60. Such an academy was not to be established in Spain until the mid-eighteenth century; see Brown, *Painting in Spain*, 82–83.

61. Angulo Iñiguez and Pérez Sánchez, *Escuela madrileña*, 99. This valuation, by Pedro Juan de Tapia and Antonio Morales for the king and by Lorenzo de Aguirre and Alonso Maldonado for the painters, was contested and a new valuation was carried out the following month. This too proved unsatisfactory, and in 1614 the painters asked the king to honor the first valuation. The following year yet another valuation was provided, but the resolution of the dispute is unrecorded. Carducho was paid for canvases painted prior to 1617 for the Capuchin monastery of El Pardo in 1625; these paintings had been valued in October 1617 by Juan de Roelas.

62. Angulo Iñiguez and Pérez Sánchez, *Escuela madrileña*, 87. On August 29, 1615, Cajés and Carducho requested an appraisal of the work in the Sagrario and named Francisco Granelo as their valuator; the cathedral representative, Canon Garay, named Juan Bautista Maino, who was already established in Toledo in the monastery of San Pedro Mártir, as theirs. On September 9, 1615, Carducho and Cajés asked for final payment for this work. On September 15 they were finally paid 6,500 ducats, an amount, however, that did not coincide with the appraised estimate; see Fernando Marías, "Nuevos documentos de pintura toledana de la primera mitad del siglo XVII," *Archivo Español de Arte* 51 (1978): 423. My thanks go to Xiomara Murray for this reference.

63. Mary Crawford Volk, *Vicencio Carducho and Seventeenth-Century Castilian Painting* (New York and London: Garland Publishing, 1977), 326–28.

64. Laura Bass graciously drew my attention to this poem.

65. Lázaro Díaz del Valle (*Epílogo y nomenclatura de algunos artífices*, as cited in Sánchez Cantón, *Fuentes literarias*, 2: 358) wrote in 1656 that "there doesn't exist in Spain an eminent painter who has [made] as many public works."

66. Angulo Iñiguez and Pérez Sánchez, *Escuela madrileña*, 87.

67. Martínez, *Discursos practicables*, 190–91. His will of 1635 specified that he should be buried in the habit of Saint Francis, "of whose Venerable Third Order of Penitence [*venerable orden tercera de penitencia*] he is a member, in the church of the Unshod Carmelites in Madrid in the part of the chapel where his wife is buried, if possible"; María Luisa Caturla, "Documentos en torno a Vicencio Carducho," *Arte Español* 26 (1968–69): 161. *The Stigmatization of Saint Francis* (cat. 38) was recorded by Angulo Iñiguez and Pérez Sánchez (*Escuela madrileña*, 168 [422]) as in the Chapel of the Third Order, for which it was probably made.

68. Their long-standing friendship dated back to the time when Carducho's brother Bartolomé and Cajés's father Patricio worked together at El Escorial; Angulo Iñiguez and Pérez Sánchez, *Escuela madrileña*, 213.

69. Ceán Bermúdez, *Diccionario*, 1: 301. Cristóbal Pérez Pastor (*Noticias y documentos relativos a la historia y literatura española* [Madrid: Imprenta de la Revista de Legislaciós, 1914], 11: 173) gave her name as Francisca Manzano, but in Cajés's last will and testament the name of his wife was correctly given as Felipa; see Mercedes Agulló y Cobo, *Noticias sobre pintores madrileños de los siglos XVI y XVII* (Granada: Departamentos de Historia del Arte de las Universidades de Granada y Autónoma de Madrid, 1978), 36–39. After his marriage there is hardly a year when Cajés is unaccounted for in the documents; see Angulo Iñiguez and Pérez Sánchez, *Escuela madrileña*, 212.

70. Pantoja referred to Cajés as a "carver of ivory," but there is no work we know by him in this medium; Kusche, *Pantoja*, 231; Angulo Iñiguez and Pérez Sánchez, *Escuela madrileña*, 219.

71. This Spanish government agency was responsible for collecting colonial taxes and duties, approving voyages of exploration and trade, maintaining information on trade routes and new discoveries, and administering commercial law; on the Casa, see Antonio Barrera-Osorio, *Experiencing Nature: The Spanish American Empire and the Early Scientific*

Revolution (Austin: University of Texas Press, 2006), chapter 2.

72. One wonders how the conception of the Nativity for this series compared to that of the small painting of the theme from 1610 in this exhibition (cat. 24).

73. Brown, *Painting in Spain*, 82; Carducho, who did not sign the petition, was then with the court in Valladolid.

74. The *Leda* by Cajés was commissioned by Philip III to record Correggio's painting that the king gave to Emperor Rudolph of Prague; *Pintores del Reinado de Felipe III* (Madrid: Museo del Prado, 1993), 64. It documents the composition before it was cut into pieces in a fit of religious mania by Louis d'Orléans, son of Philippe, duc d'Orléans, who had acquired the painting in 1721.

75. Martínez (*Discursos practicables*, 191) called the altarpiece by Cajés in San Felipe "sumptuous . . . a grand [work of] art and beauty worthy of great admiration." He recounted that an Italian painter friend of his remarked that no one in Rome could have painted it better.

76. Ceán Bermúdez (*Diccionario*, 1: 301) based his description on that of Palomino (*Museo pictórico*, 863–64); Cajés's decoration was also mentioned by Martínez (*Discursos practicables*, 192) and was first described in Vicente Carducho's *Diálogos de la pintura* (ed. Francisco Calvo Serraller [Madrid: Ediciones Turner, 1979], 331). Carducho further recorded that Cajés owned drawings by the king's siblings (446) and that he was one of the judges for the competition to replace González as *pintor del rey* in 1627 (447, n. 1191). As Sarah Schroth observed in conversation, it is curious that so little was written by Carducho about his close friend.

77. Book XIX, as cited in Sánchez Cantón, *Fuentes literarias*, 5: 412: "Al pie de un lauro tres sepulcros veo/Apeles yace aqui, Zeuxis, Cleoneo,/Juan de la Cruz, Carvajal, Carducho/murieron ya; ¡que fúnebre trofeo!,/muerte cruel, mas no te alabes mucho, /Cárdenas queda y con divino ingenio/Mora, Guzmán, Vicencio, Andrés, Eugenio" (At the foot of the laurel I see three sepulchers:/Apelles lies there as do Zeuxis and Cleon/since Juan de la Cruz, Carvajal and Carducho [Bartolomé]/have passed away; What a mournful triumph!/Cruel death, you will no longer be pleased:/Cárdenas remains and with divine skill so do/Mora, Guzmán, Vicencio [Carducho], Andres and Eugenio [Cajés]).

78. Díaz del Valle (as cited in Sánchez Cantón, *Fuentes literarias*, 2: 344) called Cajés one of the most famous painters of the court, and Palomino (*Museo pictórico*, 862) called him one of the most outstanding.

79. According to Pacheco himself in *Arte de la pintura* (2: 46–48). The commission for the image was given to Pacheco by Juan Gómez de Mora, *maestro mayor del rey*, on the part of the countess of Olivares; the sculpture was painted in Madrid and sent to Olivares (Seville), where it was taken to the high altar of the convent of the Recolletes of San Francisco. Cajés valued it at 500 ducats.

80. Carducho empowered Cajés to negotiate for the painting and gilding of the Sagrario on October 3, 1614; a short year later the artists received 6,500 ducats for the work.

81. This work replaced El Greco's *Adoration of the Shepherds*, the painting he had made as his own

memorial, as a result of litigation between Jorge Manuel and the nuns of Santo Domingo el Antiguo; see Harold E. Wethey, *El Greco and His School* (Princeton: Princeton University Press, 1962), 1: 73.

82. In 1620 Cajés made a painting of *San Isidro* for the provisional principal altar of the church. The main retable, contracted for on November 11, 1621, required Cajés to paint twenty-six canvases; see Angulo Iñiguez and Perez Sanchez, *Escuela madrileña*, 224. Work on this commission was somehow stymied and was only resumed in the late summer of 1627; a new contract to size and gild the altarpiece was signed in January 1632.

83. For *Recapture of Puerto Rico*, 1625 (Museo Nacional del Prado), and *Recapture of Saint Martin*, 1633 (now lost), see Jonathan Brown and John H. Elliott, *A Palace for a King*, rev. and exp. ed. (New Haven and London: Yale University Press, 2003), 173, 176.

84. Jordan, *Van der Hamen*, 130.

85. This was an elite group of one hundred nobles of Flemish birth or ancestry charged with guarding the royal person; see Jordan, *Van der Hamen*, 41.

86. William B. Jordan, *Spanish Still Life in the Golden Age 1600–1650* (Fort Worth: Kimbell Art Museum, 1985), 105.

87. Van der Hamen became eligible for this highly visible position at court in April 1621, but he had to wait until a vacancy occurred to be awarded the post. Although he was assigned the post on the first day of January 1622, because of a bureaucratic mistake he did not begin his service until January 1623; see Jordan, *Van der Hamen*, 69.

88. Among those in the cardinal's entourage was the Roman connoisseur and collector Cassiano dal Pozzo. Cassiano evidently persuaded the cardinal to have his portrait painted by Van der Hamen, to replace one by Velázquez, which had a "melancholy and severe air." In his diary, Cassiano wrote of Van der Hamen, "in the painting of portraits, flowers, fruits and the like, he was eminently successful" (*per far rittrati fiori frutti e simile riusciva eccellentemente*); Enriqueta Harris, "Cassiano dal Pozzo on Diego Velázquez," *Burlington Magazine* 112 (1970): 364.

89. Jordan (*Van der Hamen*, 64–65) dated Van der Hamen's religious paintings of *San Isidro* (National Gallery of Ireland) and *Saint John the Baptist in Prayer* (private collection, Madrid) about 1620–22 and, based on the sitter's age, the portrait of his brother Lorenzo (cat. 15) about 1620.

90. In the appraisal of the paintings in the estate made by Pedro Núñez del Valle (1590/94–1649) and Angelo Nardi, the sitters of many of the portraits were identified; see ibid., 147.

91. Ibid., 15–16. Juan Pérez de Montalbán was the father of Alonso Pérez de Montalbán, the guardian of Van der Hamen's children.

92. Pacheco, *Arte de la pintura*, 2: 126. It has been posited that Van der Hamen met Pacheco about the time the former was working for La Encarnación. As Jordan observed (*Van der Hamen*, 147), "Van der Hamen . . . must have been particularly sensitive to his reputation as a history painter at the time he met Pacheco, because of the important commission upon which he had just been engaged."

93. Palomino, *Museo pictórico*, 887: "Pero si las historias vencedoras/De quanto admira en únicos pintores,/No vencen las envidias detractoras,/Y callan tus retratos sus favores/Vuelvan por ti, Vander, tan-

tas Auroras,/Que te coronan de tus mismas flores" (But if your histories, victorious/in all that is admired in the singular painter,/do not vanquish that detracting envy,/and if your portraits do not speak your praises,/let as many Dawns stand up for you, Vander,/who crown you with your own flowers).

94. Sarah Schroth, "Early Collectors of Still-Life Painting in Castile," in Jordan, *Spanish Still Life*, 30.

95. Jordan, *Spanish Still Life*, 52 n.1.

96. Ibid., 45.

97. Ceán Bermúdez, *Diccionario*, 4: 338.

98. Ibid.; Diego Angulo Iñiguez and Alfonso E. Pérez Sánchez, *Historia de la pintura española: Escuela toledana de la primer mitad del siglo XVII* (Madrid: Instituto Diego Velázquez, 1972), 70–71.

99. Pacheco, *Arte de la Pintura*, 1: 175.

100. Palomino, *Lives*, 90.

101. Jordan, *Spanish Still Life*, 94.

102. Antonio Méndez Casal, "El pintor Alejandro de Loarte," *Revista Española de Arte* 3, no. 4 (1934): 194.

103. Ceán Bermúdez, *Diccionario*, 3: 42–43.

104. There were also portraits and landscapes in addition to still lifes; see Jordan, *Spanish Still Life*, 95.

105. Ibid., 95.

106. Martínez, *Discursos practicables*, 237.

107. Miguel Falomir Faus, *Los Bassano en la España del Siglo de Oro* (Madrid: Museo del Prado, 2001), 195; my thanks go to Jonathan Brown for bringing this catalogue to my attention. The bill of exchange from Giovanni Battista Paravicino of Alicante (the Mediterranean port from which people living in Madrid or Murcia left Spain for Naples or Rome) signed on October 26, 1602, indicates that Orrente probably left for Italy about that time; the fact that he gave power of attorney to Gasparao Manart, a lawyer in Rome, suggests he spent time there.

108. Sarah Schroth, "The Private Picture Collection of the Duke of Lerma" (Ph.D. dissertation, New York University, 1990), 37–93; Brown, *Painting in Spain*, 92; Falomir Faus, *Los Bassano*, 180 ff.

109. Alfonso E. Pérez Sánchez, *Pintura barroca en Espana, 1600–1750* (Madrid: Cátedra, 1992), 132; Alfonso E. Pérez Sánchez, "Pedro Orrente," Grove Dictionary of Art online (Oxford University Press, 2007), http://www.groveart.com. In neither publication does the author provide documentation for Orrente's return to Murcia.

110. Nardi solicited the appellation of *pintor del rey* in 1625 citing his previous work, and in 1658 declared he had resided at the court already for fifty-one years; see Angulo Iñiguez and Pérez Sánchez, *Escuela madrileña*, 278, 280.

111. There are indications that later in his career, Orrente was connected in some way to the court of Philip IV. In a document of June 8, 1629, regarding a commission for the monastery of Saint Francis in Yeste, Orrente is referred to as "painter to His Majesty" (Garcia Rey, "Estancias del pintor Pedro Orrente en Toledo," *Arte Español* 18 [1929]: 434). As Angulo Iñiguez and Pérez Sánchez suggest (*Escuela toledana*, 230), this implies that he worked for the court. Martínez (*Discursos practicables*, 237) commented that in Madrid "he emulated the best painters at the court, and was not less celebrated than the rest," and Palomino (*Museo pictórico*, 864) mentioned that paintings by Orrente kept in the

Buen Retiro "were collected by the Count Duke (Olivares) to decorate the Palace." Another connection to the court is found in a document of May 1634, which specified that the artist owed money to Don Francisco Gómez de Asprilla, secretary to His Majesty.

112. Marcos Antonio Orellana, *Biografía pictórica valentina*, ed. Xavier Salas (Madrid: Gráficas Marinas, 1930), 117–19, 537.

113. Ponz, *Viaje de España*, 327. The other story of the rivalry between the two artists—the one Orellana thought more likely—had Ribalta denigrating Orrente's *Saint Sebastian*, which led to the challenge that the former paint a *Martyrdom of Saint Lawrence* and the latter, his *Martyrdom of Saint Vincent*. Although there is no other documentary evidence for the commission of Orrente's *Martyrdom of Saint Sebastian*, from at least 1659 until the early twentieth century the altarpiece was in a chapel of the Valencia Cathedral dedicated to Saint Sebastian founded in 1606 by Diego de Covarrubias, a member of an esteemed Toledan family and vice chancellor of Aragón; see Orellana, *Biografía pictórica*, 537, 539 n. 3; Angulo Iñiguez and Pérez Sánchez, *Escuela toledana*, 256. Palomino (*Museo pictórico*, 864) saw it in "a chapel at the foot of the Cathedral of [Valencia], next to the main entrance."

114. Ibid., 865.

115. Palomino, *Lives*, 91.

116. Ponz, *Viaje de España*, 460; Ceán Bermúdez, *Diccionario*, 4: 174.

117. Alfonso E. Pérez Sánchez, "On the Reconstruction of El Greco's Dispersed Altarpieces," in *El Greco of Toledo*, 159.

118. David Martin Kowal, "The Life and Art of Francisco Ribalta" (Ph.D. dissertation, University of Michigan, 1981), 1: 31–34; David M. Kowal, *Francisco Ribalta and His Followers: A Catalogue Raisonné* (New York and London: Garland Publishing, 1985), 135–36.

119. In a document of February 13, 1618, related to his marriage, Juan is referred to as "oriundus ville Madriti Toletana diocesis" (originating from Madrid in the diocese of Toledo); his birth year is based on the inscription on his first signed and dated painting, which establishes him as eighteen years old in 1615; see Kowal, "Life and Art of Francisco Ribalta," 17.

120. Delphine Fitz Darby, *Francisco Ribalta and His School* (Cambridge: Harvard University Press, 1938), 46.

121. Philip III's former tutor, the inquisitor general and archbishop of Toledo, Cardinal García de Loaisa, performed the marriage mass; see Sarah Schroth's "A New Style of Grandeur" in this catalogue, 77. The marriages had already been celebrated by proxy by Pope Clement VIII in Ferrara on November 13, 1598.

122. On Matarana, see Rosa López Torrijos, "Bartolomé Matarana y otros pintores italianos del siglo XVII," *Archivo Español de Arte* 51 (1978): 184–96. I am grateful to Jonathan Brown for this reference.

123. Kowal, "Life and Art of Francisco Ribalta," 55.

124. Ceán Bermúdez, *Diccionario*, 4: 259; Armand Baschet, "Pierre Paul Rubens: Rubens revient d'Espagne a Mantoue (1604–1606)," *Gazette des*

Beaux-Arts 22 (1867): 307 n. 1; Max Rooses and Charles Ruelens, *Correspondence de Rubens et documents épistolaires concernant sa vie et ses oeuvres* (Antwerp: Vueve de Backer, 1887–1909), 1: 251–52; Vergara, *Rubens and His Spanish Patrons*, 203 n. 56, dismissed Ceán's statement, citing the unlikelihood of such praise given Rubens's contempt for his Spanish contemporaries in Madrid and Valladolid.

125. Kowal, "Life and Art of Francisco Ribalta," 55.

126. Polychrome wood sculptures were also part of the altarpiece; ibid., 55–56.

127. In 1609–10 he would paint the eight lateral canvases of the altarpiece and in 1610 he received payment for painting and gilding the retable; ibid., 56.

128. In Lope's *Hermosura de Angélica* of 1602, Ribalta is mentioned as raising the art of the time to a new level (canto xiii, fols. 129v–130r); Lope also described the engraved portrait that served as the frontispiece to *Rimas humanas y divinas* (Madrid, 1634) as based on a canvas by Ribalta; see Darby, *Francisco Ribalta and His School*, 26.

129. It was established to protect painters and gilders then resident in Valencia against the competition of newcomers; see Darby, *Francisco Ribalta and His School*, 51.

130. Kowal, "Life and Art of Francisco Ribalta," 84.

131. Darby, *Francisco Ribalta and His School*, 57–58; Miguel Falomir Faus, "Artists' Responses to the Emergence of Markets for Paintings in Spain, c. 1600," in *Mapping Markets for Paintings in Europe, 1450–1750*, ed. Neil De Marchi and Hans J. Van Miegroet (Turnhout: Brepols, 2006), 152–53.

132. Palomino, *Lives*, 91.

133. Ceán Bermúdez, *Diccionario*: 4: 171–72.

134. Kowal, "Life and Art of Francisco Ribalta," 130.

135. Fernando Benito Doménech and Vicente Vallés Borrás, "Un proceso a Francisco Ribalta en 1618," *Academia: Boletín de la Real Academia de Bellas Artes de San Fernando* 69 (1989): 146. Jonathan Brown graciously indicated to me the significance of this article.

136. A record of debt owed to Angelo Nardi by Ribalta at the time of Nardi's wedding in Madrid in 1623 indicates that Ribalta knew him; Fernando Benito Doménech, *The Paintings of Ribalta* (New York: Spanish Institute, 1988), 45.

137. Ibid., 94.

138. Ponz, *Viaje de España*, 367.

139. Martínez, *Discursos practicables*, 235–36.

140. Palomino, *Museo pictórico*, 849.

141. Giovanni Gaetano Bottari and Stefano Ticozzi, *Raccolta di lettere sulla pittura, scultura ed architettura scritte da' piu celebri personaggi dei secoli xv, xvi e xvii* (Milan: G. Silvestri, 1822), 1: 289.

142. Giulio Mancini, *Considerazioni sulla pittura*, ed. Adriana Marucchi (Rome: Accademia nazionale dei Lincei, 1956), 1: 249.

143. Giovanni Pietro Bellori, *Le vite de' pittori, scultori et architetti moderni*, 1672, ed. Evelina Borea (Turin: G. Einaudi, 1976), 235.

144. Palomino, *Lives*, 122.

145. Pérez Sánchez suggested that this unnamed Spaniard brought the paintings to Seville, where

they were seen by the young Velázquez; see Alfonso E. Pérez Sánchez, "Ribera and Spain: His Spanish Patrons in Italy; The Influence of His Work on Spanish Artists," in Alfonso E. Pérez Sánchez and Nicola Spinosa, *Jusepe de Ribera* (New York: The Metropolitan Museum of Art, 1992), 37. The two artists may have met when Velázquez was in Naples in the autumn of 1630, where he painted the portrait of the Infanta María, queen of Hungary.

146. Ibid., 35–6. Jusepe Martínez, who met Ribera "in the celebrated court of the viceregency" in Naples in 1625, reported that the artist longed to return to Rome, not to see the work of contemporary painters but to see history painting, "especially that of Raphael." Martínez asked Ribera why he did not consider returning to Spain, assuring him that he would be held in high esteem. Ribera memorably replied, "My dear friend, I desire it very much but . . . I judge Spain [to be] a merciful mother to foreigners but a most cruel stepmother to her own children." Martínez, *Discursos practicables*, 98–9.

147. Marcus B. Burke and Peter Cherry, *Spanish Inventories I: Collections of Paintings in Madrid 1601–1755*, part 1 (Los Angeles: Provenance Index of the Getty Information Institute, 1997), 120. My thanks go to Sarah Schroth for this reference.

148. According to Pérez Sánchez ("Ribera and Spain," 36) this decorative work was "probably a reference to none other than the Spanish armada of the duke of Lerma, whose name was erroneously transcribed by a secretary who did not speak Spanish." The payment of 300 ducats to Ribera by the viceroy's secretary from the secret coffers of the king of Spain on February 12, 1618, might have been for this commission.

149. Ibid., 36

150. Gabriele Finaldi, "A Documentary Look at the Life and Work of Jusepe de Ribera," in *Jusepe de Ribera*, 4.

151. Carducho, *Diálogos*, 433–35.

152. Pacheco, *Arte de la pintura*, 2: 13.

153. John H. Elliott, "The Seville of Velázquez," in David Davies and Enriqueta Harris, *Velázquez in Seville* (Edinburgh: National Gallery of Scotland, 1996), 17.

154. Probably Orrente; see Jonathan Brown and Richard L. Kagan, "The Duke of Alcalá," *Art Bulletin* 69 (June 1987): 238.

155. According to Enrique Valdivieso and Juan M. Serrera (*Historia de la pintura española: Escuela sevillana del primer tercio del siglo XVII* [Madrid: Instituto Diego Velázquez, 1985], 16), Pacheco stated in *Arte de la pintura* that he apprenticed with Luis Fernández, who was active in Seville until 1581, a terminus ante quem for Pacheco's move to the city.

156. Jonathan Brown, *Images and Ideas in Seventeenth-Century Spanish Painting* (Princeton: Princeton University Press, 1978), 34. The book was never printed and remained in the artist's possession until his death. The drawing from the Biblioteca Nacional (cat. 18), whose laurel wreath signifies that the sitter is a poet, was at some point cut out and separated from the book. For a discussion of his identity, see Davies and Harris, *Velázquez in Seville*, 184 (47).

157. Brown, *Images and Ideas*, 63. Lope de Vega, who lived in Seville from 1602 until 1604, praised Pacheco in *Jerusalén conquistada* of 1609 ("If your brushes were this pen/And if these brushes were of your pen,/I would write or paint part or all/Of the many virtues esteemed in you;/Your own perspective should sum them up,/Your pen and your brushes relate them,/Oh, great Pacheco, in whom without flaw we see/pen and brush of the heights of your virtue." [My thanks go to Laura Bass for this translation.]) As Portús indicated, this is a laudatory reference as much to Pacheco's artistic and literary activity as to his virtuous character; see Javier Portús Pérez, *Pintura y pensamiento en la España de Lope de Vega* (Hondarribia-Guipúzcoa: Nerea, 1999), 140. Again in 1630 Lope praised Pacheco in his *Laurel de Apolo* ("May Francisco Pacheco's brushes and famous pen/Make verse and prose be equal to the [painter's] panel./May he be the Sevillian Apelles,/And like a ray from his same sphere,/ be the planet from which Herrera is born,/for coming with [the planet] and within [the sphere],/Where Herrera is the sun and Pacheco is a star." [Laura Bass again graciously provided this translation.]) Fernando de Herrera was one of the poets associated with Pacheco's academy; see ibid., 140.

158. According to Brown (*Images and Ideas*, 34), in a letter from late February 1634 (published by Martí y Monsó, "Dos cartas de Francisco Pacheco," 38), Pacheco wrote: "This book of portraits [*Libro de retratos*] would have been finished if I had not desired to write the book on painting, on which I have been working for more than thirty years." In the *Arte* itself (1956 ed., 2: 194), Pacheco mentioned the year 1605 in connection with his book: "I now find myself rich in notes and observations that have been seen and approved by the most learned men since 1605." The tract was finally published in 1649.

159. Introduction to Pacheco, *Arte de la pintura*, ed. Bonaventura Bassegoda i Hugas (Madrid: Cátedra, 1990), 41.

160. In *Arte* (1956, 2: 208–12; as in Robert Enggass and Jonathan Brown, *Italy and Spain 1600–1750* [*Sources and Documents*] ([Englewood Cliffs, N.J.: Prentice-Hall, 1970], 165–67), Pacheco discussed at length the proper way to depict this popular subject. He specified that he had consulted "the learned Jesuit Father Alonso de Flores" and decided that, despite the many images with the Christ Child in her arms, in this subject Mary should be depicted without the Child. Further, she should appear as described by Saint John the Evangelist in *Revelation*, who saw her in the sky with all her attributes. Pacheco proceeded to explain each and even stipulated that the points of the moon on which she stands should point downward.

161. Pacheco wrote, "I will not use gold in anything if I can imitate what I want with the use of colors." Bassegoda i Hugas, *Arte de la pintura*, 42, 499, 583, 607.

162. A trip to Italy—Venice according to Valdivieso and Serrera, *Escuela sevillana*, 117 (Palomino [*Museo pictórico*, 834] called him a disciple of Titian) and Naples according to Brown, *Painting in Spain*, 106—has been posited based on his style. It would be interesting in light of the discovery of his Flemish heritage to consider how this artistic tradition might have informed his stylistic development. A Venetian

influence is certainly evident in *Christ with the Cross* (cat. 29); Venetian paintings were abundant at court. Justi (*Diego Velázquez and His Times*, 36) recognized "in his forms, in his sentiment and technique there is a peculiar blend of the Spanish and Flemish way."

163. Valdivieso and Serrera, *Escuela sevillana*, 118.

164. Bassegoda i Hugas, *Arte de la pintura*, 42.

165. Valdivieso and Serrera, *Escuela sevillana*, 119.

166. Ponz called this painting his masterpiece and said that it, more than any other of his paintings, suggests that he studied with Titian, not only because of its color but also because of its composition (Ponz, *Viaje de España*, 780). Ceán (*Diccionario*, 4: 225) realized that Roelas was too young to have studied with Titian and substituted the idea that he studied with Titian's disciples.

167. Ibid., 4: 226.

168. Palomino (*Museo pictórico*, 836) praised his good composition and general organization, his great skill and excellent drawing, and his beautiful coloring.

169. Pacheco, *Arte de la pintura*, 2: 387–8

170. Beatrice Gilman Proske, *Juan Martínez Montañés* (New York: Hispanic Society of America, 1967), 12.

171. Ibid., 17.

172. Montañés had been chosen "because he is so highly esteemed for his art and other fine qualities that are joined in his person; . . . only the material was lacking to make [these sculptures] able to compete with the most celebrated statues of antiquity"; see Francisco Gerónimo Collado, *Descripción del túmulo y relación de las exequias que hizo la ciudad de Sevilla en la muerte del rey don Felipe Segundo* (Seville: Imp. de d. J. M. Geofrin, 1869), 208, in ibid., 24, 144 n. 93.

173. These royal gifts were made to monastery churches in the New World as these institutions were largely responsible for making converts of the natives and spreading the faith; ibid. 27.

174. Ibid., 40–42.

175. According to the inscription on its base, the sculpture was finished in 1608; ibid., 151 n. 178.

176. Montañés completed a statuette of the *Virgin of the Immaculate Conception* by April 10, 1621, for Juan Bautista González of Lima (ibid., 85); he also made sculptures of the subject for the convent of Santa Clara, Seville, contracted for in 1621 (ibid., 104) and for the Seville Cathedral in 1628–29 (on which he is known to have spent extra effort) (ibid., 115–18, 137).

177. Ibid., 52, 152 n. 191.

178. Ibid., 77.

179. Enggass and Brown, *Sources and Documents*, 221.

180. Proske, *Juan Martínez Montañés*, 103–4.

181. Ibid., 121–23.

182. Ibid., 138.

183. In his *Arte de la pintura*, Pacheco (1990, 512, quoted in translation from Enriqueta Harris, *Velázquez* [Oxford: Phaidon, 1982], 194) wrote, "Well, then, are *bodegones* not worthy of esteem? Of course they are, when they are painted as my son-in-law paints them."

SARAH SCHROTH

A New Style of Grandeur: Politics and Patronage at the Court of Philip III

To Jonathan Brown, who suggested this avenue of research some twenty years ago. It has enriched my life ever since.

1. Francisco Herrera y Maldonado, *Libro de la vida y maravillosas virtudes del Siervo de Dios Bernardino de Obregón* (Madrid, 1634), fol. 211r, quoted in Elizabeth Wright, *Pilgrimage to Patronage: Lope de Vega and the Court of Philip III* (Lewisburg: Bucknell University Press, 2001), 52–57.

2. Juan Miguel Serrera, "Alonso Sánchez Coello y la mecánica del retrato de corte," in *Alonso Sánchez Coello y el retrato en la corte de Felipe II* (Madrid: Museo del Prado, 1990), 49.

3. Virginia Tovar Martín, "La entrada triunfal en Madrid de doña Margarita de Austria," *Archivo español de arte* 244 (1988): 388.

4. Sarah Schroth, "Early Collectors of Still-Life Painting in Castile," in William B. Jordan, *Spanish Still Life in the Golden Age 1600–1650* (Fort Worth: Kimbell Art Museum, 1985), 30. Loaisa's death inventory, for example, lists four still lifes; one "picture of fruits" described as "melon, quince, pomegranate, orange, carrots and cardoon" contains the same elements favored by Sánchez Cotán in his distinctive still lifes, which are also listed this way in Cotán's 1603 studio inventory, itemizing each fruit and vegetable.

5. Wright, *Pilgrimage to Patronage*, 53.

6. Antonio Feros, *Kingship and Favoritism in the Spain of Philip III* (Cambridge: University of Cambridge Press, 2000), 100, quoting from Gil González Dávila, *Historia de la vida y hechos del ínclito monarca, amado y santo don Felipe Tercero* (1632) (Madrid, 1771), 65.

7. Tovar Martín, "La entrada triunfal," 386.

8. Philip II's term for his journey through the Netherlands and Italy. Unlike his father, Philip II did not send Prince Philip (III) on a European tour as part of his education.

9. John H. Elliott, "Maquina insigne: La monarquía hispana en el reinado de Felipe II," in *España en tiempos del Quijote*, ed. Antonio Feros and Juan Gelabert (Madrid: Taurus, 2004), 60.

10. Feros, *Kingship and Favoritism*, 50–51, 68–69.

11. Ibid., 145–62.

12. Ibid., 1–8.

13. See Sarah Schroth, "The Private Picture Collection of the Duke of Lerma" (Ph.D. dissertation, New York University, 1990).

14. Miguel Morán Turina and Javier Portús Pérez, *El arte de mirar* (Madrid: Ediciones ISTMO, S.A., 1997), 63–82.

15. Jonathan Brown, *Painting in Spain, 1500–1700* (New Haven and London: Yale University Press, 1998), 79.

16. Jesús Urrea, "La pinturas española en el reinado de Felipe III," and Miguel Morán Turina, "Los gustos pictóricos en la corte de Felipe III," in *Los pintores del reino de Felipe III* (Madrid: Museo del Prado, 1992).

17. Marcus Burke and Peter Cherry, *Spanish Inventories I: Collections of Paintings in Madrid 1601–1755* (Los Angeles: The Provenance Index of the Getty Information Institute, 1997), 117.

18. I am most thankful to Dr. Maria Kusche (e-mail correspondence, November 26, 2006) for sharing new information that securely identifies this portrait as a work by Pantoja (currently attributed to Bartolomé González as a copy of a lost original by Pantoja in the Kunsthistorisches Museum catalogue) and provides a date, according to an inventory entry of the royal guardajoyas (A. H. N. Sección de Consejos, Libro 252 [libro Segundo de Despachos de la Cámera], 442v): "el otro de la dha.Serenissima Reina preñada con ropa y basquiña de tela negra con fajas bordadas con el retrato de doña Sophia enana . . . que mandamos ymbiar a la Sma Archiduquesa a Alamania" (Valladolid, October 6, 1601).

19. See Fernando Checa, *Felipe II: Un principe del renacimiento* (Madrid: Museo del Prado, 1998), 401.

20. Magdalena S. Sánchez, *The Empress, the Queen and the Nun: Women and Power at the Court of Philip III* (Baltimore: Johns Hopkins University Press, 1998), 72.

21. Toledo, Archivo de los duques de Lerma, legajo 52–expediente 13, September 1603: "retrato de la Reyna de yngalaterra en tabla," appears again the following year in ducal quarters, and finally in La Ribera in 1607. Interestingly, it was in the duke of Lerma's collection *before* the peace treaty with England was signed in 1604, and less than six months after Elizabeth's death.

22. Roy Strong, *Portraits of Queen Elizabeth* (Oxford: Clarendon Press, 1963).

23. Maurice Howard, *The Tudor Image* (London: Tate Gallery, 1995), 68–69; Ellis Waterhouse, *Painting in Britain 1530–1790* (Middlesex: Penguin Books Ltd., 1978), 35–36.

24. Feros, *Kingship and Favoritism*, 94–95.

25. Elena Santiago, "Ambrosio Spínola," in *Los Austrias grabados de la Biblioteca Nacional* (Madrid: Julio Ollero Editor, 1993), 228–29.

26. J. Miguel Morán Turina and Fernando Checa, *El coleccionismo en España* (Madrid: Ediciones Cátedra, 1985), 232–34.

27. *Dichos y hechos del Señor Rey D. Felipe III el bueno* (Madrid, 1723), 330, quoted in Morán and Portús Pérez, *El arte de mirar*, 65.

28. Pieter Martens and Jean-Luc Mousset, "La Donación Mansfeld a Felipe III," *Reales sitios* 43, no. 168 (2006): 16–35.

29. Morán and Portús Pérez, *El arte de mirar*, 63–82.

30. Later given away by Philip IV to the prince of Wales; see Sarah Schroth, "Charles I, the Duque de Lerma and Veronese's Edinburgh 'Mars and Venus,'" *Burlington Magazine* 139, no. 1133 (August 1997): 548–50.

31. *Juan Gómez de Mora (1586–1648)* (Madrid: Museo Municipal, 1986), 389. Also quoted in William B. Jordan, *La imitación de la naturaleza: Los bodegones de Sánchez Cotán* (Madrid: Museo del Prado, 1992), 50.

32. Magdalena de la Puerta Montoya, *Los pintores de la corte de Felipe III* (Madrid: Ediciones Encuentra, 2002), publishes invaluable documentation on the project.

33. Schroth, "The Private Picture Collection," 19 ff.

34. Morán and Checa, *El coleccionismo en España*, 226.

35. Jesús Urrea, *Gregorio Fernández 1576–1636* (Madrid: Fundacion Central Hispano, 1999), 94. See also J. Martín González, *El escultor Gregorio Fernández* (Madrid: Ministerio de Cultura, 1980), 189–201.

36. Lerma continued to be an important patron for Fernández, commissioning sculptures for altars in San Diego and San Pablo, Valladolid, as well as for the Colegiata de San Pedro in Lerma.

37. Toledo, Archivo de los duques de Lerma, legajo 73–expediente 7, June 1606: "Otro de dominico Greco de S. Francisco;" see Schroth, "The Private Picture Collection," 251.

38. Madrid, Archivo Historico Protocolos 7125 Folio 258, 1636 ("otro quadro de San Francisco de [?] arrovado que es original del griego esta con un cristo y una calavera y un marco dorado y negro que se truxo de la casa de Lerma").

39. Harold E. Wethey, *El Greco and His School*, 2 vols. (Princeton, N.J.: Princeton University Press, 1962), 114. For versions of both compositions, see Gianna Manzini, *El Greco: L'opera completa del Greco* (Milan: Rizzoli, 1969), 100. This is a reversal of the opinion I expressed in my dissertation (Schroth, "The Private Picture Collection"), at which time I suggested Lerma's El Greco may have been the one now in Torelló collection, Barcelona.

40. On El Greco's workshop practice, see Jonathan Brown, *El Greco: Themes and Variations* (New York: Frick Collection, 2001), 9–26.

41. On Bassano in Spain, see Miguel Falomir Faus, *Los Bassano en España del Siglo de Oro* (Madrid: Museo del Prado, 2001).

42. Ruth Saunders Magurn, *The Letters of Peter Paul Rubens* (Evanston: Northwestern University Press, 1991), 33.

43. Morán and Checa, *El coleccionismo en España*, 226.

44. Alejandro Vergara, "El universo cortesano de Rubens," in *Velázquez, Rubens y van Dyck*, ed. Jonathan Brown (Madrid: Museo del Prado, 1999), 69.

45. Rudolf Wittkower, *Art and Architecture in Italy 1600–1750* (Middlesex: Penguin Books Ltd., 1980), 23.

46. Ibid., 23.

47. John W. O'Mallery et al., eds., *The Jesuits: Cultures, Sciences, and the Arts* (Toronto: University of Toronto Press, 1999), 18–26.

48. Carol Lee Flinders, *Enduring Grace: Living Portraits of Seven Woman Mystics* (San Francisco: Harper San Francisco, 1993), 167–68.

49. Helen Rawlings, *Church, Religion, and Society in Early Modern Spain* (New York: Palgrave, 2002), 36–37.

50. Jonathan Brown, "Patronage and Piety: Religious Imagery in the Art of Francisco de Zurbarán," in *Zurbarán*, ed. Jeannine Baticle (New York: Metropolitan Museum, 1988), 20.

51. Antonio Palomino, *Lives of the Eminent Spanish Painters and Sculptors*, trans. Nina Ayala Mallory (Cambridge and New York: Cambridge University Press [1724], 1987), 70.

52. In 1610 Carducho painted *Preaching of Saint John the Baptist* (Museo de la Real Academia de Bellas Artes de San Fernando, Madrid) for the old church.

53. Sánchez, *The Empress, the Queen and the Nun*, 71.

54. Rawlings, *Church, Religion, and Society*, 99.

55. Wright, *Pilgrimage to Patronage*, 54–55.

56. Alfonso Rodríguez G. de Ceballos, "El mundo espiritual del pintor Luis de Morales," *Goya* 196 (1987): 194–203. See also Brown, *Painting in Spain*, 44; Rawlings, *Church, Religion, and Society*, 57.

57. Rodríguez G. de Ceballos, "El mundo espiritual," 196.

58. First recorded in 1607, Toledo, Archivo de los duques de Lerma, legajo 52–expediente 14, "Un S. Pedro llorando de medio cuerpo," which is said to be "a copy of Badajoz." Only two versions of this unusual composition of Morales are known; the original of Lerma's copy may have been the painting described by Palomino in the Jesuit Colegio Imperial in Madrid. See *Navarrete el mudo: Pintor de Felipe II* (Logroño: Gráphicas Ochoa, S.A., 1995), 304. I am grateful to José Antonio de Urbina for supplying the example illustrated.

59. Fernando Marías, "La obra artística y arquitectónica del Cardinal Sandoval y Rojas," in *El Toledo de Felipe II y El Greco* (Toledo: Museo de Santa Cruz, 1986), 11–23.

60. Cristóbal's unorthodox behavior caused him (along with Juan de Avila, Fray Luis de Granada, and Juan de Ribera) to be openly accused of instigating the establishment of the radical cells of the Erasmian sect called *Alumbrados*; the charge was dropped; see Rodríguez G. de Ceballos, "El mundo espiritual," 196.

61. Amarie Dennis, *The Shadow of a King* (Madrid: A.W. Dennis, 1985), 59.

62. Gil González D'Avila, *Historia de la vida y hechos del gran monarca amado y santo Rey Don Philip III deste nobre*, (1638), quoted in Lisa A. Banner, "The Religious Patronage of the Duke of Lerma" (Ph.D. dissertation, New York University, 2005), 37.

63. A forthcoming book by Lisa Banner details Lerma's patronage of religious institutions based on his post as *comendador mayor* of the knighthood of the Order of Santiago; see also Banner, "Religious Patronage."

64. The duke of Lerma's maternal uncle, Juan de Borja, was the son of the Jesuit Francisco de Borja; he served as *camarero mayor* to Empress Maria. Juan de Borja convinced the empress to bequeath her estate to fund the Colegio Imperial for the Jesuits in Madrid; Checa, *Felipe II*, 445.

65. Recorded in Ventsilla in 1605 (Toledo, Archivo de los duques de Lerma, legajo 43–expediente 10) were two portraits: "Madre Teresa de Jesus" and "Padre Ignacio." An image of "Padre Javier" appeared in the list of works in Lerma's cell at San Blas in 1617; see Luis Cervera Vera, *El Monasterio de San Blas en la villa de Lerma* (Madrid and Valencia: Editorial Castalia, 1969), 116. Also in 1617, Lerma's grandfather is declared a saint before the fact: "otro retrato de Santo Francisco de Borja" (Toledo, Archivo de los duques de Lerma, legajo 53–expediente 5, folio 56).

66. Trinidad de Antonio, in Checa, *Felipe II*, 463–64.

67. Rodríguez G. de Ceballos, "El mundo espiritual," 196.

68. David Kowal, *Ribalta y los Ribaltescos: La evolución del estilo barroco en Valencia* (Valencia: Disputación provincial de Valencia, 1985), 82–83.

69. Ibid., 106 n. 4.

70. Lerma's two portraits of Simón were first recorded in the 1617 inventory of works in his private cell overlooking the altar in the Dominican convent of San Blas in Lerma, with a marginal note indicating

one came from his palace in Madrid. In this inventory, Simón is already referred to as a saint: "retrato de Mosén [title given to ecclesiastics in Valencia] Simón, santo que dicen de Valencia." See 1617 inventory of pictures in Lerma's cell in San Blas; see Cervera Vera, *El Monasterio de San Blas en la villa de Lerma*, 116.

71. Neil MacLaren, rev. by Allan Braham, *The Spanish School* (London: National Gallery, 1988), 89. Both of Lerma's images of Padre Simón later appear in the 1628 inventory, Toledo, Archivo de los duques de Lerma, Toledo legajo 54–expediente 3, January 27, 1628, still using title "santo," indicating how out of touch (or beyond the law) Lerma's grandson was.

72. Alfonso Pérez Sánchez, "On the Reconstruction of El Greco's Dispersed Altarpieces," in *El Greco of Toledo* (Boston: Little, Brown, and Co., 1982), 156–64.

73. For the discussion of this commission, see Richard Mann, *El Greco and His Patrons* (Cambridge: Cambridge University Press, 1989), 47 ff.

74. Ibid., 67–68.

75. Ibid., 55.

76. Palomino, *Lives*, 133.

77. Ibid., 91.

78. Antonio Ponz, *Viaje de España*, ed. Casto María del Rivero (Madrid: M. Aguilara, 1947), 460.

79. Palomino, *Lives*, 108.

80. Ignatius Loyola, *The Spiritual Exercises*, trans. Athony Mottola (New York: Doubleday, 1964), 72.

81. There is a similar picture by Cajés's friend Orazio Borgianni in the convent of the Reform Augustinians in Pamplona, founded by one of the duke of Lerma's own favorites at court, Juan de Ciriça. The Borgianni is illustrated in William B. Jordan, *Juan van der Hamen y Leon and the Court of Madrid* (New Haven and London: Yale University Press, 2005), 254, fig. 16.6. Jordan and I discovered this picture together, which was important for his work on Van der Hamen as well as mine on the sources for Carducho and Cajés.

82. Rafael Laínez Alcalá, *Don Bernardo de Sandoval y Rojas, protector de Cervantes* (Salamanca: Ediciones Anaya, 1958), 43.

83. Richard Kagan, "The Toledo of El Greco," in *El Greco of Toledo*, 53.

84. Trouble between Bernardo and Lerma began in 1601, when Lerma appointed a brother of one of his *hechuras* (creatures) as canon of the Cathedral of Toledo; see Laínez Alcalá, *Don Bernardo de Sandoval y Rojas*, 103–4.

85. Hilary Dansy Smith, *Preaching in the Spanish Golden Age: A Study of Some Preachers of the Reign of Philip III* (Oxford: Oxford University Press, 1978), 156.

86. Marías, "La Obra artistica," 11–23.

87. Wethey, *El Greco and His School*, 2: 66.

88. Alfonso Pérez Sánchez, "Carlo Saraceni a la Catedrale di Toledo," in *Actes du XXIIeme Congres International d'Histoire de l'art*, vol. 2 (Budapest: Académiai, 1971), 25–28.

89. Burke and Cherry, *Spanish Inventories I*, 573–78.

90. Brown, *Painting in Spain*, 88.

91. Marías, "La Obra artistica," 18.

92. Feros and Gelabert, *España en tiempos del Quijote*, 61–96.

93. This section is largely based on the ideas articulated by Javier Portús Pérez, *Pintura y literatura en tiempos del Quijote* (Madrid: Empresa Pública Don Quijote de la Mancha, 2005), 13–34.

94. Bernardo Vincent, "La sociedad española en la epoca del Quijote," in Feros and Gelabert, *España en tiempos del Quijote*, pp? The many inns and boarding houses in Spain, Vincent has pointed out, attest to the fact that people were moving around the peninsula a great deal. He also found evidence that, despite displacement, personal identity was still rooted in one's specific native region and/or town, perhaps offsetting a lack of stability.

95. Ibid., 284.

96. Ibid., 75.

97. Portús Pérez, *Pintura y literatura en tiempos del Quijote*, 15–16.

98. This number was published in Juan E. Gelabert, "La restauración de la república," in Feros and Gelabert, *España en tiempos del Quijote*, 207, and Jonathan Brown and John Elliott, *A Palace for a King* (New Haven: Yale University Press, 1980), 3.

99. Portús Pérez, *Pintura y literatura en tiempos del Quijote*, 15.

100. Ibid., 18–19; Morán, "Los gustos pictoricos en la corte de Felipe III," 31–33.

101. Barry Wind, *Velázquez's Bodegones: A Study in Seventeenth-Century Spanish Genre Painting* (Fairfax: George Mason University Press, 1987); David Davies, "Velázquez's Bodegones," in *Velázquez in Seville* (Edinburgh: National Gallery of Scotland, 1996), 63–64.

102. See David Davies's discussion of Velázquez's *bodegones* in *Velázquez in Seville*, 51–65, in which he links these works to the Christian virtue of aiding the poor.

103. Morán, "Los gustos pictoricos en la corte de Felipe III," 30.

104. Jordan, *Spanish Still Life of the Golden Age 1600–1650*, 8–17; William B. Jordan, *Spanish Still Life from Velázquez to Goya* (London, National Gallery of Art, 1995), 13–18. See also Alfonso Pérez Sánchez, *Pintura española de bodegones y floreros de 1600 a Goya* (Madrid: Museo del Prado, 1983), 14.

105. Peter Cherry, *Arte y naturaleza: El bodegón español en el Siglo de Oro* (Madrid: Fundación de apoya la historia del arte hispánico, 1999), 48–61.

106. Vincent, "La sociedad española en la epoca del Quijote," 289.

107. Banner, "The Religious Patronage of the Duke of Lerma," 20.

108. J. J. Martín González, "Bienes artísticos de don Rodrigo Calderón," *Boletín del seminario de estudios de arte y arqueología, Universidad de Valladolid* 54 (1988): 267–92.

109. Most workshop productions are of poor quality and by many hands that have nothing to do with González, who was not untalented, as the portrait of the infantes (cat. 9) and *Rest on the Flight into Egypt* (cat. 25) demonstrate.

110. Jordan, *Spanish Still Life*, 2.

111. Portús Pérez, "Pintura y literatura en tiempos del Quijote," 16–17, 26–29.

112. Palomino, *Lives*, 97.

113. Jesús Urrea, "A propósito del pintor Juan Bautista Maino," in *Velázquez y el arte de su tiempo, v, Jornadas de Arte* (Madrid: Editorial Alpuerto, 1991), 297.

114. Jonathan Brown, *Images and Ideals in Seventeenth-Century Spanish Painting* (Princeton: Princeton University Press, 1978), 102–10; Julian Gállego, *El pintor de artesano a artista* (Granada: University of Granada Press, 1976).

115. Vincent, "La sociedad española en la epoca del Quijote," 295.

116. Rawlings, *Church, Religion, and Society*, 14

117. Ibid., 14–23.

118. Elliott, "Maquina insigne," 57.

119. On the formation of Spanish academies, see Jonathan Brown, "Academy of Paintings in Seventeenth-Century Spain," *Leids Kunsthistorisch Jaarboek* 5–6 (1986–87): 177–85.

120. Feros and Gelabert, *España en tiempos del Quijote*, 62.

121. Ibid., 75.

122. In a letter of July 5, 1599, the duke of Lerma wrote to his uncle Juan de Borja expressing his hope that "we will be able to accomplish deeds worthy of his [Majesty's] holy fervor"; Feros, *Kingship and Favoritism*, 143.

123. Stuart Lingo, "Federico Barocci: Retrospective and Modernity in Late Renaissance Painting," in *CASVA Center 25* (Washington, D.C.: National Gallery of Art, 2005), 109.

124. For summaries on the influence of Caravaggio on Spanish art of this period, see Brown, *Painting in Spain*, 91; Alfonso Pérez Sánchez, *Pintura Barroca en España 1600–1750*, 2nd ed. (Madrid: Cátedra, 1995), 102–3.

125. Phrase by Walter Friedlander, quoted in Eric Zafran, *Renaissance to Rococo: Masterpieces in the Wadsworth Atheneum Museum of Art* (New Haven: Wadsworth Atheneum, 2004), 66.

ROSEMARIE MULCAHY
Images of Power and Salvation

I am deeply grateful to Sarah Schroth for her encouragement in the preparation of this text, and to Peter Cherry for his helpful comments. Jesús Urrea was most generous with his unique knowledge of Valladolid. I also wish to thank Marta Bustillo, Mark McDonald, Miguel Morán, Javier Portús, María Leticia Sánchez Hernández, Juan Angel Sayans, and Patrick Williams.

1. The king's last days are described by Matías de Novoa, "Historia de Felipe III, Rey de España," in *Codoin* (61): 329–43, and by Gil González Dávila, *Teatro de las grandezas de la villa de Madrid Corte de los Reyes Cátolicos de España al muy poderoso Señor rey don Felipe III* (Madrid, 1623). For his reign, see Antonio Feros, *Kingship and Favoritism in the Spain of Philip III 1598–1621* (Cambridge and New York: Cambridge University Press, 2000).

2. González Dávila, *Teatro de las grandezas*, 43.

3. For a discussion of religious paintings in Spanish collections, see Peter Cherry, "Seventeenth-Century Spanish Taste," in *Collections of Paintings in Madrid, 1601–1755: Documents for the History of Collecting*, by Marcus Burke and Peter Cherry, 2 vols. (Los Angeles: The Provenance Index of the Getty Information Institute, 1997), 1: 18–20, 75–78; see also Miguel

Morán and Fernando Checa, *El coleccionismo en España* (Madrid: Ediciones Cátedra, 1985), 231–32, 240–44.

4. González Dávila, *Teatro de las grandezas*, 21; see also Jerónimo de la Quintana, *A la muy antigua, noble y coronada villa de Madrid, historia, de su antiguedad, nobleza y grandeza* (1629) (Madrid: Ayuntamiento, 1954).

5. Miguel Morán Turina, "Felipe III y las artes," *Anales de historia del arte* 1 (1989): 159–75; for the extravagant nature of Philip III's reign, see 162–65.

6. Marta Bustillo, "Peculiaridades del arte de la contrarreforma en España: El ejemplo de la capilla de Las Carboneras," in *Cauces: Revue d'etudes hispaniques* 3 (2002): 151–62; Juan José Martín González, *El escultor Gregorio Fernández* (Madrid: Ministerio de Cultura, 1980), 102–5.

7. H. Shroeder, *Canons and Decrees of the Council of Trent* (St. Louis and London: Herder, 1941).

8. "Estaba Coronado de espinas. Los ojos, las orejas y la barba chorreaban sangre; sus mandíbulas estaban distendidas, la boca entreabierta, la lengua sanguinolenta. El vientre encogido, tocaba la espalda, como si no tuviera intestinos"; *Tratado de la oración y meditación* (Salamanca, 1554), quoted in Maximiliano Barrio Gozalo, "Iglesia y vida religiosa," in *El mundo que vivió Cervantes* (Madrid: Sociedad Estatal de Conmemoraciones Culturales, 2005), 208.

9. "Tener imagines bien proporcionadas de los pasos de la Pasión, en los cuales, mirando algunas veces, os sea alivio, para que sin mucha pena las podáis vos sola imaginar" (ch. 75), cited in Emilio Orozco, "Mística y plástica," *Boletín de la Universidad de Granada* (1939): 280. See María Leticia Ruiz Gómez, "Dos nuevos lienzos de escuela madrileña en las Descalzas Reales de Madrid, y una hipótesis sobre la devoción al Santo Sepulcro," *Reales sitios* 35, 138 (1998): 55–62.

10. Teresa of Avila, *Libro de vida* 28: 3–7, in *Obras Completas*, 123–35; for a discussion, see Victor I. Stoichita, *Visionary Experience in the Golden Age of Spanish Art* (London: Reaktion, 1995), 45–48.

11. Jordan Aumann, *Christian Spirituality in the Catholic Tradition* (London: Sheed and Ward, 1985), 192; see E. Allison Peers, *The Complete Works of Saint Teresa of Jesus*, 3 vols. (London: Sheed and Ward, 1950).

12. For the brothers Wierix, see F. W. H. Hollstein, *Dutch and Flemish Etchings, Engravings and Woodcuts c. 1450–1700* (Amsterdam: M. Hertzberger, 1920), 65, pt. 7, 146.

13. The confraternity was dedicated to the Good Death (*buena muerte*) and performed specific rites in preparation for death and for the commemoration of the deceased. It was stipulated that for the ceremonies of the confraternity, Christ should be shown dead on the cross. In the constitutions of the Company of Jesus a whole chapter deals with the assistance to be given to its members at the time of death. See Alfonso Rodríguez y Gutiérrez de Ceballos, "Juan de Mesa y la Compañía de Jesús: La religiosidad postridentina," in *Juan de Mesa*, ed. Alberto Villar Movellán (Córdoba: Universidad de Córdoba, 2003), 237; see also J. B. Poza, *Práctica de ayudar a morir* (Madrid, por Melchor Sanchez, 1629); Fernando Martínez Gil, *Muerte y sociedad en la España de los Austrias* (Madrid: Universidad Complutense, 1993).

14. Beatrice Gilman Proske, *Martínez Montañés, Sevillian Sculptor* (New York: Hispanic Society of America, 1967), 40.

15. Hollstein, *Dutch and Flemish Etchings*, 66, pt. 8, 165.

16. Bert Treffers, "The Art and Craft of Sainthood: New Orders, New Saints, New Altarpieces," in *The Genius of Rome, 1592–1623*, ed. Beverly Louise Brown (London: Royal Academy of Arts, 2001), 340–71.

17. Jesús Urrea, *Gregorio Fernández 1576–1636* (Madrid: Fundación Central Hispano, 1999), 94; Martín González, *Gregorio Fernández*; Beatrice Gilman Proske, *Gregorio Fernández* (New York: Hispanic Society of America, 1929).

18. Traditionally a tumulus, or *monumento*, was constructed upon which a casket in the form of a sepulchre was placed containing the Blessed Sacrament, in memory of the three days Christ's body lay in the tomb. A Portuguese visitor to Valladolid in 1605 describes the casket being locked and sealed by a prominent hidalgo and witnessed by a notary—an allusion to the sealing of the tomb by Roman soldiers as recorded in the Gospel of Matthew (27:66); Tomé Pinheiro da Veiga, *Fastiginia: Vida cotidiana en la corte de Valladolid (1605)* (Valladolid: Ayuntamiento de Valladolid, 1989), 46.

19. The sculpture also has an opening in the side containing a silver receptacle for the Eucharist. The Christ is usually venerated in a chapel in the upper cloister of the convent, but for the ceremony of the Holy Entombment on the afternoon of Good Friday it is taken to the church, and after its exhibition in the divine liturgy, it is carried in solemn procession around the cloister. The liturgy was enriched during the early seventeenth century with the inclusion of the *Lamentations* (or Eheu!), a composition by Tomás de Vitoria. This strange, repetitive song is still interpreted by the nuns on Good Friday; see María Leticia Sánchez Hernández, *El monasterio de la Encarnación: Un modelo de la vida religiosa en el siglo XVII* (Madrid: Real Monasterio de El Escorial, 1986), 57.

20. An account is given in *Anales de Madrid de León Pinelo, reinado de Felipe III, años 1598–1621*, ed. Ricardo Martorel Téllez-Girón (Madrid: Biblioteca Nacional, 1931), 115–16.

21. "Alma duélete de mí, puesto que tú me pusiste así." The source is a passage in Saint Bonaventure, quoted in Enrique Valdivieso and Juan Miguel Serrera, *Historia de la pintura española: Escuela sevillana del primer tercio del siglo XVII* (Madrid: Instituto Diego Velázquez, 1985), 158.

22. Fray José de Sigüenza, *Historia de la Orden de San Jerónimo. Fundación del Monasterio de El Escorial* (1605) (Valladolid: Junta de Castilla y León, 2000), 244–5.

23. Martín González, *Gregorio Fernández*, 169. See also Gridley McKim-Smith, "Dos Cristos de la columna y Gregorio Fernández," in *Boletín del Seminario de Estudios de Arte y Arqueología* (1976): 333–40.

24. Luis Muñoz, *Vida de la Venerable M. Mariana de S. Joseph, Fundadora de la Recolección de las Monjas Augustinas, Priora del real convento de la Encarnación* (Madrid, 1645), 236.

25. The penitential confraternities were the main protagonists in Holy Week when they took their images, or *pasos*, in procession. The *Christ at the Column* in the penitential church of the True Cross (Vera Cruz), Valladolid, is the only surviving figure of a group of seven, which made up Fernández's *paso* of the Flagellation. In 1619 they solicited from the pope an indulgence and jubilee in "imitation of the wound that was made in the sacred back of our Jesus Christ," as this was "the insignia and the *Eccehomo* at the column that the said confraternity has on the altar of its church"; Martín González, *Gregorio Fernández*, 169. This explains the exceptionally bloody state of the back of this sculpture.

26. "[Y] afirmo que ví a algunos llevar trozos de sangre coagulada de más de una libra, que me pareció demasiada crueldad, y me escandalizó se permita tanto exceso"; Pinheiro da Veiga, *Fastiginia*, 45.

27. For the history of the altarpiece, see Richard G. Mann, *El Greco and His Patrons* (Cambridge and New York: Cambridge University Press, 1986), 47–110.

28. Fray Juan de San Jerónimo, *Memorias*, ed. Miguel Salvá and Pedro Sainz de Baranda, in *Codoin* 7 (Madrid, 1845), 157–58; see also Susana Zapke and Gabriel Sabau, "El sepulcro de los magos," *Apuntes de la Sierra* (San Lorenzo del Escorial) 52 (1998): 5–12. I am grateful to Gabriel Sabau for drawing my attention to this article.

29. Fray Hortensio Félix Paravicino, *Sermones cortesanos*, ed. Francis Cerdan (Madrid: Editorial Castalia, 1994), 243.

30. Magdalena Sánchez, *The Empress, the Queen and the Nun* (Baltimore: Johns Hopkins University Press, 1998); see also Ana García Sanz and María Leticia Sánchez Hernández, *The Monasteries of the Descalzas Reales and the Encarnación* (Madrid: Patrimonio Nacional, 2004); Fernando Checa Cremades, "Monasterio de las Descalzas Reales: Origenes de su colección artística," *Reales sitios* 102 (1989): 21–30; also Alfonso Rodríguez y Gutiérrez de Ceballos, "Arte y mentalidad religiosa en el Museo de Las Descalzas Reales," *Reales sitios* 138 (1998): 13–24.

31. Sánchez Hernández, *El Monasterio de la Encarnación*; for a description of the inauguration of La Encarnación, see *León Pinelo*, 115–16; for Vicente Carducho, see Diego Angulo Iñiguez and Alfonso E. Pérez Sánchez, *Pintura Madrileña, primer tercio del siglo XVII* (Madrid: Instituto Diego Velázquez, 1969); also Magdalena de Lapuerta Montoya, *Los pintores de la corte de Felipe III* (Madrid: Fundación Cajamadrid, 2002).

32. Edward Goldberg, "State Gifts from the Medici to the Court of Philip III: The *Relazione segreta* of Orazio della Rena," in *Arte y diplomacia de la Monarquía Hispánica*, ed. José Luis Colomer (Madrid: Ediciones El Viso, 2003), 114–33.

33. Florentine painters were: Alessandro Allori, Cristofano Allori, Ludovico Cigoli, Jacopo da Empoli, Jacopo Ligozzi, Valerio Marucelli, Domenico Passignano, and Bernardino Poccetti; see Edward Goldberg's pioneering study, "Artistic Relations between the Medici and the Spanish Courts, 1587–1621: Part II," *Burlington Magazine* 138 (August 1996): 537. The queen's buffoon Ravel advised that they send small paintings, suitable for a portable oratory; see Montoya, *Los pintores de la corte*, 27.

34. For a detailed study of this commission, see Lisa Goldenberg Stoppato, "Pinturas florentinas para las Descalzas Reales de Valladolid," in *Glorias efímeras: Las exequias florentinas por Felipe II y Margarita de Austria* (Valladolid: Museo de la Pasión, 1999), 86–111.

35. In 1605 the papal nuncio reports of the construction of an oratory (probably in Madrid) and that the queen is looking for relics; Montoya, *Los pintores de la corte*, 27.

36. González Dávila describes the reliquary room in the Descalzas as "una Gloria, que se compone de cuerpos santos y de notables reliquias. En este santo convento (Encarnación) hay otro Nuevo parayso de cuerpos santos y de muy grandes reliquias que están guarnecidas y guardadas en arcas, y en relicarios de plata, bronce y ebano," in González Dávila, *Teatro de las grandezas*, 297.

37. Goldberg, "Artistic Relations," part 1: 110.

38. Javier Portús Pérez, *El culto a la Virgin en Madrid durante la edad moderna* (Madrid: Comunidad de Madrid, 2000), 171–72; see also William A. Christian, *Local Religion in Sixteenth-Century Spain* (Princeton: Princeton University Press, 1981); and Sarah Nalle, "Spanish Religious Life in the Age of Velázquez," in *The Cambridge Companion to Velázquez*, ed. Suzanne Stratton-Pruitt (Cambridge and New York: Cambridge University Press, 2002), 109–29.

39. *León Pinelo*, 114.

40. Suzanne L. Stratton, *The Immaculate Conception in Spanish Art* (Cambridge: Cambridge University Press, 1994).

41. A similar composition is singled out for particular praise, in an account of the fiestas in the monastery of San Francisco in Granada. This altarpiece was admired because it was "new and cleverly thought out . . . a splendid Hieroglyph of the Conception, containing in addition, all the saints of the Order (Franciscan), writers on this mystery; each one with an inscription around his chest from his particular writing on the subject." See María del Pilar Dávila Fernández, *Los sermones y el arte* (Valladolid: Universidad, Departamento de Historia del Arte, 1980), 125.

42. Francisco Pacheco, *Arte de la pintura*, ed. Bonaventura Bassegoda 1 Hugas (Madrid: Cátedra, 1990), 575–77; also Stoichita, *Visionary Experience*, 113–16.

43. Jesús Urrea Fernández, ed., *Valladolid, capital de la corte (1601–1606)* (Valladolid: Ayuntamiento de Valladolid & Instituto Universario de Historia Simancas, 2003), 108–16. For a study of Lerma as connoisseur and collector of paintings, see Sarah Schroth, "The Private Picture Collection of the Duke of Lerma" (Ph.D. dissertation, New York University, 1990).

44. Stoichita, *Visionary Experience*, 192.

45. Pedro de Herrera, *Translación del santísimo sacramento a la iglesia colegial de San Pedro de la villa de Lerma* (Madrid, 1618), 373b; see Patrick Williams, *The Great Favourite. The Duke of Lerma and the Court and Government of Philip III of Spain, 1598–1621* (Manchester and New York: Manchester University Press, 2006), 227–30; Luis Cervera Vera, *El conjunto palacial de la villa de Lerma*, 2 vols. (Valencia: Editorial Castalia, 1967).

46. Alfonso E. Pérez Sánchez, *Borgianni, Cavarozzi y Nardi en España* (Madrid: Instituto Diego Velázquez, 1964), 16–18.

47. J. J. Martín González, "Bienes artísticos de Don Rodrigo Calderón," *Boletín del Seminario de Estudios de Arte y Arqueología* 54 (1988): 267–91; his execution is described in José Simón Díaz, *Relaciones breves de actos públicos celebrados en Madrid de 1541 a 1650* (Madrid: Instituto de Estudios Madrileños, 1982), 147–49.

48. Pedro de Ribadeneyra, *Vida del padre Ignacio de Loyola* (Madrid, 1597); see also Pacheco, *Arte de la pintura*, 708–9.

49. Urrea Fernández, *Gregorio Fernández*, 118–19. For descriptions of the fiestas, see Dávila, *Sermones*, 115.

50. For a discussion of the work of these painters, see Jonathan Brown, *The Golden Age of Painting in Spain* (New Haven and London: Yale University Press, 1991), 89–113; also Jesús Urrea, *Pintores del reinado de Felipe III* (Madrid: Museo del Prado, 1993); see also Leticia Ruiz Gómez, "De la encrucijada de la pintura española entre 1590 y 1630," in *El arte en la España del Quijote*, ed. Javier Portús (Ciudad Real: Empresa Pública Don Quijote de la Mancha, 2005), 37–53.

51. The celebrations are vividly described by Manuel Ponce, "Relación de las fiestas, que se han hecho en esta corte, a la Canonización de cinco Santos," in Díaz, *Relaciones breves*, 169–76. In celebration of the beatification of Saint Isidore in 1620 Lope de Vega, the most celebrated literary figure at the court, organized a spectacular poetry competition. See J. Entreambasaguas, *La justa poética en honor de San Isidro Labrador* (Madrid, 1967).

52. "Barlan y Josefa," in *Biblioteca de Autores Españoles* 137 (1964): 9. For a fascinating description of the combination of sacred and profane, see Vicente Lleó Cañal, *Arte y espectáculo: La fiesta del Corpus Christi en Sevilla en los siglos XVI y XVII* (Seville: Diputación Provincial, 1975). For Pacheco on the power of religious images (book 1, ch. 11), see Pacheco, *Arte de la pintura*, 253.

LAURA R. BASS
The Treasury of the Language: Literary Invention in Philip III's Spain

I am most grateful to Sarah Schroth and Ronni Baer for inviting me to contribute to this volume and to Matthew Battles for his excellent editorial eye. I would also like to thank Tanya Tiffany, Suzanne Walker, and Ari Zighelboim for reading drafts and offering other assistance. Finally, I express my deep gratitude to Henry Sullivan for generously sharing his time and knowledge in numerous conversations about literature in Philip III's Spain. I dedicate this essay to him.

1. Sebastián de Covarrubias Orozco, *Tesoro de la lengua castellana o española*, ed. Felipe C. R. Maldonado, 2d ed. rev. (Madrid: Castalia, 1995), 994.

2. "Cosa nueva y no acostumbrada. Suele ser peligrosa por traer consigo mudanza de uso antiguo"; ibid., 780.

3. Fray Hortensio Félix Paravicino, *Sermones cortesanos*, ed. Francis Cerdan (Madrid: Castalia and Comunidad de Madrid, 1994), 224. I owe this reference to Jeremy Robbins, *The Challenges of Uncertainty: An Introduction to Seventeenth-Century Spanish Literature* (Lanham, Md.: Rowman and Littlefield, 1998), 30.

4. Richard L. Kagan, *Students and Society in Early Modern Spain* (Baltimore: Johns Hopkins University Press, 1974), 200.

5. Kagan, Ibid., 63.

6. Sara T. Nalle, "Literacy and Culture in Early Modern Castile," *Past and Present* 125 (1989): 65–96.

7. María Cruz García de Enterría, "Lectura y rasgos de un público," *Edad de Oro* 12 (1993): 121–30.

8. María Marsá, *La imprenta en los Siglos de Oro* (Madrid: Laberinto, 2001), 15–17.

9. Margit Frenk, *Entre la voz y el silencio* (Alcalá de Henares: Centro de Estudios Cervantinos, 1997), especially ch. 2, "Lectores y oidores en el Siglo de Oro," and ch. 3, "Ver, oír, leer. . . ." Also see Fernando Bouza, *Communication, Knowledge, and Memory in Early Modern Spain*, trans. Sonia López and Michael Agnew (Philadelphia: University of Pennsylvania Press, 2004), 51–52.

10. For the following overview of the book market, I draw primarily from Keith Whinnom, "The Problem of the 'Best-Seller' in Spanish Golden-Age Literature," *Bulletin of Hispanic Studies* 57 (1989): 189–98. Also see D. W. Cruickshank, "'Literature' and the Book Trade in Golden-Age Spain," *Modern Language Review* 73 (1978): 799–824; Nalle, "Literacy and Culture."

11. In addition to the works cited in the previous note, see Sara T. Nalle, "Printing and Popular Religious Texts in Sixteenth-Century Spain," *Culture and the State in Spain, 1550–1850*, ed. Thomas Lewis and Francisco J. Sánchez (New York: Garland Press, 1999), 126–56.

12. This brief review of the regulation of the book trade draws from Marsá, *La imprenta*, 13–35, and José Simón Díaz, *El libro español antiguo: Análisis de su estructura* (Kassel: Reichenberger, 1983), 5–28.

13. "Pragmática-sanción de Felipe II y en su nombre la princesa Dª Juana, sobre la impresión y libros," in *El libro en España y América: Legislación y Censura (Siglos XV–XVIII)*, ed. Fermin de los Reyes Gómez (Madrid: Arco/Libros, 2000), 2: 800.

14. Marsá, *La imprenta*, 35.

15. P. E. Russell, "El Concilio de Trento y la literatura profana: Reconsideración de una teoría," in *Temas de "La Celestina" y otros estudios del Cid al Quijote* (Barcelona: Ariel, 1978), 455.

16. B. W. Ife, *Reading and Fiction in Golden-Age Spain: A Platonist Critique and Some Picaresque Replies* (Cambridge: Cambridge University Press, 1985).

17. The ban lasted until 1635. Cruickshank, "'Literature' and the Book Trade," addresses its impact on the publishing industry.

18. As commercial authors, Alemán, Cervantes, and Lope are the main focus of the recent book by Donald Gilbert-Santamaría, *Writers on the Market: Consuming Literature in Early Seventeenth-Century Spain* (Lewisburg, Pa.: Bucknell University Press, 2005).

19. Aurora Egido, "Góngora," in *Historia y crítica de la literatura española III. Siglos de Oro: Barroco*, ed. Bruce W. Wardropper (Barcelona: Crítica, 1983), 381.

20. Miguel Artigas, *Don Luis de Góngora y Argote: Biografía y estudio crítico* (Madrid: Revista de Archivos, 1925).

21. How Lope's employment by the duke of Sessa affected his poetic practice is the subject of a recent article by Alison Weber, "Lope de Vega's *Rimas sacras*: Conversion, Clientage, and the Performance of Masculinity," *PMLA* 120 (2005): 404–21.

22. Díaz, *Libro español*, 31, 93–98.

23. Harry Sieber, "The Magnficent Fountain: Literary Patronage in the Court of Philip III" *Cervantes* 18 (1998): 85–116.

24. Robbins, *Challenges of Uncertainty*, 31. Also see Anne J. Cruz, "Art and the State: The *Academias Literarias* as Sites of Symbolic Economies in Golden Age Spain," *Calíope: The Journal of the Society for Renaissance and Baroque Hispanic Poetry* 1: (1995) 72–95.

25. See Leo Spitzer's brilliant close reading of the *Dedicatoria*, "On Góngora's *Soledades*," in *Leo Spitzer: Representative Essays*, ed. Alban K. Forcione, Herbert Lindenberger, and Madeline Sutherland (Stanford: Stanford University Press, 1988), 87–103.

26. Frederick A. de Armas, "Introduction," *Writing for the Eyes in the Spanish Golden Age* (Lewisburg: Bucknell University Press, 2005). On ekphrastic poetry, Emilie Bergmann's *Art Inscribed: Essays on Ekphrasis in Spanish Golden Age Poetry* (Cambridge: Harvard University Press, 1979) remains essential. On the connections between poetry and painting in the Spanish Baroque, also see Aurora Egido, "La página y el lienzo: Sobre las relaciones entre poesía y pintura en el Barroco," *Fronteras de la poesía en el Barroco* (Barcelona: Crítica, 1990), 164–97, as well as Emilio Orozco Díaz, *Temas del barroco de poesía y pintura*, facsimile ed. (Granada: Universidad de Granada, 1989).

27. Jonathan Brown, *Italian and Spanish Art 1600–1750: Sources and Documents*, ed. Robert Enggass and Jonathan Brown (Evanston: Northwestern University Press, 1999), 167.

28. On the professional formation of artists, see Juan José Martín González, *El artista en la sociedad española del siglo XVII* (Madrid: Cátedra, 1993), 17–34.

29. On Pacheco's academy, see Jonathan Brown, *Images and Ideas in Seventeenth-Century Spanish Painting* (Princeton: Princeton University Press, 1978), 21–43.

30. "Y contra veinte y nuevo años de trato,/entre tu mano, y la de Dios, perpleja,/quál es el cuerpo en que ha de vivir duda" (And, against twenty-nine years of acquaintance,/my soul finds itself confounded between your hand and that of God,/doubtful as to the body in which it lives), in Manuel B. Cossío, *Dominico Theotocopuli, El Greco* (Oxford: Dolphin Book Co., 1955), 28. Paravicino dedicated a total of four sonnets to El Greco, which were originally published in his *Obras posthumus divinas y humanas* (Madrid, 1641), 62v, 63r, 73v, 74r. All four are reproduced in Cossío, *Domenico Theotocopuli*.

31. For this overview of Cervantes's life, I have consulted, among others: Anthony Close, "Miguel de Cervantes," *The Cambridge History of Spanish Literature*, ed. David T. Gies (Cambridge: Cambridge University Press, 2004), 201–21; Georgina Dopico Black, "La historia del ingenioso hidalgo Miguel de Cervantes," in *España en tiempos del Quijote*, ed. Antonio Feros and Juan Gelabert (Madrid: Taurus, 2004), 23–40; Melveena McKendrick, *Cervantes* (Boston: Little, Brown and Company, 1980).

32. See in particular Frederick A. de Armas, *Cervantes, Raphael, and the Classics* (Cambridge: Cambridge University Press, 1998); *Quixotic Frescoes: Cervantes and Italian Renaissance Art* (Toronto: University of Toronto Press, 2006).

33. Miguel de Cervantes, "Prologue to the Reader," trans. B. W. Ife, in *Exemplary Novels I/Novelas ejemplares*, ed. B. W. Ife (Warminster, Eng.: Aris and Phillips, 1992), 3.

34. For a thorough treatment of the impact of Cervantes's captivity on the rest of his literary works, see María Antonia Garcés, *Cervantes in Algiers: A Captive's Tale* (Nashville: Vanderbilt University Press, 2002).

35. Mary Malcolm Gaylord, "Cervantes's Other Fiction," *Cambridge Companion to Cervantes*, 101–8.

36. The most important treatise on this concept is the physician Huarte de San Juan, *Examen de ingenios* (The Examination of Men's Wits) (1575).

37. For excellent introductions in English to the novel as a whole, see Anthony J. Cascardi, "*Don Quixote* and the Invention of the Novel," in *Cambridge Companion to Cervantes*, pp?; Carroll B. Johnson, *Don Quixote: The Quest for Modern Fiction* (Boston: Twayne, 1990); E. C. Riley, *Don Quixote* (London: G. Allen and Unwin, 1986).

38. Miguel de Cervantes, *Don Quijote*, trans. Edith Grossman (New York: HarperCollins, 2003), 193. In the Spanish original, "Digo asimismo que, cuando algún pintor quiere salir famoso en su arte procura imitar los originales de los más únicos pintores que sabe; y esta mesma regal corre por todos los más oficios o ejercicios de cuenta que sirven para adorno de las repúblicas"; Miguel de Cervantes, *Don Quijote de la Mancha*, ed. Francisco Rico (Barcelona: Instituto Cervantes/Crítica, 1998), 274. Christopher B. Weimer comments on this passage in "The Quixotic Art: Cervantes, Vasari, and Michelangelo," in *Writing for the Eyes*, 63–84.

39. Cervantes, *Don Quijote*, 848. In Spanish, the first part of the quote reads, "[S]e había de mandar que ninguno fuera osado a tratar de las cosas del gran don Quijote, si no fuese Cide Hamete, su primer autor, bien así como mandó Alejandro que ninguno fuese osado a retratarle sino Apeles"; Cervantes, *Don Quijote*, 1114.

40. Javier Portús Pérez, "Pintura y literatura en tiempos del *Quijote*," in *El arte en la España del* Quijote (Empresa Pública Don Quixote de la Mancha and Sociedad Estatal de Conmemoraciones Culturales, 2005), 17.

41. David Davies, "Velázquez's Bodegones," *Velázquez in Seville* (Edinburgh: National Gallery of Scotland, 1996), esp. 62–64.

42. Anne J. Cruz, *Discourses of Poverty: Social Reform and the Picaresque Novel in Early Modern Spain* (Toronto: University of Toronto Press, 1999), 81.

43. Harry Sieber, "Literary Continuity, Social Order, and the Invention of the Picaresque," ed. Marina S. Brownlee and Hans Ulrich Gumbrecht (Baltimore: The Johns Hopkins University Press, 1995), 143–64.

44. Portús Pérez, "Pintura y literatura en tiempos del *Quijote*," 20.

45. Cervantes, "Prologue," 3.

46. B. W. Ife, "General Introduction," in *Exemplary Novels I*, viii–x.

47. Alban Forcione, *Cervantes and the Mystery of Lawlessness: A Study of "El casamiento engañoso" and "El coloquio de los perros"* (Princeton: Princeton University Press, 1984), 48–58.

48. Gaylord, "Cervantes's Other Fiction," 108–17; Barbara Fuchs, *Passing for Spain: Cervantes and the Fictions of Identity* (Urbana and Chicago: University of Illinois Press, 2003).

49. This brilliantly metatheatrical work (the trickster ultimately finds his true calling as an actor) was one of four Golden-Age Spanish comedies performed to great acclaim by the Royal Shakespeare Company in 2004.

50. Melveena McKendrick, *Theatre in Spain 1490–1700* (Cambridge: Cambridge University Press, 1989), 70.

51. Ezra Pound, "The Quality of Lope de Vega," in *The Spirit of Romance* (New York: New Directions, 1968), 181.

52. Victor Dixon, "Lope Félix de Vega Carpio," in *Cambridge History of Spanish Literature*, 251–64.

53. This was another of the Spanish Golden-Age dramas performed by the Royal Shakespeare Company in its 2004 season.

54. This brief summary paraphrases Dixon, "Lope de Vega," 263.

55. Mary Malcolm Gaylord, "How to Do Things with *Polimetría*," in *Approaches to Teaching Early Modern Spanish Drama*, ed. Laura R. Bass and Margaret R. Greer (New York: Modern Language Association, 2006), 82–83.

56. Dixon, "Lope de Vega," provides an excellent overview of the author's vast corpus, as does Emilie L. Bergmann, "Vega Carpio, Lope de," *Encyclopedia of Renaissance Literature*, ed. James Wyatt Cook (New York: Facts on File, 2006), 220–23.

57. The impact of Philip III's court on Lope's literary career as well as the impact of his literary practice on the cultural shaping of the court are the subjects of Elizabeth R. Wright's superb study *Pilgrimage to Patronage: Lope de Vega and the Court of Philip III, 1598–1621* (Lewisburg, Pa.: Bucknell University Press, 2001).

58. Quoted in ibid., 31.

59. See Elizabeth R. Wright, "Virtuous Labor, Courtly Laborer: Canonization and a Literary Career in Lope de Vega's *Isidro*," *MLN* 114 (1999): 223–40.

60. María José del Río traces the construction of Isidro as Madrid's ideal patron in chapter 3 of *Madrid, Urbs Regia: La capital ceremonial de la Monarquía Católica* (Madrid: Marcial Pons, 2000), 93–118.

61. Wright, "Virtuous Labor," 234–35.

62. Ibid., 235, 238.

63. Javier Portús Pérez, *Pintura y pensamiento en la España de Lope de Vega* (Hondarribia: Nerea, 1999), is the definitive source on Lope's lifelong interest in painting. See esp. chapter 3, 122–88.

64. Portús Pérez, *Pintura y pensamiento*, 129–30.

65. Originally published in *Memorial informatorio por los pintores en el pleito que tratan con el Señor de su Magestad, en el Real Consejo de Hazienda, sobre la exempción del arte de la pintura* (Madrid: Juan González, 1629), Lope's deposition and the others were subsequently included as an appendix to Vicente Carducho, *Diálogos de la pintura* (Madrid, 1633). It is reproduced in Francisco Calvo Serraller, *Teoría de la pintura del Siglo de Oro* (Madrid: Cátedra, 1991), 341–44. The deposition has been translated into English as "Lope de Vega: The Case for Painting as a Liberal Art," in Brown, *Italian and Spanish Art*, 167–72.

66. "Case for Painting as a Liberal Art," 172. The Spanish reads, "habiendo salido todos los oficios en Zuiza, y soldadesca, con capitanes, y banderas, cajas, o acrabuces, sólo se habían reservado pintores, bordadores, y plateros," in Calvo Serraller, *Teoría de la pintura*, 343.

67. Brown (*Italian and Spanish Art*, 168) and Bergmann (*Art Inscribed*, 30) have also noted Lope's witty analogy.

68. This overview draws from Portús Pérez, *Pintura y pensamiento*, 130–52. Also see Ronni Baer, "Artists of the Reign of Philip III," in this catalogue.

69. "Nació v[uestra] m[erced] con ingenio sin invidia, parécenle bien los ajenos, celebra los que saben, honra los que supieron, y solicita no solo hacer inmortal la memoria de sus escritos, sino también las efigies de sus rostros con sus retratos. Años ha que en su famoso libro puso v[uestra] m[erced] el mío, como suele naturaleza el lunar en las hermosas, para que mi ignorancia hiciese lucir la fama de tantos doctos. No he podido pagar aquella memoria como debo, porque en mi *Jerusalén* [*conquistada*] fui breve cuando dije [the poem follows]" (You were born with genius but without envy, as you appreciate that of others, you celebrate those who know, honor those who knew, and aim not only at making their writings immortal, but also their faces' effigies with their portraits. Years ago in your famous book you included my own, just as nature places a mole on a beautiful face, so that my ignorance could add luster to the fame of so many learned men. I have not been able to pay that remembrance as I should, for in my *Jerusalem* I was brief when I said); *La gallarda toledana*, in *Parte catorze de la comedias de Lope de Vega Carpio* (Madrid: Juan de la Cuesta, 1620), 55v. Pacheco's portrait of Lope was thought to have been lost until Enrique Lafuente Ferrari made a probable identification of it in *Los retratos de Lope de Vega* (Madrid: Junta del Centenario de Lope de Vega Exposición Bibliográfica de la Biblioteca Nacional, 1935), 29–37.

70. Lope de Vega, *Jerusalén conquistada: Epopeya trágica*, ed. Joaquín de Entrambasaguas, 3 vols. (Madrid: C.S.I.C., 1951), 1: 15.

71. Curiously, El Greco and Velázquez are both absent from the list of artists the author knew and celebrated in his writing. Having lived in Toledo from 1604 to 1607, he must have been familiar with the work of the former, yet why he never mentions him remains a matter of debate. Portús attributes that silence to a possible personal animosity and, on an aesthetic plane, to Lope's preference for closer fidelity to nature ("la imitación de lo natural") over El Greco's intellectualizing, subjective renditions of the visible world; Portús Pérez, *Pintura y pensamiento*, 142. As for Velázquez, Lope surely knew of the rising painter, who was, after all, the son-in-law of his longtime friend Pacheco. Moreover, he must have seen some of his work after the artist's establishment at court in 1623. In this case, the author's silence does not seem to be related to any distaste for Velázquez's style but rather to his loyalty to Carducho, notoriously resentful of the newcomer who had displaced him at court; Portús Pérez, *Pintura y pensamiento*, 149–50.

72. Lope de Vega, *Laurel de Apolo*, ed. Antonio Carreño (Madrid: Cátedra, 2007), 210.

73. I analyze this lesson on portraiture in greater depth in Laura R. Bass, *The Drama of the Portrait: Theater and Visual Culture in Early Modern Spain* (University Park, Pa.: Penn State University Press, in press).

74. Frederick A. de Armas, "Lope de Vega and Michelangelo," *Hispania* 65 (1982): 172–79; "Lope de Vega's *La quinta de Florencia*: An Example of Iconic Role-Playing," *Hispanófila* 28 (1985): 31–42; Javier Portús Pérez, *La Sala Reservada del Museo del Prado y el coleccionismo de pintura de desnudo en la corte española, 1554–1838* (Madrid: Museo del Prado, 1998), 66–67.

75. Mary Gaylord Randel, "The Portrait and the Creation of *Peribáñez*," *Romanische Forschungen* 85 (1973): 145–58.

76. Donald McGrady convincingly argues that Lope must have composed the drama as a resident in Toledo in 1605 for the August feast days of Saint Roch and the Virgin; "Prólogo," Lope de Vega, *Peribáñez y el Comendador de Ocaña*, ed. Donald McGrady (Barcelona: Crítica, 1997), LXI–CXXV.

77. The 1605 dating of the play puts it squarely in that brief parenthesis (1601–6) during the reign of Philip III in which the court had moved to Valladolid.

78. Lope began his praise for the city with the following, "Finally Toledo, illustrious, glorious, powerful,/Toledo the imperial, noble city,/The capital of Spain, that onetime famous court of the Gothic kings,/As the heart in the body is the core and fount of life,/So is Toledo, the heart of Spain"; in Richard L. Kagan, "The Toledo of El Greco," *El Greco of Toledo* (Boston: Little, Brown, and Company, 1982), 35–73.

79. *Peribáñez y el comendador de Ocaña*, lines 921–33.

80. Portús Pérez, *Pintura y pensamiento*, 161. Also see Enrique Lafuente Ferrari, *Los retratos*.

81. Juan Bautista Avalle-Arce, "Introducción," *El peregrino en su patria* (Madrid: Castalia, 1973), 9–46. Mocked by his literary rivals for its false claims to nobility, versions of this portrait with the coat of arms appeared in other works by Lope published between 1602 and 1609; Portús Pérez, *Pintura y pensamiento*, 165.

82. I draw this description from Wright, *Pilgrimage to Patronage*, 83–84.

83. Javier Portús Pérez, "Catálogo," in *El arte en la España del Quijote*, 290.

84. Portús Pérez, *Pintura y pensamiento*, 144–45.

85. Lope's poem appears at the end of the fifth dialogue; Vicente Carducho, *Diálogos de la pintura*, ed. Francisco Calvo Serraller (Madrid: Turner, 1979), 254–56.

86. Ibid., 211–12.

87. Robert Jammes sums it up in these words, "Desprecio de Corte y atracción de la Corte son . . . los dos polos de su vida, y no es posible separarlos" (Disdain for the Court and attraction to the Court are the two poles of his life, and it is not possible to separate them); *La obra poética de Don Luis de Góngora y Argote*, trans. Manuel Moya (Madrid: Castalia, 1987), 293.

88. Jonathan Brown, *Velázquez: Painter and Courtier* (New Haven: Yale University Press, 1986), 34.

89. In Pacheco's words, "Hizo, a instancia mía un retrato de don Luis de Góngora, que fue muy celebrado en Madrid" (He made, on my request, a portrait of don Luis de Góngora that was much celebrated in Madrid); Francisco Pacheco, *El arte de la pintura*, ed. Bonaventura Bassegoda i Hugas (Madrid: Cátedra, 1990), 203. Góngora's likeness did not end up in Pachecho's series of illustrious men, which the artist-writer never finished.

90. Xavier Bray, "Luis de Góngora y Argote, 1622," in *Velázquez* (London: National Gallery, 2006), 144

91. El Greco's portraits of Toledan intellectuals, many of which employ the bust format against a neutral background, also come to mind. Van der Hamen's lost portrait of Góngora is discussed below.

92. Pacheco, *Arte de la pintura*, 202.

93. Jonathan Brown, "Enemies of Flattery: Velázquez's Portraits of Philip IV," *Journal of Interdisciplinary History* 17 (Summer 1986): 137–54.

94. Bray, "Luis de Góngora," 144.

95. Although the poet does not name the painter directly, William Jordan has made a convincing case that the epithet "Belga gentil" must allude to Van der Hamen; William B. Jordan, *Juan van der Hamen and the Court of Madrid* (New Haven: Yale University Press, 2005), 121–22.

96. On the *topos* of Prometheus in connection with writings on portraiture, see Bergmann, *Art Inscribed*, 81–101; Góngora's sonnet is discussed on 82–84.

97. We can assume that the Chacón portrait was based on Van der Hamen's because of the title Chacón gave to the sonnet, "A un pintor flamenco, haciendo el retrato de donde se copió el que va al principio de este libro" (To a Flemish painter, making the portrait from which the one that appears at the beginning of this book was copied); Jordan, *Juan van der Hamen*, 121–22.

98. Góngora was successful enough in winning the archbishop's favor through this and other instances of adulation that Sandoval invited him to participate in the poetic jousts he organized in Toledo in 1616 to celebrate the completion of the new cathedral chapel of the Virgin del Sagrario; Jammes, *La obra poética*, 423–24.

99. Jammes, *La obra poética*, 424 n. 110.

100. This translation is mine. The Spanish reads, "Esta en forma elegante, oh peregrino,/de pórfido luciente dura llave,/el pincel niega al mundo más süave,/que dio espíritu a leño, vida a lino./Su nombre, aún de mayor aliento dino/que en los clarines de la Fama cabe,/el campo ilustra de ese mármol grave:/venéralo y prosigue tu camino./Yace el Griego. Heredó Naturaleza/Arte; y el Arte, estudio. Iris, colores./Febo, luces-si no sombras, Morfeo—./Tanta urna, a pesar de su dureza,/lágrimas beba, y cuantos suda olores/corteza funeral de árbol sabeo"; Luis de Góngora, *Sonetos completos*, ed. Birutė Cipiljauskaité (Madrid: Castalia, 1985).

101. This observation and the commentary that follow are greatly indebted to Emilie L. Bergmann's analysis of the poem in *Art Inscribed*, 154–65.

102. For concise overviews, see Mary Malcom Gaylord, "The Making of Baroque Poetry," in *Cambridge History of Spanish Literature*, 230–33; María Cristina Quintero, "Góngora y Argote, Luis de," in *Encyclopedia of Renaissance Literature*, 76–78.

103. The "jointed mother-of-pearl," for instance, refers to the lady's finger (of translucent white skin), while its "prison" is the ring that encloses it.

104. Gaylord, "Making of Baroque Poetry," 231.

105. From Arthur Terry's translation of "oscura concha de una Margarita,/que rubí en caridad, en fe dia-

mante,/renace un nuevo Sol en nuevo Oriente," in *Seventeenth-Century Spanish Poetry: The Power of Artifice* (Cambridge: Cambridge University Press, 1993), 54.

106. Besides Ovid, Góngora had a more immediate rival to surpass, the poet Luis Carrillo de Sotomayor, whose own version of the story, *Fábula de Acis y Galatea*, had been posthumously published in 1611. On the issue of *Polifemo* and literary competition, I have profited from Edward H. Friedman, "Ideologies of Discourse in *Polifemo*," in *Cultural Authority in Golden Age Spain*, 51–78.

107. As Jeremy Robbins has put it, "It is this perfect fit between style and theme that makes the *Polifemo* possibly the greatest poem in Spanish"; *Challenges of Uncertainty*, 106.

108. "El celestial humor recién cuajado" appears in stanza 26; the English rendering is from Elias Rivers, *Renaissance and Baroque Poetry of Spain* (Prospect Heights, Il., 1988), 172.

109. From stanzas 39 and 40; Ibid., 172.

110. John R. Beverley initiated historicist readings of Góngora's most ambitious poem in *Aspects of Góngora's 'Soledades'* (Amsterdam: John Benjamins B. V., 1980). On Góngora's reflections on Spain's imperial expansion, see Betty Sasaki, "Góngora's Sea of Signs: The Manipulation of History in the *Soledades*," *Calíope: Journal of the Society for Renaissance and Baroque Poetry* 1 (1995): 150–68; Elizabeth M. Amann, "Orientalism and Transvestism: Góngora's 'Discurso contra los navegantes' (*Soledad primera*)," *Calíope: Journal of the Society for Renaissance and Baroque Poetry* 3 (1997): 18–34.

111. "[N]uestra lengua a costa de mi trabajo haya llegado a la perfección y alteza de la latina"; Luis de Góngora, "Carta de don Luis de Góngora, en respuesta de la que le escribieron" [1615], *Soledades*, ed. John Beverley, 10th ed. (Madrid: Cátedra, 1998), 172.

112. Pedro de Valencia, "Carta a Góngora," in *Pedro de Valencia, primer crítico gongorino*, ed. Manuel M.ª Pérez López (Salamanca: Universidad de Salamanca, 1988), 60.

113. Francis Cerdán, "Introducción crítica," in Paravicino, *Sermones cortesanos*, 14.

114. Baltasar Gracián, *Agudeza y arte de ingenio*, ed. Evaristo Correa Calderón, vol. 2 (Madrid: Castalia, 1969), 252.

115. Edward Baker comments on this gibe in his fascinating analysis of the novel as a parody of the patronage system, "Patronage, the Parody of an Institution in *Don Quijote*," in *Culture and the State in Spain, 1550–1850*, ed. Tom Lewis and Francisco J. Sánchez (New York: Garland Press, 1999), 116.

116. Alison Weber examines late-twentieth-century political readings of Cervantes in "The Ideologies of Cervantine Irony: Liberalism, Postmodernism, and Beyond," in *Cervantes and His Postmodern Constituencies*, ed. Anne J. Cruz and Carroll B. Johnson (New York: Garland Press, 1999), 218–34.

117. See Melveena McKendrick, *Playing the King: Lope de Vega and the Limits of Conformity* (London: Tamesis, 2000).

118. Gaylord, "Making of Baroque Poetry," 235.

119. Artigas, *Don Luis de Góngora*, 128–29.

120. The first collection of his works appeared in 1627 under the title *Obras en verso del Homero español*, ed. Juan Lopez de Vicuña (Madrid: Vinda de Luis Sánchez, 1627.

121. Antonio de Nebrija, *Gramática castellana, texto establecido sobre la ed. "princeps" de 1492*, ed. Pascual Galindo Romeo and Luis Ortiz Muñoz, 2 vols. (Madrid: Junta del Centenario, 1946), vol. 1, p. 5.

122. The Covarrubias quote is from his dedication to the king in *Tesoro de la lengua castellana*, 1001. Lope refers to "la cólera de un español" (Spanish choler) in his justification for breaking the unity of time in the *Arte nuevo de hacer comedias*, ed. Enrique García Santo-Tomás (Madrid: Cátedra, 2006), lines 205–6, 142.

Late El Greco

1. Fernando Marías, *Greco: Biographie d'un peintre extravagant* (Paris: Adam Biro, 1997), 208–16.

2. Richard Mann, *El Greco and His Patrons* (Cambridge: Cambridge University Press, 1989), 47.

3. Gabriele Finaldi, "The Doña María de Aragón Altarpiece," in David Davies et al., *El Greco*, (London: National Gallery, 2003), 169.

4. Jean Sutherland Boggs et al., *Degas* (New York: Metropolitan Museum of Art, 1988), 489.

5. Marías, *Greco*, 231.

6. Jonathan Brown and Richard Kagan, "The View of Toledo," *Studies in the History of Art* 13 (1984): 19–30.

7. J. Miguel Morán and Fernando Checa, *El coleccionismo en España* (Madrid: Ediciones Cátedra, 1985), 223.

8. A. G. P. (Archivo General del Palacio) Patrimonio Pardo, November 18, 1619, caja 9389/10 folio 95, transcibed in Magdalena de la Puente Montoya, *Los pinotres de la corte de Felipe III* (Madrid: Ediciones Encuentro, 2002), 594.

9. Both views have been tentatively identified with entries in the 1629 inventory of Salazár de Mendoza. They were installed in rooms with other maps and city views; see Richard Kagan, "Pedro de Salazár de Mendoza as Collector, Scholar and Patron of El Greco," *Studies in the History of Art* 13 (1984): 85–92. The appendix is a complete transcription of the inventory. For a good summary of the opinions on the provenance of the painting, see Keith Christiansen in Davies, *El Greco*, 233–34. The only other Spanish painter who created "views" was the Escorial painter Fabricio Castello (about 1554–1617), but his formulaic records of buildings and city places cannot compare to El Greco's expressionistic masterpiece.

10. The chapel was the first anywhere to be dedicated to Saint Joseph. Martín Ramírez originally planned to build an Unshod Carmelite convent for Saint Teresa, but the project changed after his death and the nuns found another site. Because Saint Teresa especially venerated Saint Joseph, she made him the patron and protector of all of the reform Carmelite convents she had founded. The Chapel of Saint Joseph was dedicated to Saint Joseph because the original donor was a patron of Saint Teresa; Harold E. Wethey, *El Greco and His School* (Princeton: Princeton University Press, 1962), 2: 11.

11. El Greco was hired to design and make paintings for the main and two side altars; see Alfonso E. Pérez Sánchez, "On the Reconstruction of El Greco's Dispersed Altarpieces," in *El Greco of Toledo* (Toledo: Toledo Museum of Art, 1982), 164–68.

12. Wethey, *El Greco and His School*, 2: 13.

13. Alfonso E. Pérez Sánchez and Benito Navarette Prieto, *De Herrera a Velázquez: El primer naturalismo en Sevilla* (Seville: Fundacion Focus-Abengoa, 2005), 168.

14. Jonathan Brown, "The Devotional Paintings of Murillo," in Suzanne Stratton, *Bartolomé Esteban Murillo: Paintings in American Collections* (New York: Harry N. Abrams, 2002), 31–45.

15. William B. Jordan, "Saint Jerome as Cardinal," in *El Greco of Toledo*, 247.

16. Mann, *El Greco and His Patrons*, 141.

17. Christiansen, "The Vision of Saint John", in Davies, *El Greco*, 210.

18. See Mann, *El Greco and His Patrons*, 134–41. Keith Christiansen has summarized the various interpretations and offered one of his own; see Davies, *El Greco*, 210–13.

19. Ibid., 210.

20. Saxl pointed out the *Dying Gaul* motif, Davies the *Fallen Giant*; see Jordan, "Lacoön," in *El Greco of Toledo*, 257.

21. David Davies, "Unraveling the Meaning of El Greco's Laocoön," in *Essays Presented to Edmund Fryde*, ed. Colin Richmond and Isobel Harvey (Aberystwyth: National Library of Wales, 1996), 275–350.

Portraiture

1. *Katalog der Gemäldegalerie: Porträtgalerie zur Geschichte Österreiches von 1400 bis 1800* (Vienna: Kunsthistorisches Museum, 1982), 74. In 1964 Maria Kusche dated this portrait as early as 1598, no doubt before the battle was identified, see Maria Kusche, *Juan Pantoja de la Cruz* (Madrid: Editoria Castalia, 1964), 144.

2. Stuart W. Pyhrr and José-A. Godoy, *Heroic Armor of the Italian Renaissance: Filippo Negroli and His Contemporaries* (New York: Metropolitan Museum of Art, 1998), 146.

3. In all of his official portraits in armor, Philip III wears very fancy suits of intricately worked armor, with one exception: his portrait by Pedro Antonio Vidal, painted in 1617 (fig. 52, p. 121), in which he appears in black armor that is plain by comparison.

4. Bluing was an oxidation technique invented in Augsburg in the sixteenth century in which metal plates turned blue or black after being heated at very high temperatures; see Stephen N. Fliegel, *Arms and Armor: The Cleveland Museum of Art* (New York: Harry N. Abrams, 1998), 85–86.

5. Fliegel, *Arms and Armor*, 97.

6. Although previously identified as a little girl, the entry in the inventory kindly shared by Maria Kusche clearly defines the figure as a dwarf, a choice some members of the court would have seen as a sign of maturity and understanding of Hapsburg etiquette. See Carmen Bernis, "La moda en la España de Felipe II a través del retrato de corte," in *Alonso Sánchez Coello y el retrato en la Corte de Felipe II* (Madrid: Museo del Prado, 1990). When she first arrived at the Spanish court, the fifteen-year-old new queen Margaret laughed out loud at a dwarf

attempting to make her solitary breakfast more pleasant. So serious a faux pas at the Spanish court was recorded. According to the account, her lady-in-waiting scolded Her Majesty for her ignorance of the rules of etiquette at the Spanish court, and explained that dwarfs, who were allowed to speak frankly to the royals without consequence, were never treated with charity as inferior or assuming creatures; one could smile at a dwarf's actions or words, but never laugh; see Juliá Gállego, "Manías y Pequeñaces," in *Monstros, enanos y bufones en la Corte de los Austrias* (Museo del Prado, 1986), 16.

7. Bernis, "La moda en la España de Felipe II," 99–100.

8. When the court was later attacked for its overly conspicuous consumption of luxury goods, these collars were the first to change. About 1607 female portraits, such as Pantoja's image of the princess Ana in his *Portrait of Philip IV and Ana* (cat. 9), show a slightly less exaggerated collar made with less material. There are fewer folds, and they are less tightly gathered; the width is reduced so it no longer reaches the top of the head; and the collar is not constructed wholly of lace—some plain white material frames the face.

9. Maria Kusche, "La juventud de Juan Pantoja de la Cruz y sus primeros retratos," *Archivo español de arte* 69 (1996): 155.

10. Similar formal characteristics are found in Florentine portraiture; see Jean Lipman, "The Florentine Profile Portrait in the Quattrocento," *Art Bulletin* 18 (1936): 58.

11. Some of this discussion appeared in Sarah Schroth, "Re-presenting Philip III and His Favorite: Changes in Court Portraiture 1598–1621," *Boletín del Museo del Prado* 18, no. 36 (2000): 39–50.

12. Anne-Marie Logan, *Peter Paul Rubens: The Drawings* (New York: Metropolitan Museum of Art, 2005), 92; first proposed by Sarah Schroth, Alejandro Vergara, and Thea Vignau-Wilberg, *Rubens: Dibujos para el retrato del duque de Lerma* (Madrid: Museo del Prado, 2002), 65.

13. J. J. Martín González, "Rubens en Valladolid," in *IV Centenario del Nacimiento de Rubens: Ciclo de Conferencias* (Valladolid: Museo Nacional de Escultura, 1978), 14. Martín González describes the natural route Rubens would have taken from Alicante to Valladolid, although he mentions only Madrid and El Escorial.

14. Harold E. Wethey, *The Paintings of Titian: The Portraits* (London: Phaidon, 1971), 2: 237.

15. Lerma commissioned Vicente Carducho to paint heads of all the emperors (153 works) which he showed at La Ribera; he had at least three sets of twelve Roman emperors in 1603, a set of twelve at his house in La Ventosilla, and another one in the Madrid palace.

16. Luis de Cabrera de Córdoba, *Relaciones de las cosas sucedidas en la corte de España desde 1599 hasta 1614* (Madrid, 1857), 171, 175.

17. Antonio Feros, *Kingship and Favoritism in the Spain of Philip III* (Cambridge: Cambridge University Press, 2000), 93

18. Cabrera de Córdoba, *Relaciones*, 185.

19. Walter Liedtke, *The Royal Horse and Rider: Painting, Sculpture, and Horsemanship, 1500–1800* (New York: Abaris Books, 1989), 62.

20. On Alfonso V, see John H. Elliott, *Imperial Spain, 1469–1716*, Pelican ed. (New York: Viking Penguin Ltd., 1985 [1970]), 35. We are grateful to Antonio Feros for making this connection.

21. William B. Jordan, *Spanish Still Life in the Golden Age 1600–1650* (Fort Worth: Kimbell Art Museum, 1985), 105.

22. William B. Jordan, *Juan van der Hamen y León and the Court of Madrid* (New Haven: Yale University Press, 2005), 151–52.

23. Jesús Urrea, "A Propósito del Pintor Juan Bautista Maino," in *Velázquez y el arte de su tiempo: V Jornadas de Arte* (Madrid: Editorial Alpuerto, 1991), 296–97.

24. *The Spanish Portrait from El Greco to Picasso* (Madrid: Museo del Prado, 2004), 337.

25. Ibid.

26. Palomino, *Museo pictórico y escala óptica*, 894.

27. José Álvarez Lopera, "The Portraits of El Greco," in *The Spanish Portrait*, 129.

28. Pacheco, *Arte de la pintura*, 1: 156.

Religious Institutions and Private Patrons

1. Antonio Dominguez Ortiz, *The Golden Age of Spain 1561–1659* (London: Weidenfeld and Nicolson, 1971), 230, quoted in Jonathan Brown, *Images and Ideas in Seventeenth-Century Spanish Painting* (Princeton: Princeton University Press, 1978), 15–16.

2. Brown, *Images and Ideas*, 16. We are indebted to Brown's contextual approach, first outlined in this essay on the historiography of Spanish art.

3. The plan of Spanish churches of the period generally followed the Roman model established in 1568 by Vignola in the Jesuit mother church, Il Gesù (consecrated 1584). The basic design featured a longitudinal plan with a central nave that subordinated all parts to a leading motif, the altar of the Mass, and accommodated large congregations to hear preaching from the pulpit. The two side aisles allowed a flow of pilgrims and visitors to approach the side chapels (often containing relics and single-paneled altarpieces), without interrupting the main event. See Julius Held and Donald Posner, *Seventeenth and Eighteenth Century Art: Baroque Painting, Sculpture and Architecture* (New York: Harry N. Abrams, 1979), 24; Rudolf Wittkower, *Art and Architecture in Italy 1600–1750*, 3d ed. (New York: Penguin Books, 1980), 40.

4. El Greco's altarpiece for the *colegio* was much admired during his lifetime and became a vibrant part of worship in this Augustinian seminary, where services were open to the public until 1810, when Joseph Bonaparte ordered the suppression of convents and monasteries in Spain and the altar was dismantled and sold.

5. Reconstructions have been proposed by Alfonso E. Pérez Sánchez, "On the Reconstruction of El Greco's Dispersed Altarpieces," in *El Greco of Toledo* (Toledo: Toledo Museum of Art) 156–64; Richard Mann, *El Greco and His Patrons* (Cambridge: Cambridge University Press, 1989), 72–79; and Leticia Ruíz Gómez, ed., *Actas del congreso sobre el retrato del Colegio de Doña María de Aragón* (Madrid: Museo del Prado, 2002), 87. See also David Davies, et al., *El Greco* (London: National Gallery, 2003), 169, for a concise summary and diagram of the reconstruction.

6. Francisco Pacheco, *Arte de la pintura* (1649), ed. Bonaventura Bassegoda i Hugas (Madrid: Cátedra, 1990), 592–95.

7. Mann, *El Greco and His Patrons*, 47.

8. Andrés Ruíz Tarazona, notes to audio compact disc *Lope de Vega: Intermedios del barroco hispánico*, Montserrat Figueras and Herspèrion 20, dir. Jordi Savall (Auvidis Astree, 1991).

9. Paul McCreesh and Grayson Wagstaff, "A Requiem for Philip II," notes to audio compact disc *Morales Requiem*, Gabrieli Consort and Paul McCreesh (Hamburg: Deutsche Grammophon, 1998).

10. Douglas Kirk, "Music to Beguile a King," notes to audio compact disc *Music for the Duke of Lerma*, Gabrieli Consort and Paul McCreesh (Hamburg: Deutsche Grammophon, 2002).

11. Kirk, "Music to Beguile a King." We are grateful to Patricia Paterson for this reference. The discovery in 1987 of a musical manuscript of a choral and instrumental work commissioned by the duke in 1617—a progressive score—offers proof that instruments were played inside the church to accompany singers (a hotly debated issue).

12. Mann, *El Greco and His Patrons*, 85–86. Keith Christiansen, in Davies et al., *El Greco*, 170, recently pointed out that Titian also included a burning bush in his *Annunciation* in San Salvatore, Venice.

13. Queen Margaret, sister-in-law of Cosimo II de Medici, decorated her foundation in Valladolid, Las Descalzas Reales, with Florentine pictures, including one by Pagani. There were further court connections to Florence: Bartolomé and Vicente Carducho were Florentines, and the duke of Lerma, the patron of the Dominicans in Spain, collected works by them and copies after other Florentines.

14. For a concise history of symbolism in the Adoration of the Magi, see Gabriele Finaldi, *The Image of Christ* (London: National Gallery Company Limited, 2000), 66–70.

15. This retable, like the one for the Colegio de Doña María de Aragón, was also a victim of the closing of the religious houses by the French rulers of Spain in the nineteenth century. In this case, there is a specific record of its dismantlement. On March 9, 1836, the mother superior of the Jerónimas wrote the archbishop of Toledo for permission to sell the works from the altar that had already encountered "major indignation" and were "almost in ruins." But before permission was granted, Baron Taylor bought it for the king of France, Louis Philippe d'Orléans. Although the secretary of state immediately intervened to recuperate the Tristán paintings, the *Adoration of the Shepherds* had already entered into the royal collection. This aptly illustrates, as Pérez Sánchez pointed out, the ineffectiveness of the Spanish authorities during the *desmortización* (state seizure of church lands). The work appeared in the London sale of Louis Philippe's collection in 1853. See Alfonso E. Pérez Sánchez and Benito Navarrete Prieto, *Luis Tristán h. 1585–1624* (Madrid: Real Fundación de Toledo and Fundación BBVA, 2001), 198–99.

16. Devotion to the saint was especially championed in Toledo by José de Valdivieso in his *Vida, excelencias, y muerto del gloriosisimo patriarca san Josef, esposa de N. Señora* (Toledo, 1604); see Charlene Villaseñor Black, *Creating the Cult of Saint Joseph: Art and Gender in the Spanish Empire* (Princeton: Princeton University Press, 2006), 89–90.

17. Diego Angulo Iñiguez and Alfonso E. Pérez Sánchez, *Historia de la pintura española: Escuela madrileña del primer tercio del siglo XVII* (Madrid: Instituto Diego Velázquez, 1969), 215, 221, 229.

18. Ibid., 229. Cajés evidently remained in Madrid while the court was in Valladolid; for this reason, he is one of the few local artists who does not figure in the Lerma inventories.

19. Antonio Palomino, *Lives of the Eminent Spanish Painters and Sculptors*, ed. Nina Alaya Mallory (Cambridge and New York: Cambridge University Press, 1987), 107. The painting was recorded in the inventory of the Musée Napoleon in 1813 but was returned the following year to the Academia de Bellas Artes de San Fernando in Madrid; see Angulo Iñiguez and Pérez Sánchez, *Escuela madrileña*, 229.

20. Palomino, *Lives*, 107.

21. In 1600 Philip III commissioned Cajés, who had recently returned from an extended tour in Italy, to make copies of Correggio's *Leda and the Swan* and *Rape of Ganymede* in the royal collection because he wished to present the originals to his cousin Rudolf of Prague. Although usually interpreted as indicative of the king's lack of connoisseurship skills or a result of his prudish nature (he was supposedly offended by the sexuality of the Correggios), it was an impressive diplomatic gift by any standard, and clearly of political benefit to the crown. In fact, it may well have been Empress Maria's idea, convincing Philip III to give her son Rudolf rare works he coveted for his collection. If they had been offensive, Philip III would not have gone to the trouble of ordering copies to replace the originals, and the "period eye" valued copies. Cajés seems to have painted two sets; Lerma owned works of these subjects as well, which were among the very few mythological paintings in his collection.

22. Alfonso E. Pérez Sánchez, *Pintura barroca en España (1600–1750)* (Madrid: Cátedra, 1996), 94–95.

23. Suzanne Stratton, *The Immaculate Conception in Spanish Art* (Cambridge and New York: Cambridge University Press, 1994), 20–22.

24. Jusepe Martínez, *Discursos practicables del nobilísmo arte de la pintura* (1673), ed. Julián Gállego (Madrid: Akal, 1988), 192.

25. Uan A. Onateo, "Las capillas deformadas," *Archivo de arte valenciano* 70 (1989): 74–75.

26. Pérez Sánchez, *Pintura barroca*, 137.

27. Palomino, *Lives*, 109–10. According to Nina Mallory, who edited the English edition of Palomino's *Lives*, the sketch is no longer extant, but this may not be the case.

28. We are grateful to the curator of the Descalzas Reales, Doña Ana Garcia Sanz, for this information conveyed in correspondence of April 4, 2006.

29. Finaldi, *Image of Christ*, 193–95.

30. Comparable paintings were made by Orazio Borgianni, who came to Spain in 1603 and again in 1605 and by Bartolomeo Cavarozzi, who came to Spain in 1617 in the company of Giovanni Battista Crescenzi. Details such as the donkey in González's painting indicate that the artist was aware of Caravaggio's art; indeed, it was recently discovered that the Spaniard had a copy of Caravaggio's *Ecce Homo* in his studio when he died; Peter Cherry, "Nuevos datos sobre Bartolomé González," *Archivo español de arte* 66 (1993): 8.

31. Marta Díaz Vañez, "Eugenio Caxes, Cristo meditando en el Calvario," in *El mundo que vivió Cervantes* (Madrid: Sociedad estatal conmemoraciones culturales, 2005), 481.

32. Ignatius Loyola, *Spiritual Exercises*, 93–94.

Apostolado

1. Fernando Checa Cremades, *Pintura y escultura del Renacimiento en España, 1450–1600* (Madrid: Cátedra, 1993), 341.

2. David Davies and Enriqueta Harris, *Velázquez in Seville* (Edinburgh: National Galleries of Scotland, 1996), 164.

3. A. D. Wright, *Catholicism and Spanish Society under the Reign of Philip II, 1555–1598, and Philip III, 1598–1621*, Studies in Religion and Society 27 (Lewiston, NY: Edwin Mellen Press, 1991), 8.

4. *El Greco of Toledo* (Toledo: Toledo Museum of Art, 1982), 250. For other treatments of the *Apostolado* in El Greco's oeuvre, see Harold Wethey, *El Greco and His School* (Princeton: Princeton University Press, 1962), 2: 99–107; José Álvarez Lopera, "Saint Luke, Toledo Cathedral," and "Saint Paul and Christ as Savior, Toledo, Museo del Greco," in *El Greco of Crete: Proceedings of the International Symposium Held on the Occasion of the 450th Anniversary of the Artist's Birth, Iraklion, Crete, 1–5 September 1990* (Iraklion: Municipality of Iraklion, 1995), 386–87, 396–398; Alonso Pérez Sánchez and Benito Navarrete Prieto, *Los Apostolados* (Coruña: Fundación Pedro Barrie de la Maza, 2002).

5. Richard Kagan, "The Toledo of El Greco," in Jordan, *El Greco of Toledo*, 69. Kagan was the first to suggest the cathedral's *Apostolado* may be identified with "las imagines del Salvador y los doce apostoles," which Sandoval bequeathed to his successor in his will dated April 22, 1618. Marcus Burke later published this section of the cardinal's will; see "Private Collections of Italian Art in Seventeenth Century Spain" (Ph.D. dissertation, New York University, 1984), 2: xvii.

6. The five complete sets are those in the Cathedral of Toledo; the Museo del Greco; Las Baroneses, Madrid (Henke collection); convent San Pelayo; and Oviedo (Marquis de San Felix collection). Most scholars have speculated that El Greco painted more than five versions based on the many isolated pictures of apostles that may have once belonged to an *Apostolado*; e.g., Museo Nacional del Prado no. 814 is variously identified as Paul, Bartholomew, and Matthew.

7. David Davies et al., *El Greco* (London: National Gallery, 2004), 192.

8. Fernando Marías, *Greco: Biographie d'un peintre extravagant* (Paris: Adam Biro, 1997).

9. Sarah Schroth, "Retratando a los apóstoles: Notas sobre el Apostolado de El Greco en el Museo del Prado," in José Álvarez Lopera et al., *El Greco* (Barcelona: Galaxia Gutenberg, 2003), 386–87.

10. The discussion on El Greco's apostles as devotional paintings is much indebted to Jonathan Brown's essay, "The Devotional Paintings of Murillo," in *Bartolomé Esteban Murillo: Paintings in American Collections* (New York: Harry N. Abrams, 2002), 31–45, as well as to David Freedberg, *The Power of Images* (Chicago: University of Chicago Press, 1989), 431; Sixten Ringbom, *Icon to Narrative:*

The Rise of the Dramatic Close-Up in Fifteenth-Century Painting (Doornspijk, The Netherlands: Davaco, 1984). Some of these ideas have appeared in Sarah Schroth, "Retratando a los apóstoles," 391.

11. See Brown, "Devotional Paintings," whose analysis of El Greco's workshop practices informed this interpretation.

12. Harris and Davies, *Velázquez in Seville*, 164.

13. The painting cannot be securely traced earlier than its 1843 appearance in the Musée des Beaux-Arts in Orléans, at which time it was thought to be by Murillo. Only one other individual apostle by Velázquez exists, *Saint Paul* in Barcelona, although it may date later and not belong to the set with *Apostle Thomas*. It seems unlikely that so many have gone missing; perhaps Velázquez was asked to complete an *Apostolado* begun by another artist; see Dawson Carr, *Velázquez* (London: National Gallery, 2006), 138, and Alfonso E. Pérez Sánchez, *Capolavori* (Rome: Museo d'arte della Catalogna, 1991), 52.

14. This discussion of Ribera's painting is indebted to Gabriele Finaldi, "Jusepe di Ribera," in Harris and Davies, *Velázquez in Seville*, 120.

Saint Francis

1. Described in Saint Bonaventure, *The Little Flowers of Saint Francis with the Mirror of Perfection* (New York: Dutton, 1910), chapter 53.

2. Keith Christiansen, "Saint Francis Meditating," in *El Greco* (London: National Gallery of Art, 2003), 180.

3. Ronda Kasl, "The Ecstasy of Saint Francis: The Vision of the Musical Angel," in *Renaissance to Rococo: Masterpieces from the Wadsworth Athenaeum Museum of Art*, ed. Eric Zafran (New Haven: Yale University Press, 2004), 98.

4. Jeannine Baticle, *Zurbarán* (New York: Metropolitan Museum of Art, 1987), 271.

5. Jonathan Brown, "Patronage and Piety: Religious Imagery in the Art of Francisco Zurbarán," in ibid., 17.

6. Ibid., 140.

7. Santa Teresa de Jesús, *Castillo Interior o Las Moradas* (Madrid: Editorial Espiritualidad, 1982), 5th ed.: "the door to enter the castle (the soul) is prayer and consideration" (21), and the soul in sin "is like a tree planted in very black water with a very bad odor . . . the darkness is such that you are not able to see" (23).

8. For the subjects, see José Camon Aznar, *Dominico Greco* (Madrid: Espasa-Calpe, 1950). For the iconography, see Harold E. Wethey, *El Greco and His School*, (Princeton: Princeton University Press, 1962), 2: 121.

9. The Saint Francis from San Francisco is known as the best example of the "Cuerva" type, after the version from the Carmelite convent in Cuerva, outside Toledo (now in Bilbao, Museo de Bellas Artes). Patronage from the Carmelites is logical given Saint Teresa's close association with Franciscan spirituality, discussed below in relation to Vicente Carducho's picture.

10. According to Réau, El Greco was the first artist to introduce the skull into the iconography of images of Saint Francis; Colin Eisler, *Paintings from the Samuel H. Kress Collection, European Schools Excluding Italian* (New York: Phaidon, 1977), 194–95.

11. Wethey, *El Greco*, 2: 155.

12. Eisler, *Kress Collection*, 194.

13. Pacheco, *Arte de la pintura* (1648), ed. Bonaventura Bassegoda i Hugas (Madrid: Ediciones Cátedra, 1990), 698.

14. Such as the *Lives* by Thomas of Celano, published in 1228 and 1248, or the *Legenda Trium Sociorum*, supposedly written by Brother Leo and two companions.

15. Pacheco, *Arte de la pintura*, 698.

16. Pacheco criticized El Greco, however, for his representation of Saint Francis's habit, which, based on documentary evidence in histories of the order and in existing relics of the habit, he felt should be of a cross form with a hood, like that presently worn by the Capuchins, not the patched robe with cloak used by the Descalzas and Alcantarians. Pacheco does admit that the painters have to accommodate what their clients ask for (the different branches naturally wanted their patron saint to be pictured in the type of habit they wore), adding that the Italians always stay true to the correct habit.

17. The stigmatization of Saint Francis was not fully sanctioned by the Church as a miracle until 1585, when a Franciscan pope, Sixtus v, allowed the stigmatization to be included in the martyrology of the saint; thereafter it became a common subject.

18. Teresa of Avila, *Relación* viii, 8–10, quoted in Evelyn Underhill, *Mysticism: A Study in the Nature and Development of Man's Spiritual Consciousness* (New York: Noonday Press, 1955), 376.

19. Ibid.

20. Benito dates the work by the maturity of its style; see Fernando Benito Doménech, *Los Ribaltas y la pintura Valenciana de su tiempo* (Madrid: Museo del Prado, 1987), 160–63, the same entry appears in English in *The Paintings of Ribalta 1565/1628* (New York: Spanish Institute, 1988), 94.

21. Kasl, "Ecstasy of Saint Francis," 98.

22. Benito Doménech, *Los Ribaltas*, 96.

23. Ibid., 94.

24. We are grateful to Dr. Susan Thorn, department of history, Duke University, for the suggestion that the symbolism of the leopard in Ribalta's painting may be connected to events involving Africa; the literature usually interprets the leopard as a symbol of evil.

25. The painting of the same subject now in the Museo del Prado was originally in the Capuchin monastery of Sangre de Cristo in Valencia, and the pointed hood worn by Brother Leo is also associated with the Capuchins; see Kasl, "Ecstasy of Saint Francis," on which this discussion is based.

26. Kasl, "Ecstasy of Saint Francis," 98.

27. We know that Ribalta copied a version of Caravaggio's *Saint Peter* for Juan de Ribera, and he presumably made a trip to Madrid about 1620, the time this picture was painted, where he would have seen the Florentine naturalism of the Carducho brothers or examples of other Spanish artists' adaptation of Caravaggesque principles, in particular Tristán and Orrente. See Jonathan Brown, *Painting in Spain 1500–1700* (New Haven and London: Yale University Press, 1998), 259 n. 44.

Spanish Saints

1. *Teresa de Jesus y el siglo xvi* (Avila: Avila Cathedral, 1995), 24.

2. Santa Teresa de Jesús, *Castillo Interior o Las Moradas*, ed. José Vicente Rodríguez, (Madrid: Editorial Espiritualidad, 1982), 17.

3. Ibid., 17–21.

4. Helen Rawlings, *Church, Religion, and Society in Early Modern Spain* (Hampshire: Palgrave 2002), 152.

5. John W. O'Malley, S. J., "Early Modern Catholicism," in *The Jesuits: Culture, Science and the Arts 1540–1773* (Toronto: University of Toronto Press, 1998), 4–5.

6. Marc Fumaroli, "Renaissance Rhetoric: The Jesuit Case," in *The Jesuits*, 95.

7. Ibid., 91–93.

8. Rawlings, *Church, Religion, and Society*, 156.

9. Harold E. Wethey, *The Paintings of Titian* (London: Phaidon Press), 2: 134.

10. Lisa Banner found this rare book in the Hispanic Society of America, as well as other useful information on this obscure saint.

11. Edgar Peters Bowron, "Carlo Saraceni," in *Renaissance to Rococo: Masterpieces from the Wadsworth Atheneum Museum of Art* (Hartford: Wadsworth Atheneum Museum of Art, 2004), 66.

The Immaculate Conception

1. Jeannine Baticle, *Zurbarán* (New York: Metropolitan Museum of Art, 1987), 168.

2. Mirella Levi d'Ancona, *The Iconography of the Immaculate Conception in the Middle Ages and the Renaissance* (New York: Archaeological Institute of America, 1957).

3. Suzanne Stratton, *The Immaculate Conception in Spanish Art* (Cambridge: Cambridge University Press, 1994), 1–4.

4. Ibid, 71.

5. Ibid, 62.

6. *Inmaculada* (Madrid: Catedral de la Almudena, 2005), 140.

7. Beatrice Gilman Proske, *Juan Martínez Montañés: Sevillian Sculptor* (New York: Hispanic Society of America, 1967), 47–48.

8. David Davies and Enriqueta Harris, *Velázquez in Seville* (Edinburgh: National Gallery of Scotland, 1996), 46. Velázquez could have been introduced to the sculpture by Pacheco, who is mentioned in the El Pedroso contract and was probably responsible for the polychromy and *estofado* (see Montañés biography, May 9, 1606).

9. Dawson W. Carr et al., *Velázquez* (London: National Gallery of London, 2006), 28.

10. Baticle, *Zurbarán*, 168.

11. Lisa A. Banner, "The Religious Patronage of the Duke of Lerma" (Ph.D. dissertation, New York University, 2005), 180.

12. Stratton, *Immaculate Conception*, 82.

13. Ibid., 87.

Still Life and the *Bodegón*

1. For one of the most recent publications on Spanish still life, see Javier Portús, ed., *Lo fingido verdadero: Bodegones españoles de la collection Naseiro adquiridos para el Prado* (Madrid: Museo del Prado, 2006), 36. The standard studies of the genre of Spanish still life are William B. Jordan, *Spanish Still Life in the Golden Age 1600–1650* (Fort Worth: Kinbell Art Museum, 1985), and Alfonso E. Pérez Sánchez, *Pintura española de bodegones y floreros de 1600 a Goya* (Madrid: Museo del Prado, 1983). Peter Cherry has also contributed to our understanding, especially identifying the market for these pictures in the seventeenth century; see Peter Cherry, *Arte y naturaleza: El bodegón español en el Siglo de Oro* (Madrid: Fundación de apoyo a la historia del arte hispánico, 1999).

2. Anne W. Lowenthal, *The Object as Subject: Studies in the Interpretation of Still Life* (Princeton: Princeton University Press, 1996), 7.

3. Actually, Blas de Prado was on the payroll of the duke of Medina Sidonia, who must have sent the artist to Morocco in a strategy to promote peace and protect the coastlines; see J. M. Serrera, "El viaje a Marruecos de Blas del Prado," *Boletín del Museo y Instituto Camón Aznar* 25 (1986): 23–26.

4. Pacheco, *Arte de la pintura* (1648), ed. Bonaventura Bassegada i Hugas (Madrid: Ediciones Cátedra), 698. As Jordan suggested, the fact that Blas de Prado brought his still lifes on his trip and showed them to Pacheco reveals a certain pride in his work: "perhaps he sensed his work was in the vanguard of a developing tradition"; Jordan, *Spanish Still Life*, 10.

5. Cherry, *Arte y naturaleza*, 72. Jordan had tentatively suggested this attribution in 1985, although he now believes the painting may be by Van der Hamen; see William B. Jordan, *Juan Van der Hamen and the Court of Madrid* (New Haven: Yale University Press, 2005), 292–93. The only Spanish artist ever mentioned as making still lifes before Sánchez Cotán was Blas de Prado, and a few other works of similar style and date have come to light that make the attribution plausible.

6. William B. Jordan and Peter Cherry, *Spanish Still Life from Velázquez to Goya* (London: National Gallery Publications, 1995), 186. Cherry pointed out that other administrators working in Spanish-controlled Milan may well have collected local examples of the novel genre and brought them back when they returned to Spain, where Blas de Prado could have seen them. Nevertheless, the dryness of the pigment in *Plate of Pears* is typical of Spanish painters, compared to the technique employed by the Lombards, who used liberal amounts of oil when mixing ground pigment, resulting in a more fluid, liquid application of paint and a highly polished, glossy surface.

7. Cherry, *Arte y naturaleza*, 72.

8. Including six pictures representing the twelve months that appear in the 1607 inventory of La Huerta de la Ribera as "frutas, Carnes, y otras cosas significadas en cada uno dellos el mes de ano." See J. M. Florit, "Inventario de los cuadros y otros objectos de arte de la quinta real llamada 'La Ribera' en Valladolid," *Boletin del Instituto de estudios madrilenos* 14 (1906): 153–60; also cited by Cherry, *Arte y naturaleza*, 58.

9. See Sarah Schroth, "Early Collectors of Still Life Painting in Castile," in Jordan, *Spanish Still Life*, 28–37.

10. Pacheco, *Arte de la pintura*, 511.

11. See William B. Jordan, *La Imitación de la Naturaleza: Los Bodegones de Juan Sánchez Cotán* (Madrid: Museo del Prado, 1992), 13–18.

12. Jordan, *Spanish Still Life*, 50.

13. It is conceivable that foodstuffs were hung in these areas, but Sánchez Cotán purposely omitted practical details, such as a hook or other means of support, which indicates he did not want associations with a specific place; his still lifes are something more than illustrations of real life. After all, who would hang these particular objects in this artful way that seems to defy gravity in a *despensa*?

14. Jordan, *Spanish Still Life*, 58.

15. See, e.g., Emile Orozco Díaz, *El Fray Juan Sánchez Cotán* (Universidad de Granada: Disputación, 1993). Others see the paintings as a masterful exercise in seeing and painting, citing the growing individualism and scientific advances in society.

16. Federico Borromeo interpreted still life in this way; see Pamela M. Jones, *Federico Borromeo and the Ambrosiana: Art Patronage and Reform in Seventeeth-Century Milan* (Cambridge: Cambridge University Press, 1993), 76–84.

17. Jordan and Cherry, *Spanish Still Life from Velázquez to Goya*, 30.

18. Jordan, *Spanish Still Life*, 56.

19. Jordan, *Juan van der Hamen*, 83.

20. Jordan, *Spanish Still Life*, 128.

21. Cherry, *Arte y naturaleza*, 55–58.

22. Reindert Falkenburg, "Matters of Taste: Pieter Aertsen's Market Scenes, Eating Habits, and Pictorial Rhetoric in the Sixteenth Century," in Lowenthal, *Object as Subject*, 19.

23. David Davies, "Velázquez's Bodegones," in David Davies and Enriqueta Harris, *Velázquez in Seville* (Edinburgh: National Galleries of Scotland, 1996), 651.

24. Pacheco, *Arte de la pintura*, 518–19.

25. Dawson W. Carr et al., *Velázquez* (London: National Gallery, 2006), 27.

26. Pacheco, *Arte de la pintura*, 519.

27. Ibid., 420.

28. Ibid., 519.

29. Barry Wind, *Velázquez's Bodegones: A Study in Seventeenth-Century Spanish Genre Painting* (Fairfax: The George Mason University Press, 1987), 60-61.

30. Pacheco, *Arte de la pintura*, 517.

31. Wind, *Velázquez's Bodegones*, 61.

32. Kenneth Moxey, "Erasmus and the Iconography of Pieter Aertsen's *Christ in the House of Martha and Mary*," in *Journal of the Warburg and Courtald Institutes* 34 (1971): 335 ff.

33. Cherry, *Arte y naturaleza*, 89–90.

34. Carr, *Velázquez*, 28.

The *Camarín* and the Duke of Lerma's Pictures

1. The depressed housing market had probably lowered the value of the property; as in most of his real estate dealings, the duke benefited financially from the situations he himself helped create.

2. Two of these, the sale contract and the inventory of the Madrid gardens and *camarín* taken in 1605, have been published in Sarah Schroth, "The Duke of Lerma's Palace in Madrid: A Reconstruction of the Original Setting for Cristoforo Stati's 'Samson and the Lion,'" *Apollo Magazine* 159, no. 474 (2001): 18–21.

3. Miguel Moran and Fernando Checa found in the duke of Infantado's collections "otro camarín especial para Bidrios grandes y pequeños," and another "camarín de vidrios y barros" mentioned in the inventories of el principe Esquilache; see *El coleccionismo en España* (Madrid: Ediciones Cátedra, 1985), 188.

4. Both are mentioned in Moran and Checa, *Coleccionismo*, 207 (Góngora), 188 (Lope). For Góngora sonnet (XXXII), see Raphael Alberti, *Luis de Góngora: Antologia poetica* (Buenos Aires: Editorial Pleamar, 1945), 38–39. For Lope de Vega, see *Las Rimas de Tome Burguillos* (Barcelona: Editorial Planeta, 1976), 61.

5. The curators have attempted to re-create the impression of one wall of Lerma's *camarín* for this exhibition, adhering to the actual proportional distribution of the pieces and their arrangement as described in the 1605 inventory. Tracey Albainy, Russell B. and Andrée Beauchamp Stearns Senior Curator of Decorative Arts and Sculpture in the Art of Europe at the Museum of Fine Arts, Boston, was instrumental in identifying the types of objects in the *camarín* and in the selection of works of art and the reconstruction of the room for this exhibition. We are greatly indebted to her for her help and expertise.

6. Only one inventory in the ducal archives documents Francisco Sandoval's collection; it lists twenty-one anonymous works of religious subjects; Archivo de los duques de Lerma (ADL), Toledo, leg. 55, exp. 15.

7. See Chiyo Ishikawa, *The Retablo of Isabel La Catolica* (Turnhout: Brepols Publishers, 2004), 5–7.

8. Sarah Schroth, "The Private Picture Collection of the Duke of Lerma" (Ph.D. dissertation, New York University, 1990), 23–37; a complete transcription is on 116–203. The earliest inventory or "memoria y tassacion de las ymagenes Pinturas y Retratos que tiene el duque mi senor" was signed and dated September 26, 1603, by Vicente and Bartolomé Carducho, who attributed nearly 40 percent of the paintings Lerma owned at this point.

9. Some were the same subjects with similar dimensions as those recorded in 1603, although it is impossible to determine from the inventory whether these were new acquisitions or works transferred from Lerma's other residences. This lack of specificity is a recurring problem that makes it difficult to apprehend the exact size of Lerma's picture collection.

10. The gift is discussed in Sarah Schroth, "Charles 1, the Duque de Lerma and Veronese's *Mars and Venus*," *Burlington Magazine* 139, no. 1133 (1997): 548–50; Jonathan Brown, *Kings and Connoisseurs* (New Haven and London: Yale University Press, 1995), 112; and Jonathan Brown and John Elliott, eds., *The Sale of the Century: Artistic Relations Between Spain and Great Britain, 1604–1655* (New Haven and London: Yale University Press, 2002), 49–50.

11. Douglas Kirk, "Music to Beguile a King," note to audio compact disc, *Music for the Duke of Lerma*, Gabrieli Consort and Paul McCreesh (Hamburg: Deutsche Grammophon, 2002), 12–18.

12. Ibid. Lerma appointed a chapel master, Gabriel Diaz, who contributed to the modernization of compositional style in Spanish music, as well as twelve canons, an organist, a consort of five minstrels, and seven singers.

13. See Moran and Checa, *Coleccionismo*, 226–27; Marcus B. Burke and Peter Cherry, *Collections of Paintings in Madrid 1601–1755. Spanish Inventories I: Documents in the History of Collecting* (Los Angeles: The Provenance Index of the Getty Information Institute, 1997), 109–24.

Index

Credits